The Making of England
Anglo-Saxon Art and Culture
AD 600-900

Miniature of St John (f. 209b) (80)

The Making of England

Anglo-Saxon Art and Culture
AD 600-900

Edited by

Leslie Webster and Janet Backhouse

with contributions by
Marion Archibald, Nicholas Brooks, Michelle Brown,
Philip Dixon, Angela Evans,
Richard Gem, Simon Keynes, Michael Lapidge,
Andrew Prescott, Dominic Tweddle and Susan Youngs

UNIVERSITY OF TORONTO PRESS
TORONTO BUFFALO

© 1991 The Trustees of the British Museum
and the British Library Board

First published in
North America 1991 by
University of Toronto Press
Toronto and Buffalo

ISBN 0–8020–7721–8

Canadian Cataloguing in Publication Data
Main entry under title:

The Making of England

Catalogue of an exhibition held at the British
Museum from Nov. 8, 1991.
Includes bibliographical references.
ISBN 0–8020–7721–8
1. Art, Anglo-Saxon—Exhibitions. I. Webster,
Leslie. II. Backhouse, Janet. III. Archibald,
Marion. IV. British Museum.
N6763.M35 1992 709′.42′0744212 C91–095402–X

Designed by James Shurmer

Set in Ehrhardt and printed in Great Britain
by Butler and Tanner Ltd, Frome

Front cover: York helmet (47)

Back cover: Detail of Barberini Gospels (160)

Contents

Foreword

The three centuries between the arrival in England in 597 of the Christian mission led by St Augustine and the death of Alfred the Great in 899 were years of momentous change which were to transform the country for ever. Nowhere is this more graphically charted than in the splendid array of manuscripts, metalwork, sculpture and coins uniquely assembled here in celebration of an age famed for its art and learning as much as for its political and social transformations.

The exhibition forms a long-planned counterpart to 'The Golden Age of Anglo-Saxon Art 966–1066', also organised jointly by the British Library and British Museum, in 1984. As the last major exhibition to be shared in the Museum building by our two sister institutions before the Library moves to its new premises at St Pancras, it is, like its subject, a watershed, and a fitting climax to almost 250 years of life together. It is proper and pleasing that the exhibition and accompanying catalogue reflect in substantial measure the particular riches of our two national institutions in the Anglo-Saxon field, together with a magnificent collection of treasures loaned from elsewhere. It is also a splendid sign of the health of Anglo-Saxon studies that we have been able to present here a significant body of new material, whether in terms of fresh research, chance discoveries, or excavated finds.

We would like to express our warmest thanks to all who have taken part in the making of this exhibition and catalogue. First and foremost, we have been particularly fortunate in the generous response of many institutions and individuals who have lent their treasures to the exhibition. We are also indebted to those colleagues who have contributed essays, specialist advice and other crucial help with the text: Noël Adams, Marion Archibald, Nicholas Brooks, Michelle Brown, Philip Dixon, Angela Evans, Vera Evison, Richard Gem, Cathy Haith, Simon Keynes, Michael Lapidge, Kevin Leahy, Ray Page, Andrew Prescott, Dominic Tweddle and Susan Youngs. To the organisers of this exhibition and editors of the catalogue, Leslie Webster and Janet Backhouse, who dreamed it up, put it together and nursed it faithfully over the years, major thanks are due.

Finally, we owe a special debt of gratitude to our sponsors: to Robin Symes Limited for a substantial contribution to the exhibition, and to the Goldsmiths' Company, OWL International Ltd and Research Machines plc for significant donations towards the catalogue and our educational programme. Their extremely generous support has made it possible to present this major exhibition in a manner befitting the splendour and importance of its contents.

Sir David Wilson
Director
British Museum

Brian Lang
Chief Executive
The British Library

Historical introduction

The Anglo-Saxons, whose artistic, technological and cultural achievements in the seventh, eighth and ninth centuries are displayed in this exhibition, were the true ancestors of the English of today. At the time these works were produced, there were several rival Anglo-Saxon kingdoms, each of which had its own dynasty, its own aristocracy and its own separate traditions and loyalties. Spoken English already showed wide regional variations of dialect. None the less the Anglo-Saxons had a sense that they were one people. Thus their greatest historian, the Northumbrian monk, Bede, chose to write the 'Ecclesiastical History' of the single 'English people', not of separate English kingdoms. This overriding sense of belonging to a common race derived from a shared experience of migration from the continent and of winning land from the native British population. It also derived from a common past allegiance to pagan Germanic gods (Woden, Thor, Frig and many others) and from having accepted Christianity in a manner that tied the Anglo-Saxons closely to the authority of Rome. It therefore makes sense to view the greatest surviving examples of their artistic skills in jewellery, sculpture and manuscript illumination in one exhibition. It is also instructive to examine the books they wrote, or the gold and silver coins they produced or their workmanship in bone, leather and textile, in one overall sequence. But if we are to understand and appreciate their achievement fully, we must know something of who the Anglo-Saxons really were and how they actually lived.

Britain by 600

In the fifth and sixth centuries Britain had undergone astonishing political, economic and cultural changes. Political control of the island came to be split between the indigenous Celtic peoples, who retained or acquired power in the western and highland areas of the island, and Germanic 'Anglo-Saxon' invaders, who took over much of the east and south, that is those regions more suited to arable than to pastoral agriculture. Unlike the other provinces of the Roman Empire, Britain reverted to barbarianism, that is to an essentially prehistoric warrior culture. After the Roman legions had been withdrawn and the Emperor Honorius had in 410 instructed the British cities to provide for their own defences, the whole structure of the Roman state rapidly disintegrated: the army and civil service immediately, the cities and villas more slowly.

With the demise of the Roman state, the Latin language was also gradually abandoned (except by the Christian church) in favour of British (or 'Primitive Welsh'). This triumph of Celtic over Romance speech sets Britain in striking contrast to the continent. The British kings, 'tyrants' or war-lords, who can be briefly seen in the fifth century in the writings of St Patrick and in the sixth in those of the Welsh monk Gildas, were not Roman senatorial aristocrats aping a Roman lifestyle in surviving Roman villas. They were rather British-speaking leaders of war-bands of aristocratic warriors, who had carved principalities for themselves out of the maelstrom of the collapse of imperial authority. Their power depended upon raiding the territories of their neighbours for gold or silver, for cattle and for captives who could be enslaved.

The economy of Roman Britain had collapsed in these so-called 'Dark Ages'. Without a paid Roman army and a paid Roman civil service, there was no longer a need for Roman currency, so the supply of new coins from Roman mints on the continent quickly dried up. Without the need to equip, feed and clothe the troops and officials of the Empire, not only the Romano-British pottery industries but also a whole range of urban crafts in metal, bone and leather died or decayed. The cities of Roman Britain had always been artificial creations superimposed upon an Iron Age economy. Many of them had already been in decay in the later fourth century; all now went into rapid decline. Their walls and ditches retained military significance. Sometimes Roman imperial or municipal authority may have passed to British kings, such as the three who seem to have been associated with Gloucester, Cirencester and Bath in 577. In other towns churches may have continued to serve a Christian population of British origin. But urban marketing and trade seem to have withered with the collapse of the currency; town-buildings decayed and were replaced either in timber or not at all, so that the Roman street-layouts and Roman property boundaries were lost almost everywhere. The economy of sub-Roman Celtic Britain was a far more primitive one than its Roman predecessor: a tiny warrior aristocracy extracted treasure and tribute from a rural population, whether free or unfree, who were engaged in subsistence agriculture, predominantly pastoral.

Whilst these dramatic changes were in train, the large part of lowland Britain was passing from British to Anglo-Saxon control, and the language of the southern and eastern half of

the island was in the process of becoming English and its culture pagan. Written sources preserve only the most rudimentary information about these cataclysmic changes. The British monk Gildas, in the mid sixth century, wrote of the 'Saxons' being invited to Britain as mercenary troops to defend the British communities from attacks by their northern enemies. He told how the Saxons rebelled against their paymasters over the issue of rations, and of their subsequent bloody conquests 'from sea to sea'. This Saxon rising and conquest of much of Britain is dated to the year 441–2 by a contemporary chronicler in Gaul. In English tradition, as recorded in 731 by Bede, the invaders were said to be 'from the three most powerful races of Germany: the Saxons, the Angles and the Jutes'. The origin-stories of the Anglo-Saxon dynasties ruling Kent, Sussex and Wessex in the eighth and ninth centuries claimed that their royal lineages had been founded by successful invaders leading small war-bands carried in three to five ships around the middle or in the second half of the fifth century. According to Gildas a generation of warfare with fluctuating fortunes culminated in a major British victory at Mons Badonicus. Unfortunately this battle cannot be located, nor can it be dated more precisely than c.500. But the result of the British revival is clear. The advance of Anglo-Saxon conquest and settlement was checked for the first half of the sixth century. In medieval Welsh tradition this was the time of the legendary 'King Arthur'. Be that as it may, it was not until the second half of the sixth century that Anglo-Saxon conquests resumed and it is not until that period that the majority of the known Anglo-Saxon kingdoms seem to have been formed.

The Anglo-Saxon invasions were, of course, part of the wider Germanic migrations which changed the political map of the whole of Europe in the fifth and sixth centuries. But only in Britain did the language and religion of the Germanic incomers triumph. The English language today contains astonishingly few words taken over during the 'Dark Ages' by the Anglo-Saxons from the Celtic and Latin languages of the indigenous population. The place names of England include a number of river, forest and hill names of Celtic origin (the proportion increases in the more westerly regions); they also include some names incorporating Latin terms for visible relics of the Roman past, such as walled fortifications or stone-lined springs (-chester/-caster, -font). Such survivals point to an era when the British and Old English languages existed side by side. But the majority of the topographical names in England and virtually all the names for actual settlements (farms, enclosures etc.) and for groups of settlers are English. The comprehensive nature of the linguistic change in lowland Britain must reflect the scale of the Anglo-Saxon settlements; it shows that we are dealing with a true migration of settler farmers, whose experience in their north German homeland had been of mixed arable farming. The totality of the ultimate replacement of the British language

by English also, however, reflects the continued military dominance of the Anglo-Saxons and the consequent gap in the social and political status of the two languages. The British language had none of the aura of imperial Rome which so attracted continental barbarians; it was simply the language of those whose land the Anglo-Saxons were taking over. The fate of much of the British population of the south and east is revealed in the English word for a Briton, *Wealh* ('Welshman'), which also served as a normal Old English term for a slave. Except in frontier areas, it was as slaves that most Britons probably survived under Anglo-Saxon rule. They would have been in no position to influence the way in which the Anglo-Saxons spoke English.

The Anglo-Saxons also brought with them their own pagan gods whose cult appears to have very largely replaced Christianity in lowland Britain by the end of the sixth century. The war-gods, Tiw and Woden, the thunder-god, Thor, and the goddess, Frig, have left traces of their worship in place names and in the days of the week (Tuesday, Wednesday, Thursday and Friday). Astonishingly the fertility goddess, Eostre, has given us the English name for the greatest Christian festival, that is Easter, and has caused us to celebrate that springtime feast with egg symbolism. But the most obvious change that Anglo-Saxon paganism wrought was to introduce new burial practices. Some early Anglo-Saxon settlers cremated their dead and deposited the ashes in distinctive funerary urns; others were buried in the ground with clothing and equipment to accompany them to the next world. Both rites make pagan Anglo-Saxon cemeteries distinct. By contrast the graves of Britons, who under the influence of Christianity followed the practice of inhumation without grave goods, are very difficult to identify. Many burials without grave goods in pagan Anglo-Saxon inhumation cemeteries may well be the graves of Britons rather than of poor Anglo-Saxons; indeed some of those with grave goods may be of Britons who had begun to follow Anglo-Saxon burial practices. What is clear, however, is that as in Frankish Gaul barbarian conquest led to the establishment of new burial grounds. The distribution of pagan Anglo-Saxon cemeteries therefore provides the best indication of the extent of Anglo-Saxon settlement up until the time in the seventh or eighth centuries when their adoption of Christian ideas about death caused the Anglo-Saxons to cease placing jewellery and weapons in the grave and eventually to establish new Christian cemeteries.

England 600–900

Our understanding of the political and social development of the Anglo-Saxon peoples in the seventh and eighth centuries is transformed by their conversion to Christianity. In 596 Pope Gregory I despatched a party of forty Roman monks to Kent to commence the missionary task there. In 634 Oswald

returned from exile among the Gaelic peoples of western Scotland to seize the Northumbrian throne. Within a year he had invited a party of monks from Iona to Lindisfarne to begin converting the peoples subject to his rule. The work of these 'Roman' and 'Celtic' missions was assisted in piecemeal fashion by others from Frankish Gaul such as St Felix, from Ireland such as St Fursey, and in the border kingdoms very probably by British clergy. By the last decade of the seventh century the process had been so successful that all the royal courts of Anglo-Saxon England had adopted Christianity; bishoprics and monasteries had been established in most kingdoms, and the work of training English clergy and setting up a network of churches to bring effective pastoral care to a rural population was well under way.

This exhibition highlights the dramatic impact of Christianity upon the English: on the one hand, the new openings that the church provided for artistic and technical expression, and on the other, the pagan forms that it brought to an end. Not that the old pagan cemeteries and burial practices were abandoned suddenly; indeed, some of them continued in use until well into the eighth century. But the restriction and eventual abandonment of the practice of placing weapons and even jewellery in the grave means that our knowledge of the skills of Anglo-Saxon metalworkers and of the work they undertook for secular patrons is interrupted and greatly diminished. Occasionally, as in the magnificent helmets from Coppergate in York (47) and from Benty Grange in Derbyshire (46), we can see that Christian noble warriors were just as sumptuously armed or bedecked as their pagan predecessors had been. Similarly an episcopal pectoral cross (98) shows that Anglo-Saxon jewellers found that churchmen now required jewellery with garnet and other stones set in fine gold- or silverwork of comparable quality to that demanded by their lay clients. But in general it is true that our knowledge of the skills of Anglo-Saxon jewellers, goldsmiths and silversmiths no longer derives from burials. Increasingly for the eighth and ninth centuries it comes instead from treasure hoards, ecclesiastical or secular, that were buried in the ground for safe-keeping in times of danger, but which were never recovered by their owners; it also comes from the growing body of finds of individual items recovered either in archaeological excavations or by chance in building work or with metal detectors. Such discoveries give us a more balanced impression of the variety of the work of English craftsmen than do the weapons and personal ornaments from pagan cemeteries.

The greatest change that Christianity introduced, however, was the art of reading and writing. Christian missionaries brought with them from Italy, from Gaul and from Ireland the manuscripts that were essential for their pastoral work and for training monks and priests: namely the books of the Bible, especially the Gospels, and also liturgical and patristic works. As the numbers of converts grew, so copies were urgently needed, and scriptoria or writing offices were set up in all major churches. In time distinctive forms of Anglo-Saxon script were developed from Roman and Irish models. Christian traditions in art that derived from the Roman and Mediterranean world were introduced to decorate the most prestigious books, and there were opportunities too for indigenous Celtic and Germanic styles to be adapted to new Christian purposes. Churches needed to be adorned with sculpture in stone and wood, with plasterwork, wall-paintings and with textile hangings; crosses were needed of stone or of precious metals; chalices, relics and other Church treasures had to be ornamented. In the seventh, eighth and ninth centuries the Church in England became enormously wealthy through donations of land and treasure by pious kings, queens and nobles. Wealth enabled the Church to become a dominant, perhaps the dominant, patron. What survives today and is displayed in this exhibition is, of course, a tiny fraction of what must once have existed. But it does convey some idea of the rich inspiration of Anglo-Saxon artists and of their technical mastery of their craft in the service of the Church.

The churches established in every kingdom by kings and nobles also served as centres where the memory of these benefactors and of their dynasties was preserved. In other words, with Christianity came historical records. As a result, and thanks above all to the *Ecclesiastical History of the English People*, which the Venerable Bede completed in 731, we are very much better informed about the political development of Anglo-Saxon England in the seventh and early eighth centuries than we are about the preceding 'Dark Ages'. It was a turbulent period in which the political map was constantly being redrawn by the activities of warrior-kings and of their followers. Bede tells us of the more substantial Anglo-Saxon kingdoms, but it is clear that each of them was an amalgamation, forged by warfare, of smaller tribal groupings. The leading families of these small groups may each have once had ambitions to become powerful war-lords and to progress from cattle-raiding to the exaction of tribute of gold and silver, and thence to the conquest of an enlarged territory. Those who were most successful in this internecine warfare were able to attract a growing army of followers by the prospect of rewards of arms, treasure and land. Thus they founded enlarged kingdoms and turned their heterogeneous war-bands into landed aristocracies who took their ethnic or folk identity from the origins of their founders. The descendants of such successful war-lords ruled the kingdom as long as it survived as an independent unit.

In the course of the century from *c*.550 to *c*.650 about a dozen kingdoms formed in this manner can be recognised: in Kent and the Isle of Wight there were kingdoms that considered themselves Jutish; the Saxon kingdoms of the East, South and West Saxons have left their trace in the modern Essex, Sussex and Wessex; whilst to the north were the Anglian kingdoms of the East Angles, the Hwicce (in

Worcestershire and Gloucestershire), the Mercians, Lindsey, and (north of the River Humber) Deira and Bernicia (fig. 1). The east midlands seem still to have been divided among some twenty tiny peoples, but they were shortly to be formed into a province of the Middle Angles. It remains uncertain whether the Middle Angles and the Middle Saxons (Middlesex) with their 'southern province' (Surrey) had been ancient kingdoms with their own royal dynasties or were simply administrative provinces formed in the later seventh or early eighth century from the enlarged Mercian kingdom. Similar uncertainties surround the origins in the mid or late seventh century of the territories of the Wreocensæte ('the dwellers near the Wrekin') in Shropshire and the Magonsæte in Herefordshire.

The wealth and fortunes of these kingdoms in the seventh, eighth and ninth centuries depended upon three factors: the exploitation of their landed resources, their external trade, and their seizure by military force of treasure and of new land from neighbouring kingdoms. To exploit their own resources kings and their military retainers toured their kingdoms ceaselessly from one royal estate to the next. In part this was in order to consume the surpluses of perishable food brought there by their subjects as a form of rent or tax; in part it was to provide occasions to gather the people of the district and to display royal power and magnificence, to distribute gifts, to enforce justice and to issue laws. Like the contemporary Celtic rulers among the Welsh or the Dalriadic Scots, English kings exacted payments and services from their subjects on the basis of notional assessments of the number of peasant households ('hides') that particular communities contained. It was a rough and ready system – round figures of tens and hundreds of hides were the norm – but it enabled kings to define what food renders should be demanded from a fixed number of hides or to calculate the military resources of their kingdoms.

Trade with the continent began to play a role in the life of these early medieval states. The first coins produced in Anglo-Saxon England were gold coins minted in Kent and in London intermittently from the late sixth century in imitation of the contemporary 'tremisses' of the northern parts of Frankish Gaul. Their first function was to facilitate trade, though they were soon also used in the law as a means of reckoning fines and composition-payments. From the 670s English mints followed the Frankish and Frisian example in abandoning the use of gold in favour of silver. The new silver 'pennies' were produced from a growing number of southern and eastern mints and they circulated throughout the Anglo-Saxon kingdoms. Coinciding with the new silver coins were new trading centres established in the major kingdoms. These planned but undefended estuarine settlements – such as those at Southampton (*Hamwic*), London (*Lundenwic*), Ipswich and York (*Eoforwic*) – were the first truly urban communities in Anglo-Saxon England. They suggest that the kings of

Wessex, Mercia, East Anglia and Northumbria were seeking to break the near monopoly of long-distance trade which Kent's proximity to the continent had hitherto secured for that kingdom. By channelling the trade of their own kingdoms through their own ports, they could exact tolls on goods and ships for their own benefit. Royal control was made even more evident from the later eighth century when English pennies, imitating the reforms of the Carolingian ruler Pippin III, were increased in size and weight and henceforth always bore the name of the king on one side. Coinage was now explicitly a royal right, and we may presume that it was a highly profitable one.

But it was the fortunes of war, rather than agricultural wealth or the profits of trade, that determined the political shape of Anglo-Saxon England. War-leaders of genius, such as Æthelberht of Kent (*c*.580–616), Rædwald of East Anglia (*c*.610–27), and three successive Northumbrian kings – Edwin (616–33), Oswald (634–42) and Oswiu (642–71) – consolidated their own kingdoms and for short periods pushed themselves into prominence as powerful overlords, who took tribute from the other English kings south of the River Humber and compelled subject rulers to attend their courts. The Northumbrians extended their kingdom northwards to the Forth and westwards across the Pennines to the Irish Sea, bringing under their rule large areas where English rule and settlement was only a thin aristocratic veneer. But it was the Mercians whose long-lived and powerful rulers – Penda (*c*.626–55), Wulfhere (658–74), Æthelbald (716–57), Offa (757–96) and Cœnwulf (796–821) – most frequently dominated the politics and warfare of seventh- and eighth-century England. Their control of the huge tract of midland England and of the port of London, their exploitation of their long border with the Welsh, and their gradual annexation of neighbouring kingdoms – the Hwicce, Lindsey, Essex, Sussex and Kent – appeared to mark them out as the English kingdom with the greatest potential.

In this turbulent world the Church worked for English unity by discouraging kings from attacking each other, and by insisting on the payment of compensation – *wergeld* or 'blood-price' – whenever an Anglo-Saxon king or prince had been slain so that prolonged feuds did not develop between kingdoms. No such forbearance was extended towards the neighbouring British states. Anglo-Saxon churchmen regarded the Welsh with scorn, in part because they claimed the Britons had neglected to convert the English to Christianity and in part because until the ninth century the Welsh Church refused to accept Roman authority on the date of the Easter festival. English kings were therefore encouraged to pillage British churches and to use the confiscated properties to enrich and endow English monasteries. This was the racialist climate of opinion in which military leadership passed in the seventh and eighth centuries to those Anglo-Saxon kingdoms (Northumbria, Mercia and Wessex) which

0 50 100 150 200km

Fig. 1 Map of Anglo-Saxon kingdoms *c*.550–650

13

had a frontier with the Britons where new conquests could be made and punitive tributes exacted.

A less unattractive aspect of English nationalism was the missionary work that Anglo-Saxon churchmen undertook among the continental Germans in the eighth century. They combined the Celtic ideal of holy exile with the Anglo-Saxon awareness that their continental kinsmen were still pagans. Northumbrians such as St Wilfrid and St Willibrord attempted to commence the conversion of the Frisians of the Low Countries; West Saxons, including St Boniface and Lul, reorganised the Church among the Rhineland Franks and the Bavarians so that it could provide a base for missionary work among their pagan neighbours, the Hessians and Thuringians. The flow of English monks who made careers for themselves in the new sees and monasteries was soon matched by a flow of English works of art: illuminated gospels, books of all sorts, crosses and chalices, embroideries for altars and vestments. It is a paradox that, because of such Englishmen overseas throughout the eighth century, more of the finest examples of English workmanship of the period have survived on the continent than in England (e.g. 133, 138).

The loss of many of the contemporary works of art that remained in England can be attributed to the Viking raids and invasions of the ninth century. The Norse and Danish bands were not only pagan, they were also equipped with the best ships known in the early medieval world. They were therefore able to subject the royal and ecclesiastical centres of the Anglo-Saxons to the sorts of terror that the English had long visited upon the Welsh: increasingly systematic raiding, exaction of tribute, and (in the later ninth century) conquest and the establishment of Viking kingdoms. Where in 850 England had been divided between four large and wealthy Anglo-Saxon kingdoms (Northumbria, Mercia, Wessex and East Anglia), by the end of the century only Wessex and a fragment of western Mercia and of northern Northumbria survived under English control. In their place powerful Viking kingdoms had been established in East Anglia and in the north at York when the larger Danish

armies had ceased campaigning, had settled on the land and established Scandinavian colonies based upon fortified boroughs. The wealth extorted from Anglo-Saxon communities and churches made these Scandinavian settlements by 900 the most prosperous parts of England and fuelled the economies of new urban settlements at York, Lincoln, Norwich and elsewhere.

The effect on the English church and on Christian culture was cataclysmic. The archiepiscopal church at York maintained a precarious existence under pagan kings, and the community of St Cuthbert retained its cohesion, along with its most important relics and treasures – the body of St Cuthbert and the Lindisfarne Gospels (80) – through years of flight until they gained permission to settle at Chester-le-Street in 883. But most bishoprics and monasteries and almost all libraries in eastern and northern England came to an end through destruction or decay. Even in Wessex there was very little inclination to follow an ecclesiastical or monastic vocation when churches were so vulnerable. Latin literacy declined disastrously so that even in major churches, like the archiepiscopal see of Canterbury, the production of books, the writing of charters and the training of clergy were at risk. In the eyes of the West Saxon king, Alfred (871–99), and of his advisers, the Vikings were God's punishment for a people who had neglected their religious duties. He therefore set about military transformation, reforming his army and building garrisoned boroughs, but also inspired a religious renaissance. He attracted to his court scholars and craftsmen from the continent and from Mercia and began an ambitious programme of education, of translation into English of the works he held to be most essential for the propagation of Christian values, and of copying and dissemination of manuscripts of these works to the major churches of his kingdom. By the time of his death in 899 it was very far from clear how successful these measures had been. No one could predict whether political and cultural power would lie with the West Saxon descendants of King Alfred or with the rich Viking kingdoms of the east and north.

NICHOLAS BROOKS

Pagan into Christian

The most important cultural change to affect Britain in the decades around 600 was the adoption of Christianity by many of the rulers of the multifarious settlers and long-term inhabitants of the island. Christianity did not initially provide a unifying element but was by the later seventh century to provide the basis of a structure of organisation, with bishops and metropolitan bishops, which overreached the frontiers of the individual, highly competitive English kingdoms. The acceptance of the Christian religion was of far-reaching importance because it involved the introduction of literacy and the written record, the introduction of Latin as a vehicle for the transmission of knowledge and because, implicitly, it involved the acceptance of an authority beyond the boundaries of the kingdom, acceptance of the servants of the Church as a source of local authority, and as consumers of precious resources. In material terms it required buildings, books, vessels for the sacraments and other furnishing, icons and shrines, all items whose models were derived from the art of the Mediterranean world.

The British and Irish kingdoms of the west and north had accepted Christianity during the fourth and fifth centuries and through them the Pictish peoples of the far north were converted. Elsewhere in Anglo-Saxon Britain the means of its introduction and acceptance were so varied from one kingdom or territory to another that this created its own internal crises within the new territorially-based churches, the most famous being resolved at the 'Synod' of Whitby in 664.

Conversion of the pagan Anglo-Saxon settlers came from a number of sources; perhaps least important was the contribution of neighbouring Christian British territories. Such meagre evidence as remains indicates legal penalties against contact with the invading pagans. There are hints in place-name evidence and in the continuity of cult sites that the sub-Roman population of Kent, the west midlands and Bernicia did maintain Christian communities under pagan Anglo-Saxon rulers, but Bede, writing in the eighth century, reproached the British for their failure to evangelise their neighbours. The introduction of the Christian faith was very much bound up with the establishment of larger units of political power, the growth of kingdoms and wider hegemonies. Three of the successive kings credited with authority over other kingdoms, Æthelberht of Kent, Rædwald of East Anglia and Edwin of Northumbria, passed on the new faith, one to the next, almost as though it were the new talisman for effective rule.

Proselytisers of the new religion had behind them the fortifying knowledge that this was indeed the *old* religion, the faith of emperors, of the Roman world, a world of cities and markets, of precious coinage, of law-codes and great armies.

This was a potent inheritance, and one that by the mid sixth century was already widely accepted and emulated by most of the Germanic conquerors of Western Europe, from the Arian Lombards in Italy itself to the powerful and aggressive ruling dynasty of the Franks across the English Channel. Frankish ambitions certainly extended into the wealthy, neighbouring kingdom of Kent in the south-east of Britain. This was the most powerful of the Anglo-Saxon kingdoms to emerge into the historical and archaeological record in the course of the sixth century. Its precocious development included the issuing of coins and codified laws and the acceptance of Christianity by its long-lived King Æthelberht, who was allied by marriage to the Christian Frankish dynasty which ruled Neustria, modern-day northern France. In Kent, as elsewhere in the Anglo-Saxon kingdoms, conversion was achieved by royal consent and patronage, but here, in a quite remarkable way, it was initiated by the direct intervention of Pope Gregory I. Gregory was himself besieged in Rome by heretical, barbarian Lombards, but he sent his prior Augustine with a band of monks 'to the English believing in Christ', on the understanding that their conversion was neglected by the neighbouring priests. From contemporary correspondence it appears most probable that Gregory understood the Frankish kings to have some authority in Kent and that his original intention was to use Augustine as his own agent to promote reforms within the Frankish Church. The reality in distant Britannia was very different, and Augustine, first as bishop and then as archbishop, turned his skills to the conversion of pagan King Æthelberht and his subjects. He had a master-plan for a structure, based on the former Roman provinces with metropolitan sees at London and York. Sees were founded at the Roman towns of Canterbury, Rochester and London, but contemporary events prevented the establishment of the southern metropolitan see in London and it has remained Canterbury-based ever since. Nevertheless, Augustine failed to form an alliance with the monks and clergy of the Welsh kingdoms and, despite the presence of Paulinus in York and of the deacon James, the work of the Roman mission was almost undone by war, apostasy and plague. Almost all we know about the mission of Augustine in Kent from English sources was recorded in the writings of the Northumbrian monk Bede. A very exotic and fragile sapling had been planted, which only took root and flourished throughout Anglo-Saxon Britain under the direction of Archbishop Theodore towards the end of the seventh century. Augustine's mission had extended into Essex, into Northumbria through the agency of a royal marriage, and into East Anglia, but all three kingdoms were to be successfully converted from other sources.

Remarkably, it was from the relatively recently founded Irish kingdom of Scottish Dalriada, centred in the area of modern Argyll, that other major missionary work was initiated. Its source was the monastery founded on the island of Iona by Columba in 563. Oswald, a Northumbrian prince, had been exiled in Dalriada and on his return to Northumbria asked the abbot of Iona to send someone to convert his people. One candidate was deterred by the barbarity of the Northumbrians, but in 635 the Irish monk Aidan came and founded his own island monastery on Lindisfarne and began the conversion of this extensive kingdom. Two aspects of this mission were critical for the success of the venture: the Christian teachers, monks in every case, came by royal request, and they were established by royal patronage. The expanding territories of Bernicia and Deira were united to form Northumbria which then came into conflict directly with the British and then the Scots of lowland Scotland. Ecclesiastical structures such as, primarily, the sees of bishops depended upon the political boundaries of a kingdom, so, for example, the ancient British see of Whithorn became a Northumbrian see in the eighth century.

Under Oswald of Northumbria the influence of Iona-derived Christian practice extended far beyond Northumbria. In 635 he stood as godfather to the first Christian king of Wessex. His brother Oswiu brought the rulers of the East Saxon kingdom back into the Church, sending the priest Cedd who owed obedience to Lindisfarne. All this activity was important because among all the Ionan foundations the Christian calendar was calculated in a different way from current continental practice, so that when Oswiu's marriage led to two retinues in the Northumbrian royal household observing feasts on different days, this matter, and others, had to be resolved, and one superior Church authority recognised. This was the source of dispute behind the Whitby gathering. The decision in favour of current Roman practice therefore brought far more than the extensive kingdom of Northumbria into line. It was also a success for the first Roman mission; Oswiu's queen was Eanfled, who as a child had been snatched from the jaws of pagan reaction and taken south by Paulinus.

Gregory the Great's apparent understanding that the Merovingian rulers of the Franks had authority over their Anglo-Saxon neighbours in Britain is supported by what we know of the conversion of the newly emerged kingdom of Wessex. First missionary activity was undertaken by a Frankish bishop, Birinus, at the court of King Cœnwalh. Birinus's successor, Agilbert, was also a Frank and returned to Gaul to become bishop of Paris while his nephew 'inherited' the West Saxon see. Looking at this succession in the light of the formal structure of authority in the Roman Church, whereby every bishop owed obedience to his metropolitan, it suggests substantial Frankish royal influence at work in the conversion of this English kingdom, given that episcopal appointments were firmly under the control of Frankish rulers. This may also explain the unexpected presence of Oswiu at Cœnwalh's baptism, a public demonstration of Northumbrian authority. The first bishop established by royal patronage in the rich kingdom of East Anglia was a Burgundian, Felix. It is not clear whether here, and in Wessex, we are looking at a bishop operating independently in a missionary context or at someone already bound by religious and political ties to their native Church. King Sigeberht of East Anglia had been baptised in Gaul, an exile like Oswald, returning home committed to the introduction of Christianity, the religion of the Roman world.

This emphasis on status, prestige and worldly standing is not to deny the moral and spiritual qualities that drew people to adopt Christianity; it is, however, the political and broader social significance that left their mark most clearly in contemporary records, from coins to law-codes, and in Bede's *Historia Ecclesiastica Gentis Anglorum*, where the aristocratic nature of the spread of Christianity is very pronounced. The presence of isolated, independent Christian communities such as the Irish monks at Bosham or of Fursey in East Anglia was apparently of little significance in the overall pattern of conversion.

Resistance to the new force is equally significant, if poorly recorded by literate Christians. The aggressive, expansionist kingdom of Mercia in the west midlands remained pagan under Penda, although he was in alliance with the Christian Cadwallon and two of his sons were Christians. He fought Northumbria under the protection of the old gods. About the latter we know very little, since contemporary records were made by monks. The early Germanic pantheon is remembered in everyday speech in the days of the week, or the rare place name. Burial practices show different systems of ritual in use contemporaneously and sequentially, cremation and inhumation for example. Myth, folklore and medicine may preserve elements of formal systems of belief. We can deduce from the pattern of the introduction of Christianity that the aristocracy played a central role in the religious life of their people. The Anglo-Saxons have left potent and enigmatic signs, symbols and decorative schemes on contemporary objects, whether simple burial urns or princely shields. The Germanic people of Britain remained aware of their pagan roots and had a conscious mission to bring their pagan kinsmen in their continental homelands to the Christian faith, a remarkable ambition on the part of a newly established Church. The South Saxons were not converted until after 678 under Mercian patronage, and the Northumbrian Wilfrid evangelised these people before undertaking similar work overseas in Frisia. How long did it take before a Christian king ruled over a Christian people? Aidan's successor, Cuthbert, was renowned for his constant journeys to preach in isolated communities in Northumberland; on the other hand, there were 'blasphemous' peasants to jeer at monks of the Tynemouth community when the latter were threatened with death. Here archaeology can provide evidence for the individual and the community, while the historical sources have preserved principally the actions of men in authority.

By the year 731 Bede could write, 'At the present time there are five languages in Britain, just as the divine law is written in five books, all devoted to seeking out and setting forth one and the same kind of wisdom, namely the knowledge of sublime truth.' The first of these was Anglo-Saxon.

SUSAN M. YOUNGS

Manuscripts

The introduction into England of the book-based Christian religion was of dual significance because it also marked the introduction of a book-based Latin culture. Both concepts were initially alien to Anglo-Saxon society but it proved remarkably receptive to them. Within two generations England was producing both churchmen and scholars equal to any in contemporary Europe. To one of these scholars, the Venerable Bede, we are indebted for the most important single narrative source of information about this vital period in English history, his *Ecclesiastical History* (2).

Supplies of the books essential to the practice of the new faith must have been among the necessities which the first missionaries carried with them. In the case of St Augustine, arriving in Kent in 597, the immediate source of these books was Rome. His mission was the direct result of the personal initiative of an outstanding scholar and theologian, Pope Gregory the Great, who had at an earlier period of his own career cherished ambitions of leading a mission to the English nation and had once actually set out upon the journey. Augustine was a personal friend and close colleague of the Pope and, like him, rooted in the ideas and attitudes of sixth-century Roman society. A single manuscript can, with reasonable certainty, be associated with his introduction of the Christian faith into southern England. It is, predictably, a fine Italian illuminated copy of the gospels (1).

In the north of England a first attempt to establish the Church, begun in 625 under the leadership of Augustine's companion Paulinus, was decisively ended when his royal patron, King Edwin, was slain at Hatfield in 633. When the work of conversion was renewed two years later the new king, Oswald, who had already accepted Christianity during his exile in Dalriada, looked to the west rather than to the south for assistance. St Aidan, who established the monastery of Lindisfarne in 635 within sight of the royal stronghold at Bamburgh, came from Iona, founded some seventy years earlier by the Irish St Columba, who died in the year in which Augustine reached Kent. From Columba's biographer Adomnan (3), from whom we learn something of the early history of his extremely influential house, we also learn that Columba himself was an active scribe, responsible for a substantial number of manuscripts. Irish scholarship and Irish scribal practices were to be fundamental to the achievements of the Northumbrian church. Furthermore a respect for the accomplishments of the scribe, implicit in Adomnan's description of Columba's work, was also handed down and is reflected in Æthelwulf's account of the scribe Ultan, monk of a dependency of Lindisfarne, which is given in his *De abbatibus*, composed at the beginning of the ninth century.

The Latin language associated with the Church was superimposed upon an extremely strong vernacular tradition which persisted until after the Norman Conquest. Both Augustine in the south and Aidan in the north encountered linguistic difficulties in their efforts to spread the word of Christ. Augustine, on Pope Gregory's advice, brought with him Frankish interpreters whose speech was intelligible in Kent.

Aidan, whose native tongue was Irish, was upon occasion assisted by King Oswald, who had become fluent in Irish while in exile. The necessity of employing the vernacular in communication with their largely illiterate flock was clear to the churchmen of the seventh and eighth centuries. In his last recorded work (96) Bede was still encouraging his friend Ecgberht to instruct the priests of his diocese to use the Anglo-Saxon tongue when instructing their congregations in the Lord's Prayer and the Creed.

Anglo-Saxon England produced the most extensive vernacular literature of any country in Europe during the early Middle Ages, with a particular emphasis on poetry. Originally this was transmitted orally, but about the year 1000 much of it was committed to writing in a number of great anthologies. Among the manuscripts produced at this time was the unique copy of the most celebrated of all Anglo-Saxon literary works, the epic poem *Beowulf* (4). It is impossible to date this work with any kind of precision and very likely that it passed through numerous stages of adaptation and modification in a long oral career. Nevertheless *Beowulf*, more than any other single source, most vividly reflects the confusion of ideas and imagery current in England during the period of conversion.

JANET BACKHOUSE

1 The Gospels of St Augustine

Cambridge, Corpus Christi College, MS 286
Vellum; ff. 265; 245 × 180 mm
Latin; 6th century
Italy

This sixth-century uncial manuscript, written and illuminated in Italy, was almost certainly among the books with which Pope Gregory the Great supplied St Augustine's mission to England at the end of the sixth century. It is thus among the most venerable relics of English Christianity. The manuscript was demonstrably in England in the late seventh or early eighth century, when an insular hand added captions to its illustrations. Documents relating to the abbey of St Augustine at Canterbury were written into it in the eleventh century. It was probably among the 'libri missi a Gregorio ad Augustinum' which were displayed with other relics at the high altar of the abbey in the fifteenth century. Although the book has been in Cambridge since the sixteenth century, its ancient association with Canterbury is maintained to this day, for on the occasion of the enthronement of each new archbishop of Canterbury, it is taken to Canterbury Cathedral to act as oath book.

Originally the manuscript was decorated with miniatures of the four evangelists, seated under arches, each accompanied by a series of small scenes from the life and ministry of Christ. At least two further illuminated pages were devoted entirely to similar small biblical scenes and there may also have been a series of canon tables. Only the miniature of St Luke and one of the pages of scenes now survives, but these serve to give a fair impression of the richness of the cycle, which originally included at least

1 Miniature of St Luke, with gospel scenes (f. 129b)

seventy-two different episodes in addition to the figures of the evangelists and their symbols. Traces of the influence of this manuscript have been recognised in Canterbury books of many later periods, both before and after the Conquest.

JMB

Bibliography: CLA, ii, no. 126; McGurk 1961, no. 3; F. Wormald 1954, reprinted in Wormald 1984, 13–35.

2 Bede's *Ecclesiastical History of the English People*

Cambridge, University Library, MS Kk. v. 16
Vellum; ff. 128; 290 × 215 mm
Latin; *c.*737
Northumbria (probably Monkwearmouth/Jarrow)

Bede's *Ecclesiastical History* is the most important single source for the story of the conversion and the development of the church during the seventh century. The work was completed in 731, when Bede was in his fifty-ninth year and had been a member of the Monkwearmouth/Jarrow community for more than half a century. He died in May 735. From his preface we learn that he had gathered his information from contacts all over England, some of whom had searched written records for him, even as far afield as the papal archives in Rome.

The *History* was in great demand from the time of its completion and more than 150 medieval manuscript copies are known. This manuscript, named the 'Moore Bede' because it once belonged to John Moore, bishop of Ely (d. 1714), is one of the earliest. It was written about 737 and is a practical rather than a luxury copy. Margins and word spacings are minimal in order to ensure economical use of vellum. The manuscript left England for continental Europe early in its history and was in the library of Charlemagne's Palace School at Aachen at the end of the eighth century. A number of later copies made in France are descended from it. Two further copies of the *History* are included in other sections of the exhibition (**92**, **170**).

Bede provides a graphic description of the first meeting between King Æthelberht of Kent and St Augustine and his followers. This took place in the open air, to safeguard the king against any magical arts which might be practised by the strangers. A silver cross and a painted image of Christ were carried in procession by the missionaries, who chanted litanies.

JMB

Bibliography: CLA ii, no. 139; Hunter Blair 1959; Colgrave and Mynors 1969; Robinson 1988, no. 68.

2 Bede's description of the arrival of St Augustine (f. 16)

3 Adomnan's Life of St Columba

British Library, Additional MS 35110
Vellum; ff. 187; 295 × 195 mm
Latin; before 1195
Durham

Columba was born in Ireland early in the sixth century. He founded the island abbey of Iona, off western Scotland, in 563 and died there in 597, the year in which Augustine's mission arrived in Kent. He also founded monasteries at Derry and at Durrow in Ireland. It was from Iona that Aidan was sent in 635 to Northumbria, where he established the monastery of Lindisfarne under the protection of King Oswald. Close contact between Northumbria and Iona was maintained throughout the period chronicled by Bede.

Adomnan, author of Columba's Life, was the ninth abbot of Iona and died in 704. He wrote the Life about 688–92, relying upon earlier, unspecified, written sources and oral traditions for his material. His work is the main source of information about the saint. Two variant versions survive. The first is in an early eighth-century manuscript in the Stadtbibliothek at Schaffhausen in Switzerland. This was probably written at Iona itself not long after Adomnan's lifetime. The exhibited manuscript is the earliest known copy of the second version and was made at Durham in the late

3 The opening of Columba's Life, with a list of bishops (ff. 96b–97)

twelfth century, during the time of Bishop Hugh de Puiset, who died in 1195. His is the last name in the listed succession of bishops of Lindisfarne, Chester-le-Street and Durham included in the volume. The manuscript also contains Lives of Cuthbert, Aidan, Oswald and Edward the Confessor, beginning with a Life of Augustine of Hippo, which suggests that it was from the first intended for the use of an Augustinian community. JMB

Bibliography: Anderson and Anderson 1991; Watson 1979, no. 370.

4 *Beowulf*

British Library, Cotton MS Vitellius A. xv (part ii)
Vellum; ff. 116; approx. 195 × 120 mm
Old English; *c*.1000 (composite volume)

Beowulf is a vernacular heroic epic for which no parallel exists amongst the substantial body of Anglo-Saxon poetry which has come down to us. The date of origin of the work remains the subject of lively scholarly controversy, opinions ranging from the seventh to the early eleventh centuries. Christian and pre-Christian imagery mingle in the poem. The bards of Heorot sing of the Creation, just as Bede records that Cædmon of Whitby sang in the vision which miraculously gave him the power of song, and the monster Grendel is characterised as the seed of Cain. At the same time the ship-

borne funerals of Scyld Scefing and of Beowulf himself, with which the poem begins and ends, bear an unmistakable resemblance to archaeological evidence from Sutton Hoo. *Beowulf* thus bears witness to a confusion of cultures in the period which followed the introduction of the Christian religion.

The poem survives in a single copy made about 1000. Most Anglo-Saxon poetry is known from anthologies written down at about this time, in what appears to have been a conscious effort to collect and preserve the vernacular literature of earlier periods. The volume, which contains other Anglo-Saxon material of entirely different origins, apparently arranged by Sir Robert Cotton, was severely damaged in the Ashburnham House fire of 1731. JMB

Bibliography: Zupitza 1959; Malone 1963; Chase 1981; Kiernan 1981.

4 The funeral of Scyld Scefing (f. 129b)

Metalwork and sculpture

The two centuries between the abandonment of Britain by the Romans and the arrival of St Augustine in Kent in 597 are amongst the most difficult to decipher. During this time the foundations of Anglo-Saxon England were established in a country that had to a great extent regressed to lifestyles more typical of the late Iron Age. The upheaval caused by the Roman withdrawal from the province led to a collapse of civic institutions, the decline of urban centres, an immediate drop in population and a retreat from marginal agricultural land exploited to support the army and civil administration in Britain and other provinces of the Empire. The agricultural heartland of the former province, however, remained substantially intact, worked by an indigenous population, of whom many were probably Christian, but who are extraordinarily difficult to see in the archaeological record. This settled landscape was subsequently infiltrated over many generations by incomers of Germanic stock, pagans, with distinctive styles of dress and metalwork, whose customs, social structure, burial practices and, eventually, language, supplanted those of the British throughout the eastern half of Britain from Kent to the Humber.

By the end of the sixth century, Anglo-Saxon England was in most ways established; the population was firmly stratified; nascent kingdoms were testing their strength, jockeying for supremacy and, in certain cases, Kent particularly, building diplomatic ties through marriage with Francia. Into this rapidly developing society Christianity was reintroduced, initially to the élite, by the establishment of the Augustinian mission in the kingdom of Kent, and written sources outline its progress. At grass-roots level, the preoccupations, as in any land-based subsistence economy, were with life, survival and death, and the changing patterns of early Anglo-Saxon attitudes to death as Christianity filtered through the population are visible in these cemeteries.

Cemetery archaeology has been a major preoccupation of archaeologists since the nineteenth century when hundreds of graves in both inhumation and cremation cemeteries were opened by a variety of excavators, mostly amateur antiquarians, who were primarily interested in the objects buried with the dead. Little or no attention was paid to grave structure, the style of burial or the development of the cemetery as a potential source of information about the structure of the community that used and respected it. Current cemetery excavations address a wide range of questions and modern excavation techniques enable archaeologists to retrieve a range of detailed information to provide a wider context in which the grave goods are a contributing rather than the prime factor. Equally, post-excavation processual techniques enable the archaeologist to approach more closely an understanding of the underlying social trends that conditioned the growth of the settlement cemeteries. Within this wider context it is possible to retrieve information about the cautious approach to the adoption of new beliefs by the early Anglo-Saxons as Christianity impinged on their society, inevitably promoting in its wake a more uniform culture in

which the regional identities that were so strong an element in the early settlement phase were submerged.

During the seventh century Christianity gradually threw a net across the Anglo-Saxon kingdoms, working via the élite to convert the populace, building churches and minsters and establishing church-associated cemeteries, so that by the end of the century pagan-style burial with possessions was almost entirely supplanted by ranks of east/west burials without possessions and the potential for face-to-face encounter with the Anglo-Saxons was extinguished. With the consolidation of the kingdoms and the near symbiotic relationship between the Church and the royal court, the seventh century, like its predecessors, was inevitably a period of dynamic social and political change and an age of religious ambivalence that is clearly seen in the archaeology of death. At Finglesham in Kent, the kingdom where Christianity immediately gained a strong foothold, the pagan cemetery was not abandoned in the seventh century but new graves were consistently oriented east/west, suggesting at least a token observance of Christian burial practice. As the adoption of Christianity spread north and west, new cemeteries were often established within easy distance of their pagan predecessors so that a community could observe current belief without fully severing its connections with its ancestors.

Adoption of new religious beliefs inevitably brings with it insecurity as familiar icons are set aside in favour of new concepts and emblems. Pagan beliefs were probably only gradually and reluctantly relinquished and during the first half of the seventh century there is evidence of pagan survival

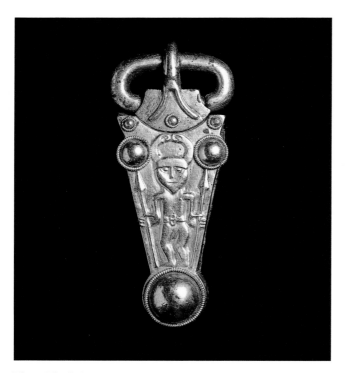

Fig. 2 Finglesham, Kent: gilt-bronze buckle from grave 95, with dancing warrior; early seventh century

or resurgence portrayed in personal possessions, for example the Finglesham buckle (fig. 2) with its lively pagan cult figure. There is also evidence of religious dualism, where two protective symbols are balanced against each other on a single high-status possession, like the boar and the cross on the Benty Grange helmet (46), an ambivalence that is reflected at all levels – in the placing of pagan amulets in middle-ranking graves, in the suggestion of ritual abuse of the dead from a variety of sites (for example, decapitation and face-down burial at Sutton Hoo), and at the highest level of society, in the ambivalence, no doubt politically motivated, shown by Rædwald of East Anglia, an early convert to Christianity who maintained altars to pagan deities alongside a Christian one.

Despite early setbacks, Christianity flourished in the social climate of the seventh century and by the middle of the century the fashion for declaring belief through the use of Christian symbols on fine metalwork becomes more popular. The fish, generally accepted from Roman times as a Christian symbol (albeit a more cryptic one than the cross) occasionally occurs on Anglo-Saxon metalwork. An outstanding example decorates the Crundale buckle (6) but whether this is an outright declaration of its wearer's belief is impossible to judge. On personal jewellery the pervasive influence of Christianity becomes stronger as prevalent fashions, which include coin pendants (e.g. the finds from St Martin's, Canterbury (5)), and pendants ornamented with idiosyncratic zoomorphic decoration, like the superb gold and garnet triple bird-headed pendant from Faversham (9), recede as jewellery carrying cross motifs proliferates (e.g. the disc-pendants from grave 93, Boss Hall, (33)). Whether such generalised cruciform motifs can be safely interpreted as specifically Christian is open to question but small equal-armed pendant crosses (e.g. Winster Moor, Derbyshire) and exceptional personal jewels of the quality of the Wilton and Ixworth pendants (12, 11) or the composite brooch decorated with cross motifs from Boss Hall (33), all high-status possessions spread across the seventh century, are a strong indication of the acceptance of Christianity by the middle and upper echelons of Anglo-Saxon society.

By the turn of the eighth century, Christianity, with tightly-woven links securing it to the royal courts, was generally the accepted religion with a continually expanding network of churches and church-associated cemeteries. The acceptance of Christian style burial by the Anglo-Saxons finally cuts archaeology off from the individual, and the development of the political structure of the English kingdoms predominates as historical sources finally overhaul archaeology as the principal source of information.

ANGELA EVANS

5a–h

5 (a–h) The Canterbury St Martin's 'Hoard'

Gold, cornelian, garnet, glass; individual dimensions below
Early Byzantine, Anglo-Saxon; c.600; Merovingian; mid 7th century
National Museums and Galleries on Merseyside, Liverpool Museum,
inv. no. M7013–M7020

Five coin pendants and a 'medalet', a composite disc brooch
fragment, and a pendant with a cornelian intaglio:

5 (a) Gold Italian tremissis of Justin II (565–78)

Ribbed suspension loop.

D. (incl. loop) 1.6 cm

5 (b) Gold Kentish so-called 'medalet' of Bishop Liudhard

Ribbed suspension loop.

D. (incl. loop) 1.7 cm

5 (c) Gold ?West German tremissis imitating a fourth-century Roman bronze coin

The plain suspension loop is a nineteenth-century replacement.

D. (incl. loop) 1.3 cm

5 (d) Gold Merovingian solidus IVEGIO VICO

Ribbed suspension loop and beaded wire rim.

D. (incl. loop) 2.2 cm

5 (e) Gold Merovingian tremissis, c.570–80, struck at Agen, Lot-et-Garonne

Ribbed suspension loop.

D. (incl. loop) 1.6 cm

5 (f) Gold composite cloisonné disc brooch fragment

Sheet gold upper plate with separately applied plain rim
edged with beaded wire. A central rectangular setting filled
with green glass is surrounded by four lozenge-shaped flat-
cut garnets alternating with four triangular ones. On the back
are the remains of two attachment rivets.

D. 2.0 cm

5 (g) Gold Merovingian tremissis, c.570–80, struck at St Bertrand-de-Comminges, Haute-Garonne

Ribbed suspension loop with twisted filigree wire strip.

D. (incl. loop) 1.8 cm

5 (h) Gold pendant

Set with an oval cornelian intaglio depicting Minerva in a gold collar, with beaded wire border and ribbed suspension loop; plain sheet gold back-plate.

D. 1.6 cm

This 'hoard' was always assumed to have been found in the churchyard of St Martin's, Canterbury, the pre-Conversion church restored for the Frankish princess Bertha after her marriage to Æthelberht of Kent, but the earliest published reference ascribes it to 'the grounds of the monastery of St Augustine' nearby (Roach Smith 1845, 187). Two of the coin pendants and the 'medalet' (*a–c*) were exhibited by William Rolfe in 1844 at a meeting of the Numismatic Society. By the following year he had acquired the rest of the group which was then published by Roach Smith in 1845. A looped gold tremissis from Oloron, Basses-Pyrenées, now in the Bibliothèque Nationale, Paris, is also thought to have formed part of this assemblage.

The character of the pieces suggests that they are neither a hoard nor do they even belong together. They appear to be the contents of more than one female grave, as stylistically and chronologically they can be divided into two distinct groups. The four coin-pendants (*a, c, d* and *e*) and the 'medalet' of Liudhard, the bishop described as Bertha's chaplain by Bede, who was in Kent from perhaps the late 570s, belong to the late sixth century, whereas the three remaining pieces (*f–h*) are clearly later. The much greater amount of wear on the St Bertrand tremissis and the filigree ornament on the suspension loop suggest that it was not buried until about 630, and the cornelian pendant is also a seventh-century type. A similar re-mounted Roman gem formed part of a necklace of gold, amethyst and garnet pendants found in a rich female grave at Sibertswold in Kent, coin-dated to the mid seventh century (Hawkes et al. 1966, 111–13), a date which would also fit the disc brooch fragment, which can be paralleled in cemeteries in northern France. However, the presence of the earlier Frankish coin pendants remains an unequivocal witness to the strength of Frankish influence at the Kentish court, and to the part it played in the early Christianisation of the kingdom. CH

Select bibliography: Roach Smith 1845; Grierson 1952–4; Hawkes et al. 1966, 105–15; Grierson and Blackburn 1986, 92, 122–4, 128, 160, 468, 641.

6 Buckle

Crundale, Kent
Silver, gold, garnet; L. 15.2 cm
Anglo-Saxon; mid 7th century
British Museum, M&LA 1893, 6–1, 204

Cast oval loop, with shield-on-tongue covered by a sheet gold plate, edged with beaded wire, and divided into two crescentic panels flanking a central rectangle, all filled with collared granules. Above them is a band of interlaced beaded wires,

6

and a smaller shield in relief inlaid with cloisonné garnet scales. The loop and cast triangular plate are attached by four interlocking hinge-plates, secured by a transverse pin with one collared boss surviving. The plate originally had three similar gilt bossed rivets, one now missing, linked by an applied gold strip edged with beaded wire. Above the rivets nearest the loop it is divided into two square panels, both containing a collared cabochon garnet, flanking a central rectangle with four granules. Below them is a Style II snake seen from above, its filigree wire body composed of interlaced knots. In the centre, its head below the shield, is a gold fish in high relief, its features outlined in beaded wire. The eyes are small cabochon settings, now empty. The plate is hollow

underneath, the sheet silver back-plate is now separate. It has a border of stamped triangles, and a lightly incised backward-gazing animal biting its own body in a rectangular panel below the loop.

The Crundale buckle was found in 1861 with a gilt copper-alloy buckle inlaid with garnets, and an iron sword, its pommel decorated with Style II animal ornament comparable to that in the Book of Durrow (Dublin, Trinity College, MS A.4.5. (57)). It is probably the latest of a group of gilt-silver triangular buckles from rich male graves in Kent, decorated with zoomorphic filigree (cf. Speake 1980, pls 6, 7). In its hollow construction it is similar to the gold buckle from Sutton Hoo, and like that, may also have been a reliquary. The fish is an early Christian symbol denoting Christ: its prominent use here and on the Eccles buckle (7) illustrates the replacement of pagan images (as for instance on the Finglesham buckle, fig. 2) by the new Christian iconography.

CH

Select bibliography: Baldwin Brown 1915, 355, pl. LXXIII: i; Bruce-Mitford 1978, 620, 625, fig. 441 c; Speake 1980, 47, 56, 60, 62, pl. 7d.

7 Buckle

Eccles, Kent, grave
Copper-alloy; L. 6.9 cm
Anglo-Saxon; mid 7th century
Dr A. P. Detsicas

Cast oval loop decorated with transverse grooves, with the tongue in the form of a stylised animal head. The sheet metal tongue-shaped plate is folded over the loop and bordered by a separately applied U-shaped frame cast in imitation of twisted wire, with an animal head at each end. The plate is divided into four panels by a cast cross-bar decorated with transverse grooves, and by a central cast mid-rib, riveted to the plate and running down its length. The mid-rib has diagonal grooves along the sides and is surmounted by a

strip of similar imitation twisted wire, with an animal head terminal at each end. The two rectangular panels nearest the loop each contain an incised cross on a hatched background. Flanking the mid-rib are two confronted incised Style II animals, their bodies formed of four loose interlace knots, also on a hatched background. On the back of the plate, within a border of incised chevrons and mock cloisons, is a sheet metal fish appliqué, its body decorated with scales. Similar scales occur on the plate below the loop.

This buckle, accompanied by an iron knife, was found in a male grave, in a seventh-century cemetery near the Eccles Romano-British villa. Its applied frame, cross-bar and mid-rib are at present unique, but in its general form and ornament the Eccles piece is related to the group of Kentish buckles discussed above; especially to the Crundale buckle with which it shares the specifically Christian fish symbol and other ornamental features. CH

Bibliography: Hawkes 1973; Speake 1980, 58–9, pl. 9e.

8 Pendant

Ash, Kent
Gold; D. (incl. loop) 3.4 cm
Anglo-Saxon; 7th century
British Museum, M&LA 1862, 7–1, 16

Circular gold repoussé pendant with a beaded wire rim and ribbed suspension loop, below which is a beaded wire strip and three collared granules in triangular formation. Two plain and two beaded concentric ridges surround an equal-armed cross, each arm a human face-mask with beard and moustache, facing the centre, which contains a spotted quatrefoil knot. The spaces between the arms each have a two-strand interlace triquetra.

Repoussé disc-shaped pendants of this type with Style II decoration are found in a number of female graves, mostly in Kent, and represent an Insular development of the Scandinavian bracteates imported into England during the sixth century. Face-masks appear on various sixth-century brooch types in purely pagan contexts, but here the cruciform arrangement may well have a Christian significance, and recalls similar bearded heads on Lombardic gold foil crosses (Speake 1980, fig. 12k).

7

8

An amuletic rather than a purely decorative function for this piece is likely and the ambiguous iconography with its mixture of Christian and pagan motifs reflects the duality of belief current in the period immediately following the Conversion. CH

Select bibliography: Smith 1923, 57, pl. III no. 1; Jessup 1950, 122, pl. XXIX no. 9; Speake 1980, 70, pl. 130, fig. 12j.

9 Pendant

Faversham, Kent
Gold, garnet; D. (incl. loop) 3.7 cm
Anglo-Saxon; 7th century
British Museum, M&LA 1145.70

Circular sheet gold pendant with a beaded wire rim and corrugated suspension loop. Three cloisonné birds' heads in the form of a triskele radiate from a central garnet ring, which encloses a circular setting, now empty. Surrounding the ring are two concentric bands of filigree, edged with twisted wire, containing heart-shaped motifs, S-shaped scrolls and single granules with beaded wire collars.

Elaborate gold and garnet pendants decorated with filigree are a seventh-century female fashion, occurring mainly in Kent, but spreading from there to other areas such as the Upper Thames and Yorkshire. The filigree bands and the central cloisonné ring on this piece are reminiscent of those found on Kentish disc brooches, but the cloisonné garnet birds' heads suggest continental influence, confirmed by the amount of imported material found in this rich cemetery, as they are related to Frankish bird brooches and bird-headed pins. The motif is probably amuletic; a similar gold pendant with four schematic cloisonné birds' heads in the form of a swastika was found in the Wieuwerd (Friesland) hoard, coin-dated to *c*.625–30 (Lafaurie et al. 1961). CH

Bibliography: Smith 1923, 39–40, pl. 1, 4; Åberg 1926, 132, 217, fig. 243; Bruce-Mitford 1974, 118, pl. 26c.

9

10 Pendant

Old Westgate Farm, Canterbury, Kent
Gold, garnet; D. 4.0 cm
Anglo-Saxon; early 7th century
Canterbury City Museums, inv. no. CANCM:CB/R2 78 456

Circular pendant of composite construction with barrel-shaped suspension loop. An outer frame of beaded and twisted wires contains a flat zone of stepped and curved garnet cloisonné work surrounding a convex central cruciform design, which rises upwards to a raised central boss. The arms of the cross, now empty, were originally inlaid with some contrasting material, probably shell, while the arm-pits have cloisonné inlay. The back is undecorated. The pseudo-plait filigree of the suspension loop and the upper edges of the pendant itself are very worn, and there are some indications of repair.

Excavated in 1983, the pendant was a stray find from a disturbed Anglo-Saxon burial on the western side of the second-century Roman cemetery 0.40 km west of Canterbury's city walls. It is one of the most complex and magnificent of the splendid series of garnet-inlaid pendants which first emerge as an Anglo-Saxon adaptation of Mediterranean fashion at the beginning of the seventh century. The Canterbury pendant's geometric elegance stands comparison with the finest of these such as the Wilton and Ixworth crosses (**12, 11**), and with them shares an expressly Christian design element. It differs from these and most of the others, however, in its zonal design and composite construction, and in its distinctive vocabulary of stepped and curved cell-work, white inlay and central boss; in all of these it is in effect an East Kentish composite brooch translated into a pendant, as comparison with the brooches from Sarre and Kingston (**31a, 32a**) shows. It is likely that this is a product of a workshop serving the newly Christian Kentish court. LW

Bibliography: Webster 1982a.

11 Pendant cross

Stanton, Ixworth, Suffolk
Gold, garnet; max D. 4.5 cm
Anglo-Saxon; mid 7th century
The Visitors of the Ashmolean Museum, Oxford, inv. no. 1909.453

The cross has flaring arms springing from a central roundel and a biconical suspension loop. It is decorated with all-over cloisonné work using stepped, T-shaped and simple cells deliberately to create a variety of effects. At the centre is a large multi-stepped cell enclosed by four garnets forming the eye of the cross. This is enclosed by a zone of rectangular garnets whose long edges are cut on the curve. Encircling this is a band of interlocking T-shaped cells, again cut to conform to the circular frame from which the arms spring.

Each of the flaring arms contains a skillfully contrived design that at first sight appears purely abstract. Within a border of small rectangular garnets lies a motif built up of four large garnets cut to the curving planes of the arms. The

10

11

12

cloisons are thinner than those of the borders and the garnets are a deeper, purplish colour, in contrast to the clear red of those in the borders. The foils are difficult to see but an empty cell suggests that differently stamped foils back the darker garnets. The motif is thus deliberately singled out, by size, tonal contrast and different foils.

The shape of the upper arm is modified to accommodate the heavy biconical loop: its outer edge is indented and the cloisons reflect this, giving the central panel an insect-like appearance (cf. Kidd 1988, 86–8) – a deliberate statement that is less apparent in the austere layout of the other arms. The loop is made of sheet gold and is embellished in the middle and at either end by applied fillets of gold. It is lightly worn.

The back of the cross is cut from a single sheet of gold. This is plain apart from the upper arm which is decorated with a chevron arrangement of four gold fillets. These are roughly cut off against the edge of a repair patch covering a break across the junction of the upper arm and central roundel. The patch, made of sheet-gold, is held in place by four gold plugs. Analysis suggests that it may be contemporary with the making of the cross.

The construction of the cross is indistinguishable from the Wilton Cross (12). In execution and variety its cell-work can be found within the repertoire of the goldsmith's workshop that produced the Sutton Hoo jewellery. It also shares the use of tonal contrast with the cross motif seen on the scabbard-bosses from the Sutton Hoo ship-burial.

The cross was found in 1886 at Stanton, near Ixworth, by workmen who accidentally disturbed a grave containing an iron-fitted coffin. The grave also contained the gold front plate of a disc brooch dating to the first third of the seventh century and apparently buried in a fragmentary condition with its settings missing. The cross, with its affinities to the Wilton Cross and the Sutton Hoo jewellery, may be of a similar date. ACE

Select bibliography: Smith 1863; Kendrick 1937; Bruce-Mitford 1974, 288–90.

12 The Wilton Cross

Wilton, Norfolk
Gold, garnet; max. D. 4.4 cm
Anglo-Saxon; second quarter of 7th century
British Museum, M&LA 1859, 5–12, 1

Garnet-inlaid pendant cross with expanded equal arms springing from a central roundel set with a lightweight solidus of Heraclius (613–32). The coin is set in a filigree collar and depicts Heraclius and Heraclius Constantine on the obverse and a cross on steps on the reverse. It can be dated to 613–30 and was struck with the reverse die upside-down in relation to the obverse.

Each of the three flaring arms of the cross is filled with a finely executed cloisonné design based on a single multi-stepped cell containing a pair of mushroom-shaped cells lying head-to-head, separated by a pair of stepped cells with

concave sides. The device may be read as a cross, establishing within the overall cruciform design a cryptic cross motif in each arm. The fourth arm is straight-sided and filled with a double herringbone motif executed in small garnets. Its upper edge is shaped to accommodate a heavy biconical loop decorated with panels of plaited gold wire and worn beaded filigree. The base of each arm rests against the outer wall of a cloisonné roundel enclosing the solidus and filled with small square and rectangular garnets set alternately. All the garnets are backed with gold foil impressed with a fine waffle pattern. The back-plate, made of fine sheet-gold, is featureless and is confined to the cloisonné frame so that the face of the solidus can be seen.

The cross on the solidus was evidently a critical element in the overall design of the pendant, yet it appears upside down. This may be because the jeweller respected the orientation of the obverse even though it is not visible when the cross is worn, or because the cross was oriented to stand upright to the wearer's downward glance.

The Wilton Cross belongs within a small group of exceptional seventh-century jewellery which includes the Ixworth cross (11), and is ascribed to an East Anglian workshop, active in the first half of the seventh century. This produced pieces of jewellery characterised by all-over cloisonné work and includes those found in the Sutton Hoo ship-burial and the adapted mount from Tongres, Belgium. The Wilton Cross shares the high quality of the Sutton Hoo jewellery as well as specific cell types and combinations and small design details, for example the double herringbone filling the suspension-loop arm, that are a familiar part of the repertoire of the Sutton Hoo workshop. A stray find, the Wilton Cross may date from the third decade of the seventh century when Christianity was making substantial impact on the élite families of the East Anglian kingdom. ACE

Select bibliography: Kendrick 1937, 283–93; Bruce-Mitford 1974, 28–33.

13 Necklace

Gold, garnet; L. 25 cm
Desborough, Northants.
Anglo-Saxon; second half of 7th century
British Museum, M&LA 1876, 5–4, 1

The necklace is strung with an alternating sequence of irregular gold and cabochon garnet pendants, gold 'bullae' and biconical gold wire spacer beads. At the centre, flanked by small biconical beads, hangs an equal-armed cross; at either end of the string is a cylindrical gold filigree bead. The cross

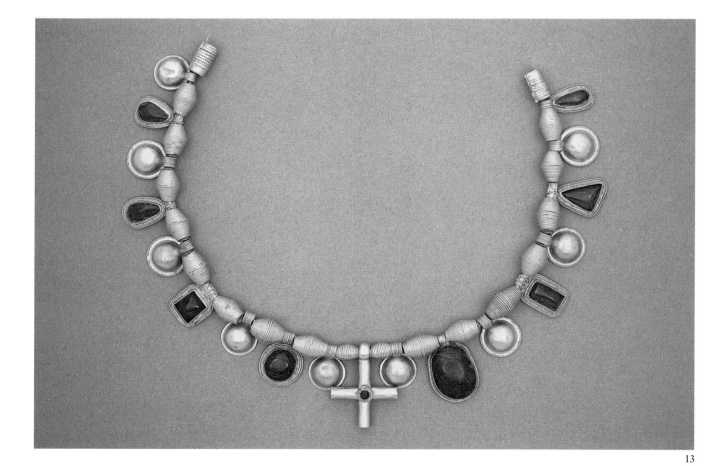

13

is curiously constructed of two tubes of heavy gold sheet, cut away where they overlap and lidded at each end. At its centre is a poorly-fashioned filigree setting containing a small cabochon garnet. The rivet securing the setting holds the cross loosely together. Both the bullae and the pendants fall into two groups. Five bullae are decorated with an edging of finely-made filigree and the ribbed suspension loop is trimmed to a semicircle at the back. The remaining bullae are undecorated and the ends of their suspension loops are cut to a point. The cabochon droplets have two distinct styles of suspension loops: five are simple gold tubes decorated in beaded filigree with geometric or heart-shaped motifs and have a distinctive V motif on the back. The remaining four have unexceptional ribbed suspension loops.

The necklace was found in 1876 in a group of about sixty graves that were disturbed by workmen digging for ironstone. They were oriented east/west and apparently laid out within an enclosure (Baker 1880). The necklace was the only find in its grave and apparently lay near the head of the skeleton. Whether it is complete or not is uncertain as the workmen had portioned the pendants and beads amongst themselves before being persuaded to hand them over for a small reward.

The necklace is the finest of its kind but it is not untypical in its composition. Similar pendants and beads occur in a wide range of high-status graves spread across the Anglo-Saxon kingdoms, for example, from Barfreston, Kent, grave 39; Boss Hall, Ipswich, grave 93 (**33**); from Roundway Down, Wilts.; Garton Station, East Yorks. or Galley Lowe, Derbys. It is made up using pendants and bullae from at least two different sources and was probably assembled in the second half of the seventh century. Its origins, however, lie in continental fashions of the second half of the sixth century when necklaces of beads, pendants and bullae appear in e.g. Lombardic cemeteries (Cividale, Menis 1990, x.40c and x178; Castel Trosino, Mengarelli 1902, 279, pl. XI, 2) before spreading north to Anglo-Saxon England via Francia or Frisia (cf. the Wieuwerd Hoard, Mazo-Karras 1985).

The necklace must have been an exceptional possession, but in the changing attitudes of the mid to late seventh century, its interest lies in the statement it appears to make via the cross. This can be accepted as being explicitly Christian in intent (whether or not it was buried with a Christian) and is another indication of the adoption of Christianity by the English élite, seen also in the Wilton and Ixworth pendants (**12**, **11**) or the cross on the composite brooch from Boss Hall (**33**). ACE

Select bibliography: Baker 1880.

14 Shoulder-clasps

Sutton Hoo, Suffolk, Mound 1, ship-burial
Gold, garnet, millefiori and blue glass; L. 12.7 cm
Anglo-Saxon; first quarter of 7th century
British Museum, M&LA 1939, 10–10, 4, 5

Pair of shoulder-clasps, made of gold with cloisonné garnet, millefiori glass and blue glass. They are superficially identical and differ only in the subtlest detail. Each clasp is curved to fit the shoulder and made in two halves joined by a concealed and precisely engineered hinge that pivots on a stout gold pin held to the clasp by a short length of chain.

The four halves of the clasps are identical in their overall decoration. Each consists of two distinct zones: an inner rectangular field enclosed by panels of zoomorphic interlace, flanked by shaped ends filled with a bold design of two interlocked boars. The inner rectangular field contains a geometric design of stepped cloisons filled with alternate inlays of garnet and millefiori glass separated by larger stepped cloisons containing garnet alone. The millefiori glass is cut from a variety of chequerboard rods, set so that the horizontal axis of each inlay reflects the horizontal axis of the panel. All the inlays are backed by gold foil stamped with a box grid pattern. These are mostly positioned to reflect the diagonal axis of the cloisons.

The inner panels are enclosed by narrow borders of sinuous Style II animal ornament executed with extraordinary skill in cloisonné garnets backed by fine waffle foil, employing cells lidded with gold sheet between the garnets. Each animal has a dominant eye filled originally with bright blue opaque glass.

The semicircular ends of the clasps are filled with a virtuoso design of interlocking boars, using large, plate garnets for the body, head and haunch and shaped slabs of chequer-board millefiori glass for the shoulders, all backed with box-gridded foil. These contrast with carefully-cut small garnets used in the crest, legs, jaws and tail. The ears are pricked and the tusks clearly defined and picked out in blue glass. The design is enhanced with a variety of knotted zoomorphs executed in fine beaded filigree.

The heavy back-plates are plain and soldered to each are ten staples for attaching the clasps on to a leather cuirass, presumably by lacing or stitching. The hinged halves are locked together by a pin, with a filigree-decorated animal-head terminal, secured to one half clasp by means of a short chain.

The clasps show no sign of wear even on the hinges where use would quickly show. This suggests both that the over-garment they fastened was worn only on exceptional occasions and that it and the clasps were in circulation for a short period of time. They are evidently based on classical prototypes but are unique in contemporary Europe although a form of epaulette has been found in two fifth–sixth century cemeteries in Soviet Abkhazia (Minaeva 1982, 230–2, fig. 6). They are essentially functional and their chunky solidity, physical strength and mechanical precision is exceptional – the interlocking elements still glide together with the ease of well-oiled machinery. They are also masterpieces of the

14

14 (detail)

jeweller's art, combining animal interlace, figural and abstract motifs with spectacular brilliance. At a different level they also provoke questions of perception in that they are a statement of how a ruler of an emerging English kingdom modelled himself on classical heroic prototypes – perhaps an overt statement of his military capability to contemporary rulers of the English kingdoms.

The clasps, together with the rest of the jewellery from the Sutton Hoo ship-burial, combine consistency with a brilliance of design and execution that is virtually unmatched in Europe in the early seventh century. Such homogeneity suggests manufacture in a single workshop by an exceptionally gifted master craftsman working to a commission from a royal patron. There is no reason to look beyond East Anglia for its location. Other related contemporary East Anglian cloisonné work includes the Wilton and Ixworth crosses (12, 11), and possibly the gold pyramid (41). Design elements in the shoulder-clasps, the geometric panels in particular, also foreshadow the art of the illuminated manuscripts, e.g. the exquisite 'carpet' pages of the Lindisfarne Gospels (80). They are a reminder of the common pool of motifs drawn on by both metalworkers and the scribes working in the rapidly developing field of manuscript art.

Bruce-Mitford has rightly emphasised the unique quality of the Sutton Hoo jewellery and its superlative execution but beyond this, the shoulder clasps, the gold buckle (15) and the purse-lid are supremely confident works of art that are the only objects from Anglo-Saxon England that offer a startling insight into the access to wealth and power, and perhaps the personal image of a seventh-century ruler. ACE

Select bibliography: Bruce-Mitford 1978; Speake 1980, 45–8.

15 Belt-buckle

Sutton Hoo, Suffolk, Mound 1, ship-burial
Gold, niello; L. 13.2 cm, WT 414.6 g
Anglo-Saxon; first quarter of 7th century
British Museum, M&LA 1939, 10–10, 1

15

Gold belt-buckle with the body cast in two parts, opening on a hinge. The massive loop, tongue-plate and display surface are decorated all over with zoomorphic interlace, enhanced with punched impressions filled with niello (with the exception of the two panels on the loop).

The buckle, deliberately shaped to the contours of the zoomorphic decoration, is dominated by three large bosses with beaded collars that stand out in undecorated simplicity against the field of writhing bodies. The decorative scheme is complex, using a variety of styles and motifs to construct a multi-faceted design that is rigorously disciplined yet elemental in its sinuous movement. The structure of the design is essentially symmetric: to either side of an unusual circular tongue plate, filled with two loosely but intricately knotted snakes, a classic Style II bird, with pointed jaw, curved beak and angular cere, thrusts out to form the shoulders. Below, two elegantly interlacing quadrupeds fill the margins of the buckle plate and enclose an asymmetric but balanced design of two interlacing serpents whose looped jaws rest against the boss at the base of the buckle. Beneath this is a tiny crouched animal whose pear-shaped hip and three-toed paws are gently held in the open jaws of the lower quadrupeds. The panels on the buckle-loop are each filled with a single knotted but undecorated serpent. Its execution is less competent than the other elements and this, together with the loop's proportions and lack of wear, has prompted the suggestion that it may be a replacement. The decoration was finished off using a variety of stamps and punches. The impressions are filled with niello emphasising the different elements of the design and lifting the blandness of the gold into sharp brilliance.

The exuberant interlace distracts from the buckle's mechanical ingenuity. It appears solid, but is in fact hollow and made from two hinged box-like castings, uneven in depth, that reflect the typical buckle construction of a solid front plate and a thin back-plate. It is locked by an ingenious system of three sliding catches that engage in the hollow interior. Providing the leading edge is chamfered, modern belt-weight leather can be fed into the buckle where it is held securely when the buckle is closed over it.

The hollow construction of the buckle has led to speculation that it may have been intended as a reliquary (Bruce-Mitford 1978, 588 ff), although there is no obviously designed cavity within it. Nothing was found inside, though organic materials barely survive in Sutton Hoo's highly acidic sand. It remains a possibility, despite the fact that reliquary buckles in the continental style are unknown in early Anglo-Saxon England.

The buckle is rightly regarded as one of the outstanding examples of Anglo-Saxon art of the early seventh century. It is a piece that combines function and cleverly disguised mechanical ingenuity with an exemplary statement of Germanic Style II animal interlace. It is unique in form and construction, although it belongs within the mainstream of large broadly triangular belt buckles that occur in high-status graves in England and on the continent, particularly in Francia (e.g., Grave 511, St Denis; France-Lanord and Fleury 1962, 344; Werner 1985, fig. 1), and in Scandinavia, where the closest analogies for the form and content of its decoration lie. None of these buckles, however, matches it in wealth and quality. Like the shoulder-clasps (14), the gold buckle stands alone in both conception and execution. ACE

Select bibliography: Bruce-Mitford 1978; Speake 1980, 26–8, 41–5; Werner 1985, 2–4.

16 Pair of spoons

Sutton Hoo, Suffolk, Mound 1, ship-burial
Silver; L. both 25.5 cm
East Mediterranean; 6th century
British Museum, M&LA 1939, 10–10, 88, 89

Silver spoons with pear-shaped bowls joined by a vertical disc to slender handles with baluster terminals by a vertical disc; inscribed in Greek Saulos and Paulos.

The spoons (a mould pair) are unexceptional examples of their kind. The bowls are well-formed with a rat-tail at the back and cast in one with the vertical discs. The handles are slender and hexagonal at the bowl end which carries a dedicatory inscription prefaced by a cross and probably originally inlaid with niello. Each inscription consists of the name of the Apostle Paul apparently in both its forms: Saulos and Paulos, which are taken to be a reference to his conversion. The spoons were placed in the burial in deliberate association with ten shallow silver bowls decorated with an equal-armed cross springing from a central medallion and infilled with poorly executed floral motifs. The association led to their interpretation as a deliberate Christian statement by the burial party. This was extended to the dead man as a reference to his conversion and was considered inferential support for his identification as Rædwald (d. after 616/17 and before 627/8), king of the East Angles and sometime overlord of the English kingdoms, who was converted in the court of King Æthelberht of Kent although he subsequently apostatised on his return to East Anglia.

The interpretation of the inscriptions as a deliberate reference to conversion has, however, been questioned. Although they can be read as Saulos and Paulos, the use of the square form of *sigma* is rare. They are clearly executed by different hands in the style of contemporary coin inscriptions, employing a different range of tools and punches. The Paulos inscription is elegantly spaced with letters clearly and competently joined. In contrast, the Saulos inscription is poorly set out with uneven and occasionally inaccurate lettering and it can be argued that it represents an illiterate attempt to copy the name Paulos. However, given the competent A form, it is quite possible that the copier was not so much illiterate as uncertain of the Greek alphabet. Other interpretations exist: that the inscription was originally intended to read vertically or that the craftsman simply joined up the wrong points of the letter, coincidentally producing a *sigma* in place of a *pi*.

There is no evidence to suggest that either inscription was added in Anglo-Saxon England where no contemporary monetary system with its associated epigraphic skills existed, or that anyone in the kingdom of East Anglia, their final destination, was capable of interpreting the names and appreciating their significance as a pair. If the spoons came into East Anglia with the rest of the silver as a diplomatic gift the inscriptions may have had no particular relevance to their ultimate possessor. Their possible significance as symbols of a royal and East Anglian *conversion* to Christianity should not be overstated.

The Sutton Hoo ship-burial contained the largest collection of eastern Mediterranean silver to have been recovered from a grave, although larger hoards are well documented. It was divided into two groups placed near the head and beyond the feet of the dead man, a division which must have had significance for the burial party. The placing of so much silver in the burial may be seen as a demonstration of wealth although it is impossible to assess what proportion of the dead man's treasury it represents or, in the circumstances of the burial, if it was viewed as an asset (cf. Hodges 1989, 46–9). In quality, the Sutton Hoo silver does not match outstanding pieces from either the continent or the eastern Mediterranean (e.g. Kaiseraugst, the Cyprus treasure or Sevso) but no doubt in the context of an emerging kingdom it had its own validity. Whether it reached the East Anglian kingdom piecemeal or as a group, via Kent or directly from the continent is unknown: the mechanics of the acquisition and dispersal of high-status material in early Anglo-Saxon England are difficult to define, despite recent efforts to formalise them within a conceptualised framework. The collection may have been personally acquired or presented as a diplomatic gift between members of the power-sharing élite who controlled kingdoms on both sides of the North Sea.

ACE

Select bibliography: Bruce-Mitford 1983; Youngs 1983.

16

17 Sceptre

Sutton Hoo, Suffolk, Mound 1, ship-burial
Stone, copper-alloy, iron; H. 82 cm
?Celtic/Anglo-Saxon; first quarter of 7th century
British Museum, M&LA 1939, 10–10, 160, 205

Stone bar surmounted by a cast bronze stag. The stone bar is four-sided and tapers in an elegant shallow curve towards the terminals which develop into rounded knops. Beneath these each side is carved with a face enclosed in pear-shaped frame. Above the faces, each end of the stone contracts before expanding into a well-shaped knop, painted blood-red. The knops are divided into segments by deeply carved grooves and at the top each develops a small protrusion which acts as a support for a copper-alloy fitting. The lower knop is enclosed in a cage made of six triangular sectioned copper-alloy bars which rise from a collar to form a support for a saucer-like fitting. The upper knop, squat in comparison to the lower, is enclosed by an arrangement of grooved copper-alloy strips. Associated with this and the stone bar is a copper-alloy 'pedestal' which engages with a Y-shaped swivelling element, also of copper-alloy, which in turn supports a ring of plaited iron wire. On this stands the stag, identified as a red deer and finely cast in copper-alloy with a proudly-held head bearing a full set of antlers. The body, neck and head are naturalistic, in contrast to the front and back legs which are conjoined to enable the attachment of the stag to copper-alloy bands encircling the iron ring.

The stone bar shows no sign of use and must be considered symbolic. The faces carved on each side are individual and divided between those with full beards and those which appear clean-shaven with an indication of hair beneath the chin. It has been argued that the latter may be representations of women. The deliberate differentiation between the faces has provoked the suggestion that the sceptre contains a rare example of portraiture and that the eight faces may represent ancestors. It could also be suggested that the sceptre has a totemic significance; it may even be a deliberate statement of legitimacy that was so important to early English rulers.

The stag, mounted on a swivelling ring, seems at first sight to be an extraordinary terminal to the whetstone, yet the asymmetric design of the whetstone knops clearly demands a different fitting from the saucer at the other end. It is a rare example of early Anglo-Saxon three-dimensional figural art which otherwise consists only of the boar on the Benty Grange helmet (46), an enamelled fish mounted in the large hanging-bowl, also from the Sutton Hoo ship-burial, and the seated figure of a man on a pot-lid from the cemetery at Spong Hill.

Of all the objects from the Sutton Hoo ship-burial, the 'sceptre' remains the most puzzling: its meaning is enigmatic but is presumed to reflect the personal authority of the man with whom it was buried. It consists of three elements – stag, ring and bar – found close to the west wall of the burial chamber: the relationship between the stag and ring is unequivocal, but that of the stag and ring to the whetstone rests on circumstantial evidence. The sceptre is unparalleled in Anglo-Saxon archaeology and the origins of its components

have been sought, not entirely successfully, outside the kingdom of East Anglia, particularly in the north (where whetstones, occasionally carved with heads, are known). It has also been suggested that the stag is a Celtic rather than a Germanic symbol. Contacts between the East Anglian kingdom and the kingdom of Northumbria were strong in the early seventh century and the stag and the whetstone may have found their way to the East Anglian court, separately or conceivably assembled, as royal gifts. However, the combination of the framed, bearded face in association with animals or birds is not uncommon in the metalworkers' repertoire in Anglo-Saxon, continental and Scandinavian contexts (e.g. the buckle from Åker i Vang, Norway (Speake

17

1980, pl. 2;) and it is possible that the sceptre may be a rare, high-status example of cultural cross-fertilisation.

Whatever their origins, the stag and whetstone pose questions of interpretation: their identification together as a sceptre is perhaps no more than an attempt to attach meaning to an otherwise inexplicable object. The sceptre has been compared to both those of the classical world and those of contemporary ethnographic tradition, but its use within the East Anglian royal court may have been vastly different. Modern assessment may attribute a formal significance to it that was not intended. Although the proposal that the sceptre in some way embodies the legitimacy and secular authority of an East Anglian ruler is attractive and perhaps affords a glimpse of the ceremony and public display that surrounded a seventh-century ruler, it might equally well be no more than a personal emblem – thus a suitable candidate for burial.

ACE

Select bibliography: Bruce-Mitford 1978, 311–77.

18 Composite capital

St Augustine's Abbey, Canterbury, Kent
Limestone: Calcaire Grossaire from the Paris Basin; H. 30 cm, W. 43 cm, D. 34 cm
Anglo-Saxon; early 7th or 9th century
English Heritage and the St Augustine's Abbey Foundation, Canterbury

Restored from two pieces, the neck and lower torus are broken away. The decoration is divided into three zones of which the lower is the largest. This is of square plan above and circular plan below. Each of the angles is rounded and decorated with a narrow, parallel-sided, upright leaf with a rounded, out-turned end, and carved as if composed of receding layers. Three similar, but shorter leaves with their tips truncated fill each surviving face. The angle leaves support a narrow block of square plan with a volute in each corner, and a rosette on the vertical axis of each face. The upper and lower elements of the capital, linked by the leaves at the angles are elsewhere separated by a narrow recessed zone decorated with narrow relief bands forming a zig-zag pattern.

Another capital fragment of broadly similar form is also known from St Augustine's Abbey; both of them appear to have come from free-standing columns. They derive from the well-known French series of sub-Roman debased classical capitals, but their date remains problematical. These capitals could be early seventh-century products made in the formative years of the Kentish Church. Alternatively, they could belong to the period of strong classical revival in the early ninth century. The use of a French limestone is interesting but of no chronological significance: the stone was probably re-used Roman material.

DT

During conservation in the Ancient Monuments Laboratory, traces of pigment were found which indicate that the capital (AML 78203098) was originally polychromed. The traces suggest that the scrolls between the volutes were decorated in bands of red, yellow and blue pigments. Minute quantities of gold have been found on the yellow zone, suggesting that it was gilded. The acanthus leaves bear traces of blue pigment. Samples of the pigments were collected and examined by the Paint Research Laboratory of English Heritage. The red and yellow pigments have been identified as ochres. The blue has been securely identified by Helen Howard (BM) and Dr Ashok Roy (National Gallery) as Egyptian blue, a synthetic

18

pigment widely used in ancient and classical painting. This is particularly important with regard to the date and context of the capital, since the technology for producing this pigment is thought to have been lost at some point between the third and seventh centuries AD. This is the only example of the use of Egyptian blue in British post-roman painting. There are examples from the continent, including San Clemente, Rome, and Castel Seprio (both ninth century, Italy) and Müstair (Switzerland), c.800 AD. This matter will be the subject of a forthcoming publication. DB, PW

Bibliography: Hope 1917, 24, fig. 13; Taylor and Taylor 1966, 48–9, fig. 20; Tweddle 1983, 35–6, pl. xa.

Coinage and currency

The making of England is vividly reflected in the coinage. Changes in political control, including some not recorded in the written record, are demonstrated in an undoubtedly contemporary source, and evidence is provided about the development of royal administration, towns and trading as well as ethnic and cultural connections.

When the relationship between Britain and the Roman Empire became merely nominal early in the fifth century, the imperial military and fiscal organisation which had required coinage ceased to exist, and the lively money-economy which it had supported rapidly disappeared. The Anglo-Saxon invaders were not unfamiliar with the concept of money from loot and ransoms, but regarded it essentially as bullion and did not make any coins of their own. Most of the rare foreign coins from the pagan Anglo-Saxon period found in England have been converted into jewellery (e.g. **5, 12**), but some were lost or buried unmounted which suggests that they had fulfilled, to however limited an extent, a true monetary function (e.g. **19, 20, 21**). The reason for their arrival can often only be guessed: loot, ransom and gift exchange all played a part, and although coin was not essential to trade, it was no doubt used to settle imbalances, particularly with respect to valuables such as slaves.

The Anglo-Saxon coinage began early in the seventh century, with small thick gold shillings (often called, without contemporary justification, thrymsas). They were modelled on the Merovingian tremisses and, like them, were essentially non-regal (**24, 48c, d**). Even so, coins naming King Eadbald (614–40) are important in demonstrating royal participation in coinage from the beginning (**48e**). The small thick silver pennies (conveniently known as sceattas) which followed in the later seventh and early eighth centuries were similarly non-regal although regional issues can be distinguished (e.g. **55**). The Northumbrian coinage was regal from c.700 (e.g. **54, 47**) and the East Anglian from c.760 (**221a, b**). Issues in the early gold and primary phase of the silver coinage were limited, and certainly not on a scale to suggest widespread commercial use. A sharp increase in volume (even in bullion terms, despite a declining silver content) occurs in the secondary sceatta phase when their trading role is clear.

It was only with the restoration of a fine silver coinage in the 770s (or possibly earlier), marked also by a change to a wider thinner penny, that the issues of Mercia, Kent and Wessex become fully regal (**214–25**). They thus are part of the general trend towards greater centralisation in the established kingdoms. The silver penny was the only denomination, and gold coins were confined to rare, donative, pieces. The broad pennies are scarcer than the preceding sceattas, but it is difficult to assess to what extent the amount of silver in circulation declined in absolute terms. The new coins were finer and heavier, and their use may have been more concentrated in urban centres rather than in open field-market sites, thus probably reducing their modern recovery rate; some payments also continued to be made in bullion not coin.

In the later eighth and early ninth centuries the coinage provides evidence, sometimes unparalleled elsewhere, for the changing extent of political control by the dominant kingdoms. Offa's authority in East Anglia and in Kent, its loss at his death to local non-Mercian rulers, and subsequent recovery by Mercian kings is clearly followed on the coinage (**218–22**). Several East Anglian kings unknown to the documentary record are identified and dated by their coins (e.g. **222c, 228**). The rise of Wessex under Ecgberht is mirrored by issues for him in Kent, and others naming him king of the Mercians (**224**). The temporary nature of his triumph in Mercia is shown by issues from London by later Mercian kings (**261a**). It is noticeable, however, that while local issues predictably dominate the circulating medium, coins were not apparently restricted in currency to their kingdom of issue. Hoards show a velocity of circulation which reflects a lively internal trade, and site finds help to establish its routes, e.g. the Mercian coins found in Dorset evidently reflecting a route from western Mercia to the Channel ports.

The coinage shows co-operation, beyond the purely military, between the Mercian and West Saxon monarchies in the period of the Viking incursions. The effect of the reverses which they suffered is seen in the marked decline in the silver content of the currency (**261**) and the increase in unrecovered hoards. Alfred's later improved position is evident in the restoration of a heavy, fine silver coinage issued from a wider range of mints (**262–70**). Round halfpence appear for the first time (**266**). The coinage also sheds independent and sometimes rather different light on the relations between Alfred and Mercia under Ceolwulf II and Archbishop Æthelred from that provided by the written sources (**262–3**). It also provides direct evidence for the political situation and commercial development of the settled Danish communities in the Mercian midland towns and of the Viking kingdoms of East Anglia and Northumbria (**273, 275–6, 278–9**). Even at the end of the ninth century, however, the donative motivation for coinage is still important in both English and Danish issues.

MARION ARCHIBALD

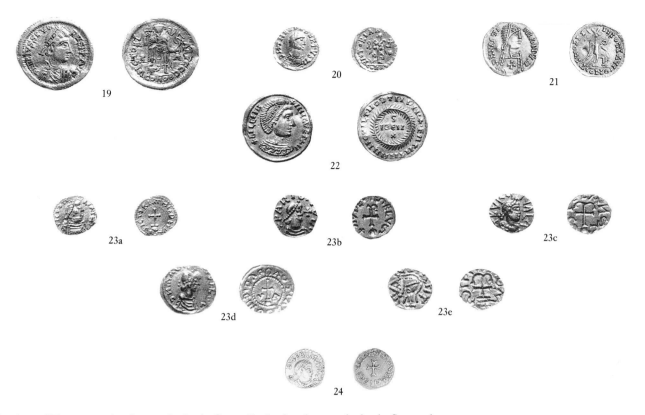

Continental European coins from early Anglo-Saxon England and two early Anglo-Saxon pieces

19 Visigothic solidus copying a solidus of the Western Roman Emperor Libius Severus (461–5), struck in southern Francia, 461–*c*.475

Gold; WT 4.25 g (65.6 gr)
British Museum, CM 1910, 5–9–1

Fifth-century coins from England are rare and confined to the south-east. Most have been converted into jewellery (**5**), but a few are unmounted. It is not possible to say to what extent such coins are the result of gift exchange (and other non-commercial activities) or trade, but unmounted coins suggest that they had some monetary role, however limited in scope. MMA

Provenance: Chequers Court Farm, near Sittingbourne, Kent, 1910.
Bibliography: Rigold 1975, no. 23.

20 Merovingian tremissis of Theodobert I (533/4–47/8), struck in eastern Francia

Gold; WT 1.48 g (22.9 gr)
British Museum, CM 1955, 8–2–1

Coins of this group, known as 'Alemannic' tremisses, were brought to England via Frisia in trade. The findspot shows that the Thames valley, as well as Kent, was already part of the trading area at this time; whether the route was direct

through London, or indirectly from Kent, there is insufficient evidence to say. MMA

Provenance: Found in the bank of a stream at Pinner, Middlesex, 1955.
Bibliography: Dolley 1955; Rigold 1975, no. 28.

21 Visigothic tremissis copying a tremissis of the Byzantine Emperor Justinian (527–65), struck in Spain or southern Francia, in third quarter of 6th century

Gold; WT 1.43 g (22.0 gr)
The Visitors of the Ashmolean Museum, Oxford, from the Evans and Rolfe collections

Visigothic coins are more plentifully found in England than any of the earlier post-Roman issues. Although inferior to the Byzantine originals, they were of better metal than other coins available in Western Europe, and would have been preferred by merchants to the then baser Merovingian issues. The trade which brought them to England involved a range of goods, but one of its most valuable components was slaves. Marseilles was the principal market for those brought from northern Europe, often by Frisian middlemen. There is documentary evidence that Pope Gregory arranged for boy slaves of Anglo-Saxon origin to be purchased in southern Francia, whether or not there is an independent historical basis for

the famous story of his earlier meeting in Rome with Anglian slave boys whom he pronounced 'Non Angli sed angeli'.

MMA

Provenance: Eastry, near Sandwich, Kent, *c.*1840.
Bibliography: Evans 1942, 35; Rigold 1975, no. 37; Pelteret 1981, esp. 102.

22 Anglo-Saxon solidus naming the Roman Empress Helena (d. 328–9), early 7th century

Gold; WT 5.50 g (84.9 gr)
British Museum, CM 1864, 11–28–195; gift of Edward Wigan, 1864

This presentation piece is based on three Roman fourth-century bronze coins: obverse bust and inscription (Helena); reverse Vota-in-wreath type and blundered 'Beata Tranquillitas' legend (several emperors) all of which could have been derived from a single hoard buried in the 330s such as that found at Enfield, Middx (Kent 1975). MMA

Provenance: Chapel Hill (said to have been 1 km north-east of Markshall cemetery), Caister-by-Norwich, Norfolk, in the mid nineteenth century.
Bibliography: Sutherland 1948, no. 21; Rigold 1975, 116a.

23 (a–e) Coins from the Sutton Hoo, Suffolk, hoard, contents struck between *c.*572 and *c.*625, found in 1939

British Museum; gift of Mrs E. M. Pretty, 1939

23 (a) Merovingian tremissis of Theodobert II (595–612)

Derivative of the First Provençal type, struck at Clermont-Ferrand, Puy-de-Dôme, probably by the moneyer Manileobus (unsigned)

Gold; WT 1.27 g (19.6 gr)
Kent 1975, no. 2
British Museum, CM 1939, 10–3–8

23 (b) Merovingian tremissis, Croix ancrée type

Struck at Paris, moneyer Audegiselus, *c.*600–15

Gold; WT 1.22 g (18.8 gr)
Kent 1975, no. 17
British Museum, CM 1939, 3–2–24

23 (c) Merovingian tremissis, Croix ancrée type

Struck for the church of St Etienne, Bordeaux, Gironde, *c.*605–15

Gold; WT 1.23 g (19.0 gr)
Kent 1975, no. 22
British Museum, CM 1939, 10–3–27

23 (d) Pseudo-imperial tremissis, Second Provençal type, naming the Byzantine Emperor Maurice (582–602)

Struck at Valence, Drôme, *c.*595–605

Gold; WT 1.22 g (18.8 gr)
Kent 1975, no. 26
British Museum, CM 1939, 10–3–2

23 (e) Merovingian tremissis, derivative of the Second Provençal type

Struck at Quentovic, near Visemarest, Pas-de-Calais, moneyer uncertain, *c.*590–600

Gold; WT 1.38 g (21.3 gr)
Kent 1975, no. 27
British Museum, CM 1939, 3–2–32

This coin is the earliest evidence for the name Quentovic.

The thirty-seven coins in the Sutton Hoo purse are all Frankish, and are the only large deposit of coins from the Anglo-Saxon period before the introduction of an English coinage. The lack of duplication in the group is not remarkable given the huge number of Merovingian mints and moneyers and the wide date range, *c.*572–*c.*625, of the pieces represented. It does however suggest that they were not withdrawn from active circulation but were taken from a treasure store, apparently containing a limited number of coins as the total required to pay the forty oarsmen and helmsman of the burial ship had to be made up in blanks and bullion. MMA

Bibliography: Bruce-Mitford 1975.

24 Anglo-Saxon shilling struck at Canterbury (DOROVERNIS CIVITAS) by the moneyer Eusebius, early 7th century

Gold; WT 1.32 g (20.3 gr)
Paris, Bibliothèque Nationale

This is one of the earliest issues in the Anglo-Saxon coinage which began during the same period of increasing contacts with the European mainland of which the marriage of Æthelberht and Bertha, and the Augustinian mission, were also part. The resemblance to contemporary Merovingian issues in style and in the inclusion of both mint and moneyer's names is so close that Grierson and Blackburn suggested that the dies for this coin were cut by a Merovingian craftsman, and struck by a visiting Frankish moneyer. By further analogy with the Merovingian coinage, so strong in ecclesiastical issues, Eusebius might have been a cleric, with a Latin name in Christ, employed in one of the church foundations in Canterbury whose leaders – the Archbishop and the Abbot of St Peter and St Paul (later St Augustine's) – are known to have enjoyed minting rights later. MMA

Provenance: Not known; acquired before 1789.
Bibliography: Sutherland 1948, no. 2; Grierson 1952–4; Grierson and Blackburn 1986, 160–1.

The developing state

The gradual extension of Christianity throughout the constituent kingdoms of Anglo-Saxon England is seen from the pages of Bede's *Ecclesiastical History of the English People* to have involved a large cast of missionaries, operating under conditions which varied from one kingdom to another, and achieving their purpose with differing degrees of success. Bede himself may have wished to create the impression that the cause of the Christian faith was advanced by the force of argument alone, and that the process was complete by the late 680s, when the last outpost of pagans (on the Isle of Wight) 'received the faith of Christ'; but of course the truth was far more complex. Converts had been won by promises of worldly power and eternal glory, by social and political pressure, by impressive displays of all the trappings of Christian civilisation, even by the lure of holy bread – and one glance at the historical and archaeological records of the late seventh and eighth centuries shows that it was some time before the new religion penetrated to all levels of English society. The kingdoms of Anglo-Saxon England were not transformed as if at a stroke into Christian polities, any more than their rulers at once began to behave as Christian kings or their peoples to observe the tenets of the Christian faith.

The earliest commentators did not shrink, however, from imposing their own constructions on the political world of newly Christian England. Bede, writing from his Northumbrian vantage-point in 731, felt able to identify a series of kings in the seventh century whose rule extended over all the kingdoms south of the River Humber, and thus he lent a semblance of order to the fragile supremacies which certain rulers managed to establish during that period. A West Saxon chronicler, writing in the late ninth century, designated these kings *Bretwaldas*, or rulers of Britain, thereby seeming to crystallise the nature of their position and to imply the precocious revival in the seventh century of a conception of unity borrowed from the Roman past. Henry of Huntingdon, in the twelfth century, made little of the *Bretwaldas*, but devised instead the notion of seven kingdoms (Kent, Wessex, Essex, Northumbria, East Anglia, Mercia and Sussex) as the organising principle of early Anglo-Saxon political history, which by the sixteenth century had further developed into the concept of the 'Heptarchy', governed by a President elected at a General Assembly. In modern times it has proved difficult to resist the accumulation of such ideas, and to avoid viewing the period except in terms derived from them.

It is doubtful that the kings of the seventh and eighth centuries would themselves have been conscious of the grand combinations with which they are sometimes credited, though that is not to say that they continued to lumber in the potbellied equanimity of their continental forebears. The kingdoms developed in their own ways, in response to the conditions which prevailed in each case. Some of the differences between them, for example in the preferred form of kingship (whether rule by a single monarch, or by a multiplicity of kings), may have originated in the distant past; others owed more to the circumstances in which the kingdoms were formed in England, and to such variable factors as the degree of assimilation between the settlers and any surviving elements of the indigenous population. A kingdom's fortunes were inseparable from the personal qualities of its ruler; but success would arise in the first instance from the effective use of the natural and human resources which were at the ruler's disposal, and it would depend in the longer run on his ability to maintain the loyalty of those around him who themselves commanded the loyalty of others. Only a foolish king would have relied on whatever kudos he gained from his membership of a royal dynasty: for although he might claim descent through his royal ancestors from tribal heroes and pagan gods, it was always possible for such claims to be fabricated and manipulated on behalf of those who acquired the power which really mattered. More important, therefore, was a king's inclination to indulge in the form of conspicuous exploitation of wealth which characterised early medieval kingship. A king had to be seen to be wealthy, and to reward his followers with all the manifestations of his wealth – land, livestock, weapons, objects of gold and silver, and so on. Supplies of wealth could be maintained in the approved manner by the plundering of neighbours, by success in battle against rivals, and by the systematic exaction of tribute from those in no position to resist; but kings also derived income, less glamorously, from the exercise of the rights which they enjoyed over their own subjects, from the management of their estates, and from the extension of royal control over centres of trade.

Of course, one should not expect to find clear evidence, at this early stage, of the means by which a king sustained his rule; and it is difficult to form much impression of all aspects of royal power in the case of a single kingdom. Rather, the picture which emerges is composite, built up from different forms of evidence relating to different kingdoms, but suggesting none the less that the rulers of the seventh and eighth centuries were far removed from the heroic world of the 'warrior-kings' beloved of chroniclers and poets. The first images of kingship come from the early seventh century: the savage mystery of the stone 'sceptre' from Mound 1 at Sutton Hoo, symbolising East Anglian kingship in a burial deposit which otherwise drips with silver and gold; and the quietly unfolding sequence of halls and other structures, serving a predominately native population, recovered by aerial photo-

graphy and excavation from the royal estate at Yeavering in Northumbria. Yet neither site is necessarily representative of its kingdom, and the images themselves, which seem contradictory, are in fact complementary. The rulers of other kingdoms speak more directly to us through their law-codes. The legislation of the kings of Kent exposes the complex structure of Kentish society in the seventh century, throwing light, for example, on matters as diverse as the position of the king in relation to his people, and the likely importance of slavery to the economic welfare of the kingdom. The Kentish laws also serve as a basis for tracing the progress of the new religion, providing a background in this respect for evidence of other kinds, ranging from the obsequies of the common man to the works produced in Archbishop Theodore's school at Canterbury. Thus while Kent was formally 'converted' soon after the arrival of St Augustine in 597, a telling contrast remains between the laws of King Æthelberht, in which the Church was set apart from the rest of society, surrounded by a high wall of royal protection and special privileges, and those of King Wihtred (near the end of the seventh century), in which one finds for the first time a sense of integration between the secular and ecclesiastical hierarchies, and signs of the infusion of Christian principles into the laws which regulated social conduct. It is impossible to trace the same process of Christianisation in the other kingdoms, though laws running in the name of King Ine (preserved only as an appendix to the much later law-code of King Alfred the Great) reflect the state of affairs which obtained in Wessex at the end of the seventh century. It is apparent that the influence of Ine's ecclesiastical councillors was as pervasive as that of Wihtred's in Kent; but in other respects the kingdom of Wessex was noticeably different. Thus, while we hear in Kentish law of the king, his noblemen, and the 'judges of the people of Kent', we get the impression in West Saxon law that the king's rule was exercised through a hierarchy of royal and local officials in a more advanced state of development. In this connection it may also be significant that whereas Kentish law recognised a basic distinction between two classes of freemen, West Saxon law recognised the existence of a third, and higher, class, with no equivalent in Kent, as if the separation of an aristocracy was more pronounced. The laws do not suggest, on the other hand, that the rulers of Kent and Wessex had yet moved far in controlling the activities of traders to their own financial advantage; and although fines and other payments are expressed in 'shillings' and 'sceattas' (in Kent), or in 'shillings' and 'pence' (in Wessex), it is clear from the earliest gold and silver coins which circulated in England that it was some while before kings established the issue of coinage as a royal prerogative.

Whatever their respective states of development, the various kingdoms of Anglo-Saxon England were now ruled by kings who professed the Christian faith, and of course that did make a difference. The replacement of informal pagan observances by a single authoritarian faith was quite possibly conducive to social cohesion; and since it was axiomatic that the king was divinely appointed to rule over his people, adoption of Christianity was also a means of strengthening the king's position. For their own part, the churchmen had everything to gain from co-operating closely with the secular powers. For while it may seem that Æthelberht of Kent had been quick on his own account to take advantage of the technology of the written word, by having his laws codified 'after the Roman manner', it is clear none the less that his code was conceived principally to protect the interests of the Church. It was also in their own interests that churchmen promoted the use of charters for recording a king's grants of land and privileges. The earliest examples, dating from the 670s and 680s, were drawn up in the king's name to protect monastic endowments; and if they seem to imply that the rulers were now moving in a thoroughly Christian world, it should be recognised that they represent what is fundamentally an ecclesiastical perception of royal action. One should add that in the eighth century charters began to be used for purposes calculated to serve the interests of laymen, for the secular powers were never slow to realise how the services of churchmen could be turned to their own advantage.

The relationship between the secular and ecclesiastical powers could not be expected to remain uncomplicated for long. Laymen resented and encroached upon the privileges which the churchmen had come to enjoy, and few churchmen could resist all the temptations of the secular world. In the early 730s Bede complained that abuses had arisen following the death of King Aldfrith of Northumbria (in 705); and the sub-text of his *Ecclesiastical History* is a plea to his contemporaries – laymen and ecclesiastics alike – that they should emulate the standards of behaviour exemplified in the Golden Age of the seventh century. In the late 740s the missionary Boniface traced the malaise back to the reigns of Ceolred in Mercia (709–16) and of Osred in Northumbria (706–16); but he chose the more direct approach, by writing to King Æthelbald of Mercia, urging him to reform his wicked ways. The question remained: would the high principles of Bede prevail, or had the rot set in? However much we may prefer to dwell on Bede and the glories of the Northumbrian renaissance, it was King Æthelbald and his contemporaries who set the pattern for the future.

SIMON KEYNES

Manuscripts

The increasing authority and development of the state during the seventh century is reflected in the emergence of three categories of document: laws, genealogies and charters. The development of these documents was due to ecclesiastical influence. Indeed, there are indications that Augustine himself may have played some part in the introduction of all three types of document.

One of the concrete results of Æthelberht's conversion was the compilation of a written law-code. The first clause fixes the levels of compensation to be paid for thefts from the Church. Bede singles out the production of this law-code as one of Æthelberht's major achievements, suggesting that the

writing down of the law was an innovation. Previously laws were presumably memorised and handed down from generation to generation orally.

How far Augustine and his associates had a hand in the compilation of Æthelberht's laws is not known. Augustine asked Pope Gregory for advice on the compensation to be paid for thefts from the Church, indicating that he was involved in the discussions which led to the issue of the laws. However, the provision of the laws on this issue conflicts with the ruling given by the Pope, suggesting that Augustine only had a limited say in the final content of the laws.

It would seem reasonable to assume that the scribes who accompanied Augustine helped write down the law-code. However, the code is written in Old English. The adaptation of the Latin alphabet for Old English would have been a complex and lengthy process. The system adopted involved the use of runic characters which were probably unfamiliar to Augustine's party and their Frankish interpreters. This suggests that some form of written alphabet may already have been in use in Kent before Augustine's arrival. If this is the case, scribes other than those in Augustine's party may have been involved in writing down Æthelberht's laws.

Augustine's influence on the compilation of Æthelberht's laws was probably limited to persuading Æthelberht that the production of such a code was an essential attribute of a Christian ruler. It is not clear what use was made of Æthelberht's laws. Their contents were presumably still distributed by word of mouth. The written code was perhaps preserved in the king's treasury as a symbol of his majesty. Æthelberht initiated a tradition of law-making in Kent which continued until its extinction as a kingdom. From Kent, this tradition spread to Mercia and Wessex, and, thanks to Alfred, continued after the establishment of a single English state.

These early law-codes are far removed from modern statutes, being mainly concerned with details of procedure and levels of compensation for particular acts. Nevertheless, they provided one of the chief means by which Anglo-Saxon kings were able to express their authority and perform one of their most important functions, the dispensing of justice to their subjects. They are among the most important surviving historical documents of the Anglo-Saxon period, providing a detailed record of the structure of early English society.

The written law-codes produced by Germanic rulers on the continent were frequently prefaced by a genealogy recording the ruler's descent from legendary gods and heroes. Similar genealogies were produced in England. Bede's description of Æthelberht's law-code is followed by Æthelberht's pedigree, suggesting that Æthelberht's code was originally prefaced by such a genealogy. The production of these pedigrees was encouraged by the Church as a means of controlling the royal succession. The earliest surviving collection of English royal pedigrees, dating perhaps from the late eighth century, was compiled by a cleric.

From the earliest stages of the Conversion, the Church attracted gifts of land. The clergy were anxious to safeguard their title to such land and arranged for gifts to be recorded in writing. This was the origin of the charter, the most common business document of Anglo-Saxon England and one of the most important categories of historical evidence for the period. Charters were not like modern title deeds. They were not the means by which the land itself was transferred. This continued to be done in the traditional way, by a ceremony before witnesses involving such formal acts as the placing of turfs on an altar. The charter was simply a written statement made 'to avoid uncertainty in future time'.

A number of copies of charters attributed to King Æthelberht survive but these are later forgeries. The earliest surviving authentic charters date from the late seventh century. The coincidence between the appearance of the first known charters and the archiepiscopate of Theodore of Tarsus is striking. It would be reasonable to assume that a vigorous administrator such as Theodore would have insisted that grants should be recorded in writing and Theodore has been credited with the introduction of charters into England. Theodore had at least one notary, Titullus, in his household. However, the earliest charters do not follow the Italian forms which would have been familiar to Theodore and Titullus. The roots of the charter apparently go further back than Theodore's time.

The most common writing material in early seventh-century Europe was papyrus. This does not survive in damp climates and if early charters were written on papyrus they would have perished. In the late seventh century, the more durable vellum was adopted by the Frankish chancery. If a similar switch was made at the same time in England, this would explain why the earliest surviving charters date from this period. Augustine had some scribes in his company and would certainly have wanted some permanent record of the gifts made to him. Some of the phrases in the earliest charters are apparently drawn from title deeds which would have been familiar to Augustine.

Augustine was probably one influence on the early development of the charter in England. However, just as a number of different Churches contributed to the conversion of England, so early English charters draw together a variety of ecclesiastical influences. They were affected by Frankish as well as Italian practice. There are some interesting parallels between Anglo-Saxon charters and those drawn up for British Churches, such as a more casual approach to authentication than continental charters. Despite the hybrid character of the early English charters, their basic form proved extremely durable and continued in use right up to the time of the Norman Conquest.

Charters were not produced by the king making the grant. They were ecclesiastical records, drawn up by Church scribes and preserved in ecclesiastical archives. They nevertheless had enormous political and social ramifications. They created a new form of tenure called bookland since the title to the land was recorded in a 'boc' or charter. The right to control the grant of such land added greatly to a king's authority. During the eighth century, the control of grants to the Church provided one of the main mechanisms by which Mercian kings consolidated their authority in conquered territories.

Although charters were ecclesiastical documents, during the seventh century written documents also began to be used for royal administrative purposes. One of the most interesting

features of the enigmatic document known as the Tribal Hidage (**26**) is that it shows that written documents were used to assist in such activities as tax collection as early as the second half of the seventh century. References to other lists in Bede shows that the Tribal Hidage was not a unique document. The Hidage would have been drawn up and used by a cleric, but for royal purposes. It is far from indicating the existence of a fully literate royal officialdom, but it does suggest that English kings were already by the seventh century displaying that administrative precociousness which was to be the hallmark of English government throughout the Middle Ages.

ANDREW PRESCOTT

25 The Textus Roffensis

Rochester Cathedral Library, MS A.35
Vellum; ff. 235; 225 × 155 mm
Old English and Latin; 1122–3
Rochester

The Textus Roffensis, a twelfth-century Rochester compilation, contains many important early English legal texts, including the only surviving copy of the Laws of King Æthelberht I of Kent, the oldest known document in English. Bede records that Æthelberht 'introduced with the consent of his counsellors a code of law inspired by the example of the Romans, which was written in English, and remains in force to this day'. The first clause of this code, Bede notes, specified the compensation to be paid by those who stole from the Church or clergy.

Æthelberht's laws were presumably issued after his conversion, perhaps in 602–3. Æthelberht's laws are not like modern statutes. They simply list details of the compensation to be paid by those committing particular acts. They read more like a tariff then a law-code. They begin, as Bede states, with a clause specifying the compensation to be paid to the Church. Those stealing Church property were to pay twelve times the normal compensation. A bishop's property rated an elevenfold compensation, a priest's ninefold, and so on. This placed a priest on the same tariff as a king, a generous provision which has led to doubts about the authenticity of the clause. However, since this clause was part of the text known to Bede, it seems likely that it is genuine.

Although at first sight the code seems like a hotch-potch, it is in fact arranged fairly systematically and is evidently the product of considerable thought and discussion. After the clause on the Church, it deals with cases where the level of compensation was dependent on the social status of the victim. This is followed by clauses concerning what would now be called 'aiding and abetting'. The laws then specify the amount of the *wergild* payable to a family when a person was killed. They deal with assault in enormous detail, specifying the compensation for every conceivable type of injury from a fractured skull to the loss of a fingernail. The final clauses relate to payments in cases of what might be called 'family law', such as the separation of a husband and wife.

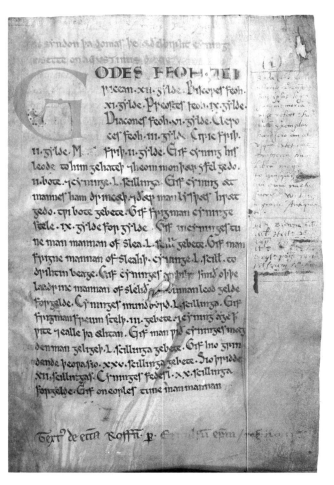

25 The Laws of King Æthelberht I of Kent (f. 1)

Æthelberht's laws are far removed from Roman law-codes and are more akin to Germanic and Frankish compilations such as the *Lex Salica*. This makes Bede's statement that Æthelberht was following the Roman example puzzling. Apart from the first clause, there is nothing to connect Æthelberht's laws with the process of conversion. Indeed some of the provisions on, for example, sexual misdemeanours or divorce seem to run counter to Christian teaching. The most likely explanation is that early law-codes were produced not as a means of propagating Christian morality, but because the Church persuaded convert rulers that a written law-code was an essential attribute of a civilised Christian ruler. It was in this sense that Æthelberht was following the Roman example. How far he simply codified existing custom or introduced new procedures cannot be established.

The Textus Roffensis was compiled at the instigation of Ernulf, bishop of Rochester from 1115 to 1124. It was originally two separate manuscripts. The first, written in 1122–3, contained legal texts, including Æthelberht's laws and other Kentish law-codes. The second, by the same scribe, was a cartulary of Rochester Cathedral Priory. The two

volumes had been bound together by the early fourteenth century. Ernulf was a canon lawyer of some distinction, which may explain his interest in secular legal texts. The text of Æthelberht's laws was probably taken from an early eleventh-century manuscript at Canterbury, where Ernulf had been prior.

The great historical interest of this manuscript is reflected in the numerous annotations in it by early antiquaries. In the right-hand margin by the beginning of Æthelberht's laws is a note dated 1573 by William Lambarde, the author of the first history of Kent. The clauses in Æthelberht's laws were numbered by another Kentish antiquary of this period, Edward Dering. The list of 'Saxon characters' opposite Æthelberht's laws is by the early eighteenth-century Anglo-Saxonist Elizabeth Elstob. Shortly before 1720, the manuscript was sent to London to be transcribed by an antiquary and was dropped in the sea. The water stain can still be seen.

AP

Bibliography: Liebermann 1898, 3–8; Attenborough 1922, 4–17; Sawyer 1957–62; Richardson and Sayles 1966, 1–13; Wallace-Hadrill 1971, 32–46; Whitelock 1979, no. 29; Simpson 1981, 3–17; Cramer 1989, 483–93.

26 The Tribal Hidage

British Library, Harley MS 3271
Vellum; ff. 129; 266 × 174 mm
Old English; early 11th century

The Tribal Hidage gives a snapshot of the political geography of England while the process of the formation of kingdoms was still under way. It lists over thirty different territories south of the Humber and notes the number of hides in each area. A hide was a unit used for taxation and other purposes, based on the area of land required to support one household. The Tribal Hidage was therefore probably a tax assessment compiled for the overlord of these territories.

Some of the political units identified in the Hidage are familiar. Mercia, for example, was assessed at 30,000 hides and the Cantwarena of Kent at 15,000 hides. Wessex was assigned the enormous total of 100,000 hides. Many of the groups named in the Hidage are, however, less well known. The Hicca, for example, controlled an area around Hitchin in Hertfordshire reckoned at 300 hides. The North and South Gyrwe lived on the edge of the Fens, in the vicinity of Peterborough and Crowland. Their lands were assessed at 600 hides each. Around the Wrekin in Shropshire were the Wreocensæta, 'the Wrekin dwellers', with 7,000 hides. Many, but not all, of these smaller groups were in the east and south midlands, an area of Middle Anglian settlement.

The small territories of the Tribal Hidage are early kingdoms which had not yet been absorbed into larger political units. Steven Bassett has compared the process of state formation in early Anglo-Saxon England to a knock-out competition. The Tribal Hidage, he suggests, 'is like the *Sports Pink* newspaper which reports the winners of, say, the fifth round of the F.A. Cup. Most of the little teams are long

26 The Tribal Hidage (f. 6b)

gone, there are a few potential giant-killers left – the Spalda, the Arosætna, the East and West Willa – survivors only because they have so far avoided being drawn against the major teams. But the next round will see them off; they have had their brief moment of glory and no more will be heard of them' (Bassett 1989, 26).

Only one pre-Conquest copy of the Tribal Hidage survives, which is on the left-hand page shown here. It is one of a series of early eleventh-century additions to a copy of Abbot Ælfric's grammar. Although this is the earliest text, and the only one in Old English, it has some serious deficiencies. Some names have been misspelt and one or two territories and hidations omitted. A number of thirteenth- and fourteenth-century manuscripts contain a Latin version of the Hidage based on an Old English original superior to the text shown here. A third recension of the Hidage was printed by Sir Henry Spelman from an 'ancient schedule' then in the possession of Sir Francis Tate but now lost, which may have been an early Latin text.

Various dates have been proposed for the Tribal Hidage, ranging from the mid sixth to the second half of the eighth

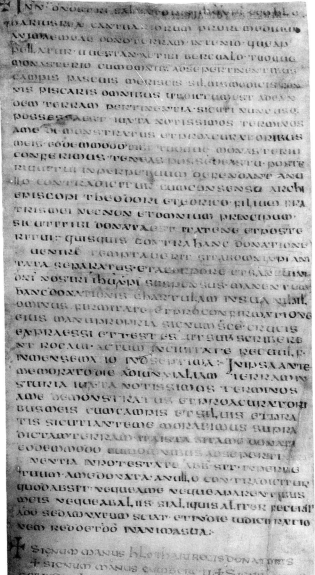

27 Charter of King Hlothere of Kent; 679

century. It has even been suggested that it was made for a ninth- or tenth-century king of Wessex. The present consensus is that it was made for a Mercian king between 660 and 680. The Hidage pays particular attention to the midlands and Mercia is the first territory named in it. Moreover, the Hidage states that the area it identifies as Mercia was 'the original Mercia', suggesting that the Mercian king was at this time overlord of a wider territory. However, it seems unlikely that Mercia would be included in a tribute list compiled for a Mercian king, since a king would not levy tribute from himself. The possibility that the Hidage was produced for a Northumbrian king cannot be ruled out. Bede had access to Northumbrian hidages compiled in the mid sixth century. These may perhaps have included the Tribal Hidage. AP

Bibliography: Hart 1971, 133–57; Davies and Vierck 1974, 223–93; Brooks 1989, 159; Dumville 1989a, 129–33; Dumville 1989b, 225–30; Kirby 1991, 9–12.

27 Charter of King Hlothere of Kent

British Library, Cotton MS Augustus II.2
Vellum; 330 × 150 mm
Latin; 679
Reculver

This is the earliest original charter of an English king to have survived. It is also the oldest known piece of dated writing by an Englishman. It records the grant of *Westanæ* in the Isle of Thanet by King Hlothere of Kent to Abbot Berhtwald of Reculver in May 679. Hlothere was a great-grandson of King Æthelberht I. In 673 Hlothere's brother, King Ecgberht I, suddenly died, leaving a child, Eadric, as his heir. The Mercians attempted to seize control of Kent. Hlothere led the Kentish resistance and, having promised to make Eadric joint king when he was old enough, became king of Kent. By 679 Hlothere had expelled the Mercians from Kent and had even obtained a foothold in London, where he had a palace and a port-reeve.

Although this is the oldest known original charter, it was not the first to be issued. The texts of a number of other late seventh-century charters are preserved in later copies. All these charters are in a broadly similar format. They begin with an invocation, consisting in Hlothere's charter simply of a cross and the words 'In the name of our Saviour the Lord Jesus Christ'. These sentiments are usually developed in a proem, but Hlothere's charter passes straight to the *dispositio*, in which Hlothere declares that he has given an estate to the abbot in perpetuity. The consent of the archbishop of Canterbury, Theodore of Tarsus, the king's nephew Eadric and other nobles is noted. The *dispositio* is followed by the *sanctio*, in which those who infringe the grant are threatened with excommunication. In the *corroboratio*, the king states that he has confirmed the grant by making the sign of the cross with his own hand and by inviting others to subscribe.

In some respects, Hlothere's charter recalls Italian deeds dating from the time of Augustine's mission to England. The

wording of the *corroboratio* is apparently derived from similar clauses in fifth- and sixth-century deeds from Ravenna. In the *dispositio* Hlothere addresses Berhtwald directly ('I Hlothere ... give you Berhtwald and your monastery'), a practice also found in some sixth-century Italian grants, including one of Gregory the Great himself. However, Hlothere's charter was not exclusively based on Italian models. Some important features of Italian deeds, such as regnal dating, are absent from Hlothere's charter. Other elements found in both types of document are treated differently. For example, the *dispositio* of Italian documents usually included an elaborate description of the boundaries of the estate. In the *dispositio* of Hlothere's charter, it is simply stated that the bounds of the land had been marked by the king and his officials, presumably by means of a perambulation.

The witness lists of Hlothere's charter and other early English grants suggest that Frankish procedures may also have influenced English practice. Despite the claim of the *corroboratio* that the king himself wrote the cross by his name in the witness list, this cross and those by the names of other witnesses were evidently made by the scribe who wrote out the witnesses' names. In contemporary Italian deeds, autograph crosses were the rule. In Frankish houses such as St Gallen, however, the scribe made the crosses and the witnesses simply touched the charter to show their approval. This seems to have been the procedure adopted here.

Although early Anglo-Saxon charters have a strong family resemblance, they often differ in the detail of their structure. It has been noted, for example, that Hlothere's charter is unusual in not containing a proem. The most singular feature of Hlothere's charter is that after the *corroboratio* there is a postscript noting that on the same day Hlothere granted to Berhtwald additional land at Sturry. This postscript is itself in the form of a miniature charter. Such relative flexibility in the treatment of the basic charter form indicates that early Anglo-Saxon charters did not derive from a single model but drew together a variety of ecclesiastical and legal influences.

In two important respects, the charter of Hlothere and other early Anglo-Saxon charters stand apart from continental practice. Unlike contemporary continental diplomas, Anglo-Saxon charters do not include any signs of validation, such as seals, autograph subscriptions or notes of the scribe's name. It is consequently difficult to establish whether a particular charter is an original or a later copy. Hlothere's charter can be shown to be an original only because the list of witnesses is in a slightly different hand, using lighter ink. Presumably the body of the charter was written out in advance and the names of the witnesses added at the time of the grant.

Contemporary Italian grants were written in a cursive business hand. Hlothere's charter is in the lavish uncial hand more usually found in a bible or liturgical manuscript. It appears that uncials continued to be used for charters in England even after minuscule hands were adopted for other documents. The use of uncials in charters was intended to emphasise that they recorded a sacred gift. Charters in England were objects of reverence not, as in Italy, relatively familiar business documents.

In 949, King Eadred granted the monastery of Reculver and its lands to Christ Church Canterbury. Hlothere's charter was transferred to Canterbury and preserved there. In the sixteenth century it came into the library of Sir Robert Cotton. At this time, it formed the last leaf of a volume containing a ninth-century psalter and eighth-century gospels, also from Canterbury. The psalter and gospels afterwards found their way to Utrecht, but the charter was retained by Cotton. It has been suggested that, since the charter has not been folded and has no medieval endorsements, it may have been placed in the psalter and gospels at Reculver. If so, this would provide a further illustration of the way in which charters were seen as almost sacred texts.

AP

Bibliography: Sawyer 1968, no. 8; *ChLA* no. 182; Chaplais 1965, 51–4; 1968, 317–27; Whitelock 1979, no. 56; Scharer 1982, 65–8; Wormald 1984, 2–7, 13–14.

28 An East Saxon charter

British Library, Cotton MS Augustus II.29
Vellum; 211 × 412 mm
Latin; *c*.686–8
St Paul's, London or Barking

Few sources relating to the kingdom of the East Saxons survive and the history of the kingdom is obscure. This is the only surviving East Saxon charter. It is a grant by Œthelred, *parens* or kinsman of King Sebbi, to Abbess Æthelburh of Barking of lands at Dagenham and elsewhere. Sebbi ruled Essex from *c*.664 to *c*.694, when, shortly before his death, he abdicated and became a monk. The witnesses include Sebbi and his two sons Swæfheard and Sigeheard. The relationship of Œthelred to Sebbi is unclear, but the estate donated to Barking by Œthelred was fairly large, indicating that he was a powerful man. It has been suggested that he was sub-king of Surrey. The appearance of some West Saxon churchmen among the witnesses to this charter indicates that it was compiled *c*.686–8, when Cædwalla of Wessex was overlord of the East Saxons. Œthelred's grant is thus the second oldest surviving original charter, compiled within nine years of the oldest known original, Hlothere of Kent's 679 grant to Reculver (**27**).

The formulae of Œthelred's charter show an even more pronounced Italian influence than those of Hlothere's grant. Unlike Hlothere's charter, Œthelred's grant contains a proem. This is derived from the proem of a grant made by Gregory the Great in 587 to his foundation of St Andrew's in Rome, of which St Augustine was later the Prior. Similar proems also occur in two seventh-century charters for monasteries at Chertsey and Farnham. A common link between these charters is that they are all witnessed by Eorcenwald, bishop of London from *c*.675 to 693. Chertsey and Barking were both founded by Eorcenwald; Æthelburh was his sister. Farnham fell within his diocese. It seems likely that all these charters were drafted and written by Eorcenwald or one of his circle. Eorcenwald was thus probably one of the channels

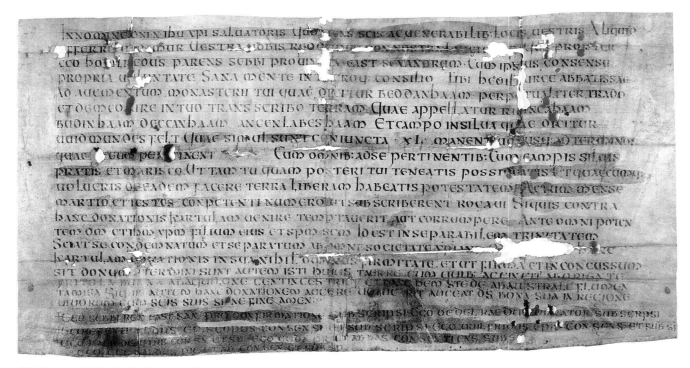

28 Charter of Œthelred of Essex; *c*.686–8

by which Italian legal formulae were imported into England.

This charter illustrates the problems encountered in trying to distinguish original charters from later copies. It has been substantially altered at various times. Originally the charter stated that Œthelred granted Barking 75 hides of land. The figure '75' has been erased and '40' inserted in its place. The reason for this alteration is not known. Perhaps the Abbey lost part of the estate and the charter was amended. The last four lines of the main text of the charter and the witness list are in a different hand to the first part. This hand is apparently an imitation of the original script and may date from as much as a hundred years after Œthelred's grant. It seems that the conclusion of the grant was originally written on a separate piece of vellum sewn to the charter. Stitch holes can still be seen on the bottom of the charter. The contents of this schedule were added to the main charter during the eighth century and the original slip of parchment discarded. The scribe responsible for this addition modernised some names in the witness list and also seems to have conflated the *corroboratio* with the witness list, so that King Sebbi appears to witness the grant twice. AP

Bibliography: Sawyer 1968, no. 1171; *ChLA* no. 187; Chaplais 1968, 327–32; Whitelock 1979, no. 60; Scharer 1982, 129–41; Wormald 1984, 9–11; Yorke 1985, 4–5, 21.

29 The Anglian collection of genealogies and regnal lists

British Library, Cotton MS Vespasian B. vi, ff. 104v, 109
Vellum; 251 × 388 mm
Latin; between 805 and 814, with later 9th-century additions
Mercia

One of the most important sources for the early history of the royal dynasties of pre-Viking England are the pedigrees which survive from the ninth century onwards and trace the descent of the kings of Anglo-Saxon England from Germanic gods and legendary heroes. The earliest and most extensive collection of such royal genealogies is the Anglian collection, so named because the dynasties represented in it were of Angle origin or connected by marriage with Anglian royal houses. The Anglian collection contains the pedigrees of the kings of Deira, Bernicia, Mercia, Lindsey, East Anglia and Kent, together with such other chronological material as episcopal lists and a list of popes. Later recensions also include a Wessex pedigree and regnal lists (stating how long each king reigned) for Mercia and Northumberland.

This is the oldest surviving manuscript of the Anglian collection, written in Mercia between 805 and 814. The right-hand page contains episcopal lists for the dioceses of York, Hexham, Lindisfarne and Whithorn and, in the extreme right-hand column, the genealogy of the kings of Deira and the beginning of the Bernician pedigree.

A royal ancestry was an essential qualification for an early Anglo-Saxon ruler. Pedigrees were the means by which a king demonstrated his right to his throne. Moreover, by

29 Episcopal lists and Northumbrian royal pedigrees from the Anglian collection (f. 109)

showing descent from gods and folk-heroes, genealogists could greatly enhance a dynasty's prestige. Perhaps as late as the reign of Offa, the Mercian pedigree was upgraded by the insertion of a number of legendary heroes. The compilation of pedigrees was not simply an antiquarian diversion, but an activity of great ideological significance.

The Church encouraged the production of pedigrees. The Anglian collection was probably compiled by a cleric. Pedigrees were useful to the Church in, for example, ensuring that illegitimate children and their offspring were excluded from the succession. Bede reports that the names of the apostate successors of Edwin were removed from the Northumbrian regnal lists (and presumably the genealogies as well).

All the royal dynasties in the Anglian collection are traced back to the pagan god Woden. It may seem surprising that the Church countenanced this, but it does not seem to reflect any lingering devotion to Woden. It was rather a means of expressing the common racial origin of these dynasties. In the only surviving Saxon royal pedigree, for the East Saxon kings (30), a different God, Seaxnet, is given as the founder of the line. When the royal houses of Kent and Wessex made connections with Anglian dynasties by marriage, their genealogies were altered to show that they too sprang from Woden.

In many respects, these pedigrees are highly artificial productions. All the trunk lines are of common length – about fourteen names. Extra names were inserted into the first part of the Lindsey genealogy to make it the requisite length. In other genealogies, some 'telescoping' has occurred, producing weird chronological distortions. For example, Æthelberht II of Kent (725–62) is in the same genealogical position as Edwin of Northumbria (616–33). Nevertheless, it appears that the sequence of rulers in individual lines is broadly correct from the late sixth century onwards.

Since this manuscript is of Mercian origin, it has been assumed that the Anglian collection was compiled in Mercia in about 796, perhaps at the behest of King Offa. However, the Northumbrian pedigrees are placed first in the collection and the kings of Lindsey are shown as being of greater antiquity than the Mercian royal family. It seems unlikely that a ruler as conscious of his dignity as Offa would have tolerated this. This suggests that the collection may be of Northumbrian rather than Mercian origin. AP

Bibliography: Sisam 1953, 287–348; Dumville 1976, 23–50; 1977, 72–104; Moisl 1981, 215–48.

30 West Saxon and East Saxon genealogies

British Library, Additional MS 23211, f. 1v
Vellum; 155 × 105 mm
Latin; late 9th century
Wessex

This manuscript fragment, formerly used as a pastedown for the cover of a small printed book, dates from the reign of Alfred. It contains the earliest known text of the West Saxon genealogical regnal list and the only pre-Conquest copy of a genealogy of the East Saxon kings. The conclusion of the West Saxon list and the East Saxon pedigrees are shown here.

The West Saxon genealogical regnal list begins with a statement that in 494 Cerdic and his son Cynric landed at Cerdicesora with five ships. It then traces the descent of Cerdic from Woden and declares that Cerdic and Cynric conquered the kingdom of the West Saxons, being the first kings to take the land from the Britons. The kings of Wessex down to Alfred are then listed. Details are given of the length of each king's reign and his relationship to Cerdic, together with a further full pedigree showing the descent of Æthelwulf, Alfred's father, from Cerdic.

This list was compiled in Alfred's reign and its production reflects Alfred's own family pride and interest in the history of his kingdom. The list predates the compilation of the Anglo-Saxon Chronicle by a few years and appears to have been used as a source for the Chronicle. Both the list and the Chronicle were intended to glorify the Cerdicing dynasty and comparison of both works with other sources shows that their accounts of the early West Saxon kings are often extremely untrustworthy. For example, it appears that Cerdic had a son called Croeda and that Cynric was actually Croeda's son, not Cerdic's. Both the genealogical regnal list and the Anglo-

30 West Saxon and East Saxon royal genealogies (f. 1v)

Saxon Chronicle omit all mention of Croeda and promote Cynric to Cerdic's son. It seems that by the late ninth century Croeda had for some reason become an embarrassment to his descendants, and he was expunged from the historical record.

The East Saxon genealogy is one of the chief sources for the history of the East Saxons, which would otherwise be extremely obscure. It gives the pedigrees of three East Saxon kings: Offa, who abdicated in 709; Swithred, who became king in 746; and Sigered, expelled when the East Saxons surrendered to Ecgberht of Wessex in 825. The descent of all three from Sledd, the founder of the dynasty, is shown. Sledd's ancestry is traced to the Saxon god, Seaxnet. AP

Bibliography: Sisam 1953, 287–348; Dumville 1977, 72–104; 1985, 21–66; Yorke 1985, 3–4, 8–24; Dumville 1986, 1–32.

Metalwork and bone

From the very start, the Conversion was intimately connected with the dynamics of royal power and influence. The wealth of Kent, King Æthelberht's supremacy among the other Anglo-Saxon rulers, and his close relationship with Francia were all crucial ingredients in the timing and setting for the Augustinian mission. This Kentish pre-eminence at the end of the sixth century owed much to its natural position as a funnel for traffic to and from Frankish Gaul and the lands to the south, whether in the export of such celebrated Anglo-Saxon commodities as slaves and hunting dogs or in receiving Frankish wine and Byzantine bronzes. The wealth this special status brought is amply reflected in rich sixth-century burials at cemeteries such as Howletts, Dover, Sarre and King's Field, Faversham. It is thus no coincidence that alongside the manifestations of the new religion which bound Anglo-Saxon England yet more strongly with its continental neighbours, the archaeological record reveals simultaneous dramatic changes in the location, structure, content and sheer wealth of Anglo-Saxon burials.

The increased access to wealth was striking, but short-lived. Increased supplies of gold in the form of Byzantine and Merovingian coinage reflect the redistribution of subsidies paid to Francia by the Byzantine emperors; in the essentially non-monetary economy of early seventh-century England these were rapidly converted into portable wealth – jewellery (31, 34). This gold glut was, however, brief, and its decline is matched in time by an equivalent debasement of the gold content in jewellery, clearly reflected in the paler, silvery pendants of the later seventh century (37).

With this short-lived access to Frankish and Byzantine gold came fashions of Gaul and Byzantium. The older Germanic dress tradition of paired brooches which fastened a dress at the shoulder, with a swag of beads hung between, was swiftly superseded in the early seventh century by a mode in which pins replaced brooches and strings of (often explicitly Christian) pendants, and wire rings and simple beads replaced the festoons of polychrome glass and amber beads (33–7). Aristocratic ladies might wear a single spectacular brooch on an outer garment (31–3). The fashion spread quickly out from Kent, so that by the middle of the seventh century aristocratic women in the midlands, west and north were wearing very similar fashions (e.g. 13).

But the increased availability of gold in the late sixth and early seventh century fostered another equally influential development. A tradition of cast chip-carved decoration in gilded bronze, derived from provincial late Roman techniques and styles, had dominated Anglo-Saxon metalwork for 150 years; its principal components were a combination of complex zoomorphic and simple geometric motifs conventionally termed Style 1. This decoration was composed of highly formulaic small parts, its glittering, sharply faceted surfaces heightening an initial effect of dislocation and rigidity. The increased availability of gold changed all that. Gold's ductility encouraged an emphasis on different techniques, and hence styles, of decoration. It lent itself especially to

filigree work, which was a major factor in the development of the new sinuous, regular interlacing animal motifs known as Style II (38). The complex origins of this style remain a matter for debate, but it is clear that late antique traditions of symmetry and motifs such as plaits and chains played some part in this sudden and dramatic change in Anglo-Saxon zoomorphic art. The essential shift from deconstructed, segmented, discrete animals to rhythmically interlacing and extensible beasts gained rapid popularity, quickly shifting into other techniques such as repoussé and cloisonné work, as well as into other media (39–44). In manuscripts, it developed a spectacular life of its own (e.g. 80, 81).

This was throughout an essentially aristocratic art style, at least where metalwork was concerned, and it is thus no surprise that some of the most dramatic and sumptuous examples of this new decoration are to be found in the royal and aristocratic jewellery from such burials as those at Sutton Hoo, Taplow and Kingston Down (14, 38, 32). These new, super-rich graves also tellingly reveal something of other profound changes at work in society at this time. The Sutton Hoo ship-burial, in common with other early seventh-century high-status burials, proclaims wealth and power in a way which is strikingly different from its royal or aristocratic predecessors. These years were a time of political shifts and consolidations, as emergent kingdoms swallowed up lesser units and jockeyed for territory and resources. It is not unconnected that this was a time of ostentatious living, seen for instance in the grand scale of the Northumbrian royal palaces at Yeavering and Milfield, and of equally ostentatious death. Burials at the upper reaches of society were often set apart from the ruled not only by their lavish customs, but sometimes physically, whether in a separate place or accompanied by special structures of which the most spectacular are the imposing barrows set over burials such as those at Taplow, Asthall and Sutton Hoo. The assertion of power and authority implied in this most conspicuous of consumption is inherent too in the frequent siting on physical boundaries and on high ground; and it is no coincidence that it is from this period too that we see symbols of power hitherto absent from the archaeological record in England – the sceptre at Sutton Hoo, the helmets modelled on that of the Roman emperor (16, 46, 47). That Christianity conferred in some sense a Roman tradition was indeed a point not lost on the ambitious seventh-century kings, some of whom claimed descent from Caesar: and it is no surprise that the new religion's spread went hand in hand with written law-codes, charters, the development of coinage and the beginnings (under royal control) of the first trading towns.

The archaeology of this period of accelerated change on almost every front offers a striking paradigm of the intimate connections between religious and secular power.

LESLIE WEBSTER

31 (a, b) Composite disc brooch and necklace

Sarre, Kent
Brooch: copper-alloy, silver, garnet, shell; D. 6.8 cm
Necklace: gold, glass (individual dimensions of pendants below)
Anglo-Saxon; early 7th century
British Museum, M&LA 1860, 10–24, 1, 2

31 (a) Brooch

Gilt copper-alloy composite, cloisonné disc brooch, inlaid with white shell, garnets set over hatched gold foil, and panels of sheet gold decorated with filigree. It consists of three plates sandwiched together (two of copper-alloy with a silver back-plate), bound by a gold corrugated rim edged with beaded wire. Three concentric zones of ornament surround a central boss, with four satellite bosses in a cruciform arrangement between the innermost zone and rim. The central boss is of white shell, with a serrated silver collar edged with beaded wire, both originally gilt. At its centre is a flat cut garnet in a similar setting. Four strips of gilt-silver pseudo-plaitwork divide the boss into equal sections. The innermost and outer zones contained a double row of stepped cloisonné garnets, although a number in the outer zone are now lost. Each satellite boss has a zone of similar garnets around a white shell cabochon, surmounted by a cabochon garnet in a tubular gold setting, one now missing. Between each boss is a sheet gold panel, divided lengthwise into three zones, edged with beaded wire, and filled with S-shaped scrolls flanked by a line of annulets.

On the back of the brooch is a garnet-inlaid copper-alloy pin with a circular head. The neck is grooved and a pin-stop projects from the shank. Around the pin-head is a gilt copper-alloy collar in the form of two chip-carved, stylised, conjoined animals. A similar collar of conjoined, opposed birds' heads with down-curving beaks surrounds the catchplate. At right angles to the pin is a safety loop.

31 (b) Necklace

Comprises eighteen beads (sixteen opaque glass and two amethysts), four gold coin pendants, and a re-used millefiori glass disc.

(*i*) Gold quasi-imperial solidus of Maurice Tiberius (582–602), probably posthumous, struck at Arles. Biconical suspension loop with three bands of beaded wire.
D. (incl. loop) 2.4 cm

(*ii*) Gold quasi-imperial solidus of Heraclius (610–14), struck at Marseilles, corrugated suspension loop.
D. (incl. loop) 2.4 cm

(*iii*) Circular gold pendant with a corrugated frame enclosing a millefiori glass roundel of light blue and white mosaic squares within a red chequerboard pattern. Ribbed suspension loop.
D. 2.9 cm

(*iv*) Gold quasi-imperial solidus of Maurice Tiberius (582–602), struck at Marseilles, similar suspension loop to (*i*) above.

D. (incl. loop) 2.1 cm

(*v*) Gold solidus of Chlotar II (613–28), struck at Marseilles, corrugated suspension loop.

D. (incl. loop) 2.5 cm

Cloisonné disc brooches, mainly found in east Kent, first appear in Anglo-Saxon graves in the early seventh century, replacing the paired brooches formerly in vogue, and represent a marked change in female fashion. They continued to be worn until the middle of the century, but were not buried on clothing in the latest furnished graves belonging to the proto-Christian cemeteries. Both the decorative techniques and the style, ultimately derived from Mediterranean models, were transmitted to England via the Frankish kingdoms.

The brooch and necklace were found in 1860 in a female burial. There are discrepancies as to the exact contents of the graves in the earliest published sources, but they included an iron weaving batten, a copper-alloy pin, a purse mount, an iron knife, and a copper-alloy Byzantine bowl, a luxury item imported from the eastern Mediterranean.

The closest parallels to the piece, all from Kent, are one presumed to be from Priory Hill, Dover, and a piece from

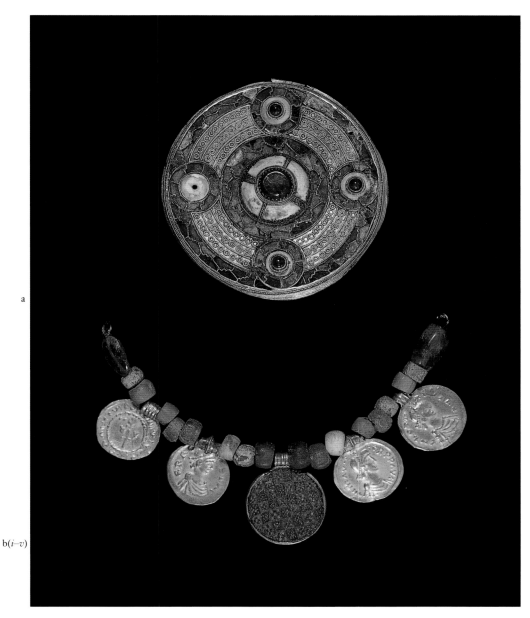

a

b(*i–v*)

31a,b

Gilton (Avent 1975, nos 174, 175). A third brooch from Aylesford has lost all its inlays (ibid., no. 173), but all three share the same cruciform arrangement of the bosses, and inset filigree panels between two cloisonné bands. The form of the pin and catchplate on the Sarre brooch also links it to the Kingston brooch (**32a**), but with its copper-alloy cloisons and coarse filigree it is by no means as technically accomplished.

On the basis of the numismatic evidence, the coins on the necklace were probably assembled about 615, so the objects cannot have been buried before that date. It is most likely that they were deposited during the second or third decade of the seventh century. CH

Select bibliography: Avent 1975, vol. I, 50–2, 71–2, vol. II, 47, no. 177; pl. 66; Rigold 1975, 668–9, nos 54, 56, 58–9, fig. 429; Bruce-Mitford 1978, 621, fig. 442b; Grierson and Blackburn 1986, 128, 160.

32a

32 (a–c) Grave group (selection)

Kingston Down, Kent, Grave 205
Gold composite disc brooch, pair of silver bow brooches and gold scutiform pendant (individual dimensions below)
Anglo-Saxon; early 7th century
National Museums and Galleries on Merseyside, Liverpool Museum, inv. nos M 6226, M 6235, M 6231

32 (a) Gold composite cloisonné disc brooch

Inlaid with blue glass, white shell, and flat-cut garnets placed over hatched gold foil, and inset with panels of zoomorphic filigree. It consists of two plates sandwiched together, bound by a narrow rim decorated with beaded and twisted wires, and repaired in antiquity. A number of inlays are lost.

D. 8.55 cm

On *the front*, five concentric zones of ornament surround a central domed boss. Linking the innermost and outermost zones are four satellite bosses, alternating with four sub-rectangular panels. The central white shell boss, divided into quadrants and edged with beaded and twisted wires, is surmounted by a domed boss with a plain collar, similarly edged, which has three semicircular cloisonné garnet settings containing T-shaped cells of blue glass, forming a Y-shaped central field composed of four cells. The innermost zone has similar semicircular garnet and blue glass cloisons, alternating with fan-shaped garnets. The second zone consists of four sub-square cells with stepped and T-shaped garnets forming one end of the sub-rectangular panels described above, alternating with eight panels flanking the satellite bosses and containing a Style II zoomorph in beaded wire. The third zone is composed of stepped and T-shaped garnets, interrupted by the four satellite bosses and four lozenge-shaped garnets set over five gold foil squares in a chequerboard pattern. The fourth zone is broadly similar to the second with four sub-square garnet-filled cells, and eight panels of zoomorphic filigree. The outermost zone has alternate semi-circular and trapezoidal garnet cloisons, each containing a T-shaped blue

glass cell. Each satellite boss originally had a central shell cabochon surmounted by a circular flat-cut garnet; only one now remains. Each cabochon is flanked by a pair of T-shaped and a pair of triangular blue glass cells alternating with garnets.

On *the back* of the brooch is a copper-alloy pin, with a circular head with a cruciform cloisonné design. Surrounding it is a collar decorated with filigree scrolls, through which the hinge passes. Around the base are two conjoined confronted Style II birds, their bodies formed of similar filigree scrolls within beaded wire borders. The pin-catch is an animal head, its features outlined in beaded wire, emphasised by filigree scrolls and annulets. Around the base are a second pair of Style II conjoined confronted birds in profile, their bodies formed of three bands of pseudo-plaitwork. At right angles to the pin is a safety loop with a beaded wire collar.

32 (b) Pair of one-piece silver bow brooches

With a triangular catchplate decorated with three groups of incised transverse lines and folded over the pin. The pin shaft is similarly ornamented with three incised bands and coiled to form a spring.

L. 3.5 cm, 3.75 cm

32 (c) Sheet-gold scutiform pendant

With a ribbed suspension loop. A central repoussé boss is surrounded by concentric zones of stamped circles. Between this and the similar outer border is a six-pointed star.

D. (incl. loop) 3.1 cm

The cemetery at Kingston, which had over three hundred graves, was excavated by the Reverend Bryan Faussett, who explored a number of rich burial sites in East Kent between 1757 and 1773, recording his discoveries in diaries edited by Charles Roach Smith in 1856 as *Inventorium Sepulchrale*. These objects were found in 1771, in a female barrow burial which also contained iron box-fittings, an iron chatelaine, a green glass palm cup, a Frankish wheel-turned biconical jar, a copper-alloy hanging bowl with enamelled escutcheons, and a Frankish copper-alloy bowl with drop handles. The woman had been buried in a coffin, and the bones of a child lay beyond her feet. The range of material found with her, including imported luxury goods, illustrates the wealth and political ascendancy of the kingdom of Kent during the early seventh century.

The silver bow brooches, found at the hip, are a rare type. Others are known from seventh-century contexts at Shudy Camps (Cambs.), Uncleby (Humberside) and from Whitby (North Yorks.) (White 1988, 40–1). Simple scutiform pendants occur in later sixth- and seventh-century contexts in Kent, but are mostly of silver, although another gold example has recently been found at Minster on the Isle of Sheppey.

Faussett described the Kingston brooch as 'one of the most curious, and for its size, costly pieces of antiquity ever discovered in England' (Faussett 1856, 78), and it is justly regarded as a masterpiece of the Anglo-Saxon jeweller's craft. Zoomorphic filigree is rarely found outside Kent. It occurs on two later composite disc brooches from Milton, North Field, Abingdon (Oxon.) (Avent 1975, nos 182–3), but these were probably produced in Kent. A pair of miniature gold buckles from Faversham (Speake 1980, pl. 2h) have a central zoomorphic filigree panel flanked by pairs of conjoined birds' heads remarkably similar to those surrounding the catchplate

on the back of this piece, but it is the metalwork from the royal burial at Sutton Hoo which provides the closest parallels to the Kingston brooch, both in the quality of the workmanship and in stylistic details such as pendant birds' heads on the buckle (15) and the backward-biting quadrupeds in filigree wire on the shoulder clasps (14). As an indication of the wealth of the Kentish kingdom in the first decades of the seventh century, as well as of the outstanding skill of their jewellers, it aptly illustrates the acceleration of artistic production consequent upon the economic and social changes which transformed Anglo-Saxon society in this period. CH

Select bibliography: Faussett 1856, 77–9, pl. 1; Avent 1975, vol. I, 53–4, vol. II, 47–8, no. 179, pls 68–9; Bruce-Mitford 1978, 625; White 1988, 40, fig. 22.1.

33 (a–i) Grave group

Grave 93, Boss Hall cemetery, Ipswich, Suffolk

Gold, silver, garnet, copper-alloy

Anglo-Saxon; late 7th century

Ipswich Co-operative Society

Grave of a woman with a ?leather pouch at the neck containing:

33 (a) Copper-alloy composite brooch

The back plate is covered with silver sheet and the front plate decorated with a bold cross design in garnets set in silver cloisonné and complemented by four triangular sheet-gold panels, ornamented with filigree scroll-work and also forming a cross.

D. 7.0 cm

33 (b) Four circular gold pendants

Decorated with filigree with central settings of garnet or glass simulating garnet.

D. 2.6–3.1 cm

33 (c) Irregular cabochon garnet pendant and oval pendant with cabochon setting of red glass

H. 1.9 cm, 1.8 cm

33 (d) Regal solidus of Sigebert III (634–56), mounted as a pendant

33 (e) Primary Series B sceat, dated *c.*690

33 (f) Fragments of several silver biconical spacer beads (not exhibited)

32c

32b

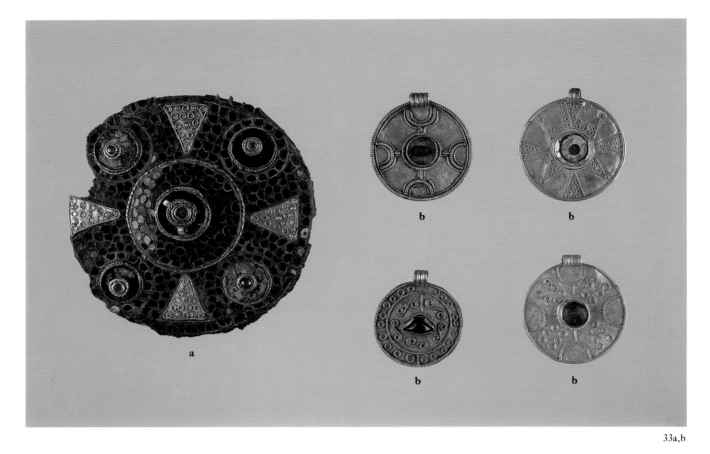

33a,b

33 (g) Silver cosmetic set

Scoops and picks with zones of incised decoration on the shafts and attached to a short chain of silver slip-knot rings.

max. L. 8.2 cm

33 (h) Separate length of slip-knot rings

33 (i) Glass beads (not exhibited)

The Boss Hall cemetery lies on the western side of Ipswich, across the river Gipping and about 1 km distant from the Hadleigh Road cemetery. Preliminary documentary research shows that the land was personally held by the king at Domesday, suggesting that it may have been land directly linked with the East Anglian royal family at the time of the cemetery's use (Newman 1991). It was excavated in the summer of 1990 as a rescue operation by the Suffolk Archaeological Unit when part of a grave-field containing twenty-two Anglo-Saxon inhumations and five cremations was identified on a development site. The graves are typical of a small settlement cemetery and include both male and female burials with possessions which date them to the sixth and early seventh century. Grave 93 is singled out by its wealth and is intrusive in the cemetery, dating from the beginning of the eighth century at the earliest. Its contents were block-lifted and excavated in the British Museum by staff of the Department of Conservation. The finds reflect the possessions of a woman of the Anglian élite and the style of burial suggests that she was a Christian, although her presence in an earlier cemetery is enigmatic.

The finds in grave 93, Boss Hall, are representative of the range of personal possessions that a woman belonging to the upper echelon of Anglo-Saxon society would have owned. The pendants are familiar from a variety of late seventh-century graves and some of the beads may originally have been assembled as an impressive necklace (cf. those from Sarre or Desborough, 31, 13). Cosmetic sets are also a typical possession of a high-status woman; however, this set is distinguished in that the instruments are delicately made in silver. Similar sets occur in contemporary Kentish graves (e.g. Kingston Down, graves 7 or 142: Faussett 1856, pl. XII, 1 and 3) and more rarely in Anglian graves, for example grave 39, Garton Station, East Yorks., where a similar though less rich assemblage of pendants and beads was also placed in a pouch at the neck (Evans forthcoming). The composite brooch is remarkable. It shows signs of repair and was clearly a treasured possession. Although belonging to the mainstream of the composite brooch series in structure and basic design (Avent 1975) and typically laid out with a central boss and

four secondary bosses (one a replacement) all containing cabochon garnets, the decoration of small garnets that covers the entire surface as a darkly glittering cruciform field to the four gold panels is without parallel. Despite its superficial opulence, the brooch does not achieve the level of craftsmanship that is characteristic of the finest examples in the series such as the Kingston brooch (32a). The garnets are all small and are crudely cut in various shapes, although they are well matched in size and skillfully inlaid in silver cloisons to create an impression of richness that is reminiscent of the all-over garnet decoration of the jewellery from Sutton Hoo (e.g. the shoulder-clasps, 14). The filigree work on the panels and cabochon settings varies in quality and twisted wire is often used as a substitute. Although the brooch is strongly designed, it gives the impression of having been made in a workshop where expertise was faltering and raw materials were scarce. Despite this, its impact is considerable even in its damaged state. Its decoration is essentially cruciform and can be read in various ways. The gold panels stand out against the garnets and can be seen as a cross of the type found in outline on gold disc pendants (e.g. 33b(iv)). Its axis is aligned on that of the pin. Alternatively, the panels can be seen as the fields to a boldly executed garnet-encrusted cross with stubby arms springing from the central roundel. Although not explicitly Christian in the sense of St Cuthbert's Cross (98), the cross motif is carefully expressed, reflecting its use as a Christian symbol on fine secular metalwork (e.g. the Wilton and Ixworth pendants (12, 11)); it is probably also an expression of the religious commitment of its owner. ACE

Bibliography: Newman 1991.

34a–f

33c,d,g

34 (a–f) Six coin pendants

Faversham, Kent
Gold; individual dimensions below
Anglo-Saxon; late 6th–early 7th century
British Museum, M&LA 1884, 12–21, 7–12

34 (a) Gold quasi-imperial tremissis, struck at Uzès

Ribbed suspension loop.

D. (incl. loop) 2.1 cm

34 (b) Gold quasi-imperial tremissis, struck at Arles

Ribbed suspension loop formed of a single strip coiled back on itself.

D. (incl. loop) 2.15 cm

34 (c) Gold quasi-imperial tremissis, struck at Marseilles

Ribbed suspension loop.

D. (incl. loop) 1.5 cm

34 (d) Gold Merovingian tremissis, overstruck on a Provençal piece at Agen

Ribbed suspension loop.

D. (incl. loop) 1.7 cm

34 (e) Gold Merovingian tremissis, struck at Campbon, near Nantes

Ribbed suspension loop.

D. (incl. loop) 1.6 cm

34 (f) Gold Merovingian tremissis, struck at Lisieux

Ribbed suspension loop.

D. (incl. loop) 1.7 cm

Increased contacts with the Frankish kingdom during the mid to late sixth century meant that Merovingian gold coins began to arrive in England in increasing numbers, concentrated mainly in East Kent and the lower Thames region. Rather than being directly used as currency, although they provided the models for Anglo-Saxon gold coins produced in the second quarter of the seventh century, they were primarily a source of bullion for the manufacture of jewellery, or mounted as pendants. This group probably came from a female grave in the rich cemetery at King's Field, Faversham.

The three coins of Marseilles, Uzès and Arles are derived from issues of Tiberius and Maurice and therefore not later than about 590; the other coins are of similar date, but their burial itself may have been slightly later. CH

Bibliography: Rigold 1975, 655, n. 3, 668–71, nos 48–9, 51, 66, 69, 78, figs 429–30; Bruce-Mitford 1978, 620, fig. 44b; Grierson and Blackburn 1986, 124, 160.

35 Pendant

Epsom, Surrey
Gold, garnet; L. 3.2 cm
Anglo-Saxon; mid 7th century
British Museum, M&LA 1970, 3–1, 1

Garnet tear-shaped cameo in a gold setting with integral suspension loop. The cameo depicts a bearded male head in a Phrygian cap, facing left; it is set in a collar with beaded frame, soldered to an undecorated base sheet. The grooved apex of this is folded over and soldered to the frame to form the suspension loop.

The pendant is a stray find from redeposited soil. It is evidently an exotic version of the plain garnet cabochon pendants fashionable in the middle years of the seventh century (e.g. 13, 33c). Romano-British intaglios were occasionally re-set in Anglo-Saxon mounts (e.g. 5h) but this use of a cameo is quite exceptional. Its scale, style, subject-matter and mere occurrence are all unique in an Anglo-Saxon context. It is clearly an outstanding example of the *exotica* which made their way to England from the eastern Medi-

terranean via Italy and Francia as a result of accelerated contacts in the early seventh century. Although a Sassanian origin has been suggested for it (Arrhenius 1985, 37), its naturalistic style indicates rather that it depicts a Roman or Byzantine oriental stereotype, signified by the Phrygian cap. The subject could be one of a number of oriental bearded male types (*Magi*, for example) and cannot be more precisely identified. The gem's origin could lie equally in Italy or Byzantium. LW

Select bibliography: Henig 1974, cat. 734; Tait 1976, cat. 385; Tait 1986, cat. 540.

36 (a–c) Three pendants

Milton, near Sittingbourne, Kent
Gold; D. (incl. loops) (*a*) 3.8 cm, (*b*) 3.8 cm, (*c*) 3.1 cm
Anglo-Saxon; 7th century
British Museum, M&LA (*a*) 1921, 10–20, 1, (*b*) 1926, 4–10, 1, (*c*) 1926, 4–10, 2

36 (a) Circular sheet-gold pendant

Beaded wire rim and corrugated suspension loop. A plain diagonal cross with expanded arms outlined in beaded wire, with a central garnet cabochon, is surrounded by a concentric border containing filigree wire omega scrolls; the spaces between the arms are filled with mock-cloisons and S-shaped motifs.

36 (b) Circular sheet-gold pendant

Beaded wire rim and ribbed suspension loop. A four-pointed cloisonné garnet star edged with beaded wire, surrounding a central circular setting, now empty, is set against a background of S-shaped filigree scrolls. Triple beaded wires link the points of the star to the rim, which has a U-shaped clip folded over it. The concentric border, edged with plain wire, is filled with omega scrolls.

36a–c, 37

38

36 (c) Circular sheet-gold pendant

Beaded and plaited wire rim repaired in antiquity, and ribbed suspension loop. A diagonal cross outlined in beaded wire, with a central circular setting, now empty, has a pair of conjoined filigree birds' heads in each arm. The spaces in between contain S-shaped and omega scrolls.

These pendants and six silver sceattas were published in 1926 as belonging to a single grave, but all that can be said with certainty is that they were all found together in a gravel pit near Cook's Lane, Milton Regis, together with a further fourteen sceattas acquired by Maidstone Museum in 1958. The coins date the deposit to around 700.

These pendants illustrate the new fashions of dress arising from increased contact with the Mediterranean world after the Conversion (see p. 47). The cruciform designs reflect the growing influence of Christianity.　　　　CH

Bibliography: Hawkes and Grove 1963; Bruce-Mitford 1974, 127, pl. 25 a–c.

37 Pendant

Wye Down, Kent
Gold; D. (incl. loop) 2.7 cm
Anglo-Saxon; later 7th century
British Museum, M&LA 1893, 6–1, 188

Sheet-gold circular repoussé pendant with beaded border and ribbed suspension loop. A cross with expanded terminals has an interlaced triquetra in each arm, and four repoussé dots in a cruciform pattern in the centre; the lentoid fields in between the arms are plain.

According to the Museum register, it was found at the neck of a female skeleton in November 1858, together with a second gold pendant decorated with filigree wire. A silver repoussé pendant from the late cemetery excavated at Camerton in Somerset, and another formerly in Hull Museum, are the closest parallels to this piece (Leeds 1936, 111–12). The pale colour of the gold reflects the continuing debasement of the coinage, the chief source of raw material for the Anglo-Saxon jeweller during this period, and confirms the late seventh-century date suggested by the decoration.　　　　CH

Bibliography: Bruce-Mitford 1974, 28; 1978, 620, fig. 44d, 624–5.

38 Pair of clasps

Taplow, Bucks.
Gold, copper-alloy; L. of each element 6.05–6.55 cm
Anglo-Saxon; first quarter of 7th century
British Museum, M&LA 1883, 12–14, 2, 3

Each clasp comprises two sub-triangular plates of equal size, engaged by means of a hook and loop; the components have copper-alloy cores wrapped in gold filigree-decorated sheet. They were sewn to a fabric or leather base by means of three loops on the underside. Three circular settings for shell inlays

mark the angles of the triangular plates, which are decorated with an identical symmetrical design of four interlaced Style II ribbon animals executed in beaded filigree wire on a raised base. The loops have identical Style II confronted bird-headed creatures in filigree: the hooks have simple pseudo-plait, twisted and S-scroll filigree. The backs are plain.

The clasps are among the latest items from the exceptional early seventh-century barrow burial overlooking the river Thames at Taplow. In its complex assemblage of luxury items it commemorates a dead man whose status approaches that of the royal dynasty buried at Sutton Hoo. Among the many trappings of status, old and new, in the burial, the clasps with a significant number of other grave goods indicate a Kentish connection; their form and fine filigree technique and Style II decoration are best paralleled in the seventh-century Kentish gold-decorated triangular buckles. It is likely that a political reality underpins this link, connected perhaps with Kentish territorial expansion in the middle Thames region during the earlier seventh century, as much as with the spread of changing fashions in dress and religion.

The supremely elliptical Style II animal ornament seen here illustrates the close relationship of this sinuous and rhythmical style to the availability of gold and consequent use of filigree technique. The (briefly) increased availability of gold in early seventh-century Anglo-Saxon England is certainly an important factor in the rapid dissemination of the new style; while the occurrence of Kentish state-of-the-art pieces such as the clasps in the Thames valley also underscores the changing power structures at work in this period. LW

Bibliography: Smith 1905, 199–204; Meaney 1964, 59 and refs; Speake 1980, 52 ff and refs; East and Webster forthcoming.

39 Mount

Barham, near Ipswich, Suffolk
Copper-alloy, gilding; L. 6.4 cm
Anglo-Saxon; early 7th century
British Museum, M&LA 1984, 1–3, 1

Pelta-shaped cast plate, gilded on the decorated face and with three cast attachment pins on the plain underside: a secondary attachment rivet pierces the plate at the centre of the flat edge. The curved edge terminates in Style II bird heads with curving beaks: the panel's main field is decorated with three back-biting ribbon-bodied Style II zoomorphs within a billeted border.

This striking piece of metalwork is probably a shield or casket fitting; it closely resembles in form mounts of similar date from a chest in a burial at Caenby.

Found on an apparent market site or meeting-place in use from the seventh to the ninth century, it is decorated in a cast version of Style II: its glittering surfaces belong in the long Germanic tradition of chip-carved gilt-bronze animal ornament, but the version of Style II back-biting ribbon creatures looks forward to the elegant interlacing beasts of seventh-century manuscript art. LW

Unpublished.

39

40b

40a

40 (a, b) Two dies

Suffolk
Copper-alloy; L. (a) 6.8 cm, (b) 6.65 cm
Anglo-Saxon; first half of 7th century
Moyses Hall Museum, Bury St Edmunds, inv. no. BSE MH 1977.868. 1, 2

40 (a) Rectangular die

Contains within a billeted border an intricate but balanced design of six chain-linked zoomorphs symmetrically arranged in two sets, one looking to the left, the other to the right.

40 (b) Narrow, rectangular die

Contains within borders of narrow billets a design that is best read as a pair of tightly interlaced zoomorphs lying head to tail.

The dies have no certain findspots within Suffolk. They are generally supposed to have been found together and are traditionally associated with Icklingham. They are both slightly curved along their length, a feature common to many dies that has been linked with their use in manufacturing

decorative foils for drinking cups. The slight curve might also ease the pressing of the die into a foil from behind, although recent experiments to reproduce fine foils (Meeks and Holmes 1985) suggests that the thin metal sheet may have been worked into dies from the front using a burnisher and some form of stylus to sharpen the impression. A combination of both methods may have been used on heavier foils.

The design of the larger die is a confident, ingenious and well-balanced combination of bodies chain-linked by ribbon jaws: an overall design readily found within the repertoire of Style II animal interlace. Precise parallels are less easy to isolate although individual elements of the design can be found, for example in the rectangular panels around the edge of the Swedish-made Sutton Hoo shield (Bruce-Mitford 1975, fig. 64). Speake also finds the closest parallels for both dies in Scandinavian interlace, supporting earlier suggestions that the dies may have belonged to Swedish craftsmen working in an East Anglian milieu (1980, 73). A strong relationship with Vendel-style interlace has long been seen in aspects of the zoomorphic art of the Sutton Hoo ship-burial, and the long-standing contacts between East Anglia and Scandinavia have been demonstrated by Hines (1984, esp. ch. 6) whose exhaustive study of dress fittings suggests continuous contact across the North Sea throughout the fifth and sixth centuries. The dies fit comfortably into this extended cultural milieu. ACE

Select bibliography: Capelle and Vierck 1971, 68–71, 77–81; Hawkes et al. 1979, 383–92; Speake 1980, 72–4; Meeks and Holmes 1985, 143–57.

41 Sword harness mount

Provenance: unknown
Gold, garnet; H. 1.2 cm
Anglo-Saxon; first quarter of 7th century
Private possession

Truncated pyramidal strap-mount of gold with a single mille-fiori setting and cloisonné decoration on each face. The pyramid is delicately constructed of sheet-gold and is hollow with the strap-bar across the open base missing. Inlaid in the top is a multi-stepped setting of chequerboard millefiori made from rods of aquamarine and red glass; the corners are filled with a small garnet. Each face is ornamented with either a

41

42

knotted or a simple Style II interlace zoomorph fluidly executed in cloisonné garnets and gold lidded cells. Both the garnets and the millefiori glass are backed with stamped gold foil.

Pyramidal mounts are found both singly and in pairs and are invariably associated with the formalised fittings belonging to contemporary styles of sword suspension harness of the mid sixth and seventh centuries (Menghin 1983). They were made in a variety of materials – the Sutton Hoo cemetery for example has produced two magnificent pyramids from Mound 1 (Bruce-Mitford 1978, fig. 27), decorated in the all-over garnet work typical of the jewellery from the ship-burial, as well as a find from Mound 7, made during the current excavations, of a copper-alloy example with a square-cut garnet in the top and single settings of translucent pale green glass filling each face.

The pyramid is an outstanding example of the metal-worker's art. Restrained, with decoration that is elegantly balanced and exceptionally well executed, it ranks high amongst the small group of pyramidal mounts associated with contemporary sword harnesses in Anglo-Saxon England and on the continent (Bruce-Mitford 1974, pl. 86 a–h and Menghin 1983, 363–5). It is unusual in its technique of decoration: its cloisonné zoomorphs reflect those found more usually in filigree, for example on the Selsey (Sussex) pyramid which also shares the use of a single zoomorph to fill each triangular field (Bruce-Mitford 1978, fig. 408c) as well as those on the Kingston brooch (32a), in the Sutton Hoo shoulder-clasps (14) or the Crundale buckle (6). The execution of zoomorphic interlace in cloisonné demands exceptional skill. It is consequently rare and confined to high quality pieces such as the Sutton Hoo shoulder-clasps and purse-lid or the Tongres mount (Bruce-Mitford 1974, pls 89b and 91), which all date from the early seventh century. Although completely without provenance, this example shares singular techniques with the jewellery from the Sutton Hoo ship-burial in the use of cloison-set millefiori and the combination of cloisonné interlace with gold lidded cells. Such similarities suggest that it may have been made in the same workshop in the early seventh century. ACE

Unpublished.

42 Mount

Caenby, Lincs.
Silver; D. 3.7 cm
Anglo-Saxon; early 7th century
British Museum, M&LA 1851, 10–11, 7

Repoussé roundel, originally pinned to a ?wooden base. An outer border of diagonal billets frames an inner zone with a procession of crouched Style II quadrupeds, the jaws of each locked about the hindquarters of the beast in front. A convex disc occupies the centre.

This fragment is one of a set of variously decorated silver mounts from a richly furnished but poorly recorded seventh-century barrow burial. It seems to have been fitted to a

substantial piece of wooden furniture such as a chest. Its decoration shows another aspect of the newly fashionable Style II animal ornament which finds its way into manuscript art; a delight in interlocked animal processions. The quirky beasts seen here have stylistic links both to the creature seen at the end of the Sutton Hoo buckle (**15**) and on the following piece. LW

Select bibliography: Speake 1980, 39, 42, pl. 15 (k); East and Webster forthcoming.

43

43 Handle fragment

Fishergate, York
Bone; L. 3.6 cm, W. 1.2 cm
Anglo-Saxon; first half of 7th century
The Yorkshire Museum, York, inv. no. 1986.45.4618

Tubular handle fragment, perhaps from a knife, carved in relief with processing Style II quadrupeds whose long jaws bite the hind legs of the beasts in front.

This piece was excavated on a seventh- to ninth-century Anglo-Saxon occupation site at York. It is a rare survival from the largely lost body of early Anglo-Saxon carving in wood and bone which must have been at least as significant as metalwork in the repertoire of artists and craftsmen of the period. Its decoration is closely related to metalwork, its snapping procession of creatures resembling other northern pieces such as the Caenby disc (**42**) and the die from Salmonby, Lincs. (Speake 1980, pl. 15e). LW

Unpublished.

44 Plaque

Southampton (*Hamwic* Saxon settlement)
Antler; L. 4.8 cm, W. 3.5 cm
Anglo-Saxon; 7th century
Southampton City Museums, inv. no. SOU 31.1573

The rectangular plaque has an incised design depicting two entwined beasts. Each beast has a long, narrow head with the jaw seizing the back leg of its companion. The eye is formed by a small, oval impression surrounded by a crescent. The animal bodies, like the head, are delineated by a double contour and narrow towards the hind quarters. The front limb is elongated and curves in front of the head, widening as it approaches the foot, which is curved back towards the limb joint. The back leg is short with the foot again curving towards the oval limb joint. The pair of beasts is enclosed within a rectangular frame, now fragmentary, with a zoomorphic ribbon interlace pattern adjoining on the longer sides. The shorter sides are plain and traces of a rivet hole survive along one of the edges. There are clear correspondences between the style of the animals on this mount and Hiberno-Saxon objects of the seventh century. The zoomorphic designs of the Sutton Hoo gold buckle also include double-contoured beasts with long closed jaws, elongated curving forelegs and bodies which narrow at the hindquarters towards a short back leg (**15**). Some of these characteristics are repeated on zoomorphic designs from the Crundale sword pommel and the Book of Durrow (Speake 1980, pl. 14b; Roth 1987, figs 2, 3, 6).

The plaque was recovered from a pit at Six Dials in the northern part of the Anglo-Saxon settlement known as *Hamwic*. Rubbish was deposited in this pit in the ninth century (Andrews forthcoming). The style of the ornamentation of the mount is undoubtedly earlier than this and should be set around the middle of the seventh century. Attempts to place objects of this style in the later sixth or early seventh century are unconvincing, as yet (Roth 1979; 1987; cf. Wilson 1984, 25). Stylistically, the mount is none the less earlier than the foundation of *Hamwic* itself, which occurred during the reign of King Ine, in the late seventh or early eighth century (Loyn 1963, 138; Yorke 1988, 93). In common with a small number of other objects, it appears to have been brought into the settlement after its foundation, possibly as part of a decorated casket. The mount was not made at *Hamwic*, although it probably remained in use in the settlement during the eighth century. IR

Bibliography: Campbell 1982, 103, fig. 3.

44

45

45 Gold plaque

Bamburgh, Northumberland
Gold; L. 1.6 cm
Anglo-Saxon; 7th century
Executors of the Rt. Hon. Lord Armstrong

Plaque, originally forming an inlay from a composite object
such as a book-cover or shrine. The decoration consists of an
engraved animal set within a rectangular frame. The beast
has two legs, sling-shaped jaws and a single elliptical eye set
high on its well-marked head. The front leg loops from
its shoulder joint to interlace twice with the jaws before
terminating in a three-toed paw beneath the head. The rear
leg, which is not marked off from the body, loops below the
belly of the animal, passes behind the beast and finishes in a
three-toed paw above its back.

The plaque was found in 1971 during excavations in the
West Ward of the castle in a seventh- to eighth-century
horizon. Many of the features of its decoration can be readily
paralleled elsewhere in seventh-century zoomorphic art.
Thus the single eye, set high and to the back of the head, is
a persistent element among Style II beasts: it occurs among
the Sutton Hoo material and on the animals engraved on the
silver back-plate of a composite brooch from Faversham,
Kent. Similarly extended jaws closed in a sling can be found
at Sutton Hoo and on a seventh-century disc from Caenby
(42); early in the following century they appear on the animals
which decorate the jambs of the porch at Monkwearmouth
(fig. 9). Sutton Hoo also offers a parallel, on the gold buckle,
for a beast whose jaws are locked around its front paw. The
most striking analogues, however, for the Bamburgh animal
are provided by the zoomorphic procession on f. 192v of the
Book of Durrow (see 6); here, in more coherent form, are
beasts with similar looped back legs, feathery three-toed feet
set over the back, and front paws interlaced in prehensile
jaws. This rare example of metalwork from Bernicia thus
contributes a further element to the debate about the origins
of the art of the seventh-century gospel book. RNB

Bibliography: Cramp 1984, 19, 126; Bailey forthcoming.

46 Helmet

Benty Grange, Derbys.
Iron, horn; gold, silver-gilt, gilded copper-alloy, garnet; H. 24.5 cm
Anglo-Saxon; mid 7th century
Sheffield City Museums, J93.1189

Helmet with an iron frame covered with horn plates, dec-
orated on the nasal with a silver cross and on the crest by the
multi-metalled figure of a boar. The iron frame and horn
plates are clamped together by rivets with silver-capped heads
and washers of double-axe form. The boar is riveted to the
frame and is constructed of two D-shaped copper-alloy tubes
riveted together, leaving a narrow space running from nose
to tail. This is assumed to have held a separate element
depicting the crest. The body of the boar is decorated with
silver studs with gilt heads, and oval silver-gilt plates form

46 (detail)

the hips and shoulders. The legs are iron. A fragment of
gilded copper-alloy may be the remains of a tail, applied like
the gilded copper-alloy ears. The head of the boar has gilded
tusks and muzzle and garnet-inlaid eyes in beaded gold
collars. The silver cross riveted to the nasal originally had
equal, slightly flaring arms springing from a central roundel,
later lengthened by an extra strip of silver added to the lower
arm. The nasal is additionally decorated with a carefully
structured pattern of silver studs: a zig-zag flanking the long
lower arm springs outward to link the arms of the original
cross together to create the impression of a wheel-headed
cross.

The cross on the Benty Grange helmet has long been
thought of as a symbol of Christianity. This may be so,
but the helmet dates from the mid seventh century when
conversion to Christianity was still new. In this context it is
possible that the cross is significant not necessarily because
it reflects the Christian faith of the wearer but because it was
seen as a symbol of victory (cf. the appearance of the cross
to Constantine). The cross may then be a talisman, perceived
in the same way as the boar, as a symbol of strength rather
than a deliberate statement of Christianity.

The Benty Grange helmet is an extraordinary amalgam
which is essentially unparalleled, although analogies for indi-
vidual elements can be isolated. The skeletal iron framework
is known from the aristocratic graves of Vendel and
Valsgärde, Uppland, Sweden, and horn was used on the small
helmet found in a princeling's grave in Cologne Cathedral.
The boar figure's association with helmets is well known
from many sources, in *Beowulf* (4) for example, where 'over
the cheek-pieces, boar shapes shone out, bristling with gold,
blazing and fire hard, fierce guards of their bearer's lives'.
Visual images also appear on the decorated panels of helmets
themselves, as on that from Grave 7, Valsgärde, Sweden
(Arwidsson 1977, fig. 120) which shows a warrior wearing a
helmet surmounted by a massive boar whose tusks, ears and
crest are deliberately emphasised. Conceptually, the Benty
Grange helmet belongs within the restricted pool of European
helmets whose ultimate ancestry lies in the helmets of the

Roman Empire (cf. the York helmet, **47**). Its iconography, containing powerful symbols of both paganism and Christianity, is unique and may well be indicative of a date in the middle seventh century when the combination of Christian and pagan talismans would not be unacceptable to a population who were only in the early stages of conversion to Christianity. ACE

Select bibliography: Bateman 1861, 28–33; Bruce-Mitford 1974, 223–52.

47 Helmet

Coppergate, York
Iron, copper-alloy; H. (of cap from crown to tip of nasal) 24.6 cm
Anglo-Saxon; second half of 8th century
The Castle Museum, York, inv. no. YORCM CA665

Iron helmet made of four main elements, a composite cap, two deep, curving cheek-pieces and a curtain of ring mail, with brass edge-bindings and copper-alloy embellishments including a crest with repoussé inscriptions.

The cap consists of a riveted framework of four broad iron bands, a broad brow band joined nose-to-nape by a band forming the crown and ear-to-ear by two short bands. The small triangular spaces between the bands are filled with shaped iron sheet. No evidence of any form of padding or lining was found. At the front the brow band is cut away to form large sub-rectangular eye-holes between which lies a shaped nasal that thrusts out at a shallow angle to accommodate the nose. The nasal is decorated with a pair of interlacing animals with hatched and contoured bodies and spiral hips. The eye-openings carry eyebrows cast in brass in the form of a ribbon animal decorated with oblique transverse hatching and terminating in a well-formed profile head with incised comma-shaped eyes, open jaws and carefully drawn teeth. Between the eyebrows, facing down towards the interlace of the nasal, is a broad, blunt-snouted animal head whose muzzle is decorated with incised chevron ornament. The eyes are incised and comma-shaped. The ears, decorated with transverse grooves, are placed at the back of the head and merge awkwardly into the ends of a pair of half-round brass mouldings, decorated with hatching, that run over the crown delimiting a narrow decorative field. This contains a single strip of thin copper-alloy sheet bearing a retrograde inscription in repoussé terminated by an interlace triquetra within a circle. It reads (front to back): IN. NOMINE. DNI. NOSTRI. IHV. SCS. SPS. D. ET. OMNIBUS. DECEMUS. AMEN. OSHERE. XPI., which may be translated as 'In the name of our Lord Jesus, the Holy Spirit, God and with all we pray. Amen. Oshere. Christ'. Placed crosswise to this inscription, and centred on the short bands that connect the brow and crown bands, are two further decorative fields of identical form. Each contains a length of copper-alloy sheet again with a retrograde inscription in repoussé that repeats part of the inscription seen in complete form on the crest. One strip is damaged, but the other reads, starting from the crown: IN. NOMINE. DNI. NOSTRA. IHV. SCS. SPS., showing that the divided inscription was mounted in reversed relationship.

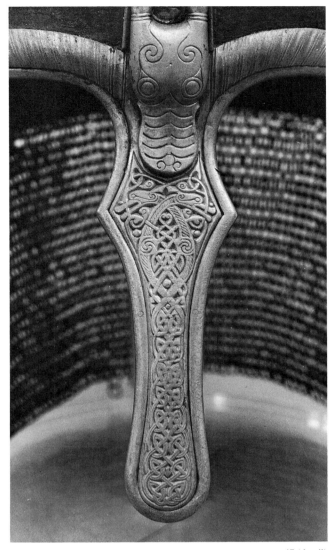

47 (detail)

The lower edge of the brow band is bound with a deep moulded brass strip. Overlapping this, behind each eye opening, is an iron hinge, riveted to the cap and to the cheek-piece. Centrally placed on the inside of each is a single square-headed rivet, probably the attachment point for a leather tie used to pull the cheek-pieces close to the face (cf. the replica of the Sutton Hoo helmet, made before the discovery of the York helmet, which was provided with chamois leather ties on the advice of the Tower of London Armouries). Brass clips, fixing points for the ring-mail neck-guard, are placed at regular intervals along the back edge of each cheek-piece. The upper edge of the mail is attached to the cap by a series of rings that pierce the lower edge of the edge strip. The mail, found folded inside the helmet, was capable of being teased from its corroded condition into a flexible curtain.

The helmet was found on the Coppergate site during final levelling prior to development, and only 9 m beyond the

limits of the excavation which uncovered a detailed sequence of the Viking settlement and subsequent town of Jorvik. It lay on its side at the bottom of a wooden lined shaft, 90 cm square, where an anaerobic micro-environment preserved it intact. It appears to have been carefully deposited in the shaft, together with a spearhead.

The helmet is one of only three complete examples known from the Anglo-Saxon period. The other two, the Benty Grange helmet (46) and that from Mound 1 at Sutton Hoo, are related to it by a common ancestry. The York helmet, dating from the second half of the eighth century, is structurally not dissimilar to the Benty Grange helmet – both share the composite cap of bands and plates whose antecedents lie in the *Spangenhelmen* of the late Roman period. Similar structure is found in the group of helmets from aristocratic

burials in the Vendel and Valsgärde gravefields, Uppland, Sweden (Stolpe and Arne 1927, Arwidsson 1942 and 1977). The York helmet shares with that from Sutton Hoo the deep curving cheek-pieces which also occur in slightly different form on the helmet from Grave XIV at Vendel and shares with other Swedish helmets (Vendel XII, Valsgärde 6) the use of mail as a protective but flexible curtain. The decorative bands running over the crest in two directions are also found amongst the Swedish helmets. Thus features of the York helmet can be found in the few broadly contemporary complete helmets. These, however, are concentrated in two cemeteries in Sweden and restricted to two other English finds. It is clear from burial evidence that helmets were the rare possessions of an élite – most of the warrior class probably relied on a simple blocked leather casque to protect their

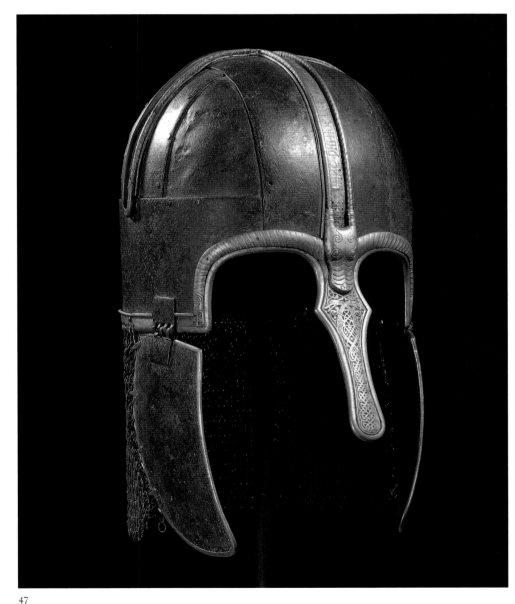

47

heads against sword cuts. This, together with the fact that none of the three complete Anglo-Saxon helmets provides a direct parallel for its companions, suggests that there was no established tradition of helmet-making in Anglo-Saxon England. Metalsmiths may have built helmets to the individual requirements of the patron who commissioned them, relying on a common pool of knowledge for their structure and decorative scheme with origins in the *Spangenhelmen* and parade helmets of the late Roman army: prototypes that were undoubtedly copied by Germanic craftsmen as the ultimate symbol of the warrior class. ACE

The decorative elements of the helmet, like the script (see below), indicate a date in the late eighth century: the interlacing creatures of the nasal have close parallels in sculpture (at Colerne, Wilts.) and in certain details seen in the Barberini Gospels (**160**), especially the beasts in the letter Q, f. 80. The particular type of pointed loop interlace is also typical of the period (e.g. in the Blickling Homilies (Alexander 1978, cat. 31, f. 27, f. 7), while decorative elements such as the ribbed mouldings of crest and brows are a feature of late eighth-century metalwork, such as the Thames mount (**179**). LW

The inscription The letter-forms of the York helmet inscriptions are of a mixed character, combining uncials with angular 'rune-like' capitals of the sort popularised by Hiberno-Saxon display script of *c*.700. The manuscript-like quality of these often rounded and fluid forms (notably that of the sinuous uncial A) contrasts with the epigraphic approach to layout, with a *punctus* (or point) separating each word. This latter feature derives ultimately from the Roman tradition of monumental inscription. In achieving the repoussé effect the craftsman has reversed the letters drawn out by a scribe who was probably familiar with the production of display scripts in books.

A taste for fluid uncials with some intruding capitals seems to have grown during the eighth century and may be seen in the inscriptions accompanying the evangelist portraits in the Barberini Gospels (**160**) of the late eighth century. A York origin has also been suggested for this book, although there is little other corroborative evidence for such an attribution. Also dating from the late eighth century, the Leningrad Gospels (Leningrad, Public Library, Cod. F.V.I.8) favours a similar combination of forms, although here their fluidity often degenerates into a mere lack of discipline. Both Northumbrian and Southumbrian origins have been advanced for the Leningrad and Barberini gospel books. Other earlier, mid eighth-century parallels include the display panels of the Trier Gospels (Trier, Domschatz, Cod. 61) and the Stuttgart (Echternach) Psalter (**128**), although these were produced under Insular influence on the continent, at Echternach. MPB

Select bibliography: Tweddle 1984; Hall 1986, 34–42; Binns et al. 1990.

Coins

48 (a–e) Coins from the Crondall, Hants., hoard deposited *c*.645 and found in 1828

The Visitors of the Ashmolean Museum, Oxford

48 (a) Merovingian tremissis of Dagobert I (629–39), struck at Chalon-sur-Saône

Gold; WT 1.30 g (20.0 gr)

This is the only Merovingian regal coin in the hoard. Its base gold suggests an issue date late in the reign.

48 (b) Merovingian tremissis struck at Quentovic, near Visemarest, Pas-de-Calais, by the moneyer Dutta, *c*.635–40

Gold; WT 1.30 g (20.1 gr)

The moneyer's name suggests that he or his family was of Anglo-Saxon origin, as does that of Anglo found on a very similar Quentovic coin from Barham, Suffolk (**144**).

48 (c) Anglo-Saxon shilling struck at London (signed LONDVNIV), *c*.640–5

Gold; WT 1.31 g (20.2 gr)

Sutherland suggested that this type was issued by the Bishop of London, but the head does not appear to be tonsured as he believed. While an ecclesiastical attribution is still quite possible, the authorities behind this and the other devolved London-signed coins in the hoard are uncertain, and a secular issue by a *monetarius urbis* could be involved.

48 (d) Anglo-Saxon shilling, devolved Witmen group, struck in Kent, *c*.640–5

Gold; WT 1.36 g (21.0 gr)

48 (e) Shilling of Eadbald, king of Kent (614–40), struck at London

Gold; WT 1.27 g (19.6 gr)

Two coins of AVDVARLD REGES (an acceptable form for King Eadbald) are the only coins naming a king so far identified in the Anglo-Saxon coinage until the eighth century (**54, 57a, 221a, b**). The mint name here reads only DENVS, but LONDENVS is clear on the other example. These coins are important evidence for royal participation in the coinage from its early days, and for Eadbald, like his father Æthelberht, having authority in the East Saxon city of London.

(*Right*) Later Anglo-Saxon gold shillings and the early silver pennies which succeeded them

48a

48b

48c

48d

48e

49

50

51

52a

52b

53a

53b

53c

53d

53e

53f

54

55a

55b

55c

56

57a

57b

The coins from the hoard now known total 101 (including three blanks), and account for most of the surviving Anglo-Saxon gold shillings of the early phase. The hoard originally included gold ornaments, but their location is now unknown. Sixty-nine coins were Anglo-Saxon, and they die-link into some of the coins found elsewhere. The small number of dies used in this early coinage suggests that it was limited in volume and of short duration. It is probably significant that about 30 per cent of the group was still Frankish, and that the total had to be made up, as in Sutton Hoo, by the inclusion of blanks. MMA

Provenance: Purchased from the Grantley II sale, Glendining, 27.i.1944 lots 495–587.
Bibliography: Sutherland 1948, nos 3a, 12a, 45a, 60b, 78a; Kent 1984.

49 Shilling attributed to York, *c*.630–40

Gold; WT 1.13 g (17.5 gr)
British Museum, CM 1850, 5-6-1

The obverse appears to show a building, based perhaps on the fourth-century Roman Camp-gate type. The attribution to York depends on provenance – a single find of three die-duplicates. The inscription is illiterate as it stands, but looks as if it had been intended to be meaningful; perhaps a literate coin originally stood at the head of the series. MMA

Provenance: Said to have been found, probably with two die duplicates, at York in or before 1846. Given by Dr Hemingway.
Bibliography: Sutherland 1948, no. 75; Grierson 1962.

Later Anglo-Saxon gold shillings (50–2)

50 Anglo-Saxon shilling derived from a Roman bronze coin of Crispus (Caesar, 317–26), showing a standard, the blundered version of the original inscription interrupted by DELAIONA (in runes, and retrograde) denoting that it was struck at London, *c*.660–70

Base gold; WT 1.30 g (20.1 gr)
British Museum, CM 1934, 10-13-1

The designs of later Anglo-Saxon gold shillings have little in common with contemporary Merovingian issues, but show an independent native inspiration from Roman coins. The persistence of the signature of London alone among the minting places of the earlier coinages (the initial issue from Canterbury (24) apart) is evidence of its already pre-eminent position. MMA

Provenance: St Albans, Herts., 1934.
Bibliography: Sutherland 1948, no. 27; Kent 1961.

51 Anglo-Saxon shilling struck in Kent in the name of Pada, *c*.660–70

Base gold; WT 1.26 g (19.5 gr)
British Museum, CM 1935, 11-17-914

If the currently accepted chronology and mint attribution are correct, Pada, who is named in runes on the reverse, cannot be equated with King Peada of Mercia who died in 656, and must be identified as a moneyer. Pada produced several types, and the number of dies suggests a fairly extensive coinage. The later Anglo-Saxon gold shillings as a whole were issued in greater numbers than before, but given that their issue covers a period of about twenty-five years, they are still too few to imply a monetary economy. MMA

Provenance: Not known; by exchange for duplicate from the T. G. Barnett Bequest, via Spink, ex Grantley II sale, Glendining, 27.viii.1944, lot 595.
Bibliography: Sutherland 1948, no. 82.

52 (a, b) Anglo-Saxon shillings showing two emperors with victory above, copied from Roman gold solidi of several joint emperors of the late fourth century, struck in Kent

52 (a) *c*.660–70

Base gold; WT 1.31 g (20.2 gr)
British Museum, CM 1862, 7-18-2
Provenance: Eastwood, Kent, 1862.
Bibliography: BMC 2; Sutherland 1948, no. 32; Kent 1961.

52 (b) *c*.665–75

Silver (small percentage of gold); WT 1.25 g (19.3 gr)
British Museum, CM 1863, 9-19-1
Provenance: Not known.
Bibliography: BMC 9; not included in Sutherland 1948; Kent 1961.

These coins were struck in considerable numbers but, like other issues of the later shillings, their gold content declined rapidly as is demonstrated by comparing their colour. (The precise dating of the stages of this decline is uncertain.) The Anglo-Saxons could not maintain a good gold coinage in the face of a collapse in the standard in the Merovingian coinage from which most of their bullion was derived. MMA

53 (a–f) Coins from the Aston Rowant, Oxon., hoard, deposited *c*.710 and found in 1971–4

53 (a) Penny (sceat), Primary Series A, 'Tic' type. Kent, *c*.675–85

Silver; WT 1.21 g (18.6 gr)
British Museum, CM 1971, 12-16-1

49 50 51

52a 52b

53b 55b 56

Anglo-Saxon gold shillings, and silver pennies of the late seventh and early eighth centuries

53 (b) Penny (sceat), Intermediate Series Bıı, Bird-on-cross type. London, *c*.690–700

Silver; WT 1.19 g (18.3 gr)
British Museum, CM 1971, 12–16–15

53 (c) Penny (sceat), Intermediate Runic type, Series C. Kent, *c*.690–700

Silver; WT 1.22 g (18.8 gr)
British Museum, CM 1971, 12–16–29

53 (d) Penny (sceat), Continental Series D, Cross-and-pellets type. Lower Rhine area, *c*.700–10

Silver; WT 1.29 g (19.9 gr)
British Museum, CM 1971, 12–16–94

53 (e) Penny (sceat), Continental Series E, 'Porcupine' type (VOIC group). Frisia, *c*.700–10

Silver; WT 1.23 g (19.0 gr)
British Museum, CM 1971, 12–16–52

53 (f) Penny (sceat), Continental Series F, Cross-on-steps type. North Francia, *c*.690–700

Silver; WT 1.18 g (18.2 gr)
British Museum, CM 1971, 12–16–84

Coins of the Primary and Intermediate sceatta periods present in this hoard have also been found, mainly in south-eastern England, in small groups in graves, and as isolated finds. Aston Rowant, totalling about 350 coins (not all were declared), is the only large hoard known except the ill-recorded find at Hougham, Kent, in *c*.1780. Only a quarter of the contents were English; the rest were continental with Series D especially numerous, and presumptively the result of a parcel recently brought over from the Rhineland which had been taken westwards along the Thames valley. Isolated finds suggest that the proportion of foreign coins in Aston Rowant is unusually large, but the hoard provides important evidence of trade with Frisia over a comparatively short period early in the eighth century. MMA

Provenance: Purchased as treasure trove from H. M. Treasury, 1971.
Bibliography: Kent 1972; *CH* I (1975), no. 87; Grierson and Blackburn 1986, 167–8. For sceattas *passim*, Hill and Metcalf 1984.

54 Penny (sceat) of Aldfrith of Northumbria (685–705), struck presumptively at York

Silver; WT 1.26g (19.4gr)
British Museum, CM 1854, 6–21–23

The attribution of the coins of this group to Aldfrith, *rex simul et magister* of Northumbria, rather than to the king of Lindsey of the same name ruling at the end of the eighth century, was confirmed by the discovery of an example in a stratified context of *c*.700 at Southampton. They are the earliest-known regal coins of Northumbria (the so-called coins of Ecgfrith are forgeries), and their weight and fine metal place them securely in the Primary Series. The sceatta coinage of Northumbria is remarkable in being explicitly regal from the start, moneyers being a later addition, unlike the south where the reverse is the rule. MMA

Provenance: Not known.
Bibliography: BMC 3; Booth 1984, 97 and no. 4.

55 (a–c) Pennies (sceattas) of the Secondary Series, regional issues

55 (a) Penny (sceat), Secondary Series L, struck at London (signed DE LVNDONIA, cf. **48c**), *c*.730–40

Silver; WT 0.96g (14.8gr)
British Museum, CM, acquired before 1838
Provenance: Not known.
Bibliography: BMC 89.

55 (b) Penny (sceat), Secondary Series H, struck in Wessex, at *Hamwic* (Southampton), *c*.725–35

Base silver; WT 1.00g (15.5gr)
British Museum, CM 1838, 9–8–82; gift of Mr R. Young, 1838
Provenance: Found in Southampton.
Bibliography: BMC 194.

55 (c) Penny (sceat), Secondary Series R, unusual modelled profile head, inscribed with the moneyer's name in runes, TILBERHT, struck in East Anglia, *c*.740–50

Very base silver; WT 1.09g (16.8gr)
British Museum, CM 1986, 8–46–17

Provenance: Found at Barham, Suffolk, a hill-top market site of the Middle Saxon period.
Bibliography: Archibald forthcoming.

In the Secondary phase the coinage was much more prolific than in the Primary and Intermediate phases, and the use of money spread from the south-east further into East Anglia, Mercia and Wessex. (For Northumbria see **57** and **118**.) Coin designs adapt some earlier Roman-inspired types, but for the most part introduce a wide range of Anglo-Saxon motifs of high artistic quality. No coins, except for an issue from London, bear the name of their minting place, so attribution depends to a considerable extent on provenance. This is less helpful than might be expected because of the velocity of circulation as a result of the very flourishing economy and long-distance trade across the country. There was apparently no restriction on the currency of coins outside the kingdom in which they were struck. Of the anonymous types, those above and of Essex (**78b**) are among the most securely located. Early in the eighth century the weight of the sceattas fell from the standard of *c*.1.25g in the Primary Series to *c*.1.00g. The metal was still fine silver, but thereafter the silver became increasingly base, and at the end of the coinage in the 740s and earlier 750s the coins had little silver in them at all and the weight was also declining. MMA

56 Penny (sceat) Secondary Series T, inscribed MONITASCORVM, struck in the ?east midlands, *c*.720–30

Silver; WT 1.10g (17.0gr)
British Museum, CM 1950, 11–5–1; gift of Mr S. W. Kirton

The form 'scorum' is a normal contraction for *sanctorum* (cf. a seventh-century stone inscription from Canterbury, Okasha 1971, no. 21) permitting the expansion 'monita sanctorum', 'money of the saints'. On analogy with the Merovingian coinage where many religious foundations issued coins in the names of their patron saints, this coin must have been issued by one dedicated to two saints. The most commonly paired are Saints Peter and Paul, but others are possible. The commercial interests of Anglo-Saxon monasteries and churches is documented in several charters of Æthelbald of Mercia e.g. granting remission of tolls in London to the double monastery at Minster in Thanet (dedicated to Saint Peter and the Virgin) *c*.732–3, and to the church of Rochester, 734. MMA

Provenance: Found at Eastcote, in Pattishall, Northants.
Bibliography: Robinson et al. 1941–50; Birch 1885–93, nos 149, 152 (Whitelock 1979, no. 66).

57 (a, b) Regal Northumbrian issues struck presumptively at York

57 (a) Penny (sceat) of Eadberht (738–57/8), animal type, precise date within the reign uncertain

Silver; WT 0.91g (14.1gr)
British Museum, CM, acquired before 1838
Provenance: Not known; purchased from the Samuel Tyssen collection in 1802.
Bibliography: BMC 5; Booth 1984, C17; Pirie forthcoming.

57 (b) Penny (sceat) of Ælfwald I (779–88), animal type

Base silver; WT 0.97 g (14.9 gr)

British Museum, CM 1838, 9–21–20

Provenance: Not known; purchased at the Spurrier sale, Sotheby, 29.viii. 1838, lot 5.

Bibliography: BMC 16; Booth 1984, E1; Pirie forthcoming.

No coins are known of Northumbria struck between the death of Aldfrith in 705 and the uncertain date in Eadberht's reign from 738 when his coinage began. They resume with the same type of animal reverse and are a prolific issue. In the following reigns the coins become, like those in the south, increasingly base, although metrological analysis (Archibald and Cowell 1988) suggests that a vain effort was made at the start of each reign to improve on the previous issue. MMA

Secular architecture

Almost all the domestic buildings of the Anglo-Saxons were built of wood. In consequence we know very much less about them than we do about the stone churches of the period, since the study of houses depends on our interpretation of mere foundations, the post-holes and beam slots uncovered in excavations. About those features which provide so much of the evidence for the study of churches, such as the shape of windows and doors, the wall heights, and the surface carving and decoration, we remain in profound ignorance. Some general points, however, emerge even from this meagre evidence. All but a few of the domestic structures of the period were rectangular, and some were very simple rectangles, a house or a hall consisting of a single room. These were not only buildings of low status, since houses of all social levels have been found, and the range of wooden structures now uncovered extends from hovels to palaces; there is a similarity in their construction, though the building methods varied from the rudimentary to the massive. Until the very end of the Anglo-Saxon period, though a few excavated buildings probably had raised or suspended ground floors, there is almost no evidence for genuine upper storeys.

The earliest buildings in Britain after the end of the Roman period fall structurally into two groups: small dug-out houses (*Grubenhäuser*), sometimes no more than 4 m by 3 m in size; and rectangular post-hole-built houses normally about 10–20 m long and 5–8 m broad. Reconstructions of both types remain controversial. The traditional view of the *Grubenhaus* as a sunken floor building, as shown in the photograph of an experimental structure at the Weald and Downland Museum, Singleton (fig. 3), has been challenged by those who see the hollow as no more than an underfloor cellar to an above-ground house. Hearths have been found in the sunken featured areas, and thus perhaps the holes were occupied; but the evidence of these and other artefacts within the hollows is doubtful: recent work at West Heslerton has demonstrated that the use of the hollows of ruined houses as rubbish dumps might include the piling in of broken hearths, loom weights, or domestic debris – precisely the sort of material used in the past to prove the function of the buildings during their actual occupation. Debate continues about the problem of the *Grubenhäuser*.

Our interpretation of the form of the post-hole-built halls is almost equally doubtful. It depends in large part on the assumptions with which we begin: what was the function of the building? What the status of its occupant? Two illustrations make the point clear. The reconstruction of the 'Chalton house' type (fig. 4), one of several from the site in Hampshire, is minimalist; evidence for the bottom of its vertical timbers was found in the excavation, the height of the walls is a reasonable minimum to allow headroom at the wall-head, and the roof structure is a reasonably simple reconstruction. In contrast, the reconstruction of one of the similarly-sized buildings from Cowdery's Down, in the same county (fig. 5), shows a building of some grandeur, whose floor was suspended on a raft of interlocking timbers. Individual elements of this drawing may well be improbable, but cannot be disproved. The difference is chiefly one of approach, and in the case of the major halls the Cowdery's Down interpretation is the more likely to give an impression of the true quality of the structure.

Simple rectangular halls may derive from Roman-British predecessors: no sign has yet been found of the aisled house-and-byre common in the German homelands. They continued in use, as the radiocarbon dates from the farming hamlet at Catholme, Staffs., make clear, at least until the ninth century. Examples can be found across the country, from the south coast to Northumberland, and from East Anglia to Hampshire and the Midlands. A similar uniformity

Fig. 3 Weald and Downland Museum, Singleton, Sussex: experimental dug-out house

Fig. 4 Chalton, Hants.: reconstruction drawing of post-built house (after Addyman)

Fig. 5 Cowdery's Down, Hants.: reconstruction drawing of post-built house

Fig. 6 Yeavering, Northumberland: reconstruction drawing of royal palace complex as it might have appeared in the early seventh century (after Hope-Taylor)

of planning is visible in the case of the great houses of the period. The classic site of Yeavering, Northumberland, country seat of the Bernician kings, has provided a characteristic plan of a rectangular hall with annexes at either end (fig. 6); the arrangement is seen also in the Mercian sites of Hatton Rock and Atcham, from aerial photographs, and Northampton, from excavation. The resemblance of this layout to the rectangular nave and chancel, with western annexe, of early northern churches suggests that these first essays in the form of the House of God owed their inspiration to the design of contemporary great houses. Even these massive buildings were comparatively short-lived. At Yeavering a plausible but unproven series of enemy destructions was invoked to explain the constant rebuilding of the site. The reason may be more interesting: that each generation thought it proper to have a new (and not an inherited) house; that, at least at this high social level, to live in an old house implied poverty, a view still to be found in western Ireland. Under those terms even a king might live in a wooden hall: the stone church implied immortality.

Divisions into rooms of separate function are clear in both the great and the modest halls. The bi-partite house is regular, but in most cases the width of the smaller room is too narrow for us to consider it a satisfactory chamber at the end of a hall; the commonly found external access into this smaller space suggests a service function for this room, a storehouse, or a pantry or buttery. Unlike their medieval descendants, the halls themselves show little sign of social orientation into upper and lower ends: access into most is by opposing doors into the centre of the space, and not into a lower-end cross passage. The parallel here is with the Carolingian great-hall-plus-service-room at Doué-la-Fontaine, on the Loire, and as in that palace the Anglo-Saxon households occupied separately constructed private chambers outside the hall. The pattern is well seen in the ninth-century complexes at Cheddar, Somerset (fig. 7), and Goltho, Lincs., both of which consisted of a hall surrounded by a hamlet of detached chambers, service buildings and storehouses.

The consequent shed-like appearance of the Anglo-Saxon house is familiar from the Bayeux Tapestry. Representations of later Anglo-Saxon or Anglo-Danish houses with swelling sides and high curving roofs may be seen in the hog-back tombstones of eastern England. Equally familiar from the Tapestry is the view of the hall at Bosham, Hants., where Harold and his companions feast on the first floor of a building supported on an undercroft of arches. Something of this sort seems clear at Calne, Wilts., where in 978 the English councillors were meeting in a room ('solarium') sufficiently raised for the collapse of its floor to throw all but St Dunstan into the basement. Evidence of this sort is rare enough to suggest that until the end of the period the normal house, even for the mighty, was a ground-floor building. Exceptions, like the recently-discovered stone palace at Northampton, seem likely to be borrowings from the continent, where Roman traditions of houses and palaces in permanent materials, and undercrofts and towers, were spreading under the influence of the Carolingian revival.

PHILIP DIXON

Fig. 7 Cheddar, Somerset: reconstruction drawing of the ninth-century palace (after P. Rahtz)

The new learning

The schools and scholarship of early Anglo-Saxon England present one of the most arresting phenomena in the entire history of Western civilisation. In this sense: that when St Augustine and his fellow Roman missionaries arrived in England in 597, there were no schools in which Latin was taught; yet within a century and a half, English schools excelled all those of Europe, and native English scholars such as Aldhelm, Bede and Alcuin eclipsed their continental contemporaries in all fields of scholarly endeavour, their writings forming the staple of the European school curriculum for many centuries to come. Tragically, this astonishing achievement was reduced to naught during the ninth century, with the result that King Alfred was obliged to start afresh, and to begin his educational programme virtually from nothing. The parabolic rise and fall of Anglo-Saxon learning during the centuries between 600 and 900 offers a stark reminder of how much may be achieved by the industry and application of a few learned men, but also of how fragile even the most remarkable achievements in the field of education may be.

The earliest phases of this achievement are not entirely clear. Christianity was, and is, a religion of the book; and if the Gregorian mission was to have any chance of success, the first task which Augustine and his companions faced was that of establishing schools in which future priests could be taught to read Latin so that they could pronounce mass, baptise, marry and bury their flock, and interpret the word of God. There is no evidence that any British schools existed in those areas settled by the English; although it is clear that, in the western (British-speaking) parts of the island there were schools of a high standard which transmitted, in an idiosyncratic way, the learning of the Roman Empire to the monastic schools of Dark Age Wales, the British abhorred the English invaders and would have nothing to do with educating them in the Christian faith. In a word, the Augustinian missionaries were obliged to begin wholly from scratch in their attempt to establish Christian culture in England. We do not know how they undertook this task; but by 630 or so a bishop of East Anglia named Felix, who had himself been trained in Canterbury (perhaps by the original Roman missionaries), established a school in East Anglia and staffed it with masters from Kent. As to how these early schools functioned, or what books constituted their curriculum, we know nothing. No manuscripts written in England survive from this very earliest period of English Christianity. The example of Bishop Felix shows that at least one generation is required to establish a functioning school system. By the mid seventh century, other schools were in existence (at Whitby, for example). By 644 the first native English

bishop (Ithamar of Rochester) was ordained, and by 655, the first native archbishop of Canterbury (one Deusdedit).

No doubt English schools would have continued to develop at this modest pace, if there had not occurred in 667 an event which was decisively to transform English learning. When Archbishop Deusdedit died in 664, an English successor, one Wigheard, was appointed; but Wigheard died of the plague while he was in Rome to receive the pallium. At that point Pope Vitalian took the extraordinary measure of appointing to Canterbury an aged Greek monk named Theodore (d. 690) who was then living in one of the Greek communities in Rome (almost certainly that of St Anastasius). Theodore, Bede tells us, had been born in Tarsus (in Cilicia) in 602; he was thus sixty-five at the time of his appointment. Bede knew nothing of Theodore's background; but recent work on a series of previously unknown (and as yet unprinted) biblical commentaries composed by Theodore enables us to fill in something of that background: that as a young man Theodore had studied in Syria, perhaps at Antioch and Edessa (there is some evidence to suggest that he knew Syriac), then – no doubt as a refugee from the Arab invasions of Syria in the 630s – he went to Constantinople and attended the university there, famous for its study of Roman law, medicine and rhetoric; he may conceivably have attended the lectures of the great polymath Stephen of Byzantium, who was lecturing there at the time. From Constantinople he went to Rome, where he joined the community of Cilician monks at St Anastasius; he was probably involved with them in drawing up the Greek *Acta* of the Lateran Synod of 649, in which Pope Martin formally condemned the monothelite doctrine of the Eastern Church. The point is simply that the Greek monk appointed to Canterbury was one of the most learned men in the Mediterranean world, and one who had been deeply involved in one of the most divisive theological controversies of the seventh century.

Theodore came to Canterbury with a Mediterranean colleague, one Hadrian (d. 710), from somewhere in Africa (like Theodore probably a refugee from the Arabs). Together Theodore and Hadrian established in Canterbury a school to which, in Bede's words, 'they attracted a crowd of students into whose minds they daily poured the streams of wholesome learning'. The nature and results of their teaching can be seen in the recently-discovered commentaries on the Pentateuch and Gospels, which are a record of their classroom exposition of the biblical text as it was copied down by their English students. These commentaries draw on an extraordinary range of patristic authorities, mostly Greek, including Basil, John Chrysostom, Clement of Alexandria, Ephrem the Syrian, Epiphanius, Gregory of Nazianzen and others.

Their orientation is predominantly literal: they explain for their English audience the unusual flora and fauna mentioned in the Bible, or they comment on Hebrew religious customs, or they explain biblical weights and measures in terms of Anglo-Saxon equivalents. Reference is made throughout to technical points of Greek medical theory and Greek rhetoric. Sometimes Greek texts are quoted (in Latin translation) at such length that we must assume the presence of Greek books at Canterbury, though none have come down to us. The presence of these two Greek scholars at Canterbury may provide an explanation of how a seventh-century Byzantine thurible (68) reached England.

The impact of Theodore's presence was felt in many domains of English learning. As a poet, he created a form of trochaic, octosyllabic Latin verse (modelled, probably, on Greek anacreontic hymns) that is to be seen in the poem 'Te nunc sancte speculator' (58), one of the few surviving literary remains which actually bears Theodore's signature. This verse-form was to prove widely influential in eighth-century England. Theodore was also influential in introducing Greek forms of prayer to England (and so to the Latin West): the litany of the saints, one of the most widely practised forms of prayer, both public and private, seems to have acquired its characteristic form in the patriarchate of Antioch during the seventh century, and was mediated to England by Theodore. Above all, the classroom teaching of Theodore and Hadrian is reflected in a family of glossaries (the so-called 'Leiden Family') which preserve the explanations by these two Mediterranean masters of difficult Latin words found in a wide variety of texts. A later descendant of this family which preserves some trace (albeit diluted) of their teaching is the famous Corpus Glossary (63).

The influence of Theodore and Hadrian is also to be seen in the English students whom they trained. Foremost among these was Aldhelm (d. 709). Aldhelm's knowledge of classical and patristic texts was extraordinary, and his learning and originality are displayed in all aspects of his writing. He pioneered a Latin prose style, for example, which is characterised by long, complex, Joycean sentences crammed with learned-sounding vocabulary, mostly drawn from glossaries. This Latin prose style is best seen in his *De virginitate*, a lengthy treatise on the merits of virginity, drawn from a wide range of patristic and hagiographical sources. The treatise was dedicated to a community of nuns at Barking (Barking, excavated finds; 67). In spite (or perhaps because) of its verbosity and prolixity, Aldhelm's *De virginitate* was intensely studied in later Anglo-Saxon schools, especially in the tenth century, when it attracted encrustations of glosses by students and teachers attempting to unravel its meaning (59). He was also influential as a poet. As he proudly says, he was the first person of the Germanic races to compose a treatise on Latin metre: he was also the first non-Latin speaker who attempted to compose Latin verse on any substantial scale. The measures which he adopted to facilitate such composition give his verse a curious ring, which is partially explained by the assumption that he was attempting to follow the conventions of Old English verse (such as alliteration) in his Latin poetry. One of Aldhelm's most original and most influential poems was his *Enigmata*, a collection of one hundred riddles on various subjects, which attempt to 'lay bare the mysteries of things' by exploring the cosmic processes of gestation, birth, growth and decay. Aldhelm's *Enigmata* inspired a host of imitators (including Tatwine, Eusebius and Boniface) and were partially translated into Old English. In the tenth century they were still attracting the scholarly annotations of English masters and students (60).

Canterbury and Malmesbury (where Aldhelm was abbot) were not the only centres in Southumbria where Latin scholarship was pursued to a high standard. The Englishman Wynfrith, who as Boniface was subsequently to achieve fame as the apostle of Germany and the archbishop of Mainz (d. 754), was trained in a school at Nursling (Hants.), and there he probably composed his *Ars grammatica*, one of the earliest grammars of Latin composed by a non-Latin speaker and certainly the first to set out verb conjugations in the paradigms which are still used today in grammar books of all kinds; or Tatwine, who was trained at Breedon-on-the-Hill (Leics.) before becoming archbishop of Canterbury (731–4) and who like Boniface composed a grammar of Latin as well as a collection of metrical *Enigmata*. We have seen that there was a school of nuns at Barking, and we know of other schools housing learned women at Wimborne (Dorset), Bath, Thanet and elsewhere. The situation in Southumbria had obviously changed dramatically in the century following the arrival of the Gregorian missionaries.

In Northumbria, too, schools flourished from the second half of the seventh century onwards: to such an extent, indeed, that Northumbrian learning has not infrequently been thought to overshadow the achievements of the southern schools. In 635, an Irish monk named Aidan was invited from Iona to establish a bishopric and school at Lindisfarne, and by the end of the seventh century Lindisfarne was producing significant works of Latin literature, such as the anonymous Life of St Cuthbert (Cuthbert was Lindisfarne's local, patron saint), as well as some of the most lavishly written manuscripts of the early Middle Ages (the Lindisfarne Gospels, 80). But it was especially the twin monasteries of Monkwearmouth and Jarrow, founded in 674 and 682 respectively, which outshone all others. The founder of these monasteries was a layman, though a very studious one, named Benedict Biscop, who had travelled many times to Rome (in fact on one occasion he accompanied Archbishop Theodore from Rome to England) and who succeeded in assembling a vast library of books for his new foundation. This library, in turn, fuelled the studies of Bede (d. 735), who was delivered as an oblate to Monkwearmouth probably in 680, and spent the remainder of his life there studying, teaching and writing. Bede was above all a teacher: in all his writings he is concerned with clarity of exposition, with explaining complex subjects in a way that could be grasped easily by his students. It was this same feature which commended many of his writings to a wider medieval audience in Europe. For example, his treatise on the computus, the *De temporum ratione*, survives in some 250 manuscript copies, and was by far the most popular and most accessible intro-

duction to the complexities of that subject (**61**). His treatise *De arte metrica* remained the most popular introduction to Latin metrics until the Renaissance. As a biblical exegete, Bede modestly attempted to assemble for his students those patristic opinions (drawn from the full extent of Bede's impressive learning) which best represented orthodox opinion on any point of biblical interpretation; also by way of helping them he directed his attention principally to those books of the Bible which had not previously been treated at length by the Church Fathers (**62**). His *Ecclesiastical History of the English People* is similarly based on first-hand familiarity with a wide range of written sources, all assimilated, coherently organised, and set out with such brilliant clarity that it deservedly became one of the most widely read histories of the Middle Ages.

One of Bede's students was Ecgberht, archbishop of York (d. 766), to whom Bede addressed what is probably his last work, a letter concerning the pastoral administration of the Church. Through the efforts of Ecgberht, and his successor Ælberht (d. 780), York too acquired a great library and became the focal point of a flourishing school, whose most famous alumnus was Alcuin (d. 804). Alcuin taught and studied at York until the death of his teacher Ælberht; he subsequently left York, aged nearly fifty, in order to become master of Charlemagne's Court School – a remarkable index to the esteem which was accorded to English scholars and schools by the late eighth century. Most of Alcuin's voluminous writings date from the later, continental, phase of his life. From the poems and letters in particular it is possible to form a clear impression of Alcuin's personality: a man deeply attached to the joys of the world, doting on his students, attached inseparably to a small coterie of friends. As Charlemagne's principal adviser on ecclesiastical affairs, Alcuin was responsible for drafting many of the documents which set out the emperor's official position on theological matters; at Charlemagne's urging he undertook to revise the text of the Vulgate Bible in order to purge it of textual error, and some aspects of Alcuin's revision survive in the standard printed editions of the Latin Bible; Alcuin also contributed to Charlemagne's liturgical reforms by compiling many supplementary prayers for the Roman mass-book. In other words, Alcuin was an Anglo-Saxon scholar who had a decisive influence on the Christian Church. It is unfortunate that less is known of Alcuin's early years at York than of his later years with Charlemagne. Yet one of his poems (arguably the only one composed in England) gives us a clear statement of the curriculum of studies at York, and of the books which nourished that curriculum, and from this evidence there can be no doubt that, by 780 or so, York was in the vanguard of European learning.

In 793, while Alcuin was on the continent, Viking raiders sacked Lindisfarne, as we know from a long poem which Alcuin composed by way of consolation for the Lindisfarne monks. During the ninth century, Viking raids on England, and especially on English churches, increased in ferocity and number. The Vikings were principally interested in the movable wealth which the churches possessed; but the effect of their raids on learning in England was devastating. Schools and scholarship virtually ceased in England during the course of the ninth century. During the central years of that century, between (say) 835 and 885, not a single work of Latin literature was composed, and the numbers of manuscripts which were written can be counted on the fingers of one hand. The written statements of those southern bishops who professed their obedience to Canterbury show an appalling ignorance of Latin. King Alfred, writing (in the 890s) his preface to his English translation of Gregory's *Regula pastoralis* (**235**), could observe that, when he had acceded to the throne in 871, there was not a single scholar south of the Thames who could read or translate a letter of Latin. To judge from evidence of many kinds, Alfred's statement was no rhetorical exaggeration, but an accurate assessment of a wretched situation. Alfred bravely set about repairing the situation, by inviting various scholars from overseas, by endowing schools, and by undertaking a programme of translation to make available in English a few texts which he deemed the most necessary for men to know: Gregory's *Regula pastoralis*, Boethius's *Consolatio philosophiae* and Augustine's *Soliloquia*, among others. Alfred and his successors persisted in this enterprise so that, by the reign of Athelstan (924–39), English schools were once again beginning to produce scholars capable of composing Latin poetry and letters. But what strikes the modern observer is the vast gulf between the homely but necessary enterprise of Alfred, designed to make available a few books, and the situation which obtained in the late seventh and early eighth centuries, when English scholars had before them a treasury of new learning which in breadth and scope was not to be equalled for centuries.

MICHAEL LAPIDGE

Manuscripts

The schools of Canterbury and of Monkwearmouth/Jarrow (along with influence from those operating in Irish, British and continental contexts) fostered the production of a new range of library books in Anglo-Saxon England. These ranged from source materials, including works by classical authors (such as Pliny), the Church Fathers, literary figures of late antiquity and the early Christian period (such as Sedulius, Paulinus of Nola and Isidore of Seville) and historians (such as Orosius), to new compositions dealing with history, chronology, science, poetry and biblical exegesis (interpretation) and commentary by scholars working in England (such as Theodore, Aldhelm, Tatwine and Bede).

The growing need for books for study purposes may well have stimulated the development of different aspects of manuscript production, as was to be the case following the rise of the European universities from around 1200, when new forms of 'publication' were introduced.

These English library or school books were made in the same monastic scriptoria as their liturgical and patristic counterparts, but generally represent a 'lower', or more economic or easily executed, standard of production. Their handwriting (of which **63** is a late example) was drawn from the

lower end of the Insular system of scripts, which had been initially developed in an Irish milieu, but which received an overhaul in England around 700, producing what is sometimes known as 'Phase II'. Similarly, the decoration of these books would generally have been confined to simple but attractive pen-drawn initials.

Re-usable tablets, carrying wax in their recessed surfaces, are also likely to have been extensively used in the schoolroom as well as for composition and for informal purposes. Such tablets were widely used in antiquity and remained in use in the West until the recent past. Two Insular examples have survived (**64, 65**) and a number of styli (pointed implements of metal or bone, often with expanded ends used to erase and to smooth the wax for reuse) have been recovered during excavation (**107c–e, 69v, w**).

There is no direct evidence for the production of books or documents by other than ecclesiastical personnel in England during the early Anglo-Saxon period, although certain secular figures (such as King Aldfrith of Northumbria) occasionally attracted praise for their learning. Production was focused primarily upon the monastic scriptorium (or writing office), within male and female communities, and participation in its work was a highly commended activity in many early monastic rules for communal life (notably those of Cassiodorus and Benedict). Working practices and styles could vary considerably, sometimes even within the same scriptorium, whilst specific house-styles are indicated in some instances. Division of labour was particularly varied, with Lindisfarne, for example, apparently favouring the work of single experienced artist-scribes on its important cult objects (such as the Lindisfarne Gospels, **80**) and larger teams for its schoolbooks (**85**). Scribes learning to write were allowed to write passages in 'works in progress' (such as **85**), with their masters occasionally being seen to have guided their work (as in **171**, a high-grade liturgical manuscript).

Many of these books were designed to be expounded upon in the schoolroom. There is reason to believe that English authors were physically capable of writing themselves (although dictation was sometimes preferred by certain of their later medieval counterparts), and Boniface's handwriting survives in his annotations to **124**. However, the copies of their works for distribution would be copied by members of scriptoria (such as **2**, an early copy of Bede's *Ecclesiastical History* written at Monkwearmouth/Jarrow). The correspondence of the period yields a number of requests for copies of books to be supplied; one particularly poignant letter from Cuthbert, abbot of Monkwearmouth and Jarrow, to Lul, dated 764, laments that he has been unable to supply all the works of Bede (as well as the Lives of Cuthbert) requested for despatch to the continent, 'For the conditions of the past winter oppressed the island of our race very horribly with cold and ice and long and widespread storms of wind and rain, so that the hand of the scribe was hindered from producing a great number of books.'

The enormous popularity enjoyed by the works of Anglo-Saxon scholars, even during their lifetimes, is demonstrated by the numbers of English and continental copies which continued to be made through the Middle Ages (such as **58–**

58 Theodore's poem to Bishop Haeddi (f. 71)

62) and by the glosses and annotations which were added by subsequent scholars (see **58–60**). Many of the texts attracted the attention of scholars in the early modern period and were produced as early printed editions, whilst others (notably some of the works of Theodore and his circle, discussed above) are still being discovered and remain to be printed and edited.

MICHELLE P. BROWN

58 Theodore's poem to Bishop Haeddi

Cambridge, Corpus Christi College, MS 320, part II
Vellum; ff. (114+) 54 (2 vols); 231 × 153 mm
Latin (with Old English glosses); second half of 10th century
England (?Canterbury)

Along with the study of scripture, the core of the syllabus at the Canterbury school consisted of metre (rules for com-

posing poetry), astronomy and computus (the calculation of time). These also formed the basis of the Monkwearmouth/Jarrow curriculum at the time of Bede.

The short verse epistle sent by Archbishop Theodore (668–90) to Bishop Haeddi (676–*c*.705) of Wessex gives an important insight into Theodore's poetic style. It occupies ff. 70v–71 of a tenth-century copy of the Penitential of Archbishop Theodore, a *Libellus responsionum* and various other texts. The poem, praising Haeddi and requesting his prayers, is composed of lines each containing eight syllables (continuous octosyllables) and is the earliest surviving example of this influential new poetic style from England. The rhythm is, however, quite distinct from other examples of the genre (such as those later composed by Aldhelm and Boniface), with the stress corresponding to the rhythmical beat and falling upon first, third, fifth and seventh syllables. Influence from Greek rhythmical verses of the sixth and seventh centuries is possible, but unproven. A few further specimens of

similar poems by Theodore and his circle are preserved anonymously in the Mercian Book of Cerne (**165**). MPB

Bibliography: Browne 1897; James 1911, II, 133–7; Liebermann 1921, 234; Ker 1957, no. 58; Mayr-Harting 1972; Lapidge 1981, 45–82; Brooks 1984, 71–6, 94–8; Lapidge 1986, 45–72.

59 Aldhelm, *In Praise of Virginity* (*De virginitate*)

British Library, Royal MS 7 D.xxiv
Vellum; ff. 168; 173 × 122 mm
Latin with Old English glosses; 10th century
Southern England (?Winchester or Christ Church, Canterbury)

Aldhelm (*c*.639–709), abbot of Malmesbury and bishop of Sherborne, was renowned as a scholar in his own time. His tract on virginity (composed in prose and metric versions)

59 Sketched author portrait of Aldhelm, introducing his *De virginitate* (ff. 85b–86)

was his best-known work and was dedicated to Hildelith, Abbess of Barking, and the nuns under her charge, of whom Cuthberga, sister of King Ine of Wessex, was one. Aldhelm had studied at Canterbury under Theodore and Hadrian and his writing style was complicated, if elegant. The tract begins by comparing virginity with athletic and scholarly exercises and amply demonstrates the demands of a serious calling to the life of a nun. Bede praises the work and his contact with the Barking community is illustrated by the response which the nuns obviously made to Bede's call for historical data, to be included in his *Ecclesiastical History*.

This early tenth-century copy is embellished with an unfinished drawing of the author (exhibited here, f. 85v), probably modelled upon an evangelist portrait, which was touched-up in ink at the end of the century. It is not known where this copy was made, but Winchester and Canterbury are both stylistic candidates. It later belonged to John, Lord Lumley (d. 1609). (See also **237**.) MPB

Bibliography: Ehwald 1919; James 1931; Ker 1957, no. 259; Mayr-Harting 1972; Temple 1976, no. 4; Lapidge and Herren 1979; Lapidge and Rosier 1985.

60 Aldhelm's Riddles (*Enigmata*)

British Library, Royal MS 12 C.xxiii
Vellum; ff. 138; 238 × 145 mm
Latin and Old English; second half of 10th century
Canterbury, Christ Church

Riddles were a favourite form of verse amongst the Anglo-Saxons; often of a somewhat ribald and humorous character, their primary function seems to have been to instil a knowledge and appreciation of metrical structure as a learning device. Aldhelm (bishop of Sherborne, *c*.705–9) was a keen exponent of the genre: his collection of riddles in hexameter verse was included in a treatise dedicated to *Acircius* (Aldfrith, the scholarly king of Northumbria). The exhibited opening shows a double acrostic prologue, in which the first and last letters of each line form an inscription recording Aldhelm's authorship. The volume also contains riddles by other authors, including Tatwine, who was trained at the monastery of Breedon-on-the-Hill in Mercia, famed for its Anglo-Saxon sculptures (figs 21–2), and became archbishop of Canterbury (731–4).

The manuscript probably later belonged to Thomas Howard, Earl of Arundel. MPB

Bibliography: Ehwald 1919; Ker 1957, no. 263; Mayr-Harting 1972; Temple 1976, no. 30 (iii); Crossley-Holland 1982; Lapidge and Rosier 1985.

61 Bede's second tract on Time (*De temporum ratione*)

British Library, Royal MS 13 A.xi
Vellum; ff. 150; 247 × 153 mm
Latin; early 12th century (composed in 725)
England

Bede composed two tracts on Time and its calculation ('computus'), one, the *De temporibus liber*, near the beginning of his career (703) and the other, the *De temporum ratione*, towards its end (725). The earlier work was apparently too condensed to be accessible to students, and its findings concerning biblical chronology led to an accusation of heresy being levelled against him at a feast at Hexham, attended by Bishop Wilfrid, in 708.

His second computistical work, a medieval 'best-seller' of

60 Prologue to Aldhelm's Riddles (f. 83)

61 Methods of calculation, from Bede's *De temporum ratione* (ff. 33b–34)

which this is a twelfth-century copy (ff. 30v–103v), designed to be expounded in the schoolroom, begins with an elementary chapter on finger calculation and a table of Greek and Roman letters signifying numbers, which are exhibited here and graphically illustrated by diagrams which have been added to the text. It goes on to discuss various methods of calculating time (a subject of particular concern to Bede in his writing of history and his promotion of dating from the Incarnation of Christ, a method still widely used), units of time (including a rare explanation of the Anglo-Saxon months which provides a valuable insight into pagan Germanic religion), the zodiac, lunar and solar movements and the seasons, the calculation of the date of Easter (a matter of some import and dispute in the Insular world) and the six ages of the world (the six phases of life, from infancy to

decrepitude, corresponding to the six days of the Creation; a doctrine inherited from Augustine of Hippo and Isidore of Seville, to which he adds two further ages, the seventh being the unfinished age of the souls of the blessed, from the death of Abel to the Last Judgement, and the eighth the age of eternal joy or woe after the end of the world). He concludes by writing 'Therefore, my book about the rolling and tossing flow of the times, having also told of the eternal stability and stable eternity, may come to a suitable end.' MPB

Bibliography: Thompson 1934, reptd. 1969; Laistner 1943, 139; Mayr-Harting 1972; Bonner 1976; Jones 1977; Ó Cróinín 1983, 229–47; Brown 1987, 36–41.

62 Bede's exegetical writing, on the Tabernacle (f. 1)

62 Bede, on the Tabernacle

British Library, Royal MS 5 F.vi
Vellum; ff. 111; 243 × 150 mm
Latin; 12th century (composed c.721)
England

In addition to his historiographical, scientific and other writings, Bede also composed a number of exegetical works, designed to interpret or explain the scriptures. One such work, the *De tabernaculo*, is based upon Exodus (chs 24, 12–30, 16) and was probably composed after his commentary on Genesis, around 721. Along with his piece on the Temple (*De templo*) this resulted from Bede's interest in the archaeology and rituals of the Old Testament Jews, an interest shared by many Anglo-Saxons and which seems to have led to certain oblique references to Jewish customs (for example, in aspects of Anglo-Saxon liturgy and vestments). The commentary on the Tabernacle is largely concerned with explaining its symbolism and illustrates the Anglo-Saxon and Celtic

preoccupation with multivalence, or layers of meaning. For example, the columns supporting the Tabernacle (the shrine upon which Jewish ritual was focused) are seen to represent the four evangelists, Matthew, Mark, Luke and John, upon whose Gospels the Christian Church is supported. The drapes of different shades of purple and of white adorning the Tabernacle are compared to the aspirations of the catechumen (the candidate for baptism and reception into the Church in the form of the Communion or fellowship of Saints) in a complex passage on colour symbolism.

The manuscript later belonged to Archbishop Cranmer (a key figure in the establishment of the Anglican Church) and to John, Lord Lumley, whose ownership has been recorded on the exhibited opening in non-autograph inscriptions.

MPB

Bibliography: Laistner 1943, 70–4; Hurst 1969, 119a; Mayr-Harting 1972; Dodwell 1982; Brown 1987.

63 The Corpus Glossary

Cambridge, Corpus Christi College, MS 144
Vellum; ff. i + 64 + ii; 320 × 245 mm
Latin and Old English; late 8th–9th century
Southumbria (?Canterbury)

63 The Corpus Glossary (f. 52r)

A glossary is designed to provide an explanation and perhaps a translation of a selection of terms. These terms might, for example, be drawn from specific texts by the Church Fathers or other early authors, or might be subject-based. They provide a valuable insight into the range of works consulted by the Anglo-Saxons and the teaching of the schools (notably that at Canterbury) upon them. Initially interpretations might be added alongside passages in manuscripts of literary texts themselves. The words (or *lemmata*) commented upon would then be copied out, with their explanations, into lists, initially in the order in which they were encountered, and then in an alphabetical arrangement. A glossary can be compiled in any of these ways. Important early Anglo-Saxon examples of the genre, which appears to have been particularly developed and promoted by the Canterbury school, include the Leiden Glossary (copied *c.*800 at the continental Insular centre of St Gall, Switzerland, but apparently compiled in England between *c.*650 and 800), the Epinal and Erfurt Glossaries and the Corpus Glossary.

The majority of glosses in this version are in Latin and expand or elucidate lists of Latin words, but there are also over two thousand glosses in Old English; ff. 1–3v carry a short alphabetical glossary dealing with words of Greek and Hebrew origin, whilst ff. 4–64v consist of an alphabetically arranged glossary of words which is essentially a fuller version of those found in the Epinal and Erfurt Glossaries.

The style of decoration and script is consistent with a Canterbury origin, perhaps around (or shortly before) the production of the Tiberius Bede (**170**) in the second to fourth decades of the ninth century. The manuscript was at St Augustine's, Canterbury, in the thirteenth century (library press-mark, f. 1). It later belonged to Archbishop Matthew Parker (d. 1575), who bequeathed it to Corpus Christi College. MPB

Bibliography: Hessels 1890; Lindsay 1921; Ker 1957, no. 36; *CLA* ii, no. 122; Pheifer 1974, xxviii–xxxi; Lapidge 1986, 45–72.

Metalwork, bone, wood and sculpture

Of all the ways in which Christianity altered the lives of Anglo-Saxons, the access it provided to literacy and learning was the most transforming. Early monastic founders such as Wilfrid and Benedict Biscop were acutely aware of the need both to build and to equip churches in a manner fully conscious of the aesthetic and intellectual traditions of Christendom, and to create in their communities the necessary libraries and accompanying skills to enable the study and preaching of the Christian message. We catch many glimpses of their activities to this end: Wilfrid commissioning a great purple and gold Bible for Ripon, Benedict Biscop bringing books and exegetical painted panels from Rome to Monkwearmouth, Aldhelm bargaining for a Bible with Frankish merchants. And not only in monasteries was learning prized; King Aldfrith of Northumbria (685–705), who

was educated in Ireland, is known to have himself possessed a cosmography and was presented by Adomnan with a copy of his book on the holy places. Aldhelm even addressed a treatise on metrics to him. Aldfrith's accomplishments were clearly exceptional even for a king; but the substantial intellectual achievements of the schools of Theodore and Hadrian, of Aldhelm and Bede, bear witness to the scope and influence of the libraries built up in this period. As well as the testimony of the surviving manuscripts, the archaeological record, haphazard, partial and intermittent as it is, also gives graphic insight into the extent and sophistication of the changes wrought in less than fifty years. A society where in 597 a text was never more than half a dozen words scratched in runes on a brooch or carved on a stone was producing law-codes and Bibles and schoolbooks written on papyrus or vellum within years. New kinds of objects and decoration were also produced to serve the growing needs of the Church; stone sculpture and lavish reliquaries, for example, and symbolic ornament such as the inhabited vine-scroll were introduced into the Anglo-Saxon cultural vocabulary at this time (**114–16**). At an everyday level, the immediate impact of the new cultural literacy is also revealed in the impedimenta of the scriptoria and the scribe: styli and, much more rarely, writing-tablets or inscribed diptychs (**64–5**). In Northumbria, memorial stones from monastic cemeteries began to record the dead in elegant display scripts, both runic and Roman and occasionally both (**71**); some of these, like the 'Herebericht' stone from Monkwearmouth, with its elegant lettering and Insular decoration, represent a very sophisticated level of achievement (**72**). Recent finds of quantities of styli and other evidence of the scriptorium on otherwise undocumented sites such as those at Brandon and Flixborough (**66r–t, 69v–w**) also raise intriguing questions about the function of such communities: were they well-endowed religious foundations, high-status secular complexes, or perhaps some mixture of both? It is, however, hard to see how sites yielding such abundant evidence of wealth, literacy and religious activity could be wholly secular. Royal or aristocratic endowment and patronage of the kind involved in the foundation of monasteries such as Whitby and Hartlepool could certainly account for the prevalence of luxurious items on both these sites, and indeed such objects as the gold evangelist plaque from Brandon or the elegantly inscribed leaden shrine-plate from Flixborough clearly reflect a certain status and sophistication of religious activity commensurate with a centre of significant learning.

Nor is it surprising to see in the two runic inscriptions from Brandon as well as in sculptural runic texts, most notably on the Ruthwell Cross, a parallel academic expertise (**66b, o**). Though rarely used in manuscripts, the runic alphabet nevertheless clearly had a place in the professional *apparatus* of the scriptorium, as that tour-de-force of epigraphic virtuosity, the Franks Casket, so ostentatiously tells us (**70**). Indeed, the Casket's daring manipulation of language and alphabet, and its combination of classical and Germanic, Jewish and Christian themes is one of the most telling witnesses to the radical transformation of Anglo-Saxon culture in the seventh and early eighth century. Most of all perhaps,

it reflects the new-found ability, crucial to the development of Anglo-Saxon religious art, to render a complex narrative in visual terms, and at more than one level of meaning. Such a skill borrowed from the classical tradition is, just as much as the literary and exegetical skills learnt in the school of Theodore and Hadrian, a remarkable witness to the achievements of the new learning.

LESLIE WEBSTER

64 (a, b) Writing-tablets

Springmount Bog, Ballyhutherland, Co. Antrim, Ireland
Yew wood, wax; (a) L. 21.1 cm, W. 7.45 cm, (b) L. 21.2 cm, W. 7.55 cm
Irish; early 7th century
National Museum of Ireland, Dublin, inv. nos 5.A.1914.2, nos 4, 6

64 (a) No. 4: rectangular wooden tablet with a central recess on both sides to accommodate wax

One recess retains wax, of a dark-grey colour, on approximately 90 per cent of the surface. A vertical line divides the nine-line script into two columns.

64 (b) No. 6: rectangular wooden tablet of plano-convex cross-section

This tablet has a recessed area on one surface only, the other side functioned as a cover. Areas of wax from adjacent tablets obscure passages of the text. This tablet displays eight lines of script.

Both tablets have two circular perforations below the writing surface to accommodate leather thongs. Diagonal incised lines may be seen on the wooden surface where the wax has flaked off. These lines would have acted as keying to help adhesion of the wax. In each of the four corners adjacent to the writing surface there are roughly scratched lentoids with a median line.

These comprise part of a set of six yew writing-tablets discovered four feet deep in a bog while cutting turf. When found the tablets were held together by a leather thong which passed through the perforations. A separate leather band was used to secure the ends of the tablets. This, in turn, was stitched to a leather carrying strap. The leather components survive.

These are an Irish adaptation of Roman writing-tablets, which were used for informal letters and official documents. The text was inscribed on the wax surface using either a bone or metal stylus. This surface could be reused by smoothing the wax with the spatulate end of the stylus. The Hisperica Famina (Herren 1974, 107) records the manufacture of decorated writing-tablets from oak. PM

The inscription The script of the tablets belongs to the tradition of Insular handwriting, rather than of epigraphic inscription, and, along with a gospel book, the Codex Usserianus Primus (Dublin, Trinity College, MS A.4.15 (55)), is the earliest evidence for handwriting in Ireland and post-Roman Britain. The script, an Insular minuscule, may be dated palaeographically to the early seventh century and was evolved independently from a provincial late antique tradition, like the tablet form itself. The Insular system of

64a

64b

scripts, which catered for formal and informal purposes, was largely evolved in an Irish milieu in its early stages, laying the ground for subsequent English developments.

The text consists of passages from Psalms 30–2, copied out by an expert, perhaps intended to be learnt by a priest who was not yet *psalteratus* (who had not yet learnt the Psalms) during a journey (as prescribed by certain monastic rules). Perhaps the study so absorbed him that it led to an accident, occasioning the loss of the tablets in the bog.

MPB

Select bibliography: Armstrong and Macalister 1920; Lowe 1971, no. 1684, 5; Wright 1963, 67, 219; Herren 1974; Brown 1984, 311–27.

65 Leaf from a writing-tablet

Blythburgh, Suffolk
Bone, copper-alloy; L. 9.4 cm, w. 6.3 cm
Anglo-Saxon; 8th century
British Museum, M&LA 1902, 3–15, 1

Rectangular panel recessed at the back and with two holes for thongs: one corner is broken away. On the front is a quadripartite knot design incised in low relief within a square frame and set with a quincunx of secondary copper-alloy rivets, with a sixth at one of the corners of the frame. In the recess at the back which originally contained wax are traces of extremely lightly incised runic lettering, arranged in three lines along the long axis.

65

The runic inscription The runes are cut in the upper surface of the writing tablet. There is a small group on the rim just by the broken corner. What remains here seems to read 'u n þ ['. The rest of the runes are cut in the recess which held the wax layer. Here the surface is worn and pitted, and the letters are not easy to make out. They are set in a series of irregular rows, apparently not forming a continuous text. Indeed they may have been trial letter forms not intended to make much sense. There are the sequences 'o c u a t * * þ [. ...]' (the asterisks represent visible but unidentifiable forms), 'l s u n t' and 'm a m æ m æ m'. The latter is fairly obviously nonsensical. The other two groups suggest – with their sequences -*uat, sunt* – that the 'scribbler' was attempting Latin verbal forms.

RIP

The panel is clearly related to late Roman and early medieval writing-tablets (e.g. Bowman 1983, pl. 9) such as those exhibited from Springmount Bog (**64**). The recesses were filled with wax, and the text was incised in this with a stylus, sometimes leaving traces of the lettering in the wood or ivory. The faint traces of lettering on the Blythburgh leaf follow the long axis, as on Roman tablets and the Springmount examples. However, M. Lapidge has suggested (pers. comm.) that the decorative quality of the Blythburgh leaf raises the possibility that it is the remnant of a diptych of the kind used during the mass of the early medieval Church; in these, the names of those who merited special commemoration were inscribed in the wax or sometimes written in ink directly on to the ivory (Bischoff 1990, 14), to be read out during the Canon of the Mass. The tablet was found before 1902 on the land of the former priory at Blythburgh: three styli are said to have been found with it (Waller 1901–3). It has been suggested that the priory site, which has produced Middle Saxon Ipswich ware, was the site of a wealthy Anglo-Saxon church.

LW

Select bibliography: Waller 1901–3, 40–2; Smith 1923, 112–3; *Proceedings of the Suffolk Institute of Archaeology* 1977, 155; Page 1989, 259.

66 (a–y) Selected finds from a high-status site at Brandon, Suffolk

Excavations of *c*.1.2 ha of a sand island beside the River Ouse have uncovered about one half of a well-defined settlement which is dated to the Middle Saxon (600–900) period by its finds. Apart from some Iron Age farming and a very small amount of Late Saxon occupation there is no domestic settlement use of the site outside the Middle Saxon period, and no other form of contamination or disturbance has affected the Saxon layers. The excavated elements of the site include thirty-five buildings, church and cemetery and a cloth-processing industrial area.

The quality of finds is generally very high, many being the products of highly skilled craftsmen, using precious metal or being imported to the site. The buildings are well constructed within the established tradition of this period; apart from the church they are apparently domestic in use. The accessories of the ecclesiastical world, literacy (represented by inscribed

objects and styli) and prestigious devotional objects such as the St John plaque (66a) are prominent, and prompt the suggestion that this was a monastic community. The arrangement of the settlement combines elements of informality within domestic enclosures, but also an overall arrangement which has placed emphasis on the location and accessibility of the church, and also on a group of high-quality buildings which accompany the church. The indications are that the settlement was high on the social scale, and that it may well have had a monastic component introduced early in its life. RDC

Select bibliography: Webster 1980; Okasha 1983, cat. 159; Carr, Tester and Murphy 1988.

66 (a) Plaque

Gold, niello; 3.5 × 3.3 cm
Anglo-Saxon; early 9th century
British Museum, M&LA 1978, 11–1, 1

Almost square plaque with an attachment hole at each corner. A niello-inlaid line acts as a border on the lower three sides, but the blank area around each hole indicates that they were filled by a circular bossed rivet. The niello-inlaid decoration consists of a half-length zoo-anthropomorphic symbol of St John with eagle head and human hands which hold a book and pen. Around the evangelist symbol is the inscription SCS/EVA/N/GE/LI/ST/A/IO/HA/NNIS 'St John the Evangelist'. The back is undecorated, except for a free-hand incised α, an assembly mark.

The plaque was found in 1978 on the edge of the site at Brandon shortly before excavation began, and reinforces the impression of high status given by the objects found there in controlled conditions. It is evidently one of a set of four, each with an evangelist symbol; it seems likely that these formed the terminals of a cross or were set in a book cover. The lack of a niello frame bordering the plaque's upper edge suggests that it could have been placed at the bottom of a cross stem, though this would certainly be an unusual position for the eagle of St John, which normally occupies the topmost position.

The use of a zoo-anthropomorphic symbol type is unusual in Insular art, but can be paralleled, for example, in the Book of Kells, and on the eleventh-century Brussels Cross. The elegant precision of both lettering and figure-drawing mark this out as a piece of the highest quality made for a wealthy patron or establishment. The crisp execution and fluid but economic use of line recall the evangelist portraits of the Book of Cerne (165), though its quality is superior. LW

The inscription is executed in angular square capitals of Insular Phase II variety. The letter forms stem ultimately from the characteristic display script developed in an Hiberno-Saxon context *c*.700, but in their homogeneity and clarity of form they relate to the manner in which capitals are employed in Tiberius group manuscripts, notably the Book of Cerne. Particular points of comparison with the latter may be found in the inscriptions accompanying the evangelist portraits in Cerne. Similar thin, angular square capitals are

employed, notably S and G, and A is inclined to the left by means of a head-stroke. However, the Brandon plaque eschews the calligraphic curvilinear extensions applied to certain of the Cerne letter-strokes. It also differs from Cerne in its precise disposition of the components of the inscription around the figure. In Cerne the inscriptions, although curiously spaced, flow from left to right, whereas on the plaque the words are disposed on either side of the figure. MPB

66 (b) Pin

Silver, gilding; L. 12.0 cm
Anglo-Saxon; late 8th or early 9th century
Brandon Remembrance Playing Field Committee, inv. no. SAU BRD 018 8679

Disc-headed pin with incised decoration on the gilded face, and a scratched runic inscription on the ungilded back: the head is pierced at one side by a small hole and the collared and hipped shaft is slightly bent. The decoration consists of a pair of confronted animals with pointed lolling tongues, their legs and wings interlocked and their tails curled round behind their necks to join; a fine interlace enmeshes them, sprouting into leafy tendrils at the right-hand side. Lines of punched dots adorn the beasts and parts of the background.

Pins of all types were extremely popular in the eighth century, having, in the course of the seventh century, come to supersede the brooch as the principal means of securing, adjusting (and embellishing) women's clothing, and perhaps sometimes men's. Simple pins with globular or faceted heads were the most common (e.g. 66i, j) and may have had specific uses, such as pinning veils and head-coverings. Alongside them, however, more opulent decorated pins occur, often with larger disc-shaped heads, since these gave more scope for ornamentation (e.g. 66b, c). Most of these fancy pins must, on grounds of size and weight, have been worn on dresses or cloaks.

This example comes from an occupation layer over medieval ditches, near the clay-floored building: this is presumably a secondary context. It belongs to the type of handsomely-ornamented disc-headed pins which become popular in the second half of the eighth century; the attachment hole shows it must have come from a linked pair or even a triple set (69i, 184). Its unusual decoration is related to long-legged winged beasts seen in manuscript, for instance in the Leningrad Gospels. In its flat linear style it is technically similar to the contemporary Leicester brooch (186), though greatly superior in design and execution. LW

The inscription consists of the first sixteen letters of the *futhorc*, the Anglo-Saxon rune-row in its traditional letter order:

'f u þ o r c j w h n i j
ï p × s'

There follow some rough scratches, perhaps the remains of a decorative pattern deliberately abraded.

Inscriptions consisting of the *futhorc* alone are rare, the only other English example being inlaid in a scramasax (short,

66a

66b (front view) 66b (rear view)

one-edged sword) found in the Thames at Battersea. Outside England the corresponding *futhark* texts are not uncommon, the earliest dating from the fifth century. There are Viking Age Norse examples in England (Penrith) and Ireland (Dublin). The purpose of such an inscription is unknown, so runologists take refuge in the explanation that it was magic.

The Brandon *futhorc* has quite orthodox rune forms save in a couple of cases. Its seventh rune, which should have been 'g', is in fact the epigraphical form of 'j'. In twelfth place, where 'j' traditionally appears, Brandon has the distinctive variant of that letter usually found in manuscript versions of the *futhorc*. The sixteenth rune, 's', has a slightly unusual form which perhaps also shows manuscript influence. RIP

66 (c) Pin fragments

Silver, traces of gilding; D. of head 3.6 cm

Anglo-Saxon; early 9th century

Archaeological Unit, Suffolk County Council, inv. no. BRD 018 2343

Disc-headed pin with chip-carved and incised decoration on one face, broken attachment fixture at right-hand side: the hipped shaft is broken with tip missing. The back of the disc is undecorated. The decoration consists of an equal-armed cross with speckled decoration and with an incised quatrefoil pattern at the centre and parallel arcs at the terminals. In the fields between the arms are four chip-carved motifs, each enmeshed in interlace produced from various appendages. In clockwise order from top right, they appear to be a bearded and crested bird, a sprigged plant, a reptile, and a human-headed creature with lobed locks and whiskers.

This unstratified find is, like **66b** above, one of a group of linked disc-headed pins. Its grotesque decoration has no very close parallel in metalwork, but the lively eccentricities reflect a similar interest displayed in manuscripts of the end of the eighth and early ninth century, notably the text flourishes of the Barberini Gospels, and in the Book of Cerne, Cotton Tiberius C.ii and Royal I.E. vi (**160, 165, 170, 171**), where closely related whiskered and horned masks, both human and animal, and wriggling beasts abound (see e.g. Alexander 1978, figs 164, 165, 310, 311). The hints of Trewhiddle style seen in the bottom left animal confirm the likely date. LW

66 (d) Pin

Silver, ?glass; present L. 4.5 cm

Anglo-Saxon; 8th century

Archaeological Unit, Suffolk County Council, inv. no. BRD 018 2000

The hipped pin shaft terminates in a tiny collared three-dimensional animal-head with ribbed snout and ?glass settings for eyes on top of the globular head.

From a probable seventh- to eighth-century pit in grid square 87/58. Small pins of this type were probably female attire and may have been used to secure veils or head-dresses. Along with an equally tiny dog-headed example from Flixborough (**69g**) it belongs to a small group of eighth-century silver animal-headed pins of high quality, which were worn by well-to-do women, whether religious or secular. LW

66 (e) Pin head

Copper-alloy, gilded; max. L. 1.8 cm

Anglo-Saxon; late 8th century

Archaeological Unit, Suffolk County Council, inv. no. BRD 018 2163

The shield-shaped plate is broken off at the apex: the chip-carved and incised decoration consists of an outer frame composed of the long curving speckled necks and heads of two confronted animals whose long muzzles meet in the centre of the top. The central field has a backward-turning quadruped with pricked ear whose legs and tail dissolve in interlace.

This unstratified find seems to be related to the pins and hooked-tags with confronted animals (e.g. **183**): the prick-eared leggy beast in the centre is cousin to animals of the Leningrad Gospels, for example in the Canon Tables (Alexander 1978, frontispiece). LW

66 (f) ?Pin head

Silver; present L. 2.6 cm

Anglo-Saxon; mid 8th century

Archaeological Unit, Suffolk County Council, inv. no. BRD 018 0602

The approximately kite-shaped plate is broken away at its apex, apparently at a perforation for suspension which may itself be secondary, indicating re-usage of a pin-head. The chip-carved and incised decoration consists of back-to-back shovel-snouted snaky creatures with double spiral bodies which tail off into an interlace grid filling the apex of the plate.

The object was unstratified. Its spiral bodied creatures with fleshy snouts carry echoes of elements seen on the St Ninian's sword fittings (**177**, **178**). LW

66 (g) Pin fragment

Silver, gilding; L. 2.31 cm

Anglo-Saxon; 8th century

Archaeological Unit, Suffolk County Council, inv. no. BRD 018 2297

The pin-shaft is broken off and terminates in a partly open-work head composed of chip-carved lobed tendrils. The pin is unstratified. LW

66 (h) Pin

Silver; max. L. 6.9 cm

Anglo-Saxon; 7th–8th century

Archaeological Unit, Suffolk County Council, inv. no. BRD 018 2298

Spiral-headed pin with ribbed collar: the lower part of the shaft changes to an octagonal section and is slightly bent.

The unstratified pin is of a type represented in silver and more commonly copper-alloy on other Middle Saxon sites such as Flixborough (**69j, k**), Canterbury and Southampton (Dickinson 1990, 181) and which first makes its appearance in the cemeteries of the seventh century; for example, a silver pair very similar to the Brandon specimen comes from the late seventh-century grave 12 at Eccles (Hawkes 1973, 283–4, fig. 4). There is evidence there, and at some other sites, that these pins were sometimes worn in pairs, and even joined by cord, in imitation of the chain-linked pins seen elsewhere. LW

66 (i) Pin

Copper-alloy; L. 8.9 cm

Anglo-Saxon; 8th century

Archaeological Unit, Suffolk County Council, inv. no. BRD 018 4174

Sub-biconical-headed pin with incised dot and circle decoration, collared neck and hipped shaft. LW

66 (j) Pin

Copper-alloy; L. 7.4 cm

Anglo-Saxon; 8th century

Archaeological Unit, Suffolk County Council, inv. no. BRD 018 4223

Polygonal-headed pin with incised dot and circle on the facets, collared neck and hipped shaft with polygonal section below the hip. LW

66 (k) Pin

Copper-alloy; L. 8.2 cm

Anglo-Saxon; 8th century

Archaeological Unit, Suffolk County Council, inv. no. BRD 018 3226

Sub-biconical-headed pin with cast and tooled knurling, collared neck and hipped shaft with triple incised rings at the hip.

All three pins (**66i–k**) come from Middle Saxon occupation layers. They represent common types on Middle Saxon sites where they were evidently a part of everyday female dress. Their simple collared heads, with or without dot and circle and knurled decoration, and hipped shafts occur on sites from Wessex to Northumbria. Their occurrence in very considerable quantities at known female monastic sites such as Whitby and Barking surely reflects the presence of significant numbers of women: but of course they do not alone signify a monastic presence. LW

66 (l) Strap-end

Copper-alloy; L. 5.6 cm

Anglo-Saxon; 9th century

Archaeological Unit, Suffolk County Council, inv. no. BRD 018 2342

Cast strap-end with double rivets at split end and double round-eared animal head at the other. The back is plain. The central panel has an incised naked male figure with raised hands, and legs akimbo.

Strap-ends are discussed in general on p. 233. This example, found in an occupation layer in grid square 91/56, is apparently unique among its kind in its carefully-detailed depiction of a naked male. Naked human figures are quite exceptional in early medieval art and the Anglo-Saxons were no exception: a naked male grotesque in the Barberini

66c–f

66g– k

66l–o

Gospels (**160**, f. 1) is the nearest surviving parallel, though (given its context) its gestures are curiously reminiscent of the Viking image of priapic Frey. The benignly smiling Brandon man, however, is manifestly not priapic. LW

66 (m) Strap-end

Copper-alloy, niello, silver wire; L. 4.2 cm
Anglo-Saxon; 9th century
Archaeological Unit, Suffolk County Council, inv. no. BRD 018 3638

Cast strap-end with double rivets at the split end and round-eared animal-head at the terminal. The back is plain. The sides are scalloped, and the brow of the terminal and two longitudinal panels on the body of the strap-end contain silver wire scrollwork set in a niello ground.

The strap-end came from the latest feature on the Brandon waterfront, a pit containing late ninth- to tenth-century Thetford ware. It is of a type which, with hooked tags with similar silver wire and niello or enamel inlays, is commonest in East Anglia, and is presumably a local product. LW

66 (n) Strap-end

Copper-alloy; L. 7.4 cm
Anglo-Saxon; mid 8th century
Archaeological Unit, Suffolk County Council, inv. no. BRD 018 7373

Cast strap-end with single-riveted split end (damaged) which narrows towards a plate with gently scalloped edges: the incised decoration consists of, on the split end, two V-shaped notches with a common base, and on the plate a double knot.

The strap-end came from an occupation layer at the northern edge of the church chancel. The length of the split end relative to the plate, its lack of animal terminal, and its narrow outline suggest a comparatively early date. LW

66 (o) Tweezer fragment

Silver, niello; present L. 2.0 cm
Anglo-Saxon; 8th century
Archaeological Unit, Suffolk County Council, inv. no. BRD 018 0836

Half of a pair of miniature tweezers, formed of silver sheet and with a niello-inlaid runic inscription.

An unstratified find. Tweezers were frequent in the Roman world and occur quite frequently in Anglo-Saxon grave equipment and on Middle Saxon settlement sites alike: their function was both cosmetic and practical (e.g. for removal of thorns and splinters). Several simple copper-alloy examples survive at Brandon, but this elegant little silver specimen, bearing a male name, is exceptional. LW

The runes of **the inscription** are clearly and competently cut, with serifs, suggesting that the rune-master was literate also in the Roman alphabet. The text is the common masculine personal name: 'Aldred'. The unbroken vowel of the first element *Ald-* indicates an Anglian dialect, which is what you would expect in this region. RIP

66 (p) Spoon/fork combination set

Copper-alloy; L. 13.6 cm

Anglo-Saxon; 9th century

Archaeological Unit, Suffolk County Council, inv. no. BRD 018 8230

Spoon and three-tined fork occupying the ends of a common stem with four sets of collared mouldings. The shallow bowl of the spoon has a quincunx of dots at its centre and vestiges of a dotted border.

The spoon was found in the occupation layer of grid square 98/61. It has two parallels, both of Middle Saxon date: a rather more elaborate silver implement from the Sevington, Hants., coin hoard, buried around 850, and an old find from Hamwic (Blackburn and Pagan 1986, 294; Addyman and Hill 1969, 61, pl. viiie). LW

66 (q) Key

Copper-alloy; L. 8.1 cm

Anglo-Saxon; 8th–9th century

Archaeological Unit, Suffolk County Council, inv. no. BRD 018 0602

The openwork shield-shaped bow has a stepped cross design and at the top, a suspension loop at right angles: a double moulding separates it from a short shank, and the long tongue has an upturned end and is pierced twice.

This handsome specimen, with its characteristic shape and proportions, is typical of the distinctive Late Saxon keys (cf. Wilson 1964, cats 38, 40, 46, 140). A very similar example is an old find from London (Brunner 1988, 91). Elaborate versions such as this were signs of status and function as much as practical implements. The 'free woman in control of the keys' mentioned in the laws of Æthelberht (chapter 73) (25) appears to have been in charge of the store room and chest (Fell 1984). It came from an occupation layer immediately south of the church. LW

66 (r) Stylus

Copper-alloy; L. 14.8 cm

Anglo-Saxon; 8th–9th century

Archaeological Unit, Suffolk County Council, inv. no. BRD 018 4993

Cast shaft with central moulding above which the section is round, below, octagonal: there is a more elaborate moulding at the junction of shaft and eraser, which has a shouldered sub-triangular form.

Styli were used mainly in conjunction with wax-filled writing-tablets (cf. 64): an error or whole text could be simply erased using the broad end. They were also used in the *scriptorium* for marking out the framework of the writing area on a page of vellum, and for making inconspicuous dry-point annotations. Their presence on Anglo-Saxon sites seems confined to those which are in other ways also of rather special status, such as the monastery at Whitby (107), and often with other material indicating the presence of sophisticated literacy, e.g. at Flixborough (69). This elaborate example resembles specimens from Flixborough: it comes from a context associated with the last phase of the waterfront area

66p–t

66u (scale of 2:5)

at Brandon, probably ninth century in date. The following stylus came from the adjacent grid square.　　　LW

66 (s) Stylus

Copper-alloy; L. 12.6 cm

Anglo-Saxon; 8th–9th century

Archaeological Unit, Suffolk County Council, inv. no. BRD 018 4980

Cast shaft with octagonal section, two sets of mouldings on either side of the mid-point, and a third at the junction of the eraser, which is of sub-triangular shape with double-shouldered profile.

Found in the grid square adjacent to the preceding specimen.　　　LW

66 (t) Stylus

Copper-alloy; L. 12.9 cm

Anglo-Saxon; 7th–8th century

Archaeological Unit, Suffolk County Council, inv. no. BRD 018 2009

Cast, with round-sectioned shaft and simple moulding above the tapering tip: a double collar separates the shaft from the triangular head.

From a ditch in grid square 87/58, rich in finds, and close to the waterfront: the context is possibly seventh–eighth century.　　　LW

66 (u) Pottery vessel fragments

Fired clay, tin-foil appliqués

Anglo-Saxon; 8th–9th century

Archaeological Unit, Suffolk County Council, inv. no. BRD 018 3542

Fragments from a handled Tating-ware jar.

This luxury ware from the Rhineland is found only at a few Anglo-Saxon sites, and in small quantities, confirming the impression that it was a prestige item, found only in wealthy communities. This large vessel was perhaps used for wine. It came from an occupation layer in grid square 90/57.　　　LW

66 (v) Three squat jar fragments

Glass; max. L. (i) 37 mm, (ii) 23 mm, (iii) 20 mm

Anglo-Saxon; 8th century

Archaeological Unit, Suffolk County Council, inv. no. BRD 018 (i) 4846, (ii) 5314, (iii) 5977

Three fragments of a squat jar in opaque red glass in varying shades of red swirled with light green. Glossy surfaces.

(i) This is the only fragment in which there is enough of the green glass to give a patch of transparency to an otherwise opaque vessel. It is the central part of a deep, cone-shaped kick with the chipped trace of a ring-shaped pontil and the mark of a chisel-ended tool used to push the base inwards. The thickness varies from 1 mm to 2 mm.

(ii) Fragment from the body of the squat jar, with two fine white trails horizontal and parallel at the base of the neck,

66v–y

and a thicker, diagonal, arc-shaped white trail below. The trails are unmarvered. The thickness of the wall is 1 mm at the top, becoming thinner lower down.

(iii) Fragment of the rim of the squat jar, diameter c.60 mm. The rim is rolled inwards, leaving a cavity and a bead outside with one, fine white trail melted in on the outside.

Red marbled glass indistinguishable from this was known in the Roman and later medieval periods. Its production in the Middle Saxon period is proved by its appearance at Southampton and comparable mid-Saxon sites, by its inclusion in an eighth-century pit at Barking Abbey (67), and by the squat jar shape of this and other examples.　　　VIE

Bibliography: Evison 1990, figs 4 and 5.

66 (w) Three fragments of claw beakers

Glass; max. L. (i) 29 mm, (ii) 32 mm, (iii) 57 mm

Anglo-Saxon; 8th century

Archaeological Unit, Suffolk County Council, inv. no. BRD 018 (i) 2063, (ii) 2345, (iii) 4955

(i) Part of the top of a claw in light green-blue, bubbly glass. The claw is flat and only slightly blown, and there is a red streak in the middle. The wall of the vessel is 1 mm thick and the claw varies from 0.5 mm to 2.5 mm thick. Bubbles in the

claw are elongated and orientated downwards following the pull as the hot metal blob was drawn into a claw (Evison 1983b, 90, fig. 3b).

(*ii*) The top part of a fully-blown, hollow claw in blue glass with a darker streak. The glass contains few small bubbles and has shiny surfaces. The remains of the vessel wall to which it is attached is thin, 0.5 mm thick, while the claw has a maximum thickness of 4.5 mm at the lower end.

(*iii*) The lower part of the hollow-blown claw with a shiny surface which appears black in reflected light except for one lighter streak. In transmitted light the glass is very dark olive green. The claw has been pulled in an arc completely free of the wall of the vessel, and there is a deep mark of the hook at the lower end and deep vertical grooves resulting from the pulling action. The thickness of the wall of the claw varies from 1 mm to 4 mm (Evison 1988a, 239, fig. 4).

The main period of production for the beakers with hollow-blown claws was from the fifth to early seventh century, with some of the finest being produced by the Anglo-Saxons (Evison 1982). In the late seventh to early eighth century, however, they were known only from Sweden, albeit with strong Anglo-Saxon connections. The first claw fragment found in England which compared with the Swedish claw beakers in colouring and shape (i.e. a light green-blue with a red streak and a flat, unblown form) was claw (*i*). The blue colour of (*ii*) occurred rarely in early seventh-century claw beakers, but the dark streak it contains might indicate red streaking as on (*i*). Unlike (*i*) it is a full-blown shape. Claw (*iii*) is a dark olive green, black in reflected light, a colour not known from the sixth and seventh centuries. It is fully blown, and shows that the form of a beaker with claws pulled in an arc from the wall of the vessel continued after the early Saxon period. VIE

66 (x) Base of a vessel

Glass; max. L. 54 mm

Anglo-Saxon; 8th century

Archaeological Unit, Suffolk County Council, inv. no. BRD 018 2344

Fragment of the base of a squat jar in brown glass with few bubbles and glossy surfaces. The kick is shallow. Decoration is by ten reticella trails which converge towards a central point on the base in irregular fashion, most stopping short of each other, but two pairs are touching. These would have continued upwards as vertical stripes on the body of the vessel. The trails are half-melted into the wall. Each trail consists of a light green rod, into which a white trail was first twisted and marvered. A second trail in yellow was then twisted on, alternating with the white trail, but it was left unmarvered, so that when the rod was applied to the vessel wall the yellow trail projected each side of the main rod (Evison 1988a, fig. 12 f). Finally, chipped damage shows that a pontil was attached over the trails at the centre of the base to hold the vessel while the rim was finished.

A pattern of reticella rods radiating from the base occurs on some squat jars and on bowls of the Valsgärde type (Baumgartner and Krueger 1988, 73, no. 15 and 70, no. 12). The rods here are thick and untidily applied. Comparison may be made with **67q** from Barking, where a yellow unmarvered trail only was wound on a light green rod for application on a brown vessel. VIE

66 (y) Window fragment

Glass; max. L. 19 mm

Anglo-Saxon; 8th century

Archaeological Unit, Suffolk County Council, inv. no. BRD 018 2698

Fragment of window glass, light green-blue, just over 1 mm thick. Dull surfaces with mark of a came along one edge, no bubbles. A number of fragments of durable window glass have been found at Brandon in various shades of light green, light olive and light blue-green, with a few in this shade of light green-blue. Thicknesses are mostly between 1 and 2.5 mm. The fragments are all small, the maximum length being 43 mm, and some can be seen to be parts of triangular or rectangular quarries. A few edges have been grozed.

Window fragments of this period have been found on the continent, e.g. at Liège, Belgium, where the existence of a coloured glass window in the episcopal palace was noted by the poet Sedulius in the ninth century (Evison 1988b, 215). In England comparable window fragments have been found at Escomb, Co. Durham, Repton, Brixworth, Northants., Winchester (Biddle and Hunter 1990) and Southampton, Hants., Old Windsor, Thetford, Glastonbury, Monkwearmouth and Jarrow (Harden 1978, 7–10) and Barking Abbey, Essex. Two window fragments from Whitby, Yorks. are exhibited (**107j**), and fragments from the guest house at Jarrow have been reassembled into a hypothetical figure portrait (**105a**). VIE

67 (a–w) Selected finds from Barking Abbey, Essex

The double monastery at Barking was founded after *c*.675 by Eorcenwald, bishop of London, for his sister Æthelburh. It appears to have consisted of separate compounds for monks and nuns including a number of scattered structures, a loose plan characteristic of monasteries of the period. Recent excavations by the Passmore Edwards Museum within the precinct of the medieval abbey have revealed evidence of seventh- to eighth-century Anglo-Saxon wooden out-buildings and associated activity, including fine glass working.

67 (a) Gold thread fragments

Gold; max. L. of largest frag. 3.0 cm

Anglo-Saxon; 7th–8th century

Passmore Edwards Museum, London, site nos BA.I.85: 1436, 1845, 1865, 1898

Gold strip fragments of varying widths from woven braids. These tiny strips are very similar to woven gold strips known from a number of (mostly female) rich sixth- and

67a

early seventh-century Anglo-Saxon graves where it is clear that gold woven braids were worn as headbands and cuffs (Crowfoot and Hawkes 1967, 42–85). Aldhelm, writing in his prose tract *De virginitate* (**59, 237**) which was dedicated to the nuns of Barking, condemned the worldly and luxurious costume worn by some men and women in religious orders, including coloured veils attached by costly *vittae* or headbands. These gold filaments from braids could well have come from nuns' fine apparel – or, of course, from ecclesiastical vestments. LW

67 (b) Hooked-tag

Silver; max. L. 3.0 cm
Anglo-Saxon; 9th century
Passmore Edwards Museum, London, site no. BA.I.85 1025

Double-hooked sub-triangular tag, the broad end missing. Beaded zigzag borders divide it into two fields, one triangular, one dentate, with Trewhiddle-style plant ornament.

The use of silver and the unusual double hook marks this out as a high quality piece. LW

67 (c) Hooked-tag

Copper-alloy; max. L. 2.15 cm
Anglo-Saxon; 9th century
Passmore Edwards Museum, London, site no. BA.I.86 1944

Sub-triangular tag with twin attachment holes at the broad end, and incised dot and circle ornament. LW

67 (d) Pin

Silver, gilding; L. 6.3 cm
Anglo-Saxon; 8th–early 9th century
Passmore Edwards Museum, London, site no. BA.I.86 1748

The sub-conical head has an incised cross with single dot between the arms, and a collar at the junction with the shaft. Pins such as this and the following examples are common, especially on sites with recorded female religious communities, such as Whitby. LW

67 (e) Pin

Silver, gilding; L. 3.8 cm
Anglo-Saxon; 8th century
Passmore Edwards Museum, London, site no. BA.I.86 1895

Globular-headed pin with gilding, double collar and hipped shaft. This elegant small pin and the following may have secured veiling on a headdress. LW

67 (f) Pin

Copper-alloy; L. 4.75 cm
Anglo-Saxon; 8th century
Passmore Edwards Museum, London, site no. BA.I.85 1432

Globular-headed pin with single collar and hipped shaft. LW

67 (g) Pin

Copper-alloy; present L. 5.85 cm
Anglo-Saxon; 8th century
Passmore Edwards Museum, London, site no. BA.I.85 149

Globular-headed pin with single collar and hipped shaft, now bent. LW

b b c c 67b,c

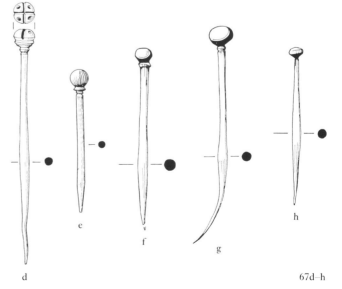

d e f g h 67d–h

67 (h) Pin

Copper-alloy; L. 4.2 cm
Anglo-Saxon; 8th century
Passmore Edwards Museum, London, site no. BA.I.85 1050

Sub-conical headed pin with flattened carination and hipped shaft. LW

67 (i) Stylus

Copper-alloy; present L. 14.0 cm
Anglo-Saxon; 8th–early 9th century
Passmore Edwards Museum, London, site no. BA.I.86 1798

The upper half of the stylus is octagonal in section, terminating in a sub-triangular eraser: the lower half is round-sectioned, the tip broken away.

The presence of styli such as this and the following examples is to be expected in literate communities such as monasteries. LW

67 (j) Stylus

Copper-alloy; L. 19.9 cm
Anglo-Saxon; 8th–early 9th century
Passmore Edwards Museum, London, site no. BA.I.85 389

The round-sectioned shaft has a double moulding half-way down and terminates in a sub-triangular eraser with chamfered edges. LW

67 (k) Stylus

Iron; L. 11.95 cm
Anglo-Saxon; 8th century
Passmore Edwards Museum, London, site no. BA.I.85 1502

The octagonal-sectioned shaft is modified to an elongated hexagonal section just below the sub-triangular eraser. This is decorated with a panel of interlace pattern in low relief.

Iron styli must have been as common as copper-alloy versions, but have survived less well. This decorated example, which resembles a silver-foil decorated stylus from Whitby (107c), is exceptional. LW

67 (l) Toilet-set

Copper-alloy; L. of nail-cleaner 7.25 cm; L. of scoop 5.25 cm
Anglo-Saxon; 7th–8th century
Passmore Edwards Museum, London, site no. BA.I.85 1759

Scoop and nail-cleaner of thick metal sheet, hanging from a slip-knotted wire ring. The scoop has diagonal incisions on the shank, the nail-cleaner herring-bone incisions.

Simple cosmetic sets of this type are common in well-to-do female Anglo-Saxon burials (cf. 33g), and appear to derive from Roman examples. Their presence at Barking shows this tradition continuing into the later seventh or eighth century, and like the gold braids reflects the status of the community. LW

i j k l 67i–l

67 (m) Vessel fragment

Glass; max. L. 48 mm
Anglo-Saxon; 8th century
Passmore Edwards Museum, London, site no. BA.I.85 1641/3436

Dark rust red, mainly plain but partly marbled in lighter and darker shades. Fragment of the shoulder of a globular vessel, 2 mm to 2.5 mm thick, probably a squat jar. Red marbled glass was used for various shapes of vessel in the Roman and medieval periods, but was largely absent in the Merovingian period apart from occasional red streaks in light green vessels (Evison 1990). As to the eighth and ninth centuries, a squat jar in this colour with yellow trail decoration was found at Helgö, Sweden (Holmqvist and Arrhenius 1964, fig. 113), and there is another unprovenanced in the Rheinisches Landesmuseum at Trier, Germany (Evison 1990, fig. 3). In England fragments of red marbled glass have been found in a number of Middle Saxon contexts at Southampton (Baumgartner and Krueger 1988, 76, no. 22), the Brough of Birsay, Repton and Brandon (66v). An unusual amount of evidence has been discovered regarding the manufacture of this distinctive type of glass as crucibles containing glass residue of marbled red and green colouring have been found in a Roman context at Trier and in probable Carolingian contexts at Cordel in Germany (Evison 1990) and Visemarest (*Quentovic*) in France (Heyworth 1988). This shows that the marbling was already present in the metal before blowing, and future analysis may elucidate the method used to achieve this effect. VIE

Bibliography: Evison 1990.

67 (n) Vessel fragment

Glass; max. L. 36mm

Anglo-Saxon; 8th century

Passmore Edwards Museum, London, site no. BA.I.85 2121a/3588

Light green-blue rim, slightly everted and 2.5mm thick. There are six unmarvered, green-blue horizontal trails on the outside up to near the rim edge, of which the top three contain a red streak.

The taste for polychrome effects in glass of the eighth century was often satisfied by the application of trails of a contrasting colour. The green-blue trails at the neck of this ?squat jar contrast pleasantly with the lighter green-blue of the body, while a subtle heightening of the effect is achieved by the additional red streaking. This is the result of drawing out a trail from a red and green-blue blob, and such bichrome trail colouring was first noticed on Swedish claw beakers from Valsgärde (Arwidsson 1932, 252, pl. XII). The earliest trace of this technique in England is a bicolour trail, translucent yellow and light green-blue, on a bag-beaker which probably came from a pagan grave at Dry Drayton, Cambs. (Evison 1983b, 90–1, fig. 4). Similar bicoloured trails, red and white, may be seen on the fragment also from Barking (**67t**). VIE

67 (o) Palm cup fragment

Glass; max. L. 34mm

Anglo-Saxon; 8th century

Passmore Edwards Museum, London, site no. BA.I.85 1872a/3738

Fragment of a palm cup with vertical ribbing. The glass is light green-blue, glossy, and 2 to 3mm thick. Four white horizontal trails are melted nearly flush into the surface. Above the lowest white trail one green-blue horizontal trail is unmarvered and remains interrupted on the high part of the ripples as blowing had continued after application. Other fragments from the same pit, light green-blue and ribbed, probably belong to the same vessel.

Ribbed palm cups are known from the sixth and seventh centuries, but none are decorated with horizontal trails, of which the white ones on this vessel must have been applied to the paraison before blowing in a mould. The curvature of this fragment shows that the vessel was widening at the top into a slightly everted rim, like the palm cup from St Martin-in-the-Fields, London, but it is probable that it was taller like the example from Katwijk, Holland, shown in Ypey's diagram of forms developing from the seventh-century palm cup to the ninth-century funnel beaker. (Ypey 1962–3, Abb. 40). The green-blue trail was added after the vessel was extracted from the mould, but it would appear that expansion from further blowing broke the trail, leaving isolated pieces on the higher parts of the ribs. A similar technique was used to produce yellow dotting on other trails on vessels from Westerland, Sylt and Kirchberg, Germany (Evison 1983b, figs 4d and 1e). VIE

67 (p) Vessel fragment

Glass; max. L. 30mm

Anglo-Saxon; 8th century

Passmore Edwards Museum, London, site no. BA.I.85 1631/3435

Wall fragment, light green-blue, bubbly, 2mm thick. Two diverging, vertical reticella trails, self and white, partly melted in. This was part of a globular form which may have been a squat jar or a bowl (Baumgartner and Krueger 1988, 73, no. 15, 70, no. 12), but the colouring conforms with that of some of the Valsgärde-type bowls as at Barking (**67s**). For other reticella vessels see **67q, r**. VIE

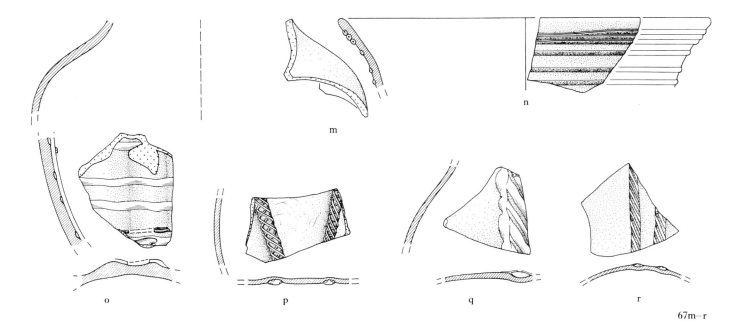

o p q r

m

n

67m–r

67 (q) Squat jar fragment

Glass; max. L. 24 mm

Anglo-Saxon; 8th century

Passmore Edwards Museum, London, site no. BA.I.85 541/890

Fragment from the slightly carinated shoulder of a squat jar. Brown glass with darker brown streaks, 1 mm thick. A vertical reticella rod is nearly completely melted into the wall, the central rod being light green wound with unmarvered opaque yellow trails. Only part of the reticella trail is present, but it must have expanded to a width of about 10 mm because of the melting in and the lateral spread of the unmarvered yellow trails. (For a diagram of the type of reticella rod see Evison 1988b, fig. 12 e.)

The squat beaker form continued from the early to the Middle Saxon period, and a slightly carinated form with reticella trails occurred at Helgö, Sweden (Holmqvist and Arrhenius 1964, fig. 113). Under magnification it can be seen that there are white inclusions in the light green and red and green flecks in the opaque yellow. For similar work on a brown squat jar, see **66x** from Brandon, Suffolk. VIE

67 (r) Squat jar fragment

Glass; max. L. 27 mm

Anglo-Saxon; 8th century

Passmore Edwards Museum, London, site no. BA.I.85 859/1459

Fragment of the globular body of a ?squat jar. Dark green glass, 1 to 1.5 mm thick, looking black in reflected light, streaky dark to lighter green in transmitted light. Two nearly parallel vertical trails, streaky opaque white and self colour, nearly completely marvered into the wall. One trail is c.2 mm wide and the other 3 mm wide, and the workmanship is neat. Some of the most colourful effects in Middle Saxon glass are achieved by the application of reticella rods on contrasting colours, and vessel fragments decorated in this way have been found mainly in England, Scandinavia and northern Europe (Näsman 1986, 76 ff; Koch 1987, 265–7; Baumgartner and Krueger 1988, 69 ff; Evison 1988b, 240 ff; Evison forthcoming a). Sometimes short lengths of the unused twisted rods have been found, more often in connection with bead-making rather than application on vessels, e.g. Armagh, Ireland (Youngs 1989, cat. no. 205a–d). VIE

67 (s) Bowl fragment

Glass; max. L. 18 mm

Anglo-Saxon; 8th century

Passmore Edwards Museum, London, site no. BA.I.85 1701/3618

Part of a light blue-green folded rim. The wall of the vessel is 0.5 mm thick, and part is missing before it folds over outwards and returns to be attached to the wall, leaving a cavity at the rim edge. The glass is bubbly with black inclusions. Opaque yellow horizontal trails were laid close together right up to the edge before folding, and so were contained inside the fold.

This very distinctive type of rim is to be found on the well-known bowl from grave 6 at Valsgärde, a bowl with yellow horizontal trail decoration and vertical reticella rods on the lower part of the vessel (Baumgartner and Krueger 1988, 70, no. 12). Fragments of this type of bowl, usually in these colours, but sometimes with a light green or light green-blue base or with white trails have been found abroad at Esslingen, Germany (Haevernick 1979, pls 1, 2), Dorestad, Holland (Isings 1980, Abb. 8), Eketorp II and Helgö, Sweden (Näsman 1986, 76 ff), but more frequently in England at Whitby, Yorkshire (**107h**), Wicken Bonhunt and Barking, Essex (**67p**), and Ipswich and Brandon, Suffolk. VIE

Bibliography: Evison 1988a, 241, fig. 7.

67 (t) Vessel fragment

Glass, max. L. 35 mm

Anglo-Saxon; 8th century

Passmore Edwards Museum, London, site no. BA.I.85 1830/3738

Wall fragment of a globular vessel 2 to 2.5 mm thick in vivid green-blue, bubbly and iridescent inside. Horizontal trails, bicolour red and white, combed in two opposite directions to form a feather pattern.

Bicolour trails of this type but red and green-blue are also noted in **67n**. Horizontal trails combed into arcades are fairly common, but trails which are combed in two opposite directions to give a feathered pattern are rare. Red and white trails were used in this fashion with dramatic polychrome effect on glass horns and beakers from seventh-century Lombardic graves in Italy (e.g. Stiaffini 1985, tav. 1, 10, 13). In England the colour combination is of white trails on light green vessels of Middle Saxon date at Shakenoak, Oxon. (Harden 1972, 67, fig. 7) and Southampton (Hunter 1980, 70, fig. 11.2.10). Fortunately one complete blue-green squat jar with feathered white trails survived from a grave at Dollerupgaard in Denmark to illustrate the appearance of a whole vessel with this decoration (Hansen 1987, 115, fig. 59; Evison 1990, fig. 2). A comparable fragment in a vivid blue-green with white two-way feathering was found at York Minster (**108d**). VIE

Bibliography: Evison 1990, fig. 1.

67 (u) Linen-smoother

Glass; max. L. 31 mm

Anglo-Saxon; 8th century

Passmore Edwards Museum, London, site no. BA.I.85 2121d/3588

Fragment of a bun-shaped hollow-blown linen-smoother. The colour is streaky and shades gradually from olive to blue-green. It contains small bubbles with surface bubble pits, and there are parallel scratches on the outer surface resulting from the rubbing use to which it was put.

Glass linen-smoothers (slick-stones) of various forms are known from the seventh century AD to the nineteenth century (Haevernick and Haberey 1963). From the late seventh or eighth century they were usually of bun shape, convex on one side, slightly concave on the other. Sometimes they were made of blown glass, usually light blue-green or olive as here,

67s–v

67w

and sometimes they were solid (Macquet 1990). Both types occurred at Dorestad, Holland (Isings 1980, 233, solid types only illustrated, fig. 156, 1–4), and at Birka, Sweden (Arwidsson 1984). Hollow types are known in England also from Brandon, and London at Jubilee Hall, Covent Garden and Bedfordbury (Evison forthcoming a, c). VIE

67 (v) Tank fragment

?Stone and glass; max. L. 90 mm
Anglo-Saxon; 8th century
Passmore Edwards Museum, London, site no. BA.1.85 1864/3738

Corner of a white ?stone rectangular container, one side L. 85 mm, w. 28 mm, the other L. 45 mm, w. 24 mm, H. c.45 mm.

The top surface and inside is covered with light blue-green glass with deeper drops on the top surface. The surfaces of this container and another fragment of stone are covered with a layer of glass which must be the result of drips in the process of glass working or glass blowing. It is similar to the corner of a tank containing glass found on a Roman site in Moorgate, London a few years ago (Museum of London), and two corners of another such tank, probably of the Carolingian period, were found at Cordel in Germany (Evison forthcoming a). It appears that some, at least, of the light blue-green vessels at Barking Abbey were manufactured on the spot, and there is the possibility of testing this by future analyses. VIE

Bibliography: Evison 1990, fig. 10.

93

67 (w) Eight sceattas

Silver
Anglo-Saxon; c.710–35
Passmore Edwards Museum, London

The eight Anglo-Saxon silver pennies (sceattas) from Barking all belong to the Secondary Series, from the period c.710–35. The Primary sceattas are scarcer, so their absence is not necessarily significant, although a representative might have been expected in this total had the area excavated been coin-using at that time. They comprise Series L, N, T, U(2), V (she-wolf and twins, the first recorded north of the Thames), a stag/cross type of fine style and one Series E ('Porcupine') derivative, possibly English. The late Secondary coins from Essex and East Anglia are significantly absent. Anglo-Saxon pennies of the ninth and tenth centuries were also found.

<div align="right">MMA</div>

68 Censer

Glastonbury Abbey, Somerset
Leaded brass; max. D. 8.75 cm; H. (including suspension lug) 7.3 cm
Early Byzantine; late 6th–mid 7th century
British Museum, M&LA 1986, 7–5, 1

The cast censer has a hemispherical body and carinated rim, both decorated with sets of lathe-turned concentric circles. At equidistant points on the rim are three suspension lugs, two with the remains of a chain composed of twisted S-shaped links. The body rests on three quadrangular-sectioned, slightly splayed feet. Part of the rim and body is cracked. A dark, burnt deposit within the bowl has been analysed by the British Museum Conservation Research Section, and consists of ash, metal corrosion products and traces of gum resin, presumably from incense materials such as myrrh or olibanum.

<div align="center">68</div>

Considerable numbers of Late Roman and Early Byzantine censers have been found throughout the Mediterranean and its hinterlands. Although these comprise many different forms, three body types for these censers predominate: cylindrical, hexagonal, or like the Glastonbury example, hemispherical. The closest parallels for the Glastonbury censer come from Sardis, Turkey, Catania in Sicily, and an unspecified findspot in Egypt (Waldbaum 1983, no. 585; Orsi 1912, 193–5; Strzygowski 1904, pl. 32); there is also an unpublished example reputedly 'unearthed in Galilee, near Tiberias', now in the Joslyn Art Museum, Omaha, Nebraska. Regrettably, none of these examples come from reliable stratified contexts. An approximate *terminus ante quem* from the early to mid seventh century for this type is suggested for those with an eastern Mediterranean provenance: much of Sardis was destroyed by the Sassanian Persian attack of AD 616, and Syria and Egypt had come under Arab control by the 630s and 640s respectively.

<div align="right">CJSE</div>

The occurrence of this example at Glastonbury is thus significant. It is said to have been found in the early 1980s during the digging of a service trench adjacent to, but outside, the abbey precinct. It has not been possible to localise the find-spot more precisely, but the Silver Street area is thought to be the most likely location.

Byzantine copper-alloy vessels of closely related types and dates were certainly entering England in the late sixth and early seventh century, appearing as luxury items in burials. The explicitly religious character of this piece, which does not appear to be from a burial, suggests that it is to be seen in the context of the early Christian community at Glastonbury. The evidence so far available for the early archaeology of Glastonbury does not yet confirm that the abbey site was active before the eighth century, but from documentary evidence we know that the monastery itself was in being before 680. The presence of such a censer quite probably by the middle of the seventh century is an important piece of evidence for the early history of Glastonbury and its abbey.

<div align="right">LW</div>

Bibliography: Cramp 1989, no. 49.

69 (a–w) Selected finds from a high-status site at Flixborough, South Humberside

The site was excavated in 1989–91 by the Humberside Archaeological Unit and Scunthorpe Museums, following preliminary exploration in 1988, when commercial sand extraction began. No direct documentary evidence for the site in the Anglo-Saxon period exists, but occupation appears to have started around 700; although there was some pagan-period activity, the site is effectively Middle Saxon in date. Following its abandonment in the 870s, the site was engulfed by a deep layer of wind-blown sand which protected it, leading to exceptional preservation of working floors, hearths and pathways.

The buildings on the site were timber built and survived only as wall trenches and post pits; some were of substantial

size, up to 14×6 m. Finds of glass and lead strips suggest that some had glazed windows, a feature only found on high-status buildings. During the two hundred years of its occupation the buildings were several times reconstructed and replaced.

The thick layer of occupation debris covering much of the site (and into which the wall trenches of some of the later structures had been cut) preserved bone well: the quantities found suggest that the inhabitants were eating rather well, and when analysis is completed, will give an account of their diet. Finds are equally prolific, including pottery which supports other evidence for an abandonment before the end of the ninth century. Finds of hearths and slag suggest that industrial processes were being carried out and the presence of more than three hundred loom-weights points to the large-scale manufacture of textiles. Amongst the most significant of the finds are the sixteen styli which, with the alphabet ring and the inscribed lead plaque (69v, b, g), provide striking evidence for literacy at Flixborough. In the Middle Saxon period, this was largely confined to clerics; it is thus likely that the site was monastic, although the services of scribes would probably be required from time to time on any aristocratic settlement. Metalwork survived well and much of it has been recovered from stratified contexts. However, until detailed analysis and phasing of the site is resolved, it is not possible to assign dates to the finds and, in the catalogue, conventional datings have been given. It can confidently be said, however, that all of the finds from Flixborough must date from the eighth or ninth century. KL

69 (a) Inscribed plaque

Sheet lead; L. 11.7 cm, D. 5.9 cm
Anglo-Saxon; mid 8th century
Scunthorpe Museums, site code FLX 89 1781

Sheet lead plaque bearing four lines of text which have been cut with a V-shaped chisel. Between the lines of text are four lightly incised horizontal lines used in setting out the letters. The individual words are separated by groups of triangular incisions. Underlying this is an earlier inscription (see below).

Around the edge of the plaque there are twelve nail holes ranging in size 0.1–0.3 cm. Five are damaged in a way which suggests that the plaque had been torn away from the

69a

surface – probably wooden – to which it was fixed. Distortion may have occurred during burial. KL

The inscription consists of seven (or possibly eight) personal names, separated by groups of triple dots. This derives from a form of punctuation of ultimately Irish origin (*distinctiones*) in which a rising number of points indicated a rising value of pause, in which three marks the greatest pause, equivalent to a full-stop. This was often used for decorative effect in English manuscripts. The inscription reads as follows: ALDUINI. ALDHERI. HAEODHAED (perhaps meant to read as two names, but undivided). EODUINI. EDELGYD. EONBERECHT. EDEL \overline{NUN}. The names assume both Southumbrian and Northumbrian forms, and two are feminine, the final one perhaps accompanied by \overline{NUN} (*nunna*, nun). An alternative, though less satisfactory, reading of the final element is UUN or UIIN. Interestingly, several of these names are represented amongst the religious establishment of Lindsey *c*.700.

The scribe responsible for this inscription was undoubtedly used to producing manuscripts, for the style of script belongs to a tradition of handwriting rather than inscriptions. The script is a calligraphic hybrid (or high-grade) minuscule, of the sort found in Mercian charters of the mid eighth to early ninth century, and in the later manuscripts of the 'Tiberius' group, notably two Mercian prayerbooks datable to the first quarter of the ninth century (162, 163). The lentoid form of letters such as the initial enlarged *a* is particularly reminiscent of Harley MS 2965 (164). Some of the distinctive ligatures may be found in charters issued by King Offa (158). The inscription overlies an earlier one. The underlying (largely illegible) letters follow the same base-lines, but are written in angular display capitals of the sort popularised by the Lindisfarne scriptorium, *c*.700, and which continued to exert an influence throughout the following century. However, these Northumbrian forms were generally being replaced by more fashionable mixed hybrid forms in Southumbria from the late eighth century onwards and the second inscription might reflect this change and be of a slightly later period. A date in the late eighth to early ninth centuries and a Southumbrian origin for the second, and probably the first, inscription is likely.

The form of the inscription, a Latin cross followed by a list of names, is reminiscent of lists of charter witnesses or of lists in a *liber vitae*, or book of benefactors. A commemorative listing of people of importance in the history of an ecclesiastical community, or a list of those whose relics were contained in an attached reliquary, are possible functions of this piece. MPB

69 (b) Finger-ring

Silver, gilding; D. 2.1 cm, W. of hoop 0.7 cm
Anglo-Saxon; early 8th century
Scunthorpe Museums, site code FLX 89 0693

Finger-ring decorated with a series of letters, in alphabetic order from A to L (omitting J in accordance with early medieval usage). They have been deeply incised with a V-shaped tool. The decorated outer face of the hoop had mer-

cury-gilding, now worn off along the edges. Around the letters are scattered small punched ovals. The hoop of the ring was formed from a flat strip of metal, the ends overlapped and secured with two rivets. A cross motif prefacing the text lies over the joint and must have been cut after the hoop had been riveted. (Illustrated on p. 99.) KL

The inscription The letters are of half-uncial form, resembling forms found in high-grade manuscripts of the late seventh and eighth centuries (although such forms are generally present throughout the Insular period). That the craftsman was unfamiliar with the precise nature of the letters may be indicated by the upside-down b. What is perhaps more surprising is that the Latin cross which separates beginning and end of the inscription should also be turned on its head.

The ring may well have been accompanied by a mate, completing the alphabetic sequence. Alphabetic inscriptions occur on sculpture in Celtic and Pictish contexts. As perhaps the equivalent inscriptions of runic *futhorcs* (e.g. **66b**), they may have fulfilled a teaching role, a talismanic function, or both. Some connection with Insular abcedarial prayers, such as that found in an early ninth-century Mercian prayerbook (**163**), which arrange their supplications in alphabetical order, emphasised by enlarged initials, is also possible, with the ring performing a devotional mnemonic, rosary-like function.

MPB

Wilson (1964) discusses a range of similar inscribed rings all of which he dates to the ninth century; they bear the names of makers, owners and magical inscriptions, but not sections of the alphabet. KL

69 (c) Disc brooch

Silver, gilding; D. 3.0 cm
Anglo-Saxon; late 8th century
Scunthorpe Museums, site code FLX 89 5467

Disc brooch decorated with the figures of two confronted beasts surrounded by deeply cut, chip-carved interlace, within a double relief border. The beasts have arched backs and neatly shaped feet and legs. Their bodies are covered with

69c

distinctive burred triangular incisions cut with the corner of a sharp tool. Mercury gilding is restricted to the face of the brooch and there are signs of wear around its edges. The integral pin is missing, but the hook-like catch survives and is faceted to suggest an animal's head. Some scratch-like tooling can be seen on the back of the brooch.

Both the style and quality of the decoration on this brooch link it to the eighth-century Witham pins (**184**) and related Insular metalwork. Its distinctive one-piece construction is paralleled on the later brooch from Barrington (**190**) and must have been a cheaper alternative to more elaborate fittings.

KL

69 (d) Pinhead

Silver, gilding; W. 1.32 cm, H. 1.42 cm
Anglo-Saxon; 8th century
Scunthorpe Museums, site code FLX 89 1241

The pinhead consists of a sphere with six cylindrical settings with beaded-wire collars, five of which contained red glass and the other traces of a silver pin. The collar of the uppermost setting has a beaded band on top of a plain one; an arrangement duplicated on one of the four side bosses, the other three having a beaded band only. Wear on the gilding shows that this object was in use for some time, and the use of gilding and of red glass inlay point to a late seventh or early eighth century date. KL

69 (e) Pin

Copper-alloy, gilding/silvering; L. 7.2 cm
Anglo-Saxon; 8th century
Scunthorpe Museums, site code FLX 89 4163

The sub-triangular flat head on collared and hipped shaft consists of a hammered and incised plate, mercury-gilded and decorated on one face. The back of the pinhead and the shaft are silvered. The coarse chip-carved decoration consists of two addorsed beasts touching at the neck and rump. Each has a disproportionately large head with gaping jaws and lolling tongues, and long necks descending into small bodies with rudimentary legs. File marks are visible beneath the gilding on the head but not on the back.

This pin belongs to a small group of related pins from the area around the Humber, these finds coming from Newbald, North Humberside (Leahy forthcoming), and near Louth, Lincs. The association of animals' heads with interlace is common in eighth-century manuscripts and this, coupled with the use of gilding, makes an eighth century date likely.

KL

69 (f) Pin

Silver, gilding; surviving L. 7.5 cm, head W. 1.0 cm
Anglo-Saxon; 8th century
Scunthorpe Museums, site code FLX 89 0324

The pin has a flat gilded head, both sides decorated with a chip-carved creature, and a hipped shaft, the tip missing.

69d–f

The backward-turning beast has a powerful beak, a pointed ear, a rudimentary foreleg and an upward-curving lobed wing.

Although this 'griffin' motif cannot be directly paralleled, its component elements, the beaked head, pointed ear, and curling wing are well known from eighth-century manuscripts and sculpture, such as the griffin on the Otley cross. The use of gilding would also support an eighth century dating. KL

69 (g) Pin

Silver, gilding; surviving L. 4.5 cm
Anglo-Saxon; 8th century
Scunthorpe Museums, site code FLX 89 0822

Pin with a carefully modelled dog's head set parallel to the collared and hipped shaft, which has lost its tip. The nostrils are represented by two small drilled holes, and the eyes contained blue glass beads, one now missing. The entire pin was gilded.

The beast's head used on this pin can be paralleled on eighth-century manuscripts, there being near-identical heads on, for instance, the carpet pages of the Lindisfarne Gospels (80) (Backhouse 1981, pl. 31). A very close parallel, also with a grinning dog's-head and glass eyes, exists (182). KL

69 (h) Pin

Silver, gilding; L. 4.54 cm
Anglo-Saxon; 8th century
Scunthorpe Museums, site code FLX 89 2294

The mercury-gilded head is in the form of a carefully modelled animal head, with a wedge-shaped section, wide between the ears and tapering towards the gaping jaws. A notch at the back of the head separates the two ears. Each eye is marked by a shallow depression and is surrounded by a small raised ring. Head and shaft are separated by a small collar.

This object has no close parallel, but like other beast-headed pins (e.g. 69g, 66d) is likely to be of eighth-century date. KL

69 (i) Pin and linked chain

Copper-alloy; pin L. 6.85 cm, head D. 1.42 cm, chain L. 14.3 cm
Anglo-Saxon; 8th century
Scunthorpe Museums, site code FLX 89 4157

The disc-headed pin is decorated with a cross with expanded terminals, outlined by punched dots, as is the edge of the disc. On the left side is the hole through which the chain was secured. Two small grooves divide the pinhead from the hipped shaft. The chain is made up of twisted S-shaped links. Both of the two end links are now open; one of them was secured to the head when found.

Linked pin sets have a long history stretching back to the small-scale and relatively simple seventh-century versions and culminating in elaborate three-pin sets such as the eighth-century Witham pins (184). The cruciform pattern on the head compares in overall design with one of the discs in the eight-century Witham pin set (Wilson 1964, no. 19). However, a pair of linked disc headed pins occurs in the ninth-century Talnotrie hoard (248b, c). KL

69 (j) Pin

Copper-alloy; L. 5.7 cm
Anglo-Saxon; 7th–8th century
Scunthorpe Museums, site code FLX 89 4729

Spiral-headed pin with a slightly hipped shaft. Pins of this type were once assigned to the sixth century (Pretty, in Brodribb et al. 1972, 84–5, fig. 34), but it is now clear that they are predominantly seventh–eighth century in date (Hawkes 1973, 283–4; Dickinson 1990). KL

69 (k) Pin

Copper-alloy; L. 5.15 cm
Anglo-Saxon; 7th–8th century
Scunthorpe Museums, site code FLX 89 5465

Spiral-headed pin with a slightly hipped shaft. See 69j above. KL

69g–o

69 (l) Pin

Copper-alloy; surviving L. 4.1 cm, head D. 1.05 cm
Anglo-Saxon; 8th–9th century
Scunthorpe Museums, site code FLX 89 0462

Pin with sub-biconical head and collared, parallel-sided shaft, broken in antiquity. The head has a double incision round its widest part and has incised lines and ring and dot decoration.

This pin has Anglo-Saxon parallels at e.g. Whitby which probably date to before its abandonment c.867. KL

69 (m) Pin

Copper-alloy; L. 7.2 cm
Anglo-Saxon; 8th–9th century
Scunthorpe Museums, site code FLX 89 0549

Pin with polygonal head and collared parallel-sides shaft. The head has a ringed-dot on each of the four side faces and a plain top. Around the shaft are four turns of a finely incised spiral line.

This is an example of a very common Middle Saxon pin-type (see discussion under **66k**). Incised lines sometimes observed around their shafts may have been intended to help the pin grip into the textile. KL

69 (n) Strap-end

Copper-alloy; L. 3.6 cm, W. 0.9 cm
Anglo-Saxon; 9th century
Scunthorpe Museums, site code FLX 89 0554

The strap-end has two rivet-holes at the split end and a stylised round-eared animal-head terminal: the sides have a border of triangular punches. The central panel is decorated

with a skilfully executed Trewhiddle-style animal reserved against a ?niello ground. Between this panel and the split end is a trefoil. The strap-end is heavily worn.

Like **69o**, this is a standard ninth-century type, though much more coherent and skilful in its decoration, which is a refined version of the Trewhiddle style (see pp. 220–1). KL

69 (o) Strap-end

Copper-alloy, enamel; L. 2.9 cm, W. 0.9 cm
Anglo-Saxon; 9th century
Scunthorpe Museums, site code FLX 89 0100

Strap-end with single rivet-hole at the split end, round-eared animal-head terminal and coarse incised Trewhiddle-style decoration, inlaid with enamel. The sides are crudely billeted. Tooling marks cover the back. The sub-rectangular panel has a backward-turning crouching beast reserved against an enamel ground (now degraded). The brow of the animal-head terminal is also inlaid with enamel. When found, the split end contained traces of fibrous material, possibly leather. The use of enamel is rare but not unknown (Keen 1986, 195–6).

In form and decoration this strap-end is a classic ninth-century type. The crude Trewhiddle-style decoration may be late and degenerate, or simply due to poor workmanship. The use of a single rivet is most unusual but does occasionally occur e.g. on the strap-ends in the Trewhiddle hoard itself, and **191**. KL

69 (p) Hooked-tag

Silver, gilding; L. 2.77 cm, W. 1.01 cm
Anglo-Saxon; 8th century
Scunthorpe Museums, site code FLX 89 1816

Sub-triangular hooked-tag with two holes at the scalloped broad end and chip-carved zoomorphic decoration and interlace. The beast has its gaping head in the apex of the tag, biting its tail: it has a curving body, outstretched leg and pointed wing. The latter connect with a crude interlaced mesh, which ignores the relationship of passing strands. The mercury-gilding is restricted to the front face and sides of the tag; the back is plain, apart from tool marks.

There are indications that this object has been reworked. The two drilled holes do not respect the interlace, which is also truncated by the scalloping, which removed gilding from the edges. The hook may also have been reworked, and there are traces of wear on the tag. The use of gilding and the large fine mesh of chip-carved interlace links it to objects such as the eighth-century triple pin-set from the River Witham, Lincs. (184) and the Ixworth brooch (Wilson 1964, cat. 25).

KL

69 (q) Hooked-tag

Silver; L. 2.46 cm, W. 1.34 cm
Anglo-Saxon; 8th–9th century
Scunthorpe Museums, site code FLX 89 0375

Triangular hooked-tag of sheet metal, with twin holes at the slightly scalloped broad end. The hook, broken in antiquity, was formed by pinching up the sheet metal.

Very similar triangular tags were found in the hoard from Tetney, Lincs., which was dated by associated coins to before 970 (Wilson 1964, cats 86, 87) and at Whitby, Yorks. (Peers and Radford 1943, figs 12, 10) where it is likely to have been deposited before 867. Other close parallels exist at Shakenoak,

Oxon., where they were apparently found in late seventh-to eighth-century deposits (Brodribb et al. 1972, nos 141–5) and at Winchester as residual material in post-conquest contexts (Hinton 1990, 549–51, fig. 148). This simple form of tag was in use for some time.

KL

69 (r) Hooked-tag

Copper-alloy; L. 2.2 cm, W. 1.15 cm
Anglo-Saxon; 8th–9th century
Scunthorpe Museums, site code FLX 89 3403

Assymetrical shield-shaped tag of sheet metal with bevelled edges and two attachment holes with circular surrounds. On the underside of the tag are two, still more poorly finished, rings which may have been trial cuts. The edges of the tag have three decorative notches.

KL

69 (s) Spoon

Bone; L. 13.8 cm, W. 2.9 cm
Anglo-Saxon; 8th–9th century
Scunthorpe Museums, site code FLX 89 4135

The spoon is elegantly carved from a single piece of bone, with traces of the cancellous tissue from the centre of the

69b, p–r

69s

99

bone apparent in the oval bowl. It was subsequently polished. The bowl is divided on the back into two rounded lobes by a central rib which expands towards the spoon handle, and where bowl and handle join, there is a small schematic animal-head with drilled eyes and nostrils. Around the edge of the bowl is a rib which extended use has worn away. The handle has a complex section which could be described as round but with four lengthwise ribs causing the section to appear square. At the end of the handle is a knop in the shape of a lobed asymmetric leaf. A small indentation has been drilled into each of the two faces of the finial.

Few Middle Saxon spoons have survived and no close parallels exist. The typical Late Saxon spoon has a bowl which expands from the handle (Macgregor 1985, 181–2, fig. 98; Kjølbye-Biddle 1990, 830, fig. 247). The closest parallel appears to be a recent find from a ninth-century site at Fore Street, Ipswich, which, though less accomplished, shares a similar bowl shape and profile. The comma-shaped leaf-like terminal appears in eighth-century manuscripts, sculpture and metalwork, but it would not be safe to attempt to date the spoon on the strength of so simple a motif. There has been some discussion of the function of Anglo-Saxon spoons and a liturgical use has sometimes been suggested. The Flixborough spoon has, however, clearly seen much hard use.

KL

69t–w

t

u

v

w

69 (t) Latch lifter

Copper-alloy; L. (excluding ring) 7.8 cm, ring D. 1.3 cm
Anglo-Saxon; 8th–9th century
Scunthorpe Museums, site code FLX 89 3776

Sheet-metal latch lifter with slip-knotted wire suspension loop and two-pronged terminal, the broken ends of which appear to have been bent at 90 degrees. Above these is a plain kite-shaped panel covered with fine tool marks.

Although both this and the succeeding object are described as latch lifters the identification is not certain. In this type of lock prongs on the key raise tumblers which are engaged in holes through the sliding bolt. Once the tumblers are clear the key was moved to slide the bolt. Early Anglo-Saxon latch lifters have simple hook- or anchor-shaped bits and it is possible that this and 69u represent a latch lifter design influenced by the more sophisticated sliding key type (Goodall 1990, 1016–17, figs 317–18). This type of key was also in use at Flixborough.

KL

69 (u) Latch lifter

Copper-alloy; L. 10.1 cm
Anglo-Saxon; 8th–9th century
Scunthorpe Museums, site code FLX 89 3820

Latch lifter with suspension loop and terminal with three square-sectioned prongs bent at 90 degrees, the central prong extending beyond its two counterparts. Beyond this is a flat section tapering towards the round-sectioned shank which is collared at the junction. A further collar marks the junction with the hole for the wire suspension loop. See 69t above.

KL

69 (v) Stylus

Silver; L. 11.2 cm, eraser W. 1.4 cm
Anglo-Saxon; 8th–9th century
Scunthorpe Museums, site code FLX 89 6143

Stylus with a trapezoid eraser at one end and a long, octagonal point at the other. There are two small grooves around the 'sugar-loaf' point. The upper portion of the shaft is slightly barrel-shaped and is separated from the other sections of the stylus by two mouldings, each of which has two finely incised lines either side of it. At the centre point of this section there are three small grooves. The edge of the eraser appears to have seen some use, but no wear marks can be identified on the point.

Other styli have been found e.g. at Brandon and Whitby (66r–t, 107c–e), but these are all of copper-alloy, bone or iron. This unique silver example from the Flixborough site indicates that some of its occupants enjoyed high social and economic status.

KL

69 (w) Stylus

Copper-alloy; L. 13.9 cm, W. of head 1.2 cm
Anglo-Saxon; 8th–9th century
Scunthorpe Museums, site code FLX 89 3775

This elegant casting has at one end a bell-shaped eraser and at the other, a tapering round-sectioned point. The central part of the stylus is octagonal in section and is separated from the other two sections by multiple mouldings.

This object can be paralleled by finds from Brandon (66r–t) and the monastic site at Whitby, North Yorks., abandoned in 867 (Peers and Radford 1943, fig. 15). KL

70 The Franks Casket

Auzon, France
Whale's bone; L. 23 cm, H. 13 cm, D. 19 cm
Anglo-Saxon; first half of 8th century
British Museum, M&LA 1867, 1–20, 1

Lidded rectangular box, carved on the sides and top in relief with scenes from Roman, Jewish, Christian and Germanic tradition. *The base* is constructed from four sides slotted and pegged into corner uprights, the bottom plates fitted into grooves at the base of the sides. It possibly stood on four low feet. Only one decorative panel now survives in *the lid*, the remaining elements being almost certainly replacements.

Scars left by lost metal fittings on the exterior – handle, lock, hasps and hinges – and crude internal repairs reflect a chequered history (see below). The five surviving decorated panels are variously accompanied by carved texts in Old English and Latin, using both conventional and encoded runes as well as Insular script, in a variety of orientations. Each side is bordered by a long descriptive text and three contain additional labels; the lid panel has only the latter, though a longer text may originally have accompanied it.

The front is divided in two: the left half shows a composite scene from the Weland the Smith legend, the right half, the Adoration of the Magi, with the label 'mægi' carved above the kings. The main inscription takes the form of a riddling alliterative verse about the casket's origin; this may be translated as 'The fish beat up the sea on to the mountainous cliff. The king of ?terror became sad where he swam on to the shingle. Whale's bone'. *The left-hand end* depicts Romulus and Remus nurtured by the wolf: the inscription is translated 'Romulus and Remus, two brothers, a she-wolf nourished them in Rome, far from their native land'. The *back panel* shows the capture of Jerusalem in AD 70 by the Roman general, later emperor, Titus: labels on the two lower corners read 'dom' = 'judgement', and 'gisl' = 'hostage' respectively. The main inscription is in a mixture of Old English, Latin, runes and insular script, and is probably intended to mean 'Here Titus and a Jew fight: here its inhabitants flee from Jerusalem'. The *right-hand end* poses special problems of interpretation. The apparently episodic scene is evidently

70

70 (back panel)

70 (right-hand end)

from Germanic legend but has not been satisfactorily identified. Three labels read: 'risci' = 'rush', 'wudu' = 'wood' and 'bita' = 'biter'. The main runic text is in alliterative verse partly encoded by substituting cryptic forms for most of its vowels and perhaps certain other letters. Debate continues about how this should be transliterated, let alone translated, but a widely accepted translation reads 'Here Hos sits on the sorrow-mound; she suffers distress in that Ertae had decreed for her a wretched den of sorrows and torments of mind'. The *lid* appears to depict an episode relating to the Germanic hero Egil and has the single label 'ægili' = 'Egil'. Detailed descriptions and discussions of the scenes may be found in works listed in the select bibliography.

Almost everything about this perplexing and ostentatiously erudite object is enigmatic, including its history. It was first recorded in the possession of a family at Auzon in the Auvergne, during which time it was dismantled. The right-hand end became separated from the rest around this time, and passed eventually into the Museo Nazionale del Bargello in Florence, where it remains. A replica of this is mounted on the original casket. The other panels were bought from a Paris dealer and presented to the British Museum by the collector and curator Augustus Franks, whose name it bears. Its history prior to its surfacing in Auzon is unknown, though one second-hand account suggests that it came from the nearby church and cult-centre of St Julian at Brioude, from which it could have been looted at the Revolution. How and when the casket came to France can only ever be a matter for speculation, though Wood has managed to identify one early medieval candidate who in theory could have taken it from the north of England to Brioude – the Frankish scholar Frithegod who was active in both areas in the middle tenth century (Wood 1990, 4–5).

Still more speculative is the question of where and why it was made. The language of the inscription shows that the carver used a Northumbrian or north Mercian dialect current in the early eighth century. The style of decoration, with its many details recalling Northumbrian manuscript art of the first half of the eighth century, accords with this (Webster 1982b, 28–30). A Northumbrian origin is thus probable, though (since even monastic craftsmen may be mobile) not strictly necessary. Aptly characterised as 'self-consciously clever' by Wood (1990, 5), there can however be little doubt that the casket was made in a learned community with aristocratic tastes and connections; at such a date, that can only mean a monastic milieu. Wood's own tentative suggestion that this could have been Wilfrid's Ripon is ingenious and attractive, but discounts too readily the possibility of an origin at other major Northumbrian centres of learning such as Lindisfarne or even the more consciously romanising Monkwearmouth/Jarrow. The Casket's heady mix of Roman Christian, Jewish and Germanic traditions certainly reflects an interest in cosmography recorded in seventh- to eighth-century Northumbrian aristocratic and monastic circles (e.g. Wood 1990, 8, fn. 48); where, as we also know from Alcuin's famous reproof to the monks of Lindisfarne, tales of Germanic heroes were also recounted (Alcuin, letter 124). The casket's programme, in so far as we understand it, is however

not merely a parade of learning and of epigraphic virtuosity. Word and image enter here a new and important Anglo-Saxon life together, in an iconographic programme which seems to be based on parallels rather in the manner of Biblical types (a form of exegesis certainly known at Monkwearmouth/Jarrow). The Adoration of the Magi, for example is juxtaposed with the Weland legend, in which the birth of a hero also makes good sin and suffering, while the adjacent sides symbolising the founding of Rome and destruction of Jerusalem draw an obvious contrast. However, while the Germanic scenes on the lid and right-hand side remain opaque to analysis, it is impossible to say whether the device of parallelism underlies the Casket's entire iconographic programme.

Nevertheless, the access to the Early Christian models evident in the use of parallels is matched in the Casket's form and design. This is manifestly based – possibly at some remove – on an Early Christian reliquary similar to the Brescia casket, which itself shares with the Franks Casket both a programme which makes notable use of parallels and a remarkably similar layout of central scenes bordered by (there iconic) commentaries. No doubt prestigious potential models of this kind reached Northumbria either through direct contacts with Rome of the kind regularly made by such as Benedict Biscop, Ceolfrid and Wilfrid, or, as Wood has argued, via contacts with Frankish Gaul. The heady impact on Anglo-Saxon culture and Christianity and with it the world of antiquity is nowhere more strikingly seen than in this extraordinary object. LW

Select bibliography: Napier 1900, 362–81; Marquardt 1961, 10–16 and ref; Page 1973, 66–8, 174–82, 188–9 and refs; Webster 1982b, 20–31; Wood 1990, 1–19.

71 Grave marker

Lindisfarne, Northumberland
Fine-grained red sandstone; H. 21.6 cm, W. 15.2 cm, T. 3.8 cm
Anglo-Saxon; mid 7th–mid 8th century
English Heritage, Priory Museum, Lindisfarne

It has a semicircular head and expands slightly towards the squared base; the lower corners are roughly broken away. The front face is decorated with a median-incised cross mitred into the double outlined frame. The cross has a circular centre with a flat recessed insert and narrow arms with semi-circular ends. In the upper quadrants are the runes

'os / / gyþ'

In the lower quadrant the equivalent in Anglo-Saxon capitals

+OS / / GYÐ

The reverse is undecorated.

There are at least fourteen fragments of similar small markers from Lindisfarne, most decorated with simple crosses and inscriptions. The inscription is usually a personal name or names, in this case the female name Osgyth. The stones are remarkably small and thin. If they stood upright marking the graves like the Lechmere stone (**210**), they must

71

orated apart from a plain raised edge moulding. The right lateral arm pushes into the edge moulding. In the quadrants created by the cross is the inscription in Anglo-Saxon capitals:

HIC	/	INSE
PUL	/	CRO
REQV	/	IESCIT

COR	/	PORE
HER	/	BERI
CHT	/	PRB

HIC IN SEPULCRO REQVIESCIT CORPORE HER(E)BERICHT PR(ES)B(YTER).

The piece could have stood upright as a grave marker, or flat on the ground surface covering the grave. Both types of monument were common in the Anglo-Saxon period (see

have been partially sunken into the ground, obscuring part of the decoration. Alternatively they may have been laid on the ground over the grave like the Repton slab, or actually in the grave as appears to have been the case on some of the small rectangular memorial stones from Hartlepool. DT

Bibliography: Okasha 1971, 94–5, pl. 76; Page 1973, 104, 143–4, fig. 104; Cramp 1984, 202–3, no. 24, pls 200, 1119–21.

72 Grave marker or cover

Monkwearmouth, Tyne and Wear
Medium-grained, massive yellow sandstone; H. 104 cm, W. 53 cm, D. 18 cm
Anglo-Saxon; 8th century
St Peter's Church, Monkwearmouth, Tyne and Wear

Rectangular slab, with the upper end and left hand side partially broken away. The decoration is confined to the front face. To the right is a roll moulding set slightly in from the edge; this appears to have returned along the upper edge to terminate on the vertical axis in a bird head or volute. A second similar feature facing it presumably terminated the lost moulding to the left. The face of the slab is decorated with a relief Latin cross with rectangular cross pieces forming the ends of each arm, and a similar base. The cross is undec-

72

104

210, 212). Such monumental sculptures were probably very early introductions into Anglo-Saxon England, perhaps as early as the seventh century at Hartlepool. The earlier slabs were very small with incised inscriptions and crosses, and may have been placed in rather than covering the grave. This piece marks a further stage in the sequence of development. It is bigger, with greater variety of decoration and sculptural technique. The inscription can be translated 'Here in the tomb rests Herebericht the priest in the body'. The name 'Herebericht' has been added to the inscription. DT

Bibliography: Collingwood 1927, 15, fig. 19; Okasha 1971, 101, pl. 92; Higgitt 1979, 360–1, 363–5, pls 62b, 63; Cramp 1984, 124, no. 5, pl. 110, 604.

Coins

73 (a, b) Roman prototype and Anglo-Saxon derivative showing a radiate bust on the obverse and clasped hands on the reverse

73 (a) Coin of Marius (usurper, 286), Concordia Militum type, struck at Trier

Bronze (originally silvered); WT 2.91 g
British Museum, CM 1961, 8–2–132
Provenance: From Hollingbourne, Kent, hoard, found in 1959.
Bibliography: Carson 1961.

73 (b) Anglo-Saxon shilling struck in Kent, c.650–60

Base gold; WT 1.24 g (19.1 gr)
British Museum, CM 1903, 10–5–1
Provenance: Found at ?Strood, Kent.
Bibliography: BMA 2; Sutherland 1948, no. 23; Kent 1961.

The clasped-hands type, proclaiming alleged military concord, was used by several Roman emperors and usurpers. The coins of Marius are the commonest of these issues found in Britain. This obverse was, in turn, the prototype for the early silver pennies (sceattas) of Series A (53a). The strong preference in the Primary and Intermediate sceatta series for imperial prototypes shows Anglo-Saxon respect for all things Roman, and the durability of the concept that proper coins should look like Roman ones. MMA

74 (a, b) Roman prototype and Anglo-Saxon derivative showing the she-wolf suckling the twin founders of Rome, Romulus and Remus

74 (a) Coin of Constantine I (307–37), struck at Trier, c.330

Bronze; WT 2.61 g
British Museum, CM 1846, 10–2–7
Provenance: Not known.
Bibliography: LRBC 76.

74 (b) Penny (sceat), Secondary Series V, she-wolf and twins/bird-in-vine type, struck in Kent (or ?East Anglia), c.725

Silver; WT 1.04 g (16.0 gr)
British Museum, CM acquired before 1838.
Provenance: Found in Thanet, Kent, in the eighteenth century.
Bibliography: BMC 77; Kent 1961; Campbell 1982b, 67.

It has been suggested that the design is a play on the name of the East Anglian dynasty, the Wuffingas. No sceattas of the type have as yet been found in East Anglia, although two have recently come from Essex. More provenances are Kentish which makes that attribution preferable. The same design was certainly used by Æthelberht of the East Angles, in the later eighth century (222a), but the Roman prototype is a common find in England, and the design may have been chosen for different reasons on each occasion. MMA

75 (a, b) Roman prototype and Anglo-Saxon derivative showing a similar effigy

75 (a) Siliqua of Honorius (393–423), Virtus Romanorum type, struck at Milan

Silver; WT 1.59 g
British Museum, CM 1968, 11–4–7
Provenance: Purchased at the Oman sale, Christies, 12.xi.1968, lot 341 (part).

75 (b) Penny of Offa of Mercia, 757–96, Light Coinage, struck in ?Mercia by the moneyer Dud

Silver; WT 1.06 g (16.6 gr)
British Museum, CM 1854, 6–21–14
Provenance: Not known; purchased at the Cuff sale, Sotheby, 8.vi.1854, lot 269.
Bibliography: BMC 13; Stewart 1986.

The images of Anglo-Saxon kings until the mid-1050s were not characterised, but were copied very closely (as here), or in a more stylised fashion, from Roman effigies. The authors of the Anglo-Saxon Chronicle and the poem 'The Ruin' both show familiarity with Roman buried treasure. MMA

73a 74a 75a

73b 74b 75b

76a 77a 78a

76b 77b 78b

Anglo-Saxon coins with the Roman and other issues which inspired their designs

76 (a, b) Roman prototype and Anglo-Saxon copy of a first-century type

76 (a) Aureus of Augustus (27 BC–AD 14), struck at Lyons in 12–14 BC

Gold; WT 7.90g
British Museum, CM 1867, 1–1–601; gift of the Duc de Blacas, 1867
Provenance: Not known.
Bibliography: BMC 488.

76 (b) Anglo-Saxon solidus/mancus by the moneyer Pendræd, struck presumptively at London in the 770s or 780s

Gold; WT 3.75g (57.8gr)
British Museum, CM 1962, 3–13–1; gift of Mr C. E. Blunt, 1962
Provenance: Not known; in the collection of Sir Robert Cotton d. 1631 and first published in Speed 1611, where it is attributed to 'Uter Pendragon'.
Bibliography: Blunt and Dolley 1968.

This Anglo-Saxon donative piece copies both sides of the prototype closely, except that it omits Diana's dog from the reverse. Gold of Augustus is found in England, but rarely.

Pendræd's name appears on both sides, with his office additionally on the obverse. He was a moneyer in Offa's light-weight silver coinage. The mancuses of the eighth and ninth centuries were struck from *ad hoc* dies, unlike the later examples struck from dies of the regular silver penny coinage.

MMA

77 (a, b) Beneventan prototype and Anglo-Saxon derivative showing a Cross-on-steps type

77 (a) Solidus of 'G', Duke of Beneventum (?Gregory, 732–9)

Gold; WT 4.1g
British Museum, CM 1923, 2–4–1
Provenance: Purchased from C. L. Plait, 1923
Bibliography: for discussion of Beneventum coinage, Grierson and Blackburn 1986, 66–72.

77 (b) Solidus/mancus in the name of the moneyer Ciolheard alone, struck probably at London c.800

Gold; WT 4.12g (63.3gr)
British Museum, CM 1984, 12–21–1

Anglo-Saxon coins of the seventh to early ninth centuries and their prototypes

Provenance: Found near Manchester in 1849. Purchased at the Mallinson sale, Spink 6.xii.1981, lot 73.

Bibliography: Sutherland 1948, no. 76; Pagan 1965; Lyon 1969, 208; Grierson and Blackburn 1986, 328–9.

The Anglo-Saxon coin, without a regal name, was a donative piece as gold was not a part of the normal regal currency at this time. The obverse is a version of the bust found on late fourth-century Roman solidi. The reverse derives from contemporary Italian gold solidi such as would have been encountered by influential Anglo-Saxon pilgrims to Rome, of which this Beneventan coin is representative. MMA

78 (a, b) Ancient British prototype and Anglo-Saxon derivative

78 (a) Coin of Cunobeline (*c.*AD 10–40), struck in Essex, presumptively at Colchester

Bronze; WT 2.60 g
British Museum, CM 1864, 2–13–1

Provenance: Found in 1796 at the Old Water Works, Colchester, Essex.
Bibliography: Mack 1975, no. 230.

78 (b) Anglo-Saxon penny, Secondary Series S, Female-centaur type, Essex, *c.*725–35

Silver; WT 1.15 g (17.8 gr)
British Museum, CM, acquired before 1832
Provenance: Not known.
Bibliography: *BMC* 19; Metcalf 1984, 56–7.

Centaurs, from classical mythology, also feature in the eighth-century Mercian sculpture in Breedon Church, Leics. This type may have been copied merely as the result of a random discovery, but it is possible that it was chosen because it had some particular significance for the East Saxons or their dynasty, on analogy with the beast on the coins of Northumbria (**54, 57**). MMA

The Church in Northumbria

In 600 political control of the land between the River Humber and the Forth–Clyde valley was shared between about half a dozen Christian British kingdoms and the two pagan Anglo-Saxon kingdoms of Bernicia (centred upon the rock stronghold of Bamburgh in Northumberland) and Deira in the Vale of York. In the course of the seventh century the two English kingdoms were fused into a single people, the Northumbrians (i.e. 'those dwelling to the north of the River Humber'). At the same time all the British kingdoms, save for that of Strathclyde with its stronghold at Dumbarton, were subjugated to Northumbrian rule by military pressure. This vast new kingdom, which was to dominate the politics of northern Britain throughout the seventh, eighth and ninth centuries, was created by a succession of warrior-kings of genius: the pagan Bernician Æthelfrith (593–616), the Deiran Edwin (616–33) and Æthelfrith's sons, Oswald (634–42) and Oswiu (642–71), and his grandson, Ecgfrith (671–85). Their conquests and the tributes that they exacted from neighbouring states made their retinues of warrior aristocrats phenomenally wealthy. These Northumbrian nobles were the Gettys or the Bransons of their generation.

The great age of Northumbrian conquests in the first three-quarters of the seventh century was also the period when both the royal dynasty and their Anglian aristocracy were converted to Christianity. The fortunes of the Roman mission of St Paulinus of York and the 'Celtic' mission of St Aidan of Lindisfarne were largely determined by political developments. Paulinus came to the north from Kent as the chaplain of the Christian Kentish princess, Æthelburh, the bride of King Edwin. On Easter Day 627 Paulinus baptised Edwin and commenced the construction of a stone church of St Peter at his episcopal see at York in the heart of Edwin's Deiran homeland. Plans to make York an archbishopric with subordinate sees for the peoples under Edwin's lordship foundered when Edwin was defeated and killed in the battle of Hatfield (633) by the British king, Cadwallon of Gwynnedd, and his pagan Mercian ally, Penda. Within a year, however, Christian rule had been re-established over the Northumbrians, but this time by Oswald, a Bernician prince who had been converted during exile among the Irish settlers of western Scotland. Oswald therefore secured from Iona a missionary party of Irish monks, who established themselves on Lindisfarne with Aidan as their abbot and as bishop of the Northumbrians. Lindisfarne was clearly intended to remind the Irish monks of the island seclusion of Iona, but it was also within sight of the Bernician royal stronghold of Bamburgh. It could therefore serve both as a convenient episcopal see and as a haven of monastic peace. Thus Northumbria became the meeting place for different (and sometimes rival) Christian traditions, Roman and Irish, which came to be associated respectively with the Deiran and Bernician halves of the kingdom; York looked to Kent and to Rome, Lindisfarne to Iona and to the centres of Irish Christianity.

The bulk of the inhabitants of Oswald's enormous kingdom, which stretched from the North Sea to the Irish Sea and from Leeds to Edinburgh, must, however, have been of British origin. That was especially true to the west of the Pennines and north of the Tees where the agriculture continued to be predominantly pastoral. Though many Britons may soon have acquired some English speech and customs, it is likely that most had remained Christian since they had spent little if any time under pagan English rule. They must certainly have had their own episcopal sees and monasteries, but for the most part we can only guess at their location. Traces of seventh-century annals kept in a northern British church under Northumbrian rule have been preserved in later Welsh sources, while stories of the 'men of the North' were kept alive through the interest of medieval Welsh bards and poets. But Bede restricted his *Ecclesiastical History* to the English people; he was not interested in preserving the church history of the Britons. Nor, we may presume, were English kings and nobles likely to endow British churches. As late as the 670s King Ecgfrith was granting to St Wilfrid's monastery at Ripon 'holy places' on both sides of the Pennines which had been deserted by their British clergy, 'fleeing from the hostile sword in the hand of our race'.

To judge from place names and from pagan cemeteries, Anglian settlement in Northumbria had been concentrated in eastern Yorkshire and in smaller areas of good arable land, mainly on the east coast and along the eastern river valleys as far north as the Lothians. It was in these areas too that the Northumbrians had their principal centres of royal power (such as Dunbar, Yeavering, Bamburgh, Catterick and Goodmanham), their episcopal sees (York, Lindisfarne, Hexham and Abercorn) and their greatest monasteries (Coldingham, Melrose, Lindisfarne, Hexham, Jarrow, Monkwearmouth, Hartlepool, Whitby, Lastingham and Gilling). Sometimes, as at Melrose, an Anglo-Saxon monastery may have been the direct successor of a British house. There was doubtless more contact between the British and English churches than Bede allows. Thus he says nothing of British claims that the baptism of Edwin was the work of Bishop Rhun, son of Urien, the British king of Rheged; nor does he identify the two British bishops who attended the consecration of Chad as bishop of the Northumbrians in 665. We must allow that a British hierarchy and British monasteries are likely to have lasted long into the seventh century in the western and

northern parts of the Northumbrian kingdom, but can only guess how quickly the deprivation of patronage and other political and military pressures led to their eventual anglicisation or decay.

If the British Church was in terminal decline in Northumbria in the seventh century, the future lay with the numerous new foundations of the Northumbrian kings and of their nobles. From about 650 until the mid eighth century, Northumbria was peopled with English monasteries. They provided the essential pastoral care for the rural population in their vicinity, they provided havens of education and communal prayer where the highly prized skills of the scribe and the illuminator were taught and practised, and they were also places where the family traditions of their founders and benefactors were preserved. Successive abbots or abbesses were drawn from the family of the founder. Monasteries also provided places to bury kinsmen and kinswomen in style and the community remembered their benefactors' anniversaries with prayers and masses. In such ways the monastery became a manifestation of aristocratic power in Northumbria, as it had elsewhere in the Christian West. It also became a showcase for noble wealth and piety.

Thus in the early ninth century a Northumbrian monk named Æthelwulf celebrated in Latin hexameters the history of his modest house or 'cell', which had been founded a century earlier by Eanmund, a king's thegn who had backed the wrong side in the power struggles of Osred's reign (705–16) and who had therefore opted for the safety of the monastic vocation. Among the early monks of the house whom Æthelwulf honoured was an Irish scribe, Ultan, whose skills with the pen were such that it was evident that 'the Lord had taken control of his fingers and had directed his mind to the heavens'. Ultan's work has not survived, but it serves to remind us that the whole of northern Britain and Ireland was a single cultural province in the late seventh and eighth century which shared in a remarkable flowering of Latin Christian learning and artistic achievement. The greatest gospel books illuminated at Lindisfarne – the Lindisfarne and the Echternach Gospels (80, 82) – display an astonishing fusion of Irish, Germanic and Mediterranean influences in their decoration, their scripts and their texts. A very similar fusion of styles is to be found in the Book of Durrow (Dublin, Trinity College, MS A.4.5 (57); Alexander 1978, no. 6), associated with one of the greatest of St Columba's foundations in Ireland, and this reminds us that as many English monks made their careers in Ireland as Irish monks in England. Sculptors likewise crossed political frontiers. Thus the greatest Northumbrian sculptures of the eighth century, such as the Ruthwell and Bewcastle crosses (fig. 11), combine Irish forms with Germanic interlace patterns and Mediterranean figural and vine-scroll traditions; they also have some inscriptions explaining scriptural scenes in Roman capitals, but Ruthwell's version of the English poem 'The Dream of the Rood' is carved in Anglo-Saxon runes.

Not all the Northumbrian houses sought this fusion of cultures. St Wilfrid, who had championed the successful Roman party at the Synod of Whitby (664) in the complex issues of the dating of the Easter festival against the Irish practices of Lindisfarne, sought to make his monasteries at Ripon and Hexham visible symbols of Roman style in their great stone buildings of fine ashlar construction, in the restrained quality of their classical sculptural ornament and in the regulation of the monastic life on Benedictine principles. A companion of Wilfrid on one of his journeys to Rome was the nobleman Benedict Biscop, who shared his enthusiasm for Roman and Mediterranean monastic culture. Biscop devoted his vast fortune to his monasteries at Monkwearmouth and Jarrow, bringing there from Gaul and Italy during repeated journeys stonemasons and glaziers, relics and books, not to mention the arch-chanter from St Peter's in Rome, so that his houses might set a standard in architecture, in learning and in their monastic liturgy that equalled or excelled anything to be found in Europe (105 a–d). The great library that Biscop established not only permitted the establishment of a scriptorium at Jarrow which perfected both the Italian uncial and the Irish minuscule scripts, but also provided the essential resource for the greatest English scholar of the early Middle Ages, the Venerable Bede. Bede, who spent almost his entire life from the age of seven until his death in 735 at Jarrow, was the great schoolmaster of England and of the continent. Generations of monks were trained not only on his *History*, his *Lives* of saints and his scientific and chronological textbooks, but above all on his scriptural commentaries. He had that supreme ability to wear his great learning lightly and to address the novice directly.

Bede, however, doubted the value of the religious life practised in many of the family monasteries that Northumbrian nobles and their wives had established, judging them to have been created in order to evade secular dues and military obligations rather than for the true service of God. He also feared that so much land had been tied up in these bogus houses that Northumbrian kings would lack the ability to attract and retain the services of sufficient aristocratic warriors to ensure the defence of the kingdom. He may not have been right to be worried. After the decisive defeat of King Ecgfrith by the Picts at the battle of Nechtansmere in 685, the northward expansion of the Northumbrians was indeed halted with the border established at the Forth in the east, but along a less settled line in Galloway and Ayrshire in the west. Though King Eadberht (738–57/8) made some gains in the west at the expense of the Britons of Strathclyde and though there were periodic conflicts with the Picts in the east, the fact was that neither the Northumbrians, the Britons, the Picts nor the Scots of Dalriada had the wealth or resources for any permanent extension of their territories. The wealth in land and treasure that each of these peoples devoted to their churches may have combined with the difficulties of communication to limit the size of kingdoms in northern Britain. Thus the Northumbrians turned in on themselves. Throughout the eighth century and for the first two-thirds of the ninth the principal preoccupations of Northumbrian princes and their military retainers were internal feuds and the struggle for the succession to the throne, not external wars of conquest. Murder, death in civil conflict, or abdication in order to adopt the monastic life were the normal fates of

Northumbrian kings in this period. But only when the pagan Viking raiders of the ninth century turned from extorting the wealth of Northumbrian churches to using that wealth to finance armies of conquest in the 870s did the Northumbrian state face a major external threat. Only then were Bede's fears for the defence of the kingdom and the standards of ecclesiastical life seen to be justified.

NICHOLAS BROOKS

Manuscripts

The manuscripts in this section fall into two categories: those which reflect the outstanding skills of the scribes and illuminators of the period and those containing copies of narrative sources which provide the historical background against which these skills were practised. A comparatively large number of illuminated books of spectacular quality has survived the centuries but it is important to bear in mind that the overall picture which they present is not necessarily an accurate or fully balanced one. What we see today is only what fate has seen fit to preserve.

The most elaborately decorated of the manuscripts are usually copies of the four Gospels, the text basic to the Christian faith and essential to the performance of its liturgy. A splendid copy of the Word of God, with richly illuminated pages and precious covers, could furthermore be used as a tangible symbol of the faith when paraded before a recently converted and largely illiterate congregation. Possession of such a book must therefore have been desirable to any major church or community. The manuscripts which have actually come down to us can be directly associated with only a very limited number of centres. Written sources provide information about one exceptionally grand gospel book that is now lost. Executed in gold on purple leaves and encased in a jewelled binding, it was given by Wilfrid to his church at Ripon and is described by his biographer (95) but whether it was made in England or imported by him from his continental journeys there is now no means of ascertaining. No contemporary books of any kind can now be associated with Ripon, nor with such other major religious houses as Hexham, Whitby, Melrose or Coldingham, though it is impossible to believe that they were not provided with them. It is furthermore unrealistic to believe that the skills of book production were confined to only one or two of the many possible centres.

The earliest of the surviving Northumbrian illuminated manuscripts, a fragmentary gospels (79), clearly reflects the Irish influence predominant in the area before the Synod of Whitby in 664. The Book of Durrow (Dublin, Trinity College, MS A.4.5 (57)) falls nearest to it in date and is of particular importance because it preserves a complete scheme of decoration. Elements borrowed from Germanic sources are incorporated and comparisons may be made with items from Sutton Hoo (14–17). The origins of the Book of Durrow are, however, still hotly debated between pro-Irish and pro-Northumbrian factions, with some scholars favouring Iona as a likely home.

Available manuscripts then reveal a flowering of book production around 700 in two major monastic communities, at Lindisfarne and at Monkwearmouth/Jarrow, each surviving group centred on a book of documented date and provenance. For Lindisfarne this book is the Lindisfarne Gospels (80), made no earlier than the death of St Cuthbert in 687, no later than the death of the artist-scribe Eadfrith in 721, and probably to be associated with the elevation of Cuthbert's relics in 698. Three further gospel books (81–3) can be linked to this manuscript, two of them attributed to another individual artist-scribe, known as the Durham–Echternach Calligrapher. To recognise two craftsmen of such stature within a single community at one time would be remarkable at any period of the Middle Ages. It is clear that several other very competent scribes worked alongside them. Within the group the Lindisfarne Gospels itself shows most evidence of being receptive to influence from outside the Insular area, its text depending upon a Neapolitan exemplar and some features of its decoration betraying similar Mediterranean models. The most likely source of such influences is the second great scriptorium of the period, that of Monkwearmouth/Jarrow.

The manuscripts of the Monkwearmouth/Jarrow scriptorium are identified through their relationship to the Codex Amiatinus (88). Numerous books were imported for the use of the community from Italy by the founder, Benedict Biscop, and his friend and successor, Ceolfrid. These included material of exceptional importance from the monastery of Cassiodorus at Vivarium. The local scribes so closely emulated the skills of their Italian models that their work was long regarded as being itself imported Italian work or, more recently, as the work of immigrant Italian scribes. However, the Codex Amiatinus and its fragmentary sister manuscript, the Ceolfrid Bible (87), are now accepted beyond doubt as identical with two of the three great bibles commissioned by Ceolfrid (d. 716) and described both by Bede and by Ceolfrid's anonymous biographer (94). The work of this scriptorium was not wholly confined to manuscripts in the Italian tradition. The earliest copies of the works of Bede, himself a monk of the community at Jarrow, must have been produced there and include the two beautiful and closely related Insular copies of the *Ecclesiastical History* now in Leningrad (Public Library, Cod. Q.V.I.18) and in the British Library (92). The former contains the earliest known historiated initial in an English book, portraying Pope Gregory the Great.

The strength of the majority of Insular illuminated manuscripts lies in their varied and exuberant decorative pages and initials. Figural representation is largely confined to evangelist portraits and narrative schemes are conspicuously absent. This may not originally have been so. Two Carolingian manuscripts containing narrative cycles, an apocalypse in Valenciennes (Bibliothèque Municipale, MS 99) and a Sedulius in Antwerp (Museum Plantin-Moretus, MS M.17.4), have been thought to depend upon Insular, probably Northumbrian, models. An apocalypse cycle is known to have been available to Northumbrian artists in the shape of pictures brought from Rome by Benedict Biscop to adorn the north wall of the church at Monkwearmouth.

To the written narrative sources we owe much incidental information about the arts, including the existence of Benedict Biscop's apocalypse pictures. The Lives of the English saints of this period are among the earliest European biographies and are remarkable for their detail and their immediacy. Overall the principal written source is, of course, Bede's *Ecclesiastical History*, which for this period includes much information drawn from his personal observation and experience. In this area, as in the production of illuminated books, both Lindisfarne and Monkwearmouth/Jarrow play a leading role, providing both patrons and authors to stimulate the writing down of contemporary history.

JANET BACKHOUSE

79 Gospels

Durham, Cathedral Library, MS A.II.10
Vellum; ff. 12; 385 × 250 mm
Latin; mid 7th century
Northumbria

Only a dozen leaves of this earliest recognisable Insular gospel book are extant, redeployed in subsequent centuries as flyleaves in later manuscripts. The most important of the fragments is shown, including a decorative frame enclosing the *explicit* of Matthew, the *incipit* of Mark, and the Lord's Prayer in Greek transliterated into Latin letters. The only other surviving decoration in the manuscript is an initial to John.

This fragment is the first witness to the sequence of decorated gospels in England during the late seventh and the eighth centuries, which reached a pinnacle of achievement at Lindisfarne about 700. There is nothing to link this manuscript with a particular scriptorium, but the script itself is strongly Irish in character. The volume was very probably made before the Synod of Whitby in 664, while Irish influence in the region predominated. If the scribe was not Irish by birth, he must have been trained in the Irish tradition. The decoration marks an important advance in that it is the first such work from an English centre to display interlace patterns and to be executed in several colours. Yellow, orange, green and blue pigments appear in the manuscript. JMB

Bibliography: CLA ii, no. 147; McGurk 1961, no. 9; Alexander 1978, no. 5; Henderson 1987, 27–9, 58–9; Verey 1989, 145–6.

80 The Lindisfarne Gospels

British Library, Cotton MS Nero D. iv
Vellum; ff. 258; 340 × 240 mm
Latin, with a later Old English gloss; *c*.698
Lindisfarne

The Lindisfarne Gospels is of supreme importance to all students of the arts in early Anglo–Saxon England. By any standards an outstanding masterpiece of early medieval book painting, it is one of the few early gospel books to have survived complete, its decorative scheme fully available for

assessment and comparisons. It is furthermore both localised and dated by a colophon which, although not added to the book until the middle of the tenth century, some 250 years after the production of the manuscript, is generally accepted as recording information much earlier in date. This may have been passed down either by oral tradition or by means of some inscription on the outer covering of the volume, now lost to us. The manuscript thus provides a touchstone for all other decorative work of the period.

The colophon tells us that the manuscript was written in honour of God and of St Cuthbert, and gives the names of four craftsmen involved. The scribe was Eadfrith, who became bishop of Lindisfarne in 698, the book was bound by Æthilwald, who succeeded him in 721, and ornaments of gems and precious metals were applied to the outside by Billfrith the Anchorite, probably later in the eighth century. The fourth contributor was Aldred, priest and later provost of Chester-le-Street, who added an interlinear translation of the Latin text into Old English (the earliest surviving translation of the Gospels into any form of the English language) and also provided the colophon itself.

The Lindisfarne Gospels is written in two columns in a stately Insular half-uncial script which may be regarded as typical of the Lindisfarne scriptorium. The text is a very pure form of the Vulgate. Gospel lections include provision for Neapolitan feasts, which suggests that the exemplar came from southern Italy, probably via Monkwearmouth/Jarrow. Each of the four Gospels opens with a miniature of the appropriate evangelist accompanied by his symbol, a decorative carpet page, and a major initial followed by lines of decorated capitals. An additional initial page occurs in Matthew at the beginning of the Christmas Gospel, and a carpet page and an initial precede the letter of St Jerome to Pope Damasus at the beginning of the manuscript. Smaller decorated initials punctuate the prefatory matter before each Gospel, and there are sixteen pages of canon table arcades. No expense was spared in the creation of the manuscript. Vellum and ink are of the finest quality. About forty different pigments have been identified, ranging from vegetable dyes available locally to lapis lazuli which must have been transported from the Himalayas. However, there are only tiny patches of gold and their use seems to have been experimental.

The evangelist miniatures are clearly based on Mediterranean models, probably absorbed from books imported from Italy to Monkwearmouth/Jarrow. The figure of Matthew is indeed recognisably derived from the same model as that of Ezra in the Codex Amiatinus (88). The purely decorative pages and initials are, however, entirely Insular in character, blending linear interlace, frets and spiral patterns with animal and bird ornament in a fashion reminiscent of contemporary metalwork. Modern study has revealed that Eadfrith was responsible for the entire production of the manuscript, both text and decoration, apart from a very few minor details. The book must therefore have been completed before his death in 721. It seems most likely that it was in fact made in time to honour the elevation of St Cuthbert's relics in March 698. The manuscript gives every impression

79 Decorated *explicit* and *incipit*, incorporating the Lord's Prayer (f. 3b)

80 Carpet page introducing St John's Gospel (f. 210b)

of having been created in one continuous process, without the interruptions which would surely have been a consequence of Eadfrith's elevation to the bishopric later in that year. His skills can be seen to develop, from the relatively simple decoration of the introductory pages to Jerome's letter, to the immensely complex patterns of the illuminated pages at the beginning of John.

The history of the manuscript can be traced almost without interruption from the time of its production to the present day. As one of the treasures associated with St Cuthbert's shrine, the book shared the travels of the saint's relics in the later Anglo-Saxon period and was thereafter one of the proudest treasures of Durham Cathedral until the Reformation. It was acquired by Sir Robert Cotton some time during the later sixteenth century, passing with his library into the care of the newly-founded British Museum in 1753.

JMB

Bibliography: CLA ii, no. 187; McGurk 1961, no. 22; Alexander 1978, no. 9; Kendrick et al. 1956 and 1960; Backhouse 1981; Henderson 1987, 99–122.

81 The Durham Gospels

Durham, Cathedral Library, MS A.II.17
Vellum; ff. 108; 345 × 265 mm
Latin; late 7th or early 8th century
Lindisfarne

Originally at least as grand in scale and decoration as the Lindisfarne Gospels, the Durham Gospels survives in a severely damaged state, bound out of order and minus all but two of its major illuminated pages. At least as early as the tenth century it was bound together with a totally unrelated fragment of Luke written in the uncial script associated with the scriptorium of Monkwearmouth/Jarrow. Both parts of the volume have marginal annotations added at Chester-le-Street where the community of St Cuthbert was settled between 883 and 995. The link with the relics of the saint, the strong stylistic relationship between the Durham and Lindisfarne Gospels, and the apparent identity of a scribe making corrections to both books all point to Lindisfarne as the most likely source of the manuscript. The Echternach Gospels (82) has been attributed to the same anonymous craftsman, now known as the Durham–Echternach Calligrapher. He was clearly a contemporary of Eadfrith, creator of the Lindisfarne Gospels, and it has been suggested that he was his master.

Of the major decorated pages which the Durham Gospels once contained, only the main initial to John remains. Its decoration features animal interlace and, within some of the roundels, the heads of birds very like those in Lindisfarne. Each Gospel must originally have had a similar initial, plus an evangelist portrait or symbol or a carpet page. There were probably also decorated canon tables. The artist's small decorated initials, also featuring birds, are exemplified at the beginning of the capitula to Mark and also at the glossary of Hebrew names on the same page. The manuscript further

contains a much-worn full-page miniature of the Crucifixion. This is placed at the end of Luke, implying that other narrative illustrations may have ended the other three Gospels. The crucified Christ is flanked by seraphim and by the figures of Longinus and Stephaton.

JMB

Bibliography: CLA ii, no. 149; McGurk 1961, no. 13; Alexander 1978, no. 10; Verey et al. 1980; Bruce-Mitford 1989, 175–88; Henderson 1987, 57–72.

82 The Echternach Gospels (photographs)

Paris, Bibliothèque Nationale, MS lat. 9389
Vellum; ff. 223; 335 × 255 mm
Latin; late 7th or early 8th century
Lindisfarne

The Echternach Gospels is attributed to the Lindisfarne scriptorium at the very end of the seventh century or during the opening years of the eighth. Although the two books are superficially very different in appearance, it has been identified as the work of the same anonymous craftsman as the Durham Gospels, the so-called Durham–Echternach Calligrapher, though some scholars remain doubtful of the attribution.

The Echternach manuscript is far simpler in concept than either the Durham Gospels (81) or the Lindisfarne Gospels (80). Its text, like that used by Eadfrith, seems to depend upon a south Italian exemplar and, also like the Lindisfarne Gospels, it is arranged in two columns. It is written out mainly in a cursive minuscule script which could have been executed with considerably more rapidity than the formal half-uncial of the other two manuscripts. The decoration, carried out in a restricted range of pigments (yellow, two shades of orange and a little purple), is comparatively simple. Each Gospel is preceded by a full-page miniature of the appropriate evangelist symbol, set off by framing lines suggesting the form of a cross but otherwise against a ground of unpainted vellum. The first page of each Gospel begins with a decorated initial, small in comparison with those in the more ambitious books but none the less exquisitely ornamented with linear interlace and spiral patterns, though animal and bird ornament is conspicuously lacking. The canon tables are contained within plain rectangular frames.

From a very early date the book belonged to Willibrord's foundation at Echternach, in what is now the Grand Duchy of Luxembourg. Reflections of its decoration can be recognised in later work of the local scriptorium. It has been quite reasonably suggested that it was in fact made as a gift from Lindisfarne to Echternach at the time of the latter's foundation in 698, the same year in which the relics of St Cuthbert were raised to the altar. Connections between the two monasteries can be found but none is sufficiently strong to make this suggestion a certainty.

JMB

Bibliography: CLA v, no. 578; McGurk 1961, no. 59; Alexander 1978, no. 11; Henderson 1987, 71–9; Avril and Stirnemann 1987, no. 1; Bruce-Mitford 1989, 175–88; Netzer 1989, 203–12; Rabel and Palazzo 1989, 1–3.

81 Miniature of the Crucifixion (f. 38^3b)

82 Decorated opening of St Matthew's Gospel (f. 20)

83 (a–c) The Otho–Corpus Gospels

83 (a) British Library, Cotton MS Otho C. V

Vellum; 64 mounted fragments representing approximately ff. 110
Latin; late 7th or early 8th century
Lindisfarne

83 (b) Cambridge, Corpus Christi College, MS 197B

Vellum; ff. 36; 285 × 215 mm
Latin; late 7th or early 8th century
Lindisfarne

These two fragments, the London portion tragically reduced
to cinders in the Ashburnham House fire of 1731, represent
what was once another major gospels from the Lindisfarne
scriptorium in its greatest period. Its present damaged state
has denied this book the degree of attention enjoyed by other
manuscripts of the same date and provenance. In its original
form the book included a miniature of the appropriate evan-
gelist symbol and a major initial page at the beginning of
each Gospel. Two of the symbols, the eagle of St John

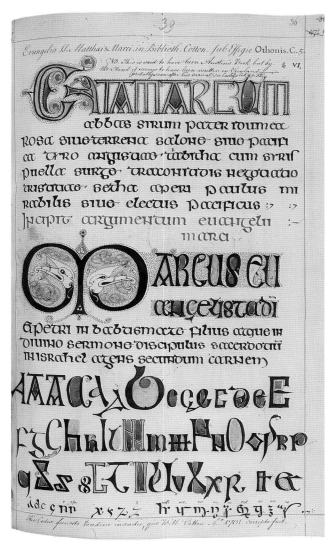

83c Eighteenth-century facsimile of a decorated page (f. 36)

83a The lion symbol of St Mark (f. 27)

(Cambridge) and the lion of St Mark (London), survive,
though the latter is very badly burned. Similarly the initial
pages to the same two Gospels may still be seen. The exist-
ence of St Matthew's man in the London fragment is recorded
in a seventeenth-century description, but this has entirely
vanished. Minor decoration was originally provided to intro-
duce lesser features such as the prefaces and the glossary of
Hebrew names, and traces of this are still visible in the
London section. Faint offsets from a set of decorated canon
tables, detectable on ff. 2 and 3 of BL, Royal MS 7 C.xii, are
thought to relate to this manuscript. The complete scheme
of decoration was therefore quite ambitious, exceeding that
of the Echternach Gospels (82) though falling far below the
Lindisfarne (80) and Durham (81) Gospels. The range of
pigments used was, however, very limited.

The surviving evangelist symbols are closely related in

83b The eagle symbol of St John (f. 1)

design and concept to those in the Echternach manuscript, though the symbols themselves, especially the eagle, are portrayed with more power and savagery. The surviving large initials have been compared to the major initial page surviving in the Durham Gospels. An analysis of the script, particularly that of the scribe mainly responsible for the London fragment, has revealed a very close dependence upon the script of Eadfrith in the Lindisfarne Gospels. Attribution to the Lindisfarne scriptorium thus seems assured.

A tradition at least as early as the seventeenth century acknowledged the great antiquity of this manuscript by claiming that it had originally belonged to St Augustine. While this cannot be true, it may well have been at St Augustine's, Canterbury from a very early date. Close contact between Canterbury and Northumbria was fostered in the time of Abbot Hadrian (d. 708) and his disciple Albinus, the friend of Bede. The Cambridge fragment formed part of the bequest of Archbishop Matthew Parker, who died in 1575.

83 (c) British Library, Stowe MS 1061

Vellum and paper; ff. 152; 375 × 240 mm
18th century

One complete decorated page copied from Cotton MS Otho C. v before it was damaged by fire is included in this collection of hand-painted facsimiles of early manuscripts, bound up together at the end of the eighteenth century. The material was collected by Thomas Astle for his pioneering book *The Origin and Progress of Writing*, published in 1784. Only part of the original page is now to be seen and both the principal decorated initials reproduced in the facsimile are missing from it. The copy is thus our only source for the design of these initials, the second of which, the initial M for the preface to Mark, is strikingly similar to the equivalent initial in the Durham Gospels, strengthening the connection between the two manuscripts.

A footnote in Astle's publication states that the copy was made at the expense of Edward, Earl of Oxford. Several professional copyists, including Elizabeth Elstob and Philip Sproson, are known to have worked for Edward Harley and his librarian, Humfrey Wanley, but it has not yet proved possible to identify with certainty the hand responsible in this case. JMB

Bibliography: CLA ii, no. 125; McGurk 1961, no. 2; Alexander 1978, no. 12; Henderson 1987, ch. 3; Brown 1989, 151–63, 158; Backhouse 1989, 169–73.

84 Gospels

British Library, Royal MS I B.vii
Vellum; ff. 155; 275 × 215 mm
Latin; first half of 8th century
Northumbria

Written and illuminated in Northumbria in the first half of the eighth century, and apparently depending for its text upon the same, possibly sixth-century, exemplar as the Lindisfarne Gospels, whose tables of lections including Neapolitan feasts it shares, this manuscript represents the less elaborate type of gospel book of the period. Its decoration is confined to simple canon table arcades, a decorated initial for each separate Gospel, and smaller initials for prefaces and chapter lists. Only three colours, yellow, orange and green, are employed. All the decorative elements are very simple, sometimes almost crude, though the sequence of tiny human profiles on the canon arcades is noteworthy.

A manuscript of the Gospels was a vital liturgical accessory for any churchman or community of the period. The proliferation of bishoprics and monasteries in the late seventh and early eighth centuries must have necessitated the creation of numerous gospel books of modest artistic status, of which this is a rare survivor. Nothing is known of either its place of origin or its early history. It was certainly in use at the beginning of the tenth century, for it contains the record of a manumission by King Athelstan, added about 925. JMB

Bibliography: CLA ii, no. 213; McGurk 1961, no. 28; Alexander 1978, no. 20.

85 The Vatican Paulinus

Rome, Biblioteca Apostolica Vaticana, Pal. lat. 235
Vellum; ff. 67; 300 × 225 mm
Latin; early 8th century
Northumbria, ?Lindisfarne

This copy of the *Carmina* (poems) of Paulinus of Nola (a late antique Christian poet from Campania, near Naples) occupies ff. 4–29v of a manuscript largely composed of tenth-century and later material, some of which was from S. Maria in Huisborch, Saxony. Another near-contemporary copy of this popular text, probably produced in the same scriptorium, is now in Leningrad (Public Library, Cod. Q.V.XIV.i). The Vatican manuscript was intended for use in the schoolroom and contains scratched syntax marks demonstrating its near-contemporary use as a teaching aid. A single Old English gloss shows that the teacher was English, although there are some indications that the book went to Germany, perhaps Fulda, later in the eighth century. A study of the text reveals that six of Paulinus's poems had already been the subject of school use in Campania, and a chain of study can be shown to have been transmitted from late antiquity, through Northumbria, to post-Alfredian England. The abridged version of Paulinus's poems may well have been introduced to England by Benedict Biscop, the founder of Monkwearmouth and Jarrow, during the late seventh century. Bede, a

86 The binding of the St Cuthbert Gospel of St John

resident of Jarrow, was certainly fond of quoting from the work.

The text was copied by five scribes, two of whom were inexperienced and responsible for very little of the work, perhaps implying that they were 'learners'. The cursive minuscule script and decoration of the manuscript suggest an origin in Bernicia (the northern part of Northumbria) during the early eighth century, with particularly close similarities to the products of the Lindisfarne scriptorium. That so many scribes should have been involved in producing a schoolbook is particularly interesting as the luxury gospel books produced at Lindisfarne (80–2) tend to be by single artist-scribes. This may imply that a special, individual devotional act was envisaged when producing a major cult object, which fell outside the general working practices of the scriptorium.

MPB

Bibliography: Migne 1847; *CLA* i, no. 87; Alexander 1978, no. 65; Brown and Mackay 1988.

86 The St Cuthbert Gospel of St John

The English Province of the Society of Jesus, on loan to the British Library (Loan MS 74)
Vellum; ff. 90; 135 × 90 mm (the covers 2–3 mm larger in each dimension)
Latin; *c.*698
Monkwearmouth/Jarrow

This beautiful little book was found, encased in a red leather satchel, inside St Cuthbert's coffin at the time of the translation of his relics to their final resting place behind the high altar in the newly-built sanctuary of Durham Cathedral in 1104. It contains the Gospel of St John, written in an Insular uncial hand attributable to the scriptorium of Monkwearmouth/Jarrow at the end of the seventh century. It may therefore have been a gift from Ceolfrid's community to their neighbours at Lindisfarne on the occasion of the original translation of Cuthbert's body from the tomb to the altar in 698. It is interesting to note that readings for the mass of the dead were marked into the manuscript, apparently in some haste as the ink was not allowed to dry before the pages were turned, by a minuscule hand which appears little later than that of the original scribe. This suggests that the book may have been used liturgically at the last mass said for Cuthbert's soul before his formal elevation to sainthood.

The binding of the manuscript is original and is the earliest surviving European binding still attached to the book for which it was originally made. It is of red goatskin over birchwood boards, ornamented with tooled lines filled with yellow and blue (now discoloured to black) pigment. The plant motif on the upper cover seems to have been moulded over cord or leather. The nearest recognisable parallels are of Coptic origin, but this binding is such a rare survival that all comparisons must be treated with caution. JMB

Bibliography: *CLA* ii, no. 260; McGurk 1961, no. 37; Brown 1969.

84 (*Left above*) Canon tables and the opening of St Matthew's Gospel (ff. 14b–15)

85 (*Left below*) Examples of the work of several scribes (ff. 7b–8)

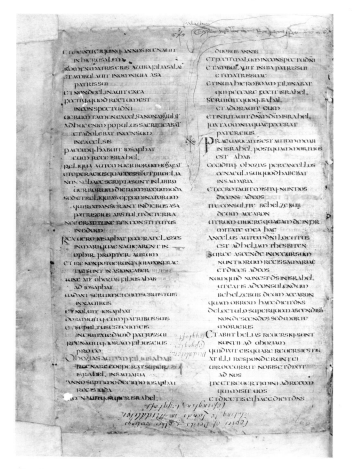

87a One page from the Middleton Leaves (f. 2b)

87 (a–c) The Ceolfrid Bible

87 (a) The Middleton Leaves

British Library, Additional MS 45025
Vellum; ff. 11; 480 × 340 mm maximum dimensions
Latin; before 716
Monkwearmouth/Jarrow

87 (b) The Bankes Leaf

The National Trust, Kingston Lacy, Dorset (on loan to the British Library, Loan MS 81)
Vellum; f. 1; 420 × 335 mm maximum dimensions
Latin; before 716
Monkwearmouth/Jarrow

During the abbacy of Ceolfrid (d. 716) a substantial and highly proficient scriptorium developed within the Monkwearmouth/Jarrow community. Both Bede in his *Lives of the Abbots* and Ceolfrid's own anonymous biographer (**94**) make special mention of three huge single-volume Latin Vulgate bibles, or 'pandects', which Ceolfrid commissioned

from his scribes to supplement the single-volume copy of the Old Translation which he had brought back with him from his journey with Benedict Biscop to Italy in 678. This earlier Bible is identifiable as the sixth-century Codex Grandior acquired from the monastery of Cassiodorus at Vivarium in Calabria. Until late in the nineteenth century it was believed that no trace of Ceolfrid's pandects had survived, but in 1886 one complete example was recognised in the form of the Codex Amiatinus in the Laurentian Library in Florence (**88**). Very shortly afterwards Canon Greenwell of Durham purchased from a Newcastle antique shop a single leaf of a similar volume, cut from the Old Testament Third Book of Kings, which had been used at a later date as a book wrapper. This he presented to the British Museum in 1909 (Additional MS 37777).

The Middleton Leaves, comprising ten full folios and fragments from an eleventh, all from the Third and Fourth Books of Kings, came to light in the archives of Lord Middleton at Wollaton Hall in Notts., and were published by the Historical Manuscripts Commission in 1911. Like the Greenwell Leaf, they had been used as book wrappers or flyleaves, and were associated with estate records compiled about the middle of the sixteenth century. They passed into the care of the British Museum in 1939.

More recently a single leaf was discovered among estate papers at Kingston Lacy, the Bankes family home in Dorset,

87b The Bankes Leaf (verso)

newly acquired by the National Trust in 1982. This leaf enclosed deeds relating to property at Langton Wallis in the Isle of Purbeck, sold by Sir Francis Willoughby of Wollaton to Sir Christopher Hatton in 1585. Its text, from the Old Testament Apocryphal Book of Ecclesiasticus, occurs considerably later in the bible than the texts found on the other leaves, which suggests that material from the manuscript was being used up in the Wollaton estate office over a substantial period of time.

All the fragments which have come to light over the last century are clearly from just one of the two bibles which were originally placed in the churches at Monkwearmouth and at Jarrow. Comparison with equivalent leaves in the Codex Amiatinus shows a very precise agreement in text and design, though the scribes are not actually identical. Both books are written in an uncial script so handsome and fluent that for many decades after the identity of the Codex Amiatinus had been established it was held that Ceolfrid's bibles must have been written by immigrant Italian scribes working in Northumbria. In fact the script was perfected at Monkwearmouth/Jarrow following examples drawn from earlier books imported from Italy by Ceolfrid and Benedict Biscop. JMB

Bibliography: CLA ii, no. 177; Bischoff and Brown 1985, 351–2.

87 (c) Fragments from a late 11th-century Worcester cartulary

British Library, Additional MS 46204
Vellum; ff. 1 + 2 fragments; 475 × 290 mm (trimmed)
Latin; second half of 11th century
Worcester

A second discovery at Wollaton Hall, also published by the Historical Manuscripts Commission in 1911, may shed light on the later history of the Ceolfrid Bible. Among further fragments of early manuscript utilised in the sixteenth century as wrappers for estate documents were pieces of an eleventh-century Worcester cartulary found associated with a 'colpyt booke' of 1548. Four similar and closely related leaves are now in the Cotton collection (MS Nero E. i, pt. 2, ff. 181–4). The unusually large format of these fragments is very close to that of the Ceolfrid fragments and it is known from a reference in Hemmings Cartulary (Cotton MS Tiberius A. xii) that St Wulfstan, bishop and prior of Worcester in the late eleventh century, ordered copies of important Worcester charters to be inserted into the bible of his church. It was not at all unusual in the late Anglo-Saxon period for copies of important documents to be written on to the flyleaves of gospel books for preservation in association with the furnishings of the altar. There was a tradition at Worcester over several centuries that an ancient bible there, regarded as a special treasure, had been presented to the church by King Offa, although the first reference to it occurs in the context of a charter now believed to be spurious. It seems possible that one of the two Ceolfrid bibles may have been transferred to Worcester through Offa rather less than a century after Ceolfrid's time and that this venerable book, regarded as a

87c Fragments from a Worcester Cartulary (verso)

suitable repository for the records of the house in Wulfstan's time, came into the hands of the Willoughby family when Worcester was dissolved in January 1540. JMB

Bibliography: Atkins and Ker 1944, 77–9.

88 Codex Amiatinus (photographs)

Florence, Biblioteca Medicea Laurenziana, MS Amiatinus 1
Vellum; ff. 1030; 505 × 340 mm
Latin; before 716
Monkwearmouth/Jarrow

Of the three great bibles made at Monkwearmouth/Jarrow in the time of Abbot Ceolfrid, one has survived intact. It is identified by a dedication inscription on f. Iv, partly erased and rewritten in Italy in the ninth or tenth century but recognised in 1886 as corresponding to the wording reported in the anonymous Life of Ceolfrid (94). The manuscript was taken by Ceolfrid when he left Northumbria in 716 on a final journey to Rome. He had intended it as a gift to the Pope, but his death in France seems to have resulted in its deflection from Rome. During the Middle Ages it was at the monastery of Monte Amiata in central Italy, where it was known and

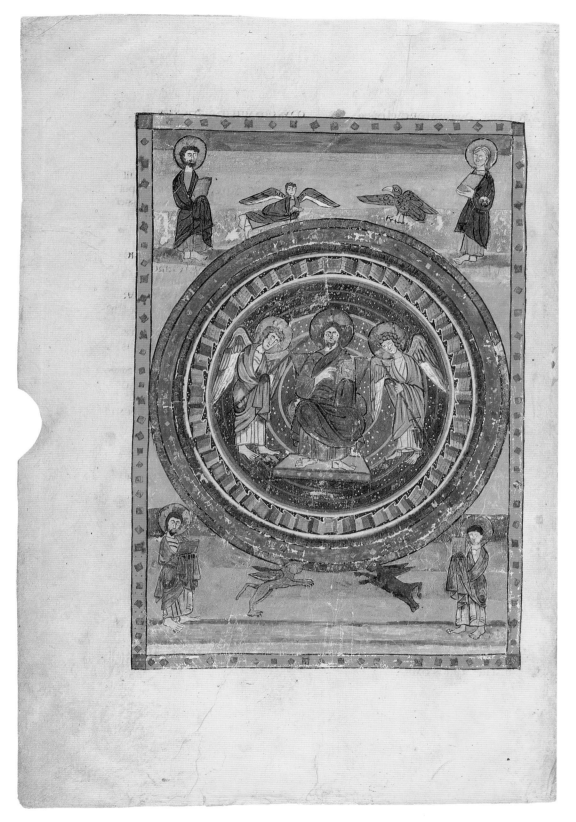

88 Christ in Majesty (f. 796b)

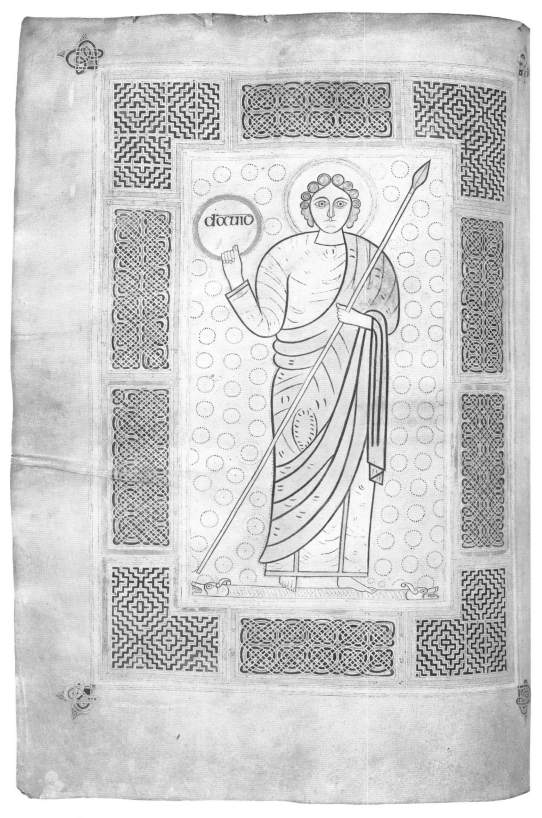

89 King David as a warrior (f. 172b)

90 (*Left*) Carpet page introducing St Luke's Gospel (p. 220); (*right*) decorated opening of St Luke's Gospel (p. 221)

admired for the purity of its Vulgate text. It entered the collections of the Laurenziana when the monastery was suppressed at the end of the eighteenth century.

This enormous and immensely heavy book includes a series of illustrations based on models brought to Northumbria from the Cassiodoran monastery at Vivarium in Calabria. Both in content and in style they emulate sixth-century originals, demonstrating the means whereby late antique material found its way into Northumbrian book painting. Particularly striking is the exact parallel between the portrait of Ezra in the Codex Amiatinus and the portrait of St Matthew in the Lindisfarne Gospels (80), proving that the monks of Lindisfarne must have had access to models in the monastery of their neighbours in Monkwearmouth and Jarrow. JMB

Bibliography: CLA ii, no. 299; Alexander 1978, no. 7.

89 Cassiodorus, Commentary on the Psalms

Durham, Cathedral Library, MS B.II.30
Vellum; ff. 266; 420 × 295 mm
Latin; second quarter of 8th century
Northumbria

The original design of this manuscript included three whole-page miniatures marking the threefold division of the psalter. This is an early example of a practice which was later to be widely accepted. Two of the miniatures, placed before Psalms 51 and 101 respectively, have survived, but the one with which the volume originally opened is missing. The first shows David enthroned as a king and playing his harp. In the second he appears as a warrior with a spear, trampling upon a serpent. Each is surrounded by a frame composed of panels containing interlace, fret and animal ornament. Circular motifs made up of coloured dots fill all or part of each background. Orange, yellow, green and mauve pigments were used, but all are now quite badly faded.

The manuscript is unusually large in format, approximating in size to the Ceolfrid bibles (87, 88), though Cassiodorus's text has been abbreviated to fit into a single volume rather than into three. The script, a handsome Northumbrian

majuscule, may be compared to that of an imperfect copy of Luke and John, now mainly in Cambridge (*CLA* ii, no. 138), and to the majuscule portion of a copy of the Sapiential Books in the British Library (*CLA* ii, no. 194b). The antiquity of the manuscript was acknowledged in the fourteenth century, when it was among volumes to which a Durham hand added the words 'de manu Bedae'. While this claim cannot be supported, the book may well have been produced during or very soon after Bede's lifetime. The identity of the scriptorium is unknown but it is possible that the exemplar behind the manuscript came from Monkwearmouth/Jarrow and that it had been brought to England from Cassiodorus's own monastery of Vivarium, the source of a number of the books acquired for that community. JMB

Bibliography: CLA ii, no. 152; Alexander 1978, no. 17.

90 The Lichfield Gospels (Gospels of St Chad)

Lichfield Cathedral, s.n.
Vellum; pp. 236; 310 × 235 mm
Latin; second quarter of 8th century

The Lichfield Gospels has suffered severely from the ravages of time but its decorative scheme was originally an ambitious one and the quality of the surviving illuminated pages is very fine. Only Luke now retains its complete original sequence of decoration, comprising an evangelist portrait with symbol, opposite a page of all four symbols, followed by a carpet page opposite a grand introductory initial. Most of the text of Luke is lost, together with the whole of John, and the decoration of the first two Gospels is represented only by initial pages and the portrait of Mark. Any canon tables that there may have been have also vanished.

The surviving carpet page and the initials, particularly the 'Xpi' in Matthew, bear a marked resemblance to the equivalent pages in the Lindisfarne Gospels (80) and it is hard to believe that their artist had never seen the earlier book. His animal ornament is, however, rather more exaggerated than that of Eadfrith and his insistence upon a uniformity of scale for the decorative letters following the great initials has resulted in a much heavier overall feeling. The evangelist figures were probably derived from late antique models, but at some distance, and may be compared both with the figure of the Matthew symbol in the Echternach Gospels (82) and with work in manuscripts from specifically Irish backgrounds, such as the St Gall Gospels (St Gall, Stiftsbibliothek, Cod. 51). The colouring of the illumination in this manuscript, which is largely purple and mauve, with occasional touches of blue, yellow, orange and brown, is most unusual and distinctive.

No original connection with St Chad, patron of Lichfield (d. 672), is possible. The manuscript reached the town from which it takes its name during the tenth century, perhaps during the reign of Athelstan. Before that it was in Wales where, according to an added note in Latin, early in the ninth century Gelhi, son of Arihtiud, gave his best horse in exchange for it and offered it to God at the altar of St Teilo,

presumably at Llandeilofawr in Carmarthenshire. Nothing at all is recorded of its date or place of origin and numerous theories have been put forward. A date in the second quarter of the eighth century seems most likely in view of its resemblance to the Lindisfarne Gospels. JMB

Bibliography: CLA ii, no. 159; McGurk 1961, no. 16; Alexander 1978, no. 21; Brown 1982; Henderson 1987, 122–9.

91 The Hereford Gospels

Hereford, Cathedral Library, MS P.1.2
Vellum; ff. 135; 230 × 170 mm
Latin; late 8th century
West Midlands or Wales

Hereford Cathedral's early gospels is among the least known of the Insular illuminated manuscripts. It was never as ambitiously ornamented a book as the great Northumbrian codices, with its decoration confined to a series of great initial pages. Three of these survive, introducing Matthew, Mark and John. Pages are missing where the 'Xpi' initial in

91· Decorated opening of St John's Gospel (f. 102)

Matthew and the opening of Luke once appeared. The colouring is restricted to yellow and orange, and the decorative detail is comparatively simple, consisting of interlace, fret and spiral patterns, with animal-head and leg terminals to major portions of the Matthew and John initials. In general appearance these initials are, however, closely akin to similar initials in the more elaborate books.

The script of this manuscript is an Insular majuscule apparently developed under Celtic influence. It has been suggested in the light of its later history that the book originated in the Welsh border area late in the eighth century. That it had reached Hereford before the Conquest is clear from the addition of two documents in Anglo-Saxon on blank leaves at the end of the volume, one of them recording a land transaction. The *ex libris* of Hereford Cathedral was entered into it in the fifteenth century. JMB

Bibliography: CLA ii, no. 157; McGurk 1961, no. 15; Alexander 1978, no. 38.

92 Bede's *Ecclesiastical History of the English People*

British Library, Cotton MS Tiberius A. xiv
Vellum; ff. 201; approx. 245 × 175 mm
Latin; mid 8th century
Monkwearmouth/Jarrow

To Bede's *History* we are indebted for much of our basic knowledge about the development of the Northumbrian Church during the seventh and early eighth centuries. The value of his work, completed in 731, was quickly appreciated by his contemporaries and manuscripts of it were soon in circulation, both in England and on the continent of Europe. Of surviving eighth-century copies, two closely-related examples were certainly produced in the scriptorium of Bede's own community, Monkwearmouth/Jarrow. The earlier and finer of these, now in the Leningrad Public Library, has been dated *c.*746 and includes what may claim

92 (*Left*) Bede's account of the miracles of St Oswald (f. 84)

93 (*Right*) Bede's account of the translation of St Cuthbert's relics (ff. 77b–78)

to be the earliest English historiated initial, a letter H at the beginning of Book II enclosing a bust of Gregory the Great.

The exhibited manuscript is thought to have been copied from the Leningrad volume and its elegantly restrained initials, ornamented with bands of colour, are very similar to the lesser initials in the earlier book. The uncial lettering employed for headings here links it closely to the tradition of the Ceolfrid bibles (87, 88), but at the same time it provides a superb example of the Monkwearmouth/Jarrow facility with an Insular minuscule script. It suffered severe damage from the Ashburnham House fire of 1731, which has diminished its value to editors. JMB

Bibliography: CLA (supplement), no. 1703.

93 Bede's Lives of St Cuthbert

British Library, Cotton MS Vitellius A. xix
Vellum; ff. 114; 220 × 130 mm
Latin; 10th century
Canterbury

Bede wrote two Lives of St Cuthbert. The first, in Latin verse, was composed before 705, the second, in Latin prose, by 721. In writing the prose Life we know that he made use of material from an earlier Life by an anonymous monk of Lindisfarne (which has the distinction of being the earliest biography written in England) and also gathered independent information from people who had known the saint personally. A draft of the Life was submitted to two days of scrutiny by the Lindisfarne community before it was finally approved for circulation. All three Lives are addressed to Bishop Eadfrith, creator of the Lindisfarne Gospels (80), who was the prime mover in the promotion of Cuthbert's cult. Bede's Life is

twice as long as that of his anonymous predecessor and provides greatly expanded accounts of some episodes. In particular he gives a very detailed description of Cuthbert's final days, using the words of his friend Herefrith who had been abbot of Lindisfarne at the time.

This manuscript dates from the middle of the tenth century and is attributed to St Augustine's at Canterbury. It is among the earliest of almost forty surviving copies of the Prose Life and also contains the Verse Life. JMB

Bibliography: Colgrave 1940; Temple, 1976, no. 19 (ii).

94 Anonymous Life of Ceolfrid

British Library, Harley MS 3020
Vellum; ff. 132; 225 × 130 mm
Latin; 10th century

Ceolfrid was, like St Cuthbert, the subject of two prose biographies. The exhibited Life is the work of an anonymous member of the Monkwearmouth/Jarrow community, writing soon after Ceolfrid's departure for Rome and subsequent death in 716. A second version, drawing upon this material, was produced by the Venerable Bede for inclusion in his *History of the Abbots of Wearmouth and Jarrow*. Both writers had been monks under Ceolfrid's abbacy and could thus write from personal knowledge. Both include information about their subject's taste for and acquisition of books, and both record the making of the three great 'pandects' (87, 88).

The anonymous author further records that two of the Ceolfrid bibles were designed to be housed in the churches of the twin communities, so that anyone wishing to refer to a chapter in either the Old or the New Testament could readily do so. He also provides the details from which it was eventually possible to prove the identity of the Codex Amiatinus (88). His Life has survived in only two manuscripts, of which the Harley copy is the earlier. JMB

Bibliography: Whitelock 1979, no. 155.

95 Eddius Stephanus: Life of St Wilfrid

British Library, Cotton MS Vespasian D. vi
Vellum; ff. 125; 190 × 140 mm
Latin; 11th century (composite volume)

The author of the Life of St Wilfrid was a Kentish priest who came to Northumbria with Wilfrid, probably about 669, and became a monk at Ripon. Bede records that he was a singing master. He was closely associated with Wilfrid for the next forty years and seems to have accompanied him on his last journey to Rome, so much of what he writes comes from his own personal knowledge. He was also acquainted with Wilfrid's friends Acca, bishop of Hexham, and Tatberht, abbot of Ripon, from whom he acquired additional information and to whom the Life is addressed. It was probably written within a fairly short time of Wilfrid's death, which took place in October 709.

94 An account of the making of Ceolfrid's three great 'pandects' (f. 27)

In the course of his account of Wilfrid's somewhat turbulent career, Eddius provides valuable details of the saint's building activities at York, Ripon and Hexham and of the ornaments provided for his churches. A gospel book at Ripon, written in gold on purple parchment and encased in jewelled covers, is described with special care.

This manuscript is one of only two known copies of the Life of Wilfrid. It dates from the eleventh century and seems to have been in Yorkshire about a century after it was written. It is now bound up with material from St Augustine's, Canterbury, but this arrangement may be due to Sir Robert Cotton. JMB

Bibliography: Colgrave 1927.

96 Bede's letter to Ecgberht of York

British Library, Harley MS 4688
Vellum; ff. 98; 290 × 185mm
Latin; early 12th century
Durham

Bede's last recorded writing is the letter which he addressed to his friend and former pupil, Ecgberht, bishop of York, on 5 November 734, only six months before his death. It was not, however, his final work, for he is known to have been preparing on his deathbed a translation into English of the Gospel of St John. The letter is concerned with the state of the Northumbrian Church, which Bede had hoped to discuss more freely with Ecgberht at a personal meeting had his failing health not prevented it.

Bede exhorts Ecgberht to obtain the support of King Ceolwulf for major reforms, including the establishment of additional bishoprics based in suitable monasteries and under the control of the see of York, raised to metropolitan status as originally envisaged by St Augustine. Ecgberht was in fact granted archiepiscopal rank in 735. He also urges measures to prevent the domination of monasteries by lay founders

96 An extract from Bede's letter to Ecgberht (f. 93b)

acting for their own advantage. The appointment of adequate teams of clergy to cover the whole of Ecgberht's vast diocese is sought, together with a recommendation that the Lord's Prayer and the Creed should be taught in local communities in the vernacular, for the benefit of those having no Latin.

Only three manuscripts containing copies of this letter are known. This copy accompanies Bede's Commentary on Proverbs in a manuscript written at Durham Cathedral priory in the early twelfth century. JMB

Bibliography: Whitelock 1979, no. 170.

95 Eddius's account of the foundation of Hexham by Wilfrid (f. 90)

97 The Durham Liber Vitae

British Library, Cotton MS Domitian A. vii
Vellum; ff. 83; 205 × 140 mm
Latin; c.840
Northumbria (Lindisfarne or possibly Monkwearmouth/Jarrow)

A *liber vitae*, or Book of Life, contains a record of the members, friends and benefactors of a religious community to be remembered at the altar. This particular manuscript is identifiable as the 'excellent fine booke uerye richly couered with gold and siluer conteining the names of all the benefactors towards St Cuthberts church from the first originall foundation thereof' which lay on the high altar of Durham Cathedral before the Reformation.

The nucleus of the book is a list of more than three thousand names compiled shortly before the middle of the ninth century, about half a century after the first Viking raid on Lindisfarne. They are entered on purple-tinted vellum in a half uncial script written alternately in gold and silver ink.

97 A list of abbots, beginning with Ceolfrid (f. 18b)

The last three of the kings named are Ecgberht of Wessex, Eoghenan of the Picts and Eanred of Northumbria, all of whom died shortly before 840. Many of the men and women included can be identified as personalities of the seventh and eighth centuries. The names are arranged in lists according to status. Kings begin with Edwin of Northumbria (d. 633), who received the original mission of Paulinus. Among the anchorites are Felgild, St Cuthbert's second successor as tenant of the Inner Farne, and Billfrith, who ornamented the covers of the Lindisfarne Gospels. The list of abbots of the grade of priest begins with Ceolfrid of Monkwearmouth/Jarrow, that of abbots not so ranked with Benedict Biscop. Bishops were not originally included and have been added by a twelfth-century hand opposite the name of Ceolfrid.

Additions were continually made to the manuscript at Durham until the early sixteenth century. Its association with Durham has generally been taken to imply that it originated within the Lindisfarne community. However, the prominence given to the names of the Monkwearmouth/Jarrow saints could indicate that it was made there and that it only later passed into the hands of the community of St Cuthbert, as did a number of other books from the same source. JMB

Bibliography: Watson 1979, no. 527; Thompson 1923.

Metalwork, bone, glass and textiles

The extraordinary assemblage of artefacts associated with the shrine of St Cuthbert reveals some significant things about the course of Anglo-Saxon Christianity and Anglo-Saxon art, as successive donations were made to the shrine down the years, from Bishop Eadfrith to King Athelstan. In particular, the earliest material associated with the enshrinement and ensuing cult (selected items from which appear here) reflect something of the complexity of cultural tradition in Northumbrian Christianity as expressed in art and artefacts.

The pectoral cross (98) for instance, the earliest piece from the tomb and possibly even Cuthbert's own episcopal cross, is a link back to the decorative techniques current in metalwork from the earliest years of Anglo-Saxon Christianity (cf. 11, 12). On the other hand, the decorated oak coffin, made for the saint's translation on Lindisfarne in 698, reflects the cultural traditions which bound Northumbrian and particularly Bernician Christianity to Ireland and the Ionan Church. Some of the other objects associated with the early years of the cult and possibly with the translation itself – notably the inscribed wooden core of the portable altar, and the Lindisfarne Gospels (99, 80) – are also part of this Hiberno-Saxon tradition, for which the community founded by the Ionan abbot Aidan on Lindisfarne was a major centre. Yet it is significant that among the earliest of these gifts to the shrine is a manuscript written in one of the chief houses

of the romanising tradition in Northumbria; the St Cuthbert Gospel of St John, written at Monkwearmouth/Jarrow, may well be a gift from that community at the time of enshrine-ment (86). Later, the growing power and popularity of the saint's cult as it developed is seen in the eighth-century enshrinement of the wooden altar in an elaborate silver case, and the fine textiles, perhaps the earliest of many gifts of vestments to the shrine (99, 100).

The two very different cultural strands seen here in the cult of Northumbria's most venerated saint dominate the art and culture of the kingdom itself. The eighth-century metalwork of this cultural province, for example, often has more in common with Irish or Scottish metalwork than with that of Mercia and the kingdoms to the south. The densely-textured chip-carved or repoussé interlace, grid patterns, spiral elements, extremely stylised human figures and above all the exuberant animal ornament which are a feature of Northumbrian metalwork (e.g. 102, 103, 107d) are all attri-butes shared primarily with Irish and Scottish metalwork, and in turn reflect parallels in the decoration of manuscripts and sculpture (e.g. 79, 80, 90), in parallel with a distinctive palaeographic tradition. At the opposite end of Northumbrian Christianity, the tradition of *romanitas* cultivated at Wilfrid's Hexham, Ripon and York and in Ceolfrid's Monkwear-mouth/Jarrow left an equally powerful imprint in metalwork and sculpture, particularly in the naturalistic treatment of figural, animal and plant motifs (e.g. 110, 116). It would be a crude misconception, however, to assume that these aspects of Northumbrian culture are mutually exclusive, as the inter-weaving of Insular and classical motifs in objects as diverse as the Codex Amiatinus (88), the Bewcastle Cross (fig. 11) and the Franks Casket (70) reveals.

The religious communities in which this art was developed and practised were founded and supported by royal and aristocratic patrons whose acts of piety also expressed wealth and power. Hartlepool and Whitby, for example, were closely associated with Oswiu, who indeed founded Whitby: both Hild and Oswiu's daughter Ælfflæd, who entered Hartlepool under Hild's tutelage and who succeeded her as abbess at Whitby, were Northumbrian princesses; and Whitby itself became a major burial place for the Northumbrian ruling dynasty. The founder of Monkwearmouth/Jarrow, Benedict Biscop, was also a member of the aristocracy, who turned to a religious career after a period of service in Oswiu's retinue. The sophisticated decoration and fittings seen at Jarrow (105) would have been typical of such houses, where occasional survivals of ornate architectural sculpture also afford glimpses of the elevated quality of their decoration (110, 112). The relative affluence reflected in the architectural treatment is matched in the excavated metalwork, glass, and other finds from such sites: shrine or altar fragments of green porphyry at Jarrow, and gilded reliquary fittings and delicate poly-chrome glass insets from Whitby and York (105c, 107n, 108e).

A related factor which is emphasised by the archaeological evidence surviving from these sites is their importance – in Northumbria as elsewhere – as centres of resources and production. The high status of these 'showcases for noble

wealth and piety' could not exist without the support of an economic infrastructure, including skilled craftsmen such as the metalsmiths and glass-makers whose activities can be traced at Jarrow, Hartlepool, Whitby and York (106–8). Though much of this craft and industrial activity was geared to making artefacts for internal consumption, some of it certainly served the needs both of their patrons and of the community at large; and, as contemporary charter evidence from elsewhere in Anglo-Saxon England indicates, religious communities themselves were active in trade and commerce (e.g. 56, 151).

LESLIE WEBSTER

98 St Cuthbert's Cross

St Cuthbert's tomb, Durham Cathedral
Gold, garnet, glass, shell; H. 6 cm
Anglo-Saxon; second half of 7th century
The Dean and Chapter of Durham

The equal-armed pectoral cross has expanded terminals, and a central boss with four attendant lobes, one in each arm-pit. It is of multiple, soldered construction, built up in three tiers on a gold backing sheet. Each tier is edged with beaded wire: the first tier is studded with dummy rivets which punctuate the wire trim, the second has soldered dogtooth decoration framing the garnet cloisonné inlay, which forms in turn the third tier. A similar dogtooth border encircles the central shell and garnet boss. A filigree decorated loop is riveted to the top of the cross. The back is undecorated but shows ancient repair to a break at the top of the lower arm.

St Cuthbert died in his cell on Farne on 20 March 687 and was shortly after buried on Lindisfarne. In 698, the body was wrapped in precious vestments and enshrined in a

98

decorated wooden coffin. It rapidly became the focus of a famous and powerful cult. The Viking raids on Lindisfarne at the end of the eighth century prompted the first of many moves for the shrine and its community: then from 883 to 995 it settled at Chester-le-Street, and in 995 moved finally to Durham where it remains to this day. During these and subsequent centuries many offerings were made to the shrine, such as the precious vestments and vessels presented by Athelstan in the tenth century. The tomb was also recorded as being opened at various times between the twelfth century and the present day, most notably by Canon Raine on 17 May 1827. It was on this occasion that the Cross was first recorded, hidden among garments close to the body. The presumption is that it was buried with the saint in 687 or, at the very least, placed there at the enshrinement of 698.

The Cross is clearly a descendant of the early seventh-century garnet-inlaid pendant crosses represented by those from Wilton and Ixworth (12, 11), and its central shell and garnet boss evidently relates to similar settings on seventh-century jewellery such as the composite brooches. Its simple cell-shapes and poor gold content, however, indicate a date of manufacture in the second half of the seventh century. It appears to have been in use for some time before burial, as the wear on the crude suspension loop (which may indeed be secondary) and the ancient repair indicate. Its architectural conception and design geometry have linked it to Northumbrian sculpture and manuscript design (Coatsworth 1989, 294–5) and there can be little doubt that a Northumbrian seventh-century origin is correct, allowing the possibility that it was worn by Cuthbert in his lifetime. LW

Select bibliography: Bruce-Mitford 1956a; Coatsworth 1989.

99 Portable altar

St Cuthbert's tomb, Durham Cathedral
Oak, silver; L. 13.3 cm, w. 12.06 cm
Anglo-Saxon; 7th and 8th century
The Dean and Chapter of Durham

Rectangular oak base with five consecration crosses and, running lengthwise, an incised inscription in Insular capitals: + IN HONOR[EM] SPETRU, 'in honour of St Peter'. The back is plain. At a later date the wood was encased in silver sheet consisting of two chased repoussé rectangular plates secured by edge bindings, the whole pinned together and set on a thick mastic base. The decoration on the casing reorientates the altar so that the short side becomes the top. On one side the fragmentary remains indicate a draped and haloed figure, with accompanying lettering in capitals: P ... [A] ... OS ... s. The figure was probably seated. The other side has two components: a silver panel with foliate motifs at each corner and a single cross or circle at the mid-point of each edge, and a separate silver disc which is pinned over a large circular hole at the centre of the main panel. The disc has an outer border with beaded frame containing part of an inscription in Insular capitals: IAꟻ ECꟻ ER[A]. The centre has an equal-armed cross with semicircular terminals each containing a

99 (back of silver casing)

leaf-flower motif: the fields between the arms are filled with interlace.

The altar seems to have been first recorded when the shrine was opened in 1104. The display script of the inscription on the wooden core resembles that of the Lindisfarne Gospels (80) and related manuscripts, dating it to the end of the seventh century; the silver casing evidently represents a later enshrinement of the wooden altar as a relic. The figural scene with accompanying inscription was identified by Radford as a seated representation of St Peter, which would accord with the inscription on the wooden altar; the very fragmentary nature of this side must however leave the identification open. On stylistic and technical grounds a date in the eighth or ninth century would be equally possible. The other side offers more precise evidence for date. The foliate sprigs in the corners of the main plate are convincingly compared by Coatsworth to similar drooping plant sprays in manuscripts of the first half of the eighth century, such as the Leningrad Bede and the Maaseik Gospels (Alexander 1978, nos 83, 89–91). Comparisons with the foliage on the ninth-century Winchester reliquary (136) (Hinton, Keene and Qualman 1981, 45–77) are not convincing. This panel originally had an opening at the centre allowing access to the enshrined relic: the disc now covering this is presumed to be later in date, and this is supported by the style of leaf-flower motifs at the cross terminals. These have affinities with similar motifs appearing on major monuments of Northumbrian sculpture of the later eighth and early ninth century – the Bewcastle cross-shaft for example (fig. 11) and especially the Jedburgh shrine fragment (114, bottom of left-hand vine

scroll). The lobed peltate leaves, with their hint of a triangular depression, are typical of later eighth or early ninth-century metalwork, for example on the Fulset disc and Hon Hoard ring (Bakka 1963, figs 17, 18). A date in the late eighth century is probable and is quite compatible with that indicated by the interlace and the letter forms of the inscription.

In sum, it appears that a seventh-century wooden altar by tradition almost certainly associated with St Cuthbert was enshrined as a relic in the eighth century, with subsequent modification to protect the relic itself from direct access. It is worth noting that when Bishop Acca of Hexham (d. 740) was translated in the early eleventh century, there was found on his chest a wooden slab in the form of an altar with a dedicatory inscription to the Trinity, Holy Wisdom, and the Virgin. LW

Select bibliography: Radford 1956, 326–35; Coatsworth 1989, 296–301.

100 Fragments of a tunic (probably a dalmatic)

St Cuthbert's tomb, Durham Cathedral
Silk; 9 fragments exhibited here, width of braid 3.2 cm
Soumak braid edging and construction of garment, Anglo-Saxon, probably Northumbrian, *c.*800
The Dean and Chapter of Durham

Four different types of textile are represented:

100 (a) Two weft-patterned cream silks, from which the garment was principally made

100 (b) Plain green tabby silk used as a seam binding

100 (c) Weft-faced compound twill silk, originally purple and yellow, used as a seam binding and as facings behind the braid

100 (d) Braid with soumak brocading decorating the edges of the garment – the Soumak braid

The sewing is in cream or dark red silk thread. The two cream weft-patterned silks, superficially the same, have slightly different repeating designs, both based on large and small crosses. Clearly of Christian origin, they were probably woven somewhere in the Mediterranean region, possibly in Italy. Two plain silks, the green silk here and a brick red silk known from separated fragments, are of uncertain origin but are probably also Mediterranean. The two-coloured compound twill silk and a possible second silk of the same kind but with three colours are of a type of cloth which, while well-represented in European church treasuries, appears to have been woven in Central Asia, probably eastern Central Asia (the distinguishing features of this sub-group of silks in weft-faced compound twill weave are the absence of twist on the warp yarns and the large-scale stepping, or 'decoupure', of the design outline). The Soumak braid appears to have been made at the time the garment was constructed and, for this reason and because of certain technical features, can be identified as Anglo-Saxon.

We cannot be certain that the tunic was an ecclesiastical dalmatic, but its context suggests that it was. At this date dalmatics in the Western Church were still light-coloured, for bishops usually of undyed silk, and two other surviving examples are also of weft-patterned silk cloth (one from the tomb of a bishop of Ravenna of the eighth to ninth century,

100d

100d

the other from the tomb of St Quiriacus, d. 769, at Taben-an-der-Saar). While the early continental dalmatics lack a brightly coloured edging braid, we know that such braids had for centuries been typical of Germanic costume and it is possible that in England this feature passed from secular to ecclesiastical dress. The best depiction of Anglo-Saxon church vestments, on the early tenth-century embroidered stole also from the tomb of St Cuthbert, shows dalmatics clearly edged with braid at the hems and necklines.

Looking at the Soumak braid in more detail, its repeating design can be seen to consist of a stylised palmette in purple on a pale blue ground (now discoloured) alternating with a heart-shaped bud or petal in red and yellow on a light brown ground, while related symmetrical half-motifs fill the spaces at the sides. The borders, between two dark red double cords, are dark red with bars of light blue, purple and yellow. The braid's construction consists of the following elements: a central area covered by short floats of soumak brocading; twisted inner double cords – these cords show the basis of the braid's construction to be tablet-weaving; borders embroidered in blanket stitch; separately-made outer double cords which disguise the stitches joining the braid to the garment. The braid's main design is not Anglo-Saxon in style but relates in particular to borders on a group of compound twill silks from western Central Asia; a silk of this type preserved at Faremoutiers in France, for instance, has a border of palmettes in niches, while one from Toul has a border of heart-shaped buds. The most famous textile in the group, at the cathedral at Huy in Belgium, according to an ink inscription in Sogdian is 'Zandiniji', that is, a product of the region of Zandana, outside Bukhara in modern Uzbek-istan. It seems, however, that the copying of such designs in local techniques was not uncommon in Western Europe and, in addition to the Durham Soumak braid and the braid with soumak brocading from Salzburg (**142**), one can mention a small cloth at Ravenna with tapestry-weave decoration where two Zandaniji-type border designs are framed by Latin inscriptions. The style of the Durham braid's own borders is meanwhile more familiar. The short and long alternation of colour is strongly reminiscent of the border of the Sutton Hoo purse mount while the proportions recall the narrow 'tramline' borders, often with similar bars, occurring in Insular manuscript illuminations, for instance in the Book of Kells, in the framework around the figure of Christ, f. 32v.

Finally, the construction and technique of the Soumak

braid confirm its local origin. It is significant that all the braid's coloured silk, including the sewing thread attaching it to the tunic, seems to be of the same yarn. Tablet-weaving in general is known to have been typical of Celtic and Ger-manic areas from the Roman period on; surviving examples include, for instance, a wool braid from the cuffs of a tunic, the cut ends finished by blanket-stitching, preserved with a pair of sixth-century wrist clasps found at Mitchell's Hill, Icklingham in Suffolk. Soumak brocading, too, was charac-teristic of north-western Europe and there are fragments from Sutton Hoo and from Taplow of linen tabby cloths with soumak designs in wool. There are two other known examples of tablet-woven braids with soumak brocading from church contexts. One, from Salzburg (**142**), again has a Zandaniji-type design. The other, however, is decorated with an inscrip-tion of an Insular style (fig. 8); interestingly, it is from the same bishop's tomb at Ravenna as the small cloth with Zan-daniji-type borders on tapestry weave mentioned above.

Though it is tempting to push the dating of the Durham tunic and its Soumak braid back to the period of St Cuthbert himself (d. 687), the cumulative evidence points to it having been made around the end of the eighth century. St Cuthbert's body remained at the abbey on Lindisfarne until 875 and thus it is possible that the tunic was added to the shrine's contents there. Equally, it could have been presented later and some of the gifts of Athelstan in 934 and Edmund in 945 are known to have been already old. If a gift of one of the Wessex kings, the tunic is likely to have been brought from the south of England. The fragments were discovered with the other 'relics' of St Cuthbert when his tomb in Durham Cathedral was opened in 1827. HG-T

Bibliography: Battiscombe 1956, esp. 452–69; Collingwood 1982, 348–50; Granger-Taylor 1989; Granger-Taylor 1990.

101 Belt-chape

No provenance
Copper-alloy, tinning; L. 4.4 cm, W. 3.5 cm
Northumbrian; second half of 8th century
British Museum, M&LA 1989, 3–3, 3

Cast openwork D-shaped fitting, the straight end thickened and split to accommodate a strap, which was secured by means of a single rivet piercing a central lug; the curving side swells to a pointed projection at its centre. The entire surface

Fig. 8 Ravenna: detail of an Insular two-sided inscribed silk braid from the tomb of a bishop, Sant' Apollinare in Classe; *c*.800

101

was originally tinned. A semicircular openwork design of two confronted birds locked in a plant scroll occupies the main body of the chape: both faces have tooled details, such as scrolled wings, beaks and eyes, but only one shows feathering and leaf veins: the lobe at the end of this face is also decorated with an incised and dotted animal mask.

This unusual piece is paralleled functionally by a similar D-shaped belt-fitting from a Viking grave at Nordrum, illustrated by Bakka (1965, pl. 1(a)) which also shares an openwork design. That forms part of an eighth-century belt-set decorated with Insular curvilinear bird-head decoration rather different in style from the demure restraint of the bird and plant motif seen here. Its firmness and economy of line recall some eighth-century Southumbrian manuscript illumination – the Vespasian Psalter (153) for example – but it is as a reduced image of the Northumbrian inhabited vine-scroll as on the Jedburgh shrine (114) that it is best seen.

LW

Unpublished.

102 Decorative plaque

Upper Rerrick Farm, Dundrennan, Dumfries and Galloway, Scotland
Copper-alloy, gilt; H. 3.5 cm, W. 4.2 cm
Northumbrian, mid 8th century
Dumfries Museum, inv. no. 87.58

Incomplete bronze decorative mount with cast decoration consisting of a beaded border outside a plain border on three sides, framing two interlaced animals, one biting the ribbon-like body of the other. Each animal has a pointed muzzle, an elongated eye and an ear (or lappet) which extends beneath the neck to run over the foreleg and form a triquetra; the body curves round, interlacing with its own hind limb and tail; the hip joints are indicated by a curl. There is gilding on the upper surface, and a large rivet hole. Remains of a plain outer flange indicate that this was part of a composite decorative cover of some kind and ?lead solder on the back that it has been mounted on a metal backing.

The stylised profile animals show that this plaque is in the Hiberno-Saxon 'Insular' style; they are in the tradition of the fine dog-like beasts drawn in the Lindisfarne Gospels (80), although details such as the ball-and-claw feet are here simplified. This is probably a piece of church metalwork from a shrine or book-cover. This coastal area is rich in settlement and ecclesiastical centres of the early medieval period. The mount was found in 1987. SY

Unpublished.

103 Male head, adapted as a weight

Furness, Lancashire
Copper-alloy, gilding, lead; H. 3.9 cm, W. 3.5 cm, WT 126.3 g
Insular; 8th century, 9th or 10th century modification
British Museum, M&LA 1870, 6–9, 1

Gilded casting of a bearded head with curled fringe and prominent ears. There is an ungilded figural attachment recess at the top. The hollow back is filled with a lead plug.

This head, later adapted by means of a lead infill to serve as a Viking weight, was originally part of a figural mount from a large shrine of some kind. The figures on the twelfth-century St Manchan's shrine give some idea of the possibilities. Its severe gaze and sorrowing mouth intend *gravitas*,

102

103

perhaps indeed Christ himself; though the best parallel for its combination of stylised features, especially the lively curls and carefully detailed beard, is to be seen in the image of St Mark in the Lichfield Gospels (**90**; Alexander 1978, no. 80).

LW

Select bibliography: Youngs 1989, cat. 135; Henry 1965, 113–14, pl. 69.

104 Plaque

Hexham, Northumberland
Silver; H. 10.0 cm, W. 7.5 cm
Anglo-Saxon; 7th–8th century
British Museum M&LA 1854, 8–14, 1

Rectangular sheet incised from both sides with a haloed figure within a diagonally hatched frame. The figure wears draped garment(s) with a cross-decorated panel, above which he seems to hold or carry a book-like object, also with a cross.

The plaque's find-spot cannot be precisely located within Hexham, where it was found before 1858. Its crudely sketched and rudimentary image makes it hard to parallel in style or content though it is evident that its maker knew some simple technical tricks to enhance the image. Bailey (1974) argues convincingly that the rectangular panel on the chest represents a discrete object such as a book or reliquary. The crude halo and crosses on the lower garment suggest a saint

104

or Christ. The simple linear style is seen in a much more accomplished Northumbrian version on St Cuthbert's coffin and on early Merovingian church metalwork, such as the St Mumma reliquary (Périn and Feffer 1985, cat. 31, pl. 91). It is most likely to have been fixed to a book-cover or reliquary.

LW

Select bibliography: Bailey 1974, 156–8; Cramp 1989, cat. 26 and cover.

105 (a–d) Selected finds from the Anglo-Saxon monastery at Jarrow, Tyne and Wear

St Paul's Church, Jarrow, and St Paul's Jarrow Development Trust

The monastery of St Paul, sister establishment to that founded at nearby Monkwearmouth in 674, was founded in 681/2 on forty hides of land given by King Ecgfrith of Northumbria. Its first abbot, Ceolfrid, came from the community at Monkwearmouth, as did its most famous member, Bede, who joined the monastery shortly after its foundation. The twin monasteries were renowned not only for learning but for the sophistication of their construction and furnishing: stonemasons and glaziers from Gaul, and painted plaster walls and *opus signinum* floors gave the stamp of Roman style to their buildings (**105a, b**). Equally Roman in manner, the great bible known as the Codex Amiatinus (**88**; Alexander 1978, cat. 7) was produced here in Ceolfrid's time. After the first Viking raid on Lindisfarne in 793, the community at Jarrow found its existence increasingly precarious, and by *c*.875, the monastery was apparently evacuated. The small selection of finds from the recent excavations gives some impression of the ambitious nature of the buildings at Jarrow and their furnishings in its heyday.

LW

Select bibliography: Cramp 1969; 1975; 1976b; 1980.

105 (a) Window glass (reconstruction)

Coloured glass set in modern lead cames; present H. 32.5 cm, W. 17.2–18.4 cm
Anglo-Saxon; late 7th–9th century
Bede Monastery Museum, Jarrow, inv. no. BMM IG119

Stained glass window composition in the form of a figure; complete or nearly complete quarries have been leaded together by York Glaziers Trust to make up the panel. It is unlikely that they were all parts of the same window originally, but certain quarries – the head and foot in plain glass, the dark amber of the halo, the semicircle of ruby glass fitting exactly into the curve of dark blue drapery – indicate that there was certainly a figural window within the building. The lower part of the figure's drapery and the main background are conjectural, but the curved strips of pale blue glass provide the dimensions of the top of the window.

The glass is extremely durable, cylinder-blown and made from sand and soda-lime, the ash produced from marine plants. It was coloured with metal oxide derivates, iron giving greens, yellows and browns, and copper producing bluey-

greens, blues and reds. These colours are paralleled in vessel and window glass from other high-status sites such as Brandon and Whitby (66v–y, **107f–j**). Individual quarries were grozed prior to setting into lead cames, the lead being used in the absence of painting on the glass to emphasise details of the panel. The discovery of window glass in large quantities at Jarrow and Monkwearmouth supports Bede's account of the re-introduction of glass-manufacture to Northumbria *c.*676. In his *Lives of the Abbots of Wearmouth and Jarrow* he relates that Benedict Biscop sent 'representatives to Gaul to bring back glass-makers, craftsmen as yet unknown in Britain, to glaze the windows of the church [of St Peter's, Monkwearmouth], its side-chapels and upper storey'. Although vessel-glass manufacture was in fact a firmly established Anglo-Saxon tradition by the seventh century, window glass was for them an innovation which arrived with the reintroduction of building in stone. These techniques, new to Anglo-Saxons, were directly associated with the special demands of Christian worship. The glass shown here reflects both a vivid and concrete response to the requirements of the new religion, and the dramatic impulses which were transforming indigenous Anglo-Saxon culture as a result of Christianity and its associated effects.

No glass furnace has been found at either site, but there is evidence for the manufacture of window glass at Jarrow, and the excavation revealed that the windows of each of the principal monastic buildings were glazed. Fragments of vessel

105a

glass, millefiori rods, beads and inlay also indicate that other types of glass were being worked in the monastery. The glass came from the debris of the monastic guesthouse.　sm, lw

Select bibliography: Cramp 1980, 12, p. 10; Campbell 1982, fig. 75; Cramp 1975, 88–96.

105 (b) Wall-plaster, three fragments

Painted plaster; (*i*) H. 8.6 cm, W. 9.2 cm, (*ii*) H. 11.9 cm, W. 12.2 cm, (*iii*) H. 7.7 cm, W. 9.2 cm
Anglo-Saxon; late 7th–8th century
Bede Monastery Museum, Jarrow, inv. no. BMM IL123, (*i*) 3137, (*ii*) 2859, (*iii*) JA 73 SW

The pure lime-plaster was tempered with river sands and some organic material, and had been applied in a single layer to the rough stone walls of the buildings. The finishing technique has given the plaster a striated surface, which is often uneven. A very thin layer of white (now cream) lime-wash had been applied over the surface to smooth it and to provide a base for the pigments. The surface was then marked out with vertical and horizontal lines, scored with a pointed tool. Another tool was used to draw arcs with a radius of 55 mm. Although many such fragments survived from the guesthouse, their condition is such that it proved impossible to determine the overall scheme of the design, which may have been quite elaborate.

In spite of the apparent care with which the designs had been laid out, the pigments were not always applied in close relation to them, and they were sometimes ignored, though on the examples as shown the pigment generally respects most of the layout lines. The dominant pigment was red ochre, though on (*iii*) a black pigment, probably carbon-based, has been used to fill the area between two arcs.

These fragments of polychrome painted wall plaster come from the monastic hall and guesthouse. The plastering of the walls of the monastic buildings is another reflection of the aim of building in the 'Roman manner'. The thick red stripes painted on the surface may have emphasised the architectural scheme as in Roman decoration and would have been in keeping with the austere Roman ornament of the sculpture, much of which was probably also painted. The geometric scheme of decoration on the plaster has parallels in both sculpture, particularly grave markers from Monkwearmouth, Hartlepool and Lindisfarne, and manuscripts, especially the Lindisfarne Gospels (**80**).　sm

Bibliography: Cramp and Cronyn 1990, 17–30.

105 (c) ?Reliquary or altar fragment

Green porphyry; L. 5 cm, W. 1.8 cm
Mediterranean; reused in late 7th–9th century
Bede Monastery Museum, Jarrow, inv. no. BMM IL061

Sub-rectangular fragment of *verde antico*, one of two such from Jarrow. This semi-precious stone was much valued in late antique and medieval times, and occasional fragments have been found at other early medieval religious sites: at St Ninian's

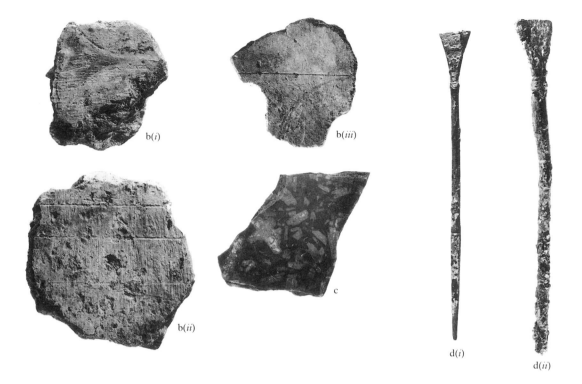

b(*i*)

b(*iii*)

b(*ii*)

c

d(*i*)

d(*ii*)

105b–d

Isle, for example (Small, Thomas and Wilson 1973, 31–2).

A further similar fragment was found with a coin of Eadred 'on the hill at Lewes' (British Museum, M&LA 1853, 4–12, 124) and other fragments are recorded from Ireland and Scotland (Lynn 1984). Red porphyry, with its imperial overtones, was certainly used in the Late Saxon portable altar in the Musée de Cluny (Backhouse, Turner and Webster 1984, cat. 76) and continued in favour for this purpose in the medieval period. Some green porphyry may also have been used in this way, but could also have been inset in shrines or reliquaries. Whatever its precise usage, the occurrence of this exotic and much-prized stone at Jarrow is another indication of the influence of classicising Mediterranean culture in the twin community. LW, SM

Unpublished.

105 (d) Two styli

Copper-alloy; (*i*) L. 10.2 cm, (*ii*) L. 10.8 cm

Anglo-Saxon; 7th–8th century

Bede Monastery Museum, Jarrow, inv. nos (*i*) BMM IMI03, (*ii*) BMM IMI04

(*i*) The round-sectioned shaft is divided from the spatulate eraser by a narrow moulding and there are traces of incised bands at intervals along the shaft.

(*ii*) Similar to (*i*) but with longer eraser and more pronounced moulding and bands.

Rather surprisingly, these are the only styli to have been excavated at the Jarrow site; one was found in the large hall (Building B) which may have served as a meeting or instruction room for the community, the other near the monastic workshops. The lack of retrieved writing equipment suggests that excavation has not been near the scriptorium. They compare closely to those from other monastic sites, such as Whitby and Barking (**107c–e, 67i–k**). LW, SM

Unpublished.

106 (a–c) Three two-piece mould fragments

Hartlepool, Cleveland

Fired clay; (*a*) 2.0 × 1.2 cm, (*b*) 3.0 × 3.5 cm, (*c*) 2.8 × 1.5 cm

Anglo-Saxon; 7th–8th century

Hartlepool Museum Service, inv. nos (*a*) HAPMG 27′89′91/92, (*b*) HAPMG 27′89′91/91, (*c*) HAPMG 27′89′91/93

106 (a) Circular fragment

Impressed design for an equal-armed cross with expanded terminals, the arms decorated with fine interlace.

106 (b) Circular fragment

Impressed square panel with the symbol of St Luke, a backward-turning calf with trumpet.

106 (c) Trapezoidal fragment

Impressed trapezoidal design of a backward-turning long-jawed animal with a finely interlaced ribbon issuing from its body. The mould's ingate runs into the narrow end of the design.

The double-minster of Heruteu was founded by the abbess Hieu in the early 640s on a headland site in what is today Hartlepool. Hild, who later founded Whitby, succeeded as abbess; and after the Northumbrian victory at Winwæd in 655, received King Oswiu's daughter Ælfflæd into her charge at Heruteu. Little is known of its history thereafter, apart from its supposed destruction by Vikings in the ninth century.

Nineteenth- and early twentieth-century works revealed graves with namestones, presumably part of the monastic cemetery. More recent excavations near the present twelfth-century church have revealed Anglo-Saxon timber buildings, and crucibles and mould fragments including these decorated fragments, which were excavated from the backfill of the monastic palisade trench. All are for making metal fittings for ecclesiastical objects, and there is evidence from at least one of the crucibles that silver was being cast on the site.

106b

106a 106c

Evidence for the production of fine metal and glass objects has been found at other early Anglo-Saxon monastic sites such as Jarrow, Whitby and Barking, confirming their importance as centres of resources and production. Like material from other Northumbrian sites, the Hartlepool material is of ambitious quality, perhaps reflecting the status and royal support given to the community in the late seventh century. All three show motifs reflected in the art of manuscripts of the Lindisfarne group; the animal on (c), for example, closely resembles Insular beasts of the kind seen in the Durham Gospels (81). The St Luke calf symbol is of particular interest, combining the apocalyptic trumpet blown by two of the Lindisfarne evangelist symbols with the youthful Insular type of calf seen in the Book of Durrow and Echternach Gospels (82: Alexander 1978, nos 15, 55). This important fragment was presumably one of a set for casting all four evangelist symbols, probably for mounting on a cross or book-cover. LW

Bibliography: Cramp 1976a, 220–3; Cramp and Daniels 1987.

107 (a–q) Selected finds from the Anglo-Saxon monastery at Whitby, North Yorks.

This double house of monks and nuns was founded by Hild in 657 on the headland site now dominated by the ruins of the medieval abbey. The estate of ten hides was donated by the Northumbrian King Oswiu, whose daughter Ælfflæd succeeded Hild as abbess ruling from 680 to 713/14. The royal connections of the house were thus especially strong and reinforced by its role as a burial-place for members of the Northumbrian royal house: Whitby's (and Hild's) importance within the ecclesiastical (and royal) politics of the day is indicated by its being the venue for the great synod of Whitby in 664, which determined the course of the Anglo-Saxon Church in the Roman, rather than Celtic, tradition of Christianity. The site was sacked by the Vikings and appears to have effectively come to an end after 867.

The finds discussed below come from a great quantity of material recovered by workmen on the site between *c.*1920 and 1928, but only with any attempt at systematic recording from December 1924. Consequently few can be reliably ascribed even to areas, let alone individual structures. However, the quantity, range and quality of artefacts tantalisingly substantiate the status of this house; in the glass-making debris, it also hints at some of the craft activity necessary to the life of a monastic site, alongside more scholarly pursuits. LW

Select bibliography: Peers and Radford 1943; Wilson 1964, 192–201; Cramp 1967b, cats 1–3; 1976a, 223–9; 1976b; Rahtz 1976.

107 (a) Mount

Copper-alloy, gilding; D. 9.0 cm
Anglo-Saxon; 8th century
British Museum, Strickland loan, W.29

The cast openwork mount is in the form of an octofoil constructed of two sets of four interlocking penannular motifs, each set formed of a continuous grooved band which interlocks with a zigzag-decorated circle half-way between the perimeter and the central circular zone, which has a grooved border and a central attachment hole. The whole may be read as two intersecting equal-armed crosses with expanded terminals. The surface is covered with a variety of chip-carved interlace motifs. There are four subsidiary attachment holes, with iron nails in two. The back is plain. The discoloration of the gilding and copper-alloy suggests it has been burnt.

One of three such mounts from Whitby, the other two from the same mould. They are probably plates from book-covers or shrines. LW

Select bibliography: Peers and Radford 1943, 52; Wilson 1964, cat. 107; Cramp 1984, cat. 34

107 (b) Strap-end

Silver, niello; L. 4.0 cm
Anglo-Saxon; mid 9th century
British Museum, Strickland loan, W.52

The strap-end's animal-head terminal has comma-shaped ears, and the split end has a single rivet. Beaded borders frame the main decorative panel in which a Trewhiddle-style quadruped disports upon a nielloed ground. The back is plain.

One of the more elegant strap-ends of its type, this delicate piece belongs to a group with a predominantly northern distribution (see p. 233). LW

107 (c) Stylus

Copper-alloy, silver; L. 13.9 cm
Anglo-Saxon; late 7th or 8th century
British Museum, Strickland loan, W. 131

The sub-triangular eraser is fitted with an applied silver foil, with a repoussé beaded border and interlaced decoration. Five triple mouldings decorate the shaft at intervals.

This stylus is unusual in having a decorated head: the foil is closely related to triangular foils with interlacing Style II animals seen on drinking cups and horns, and may indeed be taken from a die intended to produce foils for such use. This piece, and the two following examples reflect the literate activity of a monastic community. LW

a

b

e

d

107a–e

c

107 (d) Stylus

Copper-alloy; L. 12.7 cm
Anglo-Saxon; 8th century
British Museum, Strickland loan, W. 148

Trapezoidal eraser with notched cross-bar, and collared baluster moulding below: the shaft is circular in section, bent towards the tip. LW

107 (e) Stylus

Bone; L. 9.3 cm
Anglo-Saxon; 8th–9th century
British Museum, Strickland loan, W. 343

Sub-triangular eraser, the shaft with tip missing. LW

107 (f) Vessel fragment

Glass; max. L. 29 mm
Anglo-Saxon; 8th century
British Museum, Strickland loan, W. 503

Rim of squat jar, diameter 6 cm, folded inwards without reheating, forming a cupped contour outside and a sharply-stepped contour inside. The glass is opaque and looks black, but is a very dark blue with slightly lighter streaking inside. On the outside are three fine channels left by decomposed trails, the remains of which are white. The wall of the vessel is over 1 mm thick. An incorrect description 'green with dark brown or wine-red streaks, with three incised horizontal grooves on the exterior' (Harden 1956, 152) was followed by Cramp 1970a, 16 and Charleston 1984, 11.

Some of the vessel glass of the Middle Saxon period appears to be black in reflected light, but on scrutiny in transmitted light can usually be seen to be a very dark shade of blue, green or brown, the colour often relieved, as here, by applied trails in a contrasting colour. The claw from Brandon (66w(*iii*)) also appears to be black although it is a very dark olive green. The rim of a similar squat jar, black but with yellow trails, is among the fragments at Brandon, Suffolk (BRD 018 2349). VIE

Select bibliography: Harden 1956, 152; Cramp 1970a, 16; Charleston 1984, 11.

107 (g) Vessel fragment

Glass; max. L. 26 mm
Anglo-Saxon; 8th century
British Museum, Strickland loan, W. 504

Rim of squat jar, diameter 6 cm, slightly thickened. Dark green-blue in reflected light, a vivid green-blue with small bubbles in transmitted light. The wall thickens from 3 mm to 4.5 mm at the rim. This is unusually thick, but squat jars with necks of equal thickness are known from Barking Abbey and Monkwearmouth/Jarrow (Cramp 1968, figs 3, 5). VIE

Select bibliography: Harden 1956, 152.

107 (h) Vessel fragment

Glass; max. L. 17 mm
Anglo-Saxon; 8th century
British Museum, Strickland loan, W. 511

Fragment of the wall of a ?bowl showing little curvature. Light blue-green with few small bubbles, ornamented with a horizontal reticella trail and a vertical reticella trail stopping short of it. The trails are half melted in and consist of a self-coloured rod wound with opaque yellow trails which were not marvered and so spread each side of the rod. Wall 1 mm thick, 2.5 mm with the trail. This is probably part of a Valsgärde type of bowl (cf. 67p, s, Barking Abbey, Essex).
 VIE

Bibliography: Harden 1956, 152; Holmqvist and Arrhenius 1964, 252; Evison 1988a, 241, fig. 6.

107 (i) Vessel fragment

Glass; 12.5 × 7 mm × nearly 3 mm thick
Anglo-Saxon; 8th century
British Museum, Strickland loan, W. 507

Fragment from the wall of a ?bowl, diameter c.10 cm, c.1.5 mm thick. Decorated with three parallel and contiguous horizontal reticella rods half melted in. The wall and reticella rods are vivid blue, the rods wound with marvered, alternating opaque yellow and finer white trails (diagram of reticella pattern, Evison 1988b, fig. 12d). The edges have been ground to form a roughly rectangular shape for use as an inset in a metal object, but leaving uncovered a small triangular area of wall remaining on each of the two long sides.

A horizontal band of reticella rods such as this is part of the decoration of a Valsgärde type of bowl (cf. 67p, Barking Abbey), but this colouring of blue with white and yellow is more vivid than usual. A similar fragment was found at St Denis, Paris (Unité d'Archéologie) where a piece broken from a horizontal band on a vessel consisted of fine, marvered white and red reticella trails, and one straight edge had been grozed, no doubt as a beginning to shaping as a square plaque.
 VIE

Select bibliography: Hencken 1950–1, 148, fig. 71; Harden 1956, 152; Holmqvist and Arrhenius 1964, 254–5.

107 (j) Window quarry fragments

Glass; max. L. (*i*) 45 mm, (*ii*) 35 mm
Anglo-Saxon; 8th century
British Museum, Strickland loan, (*i*) W. 512, (*ii*) W. 513

(*i*) Fragment of light blue durable window glass fractured with curved edges, no original edge remaining. Bubbly glass with iridescent, scratched surfaces.

(*ii*) Fragment of durable blue glass, flat with a slight curvature, bubbly and irregularly fractured. Thickness 1.5m. Both surfaces dull and iridescent.

As none of the edges appear to be original, the sides of the quarries must have been longer than 45 mm and 35 mm respectively, while the thickness of 1.5 m is normal for window glass of the seventh to ninth century. Evidence is accumulating of glazed windows in north-west Europe from the seventh century onwards, the quarries being small, mostly rectangular and triangular, but also other shapes, and in light greens but sometimes in definite colours, blue, green, brown and red-streaked. Substantial groups have been published from Monkwearmouth/Jarrow (Cramp 1970a; 1970b; 1975), and Winchester (Biddle and Hunter 1990). A light green-blue fragment is exhibited from Brandon, Suffolk (66y). VIE

107 (k) Imitation jewel

Glass; 32 × 27 mm
?Anglo-Saxon; 8th century
British Museum, Strickland loan, w. 49

Oval inset, dull green in reflected light, vivid blue-green in transmitted light. A flat background, 3 mm thick, is chipped at one place at the edge where there is an impurity in the glass. It is cast with a bust in relief 3 mm high, and there are many bubbles in the glass, including a large one behind the head. Both surfaces are dull and the edge is ground to a bevel. The figure has waving locks to the neck, a cloak in folds on the right shoulder continuing in a narrow band round the neck. The face has a pointed chin and is turned three-quarters left with the right ear showing. The left arm is bent to mid chest, an object being held between fingers and thumb. The right hand grasps a long stem which terminates over the right shoulder in four lobes.

Ornament in relief occurred rarely on semi-precious stones in the post-Roman period, but an Anglo-Saxon pendant with a garnet carved as a profile head was found at Epsom, Surrey (35). Imitations in moulded glass as studs for inlay in metal objects, as well as pseudo-cameo brooches, were produced in the seventh and eighth centuries in the Rhineland (Ypey 1962–3, 139–41). Studs with decoration in relief or with a grille were made in Ireland in the seventh and eighth centuries, and possibly also in England (107n), and two small glass human heads in relief occur on the Tara brooch (Youngs 1989, 77) so that the kind of technique required to produce this plaque would have been known at Whitby. VIE

The lively blue-green colour and bubbly nature of the glass support an Anglo-Saxon rather than Roman or more recent origin, though the cameo is certainly without close Anglo-Saxon parallel. However, an Anglo-Saxon interest in carved gems is apparent from a few sixth- and seventh-century finds, while recent finds from the sister foundation at Hartlepool show the casting of small-scale relief inlays in metal for inlaying on religious objects (106). Though clearly based at some remove on late antique models, the uncomfortable proportions and unarticulated anatomical details betray something of the Insular stylisation seen in the formulaic ears and hair of the later Furness head (103). Neither iconographically or stylistically, however, do any close Romano-

107f–p

British, late antique or early Christian parallels exist, though the sprigged stem held in the right hand suggests that the figure might be seen as a beardless Christ grasping the flowering staff of Aaron, conventionally perceived as an Old Testament type of Christ. Similar flowering rods appear elsewhere in Insular art; for example, held by Christ in the Book of Kells (e.g. Henry 1974, fig. 68) and by Christ/Sight on the Alfred Jewel (260). LW

107 (l) Two imitation jewels

Glass; (i) 22 × 13 × 4.5 mm, (ii) D. 12 mm
Anglo-Saxon; 8th century
British Museum, Strickland loan, (i) w. 505, (ii) w. 508

(i) Oval cabochon, rough surface at back, blue bubbly glass

(ii) Flat glass, nearly 3 mm thick, grozed to a roughly circular shape with a slight bevel. Blue, with few bubbles and both surfaces slightly pitted. The colour is similar to (i), but not exactly the same.

The fashion of Byzantine cabochon jewels as pendants on a necklace or decoration on church objects such as a metal

cross or book-cover was taken up by the Anglo-Saxons in the seventh century. Two oval, blue glass cabochon pendants decorated with a lattice work of marvered reticella trails occurred in the well-furnished grave 172 at Kingston Down, Kent (Faussett 1856, pl. IV, 8, 9). These two imitation jewels at Whitby, however, were no doubt intended for use on church furniture. **108e** from York Minster is comparable with (*i*). VIE

107 (m) Square plaque

Glass; 10.5 × 10.5 × 3 mm
Anglo-Saxon; 8th century
British Museum, Strickland loan, W. 566

Flat square mount with very light green backing 1 mm thick. On the front seven parallel, contiguous reticella rods. The two outer rods and two others alternating are translucent yellow, and the three intervening rods are vivid green-blue, all wound with decomposed, marvered white threads. The square has been neatly cut from a larger piece, the edges being ground, and was probably specifically manufactured in the first place as a mount as opposed to **107i** which was re-used from a vessel. (For comparable reticella decoration see **67r**.) VIE

Select bibliography: Hencken 1950–1, 148, fig. 71; Harden 1956, 152; Holmqvist and Arrhenius 1964, 254–5.

107 (n) Square stud

Glass; 20 × 20 mm
Anglo-Saxon; 8th century
British Museum, Strickland loan, W. 50

A square stud of translucent dark blue glass with an irregularly bevelled edge and flat surface. Inset in the surface is a gold grille, probably cut from sheet metal, with an outer frame and an interlaced design of two serpents, their heads in opposing corners and the curving line bodies looping across each other to terminate in the other two corners. A silver stud represents an eye in each of the animal heads and part of the gold grille is missing, leaving shallow channels in the surface of the glass.

Studs for mounting in metalwork such as a cross or chalice were often hemispherical in shape, but enamel mounts of flat, rectangular shape occur on the Derrynaflan paten and stand (Youngs 1989, 131–2, no. 125a, b). The simple zoomorphic pattern of head and body line interlacing at right angles is similar to the filigree patterns on Anglo-Saxon gold buckles of the seventh century, e.g. from Faversham (Youngs 1989, 56–7, no. 43), and is also to be found on the Ardagh chalice (Haseloff 1990, 180, no. 128a). The strip grille is in similar technique to the gold step pattern on the surface of the stud from Deer Park Farms, Co. Antrim (Youngs 1989, 206, no.

210), although its surface is flat like that of the mould and stud without the metal grille from Lagore Crannog, Co. Meath (Youngs 1989, 205–6, nos 209–10). The Anglo-Saxon origins of the patterns on the Whitby stud and also on the cabochon found at York (**108e**) suggest that although evidence for manufacture in the techniques involved is so far forthcoming only from Ireland, they may have been followed also in Anglo-Saxon monastery workshops. VIE

Bibliography: Peers and Radford 1943, 55, no. 34, figs 22, 2, pl. XXIX, d; Hencken 1950–1, 148, fig. 71; Youngs 1989, 60, no. 48.

107 (o) Millefiori rod

Glass; L. 21 mm, 13 mm
Anglo-Saxon; 8th century
British Museum, Strickland loan, W. 758

A rod, length 34 mm, broken into two pieces. The surfaces are decomposed, but at the break it can be seen to be opaque light blue-green glass of square section. This could have been destined for use as one component of the pattern of a composite millefiori rod such as the chequered rods found at Monkwearmouth and Jarrow (Cramp 1970a, fig. 1, a–f), Lagore (Hencken 1950–1, 132, fig. 64) and elsewhere. VIE

107 (p) Two tessera fragments

Glass; max L. (*i*) 16 mm, (*ii*) 11 mm
British Museum, Strickland loan, (*i*) W. 509, (*ii*) W. 510

(*i*) Tessera. One nearly square face remains, 12 × 12 mm, and two sides, but the rest is chipped. Opaque, light blue-green.

(*ii*) A chip of a tessera, as (*i*). (*i*) and (*ii*) appear to be the same glass as the rod (**107c**) above; indeed, the similarity of colour suggests that the tesserae may have been used to make the rod. Tesserae have been found on a number of sites where they could have been used to manufacture beads or trails for decoration on vessels, e.g. Paviken (Lundström 1975). It is likely that they were imported from the Mediterranean area. VIE

107 (q) Selected coins

British Museum, Strickland loan (illustrated below*)

Seventeen pennies (sceattas) of the early Anglo-Saxon period survive, and twelve more were listed. They represent series from southern England from both the Primary and, more plentifully, the Secondary sceatta phases (i.e. before and after *c*.710), including coins struck in London, Mercia and Kent. The major Continental series produced in Frisia* and the Lower Rhineland are also present, except Series X (the Woden/monster type) which is rarely found in England. The early silver issues of Northumbria are well represented:

107q

Aldfrith (685–705)*, 2, Eadberht (738–58), 9*, and Archbishop Ecgberht (735–66), 3. The silver coins of Eadberht's immediate successors are absent, but the copper-alloy pennies (stycas) issued before 867 are present in considerable numbers, often in very corroded condition. There are no later Anglo-Saxon silver pennies. MMA

Bibliography: Hill and Metcalf 1984, 68 and 265; Booth 1984.

108 (a–e) Selected finds from excavations at York Minster

The York of Wilfrid, Ecgberht, Ælberht and Alcuin was renowned for the splendour of its churches and the excellence of its scholars. The glass described below, together with the Anglo-Saxon cross-shaft (116), are among a series of seventh- to ninth-century Anglo-Saxon artefacts excavated between 1967 and 1972 underneath the medieval Minster. The Norman Minster was constructed on the site occupied by the Roman military headquarters at York, which was still standing in the fourth century. Interpretation of the archaeological sequence between these two dates remains speculative, but it is certainly clear that there was considerable activity on the site during the intervening six hundred years. The presence of

d

e

a(*i*)

a(*ii*)

b

c

108a–e

seventh- to eighth-century grave stelae indicates that an early church was established nearby by the eighth century, and in the ninth century a prestigious cemetery was founded, accompanied by high-quality sculpture. While these finds cannot be directly associated with the church of Wilfrid or Alcuin, they indicate something of the wealth and prestige of York in this period. LW

Select bibliography: Phillips with Haywood forthcoming.

108 (a) Vessel fragments

Glass; max L. (*i*) 37 mm, (*ii*) 37 mm
Anglo-Saxon; 8th–9th century
The Dean and Chapter of York, (*i*) XB7 YH72, (*ii*) XB59/84

(*i*) Dark green-brown rim, thickened and cupped, iridescent. Four fine parallel trails, melted in. The diameter is *c*.100 mm and the thickness 1.5–3.5 mm.

(*ii*) Dark green-brown wall fragment with applied blob drawn down leaving a jagged edge caused by adhesion to four horizontal trails and containing an elongated air bubble. The wall is just over 1 mm thick with a strong curvature, possibly caused by the blob, which is 2.5 mm thick.

These two fragments are probably part of the same vessel, and may be compared with funnel beaker fragments in light green with red streaks found at Helgö in Sweden, for the rim profile is similar and there are also claws although they are solid and are drawn free from the wall (Holmqvist and Arrhenius 1964, 249–50, fig. 110). Flat, unblown claws are known on some Swedish claw breakers, and a flat claw was found at Brandon, Suffolk (66w(*i*)). Continued use of this feature is shown by later evidence of a flat, drawn blob which occurs on a fragment of a globular squat jar found in a pit of the ninth to tenth century at St Denis in France (Evison 1989, 140).

(*i*) is from a post-1080 intrusion, (*ii*) from the demolition levels of Building 22. VIE

Bibliography: Evison forthcoming a.

108 (b) Vessel fragment

Glass; max L. 30 mm, thickness 2–3.5 mm
Anglo-Saxon; 8th–9th century
The Dean and Chapter of York, YM 71 AH4(11)

Green-brown rim of a ?funnel beaker, thickened and cupped, diameter *c*.100 mm. Three fine parallel trails melted in near the rim. Small bubbles and iridescent. Both colour and shape are similar to those of **108a** above, and this also was probably a tall palm cup or funnel beaker. Similar rims were found at Southampton (Hunter 1980, fig. 11.3.6), and complete funnel beakers occurred at Birka, mostly in ninth-century graves (Arbman 1937, Taf. 3–7).

From a layer containing an Anglo-Scandinavian comb towards the top of the pre-Norman building outside the west end of the Norman Minster. VIE

Bibliography: Evison forthcoming b.

108 (c) Vessel fragment

Glass; max L. 36 mm
Anglo-Saxon; 8th–10th century
The Dean and Chapter of York, XP 50

Light yellow-brown, nearly straight rim, sloping slightly inwards, sheared edge, not re-heated as the decoration of seven horizontal trails nearly to the rim edge is not melted into the wall. Few small bubbles. The colour is clear and bright in spite of slight iridescence. Diameter of mouth c.85 mm, thickness 2.5 mm.

An inward-sloping rim is not common, but it does occur on the moulded grape beaker at Birka (Arbman 1937, Taf. 11.1). Similar rims decorated with horizontal trails belong to beakers of the tenth and eleventh centuries, the beakers blue with white trails or opaque white with purple trails (Baumgartner and Krueger 1988, nos 26b, c, 29). The form of these beakers is squat and globular, resembling the Carolingian silver vessels of the Fejø cup type produced between the eighth and tenth centuries (Wilson 1960), so that it is possible that the shape could have been copied in glass much earlier than the tenth century.

From the pre-Conquest graveyard. VIE

Bibliography: Evison forthcoming b.

108 (d) Vessel fragment

Glass; max L. 27 mm
Anglo-Saxon; 8th century
The Dean and Chapter of York, XL 122

Vivid blue-green, three marvered opaque white trails dragged alternately in opposite directions. Minute bubbles, glossy surfaces, thickness 2 mm.

The colour is striking, and is one of the glass colours introduced into Anglo-Saxon England after the period of pagan burials. A pattern of trails combed into arcades is not uncommon, but the combing of trails in two opposite directions, or feathering occurs much less frequently. Such feathering, bicoloured white and red, occurred on a vivid blue-green fragment from a Middle Saxon pit at Barking Abbey, Essex (67f). Further examples of two-way feathering on light shades of green occur in England, Holland and Denmark, probably beginning in the eighth century.

From the pre-Conquest graveyard. VIE

Bibliography: Evison 1990.

108 (e) Cabochon imitation jewel

Glass; 23 × 15 mm, thickness 5.5 mm
?Anglo-Saxon; 7th–8th century
The Dean and Chapter of York, S.254

Imitation cabochon jewel of oval shape slightly narrower at one end, in very dark glass which is olive green in transmitted light. The back is uneven and the edges at the narrow ends have been shaped by grinding. A pattern on the surface of channels filled with opaque yellow glass consists of a central rectangle with incurved sides surrounded by four semicircles, each containing a stepped design. This semicircular element frequently occurred in garnet cloisonné work of the seventh century, e.g. at Sutton Hoo (Bruce-Mitford 1978, 491, fig. 359), and continued into eighth-century enamelwork. Already in the seventh century women wore glass cabochon pendants of this almond shape, and even cabochon pendants with marvered reticella trail decoration were found in Late Saxon graves (Faussett 1856, pl. IV 8, 9). There are also technical affinities in the Anglo-Saxon glass cabochon jewels with step pattern recessed ornament in similar contexts of this date at Roundway Down, Wilts., and cruciform design with step pattern metal grille at Camerton, Somerset (Youngs 1989, 53, no. 40; Haseloff 1990, 165, 190, no. 137). The method of casting is illustrated by a clay mould with the cast glass stud still in position found at Lagore Crannog, Co. Meath (Youngs 1989, 205, no. 209). There the design also included step patterns which were recessed for possible later inlay by metal or, as on the York cabochon, by glass. Blue studs with similar metal grille patterns are on the Derrynaflan paten (Haseloff 1990, 183, no. 310). A circular stud in the same technique in blue glass with yellow inlay and very similar pattern was found at Haithabu, where the centre of the design is a cross-in-circle in a square with incurved sides, surrounded by step-patterns in the resulting semicircular sections (Haseloff 1990, 164–5, 190, pl. 138). The York jewel was no doubt destined to be inlaid in ecclesiastical metalwork such as a cross or book-cover, like a comparable blue glass cabochon found at Whitby (**107n**).

From layer over Roman Building 4. VIE

Bibliography: Evison forthcoming b.

Sculpture

The conversion of Northumbria to Christianity and the subsequent predominance of the Roman tradition inevitably meant the introduction of building in stone for new churches inspired by continental models. Since the techniques required to cut and dress stone for building are similar to those required for sculpture, it is scarcely surprising that the most abundant early Northumbrian sculptures appear to be architectural. Unfortunately, few architectural sculptures remain *in situ* in fabrics constructed in the early years of Christianity in Northumbria. Only at St Peter's Church, Monkwearmouth, does anything resembling a complete sculptural scheme survive, although so heavily damaged that is difficult to reconstruct.

At Monkwearmouth the two-storey west porch remains of the church begun in 674, and constructed, according to Bede, in the Roman manner by workmen brought from Gaul. The porch itself is secondary, but was probably completed by 689. In the gable are the remains of a monumental sculptured figure, probably that of St Peter. Below this at first-floor level is a large round-headed opening, the inner face of which has a cable-moulded arris. Separating the ground and first floor

is a string course, now heavily weathered, but originally sculptured with a frieze of naturalistic animals. The west door has jambs, each composed of a pair of lathe-turned balusters supported by a soffit of square section, the faces of which are carved with a pair of inward-facing ribbon-like animals, their long snouts interlacing and their tails twisted together on the axis of the face (fig. 9). This form of animal is reminiscent of the decoration in early manuscripts, particularly the Book of Durrow (Dublin, Trinity College MS A.4.5 (57)).

The types of sculpture represented, however imperfectly, *in situ* at Monkwearmouth can be paralleled in a number of other early Christian sites in Northumbria. At Jarrow, the twin monastery of Monkwearmouth, there are twenty-five lathe-turned balusters (109). Some of them may have formed parts of doorways as at Monkwearmouth, but others may have been used as church furnishings, perhaps as an altar screen, possibly used in conjunction with narrow friezes decorated with closely-spaced depictions of small lathe-turned balusters. Such baluster friezes are known from Monkwearmouth itself, as well as Simonburn and Hexham. Hexham has also produced fragments of friezes or imposts decorated with naturalistic animals (110), very similar in form to those used on the external string course at Monkwearmouth, as well as fragments of a monumental figure of the crucified Christ, closely paralleling, at least in approach, the St Peter figure at Monkwearmouth.

As well as possible screen fragments, a number of these early sites have produced evidence for other church furnishings, such as the suggested lectern base from Jarrow, the complete bishop's or abbot's seats from Hexham (fig. 10) and Beverley, and the animal-decorated panels from Monkwearmouth, which it has been suggested should be viewed as bench ends.

Not only architectural sculpture but memorial sculpture also seem to have originated early in Northumbria, probably in the late seventh century. The earliest monuments are either rectangular, as is the case with the Hartlepool series, or semicircular-headed as at Lindisfarne. They are very small, typically *c*.20–30 cm in length and 2.5–10 cm in depth. The decoration is simple, consisting of an incised cross, usually combined with a personal name and sometimes with the letters alpha and omega (71).

Precisely how these memorial sculptures were used is uncertain. They may have been laid on the ground surface over the grave, alternatively they may have been placed in the grave. Later and larger grave slabs such as the Herebericht stone from Monkwearmouth or the series from excavations at York Minster have very similar decoration, but were certainly used as recumbent slabs over the grave, although it has been suggested that the Herebericht stone (72) may have stood upright.

In the eighth and early ninth century the Northumbrian sculptural traditions which originated in the late seventh century survived and flourished, although the evidence remains incomplete. Large-scale architectural sculpture is represented, for example, by fragments from Lastingham, North Yorks., which are best interpreted as parts of door

jambs decorated with vine scroll and interlace (113). These clearly belong in the tradition of decorated doorways begun at Monkwearmouth, although the form and nature of the decoration has been transformed. Equally there are abundant survivals of church furnishings from this period. Part of one side of a decorated chair survives from Lastingham, and a three-dimensional stone head from Monkwearmouth probably formed one of the finials to a tall stone chair back (112, 111). The fragments from Jedburgh (114) probably formed part of a screen or shrine. As with the architectural sculpture, the forms have survived from the seventh century but the nature and content of the decoration is very different.

In addition to the reworking and transformation of familiar forms, the eighth century also probably witnessed the most important single development in Anglo-Saxon sculpture, the introduction of the standing cross. How and why this type of monument was developed remains obscure, but the cross-shaft rapidly established itself as the most important and abundant sculptural form in Northumbria. The decoration on these crosses was often very complex as at Ruthwell and Bewcastle, where plant and animal ornament is combined with figural scenes and with text in an elaborate programme (fig. 11). Elsewhere, as on Acca's Cross, Hexham, decoration was simpler, consisting of animal and plant ornament often combined with interlace. These types of elaborate combinations of decoration, often repeating or alternating, were particularly common in works of the late eighth and early ninth century.

With the increasing Viking attacks on Northumbria after the sack of Lindisfarne in 793, it is often assumed that

Fig. 9 (*Left above*) Monkwearmouth, Tyne and Wear: west porch of St Peter's church; *c*.700

Fig. 10 (*Left below*) Hexham, Northumberland: ceremonial seat for bishop or abbot; eighth century

Fig. 11 (*Above*) Bewcastle, Cumbria: cross shaft; late eighth century

Fig. 12 (*Right*) Easby, Yorks.: cross shaft (details); early ninth century

110a

109

110b

ecclesiastical life and ecclesiastical patronage dwindled rapidly. Clearly the Viking attacks did have a catastrophic effect on particular centres, but in the heartlands of southern Northumbria, sculptural innovation continued. The great crosses at Easby and Otley represent new, naturalistic traditions in both figural and non-figural art drawing on Classical antiquity probably through works of the Carolingian renaissance (fig. 12). After all, Alcuin, one of the key figures of the Carolingian renaissance, was himself Northumbrian, and it is reasonable to think of Northumbria participating fully in the Carolingian intellectual and artistic rebirth. Arguably these late sculptures, of the first half of the ninth century, represent one of the high points of Northumbrian sculptural art in both technique and composition.

DOMINIC TWEDDLE

109 Two balusters

St Paul's Church, Jarrow, Tyne and Wear
Medium-grained yellow sandstone; (a) DIAM. 31 cm, H. 71 cm, (b) DIAM. 31 cm, H. 68 cm
Anglo-Saxon; 7th–8th century
St Paul's Church, Jarrow

These are lathe-turned and decorated with a combination of circumferential mouldings and grooving. Each has a hole at one end.

In all there are twenty-five baluster shafts or fragments from Jarrow. The uniform height of the intact examples suggests that they all derive from the same feature, possibly part of a screen enclosing the altar. The Jarrow balusters differ in detail, but not in overall concept, from those at nearby Monkwearmouth where pairs of balusters survive *in situ* on either side of the west door of the porch, normally dated to before 689. This provides a reasonably secure date for the series from the late seventh into the early eighth century. DT

Bibliography: Cramp 1984, 120–1, no. 30 a–y, figs 9–10, pls 103, 551–8; 104–5; 106, 571–5.

110 (a, b) Imposts or frieze fragments

Hexham Abbey, Northumberland
Massive yellow sandstone; (a) H. 18 cm, W. 35.5 cm, D. 29 cm, (b) H. 17.8 cm, W. 31.4 cm, D. 14.2 cm
Anglo-Saxon; late 7th or early 8th century
Rector, Churchwardens and PCC of Hexham

Fragment (a) is originally of square section but now roughly broken at each end, below, and to the rear; the upper face is dressed flat. The front face is decorated with a naturalistic animal facing right, it has a well-modelled bovine head with small rounded ears and a convex back which impinges on the upper plain frame. The front haunch is lentoid and the front leg extended almost horizontally. The fragment is covered in a white base.

Fragment (b) is of square section, roughly broken to the right but dressed flat above, below and to the rear. The front face has a plain raised frame and is decorated with an animal similar to that on (a), but facing left. The left-hand end of the stone is also decorated, having a plain raised frame containing a relief circle enclosing a double diamond. There are extensive remains of a white base.

These two fragments are clearly related in size, material and in the nature and handling of the decoration. They may have formed part of a narrow frieze decorated with naturalistic animals such as that on the seventh-century porch of St Peter's Church, Monkwearmouth. In that case the decorated end of (b) would place the piece at a point where the frieze turned a corner. Alternatively the pieces may have been imposts to a relatively small arch. In either case the parallel with the Monkwearmouth frieze suggests an early date, perhaps in the late seventh or early eighth century. The white base covering much of the fragments was clearly intended as the base for paint. DT

Bibliography: Cramp 1974, 119–20, 177, pl. 9A–C; 1984, 189–90, nos 33–4, pls 1007–10, 1112–15.

111 Animal-head terminal

St Peter's Church, Monkwearmouth, Co. Durham
Medium-grained massive yellow sandstone; H. 30 cm, W. 31 cm, D. 18 cm
Anglo-Saxon; 8th–early 9th century
St Peter's Church, Monkwearmouth

It is three-dimensional with a short squared muzzle, now partially broken away. This curves up into a low domed forehead. The mouth is indicated by a deep groove running down and back on each side towards the neck, and linked at the front. On each side the muzzle is divided from the rear of the head by a pair of S-shaped grooves defining a shallow moulding which comes up and over the pointed ovoid eye to outline the dome of the head. A similar moulding forms a collar which curves up to form a point under the muzzle.

The original function of this piece is unclear, but it seems likely that it was the finial to a chair end in the same way as the Lastingham piece (112), although rather larger. Chairs with animal head finials to their backs are depicted in

111

numerous contemporary manuscripts, for example in the Lindisfarne Gospels (80) and Durham MS B.II.30, f. 81v (89). DT

Bibliography: Bruce-Mitford 1969, pl. 19A; Cramp 1984, 139, no. 16, pls 124, 673–6.

112 Chair fragments

Lastingham, North Yorks.
Sandstone; *Head:* H. 19 cm, W. 23 cm, T. 9 cm, *Support:* H. 26 cm, W. 27 cm, T. 9.5 cm
Anglo-Saxon; 8th–early 9th century
Ryedale Folk Museum, inv. no. A.3072; St Mary's Church, Lastingham

The head is three-dimensional. The almost parallel-sided muzzle is broken away at the end. There is a high, domed forehead and the back of the head is rounded. At each side of the muzzle the mouth is indicated by a deep incision and the muzzle is separated from the rest of the head by an incised, reverse S-shaped line. The eyes are indicated by incised circles with a central drilled pupil. From the rear of each is a downcurved, sub-triangular extension. On the top of the head is a pair of lobes, perhaps representing the ears. On the rear of the head and running down the neck is a recessed field filled with linked heart-shaped motifs. The support fragment is sub-triangular with a straight back and sloping front edge. The top and bottom are roughly broken away. The front edge is decorated with a plant scroll between plain raised frames. Each of the main faces is largely undec-

112

113

orated apart from a narrow recessed zone along the front edge decorated with incised interlace. There is a similar recessed zone, but undecorated, on each side along the rear edge. The edge itself is decorated with adjoining heart-shaped motifs.

The two fragments have been reconstructed as part of a chair: either one side of a tall chair back, or perhaps broadening out to form a complete side piece. The animal head finial is clearly related to that from Monkwearmouth and is probably of broadly similar date. DT

Bibliography: Lang 1991.

113 (a, b) Door jamb fragments

Lastingham, North Yorks.

Sandstone; (*a*) L. 46 cm, W. 18 cm, T. 12 cm, (*b*) L. 69 cm, W. 20 cm, T. 20 cm

Anglo-Saxon; 8th–early 9th century

St Mary's Church, Lastingham

Both are of square section and undecorated apart from the front face; the ends are trimmed roughly flat. On fragment (*a*) the decoration consists of a spiral scroll with trumpet bindings and triangular berry bunches confined between pairs of plain frames. On fragment (*b*) the decoration consists of interlace disposed around a series of regularly-spaced shallow bosses along the vertical axis of the field. There is a double plain frame to the left. To the right is a single plain frame with, outside it, a broad undecorated zone.

114

In both cases the lack of a taper and the confinement of the decoration to a single face confirms that these are not cross shaft fragments. The most likely explanation for them is that they are architectural, perhaps decorated jambs used to enrich a doorway or arch in the manner of the surviving examples at Britford, Wilts. With the chair fragment (112), these pieces suggest something of the quality and richness of the pre-Viking church at Lastingham, despite the lack of surviving documentation for the site. DT

Bibliography: Collingwood 1907, 277, 358–9, figs p, q.

114 Screen fragment

Jedburgh, Borders
Fine-grained sandstone; L. 79 cm, w. *c*.60 cm, T. 26 cm
Anglo-Saxon; early 9th century
Historic Scotland, Site Museum, Jedburgh Abbey

Sub-rectangular, roughly broken above and to the left and dressed flat below and to the right. The rear face is roughly dressed flat. The front face has a flat broad plain frame below, and, partially cut away, to the left. To the right is a similar frame, with a second frame paralleling it a short distance in from the edge and forming the left-hand side of a narrow vertical decorated field. A similar plain frame forms its upper edge. The field itself is filled with fine interlace. The rest of the face is filled by a second large field with no upper frame, and filled with a single tree scroll. The scroll has ridged nodes, long triangular berry bunches, and leaf flowers. The lowest pair of scroll is filled with quadrupeds, the second pair with birds and the third, upper pair with winged bipeds. The animals are very naturalistic, and in high relief.

The fragment probably formed part of a decorative panel, or perhaps part of a screen, or a shrine like that from St Andrews. The fine naturalistic vine scroll can be compared in quality with that of the Easby shaft (fig. 12), while in organisation there are clearly close comparisons with the decoration of the cross fragment (115). A similar date can be proposed for this piece. DT

Bibliography: Collingwood 1927, 43–5, fig. 57; Wilson 1984, 77, fig. 78.

115 Cross-shaft fragment

Croft on Tees, North Yorks.
Limestone; H. 47.5 cm, W. 30 cm, T. 19 cm
Anglo-Saxon; 9th century
St Peter's Church, Croft on Tees, North Yorks.

Of square section, dressed roughly flat above and below, and with part of Face D chiselled away. All the faces have a double plain raised frame. Face A is decorated with a symmetrical tree scroll with trumpet bindings and pointed and triple leaves. The scrolls of the tree contain symmetrical pairs of semi-naturalistic animals, inward-facing birds at the bottom, outward-facing quadrupeds in the middle register,

115

and inward-facing birds again on the top. Face B is decorated with a median incised interlace. Face C is divided into two roughly equal fields by a pair of horizontal plain raised frames. The lower half is filled with a plant scroll having pointed leaves and interlace elements enmeshing below a pair of quadrupeds, and above a pair of birds. The upper field contains a bush scroll with pointed and triple leaves. In it are a pair of semi-naturalistic inward-facing birds, partially cut away at the upper end of the shaft. Face D contains a delicate plant scroll of similar form, largely destroyed.

The decoration of this shaft seems to be more closely related to southern English fashions than those of Northumbria. Both the semi-naturalistic animals and the leaf forms of the scroll, for example, lie close in spirit to those of the south-west Mercia material (see 209), even if the detailing is different. This type of very fine, small-scale low relief ornament does occur elsewhere in Northumbria in the ninth century, as for example on the York shaft (116). DT

Bibliography: Collingwood 1907, 306; Collingwood 1927, 47, fig. 59; Kendrick 1938, 149–50, pl. LXI; Cramp and Lang 1977, no. 3; Wilson 1984, 77, fig. 79.

116

116 Cross-shaft fragment

York Minster

Magnesian limestone; H. 28 cm, W. 39 cm, D. 17 cm

Anglo-Saxon; 9th century

The Dean and Chapter of York: Foundations of York Minster Display

Fragment of a tapering shaft of rectangular section. It is
roughly broken below and dressed flat above. Faces A and B
are decorated, Face D is dressed flat and Face C dressed
almost flat. The decoration on Face A is in very shallow
relief; it consists of a flat median moulding with a simple
scroll to each side. Each of the scrolls is inhabited with
naturalistic birds and animals. The plants have triangular
and triple leaves. To the left is a fine roll moulding on the
angle with Face B. This has a similar moulding on the
opposite angle, and is filled with ten-strand plait with breaks.
The strands are wide and flat and fit closely together. Face
C was decorated in the same way as Face A, but the decoration
is largely chiselled away.

117 (front)

The decoration on Face A is similar to that on the pieces
from Croft and Jedburgh (115, 114) and on this basis a
date in the first half of the ninth century is plausible. The
decoration on Face B, however, is more reminiscent of Anglo-
Scandinavian interlaces. Such flat, closely-fitting strands are
not common before that time. Either this shaft documents
the earliest introduction of this form of interlace, or it rep-
resents the survival into the later ninth century of earlier
traditions. DT

Bibliography: Lang 1991.

117 Grave marker

Lindisfarne, Northumberland
Greyish sandstone; H. 28 cm, W. 42 cm, T. 8.5 cm
Anglo-Saxon; late 9th century
English Heritage, Priory Museum, Lindisfarne

Semicircular headed with slightly splayed sides. Both main faces have a plain raised frame and are decorated. On the front face is a procession of seven figures moving right. They wear short garments falling to mid-thigh level and which are horizontally hatched. Five of the figures brandish swords or axes. On the reverse is a standing Latin cross with parallel-sided arms and almost circular re-entrant angles. To either side is a bowing figure with its hand outstretched towards the cross. A hand develops from the frame to each side at the level of the lateral arm of the cross. The upper arm of the cross is flanked by the sun to the left and the moon to the right. The edge is undecorated.

The apocalyptic scene on the front has often been taken to depict a Scandinavian raid on Lindisfarne, such as that which took place in 793. These raids were regarded by Alcuin and other Anglo-Saxon writers as a judgement. Such a theme would, therefore, link closely with the scene on the reverse, which probably represents the Day of Judgement. DT

Select bibliography: Peers 1923–4, 269, pl. lvi, 1–2; Collingwood 1927, 106; Kendrick and Hawkes 1932, 343–4, pl. xxx; Graham-Campbell 1980, no. 1, pls Ia, b; Cramp 1984, 206–7, no. 37, pls 201, 1132–4.

(*Below*) Coins of the Archbishop of York, and a gold donative solidus/mancus of Archbishop Wigmund (**120**)

Coins

118 (a, b) Pennies of Ecgberht, archbishop of York (735–66), with his brother Eadberht, king of Northumbria (738–58), struck at York

Silver; WTS (*a*) 1.15 g (17.7 gr), (*b*) 1.24 g (19.1 gr)
British Museum, CM acquired from the collection of Sir Robert Cotton (d. 1631), and CM 1935, 11–17–572 from the T. G. Barnett Bequest

These coins are the earliest to bear the name of an archbishop of York. Ecgberht was the first archbishop of York and received his pallium in 735. When exactly in the reign of Eadberht his brother's coins were produced is not known, but the issue as a whole appears to have lasted some time.
MMA

Provenances: Not known.
Bibliography: BMC 140 (**118a**); Booth 1984, nos 20 and 12; Archibald and Cowell 1988.

119 (a, b) Pennies of Ecgberht, archbishop of York (735–66), with Alchred, king of Northumbria (765–74), minted at York, 765–6

Silver; WT (*a*) 1.08 g (16.6 gr), (*b*) 1.06 g (16.3 gr)
British Museum, CM 1858, 12–21–1 and 1935, 1–17–575

These coins can be dated very closely between the accession of Alchred and the death of Ecgberht. MMA

Provenance: Not known.
Bibliography: (Neither in *BMC*); Booth 1984, nos 4 and 2; Archibald and Cowell 1988.

118a

119a

118b

119b

120

121

122

120 Solidus/mancus of Wigmund, archbishop of York (837–54 or later), minted at York, ?c.837, holed for use as jewellery

Gold; WT 4.16g (68.2gr)
British Museum, CM 1848, 8–19–171

The obverse copies the distinctive full-face tonsured bust used on coins of the archbishops of Canterbury (226), derived from eighth-century papal issues, and ultimately from the facing effigies on Byzantine coins. The reverse design and inscription are so closely copied from the gold solidi of the Carolingian Emperor Louis the Pious struck in c.816–19 that the prototype must have been an original or good-quality copy, rather than one of the more plentiful Frisian imitations or their southern English derivatives (147a–c). Although Wigmund's coin cannot be dated, the 'Divine gift' may allude to the bestowal of his office or pallium, but it may have been required for a donative on some other occasion. MMA

Provenance: ex Pembroke sale, Sotheby, 31.vi.1848, lot 34. This collection had been formed by Thomas, 8th Earl of Pembroke (c.1656–1733).
Bibliography: BMC 718; Stewart 1978a, A123.

121 Penny ('styca') of Wigmund, archbishop of York (837–54 or later), struck at York, moneyer Ethelweard

Very base silver; WT 1.26g (19.4gr)
British Museum, CM 1838, 9–21–2

This coin with the archbishop's title IREP is not among his earliest. The moneyer Ethelweard also worked for King Eanred who died c.840 (or later, see 229). MMA

Provenance: ex Hexham, Northumberland, hoard, found between 1832 and 1841; purchased at the Spurrier sale, Sotheby, 29.viii.1838, lot 5.
Bibliography: BMC 754; Lyon 1956; Pagan 1969; Pirie forthcoming.

122 Penny ('styca') of Wulfhere, archbishop of York (c.854–?900), struck at York, moneyer Wulfred

Copper with a very little silver; WT 1.22g (18.8gr)
British Museum, CM 1896, 4–4–52

The retrograde legends are indicative of the increasing dislocation of the Northumbrian kingdom in the years before it submitted to the Danish Viking invaders in 866/7. Wulfhere's coins are die-linked into both the contemporary regal issues of Osbert (231) and the extensive series of blundered and illiterate coins issued at this time. MMA

Provenance: Not known; purchased at the Montagu I sale, Sotheby, 18.xi.1895, lot 399.
Bibliography: BMA 299; Lyon 1956; Pagan 1969; Pirie forthcoming.

England and the continent

Situated at one of the extremes of the known world, and separated from its nearest continental neighbour only by the narrow sea, Anglo-Saxon England established and developed close and vital relations with continental Europe during the seventh and eighth centuries. The Anglo-Saxons themselves were aware of their Germanic origins, which are described by Bede. When Augustine arrived in Kent in 597 current relations with neighbouring Gaul already took a tangible form in the person of the Frankish princess Bertha, Æthelberht's queen, who had come to England attended by her Christian chaplain and supplied with the accessories necessary to the practice of her religion as a condition of the marriage agreement. This arrangement implies close contact between the two royal families prior to their alliance.

The nearest coast of Gaul was visible from south-eastern England and the sea was as much a highway as a barrier. The Lives of several of the Anglo-Saxon saints provide in passing practical details concerning the travel arrangements of the period. It was relatively easy to obtain a passage across the Channel from one of the English trading ports, such as London or Southampton. Information about the merchandise handled in these centres is constantly being enriched by archaeological evidence. The development of their organisation can also be seen from such written evidence as the early eighth-century documents exempting certain shipping from the payment of port dues (151). Passengers were among the cargoes carried. St Boniface, setting out on his first journey to Frisia in 716, made his way to London and took ship for Boulogne, paying a fare to the captain. Similarly his kinsman Willibald, embarking four or five years later on the mammoth journey that was to take him to the Holy Land and to Constantinople, went to one of the ports in the Southampton area and paid to cross to the mouth of the Seine on a vessel provided with both sails and oars. He and his companions then pitched their tents on the riverbank near Rouen before setting out on the long road southwards towards Rome. Coastal shipping might also be utilised for travel. When Abbot Ceolfrid left Northumbria for Rome in the summer of 716, he apparently made his way down the east coast of England and across to Gaul by sea, making three stops on the way and devoting some forty days to this portion of the journey.

The road to Rome was indeed a long one. A later source, detailing Archbishop Sigeric's return route from Rome to Canterbury in 990, names eighty separate stages on his journey, which crossed the Alps by way of what was later to be named the Great St Bernard Pass. The road was increasingly well-trodden in the century after Augustine's arrival with his mission in 597. Gaul was a Christian area, with towns and communities where support and hospitality might be sought. Most travellers were on foot, though horses might be used and, in case of necessity such as illness, litters carried either by servants or between horses. Both men and women eagerly undertook the pilgrimage to the shrine of St Peter, many of them seeking, like Ceolfrid, to end their lives there. A number of English rulers, including Cadwalla of Wessex in 689 and Cœnred of Mercia twenty years later, took this step. Female pilgrims included Boniface's friend and kinswoman Eadburh, abbess of Minster in Thanet. Boniface himself did, however, advise women against undertaking the arduous journey, warning one correspondent of the threat from the Saracens and in 747 suggesting that English female pilgrims should generally be forbidden, as so many of them lapsed from virtue on the journey. According to him, there were few cities along the way that did not contain at least one English prostitute.

The most widely influential of the seventh-century English travellers to Rome was to be Benedict Biscop, founder of Monkwearmouth/Jarrow, who was accompanied on separate occasions by the young Wilfrid and by his own friend and colleague, Ceolfrid. Biscop made the journey no fewer than six times over a period of some thirty years, taking in many of the leading continental religious communities in the course of his travels and thereby influencing the development of his own foundations. He brought home with him not only books and artefacts but also craftsmen whose skills he employed in his native Northumbria. Stonemasons from Gaul worked on his monastic buildings and glaziers filled their windows with coloured glass, at the same time passing on to the local population their techniques for the production of glass vessels. He also invited John the Archchanter to come from Rome in 680 to teach the members of his communities the correct performance of liturgical music and the proper readings. Church music had been among the skills introduced into England by St Augustine's mission and was apparently continuously practised in Kent, whence the singing master Eddius Stephanus came with Wilfrid to Ripon about a decade earlier (95), but the arrival of John at Monkwearmouth/Jarrow was clearly a landmark in the history of early liturgical practice. His material was written down and copied for transmission to other centres, but it is among the manuscript material now entirely lost to us. The continuous changes and developments of liturgical practice over the centuries made service books particularly vulnerable to rejection, and the early ninth-century mass text included in the exhibition (166) is a rare survival of a once widely-available type of Anglo-Saxon manuscript.

The books imported from the continent by Benedict

Biscop and by Ceolfrid are reflected in some of the major manuscripts made in the Monkwearmouth/Jarrow scriptorium (86–9), in which the scribal practices of sixth-century Italy are brilliantly emulated. Their influence is also apparent in the scholarly writings of the Venerable Bede, who clearly had access to a very extensive reference library. The book-collecting activities of the two men suggest an extensive secondhand book trade in both Gaul (where on at least one occasion Biscop left major purchases in the care of friends, to be collected on his return journey) and Italy (where Ceolfrid contrived to acquire a major part of the library of Cassiodorus's foundation at Vivarium). They also brought into England a series of narrative paintings of biblical subjects, including types and antitypes, destined to be hung in their monastery churches for the instruction of the faithful. These paintings might be expected to have attracted the attention of local illuminators and to have been copied by them, but no direct evidence of English imitations has come down to us.

For most of the seventh century, Anglo-continental relations resulted largely in the introduction into England of cultural and scholarly skills, but towards the end of the century the tide turned. The impulse to spread the gospel message to peoples who were still in pagan darkness was very strong in the early Middle Ages. A century after the arrival of Augustine, the English Church had begun to send out its own missionaries into the heathen regions of the continent, roughly speaking to the north and east of the valley of the Rhine. The two main areas of English activity were Frisia, opposite the English east coast, and that part of southern Germany which now constitutes Hesse, Thuringia and Bavaria.

Many Anglo-Saxon men and women were to be involved with the missions during the ensuing century. Their backgrounds were very varied. The earlier of the two leading personalities, Willibrord, was a Northumbrian and spent his childhood and youth under the tutelage of Wilfrid, leader of the 'Roman' faction in the Northumbrian Church. He then studied for twelve years in the Irish community headed by the Northumbrian exile Ecgberht, who had himself dreamed of undertaking a mission to the continent but, like Gregory the Great before him, eventually sent his friend and pupil in his stead. Willibrord went to Frisia in 690, at the head of a mission comprising both English and Irish assistants. The respective influence of the two groups on the subsequent artistic achievements of Willibrord's scriptorium at Echternach is much debated (82, 128). Contacts with Northumbria were certainly maintained, for we hear of an emissary from Willibrord at Lindisfarne and of a visit paid by Wilfrid and his friend and successor Acca to Willibrord himself in 703.

The second great missionary leader, Boniface, was born and educated in Devon, moving on to Nursling in Hampshire in his maturity. His main contacts were with the people and places of southern England. Frisia was his initial objective and it was to Frisia that he returned at the end of his life, resigning the archbishopric of Mainz after almost forty years of apostolic service in Germany. In Frisia he met a martyr's death at the hands of a pagan mob greedy for material gain, sixty-five years after Willibrord had landed in the area to bring the Christian message.

Not all the English churchmen in the mission field came to it with a totally English or Irish background. Boniface's kinsman Willibald, already mentioned as having undertaken an ambitious pilgrimage to the Holy Land early in the eighth century, spent ten years as a monk at St Benedict's foundation of Monte Cassino in Italy before joining Boniface in Germany, where he became bishop of Eichstätt and founded the monastery there.

The establishment of the continental missions followed very much the same pattern as that of St Augustine to England at the end of the sixth century. The approval and collaboration of local rulers and overlords was sought and the participation of the papacy was actively encouraged. From the biographies of the missionary saints (125) and from their collected correspondence, which has been extensively published, we know a very great deal about their lives and activities. In particular we see the links which they maintained with their native England, exchanging not only letters but books, clothing and even apparently livestock. In the middle of the eighth century King Æthelberht of Kent asked Boniface to procure for him a pair of falcons, capable of being trained for hunting, at the same time sending to the saint a precious drinking cup and, more practically, two woollen cloaks.

Also following the pattern of earlier missions, the English took with them into pagan Europe supplies of books and other accessories required for Christian worship. Continental treasuries cherish manuscripts, metalwork and textiles of the period, some obviously imported from Anglo-Saxon sources, others, of local manufacture, clearly drawing upon Insular models which sometimes have no known counterpart among surviving English artefacts. The work produced in Willibrord's scriptorium at Echternach has already been mentioned, much of it reflecting Insular illumination. Two library lists dating from the early ninth century, one from Boniface's chief monastic foundation of Fulda and the other from Würzburg, give some idea of the scholarly books collected in the period at two of the centres within the sphere of Boniface's influence.

England made a further contribution to continental scholarship at the end of the eighth century in the person of Alcuin of York, who joined the entourage of Charlemagne in 781 as a teacher and adviser (129, 130, 159). A pupil of Bede's friend Archbishop Ecgberht, and thus in direct line of succession from England's most famous scholar, his role involved not only direct instruction at the court school and the dissemination of his own writings but also a major contribution to the revision of the liturgy and of the text of the bible which was undertaken at Charlemagne's behest. He furthermore provided a point of contact between Charlemagne's court and the English royal and ecclesiastical dignitaries of the day, ideas and information passing back and forth across the Channel through the medium of his extensive correspondence.

Alcuin's continental career coincided with a new aspect of

Anglo-continental exchange – and one that the English would have been only too happy to forego. In 793 the first Viking raid, descending without warning upon the Holy Island of Lindisfarne, marked the beginning of a completely different relationship.

<div style="text-align: right">JANET BACKHOUSE</div>

Manuscripts

England's fundamental contribution to the manuscript culture of early medieval Europe, transmitted during the eighth century largely through the missionary endeavours and related monastic foundations of a number of outstanding individuals, is not easy to present within the context of an exhibition. The most important witnesses to it, produced within continental centres, are cherished today as the foundational treasures of their own national churches and libraries, from which they may not be removed.

Just as Augustine and Aidan came to their work in the English mission field provided with the books necessary to their task and with scribes and scholars in their immediate following, so Willibrord and Boniface – to name only the two outstanding characters involved – introduced into pagan Frisia and southern Germany the book-based skills of Christian England, now a century old. Both men founded major monastic houses to which scribes and illuminators were quickly attracted and which, not subject to the Viking depredations which extinguished the scriptoria of Lindisfarne and Monkwearmouth/Jarrow in the ninth century, were to continue to rank among the leading centres of book production under the Ottonian emperors of the late tenth and early eleventh centuries. Willibrord and Boniface are themselves among the handful of early medieval personalities whose own handwriting can be identified with fair certainty. It is found in such practical contexts as the notes on a calendar (123) and the marginalia of a scholarly text (124). Their personal enthusiasm for books and learning is chronicled by biographers (125) and in letters.

The Echternach Gospels (82) and the Collectio canonum (126) demonstrate the grandeur of the specifically Insular decorative work which is known to have been familiar to craftsmen in the continental monasteries. The Stuttgart Psalter (128) represents the magnificent work of which their own scriptoria were capable. The importance of the manuscripts associated with English continental foundations to students of Insular art must be emphasised, for it can often reflect aspects of English work now lost to us.

Towards the end of the eighth century another Englishman, Alcuin of York, was invited to settle in Aachen, at the court of Charlemagne, to assist his patron in carrying out an ambitious educational programme, both personal and general. His work, directly supported by Charlemagne himself, had a lasting influence not only upon the development of his own generation but upon that of his successors. He was the foremost man of letters of the time and his own

writings reflect many and various aspects of the scholarly activities of the day (130). His substantial surviving correspondence (129) is a major source for the social and political history of Charlemagne's reign. He was also a moving force behind much of the liturgical and biblical revision deliberately undertaken at the end of the eighth century. In this last role he was to be an abiding influence upon the development of the medieval Church.

<div style="text-align: right">JANET BACKHOUSE</div>

123 The Calendar of St Willibrord

Paris, Bibliothèque Nationale, MS lat. 10837
Vellum; ff. 45; 220 × 170 mm
Latin; beginning of 8th century
Echternach

Born in Northumbria in 658 and of the same noble family that was later to produce his biographer Alcuin, Willibrord was entrusted in infancy to the monks of the recently founded community of Ripon. There he was brought up under the influence of Wilfrid, back in England after several years of

123 Marginal note in the autograph of St Willibrord (f. 39b)

study at Rome and Lyons. At the age of about twenty, Willibrord moved to Ireland and spent twelve years at the monastery of Rath Melsigi under the English abbot Ecgberht. In 690, with eleven companions, he set out on a mission to the Frisians, support for his activities being carefully obtained both from the local Frankish ruler Pippin, father of Charles Martel, and from the pope in Rome.

This manuscript, a particularly emotive relic, contains a calendar and martyrology used personally by the saint at the beginning of the eighth century. It was written at the monastery of Echternach, which he founded in 698, by two scribes, Virgilius and Laurentius, both of whom seem to have originated in Ireland. Among the original names in the calendar are saints of Roman, Frankish, Irish and English origin, including Cuthbert and Oswald. A number of anniversaries of a strictly personal nature are entered, some by the original scribe and some as additions. Among the latter is a long note in Willibrord's own handwriting, added in 728, recording his arrival in Frisia in 690 and his consecration at Rome in 695 as archbishop of the Frisians. On this occasion Pope Sergius I gave him the religious name of Clement. Willibrord lived and worked for a further decade after writing this note. He died in 739 at the very great age of eighty-one.

<div align="right">JMB</div>

Bibliography: CLA v, no. 605; Wilson 1918.

124 Marginal annotation by St Boniface (f. 59b)

124 Primasius on the Apocalypse, with annotations by St Boniface

Oxford, Bodleian Library, MS Douce 140
Vellum; ff. 149; 240 × 185 mm
Latin; late 7th or early 8th century
Southern England

The second great English missionary bishop, Boniface, apostle of Germany, was born at Crediton in Devon in 680 and received his early education and upbringing in the monastery at Exeter. At the beginning of the eighth century he moved on to Nursling, between Winchester and Southampton, where he devoted himself to theological and classical studies until, in 716, he embarked upon his first missionary journey to pagan Frisia. During his years at Nursling he was widely known and very highly regarded as a scholar and teacher. Books and learning remained an abiding concern throughout his life. His considerable surviving correspondence with English friends and colleagues during his more than three decades in Germany is frequently taken up with requests for particular books not readily available to him from continental sources.

Several surviving manuscripts are annotated in an eighth-century script which has been convincingly identified as the autograph of Boniface. This particular volume, written out in a clear Insular half uncial, was apparently made in England and remained there until annotated in the tenth century by St Dunstan, so the marginal capitula attributed to Boniface were presumably added while he was at Nursling. One of his additions appears in the margin near the top of the opening page of text. Corrections lower down the page are by Dunstan. Other volumes annotated by Boniface are preserved at Fulda and in Leningrad.

<div align="right">JMB</div>

Bibliography: CLA ii, no. 237; Parkes 1976, 162–79; The Douce Legacy 1984, no. 212.

125 Willibald's Life of St Boniface

British Library, Additional MS 21171
Vellum; ff. 43; 205 × 155 mm
Latin; beginning of 11th century

At the end of a long and distinguished apostolic career in Thuringia, Hesse and Bavaria, Boniface resigned the dignity of the archbishop of Mainz and returned to Frisia, the scene of his first missionary endeavours some forty years earlier. There he and his companions were martyred on 5 June 755 by a pagan horde, who apparently expected to find great riches in the chests of relics and books that the missionaries carried with them.

Demands for a Life of the saint were very soon being directed to his friend Lull, who had succeeded him at Mainz. The task of compiling it was entrusted to an Anglo-Saxon priest named Willibald, who gathered much of the material from Boniface's surviving disciples. The finished work was addressed to Lull (d. 785) and to Megingoz, archbishop of Würzburg. The latter died in 768, so the book must have

125 Account of the martyrdom of St Boniface and his companions (ff. 19b–20)

been completed within a dozen years of Boniface's death. According to information in a later Life, Willibald drafted his text on wax tablets and submitted it for the approval of the two archbishops before a fair copy on parchment was made. JMB

Bibliography: Levison 1905; Talbot 1954, 23–62; Whitelock 1979, no. 158.

126 Collectio canonum

Cologne, Dombibliothek, MS 213
Vellum; ff. 143; 330 × 230 mm
Latin; early 8th century
Northumbria

In this fine and comparatively little-studied manuscript a collection of canons (ecclesiastical legislation based on the rulings of early Church councils) is written and illuminated to a standard almost equal to that found in the luxury gospel books of the period. The volume was clearly designed to impress. There are no clues to its precise place of origin though the style of both script and decoration clearly indicates Northumbria, but it reached the continent very early in its history.

The manuscript opens with a fully-decorated initial page, very similar to the major initial pages of Insular gospel books. Details such as the bird interlace invite comparison with the Lindisfarne Gospels (**80**), though the range of colours is limited to orange, yellow and green. The early part of the text includes a series of extremely fine minor initials, incorporating both bird and geometric ornament. Later in the volume initials take on a simpler, more calligraphic form, though this is no less exuberant. The greater part of the text is written in an assured Insular majuscule though some sections, including several lines at the foot of most pages, are in an elegant minuscule.

The manuscript may be regarded as a fine example of the type of illuminated book which, like the Echternach Gospels (**82**), was sent from England to the continent during the

126 Decorated opening page (f. 1)

eighth century. It is possible that it was commissioned for that purpose. The scriptorium which produced it was capable of the very highest standard of work. At the end of the manuscript (f. 143) the words 'Sigibertus scripsit' appear, written in a rather uneven uncial. This hand, in spite of the wording, was not responsible for writing out the book, but the inscription does link the volume to a second collection of canons (127), which in turn offers evidence to suggest that both books had reached Cologne by the end of the eighth century. JMB

Bibliography: CLA viii, no. 1163; Alexander 1978, no. 13; Henderson 1987, 88–90.

127 Collectio canonum

Cologne, Dombibliothek, MS 212
Vellum; ff. 171; 335 × 270 mm
Latin; 590–604
Gaul

Although this heavily used manuscript is neither English nor the product of an English foundation on the continent, it is linked to the previous manuscript (126) by the inscription 'Sigibertus bindit [i.e. vendit] libellum' written at the foot of the text on f. 167b. Among the added inscriptions at the beginning of the volume is one naming Hildebald, who has been identified as the bishop of Cologne from 785 until 819. Before his elevation to the bishopric, Hildebald had been abbot of Mondsee near Salzburg, founded in the mid eighth century within the area directly influenced by Boniface. Other Cologne books are known to have been brought by him from Mondsee, and it is possible that this was the source of both copies of canons, though the Northumbrian book could also have been acquired from a centre nearer at hand, such as Echternach.

This manuscript is of interest in the context of the present exhibition, not only for the light it sheds upon the history of the other 'Sigibertus' book, but also as an example of a continental manuscript of the period. It was written and decorated in Gaul and can be very precisely dated to the time of Gregory the Great, the pope responsible for St Augustine's mission to Kent, because no dates are assigned to his name, which is the last in its list of popes. It is the kind of manuscript that Anglo-Saxon travellers and missionaries might well have acquired for their libraries. Decoration of the type it contains provided elements which were assimilated into the work of scribes and illuminators working in the English missionary foundations. JMB

Bibliography: CLA viii, no. 1162.

128 The Stuttgart Psalter

Stuttgart, Landesbibliothek, Cod. Bibl. 2° 12
Vellum; ff. 93 (divided into 3 volumes); 305 × 210 mm
Latin; mid 8th century
Probably Echternach

At Willibrord's foundation of Echternach a notable scriptorium was established, producing magnificent illuminated manuscripts as well as plainer books for practical use. In the work of this scriptorium the scribal and decorative traditions of Ireland, Northumbria, Italy and Gaul meet and are blended. Willibrord and his eleven original companions had come to Frisia direct from Ecgberht's monastery in Ireland and their number included scribes. The famous Echternach Gospels, now in Paris (82), was probably not the only fine manuscript acquired from Northumbria, and its influence is clearly discernible in local products such as the Trier Gospels (Trier, Domschatz, Cod. 61). Further books were collected by Willibrord from Rome and elsewhere in the course of his travels, to provide much-needed texts for his community.

128a Initial to Psalm 1 (f. 1)

128b Initial to Psalm 51 (f. 32)

ORA....TIO PAUPERIS CUM ANCXIARETUR ET
IN CON........SPECTU DNI EFFUNDIT ORATIONE

DNE EXAUDI ORATIONE

meam etclamor manducare panem
meus adte perueniat meam aduoce gemi
Neauertas faciem tus mei adhaeserut
tuam ame inqua ossa mea carni meae
cumque dietribu Similis factus sum
lor inclinaadme pelicano insolitadi
aurem tuam inqua nem factus sum si
cumque die inuoca cut nycticorax in
uerote uelociter domicilio uigilaui
exaudime etfactus sum sicut
Quia defecerunt passer unicus in
sicut fumus dies aedificio
mei et ossa mea si Tota die exprobra
cut frixorio con uerunt me inimici
frixa sunt mei et qui melau
Percassus sum sicut dabant aduersum
fenum etaruit cor me iurabant
meum quia oblitas Quia cinerem sicut pa
 sum ..e.m

128c Initial to Psalm 101 (f. 63)

This majestic psalter, written out in two volumes in a fine uncial script, is attributed to the Echternach scriptorium about the middle of the eighth century. Both the large initials marking the main divisions of the text and the lesser initials incorporated within the text itself are based on fish motifs borrowed from continental book decoration. The manuscript once contained a litany in which a petition for the congregation of St Willibrord (d. 739) was included, but this is now lost. It was divided into three parts by an eighteenth-century owner, which permits all three major initials to be shown. JMB

Bibliography: CLA viii, no. 1253; Alexander 1978, no. 28.

129 Letters of Alcuin

British Library, Harley MS 208
Vellum; ff. 119; 250 × 145 mm
Latin; end of 9th century

Among the written sources for the activities of Anglo-Saxon churchmen working on the continent, the volumes of their letters provide a great sense of personal contact. Exchanges were maintained not only with leaders of Church and state,

on whose goodwill the success or failure of a project might depend, but also with personal friends, both men and women, to whom requests were not infrequently addressed for the supply of books, clothing and other items not readily available abroad.

Among those whose letters were collected for later circulation was Alcuin, pupil of Bede's friend Ecgberht of York, who achieved scholarly renown early in life and in 781 was invited by Charlemagne to head his palace school at Aachen. Alcuin corresponded with many important figures, including King Offa of Mercia (**159**), but his most widely quoted letters are those which were inspired by the Viking raid on Lindisfarne on 8 June 793. This disaster, striking without warning at one of the holiest places in England, was regarded by Alcuin as a sign of the wrath of God and he dispatched a number of exhortatory letters to such dignitaries as the archbishop of Canterbury, the king of Northumbria and the abbot of Lindisfarne itself. He also, however, penned a much more personal letter, the opening of which is shown (f. 11), to a friend who was a priest at Lindisfarne. To this man, named Cudrado, he sent first and foremost congratulations that God had seen fit to deliver him out of the clutches of the pagans. JMB

Bibliography: Thompson 1884, 86.

130 Alcuin on the Song of Songs

British Library, Royal MS 5 E.xix
Vellum; ff. 52; 232 × 165 mm
Latin; 11th–12th century
Salisbury

This example of Alcuin's exegetical writings occupies ff. 37–45v of a collection of homilies and commentaries probably copied at Salisbury during the twelfth century. Designed to interpret or explain the scriptures, exegesis was a popular early medieval form of theological writing, of which Alcuin was a keen exponent. His training at York (the library of which he praised in a poem on the archbishops of York) meant that he was well versed in the Insular exegetical tradition and he was probably acquainted with Bede's earlier commentary on the Old Testament text, Solomon's Song of Songs (as well perhaps as those by the Greek Fathers, with whom it was particularly popular).

The inscription at the head of f. 37, noting the existence of two further copies, is by Patrick Young (1584–1652), an important scholar and royal librarian, who undertook a printed edition of this Alcuinian commentary in 1638. MPB

Bibliography: Young 1638; Migne 1851, 639–65; Duckett 1951; Heil 1970; Mayr-Harting 1972, 212–14, 262–3; Bullough 1973.

129 Alcuin's letter to Cudrado (f. 11)

130 Alcuin on the Song of Songs (f. 37)

Metalwork, ivory and textiles

Regular Anglo-Saxon traffic with the continent goes back to the earliest settlements; contacts with the western seaboard of Europe from Norway down to south-western Gaul are well attested by archaeological evidence on both sides of the sea, and it is clear that there were also some contacts with the lands beyond to east and south. However, such traffic was considerably strengthened and extended after the Conversion, as much through developing commerce, it is inferred, as by the documented movements of churchmen and pilgrims. With all of these, whether merchants and diplomats, monastic craftsmen or missionaries, goods and ideas of all sorts travelled, the profane and the sacred. Glimpses of this constant exchange emerge from time to time in the documents; Charlemagne complains famously to Offa about the declining quality of English cloaks, Boniface sends gold to Eadburh, abbess of Minster in Thanet, to decorate a copy of St Peter's epistles she is making for him. The tangible evidence of these contacts, however, is inevitably a rare survival.

Ironically, one of the more striking accidents of the frequent ecclesiastical traffic between England and the continent at this time is the fact that many of the major pieces of Anglo-Saxon church metalwork and ivories have survived more or less intact in continental treasuries or collections, when their counterparts in England, which endured the vicissitudes of Viking raids and later the Dissolution, more often than not survive only in mutilated condition. That the Codex Amiatinus (88), the Mortain *chrismal* (137) and the Bischofshofen cross (133) have survived in so much more complete a state than the pitiful few leaves of the Ceolfrid Bible (87), the mutilated Winchester reliquary (136) and Dumfriesshire fragments (135) is an unforeseen happy byproduct of this relationship. From these important survivals we can more easily gain some idea of what is lost and how to reconstruct what survives in damaged state, as well as see something of the two-way cultural currents in action.

Of course, not all eighth- and ninth-century Anglo-Saxon objects abroad necessarily reached the continent at that time. Some, like the Franks and Gandersheim caskets, might well have been taken abroad at a later period (70, 138), though in fact, for most of these pieces, there is no way of telling by what agency they came to end up at, for instance, Aldeneik, Genoels-Elderen, or Mortain (141, 137). However, a few tell a more revealing story: the Cutberht Gospels and the Bischofshofen cross (133), for example, are two of a number of objects and manuscripts made by Anglo-Saxons or strongly influenced by Anglo-Saxon style which survive from southern Bavaria, some with particular connections to Salzburg. Here there is an obvious reflection of strong Insular links represented by the presence of the Iona-trained scholar Virgil as Salzburg's bishop in the mid eighth century. The Bischofshofen cross is indeed so substantial and ambitious a piece of workmanship that it seems reasonable to suppose that it was produced, like the Cutberht Gospels, by an Anglo-Saxon craftsman working abroad, rather than transported ready-made. The presence of active Anglo-Saxon scribes, illumi-

nators and metalworkers in communities abroad also had another highly visible consequence, namely the spreading influence of Insular style upon continental ivories and metalwork as well as in books (e.g. **140, 141**).

One notable result of this is the so-called Anglo-Carolingian style of metalwork, seen at its most exuberant on the chalice commissioned by Duke Tassilo of Bavaria for Kremsmünster Abbey between 777 and 778, and the somewhat later but even more lavish cover of the Lindau Gospels (**131, 132**). These are prestigious artefacts presented to major foundations by powerful princes, and their Anglo-Saxon-influenced decoration was clearly perceived as appropriate to such high status – a fact reflected in the extended popularity of this ornament on high-class secular metalwork. A similar process, though much different in effect, seems to be at work in the Munich and Victoria and Albert Museum ivory panels (**140**) which, while though certainly of continental manufacture, show strong Insular stylistic influence, for instance in details such as the animal-head volutes, which are of a type closely related to those seen in Anglo-Saxon metalwork and on the Bischofshofen cross.

This traffic is by no means one-way, however, as the Bischofshofen cross itself shows in elements of Carolingian acanthus leaf on its arms. And as the presence of cannibalised metal sheet with Carolingian acanthus decoration on the back of the Winchester reliquary shows (**136**), continental influences were as readily introduced via Carolingian artefacts and manuscripts reaching England as by direct assimilation by Anglo-Saxon craftsmen working abroad.

LESLIE WEBSTER

131 The Tassilo Chalice (copy)

Copper-alloy, gilt; on the exterior decorated with silver plating and niello and glass inlay; H. 26.6–27.0 cm; CAP. 1.75 l

Anglo-Carolingian; 777–88

Benedictine Abbey, Kremsmünster, Austria (copy: Römisch-Germanisches Zentralmuseum, Mainz)

The Chalice comprises three elements: cup, knop and foot. Between the cup and the knop is a collar of beaded wire, the foot and knop being cast together. The chief ornamental element of the cup comprises five oval fields, each engraved with a single figure (Christ and the four evangelists); the background of each figure is silvered. Four similar fields occur on the foot, only three of which have been identified (John the Baptist, Mary and Theotokos). The rest of the ornament consists of chip-carved animal, vegetal or interlace ornament, apart from lozenge-shaped fields on the knop, each of which is decorated with a series of overlapping circles (all silvered) and an inscription on the foot.

The cast inscription, + TASSILO DVX FORTIS + LIVTPIRC VIRGA REGALIS, refers to Tassilo (last duke of Bavaria), who was deposed by Charlemagne in 788, and his wife Liutpirc, daughter of the Langobard king Desiderius. As the monastery of Kremsmünster was founded (by Tassilo) in 777, this places the Chalice's manufacture between 777 and 788 (unless it was given to the monastery after the deposition of Tassilo).

131

The animal ornament of the Chalice is characterised as 'Anglo-Carolingian', having been defined by Haseloff as derived from an English model (e.g. the Witham pins, **184**); the most typical continental feature is the splayed hind-leg. The Chalice, apart from being a splendid object, is important in being an index for dating not only the Anglo-Carolingian style, but also chip-carved Anglo-Saxon ornament. DMW

Select bibliography: Haseloff 1951; Ryan 1990, 303–4.

132 The Lindau Gospels Cover (copy)

Silver-gilt, ornamented with enamel and semi-precious stones, on a wooden (?oak) base; 34.4 × 26.2 cm

Anglo-Carolingian; c.825

New York, Pierpont Morgan Library, MS 1 (copy: Römisch-Germanisches Zentralmuseum, Mainz)

Lower cover of a gospel book (not that which it now protects). Later additions include the borders towards the sides and top, the plate at the corner of the lower edge, the plates in

the angles of the main field, the settings in three of the fields between the arms of the cross, and a number of semi-precious stones.

The mounts of the cover consist of an enamelled silver-gilt cross within an enamelled border. Within the arms of the cross are silver chip-carved plates decorated with Anglo-Carolingian animal ornament (cf. the Tassilo Chalice, **131**). In the middle of these plates were mounts containing garnet and crystal. The centre of the cross has been replaced but the contracted words in the triangular fields around it refer to Christ, whose bust appears in champlevé enamel on each arm. The roundels in the long arms are contemporary and contain a mount decorated with gripping-beast ornament of Scandinavian type. The arms also contain *Zenkschmelz* enamel panels which provide the earliest occurrence of this technique (a century earlier than its appearance in Byzantine art). The surviving borders are made up of cloisonné enamelled birds and animals interspersed with cloisonné fields of garnets. The enamels of the border are best paralleled on the reliquary from Enger in Westphalia, which must, however, be of slightly earlier date, and on the Oviedo plaque.

The Enger, Oviedo and Lindau objects were almost certainly made in the same workshop in the southern Rhine region of Germany. The Anglo-Carolingian ornament is a developed (perhaps degenerate) version of that found on the Tassilo Chalice, and it is for this reason that Lindau is dated at least a quarter of a century later, chiming with the date of the Scandinavian gripping-beast plaques (although it should be noted that some see these plaques as derived from the Anglo-Saxon inhabited vine-scroll).

At the secularisation in 1802 the cover was in the possession of the monastery of Lindau on the Bodensee in south Germany; it was probably repaired in Prague in 1594 and may have been at St Gall before that. After 1802 it passed through a number of hands until bought by Morgan from Lord Ashburnham in 1901. DMW

Select bibliography: Haseloff 1990, 86–8, ills 138–9.

133 Standing cross (so-called Rupertus Cross) (copy)

Bischofshofen, Pongau (Salzburger Raum), Austria

Copper-alloy, gilding, polychrome glass, maple; H. 158 cm, W. 94 cm

Anglo-Saxon; second half of 8th century

Bischofshofen parish church, Salzburg Diocesan Museum (copy: Römisch-Germanisches Zentralmuseum, Mainz)

The cross consists of an equal-armed cross-head with square centre and arms which expand gradually to shovel-shaped ends, surmounting an integral straight-sided shaft. It is constructed of repoussé and chased gilt-bronze sheets with glass-paste insets, pinned on one face, and sides of a three-part mountain oak base with tenon at the foot; the wood is of unknown date but certainly a replacement. No covering for the other face of the cross survives: on the remaining face, only nine of the thirty-eight settings for glass insets survive, and the original total may have been greater for the metal on

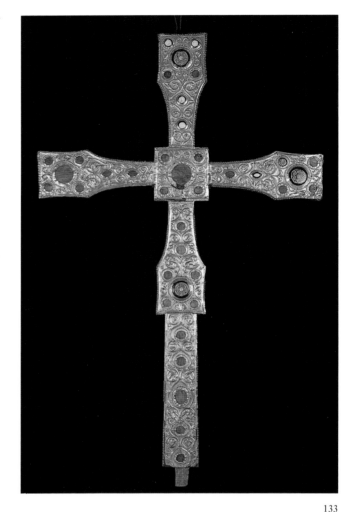

133

the lower end of the shaft has clearly been cut down in the course of refurbishment. Elsewhere, elements of the beaded frame which binds the edges are missing as well as parts of the side strips. The metal sheets of the surviving face are decorated with complex inhabited vine-scrolls in which birds and quadrupeds clamber and feed, and where scrolls terminate in a variety of animal heads. On the *cross-head*, although the overall design of the vine-scroll is symmetrical, each arm differs in the detailed disposition of birds, beasts and animal-headed volutes. In particular, the latter appear (in the form of ox-, hound-, lion-, and reptile-heads) on the central field, and as bovine heads on the lower arms and shaft of the cross. The vine-scroll on the *shaft* of the cross also differs from that on the cross-head in its continuous construction and in the use of different leaf forms (it lacks e.g. the acanthus sprays seen on the arms), and it has many berry bunches which occur only once elsewhere on the cross. The animal and bird forms, though very similar to those on the cross-head, are more ambitious in their design and treatment, and straddle the vine stem in a distinctive leg-lock not seen elsewhere on the cross. The *sides* of the entire cross are

decorated with die-impressed sheets in a triple pattern: one panel each of interlaced mesh, interlaced knotwork, and a highly stylised spiral vine-scroll. The surviving *glass insets* are of three kinds, all of flattened or low convex profile: lentoid, and small and large circular. The colours of the glass paste are opaque throughout. The surviving lentoid stud and all but one of the small round studs have a white centre on a dark blue base: the remaining small stud has a blurred cruciform design in white, yellow and light blue on a dark blue ground. Two of the large circular studs have a design of six running spirals in white around a white centre, all on a dark blue base; the third has a similar design but with a light blue centre and sub-triangular infills around the rim. It is possible that the central setting of the cross may have been the covering to a relic, but it is impossible to be certain of this in view of the reassembly of the original fittings on a later wooden base.

Tradition associates the cross with St Rupert, founder of the cathedral at Salzburg, who is said to have given it to Bischofshofen. This is, however, inherently impossible on grounds of chronology (St Rupert was active in the early years of the eighth century) and it is much more likely that the cross is in some way associated with the bishopric of the Iona-trained Irish scholar Virgil of Salzburg (746/7–84) in whose time the cathedral was consecrated, accompanied by the translation of St Rupert, in 774. While the association of this event with the cross can only remain speculative, it fits the date and origin of the cross implied on stylistic grounds.

As the tenon at the base of the cross shows, it was designed to be free-standing, probably in the vicinity of the altar, rather than a processional cross. Majestic in scale, it is the largest and most splendid of such metal-encased crosses to have survived from the early medieval period, providing a rare glimpse of the theatrical quality of early Anglo-Saxon church furniture. Its programme of jewel-like glass insets within a network of delicate inhabited vine-scroll shows that it is conceived as a *crux gemmata*, laden with symbolism; the quincunxes of glass roundels at the centre and terminals of the arms, for example, evoke the five wounds of Christ, and the inhabited vine-scroll, the *vitis vera* of John 15, v. 1, is both the image of Christ as the true vine nourishing his Church and the living tree on which Christ was crucified. Other layers of meaning have been discerned in this: Hauck (1974) identified the cross as the life-giving tree in which Creation dwelt in a new paradise (Psalm 104, vv. 16 ff), and more recently Elbern (1990, 103) has seen in the animal groups the creatures of Earth, Air and Water in Genesis 1. A strikingly close Anglo-Saxon literary parellel to the cross is given in the poetic meditation 'The Dream of the Rood', where, in a vision, the cross is seen as a living tree, covered with gold and set with five gems on the cross-beam (Swanton 1970). A version of this poem was evidently current in eighth-century Northumbria, as it appears on the Ruthwell Cross, and indeed Northumbrian elements are also seen in the decoration of the Bischofshofen cross.

The interlaced mesh and knot-work decoration on the sides of the cross have been identified for some time as

Northumbrian, and we may now also recognise a close parallel to the tight vine-scroll of these sides in the Dumfriesshire mounts (**135**). The vine-scroll decoration of the principal face was, however, only identified as Anglo-Saxon in 1950 (Jenny 1952). Inhabited vine-scroll is of course a commonplace feature of Northumbrian and Mercian sculpture, and the version seen here has rightly been compared to the metalwork version seen on the Ormside Bowl (**134**); it also bears very close comparison with the MS version seen in the Barberini Gospels (**160**, f. 18). Specific details such as the leg-lock seen on the shaft of the cross also occur on the Bowl and are widespread in Northumbrian and Mercian sculpture (e.g. on the Croft cross, **115**), while animal-head volutes are also a *leitmotif* of Anglo-Saxon eighth-century art (cf. **138**). Equally, the glass pastes reflect northern Insular traditions both technically and in their decoration (cf. the contemporary polychrome glass inset from York, **108e**).

However, it is noteworthy that there are elements here which find better parallels in the more obviously classicising art of the early Carolingian period – the acanthus-like fronds on the cross arms, for example. They hint that the cross, while undoubtedly conceived and made by an Anglo-Saxon craftsman, could have been commissioned and made on the continent, where Anglo-Saxon craftsmen and illuminators

133 (detail of side) 133 (detail)

134

134

certainly worked and were also open to new influences. From a practical point of view, such a massive but fragile piece of work could more safely have been constructed abroad than brought ready-made on the long and hazardous journey from England, though it must be said that the metal analysis may favour Insular rather than local manufacture (Wibiral 1987). But in the end, whether or not it came to be in the Salzburg area as a direct result of the Insular connections which flourished in Virgil's episcopacy, even, indeed, to adorn the newly-consecrated cathedral at Salzburg and the saint's tomb within it, this splendid and imposing piece stands witness to the complex network of relationships between England and the continent in the eighth century. LW

Select bibliography: Jenny 1952, 383–9; Fillitz 1963, 184 f; Hauck 1974, 105 ff; Bierbrauer 1978, 223–30; Budny 1984, 112; Topic-Mersmann 1984, 125–52; Bierbrauer 1985; Fillitz and Pippal 1987, Kat. no. 1 (and refs); Wibiral 1987; Bierbrauer 1988, 328–41 and Kat. R.100; Elbern 1990, 96–111.

134 The Ormside Bowl

Ormside, Cumbria, from the churchyard
Silver, copper-alloy, gilding, blue glass; D. 13.8 cm
Anglo-Saxon; second half of 8th century
The Yorkshire Museum, York, inv. no. 1990.35

The double-shelled bowl consists of a plain gilt-bronze inner bowl and a decorated silver-gilt outer bowl with separate decorated inner and outer base plates, the whole riveted together by large bossed rivets in wire-collared settings. A separate beaded and wire-embellished band around the exterior of the rim is attached to the inner bowl by rivets concealed by four rectangular settings, originally containing blue glass on the exterior, and by small collared rivets (the settings lost) on the interior. Above it is a (fragmentary) ribbed silver binding secured by two secondary silver clamps with animal-head terminals with comma-shaped ears. The circular inner and outer base plates have a design of a cross with expanded arms and central settings and, between the arms, collared bosses which conceal the rivets fixing both plates to the inner shell. On the inner plate, the cross-arms are decorated with beaded silver wire interlace, the four bosses were blue glass cabochons, and a ring of small circular greenish glass pastes (all but one missing) surround the now empty central setting. On the simpler exterior plate, the interlace is in repoussé and the four collared sub-conical bosses are of silver, surrounding a single central domed boss.

The silver-gilt outer shell is decorated in four quadrants with repoussé and chased inhabited vine decoration; each quadrant has a different design of a symmetrical bush-vine in which four lively and sometimes grotesque beasts and birds feed and clamber.

The Bowl was found early in the nineteenth century in Ormside churchyard, where subsequent finds hint that it may have come from a Viking grave: the secondary animal-headed rim clamps are closely related to early ninth-century strap-ends, indicating that the Bowl had been repaired in that

period and thus could indeed have been available for burial in a Viking context. In its form and small size, the Bowl itself is clearly related to some of the silver bowls from St Ninian's Isle (Wilson 1973, pls 18–25) but its double-shelled construction is a unique survival. The striking use of prominent bossed rivets and filigree-decorated twin centre plates also recall the lost Witham hanging-bowl (Wilson 1973, pls 51–2), which probably belongs to the first half of the eighth century. The Ormside Bowl is certainly later: in particular, the bush-vine and its eccentric inhabitants reflect the increasing fondness for the symmetrical bush-vine type characteristic of metalwork of the second half of the eighth century (cf. **101, 187f**), and the delight in the quirky and grotesque seen in, for example, the later eighth-century Barberini Gospels (**160**) and the sculptured friezes at Breedon-on-the-Hill, Leics. The close stylistic and technical parallel seen with the Bischofshofen cross (**133**), which was probably made in the episcopate of Virgil (746/7–84), further supports a dating in the second half of the eighth century. LW

Select bibliography: The Reliquary and Illustrated Archaeologist 1907, 200–4; Baldwin Brown 1921, 318–28; Brøndsted 1924, figs 72–3; Bakka 1963, 8–11, 22–3; Cramp 1967b, cat. 38; Roesdahl et al. 1981, cat. C.8; Wilson 1984, 64, 67.

135 (a–d) Sheet-metal fragments

Dumfriesshire, Scotland
Copper-alloy, gilding; individual dimensions below
Anglo-Saxon; second half of 8th century
National Museums of Scotland, Edinburgh, inv. no. FC 179

135 (a) Gilded copper embossed strip

Running vine-scroll with spiral structure, within a rectangular frame and beaded ovolo border. Three fragments show the end of the rectangular frame, indicating that there were at least two strips.

W. of strip 2.8 cm, estimated overall L. 40 cm plus

135 (b) Gilded copper embossed sheet with arcaded vine pattern

The decoration is heavier and larger than on (*a*) and a folded packet of this foil suggests that these are fragments from a wide sheet rather than a strip.

Largest fragment *c*.5 × 6 cm

135 (c) Gilded copper embossed and chased sheet

Figural decoration set within elaborate borders and against a background with vegetation and perhaps architectural detail. Identifiable on three separate fragments of foil are a right foot in the corner of a decorative border, shoulder-length hair with torso, and a hand against flowing drapery. As the fragments of foil are small and from a complex image, any reconstruction is necessarily speculative. It is clear however

that while the vegetation and architectural designs are executed to a very high standard and to the same scale, the foot is drawn to a larger scale than either the hand or hair. Extrapolating from the surviving portions of these figures, it would appear that the figure to which the foot belonged would originally have stood some 25–7 cm high while the hand, hair and drapery would have come from a figure or figures approximately half that size.

135 (d) Gilded copper fragments from five bosses

Fine pin-holes around the rims of these show that they were fixed to a backing.

DIAM. 5.9–6.7 cm

These fragments are from a surviving total of around fifty decorated pieces of repoussé sheet and five bosses, found at an unknown locality in Dumfriesshire many years before their first mention in 1905. The embossed sheets and strips appear to have been folded into packets and buried with the bosses. Given their very fragmentary state and unknown

circumstances of discovery, it is impossible to say whether they are from one or more objects. However, the presence of the five large bosses hints at a cross-pattern, which would be consistent with the religious symbolism of vine-scroll and figural foils. As they stand, all the surviving fragments could have come from a large wood-based ecclesiastical object, such as a shrine or altar cross.

Despite de Paor's suggestion that the vine-scroll and some of the other fragments might have come from a late sixth-century continental helmet (de Paor 1960–1), it is obvious that all the fragments belong at earliest to the later eighth century. The running vine-scroll finds its closest parallel in the foils on the sides of the Bischofshofen cross (133), which have panels with very similar spiral vine-scrolls and stylised berry bunches; similar motifs appear on some of the Northumbrian styca coinage (e.g. Wilson 1964, pls IV, C). The width of these foils is indeed very similar to those on the Bischofshofen cross and they could well have come from the sides of such a cross. The figural elements cannot be so easily read, but the presence of a hand, drapery, diagonal framework and decorative elements such as marigold motifs and beaded

135a 135c

borders suggests at the very least a clothed religious figure within a fairly elaborate setting, such as the figure on St Cuthbert's portable altar (**99**) or the seated Christ on the early ninth-century Winchester reliquary (**136**).

The chased repoussé technique on the figural fragments also seems to become popular after the middle of the eighth century, as the Ormside Bowl, Bischofshofen cross, Hexham shrine plates and Mortain 'casket' suggest (**134, 133, 104, 137**). The likelihood must be that all the fittings came from one or more shrines or crosses and belong at least to the second half of the eighth century. LW, RMS

Bibliography: Kinnear 1906, 342–3; de Paor 1960–1.

136 Reliquary

Winchester, Sussex Street, 1976
Copper-alloy, gilding, beechwood; H. 17.5 cm, W. 15 cm
Anglo-Saxon (front), Carolingian (back); first half of 9th century
Winchester Museums Service, inv. no. Arch. 3157.80

Purse-shaped reliquary consisting of a beechwood core mounted with gilt-bronze chased repoussé sheets. In the base are two cavities intended for relics: an object *c.*5 cm long has been identified as a parchment or textile roll. A piece of parchment protrudes from the centre of the wooden core, presumably an authenticating label.

The front plate of the reliquary was ripped off and rolled up before disposition: now fragmentary, it bears a seated figure of Christ within a double beaded border. The back plate is made up of three pieces of cut-up sheet decorated

136 (back)

with continuous acanthus ornament, mounted without regard to the unity of the ornament, and within beaded frames.

The reliquary had been partly dismembered before being discarded in a pit containing late ninth–tenth-century pottery. It is a rare Anglo-Saxon survival (cf. **137**) of a class of small portable reliquary well known on the continent and, in house-shaped form, from Irish and Pictish examples (Youngs 1989, *passim*). The seated figure of Christ recalls the style of evangelist figures in eighth-century manuscripts such as the Codex Aureus (**154**) and Barberini Gospels (**160**), while the obviously cannibalised acanthus-decorated strips have an evident Carolingian origin.

This find from the heart of the kingdom of Wessex seems to reflect the close contacts of the court of Æthelwulf with Francia. LW

Select bibliography: Hinton, Keene and Qualman 1981; Wilson 1984, 159–60; Backhouse, Turner and Webster 1984, cat. 12.

137 Reliquary or container for the host

Mortain (Manche) France, collegial church of St Evroult
Copper-alloy, gilding, beechwood base; L. 13.5 cm, H. 11.5 cm, W. 5.0 cm
Anglo-Saxon; 8th century
M. le Maire et la Ville de Mortain (Manche), France

House-shaped shrine consisting of a rectangular wooden base with hinged gabled lid, encased in sheets of decorated and inscribed gilt-bronze, the lid surmounted by an equal-armed cross and with openwork finials on the tops of the gables: these all appear to be secondary, as are the hinged carrying attachments at each end of the gables. A rectangular window in the front of the lid was an aberration made between 1864 and 1899. The ends and lower part of the back of the shrine are undecorated, but the front is decorated in chased repoussé while the back of the lid has an incised runic inscription. The front of the lid has a haloed winged figure flanked by two profiled birds, while the base has half figures of Christ, with a cruciferous halo and book in his left hand, flanked by the archangels Michael and Gabriel each with a circular object, probably the host, in his left hand. Identifying inscriptions in Insular square capitals run vertically between Christ and the archangels, reading respectively SCS/MIH and SCS/GAB. These and the runic inscription on the back are discussed below.

The history of the shrine is not known before 1864, when Moulin discovered it in the treasury of the church. While the shape resembles other Insular reliquaries (e.g. Youngs 1989, cats 128–32), the inscription may indicate that it was a box for the consecrated host, a function supported by the identification of the circular objects held by the archangels as the host. Scriptural bread, specifically as an image of the host, is normally represented in circular form in Insular art – as for instance in the multiplication of the loaves and fishes on the Moone, Co. Tipperary, cross, and in the Book of Kells. The Anglo-Saxon origin indicated by the Old English runic inscription is supported by the Insular capitals of the Latin text and the style and technique of its figural decoration,

137

137 (back)

which is similar to the Hexham plaque and the figural elements of the Dumfriesshire mounts and Winchester reliquary (**104, 102, 136**).

Gabriel and Michael appear in similar prominence and attitude on St Cuthbert's coffin (*c*.698), which shares some of the stylistic formulae of the Mortain shrine – the tubular garment folds, swept-back hair, enlarged eyes and gestures. The winged figure on the roof, probably the Holy Spirit, is reminiscent of evangelist symbols in (e.g.) the Codex Aureus and BL Royal MS I E.vi (**154, 171**). Its flanking birds derive from late antique sources but may also be seen in Insular manuscripts, for instance, the Maaseik Gospels (Alexander 1978, no. 22). Although the roof fittings are possibly later additions, they may copy earlier fittings. A lost eighth- or ninth-century house-shaped shrine from Wales seems to have had a similar central cross on the ridge (Butler and Graham-Campbell 1991) and it is also possible that the gable terminals represent an attempt at copying a lost pair of finials of the type seen on Insular shrines (e.g. Harbison 1970, 54–5) and on the Temple of Jerusalem in the Book of Kells (f. 202v). A date in the second half of the eighth or first half of the ninth century seems plausible on the combined evidence of inscriptions and decoration. LW

The runic inscription The runes are cut in three uneven lines on the metal plate that forms the roof of the shrine. Raised mouldings divide it further into six sections. The text reads:

> '+ g o o d h / / e / / l p e : æ a d a n
> þ i i o s n e c i i s / / m / / e e l g e w a r
> a h t æ'

Good helpe: Æadan þiiosne ciismeel gewarahtæ. 'God help Æada (who) made this *cismel*'. The meaning of the last word is debated – it occurs nowhere else in Old English. Suggestions link it with (*a*) Med. Lat. *crismal(e)*, *chrismarium*, 'box for the consecrated host', 'reliquary', (*b*) Med. Lat. *cimelium*, 'treasure', (*c*) Old English **cistmel*, 'casket cross' or 'choice cross'. All these present formal or semantic difficulties, though (*a*) is most likely.

The rune forms are standard Anglo-Saxon with no special characteristics that help to date or localise them. The language forms are Anglian, perhaps Mercian, and tentatively suggest a date in the eighth or ninth century. The spelling, with its doubled vowels in *good*, *þiiosne* and *ciismeel*, is distinctive but not unparalleled in English runic texts. RIP

The Latin inscriptions The two Latin inscriptions identifying the figures flanking Christ may be read as S[AN]C[TU]S MI[C]H[AEL]; S[AN]C[TU]S GAB[RIEL]. The inscriptions are symmetrically disposed in vertical strips on either side of the Christ figure and are executed in angular square capitals, of a sort popularised by the Lindisfarne scriptorium *c*.700 but which continued in use throughout the Insular period for inscriptional purposes. A late example of their use may be found in the evangelist miniatures of the ninth-century Mercian Book of Cerne (**165**), to which the figure style may also be compared. MPB

Select bibliography: Moulin 1864; Cahen and Olsen 1930; *Trésors des églises de France* 1965, cat. 234; Périn and Feffer 1985, cat. 30.

138 Casket

Gandersheim Abbey, Germany
Whale's bone, copper-alloy; H. 12.6 cm, L. 12.6 cm, W. 6.8 cm
Anglo-Saxon; late 8th century
Herzog Anton Ulrich-Museum, Braunschweig, inv. no. MA 58

The house-shaped casket consists of a rectangular base with hinged gabled lid: base and lid each consist of four whale's bone (often incorrectly described as walrus ivory) panels set in a bronze frame. The panels are carved in high relief with a varied repertoire of interlaced animal and bird motifs, some inhabiting vine-scrolls, and, in one case, crawling out from the trumpet scrolls of a triple triskele pattern. The two larger base panels are framed and divided by twisted mouldings into twelve and six square fields respectively: similar mouldings divide the roof panels into two and three fields respectively. All of these layouts take account of the metal clasp and hinge fittings. None of the gable and end wall panels is subdivided but the gable panels are bordered with the same twisted mouldings. With the exception of the base mount (see below) all the metal fittings are contemporary: the main frame is

138 (back)

138

soldered together from cast L-sectioned strips of copper-alloy. The decoration consists of guilloche, scalloped and interlace motifs, the last terminating at four points in an identical animal-headed scroll.

The clasp and hinges are of the same date, and have cast interlace and linear decoration. All are riveted to the panels with original rivets but additional rivet holes down the vertical edges of all four base panels may indicate crude repair work at some time. Further attachment holes exist along the rebated lower edges of the side panels, evidently for the original base mount. This has been replaced at some unknown time by the present fitting, a square bronze frame in which the casket simply rests, without attachment. This has cast decoration in crude imitation of that on the original mounts. On its underside is an incised inscription in runes. LW

The inscription The Gandersheim runes are cut on the four faces of a quadragular copper-alloy plate loosely fitted to the base of the casket. It is doubtful if they can be accepted as genuine as they present so many uncertainties of form, meaning and context, and make no obvious sense. There is clearly a text repeated, but no indication where its beginning is, or whether the symbol ✳ (which occurs at the mid-point of each side) is the rune 'j' or a decorative or cross symbol. As far as it can be read (that is, not transliterating the baffling symbols at the corners, and beginning at the first rune of the long side) each text reads:

'u r i t n e þ i i s i ✳ h �072 r æ l i i n m c ✳
h æ l �072 ✳ æ l i ea ✳'

The inscription, whatever its date, shows thorough knowledge of runic forms, though perhaps the distinction between 'u' and 'c' is not so clear as indicated above. The letters are carefully formed and seriffed. Some sequences of letters look convincingly, as 'þ i i s' (cf. 'þ i i o s n e' on the Mortain casket (**137**)) and 'l i i n', 'linen'. Thus, if this is a fake, it is one produced by someone with a knowledge of runes or with a good exemplar before him. Several interpretations of the texts have been produced, but none of them much resembles Old English. Certainly the one that attributes the casket to Ely ('æ l i ea' in the original) can be rejected with confidence.
 RIP

The casket is one of the most exquisite pieces of craftsmanship to have survived intact from the period. It is not known how it came to be at the convent of Gandersheim in Saxony, but it is very likely that it reached Germany during the Anglo-Saxon period. Fink makes the plausible suggestion that it might have reached Gandersheim in the tenth century through the close relationship of King Athelstan (himself a noted giver and collector of gifts) with the Saxon court, which certainly earned him commemoration at Gandersheim (Fink 1957; Keynes 1985, 147–8). After the secularisation of the abbey, the casket passed in 1815 into the ducal collection at Braunschweig, where it remains to this day.

It has been suggested that the runic base plate, which appears to copy a lost original, was most likely to have been added after it passed into secular, antiquarian hands, but this

Fig. 13 Rothbury, Northumberland: cross shaft; late eighth or early ninth century

is hard to prove. A few medieval copies or forgeries of Anglo-Saxon inscriptions exist, but they rarely exhibit the combination of stylish competence with opacity of meaning seen in the Gandersheim runes. In the absence of any acceptable meaning to the text, the runes can shed no light on the function or origin of the casket.

The decoration of the rest of the metal frame and the whale's bone panels is contemporary and can without difficulty be assigned to the late eighth century. Its brilliantly controlled array of variations on the theme of animals, vine-scroll and interlace may be closely compared with sculpture: as on the panelled ornament on the roof of the Hedda stone in Peterborough Cathedral (Wilson 1984, fig. 93) and with the reptilian beasts which crawl about the base of the Rothbury cross-shaft (fig. 13), both dated to the early ninth century. All the creatures also share links with the beasts of the Leningrad Gospels (Alexander 1978, cat. 39), especially the combination of the pointed wings with long interlacing tails and the interest in textured reptiles seen from above. The little-discussed animal-head volutes on the metal mounts also fit this chronological picture. With their distinctive long ears and lolling tongues, they are a *leitmotif* of late eighth-

century metalwork, from the Navenby pin to the Bjørke, Re and Lunde mounts (Bakka 1963, figs 6–8).

Its house-shaped construction and small scale seems to relate it, albeit distantly, to the surviving Insular metal-fitted wooden shrines though its proportions differ. The inhabited vine-scroll suggests a religious context for the box, either as a reliquary or, like the Mortain casket, perhaps as a container for the host. LW

Select bibliography: Goldschmidt 1918, vol. II, cat. 185; Fink 1957, 277–81; Charlemagne 1965, cat. 230; Beckwith 1972, cat. 2, 18–19, figs 10–13; *Ivory Carvings in Early Medieval England 700–1200* 1974, cat. 2; Hedergott 1981, 4, pls 1–2 and refs; Budny 1984, 117–18; Wilson 1984, 64–7.

139 Panel fragment

Larling, Norfolk

Whale's bone; L. 7.2 cm

Anglo-Saxon; late 8th century

The Castle Museum, Norwich, inv. no. 184.970

Half the panel is broken away along its long axis. The lower edge is undecorated and pierced with three attachment holes; above this the decoration originally consisted of a rectangular raised panel with plain border subdivided by a cross with rounded centre and terminals, and flanked by vertical panels with inhabited vine-scroll ornament carved in relief. The two surviving fields between the arms of the cross contain (left) the wolf and twins motif and (right) a winged and maned biped biting its interlaced tail. The back is flat and undecorated.

The panel was found in 1970, near the church which is dedicated to Æthelberht of East Anglia (d. 794) whose coins also bear the Romulus and Remus motif of wolf and twins. The later East Anglian kings uniquely included Caesar in their ancestry; but as the Romulus and Remus motif is also commonly used to symbolise the Church nourishing the faithful, we should not be too hasty to seek a royal connection for the plaque. Indeed, the panel's prominent cross and vine-scroll motif suggests that the wolf and twins are primarily to be seen in a religious context, a reading supported by the panel's likely function as a fitting from a book-cover, or possibly as half of a diptych like that from Blythburgh (65) which it closely resembles in scale and design. Its find-place suggests that it may indeed have been connected with the presence of an early church with royal associations.

The high-relief decoration is of considerable quality, and is closely related in technique and style to the Gandersheim casket (138) and the Rothbury cross, where shaggy wolf-like beasts of very similar appearance appear (Cramp 1984, pls 1223–4). LW

Bibliography: Green 1971; *Ivory Carvings in Early Medieval England 700–1200* 1974, cat. 3; Campbell 1982a, 67; Wilson 1984, 87.

140 Panel

No provenance: Webb Collection

Ivory; H. 13.02 cm, w. 8.1 cm

Continental, Insular style; late 8th century

Trustees of the Victoria and Albert Museum, London, inv. no. 254–1867

A rectangular panel of great thinness, it is probably cut down from a late antique diptych, and has a late ninth-century Carolingian Ascension of Christ carved on the back (Beckwith 1972, cat. 22). The carved relief decoration consists of two double-framed square panels set one above the other and

139

140

surrounded by a continuous border of inhabited vine-scroll with some beast-headed volutes with horns and lolling tongues. The upper panel contains a pair of affronted birds which bite their interlacing legs: the lower panel has a pair of addorsed goats enmeshed in their interlacing tails and legs. The animal-head volutes of the surrounding vine-scroll also appear to be goats. The panel's upper edge was cut down and the whole modified to accommodate hinges and lock when the other side was carved to form, with another ivory (Beckwith 1972, cat. 4), the doors of a small Late Carolingian shrine. The decoration is very rubbed, probably deliberately at the time of reuse.

This ivory has sometimes been called Anglo-Saxon, most recently by Beckwith (1972, cat. 8) and Budny (1984, 112), but it is more probably to be seen as a continental reflection of Anglo-Saxon artistic influences of the kind represented by the Bischofshofen cross (133) with which it shares the rather distinctive animal-head vine-scroll volutes with shovel-snouts and lolling tongues. It is even more closely related to another ivory panel now in Munich (Beckwith 1972, cat. 9) which has a border of vine-scroll very similar in both motif and technique, and which notably contains a variety of animal-head volutes including several goat-heads with distinctive shovel-shaped muzzles, as here. This too has sometimes been called Anglo-Saxon, but Wright has ascribed both to the time of Charlemagne, and possibly a centre in southern Germany or northern Italy (Wright 1985, 11–12). The Munich ivory in turn has features which relate it stylistically to the Anglo-Saxon vine-scroll seen on the Bischofshofen cross – bull-headed and shovel-snouted snake-head volutes occur on both. It is tempting to suggest that the two ivory panels are not only, as Wright tentatively suggests, southern German in origin, but perhaps belong to the Salzburg *Kulturkreis* in which Anglo-Saxon artistic currents, variously exemplified by the Bischofshofen cross, the Tassilo Chalice (131) and the Cutberht Gospels (Alexander 1978, cat. 37), were so active in the late eighth century. LW

Select bibliography: Goldschmidt 1914, I, cat. 179, pl. LXXXIII; Longhurst 1927, 66, pl. XLV and refs; Beckwith 1972, cat. 8; *Ivory Carvings in Early Medieval England 700–1200* 1974, cat. 7; Wilson 1974, 66–7, Budny 1984, 112; Wright 1985, 12.

141 Two panels from a book-cover

St Martin's Church, Genoels-Elderen, Belgium
Ivory, blue glass; each panel, H. 30 cm, W. 18 cm
Continent, Insular style; 8th century
Musées Royaux d'Art et d'Histoire, Brussels, inv. 1474

Pair of ivory openwork panels, each assembled from seven parts, now mounted on a modern support; numerous rivet holes indicate previous attachment to a lost wood or metal base. The left-hand panel shows Christ Triumphant flanked by two angels, with a book in his left hand and cross in his right, borne on the shoulders: he treads on the lion and dragon with asp and basilisk below. His cross-halo is inscribed REX, and above and below the figures runs the interrupted inscrip-

tion + VBI DNS AMBVLABIT SVPER ASPIDEM ET BASILISCV ET CONCVLCABIT LEONE ET DRACONEM (Psalm 90 (91), v. 13). Two columns stand behind the angels, and below Christ's feet, a series of struts supports the openwork beasts. A border of key pattern frames the scene. The right-hand panel is in two registers: the upper scene depicts the Annunciation, with Mary, a distaff in her left hand, seated on a cushioned chair with Gabriel on her right and a female attendant drawing aside a curtain on her left. An inscription above reads [+ V]BI GABRIHEL VENIT AD MARIAM. In the scene below, Elisabeth greets Mary flanked by two gesturing figures, sometimes identified as an elliptical or misunderstood Annunciation to Zachariah. The inscription above reads + VBI MARIAM SALVTAVIT ELISABETH. Both scenes are set against columned architecture draped with hangings.

The carving is in a distinctive flat relief, and the bold use of openwork sets the figures against an airy background. The eyes of all the figures and of the beasts are set with bright blue opaque glass.

There is general acceptance that the scale and proportions of this eloquent and sophisticated pair of ivories suggests that they were made for a book-cover, and probably set on a coloured or gilded ground which would enhance the openwork effect. Both the Christ Triumphant and the Annunciation are used on book-covers in the early medieval period, for instance on the Carolingian book-covers attached to Bodleian MS Douce 176.

There has, however, been considerable debate concerning the origin and date of the ivories, conveniently summarised in a recent article by Neuman de Vegvar (1990). Briefly, opinions have polarised between a Carolingian, early ninth-century, date, as propounded for example by Goldschmidt (1914) and Braunfels (1968), and an eighth-century Northumbrian attribution, e.g. Bischoff (1967) and Beckwith (1972). Neither argument has fully convinced, and more recently, the suggestion that the ivory was produced in the late eighth century on the continent at some centre under strong Anglo-Saxon influence has gained ground, e.g. Lafontaine-Dosogne (1977), Neuman de Vegvar (1990). The pro-Carolingian argument rests chiefly on grounds of *iconography*, for which the closest surviving parallels lie in surviving Carolingian ivories and manuscripts (e.g. the Christ Triumphant on the aforementioned Bodleian ivory, and the Lorsch Gospel covers (Neuman de Vegvar 1990, figs 8, 7; and – if the identification of the ancillary figures in the Genoels-Elderen Visitation scene is indeed correct – the Annunciation to Zachariah in the Harley Gospels (BL, Harley MS 2788, f. 109). Carolingian *stylistic* parallels have been less convincing, however, for the extreme linear stylisation of classical form seen in the ivories is very different from the more fluid naturalistic line of mainstream Carolingian art, as for example in the Godescalc Evangelistary (Neuman de Vegvar 1990, fig. 9). However, the lack of exact surviving Insular parallels for the iconography is an insufficient argument for denying they ever existed, while the existence of an Annunciation to Zachariah in so influential a manuscript in Anglo-Saxon England as the St Augustine Gospels (1) is merely one example of the kind of north Italian source available to Anglo-

141

141

Saxon artists – no doubt many other such reached England, or centres of Anglo-Saxon influence abroad. One may reasonably suppose that the late antique, probably north Italian, iconographic models on which these scenes were based were widely accessible in Insular circles, whether in England or in centres of Anglo-Saxon influence on the continent.

The arguments for an Anglo-Saxon origin have chiefly centred on the *style* of the carvings; notably, the schematic linear draperies, highly stylised features and gestures, and particularly such seemingly Insular features as the script, and the key pattern and interlaced borders. The evangelist portraits in the Lindisfarne Gospels (**80**) and the David Victor in the Durham Cassiodorus (**89**) characterise this powerfully linear figural style. Nevertheless, the closest surviving iconographic counterparts are continental, not Insular; moreover, the use of Insular decorative elements and script styles also occurs in continental manuscripts and would be entirely possible within the context of a continental house with strong Anglo-Saxon connections. It was this possibility which led

Neuman de Vegvar recently to locate the ivory's origins in southern Bavaria, possibly Salzburg, where Anglo-Saxon links were extremely strong, and from which manuscripts associated directly with Anglo-Saxon scribes, such as the Cutberht Gospels (Wilson 1984, fig. 157) survive. As she points out, an apparent stylistic connection may also be seen in the figural style of the Tassilo Chalice (**131**), which was undoubtedly produced in this area under strong Anglo-Saxon influence. Aspects of the figural style of the Chalice and other features such as interlaced borders are also common to the ivory panels, and to Bavarian manuscripts such as the Montpellier psalter and Cutberht Gospels (Wilson 1984, figs 160, 157), and as Neuman de Vegvar argues, also manifest the Italian influence in this region. However, north Italian influence is equally strong in northern France, and indeed in eighth-century Anglo-Saxon England. Moreover, a further difficulty is that the two contemporary ivories that may be identified as Bavarian are quite different in style. These are two ivories of continental origin but with a strong Anglo-

Saxon flavour, assigned by David Wright to a southern German or north Italian source (Wright 1985, and see **140**). His case is strengthened by their suggestive links with the Bischofshofen cross (**133**). If these are indeed correctly assigned, it is hard to locate the Genoels-Elderen panels in their vicinity.

Thus, on balance, the argument for a late eighth-century continental origin in a centre with a strong Insular links best fits the nature of this remarkable survival. The lack of close stylistic parallels among the very few contemporary surviving ivories need not cause alarm when the survival rate for ivories is so poor; and there are reasonably close Insular or Insular-influenced analogies in metalwork and manuscripts; a piece of this quality and sophistication must be the sole surviving witness to a notable centre of ivory-carving in the Insular style. Whether this was indeed in Bavaria or, on present evidence equally plausibly, in some more northerly centre is impossible to determine on present knowledge, given the poor survival of strictly comparable material. LW

The inscriptions on the Genoels-Elderen plaques are executed in elegant, thin square capitals, incorporating some uncial forms. The parts of the inscription are introduced by Latin crosses. There is a marked tendency to lateral compression and attenuation of script and a pronounced use of ligatures and monograms.

There are signs of Insular influence in the 'runic' appearance of occasional variant letters, such as a diagonal bar with wedges for M, and in the angular, capped A with V-shaped cross-stroke which sometimes occurs. Otherwise, the angular or fluid, ribbon-like variants which one might expect from Insular Phase II display script are absent. Examples of the 'Anglo-Carolingian' style on the continent, such as the Tassilo Chalice (**131**), would tend to incorporate more of these distinctively Insular features. The Stuttgart Psalter (**128**), produced at Echternach under Insular influence, displays a love of monograms and similarly misinterprets 'runic' stylistic features, but its capitals are far more organic in conception.

Square capitals are not a Carolingian rediscovery, as is often implied. They may be found in Insular manuscripts, notably those of the 'Tiberius' group, which again feature more angular or rounded variants, and, in an epigraphic form, on the Ruthwell Cross, used in a straightforward manner.

Carolingian manuscripts, especially those of the 'Court School' such as the Harley Golden Gospels (BL, Harley MS 2788) and the Gospels of St Médard (Paris, BN, MS lat 8850), feature square capitals as a display script, incorporating a number of monograms and a variation in the scale of letters. This practice is similar to that found on the plaques, but the elegant, attenuated forms found on the latter also bear an affinity to continental epigraphic traditions, as seen, for example, on the epitaph of St Cumian from Bobbio of the first half of the eighth century.

In conclusion, an origin on the continent, in a centre partially influenced by Insular developments but which is not at present localisable, is suggested by the inscriptions.
 MPB

The iconography Ivories composed of two panels occur already in sixth-century Byzantine art. The Berlin diptych, for example, depicts on one side Christ enthroned between Peter and Paul, and on the other the Virgin and Child also enthroned, between two angels; these themes also appears with subsidiary scenes from a Christ cycle on the five-compartmented Matenadaran book-cover and on the St Lupicin diptych.

Closely similar programmes occur in Carolingian art, notably on the five-compartmented Lorsch Gospels cover, where the main fields show Christ between two angels and the Virgin between John the Baptist and Zachariah, with, above and below, scenes similar to the early Byzantine examples. Here, Christ treads on the four beasts, as also on the c.900 cover of Bodleian MS Douce 176. On the latter, the central scene is bordered, as on the Matenadaran ivories, by scenes from the Infancy and Ministry of Christ. The Annunciation here includes a female attendant before an architectural setting, and its association here with Isaiah and the Nativity clearly evokes the Incarnation.

That Christ is flanked by two angels on both the Lorsch and Genoels-Elderen panels may be either a transposition of a motif usually associated with the Virgin, or a reflection of the Adoration of Christ by angels, following the Temptation, and defeat of Satan, which the trampling of the beasts may recall. Christ Triumphant, treading the beasts with open book and long cross over his shoulders, is well attested in proto-Byzantine art in Ravenna – though not, apparently, in later Byzantine art. He appears, for example, as the Warrior Christ on the mid fifth-century wall-paintings in the Orthodox Baptistery, and another apparently existed in mosaic in the Santa Croce church (c.440); other instances are an early sixth-century mosaic in the episcopal chapel, and on the tympanum of the Theodoric palace at Sant' Apollinare Nuovo.

The motif clearly symbolises victory over the forces of evil, with reference also to the Resurrection, and the Harrowing of Hell. It was borrowed from the imperial iconography of triumph: Christ defeats evil in the same manner as the emperor vanquishing his enemy (Grabar 1936, 237 ff). The topic enjoyed considerable favour in the high Middle Ages, especially in Mosan art. Although the warrior aspect of Christ is usually attenuated, he may still appear in war-like garb, as on the eleventh-century St Hadelin chasse at Visé (Didier and Lemeunier 1988, pl. 1; Squilbeck 1966–7, 117–52).

The fact that the Genoels-Elderen companion panel does not show an image of the Virgin equal in value to that of Christ, but rather two scenes from her life linked with the Incarnation, is very specific. For the juxtaposition of these two scenes, the testimony of the mid-sixth-century mosaics at Parenzo/Poreč Cathedral is important. Here, the Annunciation and Visitation combine in a tripartite image of the Incarnation with the Virgin and Child enthroned above. In the Annunciation, Gabriel greets Mary alone, spinning (an apocryphal detail not always present in Western images). In the Visitation, Mary and Elisabeth, both visibly pregnant, and accompanied by a female attendant, meet in front of draped architecture.

The Genoels-Elderen Annunciation includes the spinning motif and the attendant. Mary enthroned between Gabriel and the girl, amid quasi-imperial architecture, also recalls the solemn image of the Virgin between two angels or saints. In the Visitation, the women embrace, and Elisabeth places her hand on Mary's belly, before a background of draped arcades. Most of these elements recur on two tenth-century works, a silver plaque in the Mosan church of Susteren, and a pierced ivory, now in Munich, but which may come from Milan or Reichenau. If the unusual figures at each side do indeed represent the Annunciation to Zachariah (see above), it may be justified because that scene is placed before the Visitation in some infancy cycles. Thus the models underlying the Virgin panels comprise both the theme of majesty and a narrative cycle.

The iconographic programme of the two panels, combining the Triumph over Evil and the Incarnation, is probably to be interpreted as an evocation of salvation. In this message as well as in details of iconography, the ivories reveal evident links with Byzantine traditions of northern Italy, which can occur in northern France, the Mosan region and perhaps southern Germany, where the conditions for the making of such a work of art were fulfilled; so much the better that an Insular influence existed there. JLD

Select bibliography: Goldschmidt 1914, I, nos 1, 2; Schnitzler 1965, cat. 534; Bischoff 1967, 296–7, fn. 65; Braunfels 1968, 90; Lasko 1972, 13, fig. 11; Beckwith 1972, no. 3; Lafontaine-Dosogne 1977, 4; Gaborit-Chopin 1978, 41 ff, fig. 48; Schiller 1981, 44 ff, figs 72, 75, 130, 131; Budny 1984, 118–19; Neuman de Vegvar 1990, 8–24.

142 Fragment of braid

Archiepiscopal abbey of St Peter, Salzburg

Silk, gold, silver; *c.*5 cm wide, two pieces sewn end to end together *c.*16.5 cm long

Insular or continental under Insular influence; probably first half of 9th century

Los Angeles County Museum of Art, 55.57.1

Two-sided tablet-woven braid with soumak brocading. The warp and main weft of light green silk, the brocading weft of gold thread and cherry red, dark red, dark blue, light blue and undyed silk, the gold thread strips of pure gold foil wrapped around a silk core, flattened after weaving. Braid edges bound with a narrower plaited braid of light green silk, this plaited braid decorated at intervals with hemispherical silver bosses (five remaining here). The design consists of a repeating lotus-type flower, surmounted by petals of another flower, set in a framework of pillars linked by diagonal pairs of rosebuds or petals. At the sides, the same flower recurs, bisected.

This is a separated fragment from a braid adapted as hanging *infulae*, or fanons, on a twelfth-century bishop's mitre; on the mitre itself, the *infulae* survive to a length of 41 cm each. The mitre was part of the treasure of the abbey of St Peter, Salzburg. It was sold with other vestments during the 1930s and is now in the collection of the Abegg Stiftung, Riggisberg, Bern. This separated fragment came to the Los Angeles County Museum of Art as the gift of Mrs William Robertson, the daughter of Mr Adolph Loewi, the dealer through whom the mitre was sold.

Like that of the Durham braid (**100d**), this braid's design appears to have been borrowed from a group of silk clothes woven in central Asia; the border of a silk preserved at Liège provides a precedent in this case for the main flower motif. The technique, tablet-weaving with soumak brocading, is also the same in principle as the Durham braid's, but, being reversible, and with the brocading only partly covering the warp, is even closer to a braid discovered at Ravenna. The Ravenna braid, from a bishop's tomb at Sant'Apollinare in Classe, rather than having an oriental design, is decorated with Latin text in display capitals and small geometric motifs

142

which are both Insular in style (fig. 8, **100d**). Parallels for the Salzburg braid's edging plaits include the narrow plaited 'sennits' on the Girdle from the tomb of St Cuthbert, while similar bosses occur on the Veil of St Harlindis, a companion relic to the Chasuble of Saints Harlindis and Relindis in this exhibition (**143**).

The Salzburg braid's original function is uncertain; it could have been a stole or a maniple. Being two-sided, it was obviously never intended to edge a garment in the manner of the Durham braid. Its presence in Salzburg is probably to be associated with the close connections between England and the Church in this region in the eighth-century (see **133**).

HG-T

Select bibliography: Tietze 1913, pls 13, 14; Granger-Taylor 1989, 312, 320–1; Flury-Lemberg 1988, 54, 467.

143 Panels of embroidery

Convent of Sts Harlindis and Relindis, Aldeneik, Belgium

Linen with silk and gold; two panels with arcades; *c*.63 × 9.5 and 66 × 10 cm; two panels with medallions, each *c*.34 × 7.5 cm; four monograms, each *c*.12 × 12 cm

Anglo-Saxon, *c*.800

Kerkfabriek St Catherina, Maaseik

Embroidery in cherry red, beige, green, yellow and light and dark blue silk threads and gold thread, the gold thread strips of pure gold foil wound around a core of horse hair, afterwards flattened; split stitch, stem stitch and surface couching, the gold thread forming the motifs and following their contours, the coloured threads used mainly in abstract blocks filling in the ground. The base textile is plain linen and in the case of the panels was originally completely covered by embroidery. On the monograms, the surface of the linen is coloured blue by means of a pigment. Further embellishment in the form of pearls is now only represented by tufts of the linen threads that held them.

Both of the larger panels have an arcade of nine arches which spring without capitals from sturdy piers. All areas are densely decorated with birds and animals, stylised foliage and abstract interlacing. The two smaller panels both have two rows of five small roundels enclosing a single animal or bird. The four matching monograms are based on two letters, probably an M and an A, and the linen is cut to this shape with the edges turned under; their embroidered design is of scrolling stems and leaves.

The embroiderers belong to a composite object by tradition said to be a chasuble made by Saints Harlindis and Relindis. On this, the embroideries were arranged in a H-shape with the medallion panels forming the cross-bar, the arcade panels the uprights, with a monogram terminating each upright. During examination prior to the recent conservation at the Koninklink Institut voor het Kunstpatrimonium in Brussels it became apparent that most of the construction of this object was not early medieval and it was decided to separate the constituent pieces. Of the six other elements not exhibited here, four are considered to be of the same period of the

embroideries, but none was found to have the curved hem typical of medieval chasubles. The embroidered panels themselves, with their thick linen base cloth and architectural elements, seem more likely to have been a church furnishing and an altar frontal has been suggested.

The 'chasuble' has been preserved with two other textile relics, the 'veils' of Saints Harlindis and Relindis. In 1577 these were moved to the parish church at Maaseik. Before that they had been nearby at Aldeneik, the abbey founded in the first half of the eighth century by the Saints Harlindis and Relindis, sisters from an aristocratic Merovingian family. The ninth-century Life of the two saints describes them as having made and left behind them at Aldeneik certain highly decorated small cloths, or *palliola*. Tradition has associated the 'chasuble' and 'veils' with these *palliola*, but the style of the embroideries at least suggests they were made fifty or more years after the probable date of the sisters' death.

The identification of the embroideries as Anglo-Saxon as

143

143

well as their dating rests on their stylistic similarities with various Anglo-Saxon works of art in other media dating to the late eighth and early ninth centuries: the use of inhabited roundel decoration resembles both sculpture and some Trewhiddle-style metalwork, and the bilateral inhabited vines in the arched fields recall related motifs on, for example, the Gandersheim casket (138) and the Hedda stone. Almost the entire repertoire of motifs can be found in the so-called 'Tiberius' group of manuscripts of the period, such as BL Royal MS 1 E.vi and the Tiberius Bede (171, 170).

The only close embroidery parallel is a group of small fragments, as yet unpublished, from the ship burial at Oseberg in Norway of around 800; it has been suggested that the embroidery decorated the buried queen's gown. A general shortage of comparative embroidered material of this period elsewhere in Europe probably reflects the unusually early development of embroidery in the British isles. The Maaseik embroideries differ in style, quality and technique from the most famous Anglo-Saxon embroideries, the early tenth-century stole and large maniple from the tomb of St Cuthbert at Durham. But this contrast may be due, in addition to different dates and functions, to an embroidery tradition that remained very fluid. The small maniple at Durham meanwhile, with a foliate gold thread design, is in many respects a true descendant of the Maaseik panels. HG-T

Select bibliography: Calberg 1951; Budny and Tweddle 1984, 1985; De Boeck 1989; Stevens 1990.

Church architecture

The Christian Church in the early medieval period was essentially an international institution with its own culture, the origins of which lay in the Late Roman Mediterranean world. With the collapse of the Roman Empire in the West, the Church remained as the sole standard bearer of Classical art and literature, in the language of which it had formulated its doctrines. In bringing Christianity to the Germanic peoples of Western Europe, therefore, the Church served also as a catalyst for Germanic culture to be transformed by the Classical inheritance. The link between Roman culture and church architecture was explicitly recognised by Bede in the early eighth century when he recounted how the Pictish king requested architects from Northumbria who could build for him a stone church 'in the Roman manner', and professed his willingness to follow the custom of the Roman Church despite his people's 'remoteness from the Roman language and nation'. A similar process had affected the peoples of Anglo-Saxon England in the previous century.

The early missionaries to southern England came from various backgrounds in Italy and Gaul, and it was to these countries that they looked both for architectural forms to serve the liturgy and its ministers, and also for craftsmen to erect the necessary buildings in masonry – since the native English tradition was one of building in timber. Churches of seventh-century date in Kent and Essex survive in part at

Fig. 14 Bradwell, Essex: exterior of St Peter's church; mid seventh century

Canterbury, Sheppey, Reculver and Bradwell (fig. 14). They were simple buildings constructed of re-used Roman materials, and their scale was modest: suited to the missionary situation rather than seeking to rival the great churches long established in the cities of the continent. A rectangular nave (without aisles) housed the congregation and the main altar; to the east was an apse for the clergy; and to either side was a pair of sacristies. Further chambers (*porticus*) westwards from the sacristies might flank the nave and served for burials and other purposes. Early churches of related type are known from Wessex at Winchester and at Bremilham; but in the latter case the church was of timber construction and formed part of a royal palace. In Northumbria also we have evidence of a timber building, probably a church, at the royal site of Yeavering; while at Lindisfarne the early cathedral was said to owe its timber construction to Irish influences. At the sites connected with Abbess Hild at Whitby and Hartlepool, excavations have indicated something of the early monasteries but not their central churches.

In the late seventh and early eighth centuries, the evidence for Northumbrian architecture increases and we see a further deliberate attempt to introduce continental forms and fashions. Both Bishop Wilfrid (*c*.633–709) and Abbot Benedict Biscop (628–89) travelled on more than one occasion to Gaul and Italy, bringing back icons and relics from Rome and, from nearer afield, masons and glaziers. Of Wilfrid's great churches at Hexham and Ripon (founded 671 × 678) only the crypts and various sculptural fragments survive (see 110), and the main buildings cannot be safely reconstructed from available evidence. At Benedict's monasteries more is

Fig. 16 Brixworth, Northants.:
interior of Church of All Saints;
?mid or late eighth century

Fig. 15 Jarrow, Tyne and Wear: eastern chapel of St Paul's church;
c.700

known of both the churches and the monastic buildings. At Monkwearmouth (founded 674) the western porch of the main church survives (fig. 9), and at Jarrow (founded 681) the complete eastern subsidiary church (fig. 15), while to the south regularly planned ranges of domestic buildings have been excavated. Important collections of worked stone and of glass from both sites (see **105**) demonstrate a Frankish connection, but not enough is known of contemporary Merovingian Frankish architecture to judge the extent to which the overall planning of the Northumbrian sites is derived from there or is the product of more local influences.

On the continent the second half of the eighth and the early ninth century saw a remarkable cultural renaissance under the Carolingian monarchy, a renaissance that was expressed not least in an architecture which attempted to recreate something of the scale and the forms of Classical antiquity: it was indeed a key phrase in the whole development of Western architecture. Where England is concerned during this period, it has sometimes been assumed that this was a time of architectural stagnation: but it is in fact an open and important question whether major buildings of the later eighth and early ninth centuries can be identified and whether they show any influence from the Carolingian renaissance. The documentary sources are not altogether silent: they refer to the construction of major churches (such as that at York built by Alcuin c.780), to the continuing patronage of kings such as Offa and Cœnwulf, and to the influence of the Carolingian reforms of the Church affecting the province of Canterbury under Archbishop Wulfred in the early ninth century.

Fig. 17 (*Right*)
Cirencester, Gloucs.:
reconstruction of excavated
church; ?early ninth century

Fig. 18 (*Below*) Britford,
Wilts.: sculptured decoration
of archway on north of nave,
St Peter's church; *c*.800

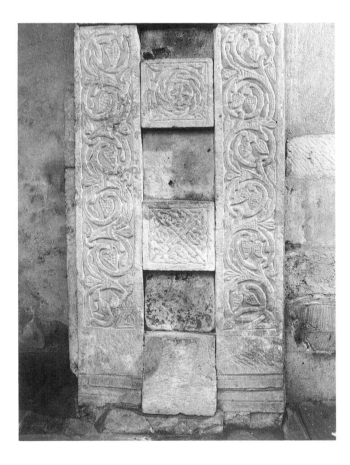

One major group of Anglo-Saxon basilican churches may
find its context in this period. The earliest is Brixworth
(Northants.) (fig. 16), which perhaps belongs to the middle
or second half of the eighth century: the spacious nave was
surrounded by a series of *porticus* entered through massive
arches; eastwards of this was a separate choir and an apse
around which ran a ring-like passageway serving as a crypt.
At Wareham (Dorset) the former church, known from nine-
teenth-century illustrations, had a somewhat similar plan but
was more sophisticated in its elevation; this was perhaps the
church where King Beorhtric of Wessex was buried in 802.
The climax of the group was the great church of Cirencester
(Glos.), known from excavation (fig. 17): it had a long aisled
nave, divided into three triple bays, to the east of which was
the main apse elevated above a ring-crypt with a further crypt
chamber to the east. The form of the crypt and the general
character of the building suggest direct contacts with Caro-
lingian Germany.

Another group of buildings of the late eighth and early
ninth centuries is to be noted for its rich sculptural decor-
ation. At Britford (Wilts.) *c*.800 the archway from the nave
to a north *porticus* has panels of sculpture around its inner
face (fig. 18): the arrangement of these suggest a comparison
with the canon tables in the Canterbury Royal Bible (see
171); but the details of the plant-scrolls point also to a
knowledge of contemporary Italian or italianising sculpture.
At Edenham (Lincs.) in the late eighth century the exterior
of the nave walls was decorated with a series of roundels, and
at Breedon (Leics.) in the early ninth century elaborate friezes
were used in similar contexts. In Northumbria at Lastingham
(North Yorks.) a doorway ornamented with plant-scroll and

interlace patterns points to a similar decorative trend (113). The question of how Italian influences might be transmitted to affect some of these sculptures raises the possibility of imported craftsmen in England, similar to those who on the continent travelled from Italy to the Carolingian territories north of the Alps to work in media such as stucco and mosaic.

During the middle and latter years of the ninth century, Viking activity and its consequences are likely to have had a significant impact on architectural patronage in some parts of England; but it would be a mistake to think of this period as one that was uniformly barren. In Mercia at Deerhurst (Glos.) many of the remarkable sculptures (fig. 19), and with them the associated architecture, can be dated on the basis of stylistic parallels with metalwork to the ninth century and suggest a vigorous native tradition. At Repton (Derbys.) the last three Mercian kings between 827 and 874 may have been responsible for the important remodelling of the church that included the four-column crypt (fig. 20) which reflects a ninth-century Carolingian type. A similar crypt formed part of the church of St Oswald at Gloucester built between c.880 and 918 by the rulers of Mercia; furthermore, this building had a western apse, another sign of Carolingian influence. For the building projects associated with King Alfred at the end of the century we have little more than documentary evidence, but his abbey church at Athelney (Somerset) appears to have been a small centrally-planned building with an elaborate timber superstructure: this may have reflected the great timber spires which were a feature of some contemporary buildings in northern France.

RICHARD GEM

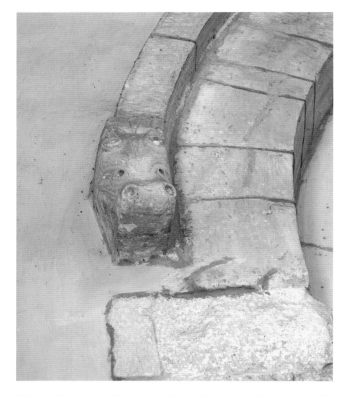

Fig. 19 Deerhurst, Gloucs.: sculptured and painted animal-head terminal on chancel arch, St Mary's church; ninth century

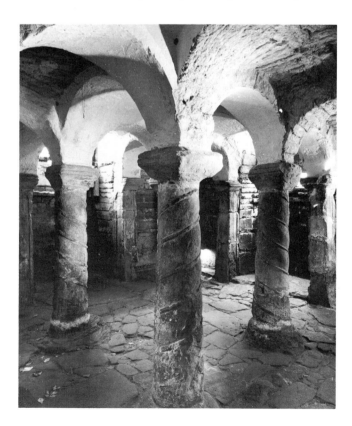

Fig. 20 Repton, Derbys.: interior of crypt of St Wystan's church; outer walls mid eighth century, columns and vault ?third quarter of ninth century

Coins

Contacts with the Merovingian and Carolingian dominions (144–5)

144 Tremissis minted at Quentovic, moneyer Anglo, c.645–50

Gold; WT 1.27g (19.6gr)
British Museum, CM 1981, 2–17–1

This is the earliest coin from a hilltop market site outside Ipswich which has yielded forty-seven coins of the later seventh and early eighth centuries. In this context, there can be little doubt that it was lost in trade. The moneyer's name suggests that he or his family were originally English. His coins are not present in Crondall, but the hoard included similar coins of Quentovic by Dutta (48b) whose name is also Anglo-Saxon in origin. MMA

Provenance: Found at Barham, Suffolk, 1980.
Bibliography: cf. Belfort 4966; Archibald forthcoming.

145 Penny (sceat), so-called Woden/monster type, Secondary Series X, struck in northern Frisia (or possibly Denmark), c.730–40 (mid-issue)

Silver; WT 1.09g (16.8gr)
British Museum, CM 1935, 11–17–261, from the T.G. Barnett Bequest

The minting place of this prolific and long-lived series is under discussion. A high proportion of Danish finds are of this type, but the major concentrations are in the lower Rhineland and Frisia. In contrast to the large numbers of earlier coins originating in this general area found in England (Series D, 53d and E, 53e), relatively few Series X have English provenances. This marks a decline and changing orientation in Frisian trade, influenced by the advance northwards of Carolingian control, but also the beginnings of the exclusion of foreign coin from currency in the English kingdoms, which was to be successfully enforced from the period of Offa onwards. MMA

Provenance: Not known.
Bibliography: Metcalf 1984.

146 (a, b) Carolingian denier with a ship type and Anglo-Saxon derivative

146 (a) Denier of Louis the Pious (814–40), ship type, struck at Dorestadt, 814–19

Silver; WT 1.33g (20.5gr, chipped)
British Museum, CM; acquired with the gift of the Sara Sophia Banks collection in 1818

Provenance: Not known.
Bibliography: BMS 29; Gariel 61 (var.)

The ship design, inspired by Roman coins (particularly a bronze issue of Allectus, usurper 293–6), was used by Charlemagne at Dorestadt and Quentovic in 812–14, and was continued by his son. All the coins are rare (Louis's less so), but their type was also copied at Hedeby in Denmark. MMA

146 (b) Penny of Athelstan I of East Anglia, ship type, struck by the moneyer Eadgar in 821 (or possibly 826)

Silver; WT 1.27g (19.6gr)
The Castle Museum, Norwich

Provenance: Found at West Harling, Norfolk in 1977.
Bibliography: Archibald 1982; Fort 1991.

This coin is the earliest issue of Athelstan I who is not historically attested except by his extensive coinage. The design is a close copy of Louis's coin and was struck for Athelstan within a few years of its prototype. It points to trading contacts with the Carolingian Empire and, in particular, with Dorestadt itself. MMA

147 (a–c) Solidus of Louis the Pious and copies found or made in England

147 (a) Solidus of the Carolingian Emperor Louis the Pious (814–40)

Gold; WT 4.36g (67.3gr)
British Museum, CM, acquired before 1838

Provenance: Not known; acquired with the Sara Sophia Banks collection in 1818.
Bibliography: Prou 1072; BMS 77; Grierson 1963, 9.

Although not the earliest of the issue, this coin stands near the head of the series issued to celebrate Louis's coronation as emperor in 816. The designs, strongly influenced by Roman types, and the reverse legend referring to the 'Divine gift' of the imperial crown, were deliberately chosen to underline his position as 'Emperor of the Romans'. MMA

147 (b) Imitation of a Louis the Pious solidus, struck in Frisia, c.830–50, holed for use as jewellery

Gold; WT 4.34gr (70.8gr)
British Museum CM 1881, 10–3–1; gift of A.W. (later Sir Augustus) Franks, 1881

Provenance: Not known, but possibly found in Britain.
Bibliography: BMS 80. Grierson 1963, Imitation type XVI, (a).

The copies are very much commoner than their prototypes; they began to be struck in Louis's lifetime and continued until the end of the ninth century. They, and base-metal imitations, were used as brooches. Grierson has suggested that a coin of this group was possibly the prototype of the next coin. MMA

147 (c) Imitation of a Louis the Pious solidus, possibly struck in England, *c.*830–50

Gold; WT 4.58 g (70.7 gr)
British Museum, CM 1860, 10–23–1

Coins from other groups of imitations are found in Britain, but Grierson has suggested that this group was struck here, possibly in Wessex. Two examples were certainly found in England, and two more are likely to have been, while none are known from Continental finds. MMA

Provenance: Not known; purchased from Joseph Beldam, 1860.
Bibliography: BMS 78; Grierson 1963, Imitation type XVI, (b).

Note: Several of Alfred's designs were Carolingian-derived (see **265** and **269b, c**).

Other contacts (148–50)

148 (a–c) Arabic dinar and Anglo-Saxon imitations

148 (a) Dinar of the 'Abbasid Caliph al-Mansur, struck at an unnamed mint (probably Baghdad) and inscribed with the date of striking, AH 157 (AD 773/4)

Gold; WT 4.25 g (65.6 gr)
British Museum, CM 1860, 12–31–7

Provenance: Not known; purchased from Baron Marochetti.
Bibliography: BMC 23; Lowick 1973.

Dinars, which were made of fine gold, were an internationally-accepted currency. They were almost certainly part of the gift of gold sent by Caliph al-Mansur to Charlemagne who may well have passed on some of them in the gifts he gave to Offa. MMA

148 (b) Dinar/mancus, copied from an 'Abbasid dinar dated AH 173 or 176 (AD 789–90 or 792–3), but with one cross added to the obverse, and two to the reverse, struck in the late eighth, or early ninth, century

Gold; WT 3.89 g (61.4 gr)
British Museum, CM OR 2368.

Provenance: Not known.
Bibliography: Lowick 1973.

Although this imitation does not name its issuer or place of production, the crosses indicate a Christian source. Lowick favoured English, rather than Italian or Frankish, manufacture and thought that this dinar was intended for donative rather than commercial purposes. Subsequent trade use was potential. MMA

148 (c) Dinar/mancus of Offa of Mercia (757–96), mint, and precise date of striking, uncertain

Gold; WT 4.28 g (66.0 gr)
British Museum, CM 1913, 12–13–1

Provenance: Purchased in Rome before 1841; purchased for the British Museum at the Carlyon-Britton sale, Sotheby, 17.xi.1913, lot 269.
Bibliography: Carlyon-Britton 1908; Allan 1914; Blunt 1961, 50; Lowick 1973.

This donative coin was copied from a dinar similar to (a). The Arabic is blundered, but the date AH 157 (AD 773–4) is clear. Offa's name and title have been inserted upside-down relative to the Arabic inscription. It is possible that this special mancus had formed part of one of Offa's annual gifts to the Pope. The coin is however rather battered, and exhibits test-marks, which point to considerable currency. Hoards of Arabic dinars found in Italy show that they were used there in trade, so the Offa dinar, whatever its original purpose, was apparently absorbed into the circulating medium, and may even have come from such a hoard rather than having been an isolated find. MMA

149 (a, b) Papal *bulla* prototype and Anglo-Saxon coin-type derivative

149 (a) *Bulla* of Pope Zacharias (741–52), giving his name in three lines on the obverse ZAC/CHAR/IAE, and his title in two lines on the reverse PA/PAE, meaning [seal] of Pope Zacharias

Lead; D. 350 mm
British Library, Detached Seal xxxviii.5

Provenance: Not known.
Bibliography: Birch 1900, no. 21670.

From the mid sixth century onwards, letters and other documents issued by the Pope were authenticated by attaching a lead seal known as a *bulla*. It was attached to the document by means of silk or hemp cords. The use of lead instead of wax followed Byzantine imperial practice. This is the sort of *bulla* which would have been attached, for example, to the admonition of Zacharias read to the reform synod of *Clofesho* in 747. The contents of the document to which this particular *bulla* was attached are not known. AP

149 (b) Penny of Offa (757–96), Heavy Issue, struck at Canterbury by the moneyer Ethelnoth, *c.*793–6

Silver; WT 1.48 g (22.8 gr)
British Museum, CM 1915, 5–7–653

Provenance: Not known; purchased from J. Pierpont Morgan, ex Sir John Evans collection.
Bibliography: Blunt 1961, 48; Stewart 1986, 30.

Although linear inscriptions are found elsewhere at this time, e.g. on Byzantine and Arabic coins (**148a**), and on rare coins

144 145 146a 146b 147a 147b 147c 148a 148b 148c 149a 149b 150a 150b

Anglo-Saxon and foreign coins with a papal *bulla*, illustrating England's overseas connections

of Pope Hadrian I struck in the late 770s, the direct inspiration of Offa's line types may well have been the *bullae* which must have been much more familiar in England from the many papal letters addressed to monarchs and churchmen. Variations on this linear theme remained a common feature of Anglo-Saxon coin types until *c*.973. MMA

150 (a, b) Offering coins of Alfred of Wessex (871–99), probably struck at Winchester, bearing on the obverse his name and title as king of the West Saxons, and on the reverse the words ELI MO, with a contraction mark, indicating *elimosina*, alms

150 (a) Complete coin

Silver; WT 10.46 g (161.4 gr, about 1/3 oz)
British Museum, CM 1875, 11–4–1; gift of the Revd G.V. Garland

Provenance: Near Poole, Dorset, 1875.
Bibliography: BMC 158; Dolley 1954; Dolley and Blunt 1961, 77–8; Martin 1961, 230; Archibald 1990, 18–19.

150 (b) Cut fragment of a coin from different dies

Silver; WT 3.48 g (53.7 gr)
British Museum, CM 1859, 7–26–1

Provenance: From the Goldsborough, Yorks., hoard, deposited *c*.920 and found in 1858; purchased from the Revd J. Lascelles, 1859.
Bibliography: BMC 159; also as previous coin.

These are the only known Anglo-Saxon silver coins larger than a penny, and they state explicitly (as deniers of Pepin inscribed, in full, '*elimosina*') that they are alms. Both were found in England, but the Goldsborough coin is heavily test-marked like the thirty-seven Arabic dirhams in the hoard, and *un*like the single un-pecked coin of Edward the Elder. The Poole coin is test-marked in a way typical of Viking rather than English finds. Archibald suggests that these might have been part of the alms sent in 883 to 'India' (probably to the Patriarch Elias of Jerusalem who had been asking for donations) and had travelled back to England with the dirhams along the usual Viking routes through Russia and the Baltic. MMA

The Mercian supremacy

When Bede surveyed 'the state of the whole of Britain at the present time', in 731, he clearly perceived a difference between political conditions respectively north and south of the River Humber. In his own kingdom of Northumbria, he could find no comfort. King Ecgfrith had rashly led an expedition northwards to ravage the Picts in 685, only to be defeated and killed; from this time, in Bede's words, 'the hopes and strength of the English kingdom began to ebb and fall away'. Bede had little to say of Ecgfrith's successors in the later seventh and early eighth century and could scarcely summon up any more enthusiasm for Ceolwulf, who became king in 729. It was to Ceolwulf that Bede addressed the Preface of his *Ecclesiastical History*, and although in that context Bede speaks warmly of the king's interest in the past and of his eagerness to learn from it, elsewhere he strikes a more ominous note: 'Both the beginning and the course of his reign have been filled with so many and such serious commotions and setbacks that it is as yet impossible to know what to say about them or to guess what the outcome will be.' Bede knew better than many, however, that the prosperity of his own world depended on the stability of the world outside monastic walls, and he was quicker than most to recognise that in order to achieve stability kings needed effective means of defence. Yet Northumbrians in his day were shirking their responsibilities, preferring to establish themselves and their families in the 'spurious' monasteries of which Bede so strongly disapproved; 'what the outcome will be', he warned, 'a later generation will discover'.

Bede must have sensed that no king of Northumbria would ever manage to restore the good fortune which the Northumbrians had enjoyed in the seventh century, and he must have feared that the flowering of monastic culture in the late seventh and early eighth century could not be sustained in such a climate. He may also have realised that a new political order was emerging to the south of the Humber, and that it threatened to eclipse his own kingdom for good. With the death in 725 of Wihtred, king of Kent since 690, and with the abdication in the following year of Ine, king of the West Saxons since 688, the two rulers who for some while had kept the Southumbrian kingdoms in an uneasy balance were removed from the scene; and it was not long before Æthelbald, king of Mercia since 716, stepped into the void. In his survey of the state of Britain in 731, Bede worked through the kingdoms of Southumbria one by one, listing their respective bishops. He then remarks: 'All these kingdoms and the other southern kingdoms which reach right up to the Humber, together with their various kings, are subject to Æthelbald, king of Mercia.' Bede has no more to say about Æthelbald's career, and nothing is known of the stages, or of

the means, by which he achieved this extraordinary position.

Yet Bede was not alone among his contemporaries in being impressed by the extent of Æthelbald's power. The draftsmen of a charter issued in Æthelbald's name in 736 (two years after Bede's death) called him 'king not only of the Mercians but also of all the provinces which are called by the general name "South English"', and even ventured to represent him as 'king of Britain'; and Felix, author of the Life of St Guthlac, had occasion to cite Æthelbald's ever-increasing worldly prosperity as proof of the saint's prophetic powers. For a hint of the nature of Æthelbald's rule we have to rely, however, on the letter which Boniface and several other missionary bishops sent to him from the continent in 747. They address him as 'the most dear lord, to be preferred in the love of Christ to all other kings, wielding the glorious sceptre of imperial rule over the English', and go on to say that they had heard that 'you give very many alms ..., that you strongly prohibit theft and iniquities, perjury and rapine, and that you are known to be a defender of widows and the poor, and that you maintain firm peace in your kingdom'. The king's attention assured, the rest of their letter comprises unrestrained criticism of the wicked behaviour of the English, instancing the king's own lascivious way of life, his violation of ecclesiastical privileges, and the widespread oppression of churchmen. One can only pity the priest Herefrith, who in another of Boniface's letters was charged with the unenviable task of delivering the message to the king.

Boniface's letter serves here as a taste of the state of affairs in England during the age of the Mercian supremacy, which was a fact of life in Southumbria for roughly one hundred years, from the 720s to the 820s. The three successive overlords – Æthelbald (716–57), Offa (757–96) and Cœnwulf (796–821) – seem to have had no chroniclers of their own to present a coherent view of the sustained revival of Mercian power, and it is not obvious how to account for their collective achievement; instead we have to piece together a picture of their activities from various and unrelated scraps of evidence, and accept that much remains obscure. The most impressive monument of the age is undoubtedly the massive earthwork stretching along the Mercian boundary with Wales, known to this day as Offa's Dyke; but coins and charters provide no less striking testimony of Mercian intervention in some of the other Southumbrian kingdoms, notably East Anglia, Sussex and Kent. It is unlikely, on the other hand, that Mercian rule ever extended far into the kingdom of Wessex, or that a Mercian king ever enjoyed much more than the studied respect of his West Saxon counterparts, though clearly the West Saxon kings were in no position at this stage to challenge their Mercian rivals.

The general impression of Mercian hegemony is of extensive power exercised in an uncompromising and often oppressive manner. One should not imagine, however, that the supremacy was maintained in any consistent way, or that the Mercian overlords aspired to break down existing political frontiers in order to create a greater, unified realm; rather, each king built up his position according to his own capabilities, and then pursued his own course of action. For the Mercians were interested not so much in expanding their territories as in increasing the revenues due to them from tribute, from tolls on trade, and from the exercise of royal rights over land; it seems, moreover, that they were largely content to enjoy the fruits of their power from a distance, and to intervene locally only when it was necessary or to their advantage to do so. The principal victims of Mercian aggrandisement were the local rulers who lost their independence and even their royal status, and among those who gained were those chosen to represent Mercian interests in the localities, and others who were only too eager to pay their respects to the overlord in return for guarantees of their own security. But now that the respective interests of all parties were so comprehensively entwined, it was open season for disputes and litigation of every kind. The kings and those whom they supported did not hesitate to claim whatever rights they considered to be theirs, and others, under increasing pressure from all quarters, became fiercely protective of their lands, their revenues, and their privileges. In Kent the stakes were especially high, since the Mercian rulers came up against the authority of the Church of Canterbury: King Offa clashed spectacularly with Archbishop Jænberht, and contrived to get papal approval for the establishment of a new archbishopric at Lichfield; and King Cœnwulf, having undone Offa's work, proceeded to clash no less spectacularly with Archbishop Wulfred.

In short, the dominant royal power was predatory, the churchmen were prickly, and contentiousness hung in the air. Yet the activities of the Mercian overlords seem in some way to have fostered a strong sense of common interest and identity among the bishops of Southumbrian Church, under the leadership of the archbishops of Canterbury; and records of the councils which were held during this period suggest not only a readiness to respond to calls for reform, but also some determination to protect ecclesiastical interests against those of the secular world. Moreover, there was clearly no shortage of opportunities for the writers and decorators of manuscripts to practise their skills: if the scriptoria of Northumbria had made the running in the late seventh and early eighth century, it was now the time for Southumbrian churches to demonstrate what they too could achieve. One should not forget, however, that Northumbrian churches retained their libraries and cherished their traditions. Indeed, the most distinguished scholar of the age was Alcuin of York; and it was Alcuin who, on moving to Francia, set himself up as guide and councillor to the English people, offering in his letters to the great and the good an astute commentary on developments in England as a whole.

The supremacy of the Mercian kings south of the Humber began to disintegrate in the early 820s. The simple explanation is that the ability of Cœnwulf's immediate successors to sustain the position he had enjoyed was compromised by dissension within Mercia itself, and then undone by the greater force of King Ecgberht of Wessex, who defeated the Mercians at the battle of Ellendun in 825. But one also detects a sense of the relief with which the people who had previously been subject to the Mercians threw off the Mercian yolk and submitted to the West Saxon king; and this only strengthens the impression that Mercian overlordship had involved a degree of repression and insensitivity to local feelings which had sowed the seed of its own destruction. In this connection it should be noted that the style of West Saxon overlordship, at least in so far as it can be observed in Kent, appears to have been significantly different from that of the Mercian regime it replaced. That is to say, the West Saxon kings were careful to establish good relations with Canterbury, to maintain a presence in the south-eastern provinces, and to entrust greater responsibilities to members of the local nobility. The contrast is perhaps between the predatory aims of the Mercian kings, who were content to feed off the wealth of others and were not concerned (or able) to pursue a greater cause, and the territorial ambitions of their West Saxon counterparts, who were determined to secure their gains and to lay the foundations of a new political order.

The battle of Ellendun proved to be the last of the battles fought between the separate peoples of Anglo-Saxon England; henceforth the West Saxons were to remain the dominant power, and besides, a common enemy was now at large to concentrate the collective mind. The earliest Viking raids had taken place in the late eighth century, along the south coast as well as in Northumbria. No raids are recorded in the first three decades of the ninth century, but Viking activity resumed in the 830s, and intensified thereafter. In the letters he wrote following the sack of Lindisfarne in 793, Alcuin of York had expressed his shock and incomprehension, as if at the very effrontery of it, and his dismay at the violation of holy places; he could only conclude that the raids were God's punishment for the sins of the English, and urge the people to mend their ways. The Anglo-Saxon Chronicle reports the raids in the south in its usual inscrutable manner, conveying nothing of the impact which they must have made on the people: in 842, for example, 'there was a great slaughter in London ... and in Rochester', and in 851, '350 ships came into the mouth of the Thames and stormed Canterbury and London'. It is doubtful indeed that the raids had much more than a local effect on the quality of life in the first half of the ninth century; but those who were responsible for the country's defence must have been wondering who on earth was to blame, and what in heaven they could do.

SIMON KEYNES

Manuscripts

The eighth and ninth centuries saw the production, south of the Humber, of a number of manuscripts, many illuminated and varying from lavishly decorated biblical volumes to more intimate prayerbooks used in private devotions. Although spread over a period of time (from *c*.725 to 850) they are related stylistically and form the 'Tiberius' or 'Canterbury' group, taking the former name from a key member, a ninth-century copy of Bede's *Historia Ecclesiastica*, the Tiberius Bede (BL, Cotton MS Tiberius C. ii; **170**). The press-mark of this manuscript stems from the practice adopted by the bibliophile Sir Robert Cotton (d. 1631) of placing his books in presses surmounted by busts of Roman emperors and ladies. The term 'Canterbury group' is something of a misnomer, for although Canterbury was an important centre it is unlikely to have produced all the manuscripts in question. Since at least the 1940s, scholars have disputed the origins of these intriguing works, propelling them like shuttlecocks between Canterbury and Mercia. The picture now emerging is one of greater complexity, with centres such as Lichfield and Worcester appearing alongside Canterbury as probable production centres.

It is important to remember that, during much of the period in question, Kent (along with many other territories) fell under Mercian overlordship. It is not, therefore, surprising that it should form part of a broader area of Mercian cultural activity. A Mercian 'writing area' (or *Schriftprovinz*), akin to the extensive geographical area which witnessed Hiberno-Saxon manuscript production, would account both for the general stylistic similarities shared by these Southumbrian books and for the many variations in approach which they display. This situation is also reflected in other media, and the 'Tiberius' group style is closely related to developments in Southumbrian metalwork and sculpture.

The Vespasian Psalter (**153**) and the Stockholm Codex Aureus (**154**) are Kentish works of the first half of the eighth century, the period of the rise of Mercia under Æthelbald. They are predictably romanising in style, with their uncial and capital scripts and their well-modelled, classicising figure style, but they have also absorbed elements of Hiberno-Saxon art, incorporating Germanic and Celtic decorative motifs. Their palettes are complex and include lavish use of gold leaf. The Stockholm volume, which was ransomed back from a Viking army during the ninth century, evidently used the late sixth-century Roman gospel book thought to have been brought to England by St Augustine (**1**) as one of its models.

The Codex Bigotianus is a later eighth-century example of this style, probably produced in Kent, although other areas may well have made romanising works too, Worcester, for example, showing signs of having favoured uncial script.

These manuscripts also incorporate independent animal motifs – the Southumbrian 'Anglian beast' – rather than enmeshing them fully in interlace. This was to become an important feature in Southumbrian art and may well have been influenced by Frankish and Byzantine art, as well as by local taste.

The reign of Offa witnessed the extension and consolidation of Mercian authority and even greater relations with the continent. The correspondence between Offa and Charlemagne and from Alcuin of York, the eminent intellectual who guided much of the Carolingian programme of ecclesiastical and cultural renewal, bears witness to the complexity of these relations. A further reflection of such contact appears in the art of the period. A taste for the exotic and for styles of Mediterranean and Eastern inspiration pervades southern English art of the late eighth to ninth centuries, producing sculptures such as those from Breedon-on-the-Hill and manuscripts such as the Barberini Gospels (**160**). The latter could well be the finest surviving manuscript from the once powerful kingdom of Mercia. It was written by at least one Mercian scribe, working with others of Northumbrian training. A Northumbrian origin cannot be ruled out though, some favouring York as its home on romantic but unsubstantiated grounds in order to restore at least one book to what is known to have been one of the greatest libraries of its day. The Barberini Gospels introduces a style of lacertine display script, linked by biting beast-heads and grotesques, which is a characteristic feature of later members of the 'Tiberius' group. These playful beasts, which often sprout foliate elements, are paralleled in Southumbrian Trewhiddle-style metalwork (e.g. **187**, **192–3**, **245–6**), many aspects of Insular art being characteristically multi-media based.

The first half of the ninth century saw the production of a closely related group of 'Tiberius' manuscripts. Four of them are prayerbooks (**162–5**) which arrange their texts around central devotional themes, such as Christ as the healer or doctor of mankind, or the Communion of Saints, forming a unique early medieval devotional genre. They were made in Mercia, probably at Lichfield and Worcester, and the most developed prayerbook, the Book of Cerne (**165**), is likely to have been made for Æthelwald, bishop of Lichfield (818–30). Along with Wulfred, archbishop of Canterbury (805–32), there are slight indications that Æthelwald was concerned with introducing reforms along contemporary Carolingian lines and with combating secular control of ecclesiastical affairs. Not surprisingly, there are signs of Carolingian influence in the manuscripts produced in their circles (notably in a little Carolingian mass-text written by the scribe of the Book of Cerne), and a Mediterranean or Carolingian Court School book was probably shared as a model by the Book of Cerne, probably from Lichfield, and the Royal Bible (**171**), from Canterbury. The latter is a splendid classicising work, its illusionistic painting style, purple pages and gold and silver inscriptions reflecting its former glory. Also from Canterbury were the Tiberius Bede (**170**) and a Saint's Lives (**168**). The script of these and other 'Tiberius' manuscripts assists in their relative dating and localisation, with charters providing a useful framework for comparison.

At the end of the Insular period, on the eve of the Scandinavian occupation, Southumbrian manuscript production was flourishing and responding actively to the Carolingian developments which Insular culture had helped to foster. At the end of the ninth century, Alfred the Great's cultural

151 Copy of 'Toll Charter' of King Æthelbald of Mercia; 844–5

revival was to be influenced by earlier ninth-century books (some of which may have evacuated to the 'safe-house' of Worcester in unoccupied Mercia, or to Wessex itself) and by Mercian scholars, as well as by the continent. A continuing Insular input into later Anglo-Saxon art, and subsequently into Romanesque and Gothic art, was thereby assured. Meanwhile, in Celtic areas the foundations had been laid for a tradition which is still alive today.

MICHELLE P. BROWN

151 'Toll Charter' of King Æthelbald of Mercia

British Library, Cotton Charter xvii.1
Vellum; 197 × 302 mm
Latin; 844–5
Rochester

From about 733, King Æthelbald of Mercian granted to a number of religious houses the right to dock ships at London without paying toll. These 'toll charters' provide the chief evidence that during the first part of his reign Æthelbald seized control of London from the East Saxons. Six such charters are recorded; many more were perhaps issued. It has been suggested that they were carried on board the ship claiming the privilege for presentation to the royal officials

collecting the tolls. This would explain why no original 'toll charter' survives and they are known only from later copies. This is the oldest of these copies.

It declares that on 1 September (or 24 September if the scribe was using Bede's system of chronology) 733, Æthelbald granted to Bishop Aldwulf of Rochester the 'entrance, that is the toll' of one ship 'whether one of his own or any other men, hitherto belonging to me or my predecessors by royal right in the port of London'. All 'kings or nobles or tax-gatherers or also any of their deputies' are enjoined to observe the grant.

This was still a valuable privilege a hundred years later, and, shortly after becoming bishop of Rochester in 844, Tatnoth asked King Berhtwulf of Mercia to confirm the grant. Details of the confirmation are recorded on the dorse of the charter. Both the original grant and the confirmation are in the same mid ninth-century minuscule hand, indicating that this document was probably compiled in the Rochester scriptorium at the time of the confirmation.

In copying out Æthelbald's charter, the Rochester scribe took some liberties with the text. The list of witnesses is suspiciously short; only three names are given. Some names were probably omitted. The second half of the introductory proem is also found in a charter of Ecgberht of Kent for Rochester, between 766 and 785. It is not now possible to establish whether these words in Ecgberht's charter were

taken from Æthelbald or added to Æthelbald's text in the ninth century.

The port of London to which the 'toll charters' refer was not in the walled Roman city but a new Saxon development which lay in the area of the Strand, running along the river bank from Fleet Street to Trafalgar Square. It was a busy and prosperous port. Writing shortly before Æthelbald issued these charters, Bede described it as 'a mart of many nations'. The revenues from it must have been considerable.　　AP

Bibliography: Sawyer 1968, no. 88; *ChLA*, no. 197; Campbell 1973, no. 2; Whitelock 1979, no. 66; Scharer 1982, 195–211; Biddle 1989, 25–6.

152 Charter of King Æthelbald of Mercia

British Library, Cotton MS Augustus ii.3

Vellum; 232 × 180 mm

Latin; 736

Worcester

King Æthelbald is described here as 'King not only of the Mercians but also of all provinces which are called by the general name "South English"'. In the list of witnesses he is given the title 'King of Britain'. The scribe who produced

152　Charter of King Æthelbald of Mercia; 736

this charter clearly regarded Æthelbald as *bretwalda*, the title traditionally held by the overlord of the Southumbrian kingdoms. Bede listed seven previous *bretwaldas*, but refused to concede the title to Æthelbald, even though he acknowledged Æthelbald's supremacy south of the Humber. The Anglo-Saxon Chronicle similarly did not consider Æthelbald a *bretwalda*. The creation of a *bretwalda* may perhaps have required some kind of assent from the subject kings and it is possible that Æthelbald was never formally granted this title. The use of such elevated regnal styles in this charter may be due to flattery on the part of the Worcester scribe who wrote it; Æthelbald was apparently a patron of the church at Worcester.

This charter not only reflects the establishment of the 'Mercian Supremacy' but also looks back to earlier territorial divisions. It records the grant in 736 to Æthelbald's 'venerable companion' Cyneberht of land for the foundation of a monastery 'in the province to which was applied by men of old the name Ismere by the river called the Stour'. This refers to territory in the Stour valley in north Worcestershire held by a tribe called the Husmerae, which had been absorbed into the kingdom of the Hwicce. The province of the Husmerae probably corresponded to the area now covered by the rural deanery of Kidderminster. The estate granted to Cyneberht included both pasture on the banks of the Stour and woodland some miles away to the north-east. This suggests that the Husmerae practised a form of transhumance farming, moving stock from the river valley to the wooded uplands in the summer.

In the early seventeenth century, Sir Robert Cotton noted that this charter was at the beginning of the Vespasian Psalter (**153**). This association was probably fairly recent, dating perhaps from the sixteenth century. The charter had been removed from the psalter by 1696.　　AP

Bibliography: Sawyer 1968, no. 89; *ChLA* no. 183; Chaplais 1965, 54; Whitelock 1979, no. 67; Scharer, 1982, 159–86; Hooke 1985, 80; 1990, 61–3.

153 The Vespasian Psalter

British Library, Cotton MS Vespasian A.i

Vellum; ff. 153; 235 × 180 mm

Latin with continuous Old English gloss; second quarter of 8th century (*c*.725)

Canterbury, St Augustine's

This is the earliest surviving 'Tiberius' group manuscript and is the first example of an illuminated book from Southumbria. It has a medieval Canterbury provenance and is executed in a romanising style which one might expect from that centre.

The script is a stately rounded uncial (an antique script denegrated by St Jerome for its luxurious status which could lead to letters 'an inch high' – hence the term 'uncial') with rustic capitals for titles, both of an artificial and distinctively English character. The scribe was also the artist, a master who drew upon Italo-Byzantine, Oriental, Frankish and Hiberno-Saxon artistic sources to forge a new Southumbrian style. A

Greek psalter of the early sixth century has been identified as a major source for the cycle of illustration which incorporates a full-page miniature of King David, author of the Psalms, with his scribes and musicians (f. 30v, but perhaps originally a frontispiece) and initials to each of the Psalms, some of which are given added emphasis by the use of panels of display script, accompanied on two occasions by initials containing narrative scenes. These are the earliest examples of 'historiated', or narrative, initials which were to become such an important feature of medieval illumination. Another early example of this form may be found in the Leningrad Bede (Leningrad, Public Library, Cod. Q.V.I.18). The exhibited initial introduces Psalm 26 and depicts David and Jonathan (f. 31), whilst that for Psalm 52 (f. 53) shows David as a shepherd, rescuing a lamb from the lion. This form probably represents the absorption of marginal or prefatory illustrations from the model into the initials as a result of the characteristic Insular concern with the integration of text, script and decoration.

There is also evidence to suggest the original inclusion of a decorated *incipit* page, incorporating a depiction of the anointing of David, at the beginning of the Psalms proper, and of a carpet page at their conclusion.

The exhibited miniature of David and his musicians gives some idea of the range of sources consulted, with its rounded, well-modelled figure and drapery style and arched surround, all of Mediterranean inspiration, its oriental-style plant motifs, its independent beasts of Germanic (possibly Frankish) derivation, its Germanic interlace and its Celtic trumpet spirals. The conflation of sources is similar in certain respects to that found in the Lindisfarne Gospels (80) and is probably indebted to it. The long-snouted beast-heads which occur are certainly derived from the Lindisfarne Gospels style. Other features, such as the projecting serifs applied to initials (termed the 'antenna style') are Southumbrian innovations. The palette is extensive, again like that of the Lindisfarne Gospels, including rarer pigments such as cinnabar, and was probably also indebted to Mediterranean painting techniques. The extensive use of gold and silver would appear to represent a distinctively Southumbrian response to Byzantine manuscripts.

The text of the Psalter follows the Roman version (accompanied by prefaces, canticles and hymns) and the major initials serve to emphasise an eightfold liturgical division in which Psalms 26, 38, 52 68, 80, 97, 109 and 118 assume prominence, along with the less explicable Psalm 17.

153 King David with his scribes and musicians (ff. 30b–31)

Distinctive panels of square capitals also introduce these textual divisions and mark the beginning of a distinctive Southumbrian approach to display scripts. They are inhabited by a range of individual zoomorphic and human figures which may be indebted to Frankish sources or to the metalworking tradition.

The relationship of the text hand and an early correcting hand to near-contemporary Kentish charters reinforces the proposed Canterbury origin, as does the later history of the manuscript. During the first half of the ninth century it received an interlinear gloss in the Mercian dialect of Old English, the earliest surviving translation of the Psalms into English. It has been suggested that this was the work of one of the scribes responsible for the Royal Bible (171), another Canterbury product. During the early eleventh century additional material was incorporated into the book, written by the famous Christ Church scribe, Eadui Basan. By the early fifteenth century the book was kept on the high altar of St Augustine's, where it was seen by Thomas of Elmham and described as a gift from Pope Gregory the Great to Augustine. It probably remained there until the Dissolution and by 1556 was owned by William Cecil, Lord Burghley, from whom it was borrowed by the bibliophile archbishop, Matthew Parker. By 1599 it had joined the library of Sir Robert Cotton, which formed one of the foundation collections of the new British Museum in 1753. MPB

Bibliography: CLA ii, no. 193; Alexander 1978, no. 29; Lowe 1960; Kuhn 1965; Wright 1967; Temple 1976, nos 61–2, 66–9; Budny 1985.

154 The Stockholm Codex Aureus

Stockholm, Royal Library, MS A.135
Vellum; ff. 193; 935 × 314 mm
Latin; mid 8th century
Kent (?Canterbury)

This is one of the most romanising of Anglo-Saxon manuscripts, with its well-modelled, naturalistic figures and its purple pages with their gold, silver and white script. The elegant crosses and geometric patterns which overlay the text, isolating parts of it, are reminiscent of the *carmina figurata* or 'figure poems' of Constantine's court poet, Porfyrius, and foreshadow the Carolingian revival of this technique by Hrabanus Maurus.

The figure style, the use of architectural arched surrounds and the panels of burnished golden display capitals are similar to those of the Vespasian Psalter (153) and seem to represent a later development of its style. A possible Canterbury origin is further reinforced by the apparent use as a model of the sixth-century Roman gospel book (1) traditionally thought to have accompanied St Augustine on his mission. An alter-

154 (*Right above*) Miniature of St John (f. 150)

154 (*Right below*) Decorated opening of St Matthew's Gospel, with inscription recording its redemption from a Viking army (f. 11)

154 Miniature of St Matthew (f. 9b)

155 Decorated opening of St
Luke's Gospel (f. 137)

native Kentish origin in Minster-in-Thanet has been
suggested, but is unsubstantiated.

The chequered history of the Kentish libraries during the
ninth century is graphically indicated by an inscription (f. 11)
which records that the book was ransomed from a Viking
army, for gold, by Ealdorman Alfred and his wife Werburh,
and given to Christ Church, Canterbury. A Viking appreci-
ation of the financial worth of books, at least, is indicated,
although the gold and silver adornment of this particular
volume probably led to its survival in this context. Ealdorman
Alfred is usually associated with an earl whose will dates to
between 871 and 889 (239).

Ironically, the book eventually found its way to Scan-
dinavia, having been acquired for the Swedish Royal Library
by Johan Gabriel Sparwenfeldt in Madrid in 1690 (f. 3). The
manuscript had reached Spain by the sixteenth century, when
it was owned by the scholar Jeronimo Zurita (1512–80).

MPB

Bibliography: CLA xi, no. 1642; McGurk 1961, no. 111; Alexander
1978, no. 30.

155 The Codex Bigotianus

Paris, Bibliothèque Nationale, MS lat. 281 (and 298)
Vellum; ff. 265 (lat. 281, ff. 216; lat. 298, ff. 49); 345–50 × 262–75 mm
Latin; second half of 8th century
Southern England (?Kent)

The damaged and perhaps unfinished state of this gospel
book belies its impressive nature. The stately uncial script,

the rustic capitals used for the prefatory matter and the use
of motifs such as the dolphin convey the classicising character
of the book. It is uncertain whether it ever contained evan-
gelist miniatures, but each Gospel opens with a major initial
and display panel, designed to shine with gold leaf in a
manner reminiscent of that found in the Vespasian Psalter
(153) and the Stockholm Codex Aureus (154), which also
provide the best parallels for script. The probable Kentish
origin of these manuscripts suggests that the Codex Bigo-
tianus may have been made there too, although the possibility
that other Southumbrian areas may have been producing
manuscripts in a similar romanising style cannot be ruled
out, with Worcester, for example, betraying a taste for uncial
script. A continental origin cannot be completely excluded
either, although this is unlikely and codicology reinforces an
English origin. The text is English in character and the
Passion in Mark's Gospel has been marked with parts for
liturgical lection or chant.

The grotesque creatures inhabiting the panelled bodies of
the initials place the manuscript within the 'Tiberius' Group
and resemble those found in the Tiberius Bede (170),
although they also inhabit works produced on the continent
under Insular influence, such as the Cutberht Gospels. A
related approach to display panels may also be found on
the continent, in the Stuttgart Psalter (128). Other parallels
include the birds on the Cropthorne cross (209) and in the
Book of Cerne (165), both from Mercia. The placing of single
beasts, with interlace, in panels may be found earlier in the
frames of the Northumbrian Durham Cassiodorus (89) and
occur further afield on the ninth-century Irish high cross at
Moone.

There is a fifteenth-century *ex libris* inscription of the Benedictine Abbey of La Trinité, Fécamp (lat. 298, f. iv) and the work was acquired by the French Royal Library in 1706 from the collection gathered in the seventeenth century by Jean Bigot, hence the present title. MPB

Bibliography: CLA v, no. 526; McGurk 1961, no. 58; Alexander 1978, no. 34.

156 Charter of Eanberht, Uhtred and Aldred, rulers of the Hwicce

British Library, Additional Charter 19789
Vellum; 256 × 172 mm
Latin; 759
Worcester

Only two original charters of the rulers of the kingdom of the Hwicce in the west midlands survive; this is the older and better preserved of the two. It records a grant in February 759 by Eanberht, Uhtred and Aldred, *reguli* (sub-kings) of

156 Charter of Eanberht, Uhtred and Aldred, rulers of the Hwicce; 759

the Hwicce, to Abbot Headda of an estate consisting of Upper Dowdeswell, Pegglesworth and Andoversford in Gloucestershire, adjoining other land already owned by Headda. The witnesses to the charter include King Offa; this is one of his earliest appearances in a charter.

The kingdom of the Hwicce was formed as the Hwicce, a tribe based in the Winchcombe area, gained power over surrounding British and Anglo-Saxon groups. The kingdom can first be identified as a political unit in the early seventh century. Its territory broadly corresponded to the medieval diocese of Worcester, although there is evidence that in the early seventh century the power of the Hwicce may have extended as far as Wiltshire and even Bath. The territories of the Hwicce were apparently divisible; this charter shows that in 759 the three brothers Eanberht, Uhtred and Aldred were ruling the province jointly.

The rulers of the Hwicce acknowledged the Mercian king as overlord as early as the 670s. By the 720s the Mercian kings had seized control of a large part of the Mercian royal patrimony. One of Offa's priorities after he became king of Mercia in 757 was the consolidation of his authority in this Mercian satellite. He appears to have actively supervised the grant recorded in this charter. It is stressed that the grant was made with Offa's 'licence and permission'. The three Hwiccan rulers are carefully described as *reguli* and Offa's name appears above theirs in the list of witnesses. In 778 Aldred was described in another charter as 'sub-king, leader [*dux*], that is, of his own people, the Hwicce', suggesting a further loss of status. By the 790s, the Hwiccans had lost their king and the individual who governed them was referred to simply as *dux*.

The estate granted to Abbot Headda was in the heartland of the Hwiccan kingdom, the area around Winchcombe which briefly in the late tenth and early eleventh centuries became a county in its own right, 'Winchcombeshire'. Between 781 and 810 Headda left this estate to the double monastery at Withington founded by King Æthelred of Mercia in the late seventh century. This monastery became extinct during the ninth century and Headda's land passed, like most of the old Hwiccan royal patrimony, to the see of Worcester. AP

Bibliography: Sawyer 1968, no. 56; *ChLA* no. 179; Scharer 1982, 214–16.

157 Charter of Oslac, *dux* of the South Saxons

West Sussex Record Office, Chichester Diocesan Records, Cap. I/17
Vellum; 140 × 211 mm
Latin; 780 with confirmation between 789 and 796
Selsey, with Mercian confirmation

This is the oldest original South Saxon charter to have survived. It is dated 780 at Selsey and records the grant by Oslac, '*dux* [leader] of the South Saxons', of Earnley and Tielæsora to 'the venerable church of St Paul the Apostle'. Oslac may perhaps be identified with one of the four kings of the South Saxons named in a charter (of doubtful authenticity) dated 770. During 770–1, Offa attacked the South

157 Charter of Oslac, *dux* of
the South Saxons; 780

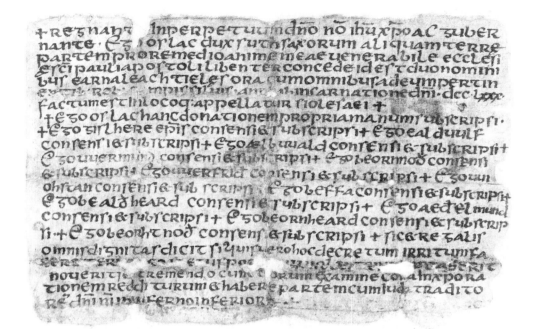

Saxons and forced Oslac and his fellow kings to recognise him as overlord. Oslac and the others lost their royal status and were reduced to the level of *dux* or *ealdorman*. During the 770s and 780s, however, Offa's authority among the South Saxons was limited. No attempt was made to seek his approval for Oslac's grant. In the late 780s, Offa returned and finally annexed the territory of the South Saxons. The new bishop of Selsey, Wihthun, thought it advisable to obtain from Offa confirmation of Oslac's gift. This was given at Irthlingborough near Leicester and is recorded on the dorse of this charter.

Oslac's charter is written in an archaic hand which fuses uncial, half-uncial and minuscule features as well as some continental elements to form a most unusual provincial script. The Latin is clumsy and primitive. It has been suggested that the orthography shows strong West Saxon influence, perhaps indicating that the scribe was trained at Winchester. The confirmation on the dorse, written perhaps by a Worcester scribe at Offa's court, is in a fluent and up-to-date minuscule hand and forms a striking contrast to the old-fashioned writing of the main grant. The vellum used for the charter was originally meant for a psalter; the last words of Psalm 65 and the beginning of Psalm 66 can be made out on the dorse. Evidently something went wrong with the writing of this leaf of the psalter, but the vellum was saved and used to record Oslac's grant.

The church of St Paul named in the charter has not been identified. The monastery at Selsey was dedicated to St Peter. It is not impossible, however, that the scribe made a mistake and that the grant was intended for Selsey Abbey. It seems unlikely that the bishop would have taken such trouble to secure the confirmation of a grant to another church. Moreover, the charter was preserved in the records of the see of

Selsey, passing to Chichester when the see was transferred there in 1075. The creases in the document show that it was kept folded from an early date. Indeed the way in which the confirmation is written indicates that the charter had already been folded at least once horizontally and vertically by the time it was presented to King Offa. AP

Bibliography: Sawyer 1968, no. 1184; *ChLA*, no. 236; Chaplais 1968, 333–35; Whitelock 1979, no. 76; Rogers 1981, 257–66; Scharer 1982, 260–1; Welch 1983, 323–31.

158 Charter of King Offa

British Library, Additional Charter 19790
Vellum; 185 × 135 mm
Latin; between 793 and 796
Mercia (?Worcester)

Between 793 and 796, at the height of his power, Offa gave to 'his faithful *minister* Æthelmund' an estate at Westbury-on-Trim in Gloucestershire. This is the record of that grant. Offa is described in this charter as 'King ordained by the King of Kings' and 'King by the gift of God'. Offa frequently stressed the divine origins of his kingship. As early as 764, he was described in a Rochester charter as 'the king of the Mercians, sprung from the royal stock of the Mercians and made King by appointment of Almighty God'. Offa gave this sacral view of kingship concrete expression by arranging for the anointment of his son Ecgfrith as king. Earlier kings, such as Æthelbald, had declared in their charters that they ruled by God's grace, but Offa, following contemporary Frankish and perhaps even Byzantine examples, took matters a stage further.

It is not known what the responsibilities of the various *ministri* mentioned in Offa's charters were. The nearest Old English equivalent of the Latin term was *thegn*, which means simply 'one who follows'. In the tenth and eleventh centuries, thegns were important local officials. Æthelmund was evidently a clerk; this grant was made by Offa 'for the salvation of my soul'. As Offa's power grew, he would have required an increasing amount of clerical and administrative assistance, but he probably did not have a formal chancery, relying instead on the *ad hoc* services of local monastic scribes. This charter was written in a careful and competent set minuscule hand (with uncial and half-uncial forms introduced to upgrade the script) by a scribe from a Mercian monastery.

The land given to Æthelmund lay in the old kingdom of the Hwicce. Offa's annexation of this area by the end of his reign is reflected in the fact that the rulers of the province were apparently not consulted about the grant. The land was given to Æthelmund free of all dues except service in the army and work on bridges and fortresses. The requirement that all landholders undertake these duties (the so-called *trinoda necessitas*) was an important feature of Anglo-Saxon land tenure. This is the first surviving original charter which refers specifically to these three 'common burdens'.

Offa made his grant to Æthelmund during a routine church council at *Clofesho* attended by the leading clergy of the provinces of Canterbury and Lichfield. The witnesses to the grant included the archbishops of Canterbury and Lichfield, four abbots and the bishops of all the dioceses ruled by Offa. The picture that emerges is of Offa presiding with his son in great grandeur over the deliberations of the southern English Church and taking the opportunity to express his gratitude to his loyal lieutenant Æthelmund. AP

Bibliography: Sawyer 1968, no. 139; *ChLA*, no. 180; Brooks 1971, 78; Scharer 1982, 275–8.

159 The Synod of Chelsea and a letter from Alcuin

British Library, Cotton MS Vespasian A. xiv
Vellum; ff. 1* + 179; 205 × 147 mm
Latin with Old English gloss; first half of 11th century
?Worcester or York (part of a composite manuscript)

The atmosphere of conflict, reform and of interaction with the Carolingian court circle which pervaded Southumbria during the late eighth and first half of the ninth century is well illustrated: by the business conducted within the English

158 Charter of King Offa; between 793 and 796

159 Letter from Alcuin to Archbishop Æthelheard (f. 154)

Church and by the correspondence which was exchanged between Charlemagne and the Carolingian reformer, Alcuin (formerly of York) and Anglo-Saxon notables such as King Offa and key ecclesiastics from both north and south of the Humber.

The exhibited letter (ff. 154–5v) contains advice and exhortation from Alcuin (c.735–804) to Æthelheard, archbishop of Canterbury (793–805), and dates to between 793 and 804. Antipathy to Mercian authority and to Offa's securement of the elevation of Lichfield to the status of a third archbishopric (787–803) led to unrest, especially in Kent. A Mercian pawn, the hapless Æthelheard was forced to flee from Canterbury during a Kentish uprising led by Eadberht Præn. The latter ruled Kent independently from 796 to 798, until carried in irons to Mercia where his hands were cut off and his eyes put out, his priestly status precluding his execution. Alcuin addressed several letters to Æthelheard, including a sharp rebuke for abandoning his community. Thus encouraged, and assisted by the tide of events, Æthelheard eventually recovered his see and, along with Cœnwulf, king of Mercia (796–821), set about restoring Canterbury's fortunes and primacy.

The only surviving copy of the proceedings of the Synod of Chelsea (Celchyth) of 816, which is exhibited here (ff. 149–53v), records one of a series of important gatherings of the English clergy. Under Æthelheard's successor, the reformer Wulfred (805–32), the synod set about extending episcopal authority and diminishing lay control of the Church. The influence of Carolingian reforming synods pervades the proceedings and is specifically manifest in measures such as the denial of the legitimacy of offices performed by Irish clergy (thereby indicating that Irish participation in the English and continental churches was still an active phenomenon).

MPB

Bibliography: Haddan and Stubbs 1869–71, III, 552–4, 579–85; Dümmler 1895, II, nos 126–30 etc.; Ker 1957, no. 204; Hughes 1958, 183–200; Brooks 1984, 118–42, 175–80.

160 The Barberini Gospels

Rome, Biblioteca Apostolica Vaticana, MS Barb. lat. 570
Vellum; ff. 153; 340 × 250 mm
Latin; late 8th century
Mercia or Northumbria (?York)

This splendid gospel book remains something of a mystery, although it represents an important landmark in the development of Insular art. Little is known of its history, other than that it formed part of the Biblioteca Barberini, founded principally by Francesco Barberini (1597–1679), which was purchased by Pope Leo XIII for the Vatican in 1902. The scribe heading the team of four who penned the work gives a colophon (f. 153) reading 'Ora pro Uuigbaldo' ('A prayer for Wigbald'), perhaps the master-scribe himself, or a patron. A tentative association with Hygebeald, bishop of Lindisfarne (c. 781–803), has been suggested but not been generally accepted. Northumbrian training is apparent in some of the scribal activity, but one member of the team would appear,

by analogy with charters and other works, to have been a Mercian.

The decoration displays eastern Mediterranean influence which is most evident in its evangelist portraits (three of which are unfinished) with their well-modelled figures and spatial conception. This may well have been transmitted via an Italo-Byzantine milieu and would accord with a general climate of exotic and classicising taste especially prevalent within Southumbria during the eighth to ninth centuries, and which is reflected in other works such as the sculptures at Breedon-on-the-Hill. The playful use of grotesque line-fillers and run-over symbols by the Mercian scribe and the panels of display script with their lacertine forms and biting beast-heads prefigure characteristic features of the 'Tiberius' group, of which the present volume may be considered a founding member. It has been marked up for use as a Gospel lectionary.

It is possible that this is the finest of a handful of manuscripts surviving from the once powerful kingdom of Mercia. Similarities between the canon tables and evangelist portraits of the present volume and those in one of the gospel books now in Maaseik have been used to bolster claims for a York origin. So too has the resemblance between inhabited vine-scroll ornament in the Barberini Gospels and on the Ormside Bowl (**134**) found in Westmorland. None the less, there is no real evidence for these items having been produced at York either, and the knowledge that the city once possessed a superb library is not adequate justification alone for attributing 'floating' works to it, however amenable its cultural climate might seem as a context for production. MPB

Bibliography: CLA i, no. 63; McGurk 1961, no. *137; Alexander 1978, no. 36

161 Charter of King Cœnwulf of Mercia

British Library, Stowe Charter 7
Vellum; 259 × 185 mm
Latin; 799
Canterbury

The control of land grants provided one of the chief means by which Offa curbed the independence of the kingdoms he conquered. This charter vividly illustrates Offa's insistence on his right as overlord to approve all land grants. For ten years after his defeat of Offa at the Battle of Otford in 776, Ecgberht II of Kent was able to act as an independent ruler. During this period, in return for 'great riches', Ecgberht granted to the see of Canterbury a large estate at Charing. Further land at Bishopbourne near Barham was sold by Ecgberht in 780 to his thegn Ealdhun, a kinsman of Archbishop Jænberht, for two thousand shillings. When Ealdhun 'set out across the sea' on pilgrimage he gave this land to Christ Church, Canterbury. After Offa resumed control of Kent, he confiscated these estates and gave them to his followers, declaring that 'it was unlawful for his *minister* [a slighting reference to Ecgberht] to presume to give away the land granted to him by his lord without his lord's testimony'.

160 Miniature of St John (f. 124b)

160 Decorated opening of St John's Gospel (f. 125)

This was one of a number of Canterbury estates seized by Offa. After Cœnwulf succeeded to the Mercian throne and had suppressed the rebellion of Eadberht Præn in Kent, he was anxious to improve relations with the metropolitan see and Archbishop Æthelweard persuaded him to return much of this property. This charter records the restoration by Cœnwulf of the estates at Charing and Bassingbourne in 799 in return for a payment of 100 mancuses. This was considerably less than the market price, which suggests that Cœnwulf either compensated the men who were given these estates by Offa or risked alienating them by confiscating the lands.

The charter is dated 799 at the royal palace of Tamworth. Although it was written by one scribe, the list of witnesses was written at a different time to the text of the grant itself. The scribe came from Canterbury; his 'rather ugly pointed minuscule' is also found in another Kent charter of 785. Perhaps the first part of the charter was prepared in advance at Canterbury, taken to Tamworth and the names of the witnesses added afterwards. The names of Cœnwulf and the ecclesiastical witnesses are on the recto. The scribe advises the reader to 'Turn the leaf and you will see the names of the ealdormen who consenting to this placed the sign of their hands'.

AP

161 Charter of King Cœnwulf of Mercia; 799

Bibliography: Sawyer 1968, no. 155; Chaplais 1968, 332–3; Whitelock 1979, no. 80; Brooks 1984, 114–15, 131, 321–2.

162 The Harley Prayerbook

British Library, Harley MS 7653
Vellum; ff. 7; 225 × 155 mm
Latin, with Old English gloss; late 8th – early 9th century
Mercia (?Worcester)

This is the earliest of a group of Mercian prayerbooks (162–5) used in private devotions. An emphasis upon female saints has led to the suggestion that it was owned by a woman. Its fragmentary state makes it difficult to ascertain whether it gathered its prayers around a central theme, as in the other prayerbooks, but its script alone suggests a rather earlier date and a Mercian origin. It has been suggested that it might represent the smaller booklets of prayers which were probably used as sources by the more sophisticated Mercian group.

It was annotated with a runic-like sign by a later Mercian hand which also left its mark in the Royal Prayerbook (163), indicating that they were probably in the same library from an early date. The Royal Prayerbook has a Worcester provenance and it is possible that both books were made there.

MPB

Bibliography: CLA ii, no. 204; Ker 1957, no. 244; Morrish 1988.

163 The Royal Prayerbook

British Library, Royal MS 2 A.xx
Vellum; ff. 52; 233 × 170 mm
Latin, with Old English glosses; first quarter of 9th century
Mercia (?Worcester)

This is one of a group of Mercian prayerbooks (162–5) which compile devotional texts around a central theme, in this case Christ as the healer of mankind. Miracles of healing from the Gospels, prayers and hymns from the Roman and Celtic churches, charms and magico-medical remedies are assembled into a programme which, in typical Anglo-Saxon fashion, acknowledges no firm distinction between overtly Christian and other material. It has been suggested that this prayerbook belonged to a physician, perhaps even a female physician in view of the number of prayers couched in the feminine form.

Both text and decoration exhibit Irish influence, an important component in 'Tiberius' group manuscripts. The exhibited initial (an IN monogram), introducing a prayer, features simplified beast-heads and a little winged biped which relate to other Southumbrian pieces, such as the Cropthorne cross-head (209) and the Gandersheim casket (138). Stylistically it slightly predates the Book of Cerne (165) and the Saints' Lives (168) and would suggest a date in the early ninth century. Script and decoration suggest a western Mercian origin and it may well have been produced at Worcester, where it was probably recorded by Patrick Young in his catalogue of 1622–3. It was annotated by a later Anglo-Saxon

162 (*Right*) Prayers for
private devotions (ff. 2b–3)

163 (*Below*) Prayers, with
decorated initial and later
marginal additions
(ff. 16b–17)

hand which also left its mark in the Harley Prayerbook (**162**). Old English glosses in Mercian dialect and other notes attest to its continued use. It was eventually owned by John Theyer (1597–1673) of Cowper's Hill, Glos., a prominent collector of material from the west midlands. MPB

Bibliography: CLA ii, no. 215; Alexander 1978, no. 35; Kuypers 1902, 200–25; Ker 1957, no. 248; Morrish 1988, 512–38.

164 The Book of Nunnaminster

British Library, Harley MS 2965
Vellum; ff. 41; 215 × 160 mm
Latin, with Old English glosses; first quarter of 9th century
Mercia

This is one of a group of prayerbooks (**162–5**) intended as a programme of private devotion arranged around a central theme, in this case a meditation upon the life of Christ. It is textually and stylistically less developed than the Book of Cerne (**165**) and is probably of similar date to the Royal Prayerbook (**163**). Many of its initials resemble those in other 'Tiberius' group manuscripts, especially the Tiberius Bede

(**170**) and the Book of Cerne (**165**). The exhibited opening displays the impact of a new exemplar, for the style of script decoration, although by the same hand, changes on f. 37, as does the text, which from this point consists of prayers of Irish rather than Roman origin. The first of these prayers, shown here, protects against poison. The colours used also change, with blue replacing the green used earlier in the book. This offers important evidence of direct contemporary Southumbrian use of Irish sources, rather than just of elements which had earlier been absorbed into Northumbrian culture.

Flyleaves at the back of the book carry a prayer in a late ninth-century hand, in the feminine form, and a record of property given to the nunnery at Winchester (Nunnaminster) by its founder, Ealhswith (d. 909), the wife of Alfred the Great. It has been suggested that Ealhswith, herself a Mercian, may have owned this book at one time and bequeathed it to the Nunnaminster along with her other gifts, although this attractive theory cannot be fully proved. Alternatively, the volume may have entered Wessex as a result of Mercian participation in West Saxon renewal, or as a refugee from the Viking occupation. It is certainly a good example of the sort of manuscript which influenced sub-

164 Prayers, with a change in style influenced by a different exemplar (ff. 36b–37)

sequent West Saxon production. It belonged to the Cornish Roscarrock family during the seventeenth century, and later to John Warburton, Somerset Herald, before entering the Harley Collection in 1720. MPB

Bibliography: CLA ii, no. 199; Alexander 1978, no. 41; de Gray Birch 1889; Ker 1957, no. 237; Morrish 1988, 512–38.

165 The Book of Cerne

Cambridge, University Library, MS Ll.1.10
Vellum; ff. 98 (plus later accretions); 230 × 184 mm
Latin and Old English; 9th century (?c.818–30)
Mercia (?Lichfield)

The Book of Cerne is a prayerbook, intended for private devotional use, incorporating Gospel Passion extracts, hymns and prayers (of Roman and Celtic character), an abridged psalter and an apocryphal *Harrowing of Hell* text which is probably the earliest extant example of a piece of liturgical drama. It is introduced by instructions for the use of the book in Old English, few written examples of which survive from the period.

The volume also contains an acrostic poem (f.21) in which the first letter of each line spells *Aedeluald episcopus*, who is also accredited (in a different form of the name) with abridging the psalter. This probably refers (if obliquely) to Bishop Æthelwald of Lichfield (818–30), the likely patron of the book, although it has been suggested that the prayerbook is substantially a copy of an earlier book associated with Bishop Æthilwald of Lindisfarne (?c.731–7 or 740), the binder of the Lindisfarne Gospels (80). However, the Book of Cerne is the most advanced of a group of prayerbooks (162–5) which compile their texts around a central theme, a genre which can be seen developing throughout this ninth-century group of Mercian manuscripts. The central theme of Cerne is participation in the Communion of Saints. Stylistically the Book of Cerne lies within ninth-century Mercia, and its contents would accord with what little is known of the interests of Æthelwald of Lichfield from the slight indications that he may have been a reformer intent upon introducing canons living the communal life into his cathedral, along contemporary Carolingian lines. Furthermore, Cerne is a later work of the artist-scribe of a Mercian copy of a mass text (166) promoted by the Carolingians which might also tie in with Æthelwald's possible reforms.

Further Carolingian influence may be apparent in the display panels introducing the Gospel extracts (as exhibited), with their use of purple and gold and of square capitals. Also, the symbol of St Luke, the bull (exhibited here, f. 21v), with its hindquarters which it appears to have borrowed from elsewhere, probably used the same Carolingian or Medi-terranean model for its upper half as that used in a more painterly manuscript, Royal MS 1 E.vi (171), made at Canterbury at a similar date. That two prelates possibly engaged in continental-style reform, Æthelwald of Lichfield and Archbishop Wulfred, should have shared their sources is hardly surprising and would account both for the simi-larities between the bulls and for the striking differences in approach.

The Cerne evangelist miniatures are unusual in that they combine full-length symbols (inspired by the vision of Ezekiel) with half-length portraits, accompanied by inscrip-tions emphasising the two different forms. This may relate to religious ceremonial in which the nature of the evangelists was explained.

The prayerbook is now bound with later material relating to Cerne Abbas, Dorset, hence the name, but there is no real evidence that the early book was ever there. It may well have been evacuated to Worcester or Wessex from Lichfield during the Viking raids, and was often consulted later for its devotional texts. MPB

Bibliography: Alexander 1978, no. 66; Kuypers 1902; Ker 1957, no. 27; Dumville 1972, 374–406; Dornier 1977, 235–44; Morrish 1988, 512–38.

166 Mass text

Oxford, Bodleian Library, MS Hatton 93
Vellum; ff. 40; 215 × 145 mm
Latin; 9th century (?c.818–30)
Mercia (?Lichfield)

This is a rare survival of a service-book, a type of manuscript particularly unlikely to be retained owing to changes in the liturgy which would often render such books redundant. None the less, each church and chapel would have needed such books in order to function. The text of the mass which it contains is very interesting, for it is the *Primum in Ordine* version (the opening words of which are exhibited), promoted within Carolingian territory. As such it is perhaps a tangible piece of manuscript evidence for Carolingian influence.

There is reason to suggest that this is an early work by the artist-scribe of the Book of Cerne (165), a prayerbook which may perhaps be associated with Bishop Æthelwald of Lich-field (818–30). Æthelwald may have been concerned with introducing reforms along Carolingian lines and this manu-script would have been well suited to such interests. The script, when compared with related manuscripts and charters, confirms a western Mercian origin. Twelfth-century additions indicate its presence at Worcester, where it was also noted in Patrick Young's catalogue of 1622–3. Worcester seems perhaps to have acted as something of a 'safe-house' for manuscripts from occupied Mercia and may have received this volume as a refugee from Lichfield.

The palette is like that of much of the Book of Cerne and one of the worm-like beasts which playfully adorn that volume occurs at the foot of the initial P seen here. They also share distinctive features in the way they are physically assembled. A most unusual feature of this book is that the scribe has given a full system of foliation (or 'page-num-bering'), adding series of letters and numbers at the foot. MPB

Bibliography: CLA ii, no. 241; Ker 1957, no. 239; Morrish 1988.

166 Decorated opening of a Mass text (f. 2)

165 (*Left*) Miniature with both portrait and symbol of St Luke
(f. 21b)

167 (*Right*) Grant of kings Cœnwulf and Cuthred to Wulfhard,
priest; 805

167 Grant of Cœnwulf, king of Mercia, and Cuthred, king of Kent, to Wulfhard, priest, of land at Swarling, Kent

British Library, Stowe Charter 9
Vellum; 344 × 122 mm
Latin; 805
Aclaeh (Oakley ?Beds. or ?Hunts.)

Cœnwulf's concern with maintaining the loyalty of the community of Christ Church, Canterbury, following the death of Archbishop Æthelheard in 805 may be indicated by this charter. It records a generous grant of land at Swarling and Ecgheannglond, Kent, hereditary and free of all taxes and services, to Wulfhard ('the devoted servant of Archbishop Æthelheard of blessed memory'). In return Wulfhard owed to the grantors his 'faithful service' along with one hundred *sicli* (shekels) of gold and the same of silver. This also shows that members of the community could hold considerable property in their own right, a practice fostered by Æthelheard's successor, Wulfred (805–32), himself a wealthy Mercian, despite his communal reforms (possibly broadly based upon the *Rule* of Chrodegang of Metz).

Unusually the charter states that it was written at 'the very famous place of Aclaeh', and the script is characteristic of the cursive minuscule popular in Southumbria from the reign of Offa (757–96). It has a rounded appearance and incorporates a number of calligraphic distortions and higher-grade letter-forms (such as N and T). Comparison with the script of later Christ Church charters (such as **169**) reveals that this sort of script formed the basis for a distinctive Canterbury 'mannered minuscule' which appears to have been formed and promoted almost as a 'house-style' under Archbishop Wulfred, and which could be used for books (such as **168**) as well as documents. MPB

Bibliography: Sawyer 1968, no. 161; Brooks 1984, 159–60 n. 28; Brown 1987, 119–37.

168 Saints' Lives

Paris, Bibliothèque Nationale, MS lat. 10861
Vellum; ff. 123; 255 × 185 mm
Latin; *c*.805–25
?Christ Church, Canterbury

This modest little book contains a collection of saints' lives or passions (of 'universal' rather than local character). The exhibited opening shows the beginning of the Passion of St Philip. Script and decoration place it within the 'Tiberius' group and it is of great importance as a chronological and regional point of reference for the later members of the group, for its script, which incorporates several distinctive, short-lived calligraphic features, relates it closely to charters produced at Christ Church, Canterbury and dated between *c*.805 and *c*.825. This 'mannered minuscule' script seems to have resulted primarily from attempts by the scriptorium to produce a prestigious documentary script as part of the heightened charter production stimulated by Archbishop

168 Opening of a book of saints' lives, written in 'mannered minuscule' (f. 2)

Wulfred's (805–32) struggles with the Mercian royal house.

Although of rather lower quality, this volume contains the style of decoration inherited from the Barberini Gospels (**160**), featuring beast-heads and grotesques, which distinguishes the 'Tiberius' group. It is closest in style to the Tiberius Bede (**170**).

It is difficult to tell how widespread this distinctive style was; indeed, this manuscript was in Beauvais by the late twelfth century, and production on the continent by a Canterbury-trained scribe cannot be completely ruled out. None the less, the script, when compared with charters not produced at Canterbury, appears to represent virtually a Canterbury 'house-style'.

This manuscript shows signs of experimentation with continental methods of physical production, such as the manner of preparing some of the vellum, a feature which also occurs in Royal MS I E.vi (**171**), probably also from Canterbury. This provides further valuable evidence of heightened continental influence during the early ninth century. MPB

Bibliography: Alexander 1978, no. 67; Brown 1987, 119–37; Avril and Stirnemann 1987, no. 11.

169 Grant of King Cœnwulf to Archbishop Wulfred, written in 'mannered minuscule'; 814

169 Grant of Cœnwulf, king of Mercia, to Archbishop Wulfred of land at ?Kingsland, Faversham Hundred, Kent

British Library, Cotton MS Augustus ii.74
Vellum; 440 × 228 mm
Latin with Old English bounds; 814
Christ Church, Canterbury

Under the formidable Archbishop Wulfred (805–32) the fortunes of Canterbury, which had suffered at the hands of Offa in favour of Lichfield, were restored. An initial phase of reconciliation and collaboration with the Mercian royal house led to a series of grants to the community, of which the present document is an example. It conveys a parcel of land at *Cynincges cua lond* (?Kingsland, Faversham Hundred) to Wulfred in return for seven *libras* (pounds) of gold and of silver, with a forbidding anathema clause to deter any false claimants.

However, following the Synod of Chelsea of 816 (see **159**) relations took a turn for the worse as Wulfred, and possibly fellow reformers Æthelwald of Lichfield and Heahbert of Worcester, stepped up their attack upon lay lordship of the monasteries.

Both climates fostered a growth in charter production at Christ Church, either in its role as a beneficiary or as a participant in litigation, and a distinctive style of script which has been termed 'mannered minuscule' was evolved in order to render the documents more impressive. This apparently corresponded to a rise in the importance of written evidence in litigation. This charter is a good example of such script, which incorporates a number of calligraphic mannerisms, such as reversing and elaborating the heads of letters (such as e and q) and the distinctive treatment of x. The effect is that of an elegant, pointed and flamboyant script which could be produced more economically than formal book scripts, but which was also imposing. Comparison with an earlier Mercian charter (**167**) shows how much more impressive Wulfred's claims could appear on parchment. A book of saint's lives (**168**) also displays a script which is closely relaed to that of the charters and has enabled documents to be used to assist in the dating and localisation of 'Tiberius' group manuscripts. MPB

Bibliography: Sawyer 1968, no. 177; Brooks 1984, 180–6; Brown 1987, 119–37.

170 The Tiberius Bede

British Library, Cotton MS Tiberius C. ii
Vellum; ff. 157; 272 × 216 mm
Latin, with Old English glosses; first half of 9th century
Mercia/Kent (?Canterbury)

This is the manuscript from which the important Southumbrian 'Tiberius' group takes its name. It contains an early copy of Bede's *Historia Ecclesiastica* (*Ecclesiastical History of the English People*), of which the opening to Book I is exhibited.

170 Opening of the *Historia Ecclesiastica* from the 'Tiberius' Bede (f. 5b)

The script of the volume resembles that of Canterbury charters of the 820s–30s and it is possible that one of its scribes also worked on Royal MS I E.vi (**171**). A Canterbury origin is likely. Its decoration features the beast-heads, independent beasts and grotesques characteristic of the 'Tiberius' group, and elements of its animal ornament, along with its use of interlace in white against a black ground, are highly reminiscent of silver-niello Trewhiddle-style metalwork (e.g. **187, 245–6**). Indeed the bow of the exhibited initial b resembles a disc-brooch in its design. It has inherited much of its ornament from Hiberno-Saxon art, from the Barberini Gospels (**160**) and other earlier members of the 'Tiberius' group (**153–5**) and from Southumbrian works in other media. It is something of a fount of 'Tiberius' group features, hence its central role. Echoes of its ornament occur in other members of the group which, it is suggested, were produced in western Mercia, but they draw upon the common repertoire to form stylistic responses of their own. Its closest relatives are the Saints' Lives (**168**) and Royal MS I E.vi (**171**), and, to a lesser extent, the Book of Nunnaminster (**164**) and the Book of Cerne (**165**).

A near contemporary addition to Bede's prefatory letter has led to the suggestion that the book belonged to the community of St Cuthbert (originally Lindisfarne) shortly after production, although this may simply represent a correction inserted from an exemplar. MPB

Bibliography: CLA ii, no. 191; Alexander 1978, no. 33; Ker 1957, no. 198; Budny 1985; Morrish 1988, 512–38.

171 The Royal Bible

British Library, Royal MS I E.vi
Vellum; ff. ii + 78; 467 × 345 mm
Latin; 9th century (*c*.820–40)
Canterbury (?St Augustine's)

This imposing but fragmentary volume, along with some detached leaves now housed in other libraries (Canterbury, Cathedral Library, Add. MS 16; Oxford, Bodleian Library, Lat. bibl. d.1(P); Worcester, Cathedral Library, Add. MS 1), formed part of a sumptuous gospel book or bible. Although the fragments are from the New Testament, the large format and the high numbers written on to the separate quires (or booklets) of which the book is formed suggest that it was a large illuminated bible, rather like those commissioned earlier by Ceolfrid (**87–8**).

The illumination, which is now confined to the canon tables, some minor initials and the exhibited *incipit* (opening) of the Gospel of Luke, is painterly and naturalistic in its figure style and classicising in its use of purple pages and of gold and silver (all with imperial connotations). These elements are combined with animal ornament and interlace common to the 'Tiberius' group and to Trewhiddle-style metalwork. Surviving inscriptions in gold and silver indicate that a full programme of illustrative miniatures was once present. The opening words of Luke's Gospel incorporate 'Tiberius'-group animal ornament (obscured by the badly

oxidised silver) and are framed by a spacious arcade, reminiscent of Carolingian Court School works. Christ Pantocrator (or the evangelist in his human guise), in the style of late antique mosaics such as those at Sant' Apollinare in Classe (Ravenna), surmounts the symbol of Luke, the bull. This was modelled upon a continental examplar, probably produced in the Carolingian Court School. A rather different response to the same model can be seen in the Book of Cerne (**165**). The Royal Bible contains further indications of continental influence in its method of physical manufacture.

This concern with continental and specifically Carolingian developments would accord well with the interests of Archbishop Wulfred (805–32), a reforming prelate who may have been joined in his reforms by Bishop Æthelwald of Lichfield (818–30), the probable patron of the Book of Cerne. This possible scenario of collaboration might account for the shared reference to a continental examplar apparent in the Royal Bible and the Book of Cerne (epitomised in the features shared by their bull symbols).

This volume carries a fourteenth-century library inscription from St Augustine's, Canterbury (which does not, however, correspond to the library catalogue) and it was probably described by Thomas of Elmham in 1414–18 as adorning the altar there. However, the *Biblia Gregoriana* to which he referred was probably not this volume. The manuscript was later owned by John, Lord Lumley (f. iv), and passed to the Royal Library after his death in 1609. MPB

Bibliography: CLA ii, nos 214, 245, 262 and Suppl. p. 5; Alexander 1978, no. 32; Brooks 1984; Budny 1985; Brown 1987, 119–37

172 Felix, Life of St Guthlac

British Library, Royal MS 4 A.xiv
Vellum; ff. 2; 277 × 180 mm
Latin; first half of 9th century
Wessex (?Winchester)

This fragment consists of a bifolium from a book which had been damaged or broken up and used as binder's waste by the late tenth century, at which date it provided fly-leaves for a manuscript of Pseudo-Hieronymus, *In Psalmos*, written in an English Caroline minuscule which is stylistically related to similar script in a book from Winchester (BL, Royal MS 2 B.v).

The script of the ninth-century fragment resembles that of the few surviving examples of early to mid ninth-century handwriting from Wessex (such as Oxford, Bodleian Library, MS Bodl. 426) and may represent a regional response to the cursive minuscule script favoured in Mercia and Kent during the first half of the ninth century (especially the second quarter). A distinctive West Saxon feature is the preference for a *g* with a reversed head, resembling a long *z*, favoured in the west country from at least the time of St Boniface. This manuscript therefore belongs to the period when Wessex stood poised to usurp the Mercian supremacy.

Guthlac (*c*.673–714) was a popular cult figure in Anglo-Saxon England. A scion of the Mercian royal house (from

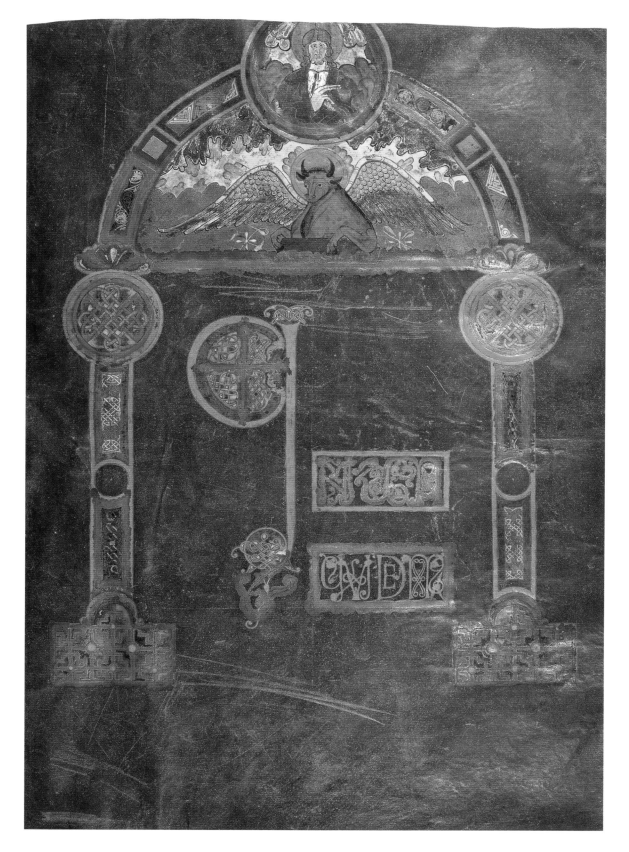

172 Fragment of Felix's Life of St Guthlac (ff. 107b–108)

171 (*Left*) Decorated opening of St Luke's Gospel (f. 43)

the line which produced kings Æthelbald and Offa), he established a reputation for himself as a boy-warrior, leading a war-band on regular raids into Wales. An incipient sign of sanctity was manifested in his practice of returning a third of the loot to his victims. Before 700, however, he experienced a religious calling and received the tonsure at the double monastery of Repton, under Abbess Ælfthryth. He subsequently sought the more ascetic life of the desert fathers, confining himself to the hermit's life at Crowland, Lincs., an island refuge in the watery fastness of the Fens and a popular haunt of every sort of demon. Felix describes the Fens as '. . . swamps and bogs, an occasional black pool, exuding dark mists, sprinkled with islands of marshy heaths and criss-crossed by winding waterways'. This mystical, menacing abode was akin to the refuge sought by Grendel in the Anglo-Saxon epic *Beowulf* (4), and there are aspects of the Life of Guthlac which invite comparison with the hero of that saga. Not surprisingly, Guthlac's story later inspired two Old English poems, as well as being enshrined by Felix.

Guthlac's biographer Felix tells us nothing about himself, but he dedicated the work to Ælfwald, king of East Anglia *c*.713–49. Felix drew upon a number of works for inspiration, including Bede's verse and prose versions of the Life of Cuthbert, the Life of Martin by Sulpicius Severus, Jerome's Life of Paul, Evagrius's translation of the Life of Anthony by Athanasius, Gregory the Great's *Dialogues* and *Exposition on Job* and Aldhelm's *De metris* and *De virginitate* (59, 237), and his style has Vergilian echoes. This gives some indication of the breadth of library resources available in East Anglia at this time.

The present West Saxon manuscript illustrates the dissemination of the cult. It later belonged to a prominent collector of west country material, John Theyer (1597–1673) of Cowper's Hill, Glos. MPB

Bibliography: CLA ii, no. 216; Colgrave 1956; Whitelock 1972, 1–22; Farmer 1974, VI, col. 466.

Metalwork

The rapid rise and durability of Mercia's fortunes coincided with what appears to have been for much of the country a relatively stable and sustained period of production which leaves a clear mark in metalwork, as in other media. Two major factors, however, alter the face of the archaeological record: the superseding of gold by silver as the dominant medium for fine metalwork, and the consequent effects on decorative techniques; and the dramatic impact of the quality and nature of the surviving metalwork as a result of the abandonment of the old pagan traditions of burial with grave goods. From the early years of the eighth century onwards, most of the surviving metalwork comes not from the well-equipped (though carefully edited) burials of the dead, but as casual losses on rural and urban settlements and from hoards deliberately buried for safe-keeping. There is thus an evident diminution in the recovery of high-status objects,

and, perhaps more telling, the invaluable information which graves provide about the precise function, date and status of objects is also often blurred in the more random processes which condition the deposit and retrieval of settlement debris. Thus we cannot readily tell whether, for example, the common single pins were primarily for fixing hair, dress, or head-coverings; or whether the ubiquitous hooked-tags were used by both sexes or only by men, and for what precise purposes. But these disadvantages are to some extent compensated for by the enhanced dating evidence provided by coin hoards, and by the chronological scope of coin assemblages retrieved from sites. From all of this, an overall pattern emerges.

The finer metalwork of the eighth century in silver and gold is in general in rather short supply, though recent, as yet unpublished, excavations on urban and rural sites such as Ipswich and Brandon, Suffolk (66) are certainly modifying this impression gained from older chance finds. This is also partly because almost no mixed hoards (coins and artefacts) survive from this period; though some Insular material finds its way into the datable Viking graves in Scandinavia, as well as into continental church treasuries (see p. 167). Nevertheless, in comparison with fine metalwork generally datable to the ninth century, the eighth-century corpus is slight, in number if not in quality, prompting the thought that this may at least partly reflect a contemporary reality. Certainly, gold was no longer seriously available for use in jewellery by the early eighth century, in the way that it had been in the seventh century, and even the silver of the finer objects – the Witham pins, the Fetter Lane sword, the Ormside Bowl (184, 173, 134) – is often of poor quality, reflecting the progressive debasement of the coinage (55, 57). The use of filigree decoration and of glass and garnet inlays, both better suited to work in gold, declines and dies out; and a return to favour of gilding, chip-carving repoussé and openwork decoration is seen. A distinctive development of zoomorphic style accompanies this, in the Mercian province south of the Humber; most prominent amongst its characteristics are heraldic winged beasts of a kind seen also in sculpture and manuscripts, and a lively interest in interlace meshes and ribbed and speckled surface textures. The most important innovation, however, occurs towards the very end of the eighth century in the form of the revival of the old technique of niello inlay in spectacular new decorative ways. The dramatic contrast of black niello on good-quality silver or gold was exploited to splendid effect by the metalworkers from the end of the eighth through to the ninth century. Its fluent precision enabled skilled craftsmen to imitate the effects of the manuscript-painter or scribe, and indeed the stylistic links between the decoration of high-class metalwork and manuscripts are particularly evident in the first half of the ninth century. The evangelist symbol on the Brandon plaque for instance, could almost have walked out of the pages of the Book of Cerne (66a, 165); while the dominant ninth-century metalwork style, the so-called 'Trewhiddle style', is closely allied to the early ninth-century 'Tiberius' group of manuscripts (e.g. 168, 170–71). Its main features are small exuberant animals which are the lineal descendants of the

winged creatures and other sprightly beasts common in eighth-century metalwork, and are usually reserved in silver (and occasionally gold) against a niello ground; interlace and simple plant and geometric motifs also play a part but, like the animal ornament itself, are restricted by the division into small self-contained fields, often separated by beaded borders, which is characteristic of this style. This lively style seems to have had its origin in the first third of the ninth century in southern and eastern England (then under Mercian control) but quickly spread north and west to become the preferred decoration for ninth-century Anglo-Saxon secular metalwork, particularly everyday and highly portable objects such as strap-ends. The universal popularity of this style led in due course to regional variations on the standard version (**192, 195**), sometimes coupled with distinctive artefact types such as the round-bezelled northern rings (e.g. **203, 204**). Overall, the secular metalwork reveals further shifts in usage: as dress pins appear to retreat in popularity during the ninth century, brooches return to favour as a major item of female dress (**187, 190**), while the notable quantities of multi-purpose hooked-tags and strap-ends which survive from this period are matched by the relative absence of the buckle. Though some strap-ends and tags appear to have been worn as personal apparel, their considerable presence at commercial centres and market sites suggests that, among their other functions, they were used in fastening packs, bags and satchels, or, in the case of hooked-tags, with pouches or purses (**196, 197**).

Perhaps the accelerated recovery of these new types hints at a new affluence, or at least a more organised commercial infrastructure, in which packs, satchels and purses were constantly in action as bargains were struck and goods bought and sold. Some confirmation of this may be seen in the recent recognition of market and meeting-place sites datable to this period, where such metalwork is usually frequent, along with exceptional quantities of coins.

Certainly the impression given by the increasing quantities of fine metalwork datable to the later eighth and first half of the ninth century is of a relatively stable and prosperous society. But the rumblings of Viking attacks heard in the 790s grew increasingly louder and fiercer from the 830s: this was a society under threat.

LESLIE WEBSTER

173 Sword-hilt (part)

Fetter Lane, London
Silver, partly gilded and inlaid with niello on modern wood base; L. 8.7 cm
Anglo-Saxon; later 8th century
British Museum, M&LA 1893, 7–15, 1

Upper part of a sword-grip and pommel of composite construction with incised decoration in low relief. The pommel consists of an arched central element flanked by grooved shoulders and six smaller lobes with riveted heads, each defined by beaded wire. The central element is decorated

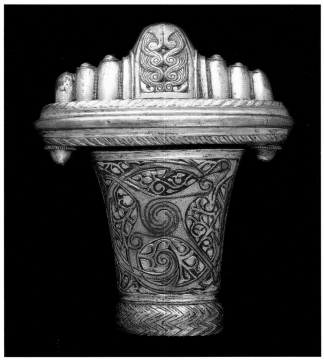

173

with a formalised tendril pattern, on one side alternating with bird heads. The pommel bar is composed of three separate elements, joined by domed rivets with wire collars; its diagonally ribbed mouldings mirror the separate zig-zag moulding at the waist of the grip. The upper half of the grip tapers from pommel bar to this moulding; it is decorated on both sides with a dense patterning of animal and plant ornament, consisting of, on one side, a spiral of four snakes separated by undulating leafy stems; on the other side, a spread-eagled beast with gaping jaws in profile encircles its body with its zoomorphic tail, against a background of leafy shoots.

This extraordinary and prestigious object is a unique survival: it resembles other surviving eighth-century sword-pommels (**180, 181**) only in having a prominent central arched element with flanking grooves, and constructionally, its composite lightweight pommel bar is much closer to the wood and metal three-part fittings of late sixth- and seventh-century swords than to the new technology of iron hilts which seems to have entered England in the eighth century and become standard in the ninth. Its sophisticated and confident decoration is equally hard to parallel precisely, though Wilson has collected analogies for both the whirling snake motif and the spread-eagled creature which incline him to place it in the later eighth century (Wilson 1964, 20–1). This dating gains support from comparison of the snake-heads with the lentoid-eyed creatures on some Mercian sculpture, such as the Brixworth cross-fragment (Wilson 1964, pl. 11b), and of the yawning jaws and elaborate lentoid eye of the splayed beast with open-jawed animals of the sort seen on the inscribed St Ninian's Isle chape (**178**). Likewise, the plant

ornament, as Evison and Bakka have independently argued, is closely related to a late eight-century silver boss from Kaupang (Evison 1961, 157; Bakka 1963, 19).

The enmeshing of leafy plant and animal forms along with extensive use of niello and speckled detail on the animal bodies are all features which in time become signatures of the Trewhiddle style. In its archaic construction and forward-looking decoration, the Fetter Lane hilt is thus most convincingly placed in the later eighth century, and stands as an exceptional example of prestige weaponry of this period.

LW

Select bibliography: Evison 1961, 157; Wilson 1964, cat. 41; Bakka 1963, 19.

174 Die

77–9 Castle Street, Canterbury, 1978
Copper-alloy; L. 2.4 cm, TH. 0.35 cm
Anglo-Saxon; mid-later 8th century
Canterbury City Museums, inv. no. CANCM: CB/R2 78 456

Cast tear-shaped die with plain underside and zoomorphic decoration in low relief consisting of two confronted open-jawed animals whose bodies, limbs, tails and jaws interlace and whose fore-haunches have a double spiral.

The lack of attachment or suspension holes coupled with its unusually thick profile and total absence of gilding strongly suggests that this object was not intended for mounting as a pendant (*pace* Budny and Graham-Campbell 1981, 10) but served as a die for impressing foils. Repoussé foils continued in popularity well into the eighth century in Insular art (Wilson 1973, 134–5) for use on such diverse objects as hanging-bowls, book-covers and belt-shrines, and took a wide range of shapes, according to the nature of the object decorated. The Moylough belt-shrine, for example (Youngs 1989, cat. 47), has sub-triangular and ovoid repoussé panels set alongside more conventionally-shaped ones: thus the unusual shape of the Canterbury die need not perplex.

The decoration has no precise parallel, though all its components, such as the double-spiral hip, the gaping jaws, lappet and S-shaped bodies, are part of the normal vocabulary of eighth-century Insular zoomorphic art. In particular, the prominent muzzle and wide-open mouths recall beasts on

such later eighth-century items as the St Ninian's pommel and chapes (**177, 178**) and Fetter Lane sword hilt (**173**). Budny and Graham-Campbell have also reasonably argued for its formal relationship to the animal ornament of the decorated manuscripts of the mid and later eighth century, particularly the Leningrad Gospels (Alexander 1978, no. 39), supporting this date.

LW

Bibliography: Budny and Graham-Campbell 1981.

175 Finger-ring

River Thames at Chelsea, London
Silver-gilt; D. of bezel 3.1 cm
Anglo-Saxon; later 8th century
Trustees of the Victoria and Albert Museum, London, inv. no. 628–1871

The oval bezel has a central roundel engraved with a speckled blunt-faced quadruped whose tongue and tail interlace rather uncoordinatedly around its body; framing the roundel at either side of the hoop are four fan-shaped fields each with a sharp-nosed, long-eared beast-head. The hoop is plain.

As with the Fetter Lane hilt (**173**) there is in the speckling of this piece, and in its frisky animal meshed in a thicket of interlace, a prefiguring of elements of the Trewhiddle style. The blunt-muzzled head of the central animal is widely matched in eighth-century art – on, for example, the gilded shrine mount from Whitby (Wilson 1964, cat. 105), and the Fetter Lane snakes, while the sharper profile of the flanking heads has a long pedigree going back to the dogs of the Lindisfarne Gospels (**80**; e.g. f. 95, dotted beasts) and their descendants.

LW

Select bibliography: Brøndsted 1924, 155, fig. 130; Oman 1930, cat. 225, 62–3, 137, frontisp.; Wilson 1964, 21, 36, 56, 108; 1973, 138, 140.

176 Key

Gloucester
Copper-alloy; L. 7.5 cm, W. 3.8 cm
Anglo-Saxon; second half of 8th century
Gloucester Archaeology, Gloucester City Museums, inv. no. GLRCM/A/2705

Cast in one piece, with an oval bow decorated with two three-dimensional animal heads which confront each other at the junction with the shank. These are somewhat flattened on one side. They have broad muzzles, and prominent eyes with trumpet-shaped extensions which terminate in a scroll. From their open jaws tongues loll out to merge into the shank.

The zoomorphic decoration of this unusually elegant key, with its shovel-shaped snouts, lobed jaws and trumpet-scrolled eyes, represents a widespread form of Anglo-Saxon ornament which was influential in Pictland. Echoes of this beast-head type may be seen, for example, in the terminal heads of the St Ninian's Isle inscribed chape (**178**). LW

Unpublished.

174 175

176

177

177 Sword-pommel

St Ninian's Isle, Dunrossness, Shetland, 1958
Silver-gilt; L. 5.5 cm, H. 3.1 cm
Pictish, or ?Anglo-Saxon, late 8th century
National Museums of Scotland, Edinburgh, inv. no. FC278

Hollow one-piece casting in 'cocked-hat' form with internal corroded concretion. Each side has crisply incised decoration with punched detail, done to an identical pattern: an arched central panel has two confronted animals with shovel-shaped snouts and speckled bodies, whose sinuous and extravagantly interlaced trunks eventually find their way to opposed pairs of haunches. Each flanking panel has a motif of two animals constructed on similar principles, placed one above the other and loosely interconnected.

This, and the two scabbard chapes (**178a, b**) formed part of a large hoard of Pictish silver brooches, bowls and other artefacts excavated in 1958. The 'cocked-hat' shape of the pommel clearly derives from late seventh-century one-piece

silver Anglo-Saxon pommels such as that from Crundale (Kendrick 1938, pl. XXXIII, 4). Its dominant central panel, however, is certainly an eighth-century development which is loosely paralleled on the embellished iron pommels from Windsor and Chiswick Eyot (**180–1**) and, less directly, on the very elaborate hilt from Fetter Lane (**173**). Its decoration, like that of the chapes, though usually acknowledged to be Pictish in execution, reveals at least very strong Anglo-Saxon influence. The use of gilding and the interlacing speckled bodies are readily paralleled on Anglo-Saxon objects such as the Chelsea ring (**175**) while the spiral element on the forequarters of the flanking animals is also widespread in Insular art, including some metalwork thought to have been made in southern England (cf. **66f, 179**). Likewise the shovel-shaped muzzles, seen also on the chapes, are most closely paralleled on the Fetter Lane hilt, and Gloucester key. Only the striking spiral convolution of the hindquarters and interlocking limbs recall the contortions of Pictish animals as seen, for example on the St Ninian's Isle bowl 3 and the Aberlemno churchyard stone (Wilson 1973, fig. 22 and pl. LV). But this too is a motif familiar from Northumbrian art – the Lindisfarne Gospels (**80**), for instance. Thus both in form and style, the pommel may reflect not simply an acknowledged Pictish facility in adapting an Anglo-Saxon artistic vocabulary, but could be an actual import of the later eighth century. At the very least, this and the associated chapes show the strength of Anglo-Saxon influence in eighth-century Pictland. LW

Select bibliography: Wilson 1970, 9–11; 1973, 58–60, 120–1, 137–40; 1984, 117–18.

178 (a, b) Two scabbard-chapes

St Ninian's Isle, Dunrossness, Shetland, 1958
Silver, gilding and blue glass; max w. (*a*) 8.1 cm, (*b*) 8.2 cm
Pictish, or ?Anglo-Saxon; late 8th century
National Museums of Scotland, Edinburgh, inv. nos (*a*) FC 282, (*b*) FC 283

178 (a) Three-piece U-shaped casting

Composed of two side-pieces and a binding strip which caps the join. The binding strip is held by rivets and terminates at each end in a stylised animal head. The chape terminates in two shovel-snouted open-jawed animals – which differ slightly on front and back: on the back their teeth are clenched in a jagged grin, while on the front, paired openwork fangs trap a tiny fish. The eyes were probably once set with blue glass and a trumpet scroll is produced behind each: the muzzles are ribbed. On the front three brambled dummy rivets divide an inscription in insular script which reads INNOMINEDS ('in the name of God'). On the back, a continuation of this reads RESADFILISPUSSCIO ('property of the son of the holy spirit'). The crest on the front has pairs of carved incisions, on the back a frieze of gaping broad-muzzled beast heads.

178a

178b

178 (b) Similar casting

Composed of two side pieces riveted together. It terminates in two shovel-snouted fanged animals, with gaping jaws, ribbed muzzles and protruding tongues. The lentoid eyes are set with blue glass studs and the face is decorated with incised triskele scrolls. A key-pattern collar on both sides separates the head from the main panel, which on the front has two fields of interlocking speckled animal pairs, separated by a central scroll pattern, and on the back, a triangular spiral pattern. The crest has key-pattern and spiral motifs.

These two chapes come from the same hoard as the pommel (177). They have no surviving Insular parallel, but there can be no doubt that they are fittings from scabbards. Both in the script of (a), and in their decoration, they draw on a range of Insular motifs. In particular, aspects of the fanged animal heads with their broad ribbed snouts, trumpet spiralled eyes and openwork jaws recall Northumbrian parallels: the runic mount from the Thames (179) and from a more recent find,

the crest terminal on the York helmet (47). The ribbed spine, blue glass eyes and openwork fanged jaws of the former, and the ribbed shovel-shaped muzzle and spiralled eyes of the latter are strikingly similar. The helmet has two further points of similarity – its ribbed crest and eyebrows and the Christian invocation in Insular script which runs along the crest. Like this, the inscription on chape (a) invokes divine protection for the owner. The interlocking animals on chape (b) cannot be closely paralleled in Anglo-Saxon art, though like the ornament on the pommel, they owe a clear debt to Anglo-Saxon sources. The shovel-snouted frieze of animal heads on chape (a) likewise recalls the Fetter Lane pommel and Gloucester key. LW

Bibliography: Wilson 1970, 9–11, 1973, 64–6, 121, 138–40; Youngs 1989, cats 102, 103.

179 Fitting (fragment)

River Thames near Westminster Bridge, London
Silver, gilded, blue glass; L. 18.8 cm
Anglo-Saxon; late 8th century
British Museum, M&LA 1869, 6–10, 1

Mount apparently originally V-shaped, consisting of two U-shaped metal strips which converge in a three-dimensional animal head. Both strips are broken off, the lower one close to its junction with the animal head. The animal head has sharp, scrolled ears, blue-glass eyes and its tongue curls out between its fangs to touch the throat, which has a hatched collar matching scrolled hatching on its forehead. The longer strip is decorated or gilded on one side only and was riveted to wood or leather by triple rivet sets with domed heads; these were apparently arranged in alternating patterns of plain or knurled heads. The edge has decorative diagonal mouldings, and the face bears a runic inscription which may be transliterated 's b e / r æ d h t ʒ b c a i / e / r h / a d / æ b s'. This has not been satisfactorily interpreted.

The function of the mount has been much debated, though the absence of decoration on the back of the upper strip, and its apparent V-shaped configuration indicate that it was fitted on a pointed wood or leather object designed to be seen from one side, most plausibly a knife or *seax* scabbard. It would appear to be a development of seventh-century *seax*-scabbard fittings with similar rivet clusters and asymmetrical chapes, such as that from Ford, near Laverstock, Wilts. (Evison 1969). Page suggests the inscription may be amuletic which would be perfectly appropriate in such a context.

There is nothing very like this striking piece in the corpus of Anglo-Saxon metalwork, though the closest parallels to the animal head, as Wilson has pointed out (Wilson 1973, 138) are the heads on the late eighth-century St Ninian's Isle chapes (178a, b), which also show similar use of hatching and ribbed mouldings. It is perhaps significant that these too are scabbard fittings. LW

Select bibliography: Wilson 1964, cat. 45, 15–16; Page 1964, 77–9; Wilson 1973, 138, pl. LII b.

180 Sword-pommel

Windsor, Berks., 1871
Silver, gold; L. 4.4 cm, max. H. 2.0 cm
Anglo-Saxon; mid 8th century
The Visitors of the Ashmolean Museum, Oxford, inv. no. 1909.518

Base-silver core, socketed to contain the sword tang; two abraded sub-conical projections, perhaps originally stylised animal heads, flank an arched central element with applied silver sheet and on one side, a gold filigree-decorated panel.

The corresponding panel on the other side is lost. Within a beaded wire frame, the panel's decoration consists of a vine, composed of twisted wire with granule clusters, interlacing in a regular latticed mesh with two snakes consuming each other's tails, composed of twisted plain wires. The snakes have distinctive shovel-shaped snouts and granule eyes. The silver-sheeted upper surface of the pommel has an incised border and a sketchy interlaced motif.

This delicate piece shows that the distinguished tradition of seventh-century Anglo-Saxon filigree continued into the

179

mid eighth century, despite the relative lack of surviving pieces. The decoration shows both a unique instance of the vine-scroll motif in filigree wire, while the broad snouted snakes seen from above bridge the gap between the similarly-viewed snakes on the Crundale buckle (6) and the larger shovel-nosed beasts seen elsewhere in Insular art – on the St Ninian's Isle chapes (178), for example. LW

Bibliography: Brøndsted 1924, 143–4, fig. 118; Evison 1961, 145–53; Hinton 1974, cats 36, 63–5, pls xviii–xix.

181 Sword-pommel

River Thames foreshore, east end of Chiswick Eyot
Iron, silver-gilt; L. 5.2 cm, H 2.0 cm
Anglo-Saxon; second half of 8th century
Museum of London, inv. no. 81.25

Iron core formed of an arched central element flanked by grooved shoulders and sub-conical terminals which may represent stylised animals' heads. The whole surface was covered with silver; silver-gilt sheet survives on the top and shoulders in extremely worn condition, and a decorated silver-gilt plate is fixed to each side of the central element. The decoration, though not identical, follows the same pattern on each side: two confronted snakes with speckled bodies and heads with bulbous fanged snouts and lentoid eyes are enmeshed in the interlacing tail of the left-hand animal: the right-hand beast consumes its own tail.

A more modest (though better preserved) version of the type represented by the Windsor pommel (180), this recent find shows more clearly the type's links both to the very much more elaborate Fetter Lane pommel (173), with which it shares a prominent central element with grooved shoulders, and to ninth-century iron pommels with their animal-head terminals, such as the River Witham sword (250).

The speckled bodies, fleshy snout, and lentoid eyes of the snakes are characteristic of later eighth-century metalwork such as the Fetter Lane hilt and Chelsea ring (175) where similarly inchoate interlace also appears, while the distinctive fangs can be seen on the St Mary's Abbey pin (183) and the creatures on the Hillesøy disc (Bakka 1963, fig. 4). Parallels with manuscript decoration argue for a date towards the end of the eighth century; for example with the early ninth-century Book of Cerne (e.g. the arched panel in A, f. 22a) (165) and the contentious snakes of the late eighth-century Barberini Gospels (160). LW

Bibliography: Murdoch 1991, 129.

182 Pin

No provenance
Silver, gilding, glass; L. 5.8 cm
Anglo-Saxon; mid–late 8th century
British Museum, M&LA 1989, 3–3, 1

Cast silver pin with gilded terminal in the form of a long-muzzled hound's head, with round eyes, inset glass eyes and speckled detail.

This is perhaps the most elegant surviving example of the small silver animal-headed pins which were worn by women of status in the eighth-century heyday of the pin (see 69g). Its long-nosed grinning dog's-head has a long ancestry, going back to the canine beasts of the Lindisfarne Gospels (80); its nearest contemporary relatives are to be seen in the Leningrad Gospels (Alexander 1978, cat. 39), for example the dog's-heads at the column bases on f. 16., and in the Barberini Gospels (160) where winged canines with round ears and long muzzles can be seen in e.g. the frame of the St Matthew portrait (f. 11v). LW

Unpublished.

180

181

182

183

184

183 Pin (fragment)

St Mary's Abbey, York
Gilded copper-alloy; L. 4.5 cm
Anglo-Saxon; c.800
The Yorkshire Museum, York, inv. no. 1990.36

Disc-headed pin with broken shank, incised with two confronted beasts, whose tails interlock with each other's legs, and whose pointed wing-tips enter each other's jaws between tongue and tooth. The back is undecorated.

Like other fancy pins e.g. from Brandon and Flixborough, the St Mary's Abbey pin suggests wealth and status and was intended to be very visible, not discreetly tucked into veiling. A very close parallel ornamentally occurs on a hooked-tag fragment from Ipswich (4601/0574, unpublished). The lively decoration is close in character to that of the Book of Cerne (**165**) and Barberini Gospels (**160**), where animated beasts with collars, pointed wings and comma-like body markings, such as appear on the wings here, are frequent. A date around the end of the eighth century seems probable. LW

Select bibliography: Cramp 1967, frontispiece.

184 Linked triple pin set

River Witham at Fiskerton, Lincs.
Silver, gilding, glass; L. of central pin 6.2 cm, D. of head of central pin 4.8 cm
Anglo-Saxon; late 8th century
British Museum, M&LA 1856, 11–11, 4

Each disc-headed pin is of composite construction, the shaft being cast separately and riveted to the disc via a highly schematised animal-head terminal on the hipped pin-shaft. The head of each pin is gilded and densely chip-carved. Each pin is attached to the next by means of an elongated lozenge-shaped link with pierced circular terminals through which a wire loop connects them to the adjacent pins. The links are chip-carved with spiral ornament, and pecked. The *central and left-hand pins*, though differing in detail, evidently belong to the same original scheme; both have been repaired at the junction with the pin-shaft. They share a cruciform design consisting of an equal-armed cross with expanded terminals and circular 'arm-pits', set at an angle to the pin-shaft. They have collared central settings originally set with glass, and the perimeter of the cross has a punched border. On the *left-hand disc*, one arm contains pure interlace, two others, symmetrically interlacing plant ornament springing from a 'flowerpot' base, while the fourth arm has a winged animal enmeshed in a skein of interlace. The three remaining arms have occasional punched details. The *middle disc* is the largest; its panels are filled with winged animals with lightly incised collars and other body markings enmeshed in interlace; confronted pairs in the two upper arms, an addorsed pair and a single animal of the same type as the confronted animls in

the lower arms. All have punching on their bodies. The *right-hand disc* is evidently a replacement, being different in style and layout. Here also the cross-pattern with (empty) central setting is observed, but based instead on a cross with expanded terminals. A rope-pattern border encloses the entire disc and there are plain borders to the lentoid spaces between the arms, each of which contains a different creature ensnared in occasionally leafy interlace; two are in profile, two spread-eagled. All have inlaid glass eyes, are pecked, and tend to be a little ragged about the edges, in contrast to the sinuous lines of the ornament on the other pins. The backs of all the discs are plain, but that of the last is gilt.

This is the most elaborate and complete surviving set of linked dress pins, which are the most spectacular manifestation of the Middle Saxon taste for showy dress pins. A number of single examples survive which have been pierced for attachment to another, and some (e.g. Wilson 1964, pl. IIIa) still have their linking elements.

Stylistically, the pin set is closely linked to a number of major art-works of the second half of the eighth century: the distinctively crisp interlace, the springy beasts with pricked ears and pointed wings and the spread-eagled creatures all find parallels in such pieces as the Gandersheim casket (**138**), Croft cross (**115**) and Leningrad Gospels (Alexander 1978, no. 39). An origin in northern or middle England for the pins is likely, an attribution which also fits the pin set's find-place and the distribution of most of the other English provenanced pieces in this style. In this connection the pins' plant ornament, first recognised by Bakka 1963, is worth noting; its long-lobed leaves and central bud find parallels in the smallest brooch from the Pentney (Norfolk) hoard (**187**) and in less schematised form on the Ormside (Cumbria) Bowl (**134**).

LW

Select bibliography: Brøndsted 1924, 138–9, 140, 219; Kendrick 1938, 170; Bakka 1963, 17–19, 22–3; Wilson 1964, cat. 19 and refs; 1984, 67.

185

supposed that it is a mount of some kind. Its decoration has been compared by Budny and Graham-Campbell (1981, 11) to that of the Canterbury die (**174**), but two much closer parallels can be seen on two Anglo-Saxon mounts from Norway – from Alstad, N. Trondelag, and Fure, Sogn og Fjordane, respectively (Bakka, 1963, figs 33 and 54a). Both these pieces come from female Viking graves of the ninth century, the Fure grave being datable to *c*.800, and the Alstad mount being adapted as a brooch and much worn before burial. The addorsed animals (Budny and Graham-Campbell 1981, fig. 2a) are very close indeed to those on one of the Fure mount panels, and the other Mavourne animal pair, while also sharing many characteristics with the Fure animals (e.g. long necks, lobed lappets and fronded feet) have the more schematic qualities of the Alstad beasts.

LW

Bibliography: Smallridge 1969, 13–15, pl. 1A; Budny and Graham-Campbell 1981, 11–13.

185 Disc

Mavourne Farm, Bolnhurst, Beds.
Copper-alloy, gilding, glass; D. 3.6 cm
Anglo-Saxon; late 8th century
Bedford Museum (North Bedfordshire Borough Council), inv. no. 62/B/70

Cast disc, with 'chip-carved' decoration arranged in four segments of a cruciform design, around a central roundel with a lightly incised cruciform pattern. The segments are filled with two opposing panels of similarly dense but non-identical interlace, and two of interlocked animal pairs, one addorsed (with glass eye inset) and one confronted. Despite very different postures, both animal pairs have much in common – long necks, fronded feet, gaping jaws, and tongues, tails and lappets which end in scrolls. The disc is pierced at opposite sides, and the back is plain.

Though similar in appearance to the disc-heads of the type seen on the Witham pins (**184**) there is nothing to suggest that the disc was ever attached to a pin shaft, and it must be

186 Brooch

Leicester, Evington Brook near Kimberley Road
Copper-alloy, tinning; D. 7.1 cm
Anglo-Saxon; early 9th century
The Visitors of the Ashmolean Museum, Oxford, inv. no. 1979.79

Flat disc with incised decoration on front and layout marks on back, and separate one-piece strip pin-attachment (the pin itself broken off) attached by three bossed rivets; a further pair of purely decorative bossed rivets is missing. An otherwise inexplicable small hole near the edge may have been for a keeper attachment of some kind. The decoration is arranged in four segments divided by a simple cross with a quincunx of bossed rivet heads at its centre and terminals. The disc has crudely incised animal ornament on a coarsely hatched ground: two panels each with two animals (three with interlacing tails, one with a foliate tail) alternate with two panels each containing a different snake with interlacing body. The back of the brooch has concentric and diagonal setting-out lines.

186

The brooch came from the bed of the ancient brook at a probable ford. The brooch is a rare example of the no doubt many poor copies of the large silver disc brooches which were beginning to appear around the year 800. In layout and decorative detail it closely resembles the second pair of Pentney brooches (**187c, d**), where the paired openwork beasts are up-market versions of the Leicester brooch's creatures with interlacing tails. These have parallels with some of the openwork creatures on the first pair of Pentney brooches (**187a, b**) not only in shape and posture but in surface treatment such as incised striping, nicking and 'commas' on the body. Some of these features are distinctive elements of the Trewhiddle style (see pp. 220–1), previsions of which can also be seen in the single foliate-tailed beast with its tortoise-like head. The snakes hark back to the spread-eagled and other snake-headed beasts of late eighth-century art, for example, in the Leningrad Gospels canon tables (Alexander 1978, no. 39, f. 16). Such conservative elements are not surprising in what is very much a cheap copy of prestige jewellery. LW

Unpublished.

187 (a–f) The Pentney hoard

Pentney, Norfolk

Silver, copper-alloy, gilding, niello, glass, D. (*a*) 8.3 cm, (*b*) 8.3 cm, (*c*) 8.5 cm, (*d*) 8.5 cm, (*e*) 10.2 cm, (*f*) 6.1 cm

Anglo-Saxon; first third of 9th century

British Museum, M&LA, 1980, 10–8, 1–6

Six openwork silver sheet metal disc brooches, four also inlaid with niello, and one with a gilded copper-alloy base plate. (*a*) and (*b*) form a pair of delicately incised brooches identical in layout but differing frequently in points of decorative detail. Within a scalloped edge, an outer zone of plant and

geometric motifs encircles the main decorative area, in which a cruciform arrangement of lobes with stemmed plants alternates with openwork panels with sprightly animals flanking the bosses (of which only one survives) which capped four of the quincunx of rivets on the brooch. The central bossed rivet is surrounded by a lozenge-shaped field, the points of which touch the other four: the field has panels of, variously, plant and animal ornament. Overall, the engraving is extremely delicate, and notable for its extensive use of pecking and beaded borders. The backs are plain, and their riveted pins survive *in situ*. (*c*) and (*d*) are a pair of brooches inlaid with niello, identical in layout but frequently differing in decorative detail. An outer zone of alternating openwork and nielloed cartouches (the openwork panels mostly plant motifs, the niello-inlaid panels invariably animal motifs) encircles the main decorative area. This consists of a quincunx of bossed rivets (three missing) connected to make a simple cross with nielloed plant and animal decoration; between its arms, are four openwork panels each containing a pair of addorsed beasts with nielloed body patterns and lolling tongues; their eyes were originally inlaid with glass. The backs are plain, with riveted pin attachments. (*e*), the largest of the brooches, has an outer zone consisting of eight nielloed panels of animals with interlacing tongues and tails, arranged in opposing pairs. Within this, the central field has a cruciform arrangement punctuated by a central quincunx of bossed rivets with four outliers. The cross's openwork centre has stylised plant decoration; each of its expanded terminals has a pair of addorsed beasts with foliage and interlacing tails. The 'armpits' of the cross each contains a subtriangular nielloed field with, alternately, interlace or animal ornament, flanked by the openwork beasts with leafy tails. Extensive pecked detail and beaded borders are a feature. The back is plain; the pin is complete and is fixed to the brooch by two stylised animal heads which clamp on to the front of the brooch and are riveted through. (*f*), the smallest of the brooches, differs from the others in that though the design is executed in openwork, it is riveted by means of a quincunx of small rivets (the central one missing) to a gilded base plate. The decoration has at its centre a small nielloed cross with square terminals from each of which springs a bushy plant with long pointed and lobed leaves. The plants are enclosed within arcs which converge towards the brooch rim where they are pinned by the rivets. The back is plain and the riveted pin attachment is damaged. Unlike the other brooches, this shows signs of wear.

At the time of its discovery this extraordinary hoard, found during the digging of a grave in Pentney churchyard in 1977, doubled the tally of known Late Saxon silver disc brooches. Not only that, the virtuoso craftsmanship and inventive decoration of at least three of the brooches put them in the first rank of Middle Saxon metalwork. They also raised, however, fresh questions: did the presence of pairs in this hoard suggest that the disc brooches were worn in pairs, something not previously suspected? or does the pristine condition of five of the brooches indicate that this is a maker's, not an owner's, hoard? There are some technical and stylistic tricks shared in varying combinations (e.g. long-leafed plant tendrils on

(c), (d) and (f), pecked surfaces and bag-bellied animals on (a), (b), and (c), but none that suggest that any but the paired brooches were made by the same hand, or even that all are necessarily from the same workshop. On balance therefore, they may more probably be seen as a personal hoard, though whether of precious metal as such, or of jewellery as worn by one individual, is impossible to tell.

On stylistic evidence, the five large pieces in the hoard must belong to the first third of the ninth century. It is possible that they were buried in the 840s, during the first Viking raids on East Anglia, but unknown local factors leading to their concealment cannot be discounted. The earliest brooch, (f), shows signs of wear, and is significantly different in scale, construction and decoration, which is wholly based on plant motifs. The low plants with their central lobe, long leaves and looping tendrils have parallels in late eighth-century metalwork, for example, on the Witham pins (184). The four paired brooches, however, (a) and (b), (c) and (d), though linked in plant decoration to brooch (f), show in their animal ornament many close stylistic links with manuscripts of the first third of the ninth century, notably the Book of Cerne (165), BL, Royal MS 1 E.vi (171) and the Cotton Tiberius Bede manuscript (170). The last two manuscripts are usually associated with the beginnings of the classic ninth-century Trewhiddle style in Anglo-Saxon metalwork, and it is no surprise therefore to see clear elements of this in the smaller beasts on brooch pair (a) and (b), and, in the border cartouches of the second pair, (c) and (d), fully-fledged early Trewhiddle-style creatures. The largest brooch, (e), makes extensive use of niello inlay as a background to ornament which is entirely composed of a completely developed and confident version of the Tre-

f

a

b

e

c

d

187a–f

whiddle style. The brooch's larger size and multiple bosses look forward to the more elaborate brooches of the later ninth and tenth centuries. Its crisply suave execution is the work of a consummate craftsman in complete control of his medium.

The fact that the brooches were buried in East Anglia does not of course imply that they were made there: but one or two pointers suggest indeed that there may have been a specifically local version of the Trewhiddle style in the early ninth century, into which context the larger brooches would readily fit. The copper-alloy motif-piece from Bawsey (very near Pentney itself) (**188a**) shows a sketch for an unusual bag-bellied animal identical in type to those on brooches (*a*), (*b*) and (*e*), and which occurs on the ninth-century strap-end (**192**) from Lincoln. Equally, the highly distinctive, finely speckled long-stemmed fruiting plants on the lobes on (*a*) and (*b*) appear elsewhere only on two unpublished East Anglian strap-ends (one from Stibbard, Norfolk, one not more closely provenanced than Suffolk), both closely similar to the Lincoln piece in type. Finally, the distinctive clamped animal-headed pin attachment on the largest brooch (*e*) has its only surviving parallel in an unpublished recent disc brooch find from Elmsett, Suffolk. That these animal-head clamps also closely resemble those that fix the River Witham (Lincs.) pin-shafts to their disc-heads (**184**) also supports a relatively early date within the ninth century as well as an Anglian origin. The possibility of a major workshop producing Trewhiddle-style metalwork somewhere in East Anglia certainly receives support from the quantity of fine ninth-century metalwork which has been found in Norfolk and north Suffolk. LW

Bibliography: Wilson 1984, 96, fig. 120.

188 (a–h) Selected finds from a Middle/Late Saxon site at Bawsey, Norfolk

Copper-alloy, unless otherwise stated; individual dimensions below

Anglo-Saxon; 8th–9th century

(*a*, *e*, *g*) The Castle Museum, Norwich, inv. nos (*a*) 198.97, (*e*) 245.986, (*g*) 198.987; (*c*) King's Lynn Museum, inv. no. KLM 119.985 (2); (*b*, *d*, *f*, *h*) Private possession

188 (a) Disc-shaped motif-piece

Finely incised marking-out lines on both faces, one quadrant containing a sketched-out bag-bellied Trewhiddle-style animal.

D. 3.6 cm

188 (b) Stylus

With grooved collar and further transverse grooves two-thirds down the shaft.

L. 11.7 cm

188 (c) Stylus

With curved mouldings below the head and collar, bent shaft.

L. 7.3 cm

188 (d) Strap-end

With round-eared animal head terminal, single rivet and panel with simple interlace on an enamelled ground.

L. 3.3 cm

188 (e) Silver ?brooch or hooked-tag fragment

With central boss with gold collar; only one quadrant of decoration survives, a Trewhiddle-style animal on a nielloed ground.

L. 1.9 cm

188 (f) Hooked-tag

With hatched sub-triangular head, pierced twice for attachment.

L. 2.0 cm

188a

188b–h

188 (g) Hooked-tag fragment

With lobed edge and twin attachment lugs: the central oval field has silver scrolls on a nielloed ground.

L. 2.0 cm

188 (h) Pin

With collared globular head with ring and dot ornament, the end of the shaft split.

L. 6.5 cm

The site centres on a prominent hill from which its name, meaning Beaw's island, came; it is situated amid low-lying land near the eastern edge of the Fen Basin. The hill is surmounted by the ruins of the medieval church, and surrounded by an encircling ditch. The prolific seventh- to ninth-century finds have come from the area around the church and include a range of high-status objects and numerous coins. On the present evidence, and in the absence of any documentary records for the Anglo-Saxon period, it could equally be a market place or a small monastic site.

The presence of the unusual motif-piece (*a*) linked stylistically with the Pentney brooches (**187**), which were found only a mile or so away, raises the possibility of local fine metalworking. LW

Bibliography: Blackburn, Margeson and Rogerson forthcoming.

189 The Strickland Brooch

No recorded provenance
Silver, gold, niello, blue glass; D. 11.2 cm
Anglo-Saxon; mid 9th century
British Museum, M&LA 1949, 7–2, I

Slightly convex bossed disc brooch of sheet silver with inlaid gold and niello ornament. The zoomorphic decoration is deeply carved and pierced to give an openwork effect. Within the beaded rim, a zone of alternate disc and lozenge patterns contains the main decorative field, which consists of a central hollow-sided cruciform design with a boss at its centre and animal-head terminals, with a quatrefoil, the cusps of which terminate in identical animal heads: all the heads are (or were) set with blue glass eyes and are interconnected by a beaded circle. This in turn creates subsidiary fields each containing a puppy-like Trewhiddle-style beast. Four more bosses lie towards the perimeter, behind the animal-heads on the quatrefoils. Numerous gold panels are hammered into the decoration and considerable use is made of speckling and beaded framing. A suspension or keeper loop is attached to one edge of the brooch, at right angles to the direction of the pin catch, only stubs of which remain. The back is otherwise plain.

The brooch has no known history, but belonged to the Strickland family of Yorkshire. It is a particularly opulent version of the large silver disc brooch, notable for its unusual use of gold inlays, seen rarely elsewhere. The deep carving

189

190

and glittering polychrome surfaces give it a dynamic quality unusual in the normally more restrained and two-dimensional ninth-century jewellery. The decoration consists of typical elements of the Trewhiddle style, such as beaded frames, collared animals, speckled bodies, and the animal heads with curling ears, which may be paralleled on many strap-ends from northern England, as well as on the Trewhiddle horn-mounts themselves (246e, and see 107b, 195 and 249b, c).

LW

Select bibliography: Bruce-Mitford 1956, 190 ff, fig. 37 and pl. xxvi; Wilson 1964, cat. 152; Wilson 1984, 110, fig. 115.

190 Brooch

River Cam, near Barrington, Cambs.
Silver, niello; max. D. 5.3 cm
Anglo-Saxon; later 9th century
British Museum, M&LA, 1985, 7–2, 1

One-piece beaten sheet disc brooch with semicircular projections at each side from which the sprung pin and pin catch respectively are produced. The incised decoration consists of a broad outer zone divided into six fields, two each of interlace, plant and animal ornament, variously separated by beaded frames or semicircular and triangular motifs. Within a beaded frame, the central circular area consists of an openwork back-biting animal containing within its trunk another, schematic, beast. The back is undecorated.

This small version of the silver disc brooch is unusual both in its adroit one-piece construction and in its decoration. Though this is essentially a coarse version of the ubiquitous Trewhiddle style, it has two exceptional features: the distinctive plant ornament, in which horizontal bands loop through leaves and cross the stem, and the beast-within-a-beast motif of the central roundel. Neither has a precise parallel in metalwork but the looped stem elements have a faintly Viking flavour, distantly reminiscent of the kind of looped chain effect popular in various versions of the Borre style and readily adapted into Anglo-Scandinavian art, for example on strap-ends from York (Hall 1986, fig. 119). Whether this particular motif seriously reflects Viking influence, or is – perhaps more probably – an independent Anglo-Saxon development, is impossible to say. It suggests, however, a relatively late date in the ninth century for this piece, which may also be reflected in its simplified structure and fluent, if coarse, animal ornament.

LW

Unpublished.

Strap-ends (191–5)

This multi-purpose object has a history going back to the Roman period, and continues in occasional use in the sixth and seventh centuries: it appears however to undergo a revival during the eighth century, developing into the ubiquitous ninth-century form known from Cornwall to Sutherland. It is clear from the varying scale and robustness of the many surviving specimens that the type served to protect the ends of textile or leather straps in a variety of functions; for instance, as belt-ends, as sword- or horse-harness-fittings, as purse or satchel strap-fittings and so on. The ninth-century type is consistent in having a riveted split-end and an animal head, however rudimentary, at the other; but within this simple formula there are a number of notable chronological and regional variations. Among the more ambitious examples, for example, there are two distinct animal-head terminal forms, which appear to be different regional types; the version with comma-shaped ears being predominantly northern in its distribution, while the round-eared type is more common in the south. Similarly, a simpler kind of strap-end where panels of animal ornament are replaced by a niello field with inset silver scrolls, is predominantly East Anglian in its distribution and may be considered a local product. From a chronological standpoint, it can be seen that there is a tendency to increased overall size in the later ninth-century strap-ends, probably in response to changing styles of harness and to the growing influence of Carolingian fashions, which led to the universal adoption of the broad tongue-shaped strap-end and its relatives in the tenth century.

LW

191 Strap-end

No provenance
Silver, niello; L. 4.05 cm
Anglo-Saxon; first half of 9th century
British Museum, M&LA 1989, 3–3, 6

Cast strap-end, with single rivet at split end and round-eared animal head at the other. The central field has an incised Trewhiddle style winged creature with head lappets and an interlacing tail, reserved against a nielloed background, now mostly missing.

The Whitby and Trewhiddle strap-ends (107b, 246g)

191
192
193

appear to be the only other single-riveted silver versions of the genre, but, the latter being atypically small, the Whitby example is much the closest parallel. Stylistically, the winged beast is very close to animals on the first pair of openwork brooches in the Pentney Hoard (187a, b): a similar date is probable. LW

Unpublished.

192 Strap-end

Lincoln
Silver, niello inlay; L. 4.1 cm
Anglo-Saxon; 9th century
City and County Museum, Lincoln, inv. no. LAU SP78Ag2

Cast strap-end with round-eared animal terminal and main field decorated with two Trewhiddle-style bag-bellied animals with interlacing tails, on a nielloed ground. The back is plain.

An elegant example of a type of strap-end more common in East Anglia and the south of England. The bag-bellied animals in decoration have particularly close parallels with the decoration of some East Anglian metalwork, including brooches in the Pentney Hoard (187). LW

Bibliography: Roesdahl et al. 1981, cat. C15; *Lincoln* 1984, 33.

193 Strap-end

Westmeston, Sussex
Copper-alloy, silver, niello; L. 3.9 cm
Anglo-Saxon; 9th century
Sussex Archaeological Society, Barbican House Museum, Lewes, Sussex, inv. no. LEWSA 1985–20

Cast strap-end and twin silver rivets, and niello-inlaid Trewhiddle-style decorative details. It terminates in a round-eared animal head, the brow ornamented with an interlacing beast; the riveted end is decorated with a stylised palmette; the central field has a sinuous creature whose hind legs develop into regular interlace which pierces the body before terminating in a leafy tip.

A superb example of the southern type of strap-end, it demonstrates that high-quality decoration was not confined to objects of silver or gold. LW

Bibliography: Graham-Campbell 1988, 239–40.

194 Strap-end

Hertfordshire
Silver, niello and glass; L. 5.9 cm
Anglo-Saxon; late 9th century
British Museum, M&LA 1984, 1–4, 1

Cast strap-end of unusually large dimensions with incised Trewhiddle-style decoration. It terminates in a foreshortened

194 195

round-eared animal-head, the prominent eyes set with glass, and below them two small protuberances which give the head a whiskered effect. The large brow has a speckled beast on a nielloed ground. The split end has two rivets and a schematic palmette, much reduced: the main field between terminals and rivets is occupied by a cross with geometric ornament, between the arms of which four assorted creatures disport themselves. The central panel of the cross and the animal bodies are speckled and the outer border is beaded. The back is undecorated.

The breadth and length of this elaborate strap-end and its curiously foreshortened terminal link it to a number of other late ninth-century strap-ends such as that from the Cuerdale Hoard (deposited *c.*905), with which it also shares a related cruciform design. The exceptional protuberances on the terminal are unparalleled, and have the effect of making the head resemble an eared owl when seen the other way up – an ambiguity which may indeed be an intentional visual riddle. LW

Unpublished.

195 Strap-end pair

Bamburgh Castle, Bamburgh, Northumberland
Copper-alloy, ?silver, ?niello; L. 6.0 cm, 6.1 cm
Anglo-Saxon; 9th century
Executors of the Rt Hon. Lord Armstrong

Matching cast strap-ends with ?silver rivets and inset panels of decoration with ?niello inlay. The inset panel survives on one strap-end only, where it is decorated with three Trewhiddle-style animals with speckled bodies, with tails and limbs that interlace and occasionally pierce one another's

bodies. The strap-ends terminate in animal heads with comma-shaped ears and the attachment end has an interlaced motif.

In their unusually large size, their comma-eared terminals and the interlaced motif at the attachment end, these strap-ends belong to a distinct northern (and probably late) group typified by the Lilla Howe foursome (**249b, c**). They were found together in 1971 in limited excavations in the West Ward at Bamburgh Castle, in a ninth-century horizon. Dr Brian Hope-Taylor, the excavator, records that the circumstances of their discovery suggest that they may have been attached to leather straps. LW

Unpublished.

196 Hooked-tag

Costessey, Norwich, Norfolk
Silver, niello inlay; L. 3.7 cm
Anglo-Saxon; 9th century
The Castle Museum, Norwich, inv. no. 438.980 (2)

The sub-circular attachment plate has two pierced lugs at the tip and a collared hook below. A beaded border frames the plate and at its centre is a small riveted boss, from which the plate is divided into three equal fields, each containing a speckled Trewhiddle-style animal on a nielloed ground.

Decorated hooked-tags enter into the Anglo-Saxon repertoire in the seventh century and appear to continue in unbroken use into the late medieval period. Two basic forms predominate, sub-triangular and sub-circular: in the eighth and ninth centuries both ran in parallel, but in the tenth century, the round-plate version appears to take precedence. Their continuing popularity is probably due, as with strap-ends, to multi-purpose use. Two sets are clearly associated with coin hoards suggesting attachment to a purse (Graham-Campbell 1982) while the Winchester pair (**200**), like a pair from a seventh-century grave at Castledyke, Humberside, appear to have been attached to garters; there seems to be no distinction in use between the two forms.

The Costessey tag is a fine piece of Trewhiddle-style metalwork, closely related to examples from Canterbury, Winchester and High Wycombe (Graham-Campbell 1982, 148, and Farley forthcoming), all datable to the mid ninth century. LW

Bibliography: Green 1980, 351–3, fig. 10, 2a; Graham-Campbell 1982, 148.

197 (a–c) Three hooked-tags

No provenance
Silver, traces of niello; L. (*a*) 2.5 cm, (*b*) 3.9 cm, (*c*) 3.5 cm
Anglo-Saxon; (*a, b*) mid 9th century, (*c*) late 9th century
British Museum, M&LA 1989, 3–3, 5; 1990, 7–6, 4, 3

All are of sheet metal with pierced twin attachment lugs at one end and a hook at the other. (*a*) has a sub-triangular plate with an openwork cross and circle below it, with lightly

incised lengthwise borders and a collar above the hook; (*b*) has a circular plate divided by coarse hatched frames into three equal fields each with an incised Trewhiddle-style backward biting beast on a (formerly) nielloed ground and a round-eared animal head decorating the junction with the hook; (*c*), the largest, has a circular plate with beaded border and a central decorative rivet around which are three lentoid fields of plant fronds. A further triple plant frond decorates the junction of hook and plate.

These three (unfortunately unprovenanced) tags show something of the range of decoration on fancy versions of the type. The triangular tag, (*a*), is a simpler version of the example from Cathedral Green, Winchester (**200**) which in turn provides the closest parallel for the plant ornament on tag (*c*). The central boss of (*c*) also links it to the Costessey tag (**196**), which in turn shares its tripartite organisation with tag (*b*). This tag's back-biting animals with their lolling tongues are, however, crude relatives to the beasts on the Huntingdon tag (**198**). The presence of an animal head above the hook has several parallels including a fine specimen from

196

197a

197b

197c

198

235

Canterbury (Graham-Campbell 1982, fig. 2, 2) and a triangular silver tag from Shenley Church End, Milton Keynes (unpublished). LW

Unpublished.

198 Hooked-tag

Huntingdon
Silver; L. 3.5 cm
Anglo-Saxon; early 9th century
British Museum, M&LA 1983, 6–1, 1

Circular plate with twin pierced attachment lugs and collared hook below. The plate is divided into quadrants each containing an identical back-biting beast with fleshy jaws and tongues lolling across the body.

One of the more elaborate tags, the fleshy muzzles of its decorative beasts recall eighth-century animal ornament, for example the beasts at the foot of the columns in the David scene in the Vespasian Psalter, f. 30v (153). A close parallel, though more schematic in its decoration, is to be seen on an example from High Wycombe (Farley forthcoming). LW

Unpublished.

199 Hooked-tag

Aldworth, Berks.
Silver, niello; L. 3.5 cm
Anglo-Saxon, mid 9th century
Private collection, per Newbury District Museum

The circular attachment plate has twin pierced lugs at the top and a pair of splayed hooks below. The plate is decorated with Trewhiddle-style ornament on a nielloed ground: interlaced plant ornament and an upward-facing mask immediately above the twin hooks, which may thus be read as horns.

Only one other double-hooked-tag is recorded, from Barking Abbey (67b), and the grotesque decoration of the Aldworth tag is equally unusual. The horned mask has distant cousins in the horned visage on a lost cup mount from Brougham (Bailey 1977, pl. xva) and in the animal masks on

the Strickland Brooch (189); but the nearest relatives are to be found in the grotesque horned masks of the canon tables of the BL, Royal MS 1 E.vi (171), especially f. 4v, f. 5, f. 5v, f. 6. A lively interest in similar masks is also displayed in the Barberini Gospels (160), e.g. in the initial B on f. 7, on f. 26, and elsewhere in that manuscript in a more naturalistic vein. The plant ornament is related to other foliate motifs in classic Trewhiddle style, as, for example, on panel 2 of the Poslingford ring (202). LW

Unpublished.

200 Pair of hooked-tags

Cathedral Green, Winchester
Silver, niello; L. (each) 3.9 cm
Anglo-Saxon; second half of 9th century
Wincheser Museums Service/Winchester Excavations Committee, inv. no. CG-323, CG-335

The sub-triangular plates have pierced attachment lugs at the base and a hook at the apex. The main field of each plate has seven beaded fields of lobed leaf ornament within a beaded border.

This pair was found by the knees of a body in grave 67 on Cathedral Green. It was the grave of a rich man, whose garments were trimmed with gold braid; the excavators suggest that the tags secured gartering. Their simple foliate decoration lacking any zoomorphic element recalls elements of the equally severe decoration of the large Beeston Tor brooch (245b) deposited c.875, and the leaf ornament on the small box from the Trewhiddle hoard itself, deposited c.871.
 LW

Select bibliography: Biddle et al. 1990, 548–52; Wilson 1965, 263–4 pl. LXXIX c; Roesdahl et al. 1981, cat. C.13.

201 Finger-ring

River Reno near Bologna, Italy, 1910
Gold, inlaid with niello; MAX. D. 3.4 cm, WT 129.20 g
Anglo-Saxon; first third of 9th century
Museo Civico Medievale, Bologna, inv. no. 2016.

Massive ring, cast in one piece, with seven concave roundels arranged in rosette form on the greatly expanded bezel. The entire surface is decorated with Trewhiddle-style plant and animal ornament reserved against a niello ground. Five roundels contain a beast, the sixth and seventh, bird and foliate motifs respectively. The shoulders have a similar design of four interlacing (and mostly) winged dragons, their tails interlacing to decorate the remainder of the hoop.

The most magnificent of the great series of ninth-century Anglo-Saxon rings to survive, the lively ornament of the roundels is in classic Trewhiddle style, with a precision and coherence unusual when so small a field is decorated. The winged beasts on the shoulders, with their collars, pricked ears, sinuous bodies and elegantly intertwining tails have a

199

200 200

clear pedigree which relates them to forebears on the Leningrad Gospels (Alexander 1978, no. 39), e.g. f. 16, or less directly, the Barberini Gospels (160) e.g. f. 18. An equivalent ancestor in metalwork is to be seen in the collared, sharp-eared dragons on the late eighth-century Hillesøy brooch (Bakka 1963, fig. 4). These links with late eighth-century animal motifs suggest that the ring should not be dated too far into the ninth century, an argument which gains support from the closest metalwork analogies to the beasts, which are to be found in the perky nielloed beasts on the largest of the Pentney brooches (187e), dated to the first third of the ninth century. LW

Bibliography: Ducati 1923–4; Bruce-Mitford 1956b, 181, pl. XXII; Wilson 1964, 31, 100; Porta 1990, 335–9.

202 Finger-ring

Poslingford, Suffolk
Gold; D. 2.2 cm
Anglo-Saxon; 9th century
British Museum, M&LA, 1955, 12–1, 1

Gold band with beaded edges and decorative panels, two with animal ornament, the rest with various forms of plant motifs.

201

202

203

A number of highly decorative ninth-century gold rings survive, reflecting a growth in popularity during this period (e.g. 203, 204). Simple bands often bear an inscription, usually an owner/maker formula; the Poslingford ring is an unusual example of panelled Trewhiddle-style decoration in such a context. LW

Select bibliography: Wilson 1964, cat. 61, fig. 29.

203 Finger-ring

Near Selkirk, Scotland: probably from the collection of Sir Walter Scott
Gold; D. 2.5 cm, WT 18.88 g
Anglo-Saxon; late 9th century
Faculty of Advocates, Edinburgh

The substantial ring has a sub-rectangular bezel with incised decoration consisting of, on the shoulders, triangular fields with foliage sprigs flanking a central circular field containing a compact backward-biting beast with punched spots on its body. Fault lines between bezel and hoop suggest the two parts were made separately and combined.

Little is known of the ring's history. It was reputedly found near Selkirk in 1808, and may have been part of the Walter Scott collection which passed to the Faculty of Advocates of Scotland. The ring is the grandest of a small group of finger-rings from the north with disc-shaped bezels decorated with single spotted creatures: the others (from Coppergate, York, 204, and possibly a fragment from Hale, Cheshire) are of silver. The distinctive fish-head of the animal with its dot-and-circle eye has a close counterpart in the beast heads on one of the two Lilla Howe strap-end pairs (249). In form, the strap-ends belong to the northern group, giving further support to the notion that the decoration and type of the Selkirkshire ring is distinctively northern. The decoration is indeed a distinct and simplified regional version of the Trewhiddle style which should probably be dated towards the end of the ninth century. It belongs to a small but significant band of ninth-century Anglo-Saxon material from Scotland – some, like the Talnotrie Hoard, probably reflecting Viking activity; others, like this, perhaps signalling a continuing Anglo-Saxon influence in southern Scotland.

LW, RMS

Unpublished.

204 Finger-ring

Coppergate, York
Silver; D. 2.0 cm
Anglo-Saxon; 9th century
York City Council, 1980.7.9212

Cast-ring with circular bezel engraved with a backward-biting Trewhiddle-style beast with lolling tongue, set in a roundel.

Closely related to the Selkirkshire ring (203), this ring was excavated from tenth-century levels at the Viking-period

commercial centre at Coppergate, York, which has produced a number of artefacts of Anglo-Saxon workmanship (cf. **253–5**). The ring may be seen as the product of a northern workshop, an attribution supported by the decoration. The animal on the bezel ultimately derives from animals of the sort seen on the Huntingdon hooked-tag (**198**) but which found popularity further north as the Hale piece, and a roundel from Whitby (Wilson 1964, cat. 114), indicate. LW

Bibliography: Hall 1986, 104–5.

204

205 Seal-die

Eye, Suffolk
Copper-alloy, glass; H. 6.9 cm
Anglo-Saxon; mid 9th century
British Museum, M&LA 1822, 12–14, 1

The cast seal-die is sub-conical in construction, with an openwork handle composed of tiered and interlocking arcading which converges in round-eared animal heads, and subsidiary animal heads which bite at the terminal, a solid triple leaf. One of the animal heads retains an inset glass eye. The circular die is engraved with an inscription which may be translated 'The seal of Bishop Ethilwald', encircling a central floriate cross.

The Ethilwald of the inscription has been identified with the ninth-century Bishop Æthelwald of Dunwich, Suffolk, who held office from 845 (or possibly earlier) to no later than 870 (Page 1964, 80–1). The die-type supports this dating, since it resembles coins of Æthelberht's second type, dating from c.865 (Wilson 1964, 34). As a rare example of an object which is probably associated with an historically recorded figure, it is of some significance to an understanding of the chronology of ninth-century metalwork. Its stylistic relationship to the arcading of the North Elmham censer (**206**) for example, to the similar zoomorphic heads of many strap-ends and other metalwork, and to the architectural sculpture at Deerhurst, is thus significant. LW

Select bibliography: Wilson 1964, cat. 18, 34.

205

206 Censer

North Elmham, Norfolk
Copper-alloy; H. 6.2 cm, D. 8.7 cm
Anglo-Saxon; mid 9th century
British Museum, M&LA 1897, 3–23, 18

Cast open-bowl censer with flat base, and rim of openwork arches on rectangular bases, standing on three engraved lines encircling the bowl. The body of the bowl is divided by triple incised lines into six vertical panels. The suspension chains (now lost) were fixed to three upward-pointing animal heads riveted to the rim; these have stubby muzzles, prominent lentoid eyes, rounded ears and comma-shaped stylised manes. Their foreheads have incised decoration inlaid with niello.

The censer was formerly in the collection of Lord Hastings:

206

according to an associated parchment label, it was found in North Elmham in 1786 'at a place called Tower Ditches on ye west side next the church'. This can be identified as the site of the Anglo-Saxon church at North Elmham as first recognised by Rigold (Rigold 1962–3), and known to have been in existence between 803 and 840. The discarding of the censer, which presumably came from the adjacent ecclesiastical site, may perhaps be associated with Danish incursions in East Anglia in the 840s and later in the ninth century. Its decoration is clearly linked to the arcaded and zoomorphic-headed decoration of the Ethilwald seal-die (205), an object independently dated to the mid ninth century, and also from East Anglia: the animal's heads also recall, in their round ears and comma-shaped manes, the animal-head terminals of both main types of ninth-century strap-ends. It is perhaps also of chronological interest that they closely resemble the sculptured animal heads seen on hood-mouldings in the tower and west doorway of the blocked chancel arch at Deerhurst Church, Glos. (fig. 27). LW

Bibliography: Rigold 1962–3, 71, fn. 22; Cramp 1989, cat. 33.

Sculpture

In central and southern England, the kingdoms of Mercia and Wessex, the development of sculpture differed very markedly from that in Northumbria. The main difference lies in the lack of early, that is seventh-century, sculpture, despite the large number of ecclesiastical sites known from this period. The only arguably seventh-century sculptures from this region are two columns from Reculver Church, two capitals and a lathe-turned baluster fragment from St Augustine's Abbey, Canterbury (18), and baluster decorated frieze fragments from the Old Minster, Winchester. There then appears to have been a hiatus before sculpture again began to be produced in the region in the mid to late eighth century.

The most important late eighth-century material is Mercian. Two major groups can be isolated, one based in eastern Mercia on the border with the old kingdom of East Anglia, and the other in south-west Mercia.

The surviving east Mercian material is predominantly architectural; the largest and most representative body of material survives at Breedon, Leics. (fig. 21). Here there are long narrow friezes, decorated with vine-scroll, pelta ornament, animal ornament, frets and interlace. There are also panels decorated with ranges of figures under arches, and other panels each decorated with a single figure beneath an arch (fig. 22). These may be shrine fragments, parts of altar frontals, or simply decorative slabs. Fragments of very similar friezes are known from Fletton near Peterborough and from Ely, and figural panels survive at Fletton, Castor (fig. 23) and Peterborough. Also at Peterborough the Headda shrine combines ranges of standing figures under arches on each side, together with panels decorated with animals enmeshed in interlace on the slopes of the roof.

Given its narrow and restricted distribution and the closely related repertoire of forms and decoration, it seems likely that this material represents the sculptural traditions of the great monasteries of Peterborough and Ely and their dependencies. These were clearly sites of great artistic importance of which virtually nothing else is now known.

In addition to the architectural sculptures there are a number of cross-shaft fragments from eastern Mercia. Many of them share a relatively restricted repertoire of decoration consisting of single or paired animals enmeshed in and/or developing into interlace, as seen, for example, on the shaft from Elstow, Beds. (207). These types of animals are clearly related to those on the roof of the Headda shrine, but differ from them in scale and in detailed handling (fig. 24). Indeed, the cross-shafts probably mark a slightly later stage in development than the architectural sculptures.

In west and south-west Mercia there is very little surviving evidence for architectural sculpture, although fragments of a fret-decorated arch from Berkeley, Glos. hint at what has been lost. Instead there are more cross-shafts and cross-heads surviving; again many of them share decorative traits, sometimes closely enough to suggest they are products of a single workshop. Especially distinctive are the cross-shafts from Wroxeter and Acton Beauchamp and the cross-head from Cropthorne (209). These are all decorated with fine, naturalistically-drawn animals, but with their bodies contoured and closely textured. The animals are usually enmeshed in plant scroll, again finely drawn and with exotic textured leaf forms. Occasionally the plant scrolls develop animal heads.

The decoration on these is close enough to suggest that they are products of a single workshop, but they also share interests, such as contoured and textured animal bodies, common to other south-western sculpture such as the cross-shaft from St Oswald's, Glos. (fig. 25). Indeed, it is from these south-west Mercian pieces that a series of cross-shafts in western Wessex emerged as at Steventon, Hants.; Dalton, Devon; or Ramsbury, Wilts. Here again the animals have contoured and textured bodies usually enmeshed in and developing into interlace, but their precise form and disposition on the monuments differs from that seen on the south-west Mercian material.

As the ninth century progressed new types of monument

Fig. 21 Breedon, Leics.: frieze with inhabited vine-scroll; late eighth to early ninth century

Fig. 22 (*Top*) Breedon, Leics.: figural panels; early ninth century

Fig. 23 (*Left*) Castor, Northants.: figural panel; early ninth century

Fig. 24 (*Above*) Peterborough, Northants.: the 'Headda' Stone; late eighth century

Fig. 25 (*Below left*) Gloucester: cross shaft, St Oswald's Priory; ninth century

Fig. 26 (*Right above*) Masham, N. Yorks.: round cross shaft; ninth century

Fig. 27 (*Right below*) Deerhurst, Gloucs.: sculptured animal head; ninth century

emerged in Mercia and Wessex. The 'Lechmere' stone (**210**), for example, represents a new type of grave marker intended to be set upright at the head of the grave; it is paralleled, for example, in Wessex in the piece from Whitchurch, Hants. The Repton slab (**212**) equally represents a new type of recumbent grave slab, probably designed to function with a head-stone, albeit of smaller size than the Lechmere example. These slabs were never common, but there are other examples, notably at Ramsbury, Wilts.

The most significant new form introduced in the ninth century was, however, the round shaft, a cross-shaft of circular section and columnar form. The form of this type is best exemplified by the late ninth-century example at Wolverhampton, but its decoration, consisting of animal and plant ornament, is unusual. Decoration on this series normally consisted of superimposed ranges of figures under arches, combined with narrative scenes, as at Reculver, Kent, or at Masham (fig. 26) and Dewsbury, Yorks. It seems likely that this type, which in its pure form was never common, was intended to be a Christian version of the triumphal columns of the Roman emperors in Rome and Constantinople. Much more abundant was the hybrid type combining a base of circular section with an upper portion of square section, also a ninth-century development.

Unfortunately, there is little surviving architectural sculpture of the ninth century to set alongside these new monumental forms. However, the single decorated arch from

Britford, Wilts., with its elaborate sculpture and polychromy (fig. 18), the figural sculpture and animal-head label stops from Deerhurst (fig. 27), and leaf-decorated roundels from Edenham, Lincs. (fig. 28) serve as a reminder of the splendid and elaborate interiors which have been lost, just as the Godalming stoup (**211**) is a reminder of the lost stone furnishings.

DOMINIC TWEDDLE

207 Cross-shaft fragment

Elstow, Beds.

Oolite limestone; Lincolnshire limestone formation (Barnack stone); H. 56 cm, W. 32 cm, D. 20.5 cm

Anglo-Saxon; late 8th century

The vicar and churchwardens of Elstow Abbey; on local exhibition with Bedfordshire County Council at Moot Hall, Elstow

It is of rectangular section, the upper end is stepped and roughly broken and the lower end is dressed flat. All the faces have plain raised edge mouldings. Face A is decorated with a pair of confronted winged bipeds with their bodies and wings contoured using an incised line. Their hindquarters develop into well-ordered interlace filling the lower half of the face. The contour line develops into a median incision on the interlace. Face B is decorated with a similar, but single, winged biped facing left. Its hindquarters and the end of the down-turned wing develop into interlace. Face C is filled with an angular interlace of similar form. It has thick, high-relief strands and cross-shaped breaks. Face D is decorated with a pair of backward-looking wingless bipeds, placed at the top and bottom of the face and upside-down with respect to each other. Their tails and tongues are linked by interlace.

The consistent use of bipeds suggests a date between the mid eighth century when this form emerged and the early part of the ninth century when it began to drop out of use in favour of more naturalistic types. The precise form of the animals together with the use of spiral elements in the interlace suggests a late eighth century date. It is one of a number of sculptures in eastern Mercia decorated with confronted or single bipeds enmeshed in or developing into interlace. These sculptures may reflect the artistic taste of the major east Mercian monastic houses such as Peterborough, or Ely whose art is otherwise undocumented.

First identified in the mid 1960s as having been reused in the later sixteenth-century blocking wall at the east end of the nave. DT

Bibliography: Baker 1969, 30–1, pl. 1b; Cramp 1977, 230, fig. 62j, k, 63h; 1978, 10, figs. 1k, 2s.

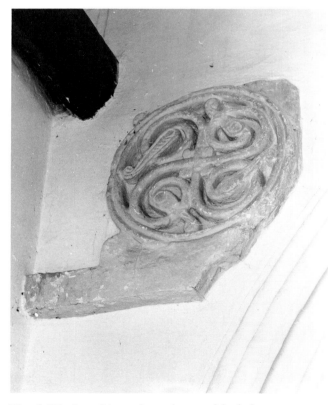

Fig. 28 Edenham, Lincs.: decorative roundel; ninth century

208 Cross-shaft fragment

Codford St Peter, Wilts.
Limestone; L. 125 cm, W. 31.5 cm, T. c.10 cm
Anglo-Saxon; late 8th century
The vicar, churchwardens and PCC of Codford St Peter

The shaft is of square section and tapers towards the upper
end. It is split longitudinally so that the front face (Face A)
and marginal fragments of the two side faces (Faces B and
D) survive. The rear face (Face C) is lost. The upper and
lower ends are dressed flat. The surviving corners are treated
as segmented columns with stepped capitals each supporting
a short plain corner moulding of square section. Above these
a zone of fret encircles the shaft which is stepped back above
this point. The front face is decorated with a single, half-
turned, figure moving left and looking upwards, the right leg
is raised and bent at the knee. He is clad in secular dress
consisting of a short belted tunic and cloak with the folds of

207

208

243

the drapery indicated by parallel grooving. He wears shoes and there is a fillet around his head. In his left hand he holds an unidentified implement – globular with a long tube or shaft held by the figure. His right hand is raised to hold a bush scroll. The stem has triangular bindings from which develop leaf flowers, triple leaves and pointed leaves. At the upper end it terminates in globular berry bunches. Above it, between the plain corner mouldings and below the band of fret is a double spiraliform leaf scroll. Face B is decorated with the margin of a bush or tree scroll with trefoil and heart shaped leaves and perhaps leaves with a bud or fruit. Above the stepped capital, and bordered to the left by the surviving plain corner moulding, is a broad zone of elaborate fret. There is similar decoration on Face D.

The dating of the Codford shaft has generated an animated debate, but the overall nature of the decoration mixing figural ornament, plant ornament, some of it with spiraliform leaves, and fretwork, is typical of the late eighth or early ninth century, a period when such elaborate combinations were particularly popular. Specific elements in the decoration support such a conclusion. For example, on the human figure, the use of hard parallel grooving to indicate the folds of the garment is matched almost exactly in the Vespasian Psalter (**153**). There, on f. 30v, the left-hand figure flanking King David holds an object very similar to that held by the Codford figure, while all of the figures in the scene apart from the king wear clearly delineated shoes with the same extended heel and triangular tongue as on the Codford shaft. The wide variety of leaf forms also supports a late eighth century or early ninth century date. As the ninth century progressed pointed leaf forms began to predominate, whereas on the Codford shaft it is the other, more exotic, forms which are in the majority, as on the Maaseik embroideries or in the Vespasian Psalter itself. DT

Bibliography: Kendrick 1938, 179–81, pl. LXXV; Cramp 1972, 140–1, abb. 1.5, 1a–b; Wilson 1984, 195–6, fig. 252.

209 Cross-head

Cropthorne, Worcs.

Limestone; H. 84 cm, W. 84 cm, T. *c.* 12 cm

Anglo-Saxon; early 9th century

The vicar, churchwardens and PCC of St Michael's Church, Cropthorne

It is equal-armed with the edges of the arms double-cusped and the ends slightly convex. At the angles are cabled mouldings which at the base become a row of pellets separating the head from the lost shaft. Inside the cabling, on each face, is a plain raised frame. The front face is decorated with a vine-scroll having trumpet bindings and trefoil leaves. In the upper arm the end of the plant tendril turns into an animal head. On the other arms the vine scroll is inhabited by semi-naturalistic quadrupeds having hatched and contoured bodies. The decoration on the rear face is very similar except that the vine scroll has triangular hatched leaves with curled ends as well as trefoil leaves. There is a quadruped in the

209 (front)

209 (back)

lower arm, but a hatched and contoured semi-naturalistic bird in each of the remaining arms. In the centre of the head is a circular hollow. The edges of the head are decorated with a regular Greek key motif.

The Cropthorne cross-head is closely related in the range of motifs, their handling, and the flat-low style of sculpture to cross-shafts at Wroxeter, Shropshire, and Acton Beauchamp, Herefordshire. So close is the resemblance that it has been suggested that the Acton Beauchamp shaft may be from the same workshop as the Cropthorne piece. Whatever their precise relationship these pieces illustrate a south-west Mercian interest in semi-naturalistic forms and in the heavy texturing of animal bodies seen also, for example, on a cross-shaft from St Oswald's, Gloucester. Similar contoured and hatched animals appear on the ornament of cross-shafts from

western Wessex, such as those from Steventon, Colyton, Ramsbury and West Camel, although the precise relationship between the two groups remains uncertain. The Wessex material may draw on Mercian prototypes, or the two series may represent parallel responses to the same stimuli.　DT

Bibliography: Kendrick 1938, 186, pl. LXXX.1; Cramp 1977, 225–30, fig. 616; Wilson 1984, 105, fig. 126.

210 Grave marker

Worcestershire (known as the 'Lechmere' stone)
Limestone; H. 49 cm, L. 21 cm, D. 28 cm
Anglo-Saxon; early 9th century
Sir Berwick Lechmere Bt

It is parallel-sided with a rounded top and squared base the corners of which are roughly broken away. On the front face there is a cabled moulding on the angle, inside which is a plain raised frame. This encloses the frontally-placed, standing figure of Christ. He has a cruciform nimbus, curled hair and holds a book in his left hand which his right hand stretches across his body to touch. The folds of his garment are indicated by parallel grooving and in both tunic and pallium there is a central triangular fold. On the reverse is a hollowed field which has both a semicircular head and foot. It is filled by an encircled equal-armed cross having almost circular re-entrant angles; the ends of the cross have volutes to each side. The head stands on a short baluster supported by a stepped base. From the base, to each side, emerges a plant scroll. A similar scroll runs up the sides and over the head of the stone.

The provenance of the 'Lechmere' stone, though presumably local, is not known, the name being taken from that of the family in whose possession it has been for many years. That it is a grave marker is suggested by comparison with the marker from Whitchurch, Hants. This is of identical form, although much smaller, and like the Lechmere stone is decorated on the front face with the figure of Christ holding a book. The function of the Whitchurch piece is clearly identified by a memorial inscription over the head. This type of semicircular headed grave marker appears to have been a ninth-century innovation in southern England. It continued throughout the ninth and tenth and eleventh centuries; some examples were freestanding as at Whitchurch and here, others were partially sunk into the ground. The drapery style of the Lechmere stone has close connections with other Mercian products, notably the Book of Cerne (**165**) and figural panels from Castor and Fletton both near Peterborough.　DT

Bibliography: Baldwin Brown 1931; Kendrick 1938, 186–7, pl. LXXXI.

210

211

211 Stoup rim

Godalming, Surrey

Limestone; Combe Down oolite formation (Bath stone); DIAM. 49 cm,
H. 17 cm, T. 8 cm

Anglo-Saxon; early 9th century

The vicar and churchwardens, Godalming Parish Church

This takes the form of a ring of fundamentally rectangular
section. The upper inner edge is chamfered, and the lower
inner edge rebated. The outer face is divided into equal fields
by four heavily weathered, high-relief animal heads, each
with a broad muzzle, drilled eyes and pointed ears. Between
each pair of heads is a decorative field designated anti-clock-
wise A to D. Fields A–C have broad plain frames above and
below, Field D has plain frames on all sides. Field A is
decorated with a four-strand interlace plant. Field B is filled
with a wingless biped with its body developing into interlace,
one strand of which develops from its extended tongue. Field
C is decorated with a plant scroll. There are three tight spirals
each ending in a long tapering leaf crossing diagonally under
or over its own stem. Field D is filled with median-incised
interlace of Adcock's simple pattern F.

It is difficult to establish the original function of this piece.
The simplest solution is to suggest that it formed the rim of
a stone vessel lined with metal. The rebate on the lower inner
edge would have fitted neatly over the edge of such a lining.
The rim is too small for the vessel to have been a font: a
stoup is a likely alternative. The use of alternating animal,
plant and interlace ornament is reminiscent of a number of
late eighth- and early ninth-century works, such as the
Maaseik embroideries and the decoration of BL, Royal MS I
E.vi (143, 171). Both works share a similar repertoire,
although simplified at Godalming. BL, Royal MS I E.vi can be
dated to the period c.820–40, and a similar date for the
Godalming piece seems likely. DT

Bibliography: Tweddle 1983, 35–6, fig. 7, pl. xb.

212 Grave slab

Repton, Derbys.

Bunter sandstone; L. 153 cm, W. 55 cm, D. 11 cm

Anglo-Saxon; 9th century

Derby Museum and Art Gallery

It is of semi-circular section and tapers slightly towards the
rounded end. The other end is squared. Around the lower
edge is a prominent roll moulding, and there is a similar
moulding along the axis of the slab. To either side of this is
a decorative field, in each case outlined, except at the squared
end, by a second smaller roll moulding. Each field is filled
with a flaccid interlace ensnaring or developing from bipeds
with sub-triangular bodies.

The squared end may represent the later removal of an

212

original rounded end, but no grave slabs of this type with two rounded ends survive, and it is possible, therefore, that the squared end is original, even though it apparently cuts across the decoration. In this case the end of the slab would probably have butted against a small headstone.

This type of grave slab is fairly unusual in Anglo-Saxon England, although examples occur from as far apart as Ramsbury, Wilts., and Co. Durham. Like the Ramsbury examples this piece probably belongs in the early ninth century. The triangular bodies of the animals look forward to the forms of the Trewhiddle style, but also have a clear relationship with east Mercian animal art of the late eighth or early ninth century, as seen for example on the shaft from Elstow, Beds. (207). DT

Bibliography: Biddle and Kjølbye-Biddle 1985, cover.

Coins

Mercia (213–17)

213 Penny (sceat) possibly of Offa of Mercia (757–96), struck in Mercia, 757–c.760

Base silver; WT. 0.75 g (11.5 gr) (illustrated slightly larger than life size)
Paris, Cabinet des Médailles, Bibliothèque Nationale

This sceat, with one bird on the obverse and four birds forming a cross with their bodies and beaks on the reverse, is late in the sceatta series, and is related to others certainly Mercian in origin. Neither the types nor the inscription on the obverse are known on any other sceat. The letters which are only partially visible can be interpreted in different ways, but 'O F' seem reasonably clear and it is perhaps essaying the name and title of Offa. It would be feasible to attribute to Offa small-flan pennies struck in his own name before he introduced the broader, heavier and finer-metal coins. The attribution remains open. MD, MMA

Provenance: Found in France, 1989 (location not known).
Bibliography: Archibald and Dhenin forthcoming.

214 Penny of Offa of Mercia (757–96), Light Coinage, struck at London by the moneyer Ibba in the 770s or 780s

Silver; WT 1.19 g (18.3 gr)
British Museum, CM 1896, 4-4-17

Die-cutters working during Offa's Light Coinage, particularly for moneyers in London, show great artistic skill and inventiveness. The work of others is more utilitarian (218c). This variety in design and style is indicative of sporadic issues, not of a sustained or highly-managed coinage. When Offa increased the weight of the coins c.792 (222b),

he tried to impose a uniformity of type, but did not totally extinguish this individuality. MMA

Provenance: Not known; purchased at the Montagu I sale. Sotheby 18.xi.1895, lot 185.
Bibliography: BMA 22; Blunt 1961, no. 65.

215 Penny of Cynethryth, wife of Offa of Mercia (757–96)

Silver; WT. 1.03 g (15.9 gr)
British Museum, CM, acquired before 1838

Cynethryth is the only English queen consort to have issued coins in her own name. The female head grafted on to the usual Offa fourth-century style Roman bust is not itself copied from any Roman or contemporary Byzantine originals, although the inclusion of royal ladies in those coinages may have inspired Cynethryth's issues. They may have been occasioned by donatives made by the queen herself for which personalised coins would have been particularly appropriate.
 MMA

Provenance: Found at Eastbourne, Sussex; purchased with coins from the Samuel Tyssen collection, 1802.
Bibliography: BMC 60; Blunt 1961, 46–7 and no. 119.

216 Penny of Offa of Mercia (757–96) with Eadberht, bishop of London (between 772 and 782–between 787 and 789)

Silver; WT. 1.19 g (18.3 gr)
British Museum, CM, acquired before 1838

The attribution to the bishop rests on the monogram below Eadberht's name. It could be read as 'EP' (for *episcopus*, bishop) or 'ME' (for *munitare* (or variant), moneyer, cf. 76b), but the first seems preferable as the title 'moneyer' is not used on the normal silver coinage at this period, and the monogram is invariably present on all Eadberht's coins of several types. The much-needed reference point which this provides in Offa's coinage is made less useful by the difficulty in dating the bishop himself, but can be helpful (see 218).
 MMA

Provenance: Not known; purchased with coins from the Southgate collection, 1795.
Bibliography: BMC 41; Blunt 1961, 34.

217 Penny of Cœnwulf of Mercia (796–821), struck at London by the moneyer Ceolheard, c.810–21

Silver; WT 1.45 g (22.3 gr)
British Museum, CM 1955, 7-8-10

This coin is by the same moneyer as the gold solidus/mancus (77b). Cœnwulf's coinage was extensive and dominated the Mercian element of the currency for twenty years after his

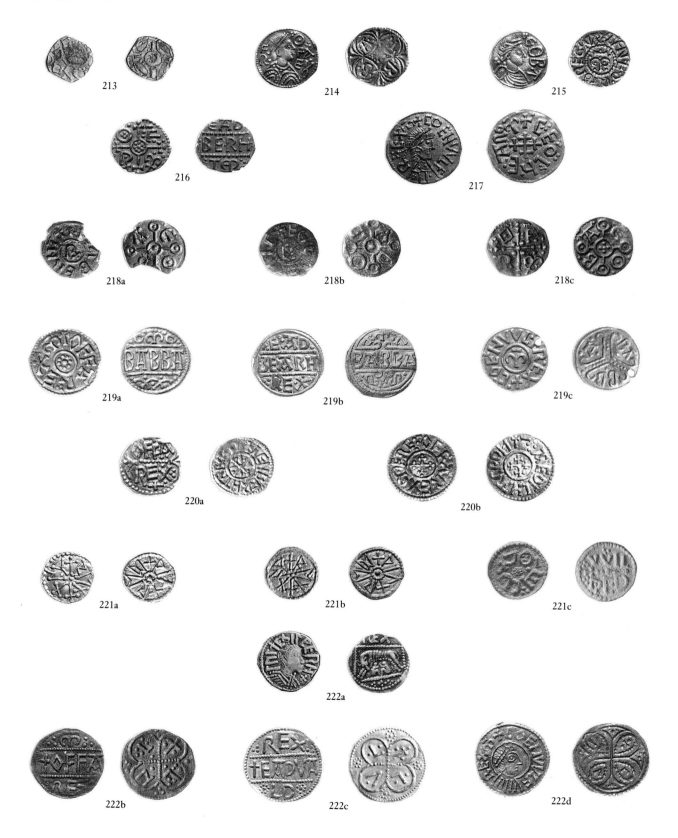

213

214

215

216

217

218a

218b

218c

219a

219b

219c

220a

220b

221a

221b

221c

222a

222b

222c

222d

Pennies of Offa of Mercia, his wife Cynethryth and his victim Æthelberht of East Anglia

death. The issues of his immediate shorter-lived successors were limited, and reflect the waning of Mercian power.

MMA

Provenance: From the Delgany, Co. Wicklow, Ireland, hoard, deposited *c.*830, and found in 1874; purchased at the Lockett sale, Glendining, 6.vi.1955, lot 367.
Bibliography: Blunt, Lyon and Stewart 1963, no. 88(a).

Mercia and Kent (218–20)

218 (a–c) **Pennies** of Heaberht and Ecgberht II, kings in Kent, and Offa of Mercia, all struck at Canterbury by the same moneyer, Eoba

218 (a) Penny of Heaberht of Kent, struck in the later 770s

Silver; WT. 0.72 g (11.1 gr, chipped)
British Museum, CM 1989, 8-8-1; bequeathed by C.E. Blunt, 1989

Provenance: Found in Rome, 1899; ex Grantley sale, Glendining 22.iii.1944, lot 878.
Bibliography: Blunt 1961, no. 1; Lyon 1968; Stewart 1986.

218 (b) Penny of Ecgberht II of Kent, struck in the later 770s

Silver; WT. 0.83 g (12.8 gr)
British Museum, CM 1989, 8-3-2; bequeathed by C.E. Blunt, 1989

Provenance: Not known.
Bibliography: Blunt 1961, no. 3, and as (*a*).

218 (c) Penny of Offa of Mercia (757–96), struck in the later 770s

Silver; WT. 1.28 g (19.7 gr)
British Museum, CM 1896, 4-4-30

Provenance: Not known; purchased at the Montagu I sale, Sotheby, 18.xi.1895, lot 216.
Bibliography: BMA 33; *cf.* Blunt 1961, no. 10, and as (*a*); Lyon 1967.

The coins of Heaberht and Ecgberht either were issued before Offa's arrival in Kent in the mid 760s, or are evidence for a bid for Kentish autonomy in the later 770s; Offa's extant early Kentish coins stylistically follow them. There are problems with both chronologies, e.g. the first requires moneyers of the same name to have operated for thirty years, but the second that Heaberht, last certainly recorded in 765, was still active ten years later. The later date is preferred here on the further grounds that the Offa obverse was the same type as that used on the earliest coins of Bishop Eadberht of London (**216**), the limiting dates for whose accession are 772 and 782.

MMA

(Left) Coins illustrating the imposition, loss and reimposition of Mercian power in adjacent kingdoms

219 (a–c) Pennies of Offa of Mercia, Eadberht Præn of Kent and Cœnwulf of Mercia, all struck at Canterbury by the same moneyer, Babba

219 (a) Penny of Offa of Mercia (757–96), Heavy Coinage, struck *c*.792–6

Silver; WT. 1.26 g (19.5 gr)
British Museum, CM, acquired before 1832

Provenance: Not known, purchased with coins from the Samuel Tyssen collection in 1802.
Bibliography: BMC 35; Blunt 1961, no. 85.

219 (b) Penny of Eadberht Præn (796–8)

Silver; WT 1.32 g (20.4 gr)
British Museum, CM 1846, 6–30–1

Provenance: Hellesdon near Norwich, Norfolk, 1846.
Bibliography: BMC 2; Dolley 1956.

219 (c) Penny of Cœnwulf of Mercia (796–821), struck *c*.798–800

Silver; WT. 1.12 g (19.3 gr, holed)
British Museum, CM 1915, 5–7–675

Provenance: Not known; purchased from J. Pierpont Morgan, 1915, ex Sir John Evans collection.
Bibliography: BMA 98; Blunt, Lyon and Stewart 1963, no. 5a.

These coins illustrate the attempt by Eadberht to restore Kentish independence following Offa's death, and the re-imposition of Mercian authority by Cœnwulf. A parallel sequence of events took place in East Anglia (221). Moneyers remained in office despite political upheavals. MMA

220 (a, b) Pennies of Offa of Mercia, struck by successive archbishops of Canterbury, at Canterbury

220 (a) Penny of Offa (757–96) with Archbishop Jænberht (765–92), Light Coinage

Silver; WT. 1.20 g (18.5 gr)
British Museum, CM 1985, 6–34–1

Provenance: Found at Reading, Berks.; purchased at the Norweb sale, Spink, 13.vi.1985, lot 18.
Bibliography: Blunt 1958; 1961, 47–8.

The die of the Offa side of this penny was also used for one of his regal coins with a normal moneyer reverse; this shows that it was the Offa side of the archiepiscopal issue which was technically the obverse, with the archbishops occupying the place of the moneyer. MMA

220 (b) Penny of Offa (757–96) with Archbishop Æthelheard (793–805), using the title PONTIFEX, Heavy Coinage, struck *c*.793–4

Silver; WT 1.43 g (22.0 gr)
British Museum, CM 1982, 11–45–1

Provenance: Said to have been a recent find in East Anglia; purchased from Messrs Baldwin, 1982.
Bibliography: Blunt 1961, 48–9; 1962.

The archiepiscopal coins help to date the increase in the weight of Offa's coins (219a) as all Æthelheard's extant coins, even this earlier group, are heavy, while those for Jænberht are light. It is not certain, however, that coins were struck for Jænberht right up to his death, so the heavier coins may have begun a little earlier. MMA

Mercia and East Anglia (221–2)

221 (a–c) Pennies (sceattas) of Beonna of East Anglia, and a penny of Offa of Mercia, all struck at ?Ipswich by the same moneyer, Wilfred

221 (a, b) Pennies (sceattas) of Beonna of East Anglia (749–*c*.760 or later), struck *c*.760

Base silver; WTS 0.98 g (15.1 gr), 1.10 g (16.9 gr)
British Museum, CM 1984, 5–72–10; CM 1982, 4–9–30

Provenance: From the Middle Harling, Norfolk, hoard, deposited *c*.760 and found in 1982–3.
Bibliography: Archibald et al. 1985.

221 (c) Penny of Offa, Light Coinage, struck in the 760s or later

Silver, WT 1.26 g (19.4 gr)
Cambridge, Fitzwilliam Museum

Provenance: Found at St Osyth's Essex, 1981; from the C.E. Blunt Bequest, 1989, ex Christie, 23.vii.1985, lot 107.
Bibliography: cf. SCBI Berlin, 67 (different dies)

Although none of these coins can be dated precisely, the issue of a penny of Offa by the same moneyer who had struck late sceattas for Beonna suggests that Offa had restored Mercian authority in East Anglia earlier in his reign than has been supposed. MMA

222 (a–d) Pennies of Æthelberht of East Anglia, Offa of Mercia, Eadwald of East Anglia and Cœnwulf of Mercia, all struck in East Anglia by the moneyer Lul

222 (a) Penny of Æthelberht of East Anglia (killed 794), with moneyer's name in runes after the king's name in Latin characters on the obverse; she-wolf and twins and REX on the reverse

Silver; WT 1.09 g (16.8 gr)
British Museum, CM, acquired before 1838

Provenance: Found at Tivoli, near Rome; purchased at the Barker sale, Sotheby 2.v.1803, lot 460.
Bibliography: BMC 2; Blunt 1961, 49–50.

222 (b) Penny of Offa (757–96), Heavy Coinage, struck c.792–6, three-line type obverse, reverse with moneyer's name on the leaves of a quatrefoil

Silver; WT 1.38 g (21.3 gr)
British Museum, CM 1855, 5–12–69

Provenance: Purchased from the Loscombe sale, Sotheby, 22.ii.1855, lot 1030.
Bibliography: BMC 52; Blunt 1961, no. 114.

222 (c) Penny of Eadwald of East Anglia (c.796–c.798), three-line type obverse, reverse with moneyer's name on the leaves of a quatrefoil

Silver; WT 1.30 g (21.1 gr)
British Museum, CM 1925, 9–9–4; gift of H.M. Commissioner of Works

Provenance: Found at Richborough, Kent, 1925
Bibliography: BMA 15; Blunt, Lyon and Stewart 1963, 2–7 and no. 2.

222 (d) Penny of Cœnwulf (796–821), three-line type obverse, reverse with moneyer's name on the leaves of a quatrefoil

Silver; WT 1.40 g (21.6 gr)
British Museum, CM, acquired before 1838

Provenance: Not known; purchased with coins from the Samuel Tyssen collection in 1802.
Bibliography: BMC 73; Blunt, Lyon and Stewart 1963, 97(a).

These coins illustrate changes in control of East Anglia as reflected by the career of the moneyer Lul. He worked for the East Anglian king Æthelberht, who was killed on Offa's orders in 794, then for Offa himself at the end of his reign. His next issues were for Eadwald, a king unrecorded except by his coinage, who ruled in East Anglia between Offa's death and the restoration of Mercian supremacy early in the reign of Cœnwulf. MMA

Mercia and Wessex (223)

223 Penny of Beorhtric of Wessex (786–802), struck at Winchester by the moneyer Weochthun, c.798–802

Silver; WT 1.43 g (22.0 gr, chipped)
British Museum, CM 1955, 7–8–24

Beorhtric's coins were struck in the period of increased independence following the death of his powerful father-in-law, Offa of Mercia, in 796. The stylistic associations of the West Saxon coins are with the Tribrach issues of the restored Mercian kings in Kent, rather than with Offa's last type, which suggests Beorhtric's extant coins are slightly later than the issues of the local contenders in Kent and East Anglia (**219b**, **222c**). Stewart has suggested that Weochthun is to be identified with the bishop of the South Saxons of that rare name. MMA

Provenance: Found near Andover; purchased at the Lockett sale, Glendining, 6.vi.1955, lot 452.
Bibliography: Dolley 1970, 58; Stewart 1990, 340.

The rise of Wessex (224–31)

224 (a–c) Pennies of Ecgberht of Wessex (802–39), illustrating the expansion of his territorial authority

224 (a) Penny of Ecgberht struck at Canterbury (denoted by DORO C in monogram) by the moneyer Bosel, c.825–c.828

Silver; WT. 1.25 g (19.3 gr)
British Museum, CM 1893, 12–4–144; gift of A.W. (later Sir Augustus) Franks, 1893

Provenance: From the Middle Temple, London, hoard, deposited c.842 and found in 1893.
Bibliography: BMA 349; Blunt 1957; Dolley 1970.

Ecgberht does not appear to have struck any coins until he conquered Kent (with Essex) in 825, when he acquired the services of the Canterbury and Rochester moneyers. The West Saxon dynasty retained control of these areas, which, added to their patrimony of Wessex, formed the nucleus of a united England under Ecgberht's descendants. MMA

224 (b) Penny of Ecgberht, with his Mercian title REX M[ERCIORVM], struck at London (signed LVNDONIA CIVIT), 829–30

Silver; WT 1.40 g (21.6 gr)
British Museum, CM 1893, 12–4–208; gift of A.W. (later Sir Augustus) Franks, 1893

Provenance: From the Middle Temple, London, hoard, deposited c.842 and found in 1893.
Bibliography: BMA 323; Blunt 1957; Dolley 1970.

This coinage is the first to bear the name of London since the sceatta period and is identified as a celebratory issue struck on the occasion of the capture of the Mercian city by Ecgberht in 829. A coinage with an similarly exceptional naming of London was struck for Ecgberht's grandson, Alfred (**265**). MMA

224 (c) Penny of Ecgberht with his West Saxon title, REX SAXONIORVM, by the moneyer Eanwald, struck at Winchester, *c*.828–39

Silver; WT. 1.23 g (19.0 gr)

British Museum, CM 1893, 12–4–207; gift of A.W. (later Sir Augustus) Franks, 1893

Provenance: From the Middle Temple, London, hoard, deposited *c*.842 and found in 1893.

Bibliography: BMA 397; Blunt 1957; Dolley 1970

The West Saxon title does not conclusively locate this issue at Winchester, but as none of the moneyers of the series is known at the Kentish mints, the attribution is likely. MMA

225 Penny of Baldred of Kent (*c*.823–5), struck at Canterbury by the moneyer Diormod

Silver; WT. 1.39 g (21.5 gr)

British Museum, CM 1915, 5–7–711

This coin was struck for Baldred before Kent was taken over by Ecgberht (**224a**). Diormod then struck coins for the West Saxon king. MMA

Provenance: From the Delgany, Co. Wicklow, Ireland, hoard, deposited *c*.830 and found in 1874; purchased from J. Pierpont Morgan, ex Sir John Evans collection

Bibliography: BMC 164; Blunt, Lyon and Stewart 1963, no. 1.

226 Penny of Archbishop Wulfred of Canterbury (805–32), Group I, struck at Canterbury, *c*.805–10

Silver; WT. 1.43 g (22.0 gr)

British Museum, CM 1896, 4–4–46

Novel features on the coins of the rich and powerful Archbishop Wulfred illustrate his view of the independence of his position which brought him into conflict with King Cœnwulf. Unlike the issues of his predecessors (**220a, b**), they do not bear the king's name, and replace the previous non-portrait obverse designs with a striking tonsured effigy derived from papal issues. This bust type was retained even when Wulfred's name disappeared from Canterbury issues during his temporary suspension from office from 817 to 821. His later issues name moneyers who often worked also for the contemporary kings. The coinage pattern Wulfred established was followed by later archbishops. MMA

Provenance: Not known; purchased at the Montagu I sale, Sotheby, 18.xi.1895, lot 308.

Bibliography: BMA 196; Blunt, Lyon and Stewart 1963, no. 1.

227 Penny of Wiglaf of Mercia, 827–9 and 830–40, struck at London by the moneyer Redmund

Silver; WT. 1.40 g (21.6 gr)

British Museum, CM 1893, 12–4–43; gift of A.W. (later Sir Augustus) Franks, 1893.

This coin was struck by a moneyer who also worked for Ecgberht when he controlled London in 829–30. It is not possible to say whether it was struck before or after the West Saxon interlude. MMA

Provenance: From the Middle Temple, London, hoard, deposited *c*.842 and found in 1893.

Bibliography: BMA 131; Blunt, Lyon and Stewart 1963, no. 39(a).

228 Penny of Athelstan I of East Anglia (*c*.821–*c*.840), struck by the moneyer Mon

Silver; WT. 1.22 g (18.8 gr)

British Museum, CM 1858, 12–31–1; gift of the Revd W. Cotterell, 1858

Athelstan is known only from his extensive and varied coinage which is located in East Anglia by the chain of moneyers' names connecting it with issues of the historical Edmund (**272**). Most of his coins come from the hoard found in Hare Court in the Middle Temple, London on 23 November 1893, whose non-recovery is plausibly associated with the descent of the Danes on London in 842. MMA

Provenance: Not known.

Bibliography: BMC 5; Pagan 1982, 59.

229 Penny of Eanred of ?Northumbria, (*c*.810–41 or *c*.830–*c*.854), the reverse reading ÐES MONETA ω meaning 'coin of that [king]'

Silver; WT. 1.06 g (16.3 gr, chipped)

British Museum, CM 1955, 7–8–27

The style of this 'unique' coin requires it to be dated, on close analogy with southern issues, to after *c*.850. This is too late to fall within the traditional bracket of Eanred's reign, but a re-examination of the evidence by Pagan suggests a revised chronology which would allow this coin to be the Northumbrian king's. The alternative, that he was an unknown southern king, presents problems too, so the question of attribution is still open. MMA

Provenance: From the Trewhiddle, Cornwall, hoard, deposited *c*.868 and found in 1774; purchased at the Lockett sale, Glendining, 6.vi.1955, lot 459.

Bibliography: Lyon 1956; Pagan 1969; Grierson and Blackburn 1986, 301.

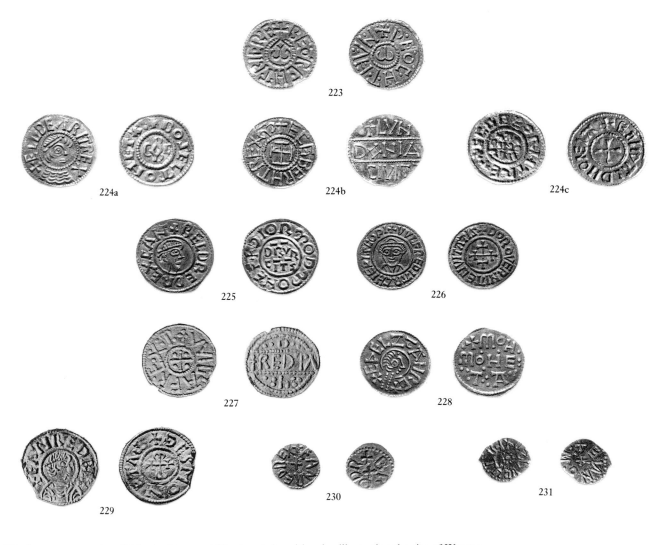

223

224a 224b 224c

225 226

227 228

229 230 231

Ninth-century pennies of Mercia, Kent and Northumbria, with coins illustrating the rise of Wessex

230 Penny (styca) of Eanred of Northumbria (c.810–41 or c.830–c.854), struck at York by the moneyer Brother

Very base silver; WT 1.21 g (18.6 gr)

British Museum, CM 1935, 11–17–523; T.G. Barnett Bequest, 1935

Northumbria did not follow the southern kingdoms in introducing the wider, finer, penny but continued to strike coins of the old sceatta-type fabric in increasingly base silver. These so-called 'stycas' were the normal coinage for Eanred. MMA

Provenance: Not known.

Bibliography: Lyon 1956; Pagan 1969; Pirie forthcoming.

231 Penny (styca) of Osbert of Northumbria (849–67 or c.862–7), struck at York by the moneyer Monne

Brass-alloy; WT. 1.53 g (20.8 gr)

British Museum, CM, acquired before 1838

The coinage being struck on the eve of the Viking conquest in 866/7 reflected the disintegration of the Northumbrian state. It consisted of exceedingly base coins in the names of the Northumbrian king, Osbert, and of Archbishop Wulfhere of York, often with retrograde and blundered legends, and other coins whose issuing authority is doubtful struck on light, ill-prepared blanks, with completely illiterate inscriptions. MMA

Provenance: Not known; purchased with coins from the Samuel Tyssen collection in 1802.

Bibliography: BMC 669; Lyon 1956; Pagan 1969 and 1973; Pirie forthcoming.

The age of Alfred

According to popular legend, King Alfred the Great was a valiant warrior, who delivered his nation from the threat of Viking conquest; a skilful ruler, who established a code of laws for his people and protected their liberties; a distinguished scholar, who cherished learning and promoted educational reform; and he was Alfred 'the truth-teller', the paragon of virtues who shone forth as a mirror of the Christian prince. It has to be said that the legendary Alfred was fashioned by writers from the sixteenth century to the nineteenth, who admired him for various reasons of their own, and that it is their composite image of the king which has become part of received tradition. Our task is to penetrate the legend and reach the genuine Alfred of the late ninth century; and although the genuine Alfred proves to have been a creature rather different from his legendary namesake, the exercise does more to enhance our understanding than to diminish our estimation of what he set out to achieve.

It is not immediately apparent from the surviving artistic monuments of his reign that Alfred was quite so exceptional. There are no decorated manuscripts to match the eighth-century Vespasian Psalter (153), or the early ninth-century Canterbury Bible (171); and other objects of art are thin on the ground. It is when one turns, however, to the evidence of the written word that one begins to see the difference. Alfred's treaty with Guthrum (242), concluded some time after the warfare of the 870s, is testimony of his desire to make a lasting peace. Alfred's charters (e.g. 236) indicate that he was not merely 'king of the West Saxons' but could be hailed on occasion as 'king of the Angles and Saxons', or 'king of the Anglo-Saxons'. Alfred's code of laws, which probably dates from the late 880s, shows by what means he sought to establish social order, and at the same time reflects his greater aspirations as the ruler of a Christian people. Alfred's will (240) reveals how his family had protected the resources at their disposal, and in what way he proposed to do the same. The Anglo-Saxon Chronicle (233), produced at a moment of grave crisis in the early 890s, provided the king's English subjects with a view of their common past, projecting Alfred himself as their natural leader in the struggle against the Vikings. Asser's Life of King Alfred (234), on the other hand, was written in 893 for the benefit of the king's Welsh subjects: in effect, Asser created his opportunity to enthuse about the qualities of the king who was now their overlord, portraying him as a devoutly Christian ruler engaged in a hard, heroic and holy war against a pagan enemy. Finally, the various writings by King Alfred himself convey a vivid impression of his own conception of the duties of a Christian king, showing how seriously he took the responsibilities of his high office. Of course we should be wary of the Chronicle and Asser's Life, for both works can be seen as a mixture of panegyric and propaganda, as hype not history; and of course we should be careful to distinguish a soaring aspiration from a brutal reality. But it is no mere accident that Alfred is the only Anglo-Saxon king whose hopes and fears we can approach so closely: the quality of the evidence is a function of his particular distinction.

The modern understanding of King Alfred the Great depends partly on a reassessment of his various activities, and partly on our perception of the relationship between them. The reassessment itself is prompted by natural suspicion of legendary virtue, complemented by a healthily sceptical attitude towards the sources; and it is informed by the results of research in other disciplines, notably archaeology, the study of vernacular prose literature, and numismatics. No one would doubt that Alfred was a capable military leader; but he earns his reputation in this respect not so much from his struggle against the Vikings in the 870s (which may not have been quite as 'heroic' as the chronicler, and Asser, would like us to believe), as from the measures he took in the 880s to defend his kingdom against the threat of a renewed invasion – in which connection it is modern work on the text known as the Burghal Hidage (241), and the identification of Alfred's network of forts (burhs) and fortified towns on the ground, which has caused the shift of emphasis. He was certainly a distinguished scholar; but the more often one reads the corpus of translations of 'those books which are the most necessary for all men to know', produced by Alfred himself and by others as part of his scheme, the clearer becomes one's sense of their particular relevance to his wider purposes – in which connection one could instance the translation of the first fifty psalms of the Psalter, recently shown to be from Alfred's hand, as a work of cardinal importance, suggesting just how much the king may have owed to the example of David. And Alfred was undeniably a statesman; though it would be mistaken to imagine that in pursuing his political ambitions he did not have to overcome resistance, or did not generate any resentment as he did so. In this last connection, the crucial matter is the nature of Alfred's relations with the successive rulers of Mercia (especially King Ceolwulf and Ealdorman Æthelred), his attitude towards the Mercian people, and their attitude towards him. This matter in turn depends on the evidence of coinage, especially the coins minted by the 'Mercian' moneyers of London: for recent analysis suggests that Alfred's authority may have been recognised in London rather sooner than hitherto supposed, perhaps for a while in the mid-870s, perhaps again from the early 880s, and so not merely from his 'restoration' of the city in 886.

Yet it is all too easy in this way to compartmentalise the king: to regard him as part warrior, part scholar, part statesman, and so on, as if these were separate aspects of a multi-faceted personality and not the several dimensions of a unified whole. His distinction comes into better focus when one begins to relate his activities to each other, and to try to understand him on his own terms. Throughout the 870s Alfred was preoccupied with his struggle for survival against the Viking invaders, and it is no surprise to find that at this stage he had to bargain desperately for peace. But in 878, after he had been forced to take refuge at Athelney in the marshes of Somerset, he defeated Guthrum's army at the battle of Edington, inaugurating a period of freedom from external attack which he used to good advantage. It was in the early 880s that he initiated his programme for the revival of religion and learning, not least because he believed that it would help gain God's support in the struggle against the Vikings, and help protect the English against the threat of invasion in years to come. For like Alcuin before him (and others after), Alfred naturally subscribed to the view that Viking invasions were divine punishment for the sins of the people; but whereas Alcuin had blamed the 'luxurious habits of the princes and people', Alfred fastened on the decline of learning as the chief cause of God's displeasure. Thus, in the preface to his translation of Pope Gregory's *Pastoral Care* (235), he contrasted the 'happy times' of the distant past, when kings 'succeeded both in warfare and in wisdom', with the conditions which prevailed at the time of his accession: 'Learning had declined so thoroughly in England that there were very few men on this side of the Humber who could understand their divine services in English, or even translate a single letter from Latin into English; and I suppose that there were not many beyond the Humber either. There were so few of them that I cannot recollect even a single one south of the Thames when I succeeded to the kingdom.' Alfred seems to have had in mind a progressive decline in the ability of churchmen to comprehend their Latin service-books, and so to conduct the divine services which were essential to their own good and to that of the people; his answer was to recruit scholars from Mercia, Wales and the continent, and with their help to set about the translation of selected books from Latin into English, for wider circulation. Alfred took further measures intended to improve standards of literacy among his people, especially among those who held high secular office: for by ensuring that they too would be able to devote themselves to the pursuit of divine wisdom, he hoped that they would also be able to discharge their duties in a more enlightened manner.

Alfred's attempt in these ways to bring God's favour upon his people, for the present and for the future, was complemented by other undertakings which we would perceive to be more practical. His continental advisers were on hand to tell him what Frankish kings had done in similar situations, though he would also have had the biblical models of David and Solomon in mind. Most important among his military reforms was the establishment of the network of defensive burhs at strategic sites throughout his kingdom, which proved so effective when put to the test in the 890s; but no less

significant are the indications that he thought hard about the practices of royal government, and brought them on to a new footing. Yet most remarkable of all was Alfred's evident determination to rise above his origins as a king of the West Saxons. Doubtless encouraged by his victory at Edington, Alfred assumed a role as leader of the English against the Danes; and although it must have seemed presumptuous to some, there were many who would have seen him as the only person in any position to provide support, protection and defence. Æthelred, ruler of the Mercians, soon submitted to King Alfred's authority; and in 886, according to the Chronicle, 'all the English people that were not under subjection to the Danes submitted to him'. The general submission of 886 was arguably the pivotal event of the whole reign. It marked the realisation of Alfred's earlier aspirations, and gave him the mandate, as it were, for his later pretensions; and since many already acknowledged Alfred as their lord, it may have involved the swearing of an oath intended to bind the king and his people more closely together. Of course he always remained the king of the West Saxons; but henceforth he was sometimes represented in his charters as 'king of the Anglo-Saxons', and he could presume to cast himself in his law-code as the natural heir of West Saxon, Kentish and Mercian traditions of legislation. In much the same way, the West Saxon compilers of the Anglo-Saxon Chronicle rose above their own horizons and produced a work which casts Alfred, implicitly, as the guardian of a wider historical tradition. Nor was the point lost on Asser, who maintains a distinction between Alfred's predecessors, styled kings 'of the West Saxons', and Alfred himself, styled king 'of the Anglo-Saxons'; it was otherwise with an eye to his Welsh audience that he took the process one stage further, dedicating the work 'to my esteemed and most devout lord, Alfred, ruler of all the Christians of the island of Britain'. These were heady notions indeed, and somewhat premature; but one has to acknowledge the foresight of those who saw the way out of their troubles in such terms.

Against this background, the surviving monuments of Alfred's reign are seen to represent the essence of his achievement. Unlike the 'renaissance' of ecclesiastical culture in the later seventh and early eighth century, the 'Alfredian renaissance' of the late ninth century did not emerge naturally from the environment of prospering monastic centres; rather, it was the product of a specific initiative from the king's court, and found its most distinctive expression not in Latin learning, but in books written (as Alfred put it) 'in the language that we can all understand'. So while the Hatton manuscript of the Old English *Pastoral Care* pales beside the decorated gospel books of an earlier age, one could not wish for a better demonstration of the Alfredian brand of Christian kingship, or of the faith which he placed in the power of the written word. And if metalwork is thin on the ground, the objects which do survive are far from disappointing. The decoration on the Abingdon sword seems designed to capture the 'Onward Christian Soldiers' mentality which pervades the reign; and the inventive imagery of the Fuller Brooch (257) evokes the new intellectual curiosity of the age. Most potent of all, however, is the Alfred Jewel (260), whatever its

function may have been. It was found in Somerset, only a few miles from the scene of Alfred's troubles in 878; but if a more appropriate symbol of Alfred's refuge at Athelney would have been a smouldering cake, the Jewel, made on the king's orders with the highest degree of skill, is the perfect sign of what was to come.

SIMON KEYNES

Manuscripts

In order to assist him in his programme of religious and educational renewal, Alfred gathered together a team of scholars. A number of these were Mercians: Werferth, bishop of Worcester (*c*.872–*c*.915), who acted as the King's tutor and translated Gregory the Great's *Dialogues*; Plegmund, a Mercian hermit who became archbishop of Canterbury under Alfred (890–923) and who was one of the scholars who taught him how to translate; and the priests Athelstan and Werwulf. Their prominent role somewhat belies Alfred's polemic, preserved in the preface to his translation of the *Pastoral Care*, in which he laments the demise of learning in England (**235**). External resources were also utilised: a Welshman, Asser, was summoned from his duties as ?bishop of St Davids to assist in the process of regeneration, and Carolingian influence was once more felt (as indeed it had been during the first half of the ninth century) through the scholarship of Grimbald of St Bertin and John the Old Saxon.

An obvious debt to earlier Insular manuscripts, and especially to ninth-century Southumbrian books, may be observed in the script, decoration and codicology, as well as in the texts, of books produced under Alfred and his immediate successors. Several earlier Southumbrian books may have been preserved at the 'safe-house' of Worcester, in unoccupied Mercia (see **162–3**, **166**), which probably continued to produce books itself (**237**). Others (such as the Book of Nunnaminster, **164**) were perhaps 'evacuated' to Wessex where they served to stimulate later production. The book of poetry with its alluring initial which first inspired the boy Alfred with his love of learning was perhaps such a book (see **234**). The pointed cursive minuscule of earlier non-liturgical manuscripts continued to be used and decorated initials still played host to a hoard of eager and voracious birds and beasts. Now, however, these creatures battened upon an exotic acanthus-like foliage, imported via the Carolingian world. Works in other media also exhibit these trends.

Elsewhere there is evidence in support of Alfred's lament. Charters produced at Christ Church, Canterbury (which had suffered Viking attack) during the later ninth century exhibit a very poor standard of Latinity and script (see **236**), although it should be noted that the work of one extremely aged scribe should not necessarily be seen as representative of standards throughout Southumbria. It is also worth noting that the decline in standards at Canterbury is most marked under Archbishop Æthelred (870–88), who found himself at odds with Alfred, leading to the latter's condemnation by Pope John VIII as an enemy of the Church.

None the less, there had undoubtedly been severe disruption during the Viking raids and settlement, and Alfred and his circle faced a daunting task. The programme for the revival of book-learning (and thereby spiritual renewal) included a policy of translation into Old English of works which were of particular relevance to the current situation (including the *Pastoral Care*, dealing with the responsibilities of government, and Orosius's *Histories Against the Pagans*, with its account of a beleaguered Christian society, **235**, **238**). A growth in the use of the written vernacular may perhaps be observed earlier in the ninth century, with the first English translation of the Psalms (in the form of a gloss to the Vespasian Psalter, **153**), but Alfred's programme, in which he himself participated as a translator, marks (along with that in Ireland) the earliest promotion of a written vernacular language in the medieval West.

Other of the works produced in 'English' England under Alfred, such as the Anglo-Saxon Chronicle and Asser's Life of Alfred (**233**, **234**), also served to promote royal aims and, even if not produced as 'official' propaganda, could certainly act as such. Asser's work may have enjoyed only limited circulation, never reaching its intended Welsh audience, but other works were apparently distributed under royal sponsorship, the *Pastoral Care* being accompanied by a covering letter or preface exhorting participation in the work of renewal along with a valuable 'sweetener' (see **235**). This process of 'publication' finds an appropriate model in the context of the Carolingian renaissance under Charlemagne.

The renewal under Alfred marks a turning-point in the history of literacy in England, but in recognising a debt to the Insular past it assisted in the perpetuation and transmission of elements of early Anglo-Saxon learning and book production, enabling them to enrich the later medieval world.

MICHELLE P. BROWN

232 Charter of King Æthelwulf of Wessex

British Library, Stowe Charter 17
Vellum; 320 × 390 mm
Latin; 843
Canterbury

This is the earliest surviving charter of a king of Wessex generally accepted as an original. (A charter recording a grant by King Cynewulf in 778 (Sawyer 1968, no. 264) may possibly be original, but it is in such poor condition that its date cannot be firmly established.) This charter records a grant on 28 May 843 by King Æthelwulf to his thegn Æthelmod of land at Little Chart in Kent together with various pieces of woodland and swine pasture. Kent was one of the areas seized from Mercia by Wessex after the victory of Æthelwulf's father, Ecgberht, at the Battle of Ellendun in 825. Æthelmod, the beneficiary of this grant, was ealdorman of Kent from 853 until his death in 859. The witnesses to the charter include the archbishop and community of Christ Church, Canterbury, who probably had an interest in the reversion of the land.

232 Charter of King Æthelwulf of Wessex; 843

The charter describes the boundaries of the estate granted to Æthelmod in great detail. From the beginning of the ninth century, the boundary clauses of charters became increasingly elaborate, providing an enormous amount of information about the topography of Anglo-Saxon England. An important feature of the Kentish landscape at this time was the forest 'den'. The dens were areas of woodland in the Weald attached to estates in the uplands. This charter names eight dens attached to Little Chart, which were scattered through the woodland to the south-west of Chart in such places as Smarden, Biddenden and Cranbrook. The scribe made a number of errors in writing this section of the charter. He scratched out the mistakes and inserted corrections between lines and in the margins.

According to a letter of Lupus of Ferrières, Æthelwulf had a Frankish secretary called Felix who wrote his letters.

Because there are some unusual spellings of place and personal names in this charter, it has been suggested that it was drafted and written by Felix. It seems more likely that it was compiled by a Canterbury scribe. The scribe's hand has been identified in another Canterbury document and some of the phraseology is taken from an earlier Canterbury charter.

A small piece of parchment is attached to the charter, on which the names of the witnesses are listed in two columns in two other Canterbury hands. This is apparently a note made at the time of the grant to assist the scribe who drew up the main charter. The preparation of such aides-mémoire was doubtless a common practice, but few have survived.

AP

Bibliography: Ward 1945, 1–7; Sawyer 1968, no. 293; Brooks 1984, 147–8, 170 n. 76.

233 Account of the years 862–74 from the Anglo-Saxon Chronicle (ff. 13b–14)

233 The Anglo-Saxon Chronicle

Cambridge Corpus Christi College, MS 173
Vellum; ff. 83; c.287 × 206 mm
Old English (and Latin); late 9th – early 10th century, with continuations to 1070 (bound with materials from 8th to 12th century)
Winchester (and continued at Christ Church, Canterbury in the late 11th century)

The Chronicle (a series of annals, or yearly entries of events) is the central historical text for our knowledge of Anglo-Saxon secular history. It is an extremely complex work, with complicated textual history, which now survives in seven varying copies, of which the present manuscript ('A', or the Parker Chronicle, occupying ff. 1v–32v of a composite volume also containing the Laws of Ine and Alfred and Sedulius's *Carmen paschale*, which was bequeathed to Corpus by Archbishop Matthew Parker in 1575) is the earliest. Parts of the Chronicle are also embedded in other Latin works, such as Asser's Life of Alfred (**234**). The copies share essentially the same material to 890 or 892, indicating that the Chronicle was probably 'published' around this time, although the original core is difficult to ascertain. The copies were continued, at various places, with the Peterborough version extending to 1154.

Linguistic studies suggest that initial compilation was the work of a team of annalists, working perhaps from the late 880s, editing and adding to a range of earlier materials. They present an essentially West Saxon view, although the intent was apparently to provide a history of the English people as a whole, consistent with the new climate of unity. Alfred's personal involvement in the project is unproven, and suggested patrons have included an unspecified West Saxon ealdorman, but the likelihood is that such a high-powered research team would have been attached to the court. Frankish historiographical influence has also been perceived and tentatively attributed to Alfred's scholarly helpers such as Grimbald of St Bertin (however, attempts to extend this influence to the idea of a Winchester scriptorium, established along Carolingian lines, are problematic and fail to acknowledge fully the debt to earlier ninth-century English influence). Although the compilation of the Chronicle was not, perhaps, an 'official' initiative, it was well-suited to royal purposes at the time of 'publication', following the return of the Viking army in 892. Its potential as propaganda was

258

234 Sixteenth-century transcript of Asser's Life of Alfred (ff. 7b–8)

apparently recognised at subsequent points in its history, for example when playing down (in all save one copy) the Mercian role in reconquering the Danelaw, and at the Norman Conquest.

The exhibited opening covers the years 862–74 and includes references to the early desperate struggles against the Danes, to the beginning of Alfred's reign (871, marked with an enlarged initial on f. 14) and to the Viking army over-wintering at Repton (Hreopedune, 874/5), as graphically illustrated by recent excavations there (see **212**). MPB

Bibliography: Flower and Smith 1941, reptd 1973; Garmonsway 1953; Ker 1957, nos 39–40; Davis 1971, 169–82; Parkes 1976; Whitelock 1979, no. 1; Keynes and Lapidge 1983; Dumville and Keynes 1983–6.

234 Asser's Life of King Alfred

British Library, Cotton MS Otho A. xii*
Paper; ff. i + 36; 228 × 170 mm
Latin; late 16th century (transcript of a copy dating to c.1000 of Asser's composition of 893)
Southern England (?Cambridge or London; originally composed at Winchester)

The only copy of Asser's biography of Alfred to survive the Middle Ages was Cotton MS Otho A.xii, which sadly perished in the Ashburnham House fire of 1731. The evidence provided by those who had seen the manuscript prior to its destruction and by a facsimile of its opening printed in Francis Wise's edition of the Life of 1722 (photograph exhibited here) has led to the conclusion that it was copied in an unidentified centre, c.1000. It passed through the hands of several notable scholars, such as Leland and Parker, and formed the basis of the first printed edition (by the latter) of 1574. It may also have been owned by William Bowyer, along with the Lindisfarne Gospels (**80**), during the late sixteenth century. Transcripts were also made, of which the exhibited copy is an example, and sections of the text were

234 Facsimile of the lost manuscript copy of Asser's Life of Alfred

attracted by the decorated initial, naturally triumphing). The scene is thereby set for the predominant trends of the reign.

MPB

Bibliography: Stevenson 1904; Wright 1951, 213; Galbraith 1964, 88–128; Whitelock 1967; 1979, no. 7; Keynes and Lapidge 1983.

235 The *Pastoral Care*

Oxford, Bodleian Library, Hatton MS 20
Vellum; ff. 98; 270 × 220 mm
Old English; c.890–7
?Winchester

This is the only English translation produced by Alfred and his circle which has survived in a contemporary copy (another early Cottonian copy having been burnt). The *Regula pastoralis*, composed by Pope Gregory the Great (590–604), was probably the first translation which Alfred undertook himself, perhaps as early as c.890. Gregory had been responsible for Augustine's mission to convert England, probably increasing his appeal as an author, but the choice of subject lies in the nature of the text which concerns the spiritual and intellectual abilities required in order to govern. This was appropriate in a climate of ecclesiastical renewal, but the application to secular government is also apparent.

embedded in other medieval works (for example, by Florence of Worcester). Attempts to assign the work to later 'forgers', notably the mid eleventh-century Bishop Leofric, have been discredited (the earlier date of the copy illustrated by Wise assisting in this), and the 'genuine Asser' is now accepted.

The Welshman Asser (named after the eighth son of Jacob), who died in 908 or 909, may already have been bishop of St Davids, Dyfed, when he was summoned by Alfred to assist in his programme of renewal (probably in 885). Welsh involvement may have been fostered by the prior submission of several southern Welsh kings to Alfred. Thenceforth, Asser divided his time between Wales and Wessex, becoming bishop of Sherborne (between 892 and 900). His contact with continental scholars at court probably led to his knowledge of Frankish affairs and of the Frankish biographical genre (notably Einhard's Life of Charlemagne). Inspired by this, and by the Anglo-Saxon Chronicle (233), he began his biography of Alfred in 893, supplementing the Chronicle with court reminiscences for the early years; for the later years Asser drew upon his personal knowledge of his pupil-king. The work was apparently addressed primarily to a Welsh audience, although its circulation seems to have been confined to England, as it was never formally distributed.

The exhibited opening contains references to the advent of the great Viking army of 865 and to Alfred's childhood passion for learning (illustrated by an accident in which his mother offered a book of English poetry to whichever of her offspring could learn it – Alfred, inspired by God and

235 Conclusion of Alfred's preface to his translation of the *Pastoral Care* (f. 2b)

236 Charter of Christ Church, Canterbury; 873

In an important preface to the work, Alfred explains his programme of translation and the way in which the texts were to be circulated (perhaps following a Carolingian royal policy of official 'publication'). Copies were circulated to notable bishops, the present copy being addressed to Werferth, bishop of Worceser (*c*.872–*c*.915), Alfred's tutor. The copies were accompanied (perhaps as an added incentive to participation in Alfred's programme) by an *æstel* worth 50 mancuses, to be kept with the book. Comparison with the Latin *hasta* (spear), and glosses, have led to the suggestion that the *æstels* were book-pointers and that the Alfred Jewel (**260**) may have been such an item.

The Vikings had undoubtedly severely disrupted the religious and intellectual life of England, but Alfred may well have engaged in a little polemic in support of his efforts towards renewal, perhaps painting an over-simplified picture of decay. His assertion that learning had declined so thoroughly that there was scarce a man south of the Humber, and not many north of it (and no one south of the Thames), capable of understanding the divine office, or of translating anything from Latin, is partially offset by apparent influence from earlier ninth-century Southumbria and the major participation of scholars from Mercia within the renewal programme.

The exhibited opening shows the end of the preface and includes the *æstel* reference. MPB

Bibliography: Sweet 1871–2; Ker 1956; 1957, no. 324; Temple 1976, no. 1; Whitelock 1979, no. 226; Brooks 1979, 1–20; Keynes and Lapidge 1983, 124–30; Gneuss 1986, 29–49; Morrish 1986, 87–107.

236 Charter of Christ Church, Canterbury

British Library, Stowe Charter 19
Vellum; 190 × 470 mm
Latin; 873
Canterbury

This charter has been cited as an illustration of the decline in literacy south of the Humber in the early years of Alfred's reign. It was written at Canterbury in 873 and records a grant in that year by Archbishop Æthelred and the community of Christ Church, Canterbury, to one Liaba, son of Birgine, of Iledon in Kent. It provides a sad contrast to the skilful penmanship and sound Latin of charters produced at Canterbury in the earlier part of the ninth century.

The scribe formed his letters with great difficulty. Some words run into one another without a space; others are arbitrarily broken into two or three parts. The scribe also found it difficult to write in a straight line. His grammar is often wayward, his spelling odd and his use of abbreviations idiosyncratic.

The scribe used as a model for this charter the original grant of the land at Iledon to Christ Church, made by King Æthelwulf some twenty or thirty years previously. He made a poor job of adapting Æthelwulf's charter. For example, he retained the initial declaration that the king was acting with the consent of his council, substituting Alfred's name for Æthelwulf's. Since the 873 grant was made by the archbishop and not the king, the inclusion of this clause was unnecessary and wrongly gives the impression that Alfred was involved with the issue of the charter. The scribe's most serious mistake occurs in the list of witnesses at the end. He copied out the witness list of Æthelwulf's charter, forgetting that the witnesses to the 873 grant were completely different. To make matters worse, he gives the wrong list of witnesses twice.

Canterbury suffered a devastating Viking attack in 851. Christ Church was presumably one of the main Viking targets and many of the community's best scribes were probably killed. In order to get its clerical work done, Christ Church was forced to use less competent scribes such as the man who wrote the present charter. His first recorded work for Christ Church is dated 855 and shortly afterwards he emerged as the principal scribe there. This is the last charter he is known to have written. It has been plausibly suggested that by the time he wrote this charter he had difficulty in seeing what he had written.

The historical interest of this charter has been eloquently summarised by Nicholas Brooks: 'The fact that in 873 the metropolitan church of Canterbury had to rely on a man whose sight was apparently failing, so that he could no longer see what he had written, is a vivid testimony to the decline in the quality of instruction there and to the crisis of literacy. We may well believe that at Canterbury there was no one who could properly understand a Latin letter or even the daily worship at the beginning of Alfred's reign' (Brooks 1979, 16). It would be dangerous, however, to assume from the work of a single scribe at Canterbury that literacy was on the verge of extinction throughout Southumbria. Other evidence suggests that elsewhere learning had not declined as much as at Canterbury. AP

Bibliography: Sawyer 1968, no. 344; Brooks 1979, 15–16; 171–3.

237 Aldhelm, *In Praise of Virginity* (*De virginitate*)

British Library, Royal MS 5 F.iii
Vellum; ff. 40; 235 × 163 mm
Latin with Old English glosses; *c*.900
Mercia (?Worceser)

The script and decoration of this copy of Aldhelm's 'best-seller' (59) are directly descended from styles popular in Mercia during the first half of the ninth century (see 163–6, 168, 170–1). A concession to up-to-date Carolingian influence occurs in the frilly foliate motifs, perhaps derived from the schools of Tours or Metz, incorporated into the beast-headed initials. Although the manuscript is now sadly despoiled, its margins no doubt having been raided by successive generations for their blank scraps of parchment, it was proficiently produced and argues in favour of a measure of continuity in Mercian manuscript production which is somewhat at odds with the bleak picture painted in Alfred's preface to the *Pastoral Care* (235).

The majority of named scholars assisting Alfred in his programme of reform were Mercian, notably Bishop Werferth of Worcester (*c*.872–*c*.915). Worcester lay in unoccupied Mercia and its scriptorium may well have continued to function throughout the ninth century, with manuscripts from other Mercian centres perhaps finding their way there.

The style of the manuscript points to a western Mercian origin. It was apparently at Worcester during the Middle Ages and is probably no. 253 in Patrick Young's Worcester

catalogue of 1622. It later belonged to John Theyer (d. 1673) whose library was purchased by Charles II in 1678. MPB

Bibliography: Atkins and Ker 1944, no. 253; Ker 1957, no. 253; Temple 1976, no. 2; Keynes and Lapidge 1983; Morrish 1986, 87–107.

238 The Old English Translation of Orosius

British Library, Additional MS 47967
Vellum; ff. iii + 88; 280 × 190 mm
Old English; second quarter of 10th century (with additions second half of 10th century)
?Winchester

Alfred's interest in learning and his promotion of the vernacular led him to initiate several translations, personally or under his direction. He is traditionally, but probably mistakenly, attributed with the authorship of the Old English translation of Orosius's *Universal Histories Against the Pagans*, of which this is the earliest copy.

Born in Spain, within the decaying Roman Empire, Orosius began his history in 417 at the behest of St Augustine of Hippo. It was the first world history written from a

237 A late ninth-century Mercian copy of Aldhelm's *De virginitate* (f. 2b)

238 Opening of the Old English translation of Orosius (f. 5b)

Christian viewpoint and this, along with the backdrop of pagan onslaught against which it was composed, did much to recommend it to Alfred and his circle.

The translator displays a particular interest in geography, introducing much additional material drawn from a number of other early sources, perhaps compiled with the aid of a *mappa mundi* (world map), and from a good knowledge of contemporary Europe. This includes an account of his voyage by the Norseman Ohthere delivered to King Alfred, his lord.

The style of the script and decoration suggest a Winchester origin for this copy, the former resembling the hand responsible for the entries for 892–924 in the Parker Chronicle (233). The initials fall into Wormald's early 'Mixed Initials Type I' and feature beasts and interlace drawn from earlier Southumbrian decoration, along with foliage of Carolingian inspiration. The manuscript eventually belonged to the Tollemache family of Helmingham Hall and is sometimes known as the Helmingham or Tollemache Orosius. It was deposited at the British Museum by their trustees in 1948 and was incorporated in 1953. MPB

Bibliography: Pauli 1853, 238–528; Campbell 1953; Ker 1957, no. 133; Bately 1970, 433–60; Temple 1976, no. 8; Bately 1981; Wormald 1984, 47–75.

239 Will of Ealdorman Ælfred

British Library, Stowe Charter 20
Vellum; 165 × 270 mm
Latin; between 871 and 888
Kent or Surrey

Wills are among the most interesting Anglo-Saxon legal documents. They provide a great deal of information about land tenure and inheritance customs and also give an insight into levels of personal wealth. Many wills are written in the vernacular and they form an important part of the surviving corpus of Old English prose.

The practice of recording wills in writing apparently began in Kent in the early ninth century. The will of Ealdorman Ælfred, drawn up between 871 and 888, is one of the earliest and best known surviving wills. Ælfred was probably ealdorman of Surrey. He and his wife Werburh were benefactors of Christ Church, Canterbury. They purchased the Codex Aureus (154) from the Viking army which had plundered it and presented the manuscript to Christ Church.

Like charters, wills were records of grants made before witnesses. It was the oral grant and the symbolic acts accompanying it which were important; the recording of the grant in writing was merely an extra precaution to ensure that the testator's instructions were not forgotten. Ealdorman Ælfred's will was declared before an illustrious company including King Alfred and his council. Other wills were made before a variety of witnesses, ranging from Church synods to groups of friends. There are a number of examples of deathbed wills, but Ælfred was apparently in good health when he made his will, since he refers to the possibility that he and his wife might have another child.

239 Will of Ealdorman Ælfred; between 871 and 888

Ælfred granted to his wife Werburh and their daughter Ealhthryth the bulk of his estate in Surrey and Kent and gave instructions for the descent of his properties after their deaths. It seems that he had agreed with Werburh that she should not remarry after his death but go to Rome, taking with her his two *wergilds*. This is an important detail, since it indicates that two sums of money were payable to an ealdorman's family if he were killed, one for the man and the other for his office.

Alfred also left land to his son Æthelwold, but the preference given to Ælfred's daughter in the will and the statement by Ælfred that he hoped to beget a nearer heir suggest that Æthelwold may have been illegitimate. This section of the will contains one of the four surviving references to the customs regulating folkland, the family patrimony held without charter. It states that the king's permission was necessary for the transfer of this land to Æthelwold, but it is likely that this was not a normal requirement and that special permission was needed because Æthelwold was illegitimate.

Other individual properties were given to various kinsmen of Ælfred, with instructions that they make gifts from these estates to Christ Church, Canterbury, Chertsey Abbey and other religious foundations in Surrey and Kent, a reminder

that the making of wills was encouraged by the Church to ensure that the faithful made proper provision for the welfare of their souls (and, incidentally, the enrichment of the Church). AP

Bibliography: Sawyer 1968, no. 1508; Whitelock 1967, 202–4; 1979, no. 97; Brooks 1984, 151–2.

240 Alfred's Will, from the New Minster Liber Vitae

British Library, Stowe MS 944
Vellum; ff. 69; 255 × 150 mm
(Latin and) Old English; *c.*1031 (composed between 872 and 899)
Winchester, New Minster

Alfred's is the earlier of only two surviving English royal wills (the other being that of Eadred, 946–55). It was copied (ff. 29v–33) into the New Minster Liber Vitae (or Benefactors' Book) during the reign of Cnut (1016–34), perhaps owing to its connection with the community's founder, Alfred's son Edward the Elder, or to its subsequent interest in the property concerned.

Bequests to Bishop Werferth and Archbishop Æthelred

240 King Alfred's will (ff. 30b–31)

date the will between 872 and 888, with a date in the 880s being likely. There are traces, however, of an earlier version in the first part of the document, and the rest of it may have been revised closer to Alfred's death in 899. The bequests represented Alfred's private property, rather than that attached to the office, the legitimacy of his right to this being established at the outset. A clear strategy may be discerned behind the allocations, with property throughout and in the heart of the kingdom passing to his wife and five offspring, with that of Edward, his elder son, being most strategically placed. Other kinsmen received gifts in less important eastern areas, probably contributing to the ill-feeling which later led his nephew, Æthelwold, to rebel against Edward the Elder. There are also signs that the complex arrangements between Alfred and his brother, Æthelred, designed to ensure that the bulk of their joint property should devolve upon whichever survived in the short term, before eventually benefiting their respective children, had been contested by Æthelred's offspring.

Gifts of money, of a sword, and of alms are also recorded. Although Alfred's female relatives receive generous bequests, they are less than those of their male counterparts (his sons receiving five hundred pounds each, whilst his wife and daughters received one hundred each), and he ensured that his 'bookland' should remain within the kindred, stating that 'My grandfather had bequeathed his land on the spear side and not on the spindle side'.

Written at the New Minster by Ælsinus, the Liber Vitae eventually belonged, in 1770, to the manuscript scholar and facsimilist Thomas Astle (see 83c), passing to Stowe in 1804.

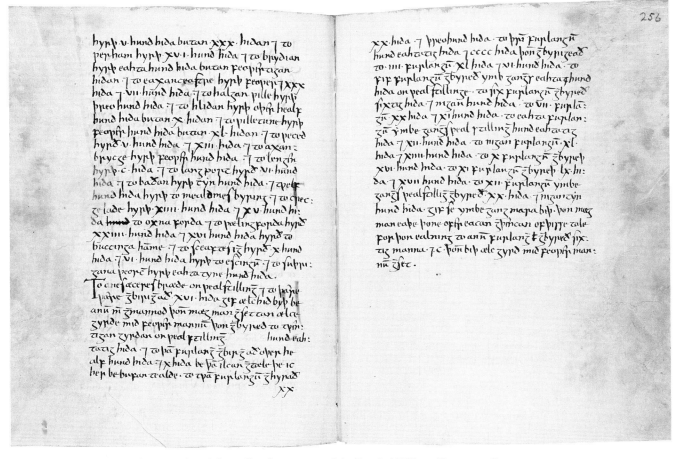

241 Laurence Nowell's 1562 transcript of the earliest known text of the Burghal Hidage (ff. 255v–256)

It was acquired by the British Museum from Lord Ashburnham in 1883. MPB

Bibliography: Sanders 1878–84, III no. 22; Birch 1892; Harmer 1914, no. 11; Sawyer 1968, no. 1507; Whitelock 1979, no. 96; Keynes and Lapidge 1983, 173–8.

241 The Burghal Hidage

British Library, Additional MS 43703
Paper; ff. 268; 260 × 152 mm
Old English; 1562

The Vikings were devastating hit-and-run raiders, but they were less effective in conducting long sieges. Recognising this, Alfred constructed during the 880s a network of *burhs* or fortresses covering his kingdom, designed to stifle any further Viking incursions and to provide refuges for local people when Viking raiders were in the area. By the end of Alfred's reign, most inhabitants of Wessex were within a day's march (about twenty miles) of the safety of a *burh* and all the main lines of communication were guarded by fortresses. The burghal network was gradually extended by Alfred's successors as they built new *burhs* to help recolonise territories captured from the Danes. The *burhs* illustrate Alfred's ability to initiate and bring to fruition schemes of an almost visionary nature.

The Burghal Hidage is the single most important surviving record of this extraordinary achievement. It lists the names of the *burhs* and the number of hides (a unit used for tax assessment) required to defend them. The version of the text shown here names thirty *burhs* (one Alfredian *burh*, Shaftesbury, is omitted from this text, probably through scribal error). The list is arranged in the form of a clockwise circuit of Wessex, starting at *Eorpeburnan* (perhaps Castle Toll at Newenden on the Kent–Sussex border) and ending opposite London at Southwark. Kent and London were omitted from the Hidage, probably because different methods of assessment were used to man the walls there. Cornwall, still an independent kingdom at this time, also does not appear.

Great ingenuity was shown in constructing the burghal network. Old Iron Age and Roman strongholds such as Chisbury and Portchester were repaired and put back into commission, and walled Roman towns such as Bath and

Exeter were incorporated into the system. Completely new forts were also built. Some were just small stockades; others, such as Lewes, Malmesbury and Wallingford, were designed not only to serve as strongholds but also to house fully-fledged towns with an active trading community. Although other rulers elsewhere built defensive networks of this kind, the deliberate creation of urban communities was completely novel and provides striking evidence of Alfred's determination not simply to deal with immediate problems but also to lay the foundations for the return of a more prosperous and sophisticated society.

The earliest known text of the Burghal Hidage was in BL, Cotton MS Otho B. xi, a Wincheser manuscript of the mid tenth and early eleventh centuries. This manuscript was, however, badly damaged in the fire which ravaged the Cotton Library in 1731, and the folios containing the Burghal Hidage were destroyed. Fortunately the Elizabethan antiquary Laurence Nowell made a copy of this version of the Hidage in 1562, and his transcript is shown here.

This version is less corrupt than the other surviving texts of the Hidage. It is the only one which includes an appendix describing how the assessments recorded in the text were calculated. This note explains that four men were required to defend each pole (five and a half yards) of wall. Local landowners were required to send one man for each hide of land they possessed. A hide was originally the amount of land required to support one household. In the later Anglo-Saxon period, it was reckoned in many areas to be the equivalent of 120 acres, but larger and smaller hides are often found, depending on such factors as the fertility of the land. The Hidage records the number of hides required to man the walls of each fort. The walls of Winchester, for example, required 2400 hides to defend them, while the small fort at Lydford in Somerset had just 140 hides allocated to it. The accuracy of the figures in the Burghal Hidage has been borne out by recent archaeological investigations.

The exact date of the Burghal Hidage is a matter of dispute. The inclusion of Oxford and Buckingham suggests that it was compiled shortly after these towns were taken by Edward the Elder in 911. On the other hand, it is possible that these towns were at some point under Alfred's control. If so, the Burghal Hidage might date from Alfred's reign. On balance, it seems most likely that it was an Alfredian administrative document which was revised and amplified during the reign of Edward the Elder. AP

Bibliography: Robertson 1956, 246–9, 494–6; Brooks 1964, 74–90; Hill 1969, 84–92; Grant 1974, 111–24; Biddle 1976, 124–37; Warnicke 1979, 201–2; Davis 1982, 803–10; Keynes and Lapidge 1983, 193–4, 339–41.

242 Alfred and Guthrum's Treaty

Cambridge, Corpus Christi College, MS 383
Vellum; ff. xii + 21 + vii + 32 + v; 187 × 115mm
(Latin and) Old English; late 11th–early 12th century (treaty drawn up between 886 and 890)
London (?St Paul's)

This important treaty (preserved in two versions on pages 6 and 83–4 in a post-Conquest collection of Anglo-Saxon legal texts) defines the boundary between 'English' England and the Danelaw and regulates relations between indigenous inhabitants and Viking settlers. It must have been drawn up before the death of the leader of the Vikings in East Anglia, Guthrum, in 890 and after Alfred's seizure of London in 886, as the city remained in English possession.

The boundary is stated as following the Thames and then the Lea, to its source, thence in a straight line to Bedford and up the Ouse to Watling Street (the modern A5). Wessex

242 Alfred and Guthrum's Treaty (p. 8)

and English Mercia are thereby preserved, and this may represent a modification of the boundary established when the Danes divided Mercia with their puppet-king, Ceolwulf, in 877. The boundary may not have followed the lines agreed here for very long, however.

Provision is made to ensure the continued function of the law, with equal *wergild* (compensation) values for the English and their Scandinavian equivalents on the social scale. Men of high standing are valued equally at 8 half-marks of gold (32 ounces, approx. 1280 shillings). Trade contacts are envisaged, but there is to be no inter-settling.

The statement in the prologue that Alfred was acting along with the councillors of 'all the English race' reflects, as do his charters, the spirit of unity, of English against Dane, which had prevailed since the recapture of London. The acknowledgement of the status quo, and the response to it embodied in the treaty, enabled consolidation which eventually discouraged the Viking army, returning from the continent in 892, from further expansion. The scene was also set for the process of gradual reconquest on the part of the English. MPB

Bibliography: Attenborough 1922, 98–101; Ker 1957, no. 65; Whitelock 1979, no. 34; Davis 1982, 803–10; Keynes and Lapidge 1983, 171–2.

Metalwork, wood and bone

The first Viking raids on the north-east and south coasts of England at the end of the eighth century were devastating – though probably more for their intellectual impact than for the physical disruption they caused. But the intensification of Viking attacks from the 830s had profound effects on society. It is from these years that the first major hoards were to appear (e.g. **187**), and as the Viking army moved inland, gaining strength and momentum, these increased in number, clustering especially in the late 860s and early 870s, and encompassing England from Northumbria to Cornwall. Some, like the Talnotrie and Lilla Howe hoards, may have been Viking loot (**248–9**); others, such as those from Beeston Tor and perhaps Trewhiddle itself, look more like Anglo-Saxon concealments (**245–6**). Another graphic witness to these turbulent years is the survival of an unusually large number of swords, datable by their developed Trewhiddle-style decoration to the middle and later years of the ninth century, compared for example to those few that are datable to the eighth and early ninth century. These include what seems to be a distinctive northern group with repetitive geometric decoration (e.g. **250–1**) which, like the northern-type rings (**203–4**) and strap-ends (see p. 233), is another indication of variations and regional production within the overall Trewhiddle style and which finds confirmation in the presence of motif-pieces in the style from York (**254–5**).

At the other end of the country, the now dominant Wessex royal house thought it entirely appropriate to decorate rings given as marks of favour and authority in the same general style (**243–4**). Indeed, the rings in the name of Alfred's father

Æthelwulf and his sister Æthelswith provide an illustration of how kings now sought to express their authority (suitably supported by divine images) through such symbolic gifts. This was a measure Alfred himself used extremely effectively, as the Alfred Jewel most conspicuously demonstrates (**260**). This, and some of the other prestigious metalwork which survives from Alfred's reign, reflects an enlarged concern with symbolic meaning entirely consistent with the practical and pious intellectual temper of the man and of those scholars he gathered at his court. The interest in intellectual themes reflected in the decoration of, for example, the Fuller Brooch (**257**) and Abingdon sword is to be seen perhaps as another by-product of Alfred's programme for the renewal of learning and piety in England. The Fuller Brooch's celebration of the Five Senses and the Christian warrior evoked by the Abingdon sword both in their different ways address the God-given, God-directed nature of man's physical being. Perhaps the Minster Lovell Jewel and Bowleaze fitting are also to be seen in the context of the Alfredian religious revival, although their precise function remains open to debate (**259, 258**).

Other metalwork from Alfred's reign indirectly recalls aspects of his military and administrative activities: the late ninth-century harness fittings from the City of London are associated with the reoccupation of the walled city following Alfred's recapture of the city from the Vikings in 886 (**252**), while the stray find of a ninth-century Carolingian silver mount from just outside the walls of the West Saxon *burh* at Wareham recalls both the continental contacts fostered at his court and Alfred's development of the defensive burghal system, itself influenced by Carolingian example (**256**).

The surviving fine metalwork of Alfred's hazardous and eventful reign is perhaps not surprisingly slight in quantity in comparison with that from his father's day; but we may glimpse in its finest pieces something of the new purpose and power for which Alfred himself is justly remembered.

LESLIE WEBSTER

243 Finger-ring

Laverstock, Wilts.
Gold, niello; MAX. D. 2.8 cm
Anglo-Saxon; 828–58
British Museum, M&LA 1829, 11–14, 1

The ring consists of a broad band at the back, rising from each side to a central point, forming a sub-triangular bezel. An inscription in capitals in a rectangular panel at the base of this may be read as 'Ethelwulf Rex'. In the field above it are two stylised Trewhiddle-style peacocks flanking a tree-of-life motif: foliate sprigs fill the spaces at either side of this, and at the back of the hoop is a circular panel containing a quatrefoil flanked by geometric and interlocked motifs. The inscription and decoration have speckled detail. The background is inlaid with niello, the lower edge beaded. The whole ring is considerably crushed and distorted.

The condition of the ring no doubt reflects the circumstances of its discovery, in 1780, in a cart-rut. Its inscrip-

tion firmly associates it with Æthelwulf of Wessex and father of Alfred the Great, who appears to have reigned from 839 to 858, and before that was king in Kent from at least 828. The ring, a particularly ambitious piece, was not the king's personal ring, but was presumably given as a gift or as a mark of royal office. Its fine Trewhiddle-style ornament would certainly fit a mid ninth-century date. LW

Select bibliography: Wilson 1964, cat. 31, 22–9; Page 1964, 82; Backhouse, Turner and Webster 1984, cat. 9; Wilson 1984, 96.

244 Finger-ring

Aberford, near Sherburn, West Yorks.
Gold, niello; D. 2.6 cm
Anglo-Saxon; second half of 9th century, probably 853–74
British Museum, M&LA, AF 458

The hoop is of sub-circular cross section, flattened out to semi-circular shoulders flanking a disc-shaped bezel, both with beaded borders and Trewhiddle-style decoration against a nielloed ground. Each shoulder has an animal, while the bezel has a cruciform design of a central disc with haloed *Agnus Dei* flanked by the letters A, Ð, the expanded arms of the cross each with a trefoil sprig, and between them a double leaf. On the back of the bezel is an incised inscription which may be transliterated + EA / ÐELSVIÐ / REGNA, 'Queen Æthelswith'.

The ring was ploughed up between Aberford and Sherburn in 1870. By an extraordinary coincidence it is associated by its inscription to the ring of King Æthelwulf (**243**) who was the father of Queen Æthelswith whose name appears on this ring. The queen of Burgred of Mercia, Æthelswith married him in 853 or 854, probably accompanied him to Rome on his expulsion from the kingdom by the Danes in 874, where he shortly died, and was herself buried in Pavia in 888. It is most likely that this ring dates from her regnal years in Mercia, rather than to those after the expulsion; like the Æthelwulf ring, it signifies a royal gift or symbol of office, not a royal possession. LW

Select bibliography: Wilson 1964, cat. 1, 22–7, and *passim*; Page 1964, 82–3; Backhouse, Turner and Webster 1984, cat. 10; Wilson 1984, 96.

243 244

245 (a–f) Hoard of brooches and other metalwork

Beeston Tor Cave, Staffs.
Silver with niello inlay, gold, copper-alloy; individual dimensions below
Anglo-Saxon; deposited *c*.875
British Museum, M&LA 1925, 1–14, 1–6

245 (a) Silver openwork disc brooch

Trewhiddle-style decoration against a nielloed ground. Within a beaded outer border is a cross with expanded terminals, each containing a peripheral boss around which an animal disports itself: each circular 'armpit' has a beaded border, containing a faceted openwork trefoil on a semi-circular base. At the centre of the cross, within a beaded frame, is an openwork cross with triangular nielloed arms around a central boss. Three of the five bosses secure the pin attachment to the plain base.

D. 4.9 cm

245 (b) Silver sheet disc brooch

Trewhiddle-style decoration against a nielloed ground. Within a beaded outer border, the decoration consists of nine equidistant bosses (one missing) interconnected by a grid of beaded lentoid fields, and joined to the rim by four beaded subtriangular fields. Each panel so created contains plant, geometric or interlaced ornament. Three of the rivets attached an iron pin, now corroded, to the reverse, to which extraneous fragments of gold wire now adhere.

D. 7.3 cm

245 (c) Gold finger-ring

Lozenge-shaped cross-section.

D. 3.0 cm

245 (d) Copper-alloy binding

Bent sheet with beaded border on one face, narrowing towards the rounded terminal which contains a single rivet; two additional rivet holes are positioned at the shoulders.

L. 2.7 cm

245 (e, f) Two copper-alloy wire rings, one broken

Each D. 1.8 cm

The hoard was found in 1924 along with coins (**261a**) which date its deposition to *c*.875 and perhaps associate its concealment with the Viking army's over-wintering at nearby Repton in 873/4. The two medium-sized brooches represent rather different aspects of the Trewhiddle style. (*a*), the smaller, belongs to a tradition of elaborate small openwork brooches and mounts going back to the eighth century (e.g. Bakka 1963, fig. 13); its delicate zoomorphic ornament is very different in quality and conception to the coarser abstract decoration of the larger brooch, (*b*). In several respects these

245a–f

animals, with their beaked heads and distinctive musculature markings, cannot be closely paralleled elsewhere in the Tre-whiddle-style repertoire, though the triple tail feathers of one creature, as Wilson pointed out, resemble those of the bird symbol on the late ninth- or early tenth-century Abingdon sword. The parallel he also drew with faceting on the sword is now less convincing, since that can now be seen to have entered the repertoire earlier in the ninth century, where it can be seen on the first pair of brooches in the Pentney hoard.

Brooch (*b*), with its flat and somewhat perfunctory array of interlaced, geometric and plant motifs, reflects a tendency to more abstract decoration seen on for example the Stock-holm brooch of the tenth century (Backhouse, Turner and Webster 1984, cat. 17), and in the fittings of a number of northern swords (e.g. **251**). It is instructive that this hoard, buried close in time to that found at Trewhiddle, should show two rather different aspects of the style seen in that

context, a reminder of the range of the style's vocabulary and many contemporary variations possible on this theme. LW

Select bibliography: Wilson 1964, cats 2–7; 29–31; Roesdahl et al. 1981, cat. c.10; Brooks and Graham-Campbell 1986, 109–10.

246 (a–j) The Trewhiddle hoard (selection)

Trewhiddle, St Austell, Cornwall
Silver, gilding, niello, glass, copper-alloy; individual dimensions below
Anglo-Saxon; deposited *c*.868
British Museum, M&LA 1880, 4–10, 1–12, 14, 19

246 (a) Silver chalice

Formed of separate foot, stem and cup, originally riveted together; the bowl is gilded internally. Just below the gilded rim are a number of rivet holes perhaps indicating the former

246a–j

presence of an applied rim or decorated band. Immediately below them is a band of gilding within which are further rivets; above it are traces of solder, and below are traces of incised interlace at points where the original surface of the (much corroded) metal survives. A now lost mount from the hoard may have served as a collar to the stem.

H. 12.6 cm

246 (b) Silver scourge

Trichinopoly chainwork with glass bead attachment at one end and four knotted tails at the other

L. 56.5 cm

246 (c) Silver pin

Hollow polyhedral head, its facets decorated with niello-inlaid plant, animal, interlace and geometric motifs. The bent pin is riveted through the head.

L. 19.3 cm

246 (d) Silver capping

Of D-shaped plan, possibly from a knife or *seax* handle. It is in two pieces (walls and top) with attachment holes in the centre of both sides and top, where a plain surround presumably also accommodated a boss. One side of the top of the capping is decorated with beaded panels of speckled interlace and foliage decoration on a nielloed ground. The back has an incised cross.

Max. L. 2.8 cm

246 (e) Pair of curved silver mounts

With straight tops and arcaded bases, terminating at each end in repoussé animal heads with comma-shaped ears and niello-inlaid geometric ornament. A plain band of silver originally extended from each of the heads (one is broken off), with an attachment hole at the end. One mount is slightly smaller than the other. Each is divided into sub-triangular decorative fields by beaded frames joining the straight and arcaded beaded borders of the strip. The panels contain speckled animal, plant and interlace decoration on a nielloed

ground, that on the larger mount being almost exclusively zoomorphic. Alternate panels have a central rivet hole with plain surround, presumably to receive a boss.

Overall L. 21.4 cm, 18.2 cm respectively

246 (f) Silver strip

Similar to (e) but hammered flat. It lacks beaded borders, and has only two fields of decoration – one of foliage, and one with a contorted quadruped, separated by a rivet hole. The strip continues as a plain band with rivet holes asymmetrically to either side of the decoration.

L. 12.2 cm

246 (g) Silver strap-end

With single rivet and schematic animal-head terminal: beaded sides frame a speckled creature on a nielloed background.

L. 3.0 cm

246 (h) Silver penannular brooch

Type G3, with pelleted lozenge-shaped panels on its terminals, and lightly incised hatching on the back: the end of the pin is broken off.

Max. L. 5.5 cm

246 (i) Silver four-piece strap-set

Two strap-slides each cast in the form of a rectangular loop, the front of which is a bilaterally faceted notched lozenge and two tongue-shaped bilaterally-faceted strap-ends with notched ends and a single rivet.

L. 2.2 cm, 2.2 cm, 2.6 cm, 2.5 cm

246 (j) Copper-alloy buckle

With rectangular sheet plate and D-shaped loop.

L. 4.2 cm

The hoard was found in 1774 in a stream-bed in an old tin-mine working, along with a number of other objects now lost, and a considerable quantity of coins which date the deposition of the hoard to c.868 (Blackburn and Pagan 1986, 294; Brooks and Graham-Campbell 1986, 109). The composition of the coin assemblage and hence the dating is somewhat problematic; but this revised date has won general acceptance. The accompanying metalwork presents an intriguing mixture of ecclesiastical and secular material, and in addition to its obvious and predominant Anglo-Saxon components includes one brooch of Celtic origin. Much of the hoard is lavishly decorated in the distinctive repertoire of lively zoomorphic, plant, interlace and geometric motifs set in small fields to which it has given its name, the Trewhiddle style, and for

which it constitutes the classic assemblage (Brøndsted 1924, passim, and see above pp. 220–1).

Apart from the decoration itself, the hoard is notable for a number of exceptional items. The chalice is the only Anglo-Saxon silver chalice from Britain: recent restoration has revealed its gilded interior and vestiges of a band of incised interlace below the rim. The recent discovery of a small silver chalice on a crannog at Lough Kinale, Co. Longford, Ireland, provides a very close parallel to the Trewhiddle piece in all but size: particularly interesting in this context is the Lough Kinale chalice's riveted rim-mount, which offers a simple analogy for the lost fitting from the rim of the Trewhiddle chalice (Ryan 1990, fig. 1, 292). The Lough Kinale chalice differs significantly from other surviving Irish chalices and might conceivably be of Anglo-Saxon workmanship.

With the scourge, which is a unique survival in an early medieval context, the chalice represents an ecclesiastical element in the hoard. However, the other objects all appear to be secular in nature, though there remains some doubt as to the precise nature of some of them, such as the capping (here identified as from a knife handle) and the curved mounts. The latter have been identified by Smith (1904) and Wilson as horn-mounts, but this explanation fails to account adequately for significant differences from all other Anglo-Saxon horn- or cup-mounts; for instance the lack of provision for a rim binding, and the fact that the mounts could only encompass half a rim. Their construction suggests rather that they were meant to be seen primarily from one side, as if attached to curved strap-work of some kind – on a bridle or spur attachments, for example. The plain riveted strips which extend beyond the decorated area certainly have the look of parts concealed in use, and it is worth remark here that the matching plain base silver strap slides and strap-ends from the hoard are of types thought to have been used with spurs.

As with the associated coins, in which several separate parcels have been discerned, it looks as if this hoard contains more than one discrete assemblage of precious metalwork.

LW

Select bibliography: Rashleigh 1789; Smith 1904; Wilson and Blunt 1961; Wilson 1964, cats 90–103, and *passim*; 1984, 94–6, figs. 104, 119.

247 Horn-mount

Burghead, Morayshire, Scotland
Silver; D. 7.5 cm
Anglo-Saxon; mid–late 9th century
National Museums of Scotland, Edinburgh, inv. no. IL 214

Circular two-part fitting consisting of a rim binding which curves over and secures an ornamental strip, the lower edge of which is zigzagged. The angles of each zigzag are punctuated by bossed rivets and the edge is beaded. The individual sub-triangular fields thus created contain Trewhiddle-style plant and animal motifs. A suspension loop is attached at one side.

The mount is a typological descendant of early Anglo-Saxon horn-mounts of the type seen at Sutton Hoo and

247

Taplow, reflecting in its zigzag trim the elongated triangular appendages to the rim bands seen on the earlier horns. The suspension loop also has pagan-period antecedents, again at Taplow (unpublished) and on a bronze horn-mount at Little Wilbraham, Cambs. (Neville 1852, 16, pl. 15). The suspension loop leads Graham-Campbell (1973) to argue that this mount was fitted on a blast horn rather than a drinking horn. The presence of a fine piece of Trewhiddle-style metalwork so far into the north may, as with the Talnotrie hoard, indicate Viking intervention. LW

Select bibliography: Graham-Campbell 1973.

248 (a–f) The Talnotrie hoard (selection)

Talnotrie, Glen of the Bar, Dumfries and Galloway, Scotland
Silver, niello, copper-alloy, gold, lead; individual dimensions below
Anglo-Saxon and Insular Celtic; deposited *c.*875
National Museums of Scotland, Edinburgh: (*a*) FC 200; (*b, c*) FC 201–2; (*d*) FC 205, (*e*) FC 198

248 (a) Silver strap-end

With animal-head terminal with comma-shaped ears, and niello-inlaid central panel with Trewhiddle-style animal.

L. 4.1 cm

248 (b, c) Pair of silver disc-headed pins

Originally linked, with geometric cruciform decoration in the Trewhiddle style.

L. of each 7.8 cm

248 (d) Gold finger-ring

Flat inner face and slightly ribbed outer face.

D. 2.0 cm, WT 1.56 g

248 (e) Lead weight

With cast copper-alloy disc attached to the top by two short pins: this has a chip-carved design of lentoid fields of symmetrical interlace around a central lozenge-shaped field with a quatrefoil knot.

D. 3.0 cm, WT 88.19 g

248 (f) Thirteen coins

These surviving coins comprise four silver pennies of Burgred of Mercia (852–74); copper-alloy pennies (stycas) of Æthelred II (841–4), Redwulf (844), Osbert (849–67), Archbishop Wulfhere (period 854–67), and two illegible; fragments of a denier of Louis the Pious (814–40), and of two 'Abbasid dirhams, one of al-Mutawakkil (AD 846/7–861/2), and one illegible. The coins provide a date of the early to mid 870s, but the remains of a mount on one of the coins of Burgred would allow for a slightly later date for the deposit. MMA

A hoard of fine metalwork, coins, scrap metal and other raw materials used in fine metalworking was salvaged from a cottar's peat fire in 1912, a small quantity of silver having already been melted in the fire. The peat had been cut from a moss on the north-west flank of Cairnsmore of Fleet where hut platforms and boundary dykes were subsequently noted. No further objects were found in the peat cut.

The coins put the deposition of this hoard in the early or mid 870s, and it has been suggested that the burial of the hoard may be associated with the campaigns of Ivar the Boneless in Strathclyde in 870–1, or Halfdan's activities there in 874–5 (Brooks and Graham-Campbell 1986, 107). The odd mixture of stycas and pennies, together with a dirham, and the presence of a Viking-type weight with an Insular mount attached in a secondary usage suggests this hoard may be put together from several parcels and also hints at a Viking context for the deposition. The pins and strap-end are of English mid ninth-century origin; the strap-end is a fine example of the type with comma-shaped ears which has a predominantly northern distribution, and the simple geometric ornament of the pins also finds its best parallel in the geometric panelled style of the Trewhiddle-style mounts of swords found in Yorkshire at Gilling (**251**), Acomb and Wensley. LW, RMS

Select bibliography: Maxwell 1912–13, 12–16; Wilson 1964, 2, 29 and *passim*; Blackburn 1986, 293; *SCBI* Edinburgh, nos. 20, 34, 41, 53–5, 60–3, 693–5.

248a–f

THE AGE OF ALFRED

249a–c

249 (a–c) The Lilla Howe hoard

Lilla Howe, Goathland, North Yorks.
Gold, silver; (*a*) each, D. 3.6 cm; (*b, c*) L. 6.2, 6.3 cm
Anglo-Saxon; late 9th–early 10th century
National Museums and Galleries on Merseyside, Liverpool Museum,
inv. nos 12.6.79 14–19

249 (a) Pair of sheet gold roundels

In the centre are five granules in the shape of a cross sur-
rounded by four inward-facing, filigree wire heart-shaped
motifs, each containing a fleur-de-lys with a single granule
in each scrolled terminal. Surrounding this central field is a
concentric band, edged with similar wire, containing running
scrolls, each terminating in a single granule.

249 (b) Pair of cast, tongue-shaped silver strap-ends

The terminal is in the form of a stylised animal head with
comma-shaped ears. Within a beaded border, an inner frame
composed of a line of annulets flanked by plain lines sur-
rounds the main panel with a Trewhiddle-style extended
quadruped, its body decorated with curved nicks. From its
jaws a sinuous tongue terminating in foliate scrolls passes
diagonally across the body. Between the two rivet-holes at
the split-end is a palmette with similar forked terminals.

249 (c) Pair of cast, tongue-shaped silver strap-ends

Similar to those above; the main panel containing four inter-
laced Trewhiddle-style animals with gaping jaws and bodies
formed of ribbon interlace.

This hoard, first published in 1871, also contained several
plain gold rings and a brooch, now lost. It was supposedly
found in a Bronze Age barrow and mistakenly considered to
be the burial of a seventh-century noble, though its com-
position shows that it was a hoard deposited in the late ninth
or tenth century.

Certain stylistic features distinguish the strap-ends in this

hoard. Their unusually large size indicates a relatively late date in the series, while the rather bulbous heads, and the looped palmette, which appears on other objects such as a strap-end from Coldingham, Berwickshire, and on the Selkirk gold ring (**203**), are all features associated with a northern variant of the Trewhiddle style being produced during the ninth century. This gains support from the discovery in Carlisle of a mould for making similar strap-ends (Taylor and Webster 1984).

The gold roundels are broadly similar to a tenth-century sheet gold filigree disc brooch from Hedeby, Denmark (Graham-Campbell 1980, no. 140), and an unpublished gold roundel from Swinderby, Lincs., although the filigree ornament lacks the small linking clips which occur on these two pieces, and on other tenth-century Anglo-Saxon objects such as the King's School, Canterbury disc brooch (Wilson 1964, cat. 10). There is no sign of any form of attachment on the roundels, and the uneven flange projecting beyond the wire border suggests that they were originally inset in a larger object. A Viking origin is possible. CH

Bibliography: Roesdahl et al. 1981, 40, 66; Watkin and Mann 1981, and refs; Taylor and Webster 1984, 178–80.

250 Sword

River Witham at Fiskerton, Lincs.
Iron, silver, niello; max. L. 90.2 cm
Anglo-Saxon; second half of 9th century
City Museum, Sheffield, inv. no. J.1954.3

Two-edged iron sword with silver-mounted hilt. The blade is pattern-welded; the hilt consists of a grip (originally with an organic covering) with three decorated silver bands, curved guards and a silver-mounted pommel with central lobed element flanked by twin stylised animal-head shoulders. The rather crudely-decorated Trewhiddle-style silver mounts on grip and pommel are inlaid with niello, the former entirely with geometric and plant ornament, the latter with geometric and animal ornament.

Swords were always prized possessions and powerful status-symbols in Anglo-Saxon England, as their occurrence in rich pagan graves and, much later, royal wills shows. By the ninth century, the sword with iron guards and pommel has replaced the composite hilts of the seventh and eighth centuries in Anglo-Saxon England, while still retaining the tripartite iron pommel and applied silver decoration of the eighth century (cf. **180, 181**). With its simple decorative silver strips, the Fiskerton sword is a typical specimen of a mid-to-late ninth-century sword; its layout and combination of geometric and animal-ornamented silver strips relates it closely to a group of contemporary Anglo-Saxon swords from Yorkshire and Viking graves in Norway (see **251**). LW

Select bibliography: Wilson 1965b, 33–5.

250 (detail)

251 Sword

Gilling Beck, Gilling West, North Yorks., 1976
Iron, silver, niello; max L. 83.8 cm
Anglo-Saxon; late 9th century
The Yorkshire Museum, York, inv. no. 1979 51

Two-edged iron sword with silver-mounted hilt. The blade is pattern-welded, the hilt consists of a grip (originally with an organic covering) with five decorated silver bands, curved guards, and a silver-mounted pommel with prominent central peak flanked by twin stylised animal-head shoulders. The Trewhiddle-style stereotyped geometric decoration of the mounts was originally inlaid with niello.

Like the Fiskerton sword (**250**), this recent find from the stream bed at Gilling West finds its nearest parallels in other swords from Yorkshire and Viking graves in Norway. Its stylised geometric decoration relates it not only to the Fiskerton sword but also to swords or sword parts from Acomb and Wensley, Yorks., and Dolven, Gronneberg and Hegge in Norway (Youngs et al. 1984 pl. xviiiv; Bruce-Mitford 1956, pl. xxiiib; Wilson 1965b, pl. iiib). The latter finds are likely to reflect Norse Viking activity in the north of England, rather than Danish pickings from the south. The tendency to simple and severe geometric ornament seen in all this group is certainly late in the ninth century, as the high-crowned pommel suggests (cf. the late ninth-century Abingdon sword and River Seine pommel, Backhouse, Turner and Webster 1984, cat. 14; Wilson 1964, cat. 66), and seems also to be a distinctly northern fashion (cf. the Beeston Tor brooch and Talnotrie pins, **245b**, **248b, c**).　　　　LW

Bibliography: Roesdahl et al. 1981, cat. D3, fig. p. 44; Watkin 1986.

252 Harness fittings

Queen Victoria Street, London, 1812
Copper-alloy, gilding; each overall L. 30 cm, overall w. *c*.32 cm
Anglo-Saxon; end of 9th century
Museum of London, inv. nos 3973, 3974

Two matching assemblages of three graded lengths of chain, united by a four-part distributor with a three-dimensional human mask at each corner; from its fourth side hangs a long pendant with ribbed shaft, animal-headed attachment loop and disc-shaped terminal with incised animal with punch marks on its body. One of the sets (3974) has a lentoid-looped buckle at the end of the shortest chain: the equivalent chain on the other set has a riveted attachment containing traces of leather.

This strange pair of items has not been satisfactorily interpreted. Though they are often described as chatelaines, the lack of attachment points for pendent artefacts seems to rule this function out, while the quadripartite distribution of chains and pendants is suggestive of some kind of decorative lightweight harness, which would have been completed by (recorded but now missing) leather straps. The cruciform orientation of chains and pendants makes it hard to see how they would form part of human dress, and the likelihood

251 (detail)

is that they were designed for use with animals. Their light construction would suit dogs rather than horses; and the possibility that they could have been worn as a pair, rather than joined up as one unit, would be appropriate to such use.

The decoration is also rather unusual; the human masks with their staring eyes and hair lappets have a distinctly Scandinavian, Borre-style, look (cf. e.g. the Åserum, Vestfold, Norway brooch, Wilson and Klindt–Jensen 1966, 88, pl. XXVIIIb), and the animal masks are remote from the standard ninth-century animal-head terminals familiar from strap-ends. The backward-biting animal on each pendant disc, however, is related to others on, for instance, the York and Selkirkshire ring bezels (**204, 203**) and is to be seen as a late ninth-century version of this motif; like the rings, these harness fittings were perhaps made in the Danelaw.

It is worth noting that they were found within the City of London, an area which appears to have only been sys-

tematically occupied by Anglo-Saxons at the end of the ninth century, perhaps indeed as an Alfredian initiative; the focus of the earlier Saxon town was down on the Strand, centring on the Aldwych. LW

Select bibliography: *JBAA* 28, 1872, 399; Guildhall Museum Catalogue 1903, 120, pl. LIII no. 11; Wheeler 1935, 189–90, pls XVIII–XIX, fig. 45.

253 Saddle-bow (fragment)

Coppergate, York
Oak-wood, silver; L. 31 cm, H. 17.7 cm
Anglo-Saxon; late 9th century
York City Council, 1977.7.1745

Arched fragment from a saddle-bow decorated on all its external surfaces with triangular (occasionally trapezoidal) fields of Trewhiddle-style interlace with beaded borders,

252

278

253

studded with silver rivets, originally bossed, which held inlaid horn strips in place.

This unique survival of Trewhiddle style in wood-carving survives as an important reminder of the lost body of decorative work in organic media. LW

Bibliography: Roesdahl et al. 1981, cat. YL11; Hall 1986, 82–3; Wilson 1984, 111.

254 Motif-piece

Coppergate, York
Bone; L. 9.8cm
Anglo-Saxon; late 9th century
York City Council, 1979.9.5692

Motif-piece with randomly incised interlace motifs and animals in the Trewhiddle style.

With the related motif-piece from Station Road, York (**255**) this craftsman's try-out confirms that Trewhiddle-style artefacts were being made in York itself. LW

Bibliography: Roesdahl et al. 1981, cat. YAB41; Hall 1986, 58.

254

255 Motif-piece

Station Road, York
Bone; L. 11.5 cm
Anglo-Saxon; second half of 9th century
The Yorkshire Museum, York, 581.48

The motif-piece has an orderly frieze of incised Trewhiddle-style animals and interlacing plant ornament running along its long edge. Below this are sketched interlaced plant motifs and two further animals.

Like **254**, this represents a craftsman's trial designs and layouts. It shows a confident control of Trewhiddle-style motifs. LW

Select bibliography: Waterman 1959, 91, pl. xx(i); Roesdahl et al. 1981, cat. C.7, pl. 117.

256 Mount

Wareham, Dorset
Silver, gilding; L. 3.0 cm
Carolingian; 9th century
Private possession

Square mount of cast silver, gilded: deeply recessed within a grooved outer frame, a border of acanthus fronds surrounds a central domed square decorated with an equal-armed cross with lozenge-shaped ends and a square-framed quatrefoil at its centre. Between the arms are acanthus tufts. The otherwise plain back has an attachment lug.

This piece of high-class Carolingian metalwork was probably originally a fitment on sword or horse harness; its elegant acanthus decoration exemplifies the Carolingian influence which shaped the future of Anglo-Saxon art in the tenth century. The discovery of this piece at the *burh* of Wareham may reflect Wessex contacts with the Carolingian empire or possibly the Viking army's sojourn there in 875–6. LW

Unpublished.

257 The Fuller Brooch

No provenance
Silver, niello; D. 11.4 cm
Anglo-Saxon; end of 9th century
British Museum, M&LA 1952, 4–4, 1

Sheet-metal disc brooch, extensively inlaid with niello, and with an openwork outer zone encircling a central roundel which is framed and divided by broad milled borders, into a central lozenge shape surrounded by four subsidiary lentoid fields, punctuated at the four points of intersection by bosses, with a fifth at the centre; three of these conceal rivets attaching the (lost) pin mechanism behind. The decorative scheme consists of personifications of the Five Senses in the central roundel, surrounded by the openwork zone of smaller roundels containing alternating geometric animal and human motifs symbolising the different aspects of Creation in a not-

quite-symmetrical arrangement. The large central field is occupied by Sight with staring eyes, wearing the *pallium* and holding two leafy cornucopias: in the subsidiary fields, *anticlockwise* from Sight's top right, are, respectively, Taste (with hand in mouth), Hearing (with hand to ear), Touch (with hand touching hand) and Smell (with plant touching nose and hands firmly disengaged behind back). Plant and interlace decoration fill every void, and everything is set upon a nielloed ground. The back is plain and the pin mechanism is now missing. Two small holes at the top may have been for suspension.

The history of the Brooch is quite unknown before the late nineteenth century, though as it has a custom-built seventeenth-century sharkskin case of its own, it was evidently already a collector's item by that date. As a uniquely suave and sophisticated piece of Anglo-Saxon jewellery it is, without contention, the most splendid of the great series of Late Saxon silver disc brooches (cf. **187, 189**). Indeed, its exquisitely controlled decoration and glossy condition for many years duped scholars into believing it could be a fake. Iconographic and stylistic study, and scientific examination of the niello inlay and silver structure, proved once and for all

255

256

257

that this view was wrong; but it remains, in sheer excellence, a piece set apart from most other surviving metalwork of the late ninth century, to which it stylistically and intellectually belongs. Its subtle iconographic programme, first identified by E.T. Leeds, is only matched in metalwork by two other surviving pieces, the Abingdon sword (Hinton 1974, cat. 1) and the Alfred Jewel (**260**). The (possible) evangelist symbols on the sword, and the personification of Sight/Wisdom on the Jewel, like the Fuller Brooch's elaborate scheme, reflect the renewal of interest in intellectual and exegetical matters to which Alfred devoted much of his energies.

Stylistically, the Brooch also accords best with a date late in the ninth century: its fleshy plant lobes and elegant biting birds are elements which come into prominence in metalwork and manuscripts of the earlier tenth century, and which certainly represent, if not go beyond, the further edge of Trewhiddle-style tradition. LW

Select bibliography: Bruce-Mitford 1956, 173 ff, figs 34b and 35, pl. xx; Wilson 1964, cat. 153 and *passim*; 1984, 110, pl. I.

258 Mount

Bowleaze Cove, Weymouth, Dorset
Gold, blue glass; L. 2.8 cm
Anglo-Saxon; second half of 9th century
Private possession

The fitting consists of a short socket surmounted by a hollow domed circular head with flattened top. It is constructed of a continuous gold sheet, originally with a separately soldered base plate (now lost) for the head. A gold rivet which pierces the end of the socket originally attached it to a wood or ivory rod. The end of the socket and perimeter of the head's flat top are each decorated with a band of beaded wire, and a similar band runs in a continuous length round the lower edge of the head and its junction with the socket. The top of the dome has at its centre a small blue glass cabochon in a simple setting with beaded wire collar, surrounded by patches of coarse granulation in apparently random arrangement. In addition to the missing back-plate, damage to its edge probably reflects plough or landslip damage.

The fitting was found in March 1990 at the bottom of cliffs at Bowleaze Cove, having evidently fallen from the cliff-top

in one of the landslips common on this part of the coast. No other evidence of Anglo-Saxon activity was provided either by other finds from the cove, or from the land at the top of the cliff.

The fitting belongs to the same type as the Minster Lovell and Alfred Jewels (**259, 260**), though at a considerably less grand level. The traditional argument that these two lavishly decorated fittings represent the handles of manuscript pointers is attractive, but the possibility remains that they had another function – terminals of staffs of office, for example (see further under **260**). Whatever their function, the Bowleaze Cove fitting certainly shares it; not only does it have a socket similar in scale to the other two fittings, it is also very close in scale and shape to the Minster Lovell Jewel, and the gold composition of the two pieces is also similar. However, where the other two fittings have elaborate enamel insets, fine filigree and granulation, and are altogether more ambitious artefacts, the simple blue glass inset, coarse granulation and plain design of the Bowleaze Cove piece suggest that it was made for a much more modest context. If the Alfred Jewel is an object appropriate for use in royal or episcopal circles, then the Bowleaze piece may represent a piece proper to a minor official or a congregation of lesser standing or resources.

Though it is evidently close in date to the other two jewels, there is no necessity (even if it is indeed the handle of a manuscript pointer) to associate the Bowleaze Cove piece directly with Alfred's decision to sent out pointers to every diocese in his kingdom with copies of his translation of the *Pastoral Care* (see **235**). Indeed, the huge value of 50 mancuses put upon these pointers by Alfred himself in his Preface, even though quite possibly appropriate to the Alfred Jewel, would seem to rule out the Bowleaze fitting on grounds of value alone. LW

Unpublished.

258 259

260

socket are also variously outlined with twisted or beaded wire.

Since its discovery in 1860, the Minster Lovell Jewel has often been compared with the Alfred Jewel, to which, though more modest in scale and ornament, it bears a notable resemblance. Detailed discussion of its decoration and function is therefore dealt with under the Alfred Jewel (**260**). LW

Select bibliography: Bakka 1966, 277–80; Clarke and Hinton 1971; Hinton 1974, cat. 22.

259 The Minster Lovell Jewel

Minster Lovell, Oxon.
Gold, enamel; L. 3.1 cm, max D. 2.3 cm
Anglo-Saxon; second half of 9th century
The Visitors of the Ashmolean Museum, Oxford, inv. no. 1869.20

The sheet gold socketed fitting consists of a hollow flat-topped dome on to which a ∩-shaped tube is soldered at one side: the hollow underside of dome and tube are sealed by a single back plate to complete the socketed fitting, with around the dome a scalloped edge which projects beyond the dome's rim. The socket is pierced through by holes for a (lost) rivet which fixed it to a wood or ivory rod. The flat top of the dome has an applied gold and cloisonné enamel setting, decorated with a double cross design in white, green, light and dark blue enamel. The remainder of the dome and the projecting scalloped edge of the base-plate are encrusted with gold filigree, consisting of dense granulation divided lengthwise by zig-zag or scalloped plain wires, which alternate with straight, beaded or twisted wires. The edges of the

260 The Alfred Jewel

North Petherton, Somerset
Gold, rock crystal, enamel; L. 6.2 cm
Anglo-Saxon; late 9th century
The Visitors of the Ashmolean Museum, Oxford, inv. no. 1836, 371

The gold pear-shaped frame holds an enamelled plaque under a polished rock-crystal; a separate back-plate is held in place by dog-toothed claws, and a socketed animal-headed terminal is attached by modern solder to the pointed end of the jewel. Round the edge of the frame runs an openwork Old English inscription in capitals which reads + AELFREDMECH/EH/T

GEWYRCAN, 'Alfred had me made'; below this is a band of granulation inset with scalloped and scrolled motifs in plain wire. The cloisonné enamel inlay of the plate within depicts an apparently enthroned male half-length figure with staring eyes, holding two floriated rods, the whole in varying shades of white, blue, green and brown. The back plate has an incised plant design on a hatched background. The sheet gold animal head is hollow inside and from its jaws issues a socket; the head is encrusted with fine granulation in which plain filigree wire delineates features such as the jaws, the elongated eyes, mane and comma-shaped ears. The head's separate backplate has incised scale decoration. The socket itself is a tube of sheet metal with a second tube within: it is pierced laterally by a single rivet and is decorated with a single beaded wire annulet on the top. A further beaded wire, worn on the underside, trims its mouth, and more are used to define the edges of the base-plate and bottom edge of the inscription.

The Jewel was found in 1693 four miles from Athelney; it passed to the University of Oxford in 1718. Its inscription has traditionally been taken to associate the Jewel with King Alfred (871–99): though it cannot be conclusively proved, it remains a very plausible attribution, in view of the Jewel's exceptional opulence and quality, and one which fits the linguistic and art-historical dating of the piece. Furthermore, Mercian elements in the language of the inscription accord with the presence of notable Mercian scholars at Alfred's court, while the Jewel's discovery near Athelney, an area with strong associations with Alfred himself, is also worth note (Hinton 1974, 44; Keynes and Lapidge 1983, 203).

Apart from the rock crystal, which is probably a reused Roman piece (Kornbluth 1989), the Jewel is entirely of Anglo-Saxon workmanship. However, the exceptional quality of the piece reduces scope for stylistic comparisons with other metalwork. Nevertheless, the stylised beast head with comma-shaped ears is clearly related to animal heads of a type widespread in ninth-century metalwork (e.g. **107b, 206**), and also seen in sculpture, for example at St Mary's, Deerhurst: likewise, the Tree of Life motif on the base-plate depends on an earlier ninth-century tradition of such motifs with heavy calices and pendulous leaf-shoots, as for example on two of the Pentney brooches (**187a, b**). However, as Hinton pointed out, its fleshy lobes and palmette leaves have affinities with late ninth- and early tenth-century plant ornament, such as the Abingdon sword and St Cuthbert's stole and maniple. Stylistically and technically, the filigree shares several traits with the Minster Lovell Jewel, and, like that piece, is also firmly within the developing tradition of Anglo-Saxon cloisonné enamelwork (Evison 1977; Buckton 1986).

The iconography of the Jewel's enamelled figure has excited much speculation, but the most convincing readings are those of Bakka, who interprets it as a personification of Sight (Bakka 1966), and Howlett, who sees it as Christ incarnating the Wisdom of God, balanced by Wisdom as the Tree of Life on the reverse (Howlett 1974). Interpreted as Sight, the figure has a striking contemporary parallel in the figure of Sight on the Fuller Brooch, which, in the staring eyes and foliate emblems held in each hand, shares some of the more immediate attributes of the figure on the Jewel.

Either of these interpretations would accord with the traditional identification of the Jewel with an object, probably a rod-like pointer, referred to in the preface to King Alfred's translation of Gregory the Great's *Pastoral Care* (**235**); in this the king states that as part of his programme for the renewing of learning and spirituality in the Church, a copy of the translation was to be sent to every bishopric in the kingdom, accompanied by 'an *æstel* worth 50 mancuses'. If, as later gloss usage suggests, *æstel* is correctly translated as 'pointer', then it quite probably consisted of a rod of wood or ivory such as seems to have been inserted in the sockets of the Alfred Jewel (and indeed those of the Minster Lovell and Bowleaze fittings). One worth as much as fifty mancuses (some half-pound weight in gold) might reasonably be expected to have had very lavish fittings such as are seen on the Alfred Jewel. This attractive theory should not, however, obscure the possibility of other explanations for the Jewel and its two functionally similar but much humbler relatives. A convincing alternative, which would also suit the iconographic interpretations above, would be to see them as terminals from staffs of office. Whatever their function, it should also be borne in mind that the much more modest workmanship of the two smaller fittings, especially the Bowleaze Cove piece, is certainly not in the fifty-mancus bracket; and that they are thus not likely to be associated directly with Alfred.

Finally, the overall conception of the Jewel also invites comment: in its unique combination of massive rock crystal with cloisonné enamel and exquisite goldwork and in its boldly conceived iconography, it is surely inspired by the goldsmiths' work of the Carolingian courts, which Alfred would have seen for himself as a youth visiting the court of Charles the Bald (Webster 1984, 18–19). In this it perhaps looks forward to the increasing influence of Carolingian art and culture which was to be so influential in the coming years. LW

Select bibliography: Bakka 1966, 277–82; Hinton 1974, cat. 23, 29–48, and refs; Howlett 1974, 44–52; 1975, 60–74; Keynes and Lapidge 1983, 203–6; Backhouse, Turner and Webster 1984, cat. 13; Webster 1984, 18–19; Collins 1985, 37–58.

Coins

261 (a–d) Pennies of Lunette type, unified issue, c.867–74

261 (a) Penny of Burgred of Mercia (852–74), struck at London by the moneyer Guthmund

Base silver; WT 1.28 g (19.7 gr)
British Museum, CM 1925, 2–2–12

Provenance: From the Beeston Tor, Staffs., hoard deposited c.875 and found in 1924.
Bibliography: Pagan 1965; 1986.

261 (b) Penny of Æthelred I of Wessex (865/6–71), struck at Canterbury by the moneyer Elbere

Base silver; WT 1.26 g (19.5 gr)
British Museum, CM 1840, 3–14–224

Provenance: From the Gravesend, Kent, hoard, deposited c.871 and found in 1838.
Bibliography: BMC 20; Pagan 1986.

261 (c) Penny of Alfred of Wessex (871–99), struck at Canterbury by the moneyer Elbere

Base silver; WT 1.24 g (19.1 gr)
British Museum, CM 1915, 5–7–796

Provenance: From the Croydon (White Horse), Surrey, hoard, deposited c.872 and found in 1862.
Bibliography: BMA 461; Brooks and Graham-Campbell 1986; Pagan 1986.

261 (d) Penny of Archbishop Ceolnoth of Canterbury (833–70), struck at Canterbury by the moneyer Tocga, c.867–70

Silver; WT 1.32 g (20.4 gr)
British Museum, CM, acquired before 1832

Provenance: Not known; purchased at the Barker sale, Sotheby 2.v.1803, lot 415.
Bibliography: BMC 60; Blunt 1960.

The Lunette type was introduced by Burgred in the early 860s. It was taken up by his brother-in-law Æthelred I shortly after his accession, and continued by the latter's brother Alfred. The coinage of the archbishop followed suit. This first unified coinage type is a sign of the co-operation between Wessex and Mercia seen also in marriage alliances and military campaigns against the Danes. The declining silver standard of the coins (eventually less than 20 per cent) was accelerated by the drain of silver to the invaders and the disruption in normal trading which their activities had caused. MMA

262 (a, b) Pennies of the Two Emperors type, unified issue, 874–5

262 (a) Penny of Alfred of Wessex (871–99), struck at London by the moneyer Cenred with the title REX ANGLO[RVM]

Silver; WT 1.30 g (20.1 gr, chipped)
British Museum, CM 1896, 4–4–63

Provenance: A single find at the Old Palace Croydon, Surrey, in or shortly before 1892; purchased at the Montagu I sale, Sotheby, 18.xi.1895, lot 545.
Bibliography: BMA 476; Dolley and Skaare 1961. 65; Dolley and Blunt 1961, 81–2.

262 (b) Penny of Ceolwulf II (874–c.880), struck at London by the moneyer Ealdwulf, with the title REX only

Silver; WT 1.30 g (20.0 gr)
Assheton collection; gift of H.M. Queen Victoria

Provenance: From the Cuerdale, Lancs., hoard deposited c.905 and found in 1840.
Bibliography: Dolley and Blunt 1961, 81–2; Dolley 1963.

Ceolwulf II was chosen by the Danes to succeed Burgred in 874. The Two Emperors type (for earlier use of same reverse see **52a, b**) is so exceptional that it must be a celebratory issue marking an accommodation between Alfred and Ceolwulf reinstating the former West Saxon–Mercian alliance. Both moneyers had worked for Burgred at London, so the difference in style is perhaps due, like that among London Monogram coins (**265**), to pressure to meet demand in a short time. Alfred's title 'King of the English' can only be an acknowledgement of his leading position in the alliance. The date is uncertain, but is unlikely to have been long after Ceolwulf's accession. MMA

263 (a, b) Pennies of Cross and Lozenge type, unified issue, 874/5–8

263 (a) Penny of Alfred of Wessex (871–99), struck at London by the moneyer Liafwald

Silver WT 1.29 g (19.9 gr)
British Museum, CM 1896, 4–4–64

Provenance: Not known; purchased at the Montagu I sale, Sotheby, 18.xi.1895, lot 546
Bibliography: BMA 479; Dolley and Blunt 1961, 82–4; Lyon 1968, 236.

(*Right*) Coins of Kent, Mercia and Wessex in the age of Alfred, with a lead weight from London (**264**)

261a

261b

261c

261d

262a

262b

263a

263b

264

265

266

267

268

269a

269b

269c

270

271

263 (b) Penny of Ceolwulf II of Mercia (874–c.880), struck at London by the moneyer Liofwald

Silver; 1.37 g (21.2 gr)

British Museum, CM 1838, 7-10-20; gift of H.M. Queen Victoria, 1840

Provenance: From the Cuerdale, Lancs., hoard, deposited c.905 and found in 1840.

Bibliography: BMC 403; Dolley 1963; Lyon 1968, 236.

This substantive type stylistically follows the occasional Two Emperors issue and, like it, is of good silver, marking a return to a fine-metal coinage. Archbishop Æthelred (870–89) also participated in this issue. This moneyer, whose name is spelt in different ways, had worked for Burgred at London, which suggests that his coins for both Alfred and Ceolwulf II were struck there also. MMA

264 Coin-weight of Alfred (871–99), struck with coinage dies of the Cross and Lozenge type, made in London by the moneyer Ealdulf, 874/5–8

Lead; WT 163.1 g

British Museum, CM 1937, 10-7-4

The weight is the equivalent of 120 pennies or four mancuses. Ealdulf, a London moneyer for Burgred, also struck the Two Emperors penny of Ceolwulf II (262b). As the weights of successive coin-types were not necessarily the same, new coin-weights would have been made appropriate to each type as it came out and marked with its dies by the moneyer who made them. In particular, the weight of the coins was increased in the London Monogram (celebratory) and Two-line (substantive) types which followed the one to which this weight referred. It was defaced to cancel it at the end of its currency-validity period. The find-spot of this object within the City (on the place where the folk-moot is known to have met later) further supports the view that it was made in London and used there. If so this strengthens the evidence that Alfred had authority in London before 886. MMA

Provenance: Found on the site of St Paul's churchyard, 1840; acquired with the C. Roach Smith collection in 1856.

Bibliography: Lyon 1969; Stewart 1978b; Archibald 1991.

265 Penny of Alfred (871–99), London Monogram type, struck at London, ?878

Silver; WT 1.62 g (25.0 gr)

British Museum, CM 1838, 7-10-285; gift of H.M. Queen Victoria, 1840

The London Monogram type has the appearance of a celebratory issue struck intensively over a short period. It is traditionally associated with Alfred's re-occupation of London in 886, but recent numismatic work now points to an earlier date; some prefer the earlier 880s, but the writer, 878. Her hypothesis is that Alfred took over London as part of the deal with Guthrum after Edington. (The veil over Ceolwulf's fate is perhaps deliberate.) A London type recall-

ing that of his grandfather (224b) would have been particularly appropriate if Alfred had taken the city over, not from the Danes but from the Mercians. The manner of this take-over might also have been a factor in his later concern for Mercian susceptibilities after a Danish re-capture of the city, and his own re-occupation of it in 886. The dating of these issues of Alfred's middle period has still to be satisfactorily resolved. MMA

Provenance: From a Cuerdale, Lancs., hoard, deposited c.905 and found in 1840.

Bibliography: BMC 92; Dolley and Blunt 1961, 82–3.

266 Round halfpenny of Alfred (871–99), London Monogram type, struck at London, ?878

Silver; WT 0.61 g (9.4 gr)

British Museum, CM 1960, 6-5-6

The first English round halfpennies, inspired by the Carolingian *obol*, were of this type. They may have been prompted by a requirement for a coin as near an equivalent as possible in value to the old base penny. In the celebratory context of this issue, there might have been a need to discharge traditional alms payments of a penny for which the new, heavier and finer, penny would have been too valuable. Cut-coins do not appear to be found in English circles at this time. Both London Monogram denominations were at once copied widely in the Danelaw. MMA

Provenance: Found in the Thames near Erith, Kent, c.1840; purchased at the Lockett sale, Glendining, 26.iv.1960, lot 3646.

Bibliography: Blunt and Dolley 1959, 235; Dolley and Blunt 1961, 89–90.

267 Penny of Alfred (871–99), Two-line type, struck at Canterbury (signed DORO for *Dorovernia*, after the king's title) by the moneyer Ethelstan, c.890–5

Silver; WT 1.51 g (23.2 gr)

British Museum, CM 1959, 12-10-20

This group with DORO was struck late in the reign, but not quite at the end. Coins of the normal Two-line type with the obverse inscription divided into four parts, introduced in 878-9, do not name their minting place, so they have been attributed on the grounds of style, and of moneyer-connections, with later signed coins. Issues from London, Canterbury, Winchester and an uncertain mint in Mercia have been distinguished, but it is possible that the coins were struck at a wider range of mints within each of these groups. The variety where the obverse inscription is divided into three parts is later (270). MMA

Provenance: From the Morley St Peter, Norfolk, hoard, deposited c.925 and found in 1958.

Bibliography: SCBI East Anglia, 1–45, and no. 40.

Pennies of Archbishop Ceolnoth of Canterbury, Ceolwulf II of Mercia and Alfred of Wessex (struck in London)

268 Penny of Alfred (871–99), struck at Oxford (signed OHSNAFORDA) by the moneyer Bernvald, *c*.890–5

Silver; WT 1.61 g (25.6 gr)
British Museum, CM 1838, 7–10–309; gift of H.M. Queen Victoria, 1840

The official coins of Oxford are distinguished from the common Danelaw copies by their literate inscriptions and neat style which is associated with dies cut in Winchester in the next reign. MMA

Provenance: From the Cuerdale, Lancs., hoard, deposited *c*.905 and found in 1840.
Bibliography: BMC 127; Lyon 1970; *CTCE*, 21.

269 (a–c) Pennies of Alfred's celebratory city issues

269 (a) Penny of Alfred (871–99), with 'portrait' obverse and king's name only (no title or ethnic), struck at Gloucester (signed ÆT GLEAϷA), 878

Silver; WT 1.57 g (24.2 gr)
British Museum, CM 1838, 7–10–28; gift of H.M. Queen Victoria, 1840
Provenance: From the Cuerdale, Lancs., hoard, deposited *c*.905 and found in 1840.
Bibliography: BMC 80.

269 (b) Penny of Alfred (871–99), with king's name and title REX SAXONVM, struck at Winchester (signed ϷIN), *c*.895–9

Silver; WT 1.58 g (24.4 gr)
British Museum, CM 1958, 12–10–24
Provenance: From the Morley St Peter, Norfolk, hoard, deposited *c*.925 and found in 1958.
Bibliography: SCBI East Anglia, 1–45, and no. 45.

269 (c) Penny of Alfred (871–99), with king's name and title REX SAXONVM, struck at Exeter (signed EXA), *c*.895–9

Silver; WT 1.55 g (23.9 gr)
British Museum, CM 1958, 12–10–21
Provenance: From the Morley St Peter, Norfolk, hoard, deposited *c*.925 and found in 1958.
Bibliography: SCBI East Anglia, 1–45, and no. 43.

Like the London Monogram issue (**265**), these coins naming cities and not moneyers on the reverse were celebratory issues. The Gloucester penny is the earliest, its style and weight suggesting that it is nearly contemporary with the London issues struck, it is argued here (**265**), in 878, and perhaps marks Alfred's taking over the Mercian city recently vacated by the Danes. The Winchester and Exeter coins are similar in style to each other (and to the Bath coins of Edward the Elder) so that they must have been issued for some local celebratory or donative purposes at about the same date towards the end of the reign, *c*.890–9. MMA

Coins of Anglo-Saxon and Danish-Viking rulers in East Anglia and Northumbria in the late ninth century

270 Penny of Alfred (871–99), Two-line type, struck probably at Winchester by the moneyer Æthe(l)red, c.895–9

Silver; WT 1.57 g (24.3 gr)

British Museum, CM 1958, 12–10–29

This Two-line type with the obverse inscription divided into three parts is the latest of Alfred's coins, and appears to have been struck only at Winchester. MMA

Provenance: From the Morley St Peter, Norfolk, hoard, deposited c.925 and found in 1958.

Bibliography: SCBI East Anglia, 1–45, and no. 64; cf. *CTCE*, 20–46.

271 Penny of Archbishop Plegmund (890–923), Two-line type, struck at Canterbury by the moneyer Hunfreth, 890–5

Silver; WT 1.45 g (22.4 gr)

British Museum, CM 1838, 7–10–1091; gift of H.M. Queen Victoria, 1840

This first issue of Plegmund was probably struck shortly after his consecration. MMA

Provenance: From the Cuerdale, Lancs., hoard, deposited c.905 and found in 1840.

Bibliography: BMC 84.

272 Penny of Edmund of East Anglia (855–69), struck by the moneyer Twicga

Silver; WT 1.3 g (20.7 gr)

British Museum, CM 1840, 3–14–211

The coinage of Edmund was an extensive one of several different types which are often identified with particular moneyers, the Omega-cross type being Twicga's. The volume of coinage suggests the wealth of Edmund's kingdom, which attracted the Vikings at whose hands he was killed in 869. MMA

Provenance: From the Gravesend, Kent, hoard, deposited c.871 and found in 1838.

Bibliography: BMC 85; Pagan 1982, 79.

273 Penny of Athelstan II (Guthrum), Danish king of East Anglia (878–90), struck by the moneyer Abenel

Silver; WT 1.30 g (20.0 gr)

British Museum, CM 1838, 7–10–3; gift of H.M. Queen Victoria, 1840

Guthrum's coinage, which is rare, was struck in the name Athelstan which he received at baptism when Alfred stood as his sponsor. His initial issue was perhaps struck for gift exchange and donative purposes after his baptism in 878; this would explain its shared moneyers with Alfred's coins. The later issues in his name, presumably struck in East Anglia and including copies, were by new moneyers, several of whom have German names. There is no continuity between the moneyers of Edmund and Guthrum. Abbonel, perhaps the same moneyer, strikes in the St Edmund Memorial issue. MMA

288

Provenance: From the Cuerdale, Lancs., hoard, deposited *c*.905 and found in 1840.
Bibliography: BMC 90.

274 Penny of the St Edmund Memorial issue, struck by the moneyer Dægmond, 890–5

Silver; WT 1.33g (20.5 gr)
British Museum, CM 1838, 7–10–681; gift of H.M. Queen Victoria, 1840

This coin from the start of the series reads, with a mark of contraction through the first word, SCE EADMVNDE REX MR ('O! Saint Edmund, King and Martyr ...'). These appear to be the first words of an invocation used in the veneration of the saint. If it is correct that Edmund's body was translated to Beadricesworth (later Bury St Edmunds) before the end of the ninth century, this might have been the occasion of the initial issue. Illiteracy quickly set in, and many blundered copies were struck by the East Anglian Danes. MMA

Provenance: From the Cuerdale, Lancs., hoard, deposited *c*.905 and found in 1840.
Bibliography: BMC 321; Blunt 1969.

275 Penny of ?Guthfrith, Danish king of Northumbria (*c*.883–95)

Silver; WT 0.83g (12.8 gr, fragment)
British Museum, CM 1984, 4–14–3

All that survives of the king's name is GVÐEF, which may reasonably, but not certainly, be expanded as 'Guthefrith'. The problem is that the style corresponds closely with that of direct imitations of Alfred's coins whose issue is attributed to the Danelaw area in the midlands, rather than to York, and whether Guthfrith ever had authority there is not known. The coin copies the Alfred Two-line type with a four-part obverse legend, which is compatible for date. MMA

Provenance: From the Ashdon, Essex, hoard, deposited *c*.895 and found in 1984.
Bibliography: Blackburn 1985; 1989.

276 Penny of Cnut, Danish king of York (*c*.900–5), struck at York (named on the reverse)

Silver; WT 1.48g (22.8 gr)
British Museum, CM 1838, 7–10–1359; gift of H.M. Queen Victoria, 1840

The coins of the Danish kings of York *c*.900 are related to the Carolingian coinage by style and type and they were probably produced by expert moneyers from France. MMA

Provenance: From the Cuerdale, Lancs., hoard, deposited *c*.905 and found in 1840.
Bibliography: BMC 882.

277 Penny of Alwaldus (Æthelwold), accepted as king in York, *c*.900

Silver; WT 1.50g (23.2 gr)
British Museum, CM 1838, 7–10–1422; gift of H.M. Queen Victoria, 1840

The coins naming Alwaldus were probably struck for Æthelwold, son of Æthelred I of Wessex, who challenged his cousin Edward the Elder for the throne on Alfred's death in 899. He was driven out by Edward, but was accepted as king by the Northumbrians. MMA

Provenance: From the Cuerdale, Lancs., hoard, deposited *c*.905 and found in 1840.
Bibliography: BMC 1078; Blunt 1985.

278 Penny of King Halfdan, probably struck in the midlands area of the Danelaw

Silver; WT 1.39g (21.4 gr)
British Museum, CM 1896, 4–4–53

This coin copies two coins of Alfred, the Two Emperors and the London Monogram types; others in the name of Halfdan copy the later Two-line type. It is not possible to attribute them to either of the historically-known Halfdans who were kings of York, Halfdan I (857–7) and Halfdan II (902–10), unless (as Grierson and Blackburn remark) Halfdan II had authority earlier in the midland area of which there is no record. MMA

Provenance: Not known; purchased at the Montagu I sale, Sotheby, 18.xi.1895, lot 400.
Bibliography: BMA 300; Grierson and Blackburn 1986, 319.

279 Penny struck by the Danes in the midland area, copying the late Two-line type of Archbishop Plegmund, by the moneyer Tidweald

Silver; WT 1.40g (21.6 gr)
British Museum, CM 1838, 7–10–403; gift of H.M. Queen Victoria, 1840

The Danes in the midland area copied the West Saxon issues successively as they appeared. This is confirmed by the progressively greater number of test-marks ('pecks') on the imitations of earlier types in the Cuerdale hoard. MMA

Provenance: From the Cuerdale, Lancs., hoard, deposited *c*.905 and found in 1840.
Bibliography: BMC 192. Grierson and Blackburn 1986, 318–19; Archibald 1990, 15–16.

Glossary

Terms in italic appear as separate entries.

anthropomorphic
composed of human forms.

aureus
standard gold coin of the early Roman Empire, weighing about 8g.

bifolia
double sheets of *vellum* which are folded to form the *quire*.

cabochon
gemstone or glass inlay of convex shape, set singly.

carpet page
manuscript page consisting purely of decoration (sometimes incorporating a cross into its design), reminiscent of an eastern carpet.

chape
protective metal fitting from the end of a scabbard. Sometimes also used to denote the more substantial strap-ends.

charter
document granting land or rights over land. Most often records a grant by a king.

chasing
decoration applied to metal, from the front, with a round-ended tool.

chip-carving
originally a wood-carving technique adapted (by way of carved models) to cast metalwork, in which sharply-angled cuts produce a glittering faceted surface on the finished product.

chi-rho
XP monogram denoting the first two characters of 'Christ' in the Greek, often used as a Christian symbol.

cloisonné
inlay, normally gemstones, glass or enamel, set in a metal framework of individual cells, or cloisons.

colophon
inscription recording information relating to the circumstances of production of a manuscript (the place and/or people involved).

corroboratio
confirmatory clause in a *charter*.

decorated initial
initial letter composed of non-figural, non-*zoomorphic* elements.

display script
decorative script, generally incorporating higher-grade letter-forms, generally used (along with an enlarged initial) to emphasise textual openings.

dispositio
clause in a *charter* giving the details of a grant of land.

escutcheon
decorative metal mount used to suspend *Insular* hanging-bowls.

evangelist symbols
the evangelists, in their symbolic guise, derived from the vision of Ezekiel: Matthew the Man, Mark the Lion, Luke the Bull, and John the Eagle.

explicit
the end of a text.

folio
sheet of *vellum*, one half of a *bifolium* (can also be used to indicate volume size).

groze
to nip to shape with pincers the edges of a glass pane, prior to setting in a lead framework.

Hiberno-Saxon
term used to signify the cultural overlap between Ireland and England, of particular relevance to Northumbria.

hide
unit of assessment of land, used for various administrative purposes, particularly taxation. Originally defined as the area of land necessary to support one household, so varied in extent in different parts of the country. Often defined in the later Anglo-Saxon period as 120 acres, but larger and smaller hides were frequently found.

historiated initial
initial letter containing a scene or figure germane to the text of the manuscript.

incipit
the opening of a text.

Insular
term used to signify the close cultural interaction of Great Britain and Ireland during the period *c.* 550–900, which sometimes obviates the need to differentiate between areas.

invocation
when used of documents, a clause at the beginning of a *charter* invoking the aid of God and his saints in making a grant.

litterae notabiliores
enlarged letters within the text.

majuscule
an 'upper-case' script, whose letters are confined between two lines (bilinear).

mancus/mancusae
generally signifies a unit of *c.* 4.25g of gold, but also used as a unit of value and account equivalent to thirty silver pennies; it occasionally took the form of an actual gold coin.

marver
to smooth applied coloured glass decoration on to the body of an object by rolling on a flat, cold, smooth surface, originally marble.

medalet
invented word denoting a small donative coin or coin-like plaque, mounted for suspension.

millefiori
literally 'thousand flowers': decorative glass inlays produced by cutting transverse slices from thin bundles of multi-coloured glass rods.

minuscule
a 'lower-case' script, whose letters incorporate ascenders and descenders, occupying four lines (quattrolinear).

niello
a soft black sulphide inlay, usually of silver or copper, occasionally a mix of both.

octofoil
eight-lobed pattern.

opus signinum
form of flooring in the Roman tradition, made of crushed tile or brick in a concrete base.

pelta
decorative motif with one convex and two concave sides, named after a classical shield which it resembles.

Phase I
term applied to the *Insular* system of scripts to denote its earlier stages of development, prior to *c.* 700 (although Phase I continues alongside *Phase II* in Ireland after this date – see below).

Phase II
term applied to the *Insular* system of scripts in its fully developed form, from *c.* 700 (see above).

pontil
metal rod used to transfer a blown glass vessel from the blower's pipe to enable the rim to be shaped and finished.

proem
clause at the beginning of a *charter*, developing the religious sentiments of the *invocation*.

quires
the 'gatherings' or 'booklets' of which a book is formed.

repoussé
technique of decorating sheet metal by impressing it from the back.

reticella
applied decoration on glass beads and vessels, composed of twisted multi-coloured glass rods.

sanctio
clause in a *charter* describing the penalties (usually excommunication) to be incurred by those who infringe the grant.

sceat/sceattas
originally denoted a weight of gold equivalent to a twentieth part of a gold *tremissis*, but used since the seventeenth century to denote the earliest Anglo-Saxon silver pennies.

scriptorium
writing office, generally (but not exclusively) of a church or monastery.

scutiform
shield-shaped, specifically used of disc pendants with a bossed centre (like a Germanic shield).

solidus
standard late Roman and Byzantine gold coin weighing *c.* 4.5g; a lighter series weighing *c.* 4.25g issued in Italy was copied by Germanic rulers in the West.

styca
Old English word meaning 'piece, bit', reused since the seventeenth century to denote a small Northumbrian copper-alloy coin, a debased continuation of the *sceat* series.

Style I
term applied to a form of predominantly *zoomorphic* decoration current in the fifth and sixth centuries in Germanic societies, especially in Scandinavia and England (see also pp. 47–8).

Style II
term applied to a style of *zoomorphic* decoration which superseded *Style I* in the late sixth/early seventh century (see also pp. 47–8).

stylus
pointed implement, generally of metal or bone, used for writing on wax; may also be used for pricking and ruling layout on sheets of *vellum*.

trail
term used in glass-blowing to denote an applied thread of glass used to decorate the surface of a vessel.

tremissis
late Roman and Byzantine gold coin, equivalent to a third of a *solidus*, widely copied by Germanic rulers in the West. The term 'thrymsa', used since the seventeenth century to describe the early Anglo-Saxon gold coins of similar weight, is derived from this word.

Trewhiddle style
decorative metalwork style widespread in the ninth century, named after the Cornish find-place of the hoard in which it was first recognised (see also pp. 220–1).

triquetra
triple loop formed of three intersecting arcs, sometimes used in contexts where it may have symbolic intent.

vellum
term often used generically to denote animal skin prepared to receive writing, although it is more correctly applied to calf-skin and the term parchment to sheep or goat-skin.

wergild
compensation payable for causing harm or loss. The money could be paid by the perpetrator, their family or lord to the victim, their family or lord.

zoo-anthropomorphic
composed of human figures with beast-heads.

zoomorphic
composed of animal forms.

Bibliography

ABBREVIATIONS USED

AJA	*American Journal of Archaeology*
Ant. J.	*The Antiquaries Journal*
Arch. Cant.	*Archaeologia Cantiana*
Arch. J.	*Archaeological Journal*
Arch. Korr.	*Archäologisches Korrespondenzblatt*
Beds. Arch. J.	*Bedfordshire Archaeological Journal*
BerRGK	*Berichte der Römisch-Germanischen Kommission*
BAR	British Archaeological Reports
BNJ	*British Numismatic Journal*
JBAA	*Journal of the British Archaeological Association*
JRSAI	*Journal of the Royal Society of Antiquaries of Ireland*
JSA	*Journal of the Society of Archivists*
Med. Arch.	*Medieval Archaeology*
NC	*Numismatic Chronicle*
PBA	*Proceedings of the British Academy*
PCAS	*Proceedings of the Cambridge Antiquarian Society*
PRIA	*Proceedings of the Royal Irish Academy*
PSA	*Proceedings of the Society of Antiquaries of London*
PSAS	*Proceedings of the Society of Antiquaries of Scotland*
YAJ	*Yorkshire Archaeological Journal*

ÅBERG, N. 1926. *The Anglo-Saxons in England*, Uppsala

ADDYMAN, P. V. and HILL, D. H. 1969. 'Saxon Southampton: A Review of the Evidence. Part ii: Industry, Trade and Everyday Life', *Proceedings of the Hampshire Field Club* XXVI, 61–96

ALEXANDER, J. J. G. 1978. *Insular Manuscripts 6th to 9th century* (A Survey of Manuscripts Illustrated in the British Isles, vol. I), London

ALEXANDER, J. J. G., BROWN, T. J. and GIBBS, J. (eds) 1984. *Francis Wormald: Collected Writings*, I, *Studies in Medieval Art from the Sixth to the Twelfth Centuries*, Oxford

ALLAN, J. 1914. 'Offa's imitation of an Arab dinar', *NC* XIV, fourth series, 77–89

AMBROZ, A. K. and ERDELI, I. F. (eds) 1982. *Drevnosti Epokhi Velikogo Pereseleniya Narodov v-vii Vekov*, Sovetsko-Vengerskiy Sbornik, Moscow

ANDERSON, A. C. and M. O. 1991. *Adomnan's Life of Columba*, 2nd edition, London

ANDREWS, P. forthcoming. 'Excavations at Six Dials', *The Archaeology of Southampton*

ARBMAN, H. 1937. *Schweden und das Karolingische Reich*, Kungl. Vitterhets Historie och Antikvitets Akadamiens, Stockholm

ARCHIBALD, M. M. 1982. 'A ship-type of Athelstan I of East Anglia', *BNJ* 52, 34–40

ARCHIBALD, M. M. 1985. 'The Coinage of Beonna in the Light of the Middle Harling Hoard', *BNJ* 55, 10–54

ARCHIBALD, M. M. 1990. 'Pecking and Bending: The Evidence of British Finds', in K. Jonsson and B. Malmer (eds), *Proceedings of the Sigtuna Symposium on Viking Age Coinage 1–4 June 1989*, Nova Series 6, London

ARCHIBALD, M. M. 1991. 'Anglo-Saxon and Norman lead objects with official coin types', in A. G. Vince (ed.), *Aspects of Saxo-Norman London* II, 333–53

ARCHIBALD, M. M. forthcoming. 'The finds from Barham, Suffolk', in M. A. S. Blackburn and D. M. Metcalf (eds), *Anglo-Saxon Productive Sites*, BAR, Oxford

ARCHIBALD, M. M. and COWELL, M. R. 1988. 'The Fineness of Northumbrian Sceattas', in W. A. Oddy (ed.), *Metallurgy in Numismatics*, London, vol. 2, 55–64

ARCHIBALD, M. M. and DHENIN, M. forthcoming. 'A possible *sceat* of Offa', *BNJ* 61

ARMSTRONG, E. C. R. and MACALISTER, R. A. S. 1920. 'Wooden Book with leaves indented and waxed found near Springmount Bog, Co. Antrim', *JRSAI* 50, 160–6

ARNOLD, M., GREEN, T., SCULLY, S. and WHITE, S. (eds) 1981. *On the Laws and Customs of England: Essays in Honor of Samuel E. Thorne*, Chapel Hill, North Carolina

ARRHENIUS, B. 1985. *Merovingian Garnet Jewellery: emergence and social implications*, Kungl. Vitterhets Historie och Antikvitets Akademiens, Stockholm

ARSLAN, E. (ed.) 1952. *Arte del primo millennio: Atti del II° convegno per lo studio dell' arte dell' alto medievo, Pavia, 1950*, Turin

ARWIDSSON, G. 1932. 'Some glass vessels from the boat cemetery at Valsgärde', *Acta Archaeologica*, III, 251–66

ARWIDSSON, G. 1942. *Die Gräberfeld von Valsgärde, I: Valsgärde 6*, Acta Musei Antiquitatum Septentrionalum Regiae Universitets Uppsalensis I, Uppsala

ARWIDSSON, G. 1977. *Die Gräberfunde von Valsgärde, III: Valsgärde 7*, Uppsala Universitets för Nordiska Fornsaker, Uppsala

ARWIDSSON, G. 1984. 'Glas', in G. Arwidsson (ed.), *Birka* II: 1, Stockholm, 203–12

ATKINS, I. and KER, N. R. (eds) 1944. *Catalogus Librorum Manuscriptorum Bibliothecae Wigorniensis, 1622–23, by Patrick Young*, Cambridge

ATTENBOROUGH, F. 1922. *The Laws of the Earliest English Kings*, Cambridge

AVENT, R. 1975. *Anglo-Saxon Disc and Composite Brooches*, BAR II, i and ii, Oxford

AVENT, R. and LEIGH, D. 1977. 'A Study of Cross Hatched Gold Foils in Anglo-Saxon Jewellery', *Med. Arch.* 21, 1–46

AVRIL, F. and STIRNEMANN, P. D. 1987. *Manuscrits enluminés d'origine insulaire VII°–XX° siècle*, Bibliothèque Nationale, Paris

BACKHOUSE, J. 1981. *The Lindisfarne Gospels*, Oxford

BACKHOUSE, J. 1989. 'Birds, beasts and initials in Lindisfarne's Gospel Books', in G. Bonner, D. Rollason and C. Stancliffe (eds), *St Cuthbert, his cult and his community to AD 1200*, 165–74

BACKHOUSE, J., TURNER, D. H. and WEBSTER, L. E. (eds) 1984. *The Golden Age of Anglo-Saxon Art 966–1066*, London

BAILEY, R. N. 1974. 'The Anglo-Saxon Metalwork from Hexham', in D. P. Kirby (ed.), *Saint Wilfrid at Hexham*, 141–67

BAILEY, R. N. 1977. 'A Cup-Mount from Brougham, Cumbria', *Med. Arch.* 21, 176–80

BAILEY, R. N. forthcoming. 'Sutton Hoo and Seventh-century Art'

BAKER, D. 1969. 'Excavations at Elstow Abbey, Bedfordshire, 1966–8, second Interim Report', *Beds. Arch. J.* 4, 27–41

BAKER, Rev. R.S. 1880. 'On the Discovery of Anglo-Saxon Remains at Desborough, Northamptonshire', *Archaeologia* XLV, ii, 466–71

BAKKA, E. 1963. 'Some English Decorated Metal Objects found in Norwegian Viking Graves', *Årbok för Universitetet i Bergen: Humanistik Serie*, no. 1, 1–66

BAKKA, E. 1965. 'Some Decorated Anglo-Saxon and Irish Metalwork Found in Norwegian Viking Graves', in A. Small (ed.), *The Fourth Viking Congress*, 32–40

BAKKA, E. 1966. 'The Alfred Jewel and Sight', *Ant. J.* XLVI, 277–82

BALDWIN BROWN, G. 1915. *The Arts in Early England*, vol. 4, *Saxon Art and Industry in the Pagan Period*, London

BALDWIN BROWN, G. 1921. *The Arts in Early England*, vol. 5, *The Christian Arts of Northumbria*, London

BALDWIN BROWN, G. 1931. 'The Lechmere Stone', *Ant. J.* XI, 226–8

BANGELS, S. and SMETS, L. (eds) 1989. *Middeleeuws Textiel in het Bijzonder in het Euregiogebied Maas-Rijn: Handelingen van het Congres, Alden Biesen 1989*, Sint-Truiden

BASSETT, S. (ed.) 1989. *The Origins of Anglo-Saxon Kingdoms*, Leicester

BASSETT, S. 1989. 'In Search of the Origins of Anglo-Saxon Kingdoms', in S. Bassett (ed.), *The Origins of Anglo-Saxon Kingdoms*, 3–27

BATELY, J.M. 1970. 'King Alfred and the Old English translation of Orosius', *Anglia* 88, 433–60

BATELY, J.M. 1981. *The Old English Orosius*, Early English Text Society, suppl. series, VI, Oxford

BATEMAN, T. 1861. *Ten Years Digging in Celtic and Saxon Hills in the Counties of Derby, Stafford and York, from 1848 to 1858*, London

BATTISCOMBE, C.F. (ed.) 1956. *The Relics of Saint Cuthbert*, Oxford

BAUMGARTNER, E. and KRUEGER, I. 1988. *Phoenix aus Sand und Asche, Glas des Mittelalters*, Bonn/Basel

BECKWITH, J. 1972. *Ivory Carvings in Early Medieval England*, London

DE BELFORT, A. 1893. *Description Générale des monnaies Mérovingiennes*, vol. 3, Paris

BIDDLE, M. 1965. 'Excavations at Winchester 1964', *Ant. J.* XLV, 230–61

BIDDLE, M. 1976. 'Towns', in D. Wilson (ed.), *The Archaeology of Anglo-Saxon England*, 99–150

BIDDLE, M. 1989. 'A City in Transition: 400–800', in M. Lobel and W. Johns (eds), *The British Atlas of Historic Towns*, III, *The City of London*, 20–9

BIDDLE, M. *et al.* 1990. *Object and Economy in Medieval Winchester* (Winchester Studies 7: ii, Artefacts from Medieval Winchester), 2 vols, Oxford

BIDDLE, M. and HUNTER, J. 1990. 'Early Medieval Window Glass', in M. Biddle *et al.* 1990, 350–86

BIDDLE, M. and KJØLBYE-BIDDLE, B. 1985. 'Repton 1985', *Bulletin of the CBA Churches Committee* 22, 1–5

BIERBRAUER, V. 1978. 'Zum "Rupertus"–Kreuz von Bischofshofen: ein insulares Denkmal northumbrischer Renaissance', *Arch. Korr.* 8, 223–30

BIERBRAUER, V. 1985. 'Das sogenannte Rupertuskreuz aus Bischofshofen', in H. Dopsch and R. Juffinger (eds), *Virgil von Salzburg: Missionar und Gelehrter*, Salzburg, 229–43

BIERBRAUER, V. 1988. 'Liturgische Gerätschaften aus Baiern und seinen Nachbarregionen in Spätantike und frühen Mittelalter: liturgie- und Kunstgeschichtliche Aspekte', in H. Dannheimer and H. Dopsch (eds), *Die Bajuwaren von Severin bis Tassilo 488–788*, 328–41

BINNS, J.W., NORTON, E.C. and PALLISER, D.M. 1990. 'The Latin Inscription on the Coppergate Helmet', *Antiquity* 64, 134–9

BIRCH, W. DE GRAY 1885–93. *Cartularium Saxonicum*, London

BIRCH, W. DE GRAY 1889. *An Ancient Manuscript of the Eighth or Ninth Century Formerly Belonging to St Mary's Abbey or Nunnaminster, Winchester*, London

BIRCH, W. DE GRAY 1892. *Liber Vitae: Register and Martyrology of New Minster and Hyde Abbey, Winchester*, Hampshire Record Society

BIRCH, W. DE GRAY 1900. *Catalogue of Seals in the Department of Manuscripts in the British Museum*, VI, London

BISCHOFF, B. 1967. 'Kreuz und Buch im Frühmittelalter und in die ersten Jahrhunderten der Spanischen Reconquista', *Mittelalterlich Studien* II, Stuttgart

BISCHOFF, B. 1990. *Latin Palaeography, Antiquity and the Middle Ages*, Cambridge

BISCHOFF, B. and BROWN, V. 1985. 'Addenda to Codices Latini Antiquiores', *Medieval Studies* 47, 317–66

BISCHOFSHOFEN 1984. *5000 Jahre Geschichte und Kultur*, Bischofshofen

BLACKBURN, M.A.S. 1985. 'A Preliminary account of the 9th century coins in the Ashdon (Steventon End) Hoard 1984', *Spink's Numismatic Circular* XCIII, no. 2, 43–4

BLACKBURN, M.A.S. (ed.) 1986. *Anglo-Saxon Monetary History: Essays in Memory of Michael Dolley*, Leicester

BLACKBURN, M.A.S. 1989. 'The Ashdon (Essex) Hoard and the Currency of the Southern Danelaw in the late 9th century', *BNJ* 59, 13–39

BLACKBURN, M.A.S. and PAGAN, H.E. 1986. 'A Revised Checklist of coin hoards from the British Isles c. 500–1100', in M.A.S. Blackburn (ed.), *Anglo-Saxon Monetary History*, 291–314

BLACKBURN, M.A.S., MARGESON, S. and ROGERSON, A. forthcoming. 'A Productive Middle or Late Saxon Site at Bawsey, Norfolk', in M.A.S. Blackburn and D.M. Metcalf (eds), *Anglo-Saxon Productive Sites*, BAR, Oxford

BLUNT, C.E. 1957. 'The coinage of Ecgbeorht, King of Wessex 802–39', *BNJ* 28, 467–76

BLUNT, C.E. 1958. 'An Offa-Iaenberht die link', *BNJ* 29, 8–9

BLUNT, C.E. 1960. 'Presidential Address. Ecclesiastical Coinage in England, Part I: to the Norman Conquest', *NC* XX, sixth series, i–xvii

BLUNT, C.E. 1961. 'The coinage of Offa', in R.H.M. Dolley (ed.), *Anglo-Saxon Coins*, 39–62

BLUNT, C.E. 1962. 'The coinage of Æthelred, Archbishop of Canterbury 870–89', *BNJ* 31, 43–4

BLUNT, C.E. 1969. 'The St. Edmund Memorial coinage', *Proceedings of the Suffolk Institute of Archaeology* 31, part 3, 234–55

BLUNT, C.E. 1985. 'Northumbrian coins in the name of Alwaldus', *BNJ* 55, 192–4

BLUNT, C. E. and DOLLEY, R. H. M. 1959. 'The hoard evidence for the coins of Alfred', *BNJ* 29, 220–47

BLUNT, C. E. and DOLLEY, R. H. M. 1968. 'A gold coin of the time of Offa', *NC* VIII, seventh series, 151–9

BLUNT, C. E., LYON, C. S. S. and STEWART, B. H. I. H. 1963. 'The Coinage of Southern England 796–840', *BNJ* 32, 1–74

BMA = BROOKE, G. C., 1922–6. 'Anglo-Saxon Acquisitions of the British Museum', *NC*

BMC = *A Catalogue of Coins in the British Museum*: KEARY, C. F. and POOLE, R. S. 1887, *Anglo-Saxon Series*, vol. I, London; GRUEBER, H. A. and KEARY, C. F. 1893, *Anglo-Saxon Series*, vol. II, London

BMS = DOLLEY, R. H. M. and MORRISON, K. F. 1966. *The Carolingian Coins in the British Museum*, London

BOND, E. A. 1873–8. *Facsimiles of Ancient Charters in the British Museum*, London

BONNER, G. (ed.) 1976. *Famulus Christi*, London

BONNER, G., ROLLASON, D. and STANCLIFFE, C. (eds) 1989. *St Cuthbert, his cult and his community to AD 1200*, Woodbridge

BOOTH, J. 1984. 'Sceattas in Northumbria', in D. Hill and D. M. Metcalf (eds), *Sceattas in England and on the Continent. The Seventh Oxford Symposium on Coinage and Monetary History*, BAR British Series 128, 71–112

BOWMAN, A. K. 1983. *The Roman Writing Tablets from Vindolanda*, London

BRAUNFELS, W. 1968. *Die Welt der Karolinger und ihre Kunst*, Munich

BRODRIBB, A. C. C., HANDS, A. R. and WALKER, D. R. 1972. *Excavations at Shakenoak Farm near Wilcote, Oxfordshire*, Part III, Site F, Oxford

BRØNDSTED, J. 1924. *Early English Ornament*, London/Copenhagen

BROOKS, N. 1964. 'The unidentified Forts of the Burghal Hidage', *Med. Arch.* 8, 74–90

BROOKS, N. 1971. 'The development of military obligations in eighth- and ninth-century England', in P. Clemoes and K. Hughes (eds), *England Before the Conquest: studies in primary sources presented to Dorothy Whitelock*, 69–84

BROOKS, N. 1979. 'England in the Ninth Century: the Crucible of Defeat', *Transactions of the Royal Historical Society* 29, fifth series, 1–20

BROOKS, N. 1984. *The Early History of the Church of Canterbury: Christ Church from 597 to 1066*, Leicester

BROOKS, N. 1989. 'The formation of the Mercian Kingdom', in S. Bassett (ed.), *The Origins of Anglo-Saxon Kingdoms*, 159–70

BROOKS, N. and GRAHAM-CAMPBELL, J. A. 1986. 'Reflections on the Viking Age Silver Hoard from Croydon, Surrey', in M. A. S. Blackburn (ed.), *Anglo-Saxon Monetary History*, 91–110

BROWN, D. 1982. *The Lichfield Gospels*, London

BROWN, G. H. 1987. *Bede the Venerable*, Boston

BROWN, M. P. 1987. 'Paris, Bibliothèque Nationale, MS lat. 10861 and the Scriptorium of Christ Church, Canterbury', *Anglo-Saxon England* 15, 119–37

BROWN, M. P. 1989. 'The Lindisfarne Scriptorium from the late 7th to the early 9th century', in G. Bonner, D. Rollason and C. Stancliffe (eds), *St Cuthbert, his cult and his community to AD 1200*, 151–63

BROWN, T. J. (ed.) 1969. *The Stonyhurst Gospel of St John*, Roxburghe Club, London

BROWN, T. J. 1984. 'The Oldest Irish Manuscripts and their Late Antique Background', in P. Ní Chatháin and M. Richter (eds), *Irland und Europa*, 311–27

BROWN, T. J. and MACKAY, T. W. 1988. 'Codex Vaticanus Palatinus Latinus 235', *Armarium Codicum Insignium IV*, Turnhout

BROWNE, G. 1897. *Theodore and Wilfrith*, London

BRUCE-MITFORD, R. L. S. 1947. *The Sutton Hoo Ship-Burial: A provisional guide*, London

BRUCE-MITFORD, R. L. S. 1956a. 'The Pectoral Cross', in C. F. Battiscombe (ed.), *The Relics of Saint Cuthbert*, 308–25

BRUCE-MITFORD, R. L. S. 1956b. 'Late Saxon Disc Brooches', in D. B. Harden (ed.), *Dark Age Britain*, 171–201

BRUCE-MITFORD, R. L. S. 1969. 'The Art of the Codex Amiatinus', *JBAA* 32, 1–26

BRUCE-MITFORD, R. L. S. 1974. *Aspects of Anglo-Saxon Archaeology*, London

BRUCE-MITFORD, R. L. S. 1975. *The Sutton Hoo Ship-Burial*, vol. I, London

BRUCE-MITFORD, R. L. S. 1978. *The Sutton Hoo Ship-Burial*, vol. II, *Arms, Armour and Regalia*, London

BRUCE-MITFORD, R. L. S. 1983. *The Sutton Hoo Ship-Burial*, vol. III, *Silver, Hanging-Bowls, Drinking Vessels, Containers, Musical Instruments, Textiles, Minor Objects*, London

BRUCE-MITFORD, R. L. S. 1989. 'The Durham–Echternach Calligrapher', in G. Bonner, D. Rollason and C. Stancliffe (eds), *St Cuthbert, his cult and his community to AD 1200*, 175–88

BRUNNER, J-J. 1988. *Der Schlüssel im Wandel der Zeit*, Bern/Stuttgart

BUCKTON, D. 1986. 'Late 10th and 11th Century Cloisonné Enamel Brooches', *Med. Arch.* 30, 8–18

BUCKTON, D. 1989. 'Further Examples of Late 10th and 11th Century Cloisonné Enamel Brooches', *Med. Arch.* 33, 153–5

BUDNY, M. 1984. 'The Anglo-Saxon Embroideries at Maaseik: their Historical and Art-Historical Context', *Medelingen van der Koniglijke Academie vor Wettenschappen, Lettern en Schone Kunsten von Belgie; Klasse der Schone Kunsten* XLV, no. 2, 118–19

BUDNY, M. 1985. 'London, British Library, MS Royal I.E.VI: the anatomy of an Anglo-Saxon Bible fragment', unpublished Ph.D. thesis, London University

BUDNY, M. and GRAHAM-CAMPBELL, J. A. 1981. 'An Eighth-Century Bronze Ornament from Canterbury and Related Works', *Arch. Cant.* XCVII, 7–25

BUDNY, M. and TWEDDLE, D. 1984. 'The Maaseik Embroideries', *Anglo-Saxon England* 13, 65–96

BUDNY, M. and TWEDDLE, D. 1985. 'The Early Medieval Textiles at Maaseik, Belgium', *Ant. J.* LXV, 353–89

BULLOUGH, D. A. 1973. *The Age of Charlemagne*, London

BUTLER, L. and GRAHAM-CAMPBELL, J. A. 1991. 'A lost shrine casket at Gwytherin, North Wales', *Ant. J.* LXX (i)

CAHEN, M. and OLSEN, M. 1930. *L'inscription runique du coffret de Mortain*, Paris

CALBERG, M. 1951. 'Tissus et Broderies attribués aux saintes Harlinde et Relinde', *Bulletin de la Société Royale d'Archéologie de Bruxelles*, Oct., 1–26

CAMPBELL, A. (ed.) 1953. *The Tollemache Orosius*, Early English Manuscripts in Facsimile 3, Copenhagen

CAMPBELL, A. 1973. *Charters of Rochester*, British Academy Corpus of Anglo-Saxon Charters 1, Oxford

CAMPBELL, J. 1982a. 'The First Christian Kings', in J. Campbell (ed.), *The Anglo-Saxons*, 45–69

CAMPBELL, J. (ed.) 1982b. *The Anglo-Saxons*, Oxford

CAPELLE, T. and VIERCK, H. 1971. 'Modeln der Merowinger und Wikingerzeit', *Frühmittelalterliche Studien* 5, 77–81

CAPELLE, T. and VIERCK, H. 1975. 'Weitere Modeln', *Frühmittelalterliche Studien* 9, 110–42

CARLYON-BRITTON, P. W. P. 1908. 'The gold mancus of Offa, King of Mercia', *BNJ* 5, 55–72

CARR, R. D., TESTER, A. and MURPHY, P. 1988. 'The Middle Saxon Settlement at Staunch Meadow, Brandon', *Antiquity* LXII, 371–7

CARSON, R. A. G. 1961. 'Hollingbourne treasure trove', *NC* 1, seventh series, 211–23

CARSON, R. A. G. and KRAAY, C. M. (eds) 1978. *Scripta Nummaria Romana: Essays presented to Humphrey Sutherland*, London

CARVER, M. forthcoming. 'Chapter 7: Roman to Norman at York Minster', in A.D. Phillips with B. Haywood, *Excavations at York Minster*, 1

CATHER, S., PARK, D. and WILLIAMSON, P. (eds) 1990. *Early Medieval Wall Painting and Painted Sculpture*, BAR 216, Oxford

CHADWICK, N. (ed.) 1958. *Studies in the Early British Church*, Cambridge

CHAPLAIS, P. 1965. 'The Origin and Authenticity of the Royal Anglo-Saxon Diploma', *JSA* 3, 48–61

CHAPLAIS, P. 1968. 'Some Early Anglo-Saxon Diplomas on Single Sheets: Originals or Copies?', *JSA* 3, 315–36

CHARLEMAGNE 1965. *Charlemagne: œuvre, rayonnement et survivances*, Dixième exposition sous les auspices du conseil de l'Europe, Aix-la-Chapelle

CHARLESTON, R. J. 1984. *English Glass*, London

CHASE, C. (ed.) 1981. *The Dating of Beowulf*, Toronto

CH 1 = *Coin Hoards*, vol. 1, 1975, The Royal Numismatic Society, London

ChLA = *Chartae Latinae Antiquiores*, vols III (British Museum) and IV (other British repositories), A. Bruckner and R. Marichal (eds), Olten/Lausanne, 1963–7

CLA = LOWE, E. A. 1934–72. *Codices Latini Antiquiores* (eleven volumes and supplement), Oxford

CLARKE, J. and HINTON, D. A. 1971. *The Alfred and Minster Lovell Jewels*, 3rd edition, Oxford

CLEMOES, P. and HUGHES, K. (eds) 1971. *England Before the Conquest: studies in primary sources presented to Dorothy Whitelock*, Cambridge

COATSWORTH, E. 1989. 'The Pectoral Cross and Portable Altar from the Tomb of St Cuthbert', in G. Bonner, D. Rollason and C. Stancliffe (eds), *St Cuthbert, his cult and his community to AD 1200*, 287–300

COLGRAVE, B. (ed.) 1927. *The Life of Bishop Wilfrid by Eddius Stephanus*, Cambridge

COLGRAVE, B. (ed.) 1940. *Two Lives of St Cuthbert*, Cambridge

COLGRAVE, B. (ed.) 1956. *Felix's Life of St Guthlac*, Cambridge

COLGRAVE, B. and MYNORS, R. A. B. (eds) 1969. *Bede's Ecclesiastical History of the English People*, Oxford

COLLINGWOOD, P. 1982. *The Techniques of Tablet Weaving*, London

COLLINGWOOD, W. G. 1907. 'Anglian and Anglo-Danish Sculpture in the North Riding of Yorkshire', *YAJ* 19, 267–413

COLLINGWOOD, W. G. 1927. *Northumbrian Crosses of the Pre-Norman Age*, London

COLLINS, R. L. 1985. 'King Alfred's *Aestel* reconsidered', *Leeds Studies in English*, new series XVI, 37–58

CRAMER, P. 1989. 'Ernulf of Rochester and Early Anglo-Norman Canon Law', *Journal of Ecclesiastical History* 40, 483–510

CRAMP, R. J. 1967a. *Anglian and Viking York*, Borthwick Papers no. 33, York

CRAMP, R. J. 1967b. *The Monastic Arts of Northumbria*, Arts Council exhibition catalogue, London

CRAMP, R. J. 1969. 'Excavations at the Saxon Monastic Sites of Wearmouth and Jarrow: an interim report', *Med. Arch.* 13, 24–66

CRAMP, R. J. 1970a. 'Glass finds from the Anglo-Saxon monastery at Monkwearmouth and Jarrow', *Studies in Glass History and Design, 8th International Congress on Glass, London 1968*, Sheffield, 16–19

CRAMP, R. J. 1970b. 'Decorated window-glass and millefiori from Monkwearmouth', *Ant. J.* 1, 327–35

CRAMP, R. J. 1972. 'Tradition and Innovation in English Sculpture of the Tenth to Eleventh Centuries', in V. Milojcic (ed.), *Kolloquium über spätantike und frühmittelalterlich Skulptur*, vol. 1, 139–48

CRAMP, R. J. 1974. 'Early Northumbrian Sculpture at Hexham', in D. P. Kirby (ed.), *Saint Wilfrid at Hexham*, 115–40, 172–9

CRAMP, R. J. 1975. 'Window-glass from the monastic site of Jarrow', *Journal of Glass Studies* 17, 88–96

CRAMP, R. J. 1976a. 'Analysis of the finds register and location plan of Whitby Abbey', in D. M. Wilson (ed.), *The Archaeology of Anglo-Saxon England*, 453–8

CRAMP, R. J. 1976b. 'Jarrow Church', *Arch. J.* 133, 220–8

CRAMP, R. J. 1976c. 'Monastic Sites', in D. M. Wilson (ed.), *The Archaeology of Anglo-Saxon England*, 201–52

CRAMP, R. J. 1977. 'Schools of Mercian Sculpture', in A. Dornier (ed.), *Mercian Studies*, 191–233

CRAMP, R. J. 1978. 'The Anglian Tradition in the Ninth Century', in J. T. Lang (ed.), *Anglo-Saxon and Viking-Age Sculpture*, 1–32

CRAMP, R. J. 1980. *The Bede Monastery Museum Guide Book*, Jarrow

CRAMP, R. J. 1984. *British Academy Corpus of Anglo-Saxon Stone Sculpture*, 1, *County Durham and Northumberland*, Oxford

CRAMP, R. J. (ed.) 1989. *Anglo-Saxon Connections*, Durham

CRAMP, R. J. and CRONYN, J. 1990. 'Anglo-Saxon Polychrome Plaster and Other Materials from the Excavations of Monkwearmouth and Jarrow: an Interim Report', in S. Cather, D. Park and P. Williamson (eds), *Early Medieval Wall Painting and Painted Sculpture*, 17–30

CRAMP, R. J. and DANIELS, R. 1987. 'New Finds from the Anglo-Saxon Monastery at Hartlepool, Cleveland', *Antiquity* LXI, 424–31

CRAMP, R. J. and LANG, J. T. 1977. *A Century of Anglo-Saxon Sculpture*, Newcastle upon Tyne

CROSSLEY-HOLLAND, K. 1982, reprinted 1987. *The Anglo-Saxon World: An Anthology*, Oxford

CROWFOOT, E. and HAWKES, S. C. 1967. 'Early Anglo-Saxon gold braids', *Med. Arch.* 11, 42–86

CTCE = Blunt, C. E., Stewart, B. H. I. H. and Lyon, C. S. S. 1989.

Coinage in Tenth-Century England from Edward the Elder to Edgar's Reform, Oxford

DANNHEIMER, H. and DOPSCH, H. (eds) 1988. *Die Bajuwaren von Severn bis Tassilo 488–788*, Rosenheim

DAVIES, W. and VIERCK, H. 1974. 'The contexts of the Tribal Hidage: social aggregates and settlement patterns', *Frühmittelalterliche Studien* 8, 223–93

DAVIS, R. H. C. 1971. 'Alfred the Great: Propaganda and Truth', *History* 56, 169–82

DAVIS, R. H. C. 1982. 'Alfred and Guthrum's Frontier', *English Historical Review* 97, 803–10

DE BOECK, J. 1989. 'Restauratie van de textielstukken uit Maaseik', in S. Bangels and L. Smets (eds), *Middeleeuws Textiel in het Bijzonder in het Euregiogebied Maas-Rijn*, 66–77

DE PAOR, L. 1960–1. 'Some Vine Scrolls and other Patterns in Embossed Metal from Dumfriesshire', *PSAS* XCIV, 184–95

DICKINSON, T. 1990. 'Early Medieval Objects: The Metal Objects', in M. R. McCarthy, *A Roman, Anglian and Medieval Site at Blackfriars, Carlisle: Excavations 1977–9*, 181

DIDIER, R. and LEMEUNIER, A. 1988. 'La châsse de Saint Hadelin de Celles-Visé', in *Trésors d'art religieux au Pays de Visé et Saint Hadelin*, 94–200

DODWELL, C. R. 1982. *Anglo-Saxon Art: A New Perspective*, Manchester

DOLLEY, R. H. M. 1954. 'The "Jewel Cross" Coinage of Ælfgifu Emma, Harthacnut and Harold I', *BNJ* 27, 266–75

DOLLEY, R. H. M. 1955. 'Three Merovingian tremisses', *British Museum Quarterly* XX (1), 13–15

DOLLEY, R. H. M. 1956. 'A new type for Eadberht "Praen"', *BNJ* 28, 243–8

DOLLEY, R. H. M. (ed.) 1961. *Anglo-Saxon Coins*, London

DOLLEY, R. H. M. 1963. 'An unpublished hoard provenance for a penny of Ceolwulf II of Mercia', *BNJ* 32, 88–90

DOLLEY, R. H. M. 1970. 'The location of the pre-Ælfredian mint(s) of Wessex', *Proceedings of the Hampshire Field Club and Archaeological Society* 27, 57–61

DOLLEY, R. H. M. and BLUNT, C. E. 1961. 'The Chronology of the Coins of Ælfred the Great, 871–899', in R. H. M. Dolley (ed.), *Anglo-Saxon Coins*, 77–95

DOLLEY, R. H. M. and SKAARE, K. 1961. 'The coinage of Æthelwulf, King of the West Saxons, 839–858', in R. H. M. Dolley (ed.), *Anglo-Saxon Coins*, 63–76

DOPPELFELD, O. 1964. 'Das Fränkischen Knabengrab unter dem Chor der Kölner Domes', *Germania* 42, 156–88

DORNIER, A. (ed.) 1977. *Mercian Studies*, Leicester

The Douce Legacy: an exhibition to commemorate the 150th anniversary of the bequest of Francis Douce (1757–1834) 1984. Bodleian Library, Oxford

DUCATI, P. 1923–4. 'L'anello del Reno', *Bolletino d'Arte*, anno III, serie iii, vol. primo, 241–7

DUCKETT, E. S. 1951. *Alcuin, Friend of Charlemagne*, New York

DÜMMLER, E. (ed.) 1895. 'Alcuini Epistolae', *Monumenta Germaniae Historica: Epistolae Karolini Aevi*, II, Berlin

DUMVILLE, D. N. 1972. 'Liturgical Drama and Panegyric Responsory from the Eighth Century? A Re-examination of the origin and contents of the ninth-century section of the Book of Cerne', *Journal of Theological Studies*, new series XXIII, part 2, 374–406

DUMVILLE, D. N. 1976. 'The Anglian Collection of Royal Genealogies and Regnal Lists', *Anglo-Saxon England* 5, 23–50

DUMVILLE, D. N. 1977. 'Kingship, genealogies and regnal lists', in P. Sawyer and I. N. Wood (eds), *Early Medieval Kingship*, 72–104

DUMVILLE, D. N. 1985. 'The West Saxon Genealogical Regnal List and the Chronology of Early Wessex', *Peritia* 4, 21–66

DUMVILLE, D. N. 1986. 'The West Saxon Genealogical Regnal List: Manuscripts and Texts', *Anglia* 104, 1–32

DUMVILLE, D. N. 1989a. 'Essex, Middle Anglia, and the Expansion of Mercia in the South-East Midlands', in S. Bassett (ed.), *The Origins of Anglo-Saxon Kingdoms*, 123–40

DUMVILLE, D. N. 1989b. 'The Tribal Hidage: an introduction to its texts and history', in S. Bassett (ed.), *The Origins of Anglo-Saxon Kingdoms*, 225–30

DUMVILLE, D. N. and KEYNES, S. 1983–6. *The Anglo-Saxon Chronicle: a collaborative edition*, Cambridge

EAST, K. and WEBSTER, L. E. forthcoming. *The Taplow, Broomfield and Caenby Burials*, London

EHWALD, E. 1919. 'Aldhelmi Opera', *Monumenta Germaniae Historica, Auctorum antiquissimorum* 15, Berlin

ELBERN, V. 1990. 'Zwischen England und Oberitalien: die sogenannte insulare Kunstprovinz in Salzburg', *Jahres- und Tagungsbericht der Görres-Gesellschaft, 1989*, Köln, 96–111

EVANS, A. 1942. 'Notes on early Anglo-Saxon coins', *NC* II, sixth series, 19–41

EVANS, A. C. forthcoming. 'The Anglo-Saxon finds from Garton Station, East Yorkshire'

EVISON, V. I. 1961. 'The Palace of Westminster Sword', *Archaeologia* 98, 123–58

EVISON, V. I. 1968. 'Quoit Brooch Style Buckles', *Ant. J.* XLVIII, 231–50

EVISON, V. I. 1969. 'The seax and belt fitting', in J. W. G. Musty, 'The excavation of two barrows, one of Saxon date, at Ford, Laverstock, near Salisbury, Wilts', *Ant. J.* XLIX, 114–16

EVISON, V. I. 1977. 'An Enamelled Disc from Great Saxham', *Proceedings of the Suffolk Institute of Archaeology* 34, part 1, 1–13

EVISON, V. I. 1979. *Wheel Thrown Pottery in Anglo-Saxon Graves*, Royal Archaeological Institute, London

EVISON, V. I. 1982. 'Anglo-Saxon glass claw beakers', *Archaeologia* CVII, 43–76

EVISON, V. I. 1983a. 'Bichrome glass vessels of the seventh and eighth centuries', *Studien zur Sachsenforschung* 3, 7–21

EVISON, V. I. 1983b. 'Some distinctive glass vessels of the post-Roman period', *Journal of Glass Studies* 25, 87–93

EVISON, V. I. 1988a. 'Some Vendel, Viking and Saxon glass', in B. Hårdh, L. Larsson, D. Olavsson and R. Petré (eds), *Trade and Exchange in Prehistory*, Acta Archaeologica Lundensia series in 80, no. 16, 237–45

EVISON, V. I. 1988b. 'Vieux-Marché, Place Saint-Lambert, Liège – The glass', in M. Otte, *Les Fouilles de la Place Saint-Lambert à Liège, 2, Le Vieux Marché*, Études et Recherches Archéologiques de l'Université de Liège 13, 215–19

EVISON, V. I. 1989. 'Le verre carolingien', in D. Foy and G. Sennequier (eds), *à travers le verre du moyen age à la renaissance*, Musées et monuments départementaux de la Seine Maritime, Rouen

EVISON, V. I. 1990. 'Red marbled glass, Roman to Carolingian', *Annales du 11e Congrès de l'Association pour l'Histoire du Verre, Bâle 1988*, 217–28

EVISON, V. I. forthcoming a. 'Glass fragments from Jubilee Hall, Covent Garden and Maiden Lane, London', *Transactions of the London and Middlesex Archaeological Society*

EVISON, V. I. forthcoming b. 'Glass fragments', in Carver, M. forthcoming

EVISON, V. I. forthcoming c. 'Glass fragments from Bedfordbury', *Transactions of the London and Middlesex Archaeological Society*

FARLEY, M. forthcoming. 'A Trewhiddle Style Garment Hook from High Wycombe, Buckinghamshire', *Med. Arch.*

FARMER, D. H. 1974. 'Guthlac von Crowland', *Lexicon der christlichen Ikonographie* VI, col. 466

FARRELL, R. T. (ed.) 1982. *The Vikings*, London/Chichester

FAUSSETT, B. 1856. *Inventorium Sepulchrale*, C. Roach Smith (ed.), London

FELL, C. 1984. 'A *friwif locbore* revisited', *Anglo-Saxon England* 13, 157–65

FILLITZ, H. 1963. 'Zum sogenannte Rupertuskreuz aus Bischofshofen', *Österreichische Zeitschrift für Kunst- und Denkmalpflege* 17, 184–5

FILLITZ, H. and PIPPAL, M. 1987. *Schatzkunst: die Goldschmiede- und Elfenbeinarbeiten aus österreichischen Schatzkammern des Hochmittelalters*, Salzburg/Vienna

FINK, A. 1957. 'Zum Gandersheimer Runenkästchen', in F. Geke, G. von Opel and H. Schnitzler (eds), *Karolingische und Ottonische Kunst, Werden, Wesen, Wicklung*, 277–81

FLOWER, R. and SMITH, H. (eds) 1941, reprinted 1973. *The Parker Chronicle and Laws, a facsimile*, Early English Text Society, original series, no. 208

FLURY-LEMBERG, M. 1988. *Textile Conservation and Research*, Bern

FORT, E. T. 1991. 'Some Notes on the Ship Coinage of Athelstan I of East Anglia', *Spink's Numismatic Circular* XCIX, no. 3, 80–2

FOX, C. 1924. 'Excavations at Foxton, Cambridgeshire in 1922', *PCAS* XXV, 37–46

FRANCE-LANORD, A. and FLEURY, M. 1962. 'Das Grab der Arnegundis in Saint-Denis', *Germania* 40, 341–59

GABORIT-CHOPIN, D. 1978. *Ivoires du moyen âge*, Fribourg

GALBRAITH, V. H. 1964. *An Introduction to the Study of History*, London

Gariel = GARIEL, E. 1883–4. *Les Monnaies royales de France sous la race carolingienne*, 2 vols, Strasbourg

GARMONSWAY, G. N. 1953. *The Anglo-Saxon Chronicle*, London

GEKE, F., VON OPEL, G. and SCHNITZLER, H. (eds) 1957. *Karolingische und Ottonische Kunst, Werden, Wesen, Wicklung*, Forschungen zur Kunstgeschichte und christliche Archäologie 3, Wiesbaden

GNEUSS, H. 1986. 'King Alfred and the history of Anglo-Saxon Libraries', in R. Rugg Brown et al. (eds), *Modes and Interpretations in Old English Literature*, 29–49

GODMAN, P. (ed.) 1982. *Alcuin: The Bishops, Kings and Saints of York*, Oxford

GOLDSCHMIDT, A. 1914. *Die Elfenbeinskulpturen aus der Zeit der Karolingischen und Sächsischen Kaiser, VIII.–XI. Jahrhundert*, I, Berlin

GOLDSCHMIDT, A. 1918. *Die Elfenbeinskulpturen aus der Zeit der Karolingischen und Sächsischen Kaiser, VIII.–XI. Jahrhundert*, II, Berlin

GOLDSCHMIDT, A. 1923. *Die Elfenbeinskulpturen aus der Romanischen Zeit XI.–XIII. Jahrhundert*, III, Berlin

GOODALL, I. 1990. 'Locks and Keys', in M. Biddle *et al.*, *Object and Economy in Medieval Winchester*, II, 1016–17

GRABAR, A. 1936. *L'empereur dans l'art byzantin. Recherches sur l'art officiel de l'empire d'Orient*, Paris, reprinted 1971, London

GRAHAM-CAMPBELL, J. A. 1973. 'The 9th Century Anglo-Saxon Horn-Mount from Burghead, Morayshire, Scotland', *Med. Arch.* 17, 43–51

GRAHAM-CAMPBELL, J. A. 1980. *Viking Artefacts*, London

GRAHAM-CAMPBELL, J. A. 1982. 'Some New and Neglected Finds of 9th Century Anglo-Saxon Ornamental Metalwork', *Med. Arch.* 26, 144–51

GRAHAM-CAMPBELL, J. A. 1988. 'Two 9th Century Strap-Ends from East Sussex', *Sussex Archaeological Collections* 126, 239–40

GRANGER-TAYLOR, H. 1989. 'The Weft-Patterned Silks and their Braid: the remains of an Anglo-Saxon dalmatic of c. 800?', in G. Bonner, D. Rollason and C. Stancliffe (eds), *St Cuthbert, his cult and his community to AD 1200*, 303–27

GRANGER-TAYLOR, H. 1990. 'The Earth and Ocean Silk from the Tomb of St Cuthbert at Durham', in L. Monnas and H. Granger-Taylor (eds), *Ancient and Medieval Textiles – Studies in Honour of Donald King*, 151–66

GRANT, R. 1974. 'Lawrence Nowell's Transcript of BM Cotton Otho B.xi', *Anglo-Saxon England* 3, 111–24

GREEN, B. 1971. 'An Anglo-Saxon Plaque from Larling, Norfolk', *Ant. J.* LI, 321–3

GREEN, B. 1980. 'Two 9th Century Silver Objects from Costessey', *Norfolk Archaeology* XXXVII (iii), 351–3

GRIERSON, P. 1952–4. 'The Canterbury (St Martin's) Hoard of Frankish and Anglo-Saxon Coin-Ornaments', *BNJ* 27, 39–51

GRIERSON, P. 1962. 'The authenticity of the York "thrymsas"', *BNJ* 31, 8–10

GRIERSON, P. 1963. 'The gold *solidus* of Louis the Pious and its imitations', *Jaarboek voor Munt- en Penningkunde* 38, 1–41

GRIERSON, P. and BLACKBURN, M. 1986. *Medieval European Coinage*, I, *The Early Middle Ages (5th–10th centuries)*, Cambridge

GUILDHALL MUSEUM 1903. *Catalogue of the Collection of London Antiquities in the Guildhall Museum*, London

HABEREY, W. 1961. 'Das frühchristliche Frauengrab von St Aldegund', *Germania* 39, 128–42

HADDAN, A. W. and STUBBS, W. 1869–71. *Councils and Ecclesiastical Documents relating to Great Britain and Ireland*, Oxford

HAEVERNICK, T. E. 1979. 'Karolingisches Glas aus St Dionysius in Esslingen', *Forschungen und Berichte der Archaeologie des Mittelalters in Baden-Württemburg* 6, 157–69

HAEVERNICK, T. E. and HABEREY, W. 1963. 'Glattsteine aus Glas', *Jahrbuch des Römisch-Germanischen Zentralmuseums Mainz* X, 130–8

HALL, R. 1986. *The Viking Dig: The Excavations at York*, London

HANSEN, U. L. 1987. *Römischer Import im Norden*, Copenhagen

HARBISON, P. 1970. 'How Old is Gallarus Oratory?', *Med. Arch.* 14, 34–59

HARDEN, D. B. (ed.) 1956. *Dark Age Britain: Studies Presented to E. T. Leeds*, London

HARDEN, D. B. 1956. 'Glass vessels in Britain and Ireland AD 400–1000', in D. B. Harden (ed.), *Dark Age Britain*, 132–67

HARDEN, D. B. 1972. 'The glass', in A. C. C. Brodribb, A. R. Hands and D. R. Walker, *Excavations at Shakenoak Farm near Wilcote, Oxfordshire*, 67–9

HARDEN, D. B. 1978. 'Anglo-Saxon and later medieval glass in Britain: some recent developments', *Med. Arch.* 22, 1–24

HARMER, F. E. 1914. *Select English Historical Documents of the Ninth and Tenth Centuries*, Cambridge

HART, C. 1971. 'The Tribal Hidage', *Transactions of the Royal Historical Society* XXI, fifth series, 133–57

HASELOFF, G. 1951. *Der Tassilokelch*, Munich

HASELOFF, G. 1990. *Email im frühen Mittelalter: frühchristliche Kunst von der Spätantike bis zu den Karolingern* (Marburger Studien zur Vor- und frühgeschichte, Sonderband 1), Marburg

HAUCK, K. 1974. 'Das Einhardkreuz: mit einem Anhang zu den Problemen des Rupertus-Kreuzes', *Frühmittelalterliche Studien* 8, 105–15

HAWKES, S. C. 1973. 'Finds from the Anglo-Saxon cemetery at Eccles, Kent', *Ant. J.* LII, 281–6

HAWKES, S. C., DAVIDSON, H. R. and HAWKES, C. 1965. 'The Finglesham Man', *Antiquity* XXIX, 17–32

HAWKES, S. C. and GROVE, L. R. A. 1963. 'Finds from a Seventh-Century Anglo-Saxon Cemetery at Milton Regis', *Arch. Cant.* LXXVIII, 22–38

HAWKES, S. C., MERRICK, J. M. and METCALF, D. M. 1966. 'X-ray fluorescent analysis of some dark age coins and jewellery', *Archaeometry* 9, 98–138

HAWKES, S. C., SPEAKE, G. and NORTHOVER, P. 1979. 'A seventh-century bronze metalworker's die from Rochester, Kent', *Frühmittelalterliche Studien* 13, 383–92

HEDERGOTT, B. 1981. *Kunst des Mittelalters: Herzog Anton Ulrich-Museum, Braunschweig*, Braunschweig

HEIL, W. 1970. *Alkuinstudien*, Düsseldorf

HENCKEN, H. O'N. 1950–1. 'Lagore Crannog: an Irish royal residence of the 7th to 10th centuries AD', *PRIA* 53c, 1–237

HENDERSON, G. 1987. *From Durrow to Kells: the Insular Gospel Books 650–800*, Oxford

HENIG, M. 1974. *A Corpus of Roman Engraved Gemstones from British Sites*, BAR British Series 8, Oxford

HENRY, F. 1965. *Irish Art During the Early Christian Period to 800 AD*, London

HENRY, F. 1974. *The Book of Kells: Reproductions from the manuscript in Trinity College, Dublin*, London

HERREN, M. 1974. *The Hisperica Famina*, I, *The A-Text*, Toronto

HERREN, M. (ed.) 1981. *Insular Latin Studies*, Toronto

HESSELS, J. H. 1890. *An 8th Century Latin–Anglo-Saxon Glossary*, Cambridge

HEYWORTH, M. 1988. 'Glass from Quentovic', *Stained Glass*, Spring, 16

HICKS, C. 1978. 'The Stag', in R. L. S. Bruce-Mitford, *The Sutton Hoo Ship-Burial*, II, 378–82

HIGGITT, J. 1979. 'The Dedication Inscription at Jarrow and its Context', *Ant. J.* LIV, 343–74

HILL, D. 1969. 'The Burghal Hidage: the Establishment of a Text', *Med. Arch.* 13, 84–92

HILL, D. and METCALF, D. M. (eds) 1984. *Sceattas in England and on the Continent. The Seventh Oxford Symposium on Coinage and Monetary History*, BAR British Series 128, Oxford

HINES, J. 1984. *The Scandinavian Character of Anglian England in the pre-Viking Period*, BAR 124, Oxford

HINTON, D. A. 1974. *A Catalogue of the Anglo-Saxon Ornamental Metalwork in the Department of Antiquities*, Ashmolean Museum, Oxford

HINTON, D. A. 1990. 'Hooked Tags', in M. Biddle *et al.*, *Object and Economy in Medieval Winchester*, II, 549–51

HINTON, D. A., KEENE, S. and QUALMAN, K. E. 1981. 'The Winchester Reliquary', *Med. Arch.* 25, 45–77

HODGES, R. 1982. *Dark Age Economics: the origins of towns and trade, 600–1000*, London

HODGES, R. 1989. *The Anglo-Saxon Achievement*, London

HOLMQVIST, W. and ARRHENIUS, B. 1964. *Excavations at Helgö II*, Stockholm

HOOKE, D. 1985. *The Anglo-Saxon Landscape: The Kingdom of the Hwicce*, Manchester

HOOKE, D. 1990. *Worcestershire Anglo-Saxon Charter Bounds*, Ipswich

HOPE, W. St J. 1917. 'Recent discoveries in the Abbey of St Austin at Canterbury', *Arch. Cant.* XXXII, 1–26

HOWLETT, D. R. 1974. 'The Iconography of the Alfred Jewel', *Oxoniensia* 39, 49–52

HOWLETT, D. R. 1975. 'Alfred's *Aestel*', *English Philological Studies* 14, 65–74

HUGGETT, J. W. 1989. 'Imported grave goods and the early Anglo-Saxon economy', *Med. Arch.* 32, 63–94

HUGHES, K. 1958. 'British Museum MS Cotton Vespasian A.XIV: its purpose and provenance', in N. Chadwick (ed.), *Studies in the Early British Church*, 183–200

HUNTER, J. 1980. 'The glass', in P. Holdsworth, *Excavations at Melbourne Street, Southampton 1971–76*, CBA Research Report 33, 59–72

HUNTER BLAIR, P. (ed.) 1959. *The Moore Bede*, Early English Manuscripts in Facsimile 9, Copenhagen

HURST, D. (ed.) 1969. 'Bedae Venerabilis Opera II', *Corpus Christianorum, Series Latina* no. 119A

ISINGS, C. 1980. 'Glass finds from Dorestad Hoogstraat, I', in W. A. van Es and W. J. H. Verwers, *Excavations at Dorestad*, I, *The Harbour: Hoogstraat I*, Nederlandse Oudheden 9, Kromme Rijn Projekt, Amersfoort, 225–37

Ivory Carvings in Early Medieval England 700–1200 1974. Arts Council exhibition catalogue, Victoria and Albert Museum, London

JACKSON, K. 1973. 'Appendix A. The inscriptions', in A. Small, C. Thomas and D. M. Wilson, *St Ninian's Isle and its Treasure*, I, 167–73

JAMES, M. R. 1911. *A Descriptive Catalogue of the Manuscripts in the Library of Corpus Christi College, Cambridge*, II, Cambridge

JAMES, M. R. 1931. *Two Ancient English Scholars: St Aldhelm and William of Malmesbury*, Glasgow

JENNY, W. 1952. 'Das Sogenannte Rupertus-Kreuz in Bischof-shofen', in E. Arslan (ed.), *Arte del primo millennio: Atti del II° convegno per lo studio dell' arte dell' alto medievo, Pavia, 1950*, 383–9

JESSUP, R. 1950. *Anglo-Saxon Jewellery*, London

JONES, C. W. (ed.) 1977. 'Bedae opera De Temporibus', *Corpus Christianorum, Series Latina* no. 123B

JONSSON, K. and MALMER, B. (eds) 1990. *Proceedings of the Sigtuna Symposium on Viking Age Coinage 1–4 June 1989*, new series 6, London

KEEN, L. 1986. 'Late Saxon Strap Ends from Dorset', *Proceedings of the Dorset Natural History and Archaeological Society* 108, 195–6

KENDRICK, T. D. 1932. 'British Hanging Bowls', *Antiquity* VI, 161–84

KENDRICK, T. D. 1937. 'St Cuthbert's pectoral cross and the Wilton and Ixworth Crosses, *Ant. J.* XVII, 283–93

KENDRICK, T. D. 1938. *Anglo-Saxon Art to AD 900*, London

KENDRICK, T. D., BROWN, T. J., BRUCE-MITFORD, R. L. S., ROOSEN-RUNGE, H., ROSS, A. S. C., STANLEY, E. G., WERNER, A. E. A. 1956, 1960. *Evangeliorum Quattuor Codex Lindisfarnensis*, 2 vols, Olten/Lausanne

KENDRICK, T. D. and HAWKES, C. F. C. 1932. *Archaeology in England and Wales 1914–31*, London

KENT, J. P. C. 1961. 'From Roman Britain to Saxon England', in R. H. M. Dolley (ed.), *Anglo-Saxon Coins*, 1–22

KENT, J. P. C. 1972. 'The Aston Rowant treasure trove', *Oxoniensia* 37, 243–4

KENT, J. P. C. 1975. 'Catalogue of the Sutton Hoo coins, blanks and billets', in R. L. S. Bruce-Mitford, *The Sutton Hoo Ship-Burial*, I, 607–47

KENT, J. P. C. 1984. 'Crondall', in H. Beck *et al.* (eds), *Reallexikon der Germanischen Altertumskunde*, Berlin/New York, V, 102

KER, N. R. 1956. *The Pastoral Care*, Early English Manuscripts in Facsimile 6, Copenhagen

KER, N. R. 1957. *Catalogue of Manuscripts Containing Anglo-Saxon*, Oxford

KEYNES, S. 1985. 'King Athelstan's books', in M. Lapidge and H. Gneuss (eds), *Learning and Literature in Anglo-Saxon England*, Cambridge, 143–201

KEYNES, S. and LAPIDGE, M. 1983. *Alfred the Great*, London

KIDD, D. 1988. 'Beauty and the Beast: ambiguity in early medieval cloisonné jewellery', *Anzeiger der Germanischen Nationalmuseums*, 81–94

KIERNAN, K. S. 1981. *Beowulf and the Beowulf Manuscript*, New Brunswick

KINNEAR, R. B. 1906. 'Donations to the Museum (An ornamented fillet of thin bronze and five bosses of bronze from Dumfriesshire)', *PSAS* XL, 342–3

KIRBY, D. P. (ed.) 1974. *Saint Wilfrid at Hexham*, Newcastle upon Tyne

KIRBY, D. P. 1991. *The Earliest English Kings*, London

KITZINGER, E. 1956. 'The coffin-reliquary', in C. F. Battiscombe (ed.), *The Relics of Saint Cuthbert*, 202–97

KJØLBYE-BIDDLE, B. 1990. 'Early Medieval Spoons', in M. Biddle *et al.*, *Object and Economy in Medieval Winchester*, II, 828–33

KLUMBACH, H. 1974. 'Römische Helme aus Niedergermanien', *Kunst und Altertum am Rhein* 51, Cologne

KOCH, U. 1987. *Der Runde Berg bei Urach VI, Die Glas- und Edelsteinfunde aus den Plangrabungen 1967–1983*, I, Heidelberger Akademie der Wissenschaften, Kommission für Alamannische Altertumskunde, Schriften Band 12

KORNBLUTH, G. A. 1989. 'The Alfred Jewel: reuse of Roman Spolia', *Med. Arch.* 33, 32–7

KUHN, S. M. (ed.) 1965. *The Vespasian Psalter*, Ann Arbor, Michigan

KUYPERS, A. B. 1902. *The Prayerbook of Ædeluald the Bishop, commonly called the Book of Cerne*, Cambridge

LAFAURIE, J., JANSEN, B. and ZADOKS-JOSEPHUS-JITTA, A. 1961. 'Le tresor de Wieuwerd', *Oudheikundige Mededelingen* 42, 78–107

LAFONTAINE-DOSOGNE, J. 1977. *Sculptures du Haut Moyen Âge*, Musées Royaux d'Art et d'Histoire, Brussels

LAISTNER, M. L. W. 1943. *A Hand-list of Bede Manuscripts*, Ithaca, New York

LAMM, J. P. and NORDSTRÖM, H.-A. 1983. *Vendel Period Studies 2*, Statens Historiska Museum, Stockholm

LANG, J. T. (ed.) 1978. *Anglo-Saxon and Viking-Age Sculpture*, BAR British Series 49, Oxford

LANG, J. T. 1991. *Corpus of Anglo-Saxon Stone Sculpture, 4, Yorkshire*, Oxford

LAPIDGE, M. 1981. 'The Present State of Anglo-Saxon Studies', in M. Herren (ed.), *Insular Latin Studies*, 45–82

LAPIDGE, M. 1986. 'The School of Theodore and Hadrian', *Anglo-Saxon England* 15, 45–72

LAPIDGE, M. 1988. 'The Study of Greek at the School of Canterbury in the Seventh Century', in M. Herren (ed.), *The Sacred Nectar of the Greeks: The Study of Greek in the West in the Early Middle Ages*, London, 169–94

LAPIDGE, M. and HERREN, M. 1979. *Aldhelm: The Prose Works*, Cambridge

LAPIDGE, M. and ROSIER, J. L. 1985. *Aldhelm: The Poetic Works*, Cambridge

LASKO, P. 1972. *Ars Sacra 800–1200*, Harmondsworth

LEAHY, K. forthcoming. 'Middle Saxon Metalwork from South Newbald, North Humberside and the "Sancton" Coins', in M. A. S. Blackburn and D. M. Metcalf (eds), *Anglo-Saxon Productive Sites*, BAR, Oxford

LEEDS, E. T. 1936. *Early Anglo-Saxon Art and Archaeology*, Oxford

LEMBERG, M. and SCHMEDDING, B. 1973. *Abegg-Stiftung Bern in Riggisberg, II, Textilien*, Bern

LEVISON, W. 1905. *Vitae Sancti Bonifatii Archiepiscopi Moguntini*, Scriptores Rerum Germanicarum in usum Scholarum, Hanover

LEVISON, W. 1946. *England and the Continent in the Eighth Century*, Oxford

LIEBERMANN, F. 1898. *Gesetze der Angelsachsen*, vol. I, Halle

LIEBERMANN, F. 1921. 'Reim neben Alliteration im Anglolatein um 680', *Archiv für das Studium der neueren Sprachen und Literaturen* 141

LINCOLN 1984. *Lincoln: 21 Centuries of Living History: Lincoln Comes of Age*, Lincoln

LINDSAY, W. M. 1921. *The Corpus Glossary*, Oxford

LOBEL, M. and JOHNS, W. (eds) 1989. *The British Atlas of Historic Towns, III, The City of London*, Oxford

LONGHURST, M. 1927. *Catalogue of Carvings in Ivory, Victoria and Albert Museum, Department of Architecture and Sculpture, Part 1, Up to the Thirteenth Century*, London

LONGHURST, M. 1931. 'The Easby Cross', *Archaeologia* 81, 43–7

LOWE, E. A. 1960. *English Uncial*, Oxford

LOWICK, N. M. 1973. 'A New Type of Solidus Mancus', *NC* XIII, seventh series, 173–82

LOYN, H. R. 1963. *Anglo-Saxon England and the Norman Conquest*, London

LRBC = CARSON, R. A. G., HILL, P. V. B. and KENT, J. P. C. 1978. *Late Roman Bronze Coinage*, London

LUNDSTRÖM, P. 1975. 'Paviken I bei Västergarn-Hafen, Handelplatz und Werft', in H. Jankuhn, W. Schlesinger and H. Steur, *Vor- und Frühformen der europäischen Stadt im Mittelalter*, Göttingen, 82–93

LYNN, C. J. 1984. 'Some fragments of exotic porphyry found in Ireland', *The Journal of Irish Archaeology* 2, 19–32

LYON, C. S. S. 1956. 'A Reappraisal of the Sceatta and Styca Coinage of Northumbria', *BNJ* 28, 228–42

LYON, S. 1967. 'Presidential Address. Historical Problems of Anglo-Saxon Coinage 1', *BNJ* 36, 215–21

LYON, S. 1968. 'Presidential Address. Historical Problems of Anglo-Saxon Coinage 2. The ninth century – Offa to Alfred', *BNJ* 37, 216–38

LYON, S. 1969. 'Presidential Address. Historical Problems of Anglo-Saxon Coinage 3. Denominations and weights', *BNJ* 38, 204–22

LYON, S. 1970. 'Presidential Address. Historical Problems of Anglo-Saxon Coinage 4. The Viking Age', *BNJ* 39, 193–204

MCCARTHY, M. R. 1990. *A Roman, Anglian and Medieval Site at Blackfriars, Carlisle: Excavations 1977–9*, Cumberland and Westmorland Antiquarian and Archaeological Society Research Series 4

MACGREGOR, A. 1985. *Bone, Antler, Ivory and Horn*, London

MCGURK, P. 1961. *Latin Gospel Books from AD 400 to AD 800*, Paris/Brussels

Mack = MACK, R. P. 1975. *The Coinage of Ancient Britain*, 3rd edition, London

MCKITTERICK, R. 1989. *The Carolingians and the Written Word*, Cambridge

MACQUET, C. 1990. 'Les lissoirs de verre, approche technique et bibliographique', *Archéologie Médiévale* XX, 319–34

MCROBERTS, D. 1960–1. 'The Ecclesiastical Significance of the St Ninian's Isle Treasure', *PSAS* XCIV, 301–13

MCROBERTS, D. 1965. 'The Ecclesiastical Significance of the St Ninian's Isle Treasure', in A. Small (ed.), *The Fourth Viking Congress*, 224–46

MALONE, K. (ed.) 1963. *The Nowell Codex*, Early English Manuscripts in Facsimile 12, Copenhagen

MARQUARDT, H. 1961. *Bibliographie der Runen nach Fundorten*, I, *Runeninschriften der Britischen Inseln*, Göttingen

MARTIN, J. S. 1961. 'Some Remarks on Eighteenth-century Numismatic Manuscripts and Numismatists', in R. H. M. Dolley (ed.), *Anglo-Saxon Coins*, 227–40

MAXWELL, H. 1912–13. 'Notes on a Hoard of Personal Ornaments, Implements, and Anglo-Saxon and Northumbrian Coins from Talnotrie, Kirkcudbrightshire', *PSAS* XI, fourth series, 12–16

MAYR-HARTING, H. 1972. *The Coming of Christianity to Anglo-Saxon England*, London

MAZO-KARRAS, R. 1985. 'Seventh Century Jewellery from Frisia – a re-examination', *Anglo-Saxon Studies in Archaeology and History* 4, 159–77

MAZZOTTI, M. 1950. 'Antiche Stoffe Liturgiche Ravennati', *Feliz Ravenna* 53, 40–6

MEANEY, A. 1964. *A Gazetteer of Early Anglo-Saxon Burial Sites*, London

MEEKS, N. D. and HOLMES, R. 1985. 'Gold Backing Foils', *Anglo-Saxon Studies in Archaeology and History* 4, 143–8

MENGARELLI, R. (and G. SERGI) 1902. 'Necropoli barbarica di Castel Trosino', *Monumenti Antichi* XII, 145–379

MENGHIN, W. 1983. *Das Schwert im Frühen Mittelalter*, Stuttgart

MENIS, G. C. 1990. *I Longobardi*, Milan

METCALF, D. M. 1984. 'Monetary circulation in southern England in the first half of the eighth century', in D. Hill and D. M. Metcalf (eds), *Sceattas in England and on the Continent*, BAR British Series 128, 27–69

MIGNE, J. P. 1844–1974. *Patrologia Cursus Completus*, Paris

MILOJCIC, V. (ed.) 1972. *Kolloquium über spätantike und frühmittelalterliche Skulptur* I, Mainz

MINAEVA, T. M. 1982. 'Raskopi Svyatilnshcha i Mogil'nika Vozle Gorodishcha Gilyach v 1965g', in A. K. Ambroz and I. F. Erdeli (eds), *Drevnosti Épokhi Velikogo Pereseleniya v–vii Vekov*, 222–34

MOISL, H. 1981. 'Anglo-Saxon Royal Genealogies and Germanic Oral Tradition', *Journal of Medieval History* 7, 215–48

MONNAS, L. and GRANGER-TAYLOR, H. (eds) 1990. *Ancient and Medieval Textiles – Studies in Honour of Donald King*, London

MORRISH, J. 1986. 'King Alfred's letter as a source of learning in England', in P. Szarmach (ed.), *Studies in Earlier Old English Prose*, 87–107

MORRISH, J. 1988. 'Dated and Datable Manuscripts Copied in England During the 9th Century', *Medieval Studies* 50, 512–38

MOULIN, H. 1864. *Dissertation historique et archéologique sur l'église collegiale de Mortain*, Mortain

MURDOCH, T. (ed.) 1991. *Treasures and Trinkets*, Museum of London, London

MUSTY, J. W. G. 1969. 'The excavation of two barrows, one of Saxon date, at Ford, Laverstock, near Salisbury, Wilts', *Ant. J.* XLIX, 98–117

NAPIER, A. S. 1900. 'The Franks Casket', in *An English Miscellany presented to Dr Furnivall*, Oxford

NÄSMAN, U. 1986. 'Vendel period glass from Eketorp-II, Oland, Sweden', *Acta Archaeologica* 55, 55–116

NETZER, N. 1989. 'Willibrord's Scriptorium at Echternach and its Relationship to Ireland and Lindisfarne', in G. Bonner, D. Rollason and C. Stancliffe (eds), *St Cuthbert, his cult and his community to AD 1200*, 203–12

NEUMAN DE VEGVAR, C. L. 1990. 'The Origin of the Genoels-Eldern Ivories', *Gesta* XXIX, 8–24

NEVILLE, R. C. 1852. *Saxon Obsequies Illustrated by Ornaments and Weapons*, London

NEWMAN, J. 1991. 'The Boss Hall Anglo-Saxon Cemetery, Ipswich', *Saxon: The Newsletter of the Sutton Hoo Society* 14, np

NÍ CHATHÁIN, P. and RICHTER, M. (eds) 1984. *Irland und Europa: die Kirche im Frühmittelalter*, Veröffentlichungen des Europa Zentrums Tübingen. Kulturwissenschaftliche Reihe, Stuttgart

Ó CROINÍN, D. 1983. 'The Irish Provenance of Bede's Computus', *Peritia* 2, 229–47

ODDY, W. A. (ed.) 1988. *Metallurgy in Numismatics*, vol. 2, London

O'DELL, A. C. 1960. *St Ninian's Isle Treasure*, Aberdeen University Studies 141, Aberdeen

O'DELL, A. C. *et al.* 1959. 'The St Ninian's Isle Silver Hoard', *Antiquity* XXXIII, 241–68

OKASHA, E. 1971. *Handlist of Anglo-Saxon Non-Runic Inscriptions*, Cambridge

OKASHA, E. 1983. 'A Supplement to *Handlist of Anglo-Saxon Non-Runic Inscriptions*', *Anglo-Saxon England* 11, 83–118

OMAN, C.C. 1930. *Catalogue of Rings*, Victoria and Albert Museum, London

ORSI, P. 1912. 'Byzantium Siciliae. IV. Incensieri e candelieri in bronzo', *Byzantinische Zeitschrift* 21, 195–8

PAGAN, H. E. 1965. 'Coinage in the Age of Burgred', *BNJ* 34, 11–27

PAGAN, H. E. 1969. 'Northumbrian numismatic chronology in the ninth century', *BNJ* 38, 1–15

PAGAN, H. E. 1973. 'The Bolton Percy hoard of 1967', *BNJ* 43, 1–44

PAGAN, H. E. 1982. 'The coinage of the East Anglian kingdom from 825 to 870', *BNJ* 52, 41–83

PAGAN, H. E. 1986. 'Coinage in southern England, 796–874', in M. A. S. Blackburn (ed.), *Anglo-Saxon Monetary History*, 45–65

PAGE, R. I. 1964. 'Appendix A. The Inscriptions', in D. M. Wilson, *Anglo-Saxon Ornamental Metalwork 700–1100 in the British Museum*, 67–90

PAGE, R. I. 1973. *An Introduction to Old English Runes*, London

PAGE, R. I. 1989. 'Roman and Runic on St Cuthbert's Coffin', in G. Bonner, D. Rollason and C. Stancliffe (eds), *St Cuthbert, his cult and his community to AD 1200*, 257–65

PAINTER, K. S. 1990. 'The Seuso Treasure', *Minerva* 1, no. 4, 4–11

PARKES, M. B. 1976a. 'The handwriting of St Boniface: a re-assessment of the problems', *Beiträge zur Geschichte der Deutschen Sprache und Literatur* 98, 162–79, Tübingen

PARKES, M. B. 1976b. 'The Palaeography of the Parker Manuscript', *Anglo-Saxon England* 5, 149–72

PAULI, R. (trans.) 1853. *The Life of Alfred the Great*, London

PEERS, C. R. 1923–4. 'The Inscribed and Sculptured Stones of Lindisfarne', *Archaeologia* 74, 255–70

PEERS, C. R. and RADFORD, C. A. RALEGH. 1943. 'The Saxon Monastery at Whitby', *Archaeologia* 89, 27–88

PELTERET, D. 1981. 'Slave raiding and slave trading in early England', *Anglo-Saxon England* 9, 99–114

PÉRIN, P. and FEFFER, L.-C. (eds) 1985. *La Neustrie: Les pays au nord de la Loire de Dagobert à Charles le Chauvre (viiᵉ–ixᵉ siècles)*, Rouen

PHEIFER, J. D. 1974. *Old English Glosses in the Epinal–Erfurt Glossary*, Oxford

PHILLIPS, A. D. with HAYWOOD, B. forthcoming. *Excavations at York Minster*, I, Royal Commission on Historical Monuments, London

PHILLIPS, C. W. 1940. 'The excavation of the Sutton Hoo ship-burial', *Ant. J.* XX, 149–202

PIRIE, E. J. E. forthcoming. *Coins of the kingdom of Northumbria, c. 700–867, in the Yorkshire Collections*

PORTA, P. 1990. 'Oreficeria ed oggetti in metallo de Museo Civico Medievale', *Il Carrobbio* XVI, 335–9

PRETTY, K. 1972. 'Two Bronze Spiral-headed Pins', in A. C. C. Brodribb, A. R. Hands and D. R. Walker, *Excavations at Shakenoak Farm near Wilcote, Oxfordshire*, 84–5

Prou = PROU, M. M. 1892. *Catalogue des monnaies françaises de la Bibliothèque Nationale: les monnaies mérovingiennes*, Paris

RABEL, C. and PALAZZO, E. (eds) 1989. *Les plus beaux manuscrits de l'abbaye d'Echternach conservés à la Bibliothèque Nationale de Paris*, Paris

RADFORD, C. A. RALEGH 1956. 'The Portable Altar of Saint Cuthbert', in C. F. Battiscombe (ed.), *The Relics of Saint Cuthbert*, 326–35

RAHTZ, P. 1976. 'The building plan of the Anglo-Saxon monastery of Whitby Abbey', in D. M. Wilson (ed.), *The Archaeology of Anglo-Saxon England*, 459–62

RASHLEIGH, P. 1789. 'Account of antiquities discovered in Cornwall, 1774', *Archaeologia* XI, 83–4

RICHARDSON, H. and SAYLES, G. 1966. *Law and Legislation from Æthelberht to Magna Carta*, Edinburgh

RIGOLD, S. E. 1962–3. 'The Anglian Cathedral of North Elmham, Norfolk', *Med. Arch.* 6–7, 67–108

RIGOLD, S. E. 1975. 'The Sutton Hoo Coins in the light of the contemporary background of coinage in England', in R. L. S. Bruce-Mitford, *The Sutton Hoo Ship-Burial*, I, 653–77

RIGOLD, S. E. and WEBSTER, L. E. 1970. 'Three Anglo-Saxon Brooches', *Arch. Cant.* LXXXV, 1–18

ROACH SMITH, C. 1845. 'Merovingian Coins, etc., Discovered at St Martin's, near Canterbury', *NC* VII, 187–91

ROACH SMITH, C. 1860. 'On Anglo-Saxon remains recently discovered in various places in Kent', *Arch. Cant.* III, 35–46

ROBERTSON, A. 1956 (revised). *Anglo-Saxon Charters*, Cambridge

ROBINSON, E. S. G. et al. 1941–50. 'Department of Coins and Medals: d. English Coins and Medals', *British Museum Quarterly* 5

ROBINSON, P. R. 1988. *Catalogue of Dated and Datable Manuscripts c. 737–1600 in Cambridge Libraries*, Cambridge

ROESDAHL, E. et al. (eds) 1981. *The Vikings in England and in their Danish Homeland*, Anglo-Danish Viking Project, London

ROGERS, H. 1981. 'The Oldest West-Saxon text?', *Review of English Studies* XXXII, new series, 257–66

ROTH, U. 1979. 'Studien zur Ornamentik frühchristlicher handschriften der insularen Bereiches', *BerRGK* 60, 5–255

ROTH, U. 1987. 'Early Insular Manuscripts: Ornament and Archaeology, with special reference to the dating of the Book of Durrow', in M. Ryan (ed.), *Ireland and Insular Art AD 500–1200*, 23–9

RUGG BROWN, R. et al. (eds) 1986. *Modes and Interpretations in Old English Literature*, Toronto

RYAN, M. (ed.) 1987. *Ireland and Insular Art AD 500–1200*, Dublin

RYAN, M. 1990. 'The Formal Relationships of Insular Early Medieval Eucharistic Chalices', *PRIA* XC (c), no. 10, 281–356

SANDERS, W. B. 1878–84. *Facsimiles of Anglo-Saxon Manuscripts*, Southampton

SAWYER, P. 1957–62. *Textus Roffensis*, Early English Manuscripts in Facsimile 7, 11, Copenhagen

SAWYER, P. 1968. *Anglo-Saxon Charters: an annotated list and bibliography*, Royal Historical Society Guides and Handbooks 8, London

SAWYER, P. and WOOD, I. N. (eds) 1977. *Early Medieval Kingship*, Leeds

SCBI Berlin = *Sylloge of Coins of the British Isles* 36: KLUGE, B. 1987. *State Museum Berlin Coin Cabinet: Anglo-Saxon, Anglo-Norman and Hiberno-Norse Coins*, London

SCBI East Anglia = *Sylloge of Coins of the British Isles* 26: CLOUGH, T. H. McK. 1980. *Museums in East Anglia: the Morley St Peter hoard, Anglo-Saxon, Norman and Angevin coins and later coins of the Norwich mint*, London

SCHARER, A. 1982. *Die Angelsächsische Königsurkunde im 7 und 8*

Jahrhundert, Veröffentlichungen des Instituts für Österreichische Geschichtsforschung 26, Vienna

SCHILLER, G. 1981. *Ikonographie der christlichen kunst*, 1 (3), Gütersloh

SCHNITZLER, H. 1965. 'Les ivoires de l'école de la Cour de Charlemagne', in *Charlemagne*, 305–16

SEARLE, W. G. 1897. *Onomasticon Anglo-Saxonicum*, Cambridge

SIMPSON, A. 1981. 'The Laws of Ethelbert', in M. Arnold, T. Green, S. Scully and S. White (eds), *On the Laws and Customs of England: Essays in Honor of Samuel E. Thorne*, 3–15

SISAM, K. 1953. 'Anglo-Saxon Royal Genealogies', *PBA* 39, 287–348

SMALL, A. (ed.) 1965. *The Fourth Viking Congress*, Aberdeen

SMALL, A., THOMAS, C. and WILSON, D. M. 1973. *St Ninian's Isle and its Treasure*, 2 vols, Aberdeen University Studies 152, Oxford

SMALLRIDGE, A. 1969. 'A Late Eighth-Century Disc from Mavourne Farm, Bolnhurst, Bedfordshire', *Beds. Arch. J.* IV, 13–15

SMITH, C. R. 1863. 'Saxon Remains found near Ixworth', *Proceedings of the Suffolk Institute of Archaeology* III, 296–7

SMITH, R. A. 1904. 'Some Anglo-Saxon Silver Ornaments Found at Trewhiddle, Cornwall, in 1774', *PSA* 20, 47–55

SMITH, R. A. 1905. *Victoria County Histories, Buckinghamshire* I, *Anglo-Saxon Remains*, London

SMITH, R. A. 1911. *Victoria County Histories, Suffolk* I, *Anglo-Saxon Remains*, London

SMITH, R. A. 1923. *A Guide to the Anglo-Saxon and Foreign Teutonic Antiquities in the Department of British and Mediaeval Antiquities, British Museum*, London

SPEAKE, G. 1980. *Anglo-Saxon Animal Art and its Germanic Background*, Oxford

SPEED, J. 1611. *The History of Great Britaine*, London

SQUILBECK, J. 1966–7. 'La tentation du Christ au désert et le *Belliger Insignis*', *Bulletin des Musées Royaux d'Art et d'Histoire* 38–9, 117–52

STEVENS, H. M. 1990. 'Maaseik reconstructed: a practical investigation and interpretation of 8th-century embroidery techniques', in P. Walton and J.-P. Wild (eds), *Textiles in Northern Archaeology, North European Symposium for Archaeological Textiles Monograph 3*, London, 57–60

STEVENSON, W. M. (ed.) 1904. *Asser's Life of King Alfred*, Oxford

STEWART, B. H. I. H. 1990. 'Ministers and moneyers', *Proceedings of the 10th International Congress of Numismatics, London 1986*, Wetteren, Belgium, 339–40

STEWART, I. 1978a. 'Anglo-Saxon gold coins', in R. A. G. Carson and C. M. Kraay (eds), *Scripta Nummaria Romana: essays presented to Humphrey Sutherland*, 143–72

STEWART, I. 1978b. 'A lead striking of William II's last coin-type', *NC* XVIII, seventh series, 185–7

STEWART, I. 1986. 'The London mint and the coinage of Offa', in M. A. S. Blackburn (ed.), *Anglo-Saxon Monetary History*, 27–43

STIAFFINI, D. 1985. 'Contributo ad una prima sistemazione tipologica dei materiali vitrei altomedievali', *Archeologia Medievale* XII, 667–88

STOLPE, H. and ARNE, T. J. 1927. *La Nécropole de Vendel*, Stockholm

STRZYGOWSKI, J. 1904. *Catalogue général des antiquités égyptiennes du Musée de Caire: Koptische Kunst*, Vienna

SUTHERLAND, C. H. V. 1948. *Anglo-Saxon Gold Coinage in the light of the Crondall Hoard*, London

SWANTON, M. (ed.) 1970. *The Dream of the Rood*, Manchester

SWEET, H. (ed.) 1871–2. *King Alfred's West Saxon Version of Gregory's Pastoral Care*, Early English Text Society 45, 50, London

SZARMACH, P. (ed.) 1986. *Studies in Earlier Old English Prose*, Binghamton, New York

TAIT, G. H. (ed.) 1976. *Jewellery through 7000 Years*, London

TAIT, G. H. (ed.) 1986. *Seven Thousand Years of Jewellery*, London

TALBOT, C. H. 1954. *The Anglo-Saxon Missionaries in Germany*, London

TAYLOR, H. M. and J. 1966. 'Architectural Sculpture in Pre-Norman England', *JBAA* 29, 3–51

TAYLOR, J. and WEBSTER, L. E. 1984. 'A Late Strap-End Mould from Carlisle', *Med. Arch.* 28, 178–81

TEMPLE, E. 1976. *Anglo-Saxon Manuscripts 900–1066* (A Survey of Manuscripts Illuminated in the British Isles, vol. 2), London

THOMPSON, A. H. (ed.) 1923. *Liber vitae ecclesiae Dunelmensis*, Surtees Society 136, Durham

THOMPSON, A. H. (ed.) 1934, reprinted 1969. *Bede, His Life, Times and Writings*, Oxford

THOMPSON, E. M. (ed.) 1884. *Catalogue of Ancient Manuscripts in the British Museum*, II, *Latin*, London

THOMPSON, F. H. (ed.) 1983. *Studies in Medieval Sculpture*, London

TIETZE, H. 1913. *Die Denkmale des benedicktinerstiftes St Peter in Salzburg*, Österreichische Kunsttopographie 12, Vienna

TOPIČ-MERSMANN, W. 1984. 'Das Kreuz von Bischofshofen als *crux gemmata*', in Bischofshofen, *5000 Jahre Geschichte und Kultur*, 125–52

Trésors d'art religieux au Pays de Visé et Saint Hadelin, Visé

Trésors des églises de France 1965. Musée des Arts Decoratifs, Paris

TWEDDLE, D. 1983. 'Anglo-Saxon Sculpture in South-East England before c. 950', in F. H. Thompson (ed.), *Studies in Medieval Sculpture*, 18–40

TWEDDLE, D. 1984. *The Coppergate Helmet*, York Archaeological Trust, York

VERDIER, P. 1981. 'Twelfth-Century Châsse of St Ode from Amay', *Wallraf-Richartz-Jahrbuch* XLII, 7–94

VEREY, C. D. 1989. 'The Gospel Texts at Lindisfarne at the Time of St Cuthbert', in G. Bonner, D. Rollason and C. Stancliffe (eds), *St Cuthbert, his cult and his community to AD 1200*, 143–50

VEREY, C. D., BROWN, T. J. and COATSWORTH, E. 1980. *The Durham Gospels*, Early English Manuscripts in Facsimile 20, Copenhagen

VINCE, A. G. 1991. *Aspects of Anglo-Norman London* II, London

WALDBAUM, J. C. 1983. *Metalwork from Sardis: the Finds through 1976*, Archaeological Exploration of Sardis Monograph 8, Cambridge, Massachusetts/London

WALLACE-HADRILL, J. M. 1971. *Early Germanic Kingship in England and on the Continent*, Oxford

WALLACE-HADRILL, J. M. 1988. *Bede's Ecclesiastical History of the English People: A Historical Commentary*, Oxford

WALLER, J. G. 1901–3. 'Part of a "Tabella" Found at Blythburgh, Suffolk', *PSA* XIX, second series, 41–2

WARD, G. 1945. 'The Lost Dens of Little Chart', *Arch. Cant.* LVIII, 1–7

WARNICKE, R. 1979. 'The Lawrence Nowell Manuscripts in the British Library', *British Library Journal* V, 201–2

WATERMAN, D. M. 1959. 'Late Saxon, Viking and Early Medieval Finds from York', *Archaeologia* XCVII, 59–105

WATKIN, J. R. 1986. 'A Late Anglo-Saxon Sword from Gilling West, North Yorkshire', *Med. Arch.* 30, 93–9

WATKIN, J. R. and MANN, F. 1981. 'Some late Saxon finds from Lilla Howe, N. Yorkshire and their context', *Med. Arch.* 25, 153–7

WATSON, A. G. 1979. *Catalogue of the Dated and Datable Manuscripts c. 700–1600 in the Department of Manuscripts, The British Library*, London

WEBSTER, L. E. 1980. 'An Anglo-Saxon plaque with the symbol of St John the Evangelist', in *Department of Medieval and Later Antiquities: New Acquisitions 1 (1976–8)*, part I, British Museum Occasional Paper 10, London, 11–14

WEBSTER, L. E. 1982a. 'The Canterbury Pendant', *Antiquity* LVI, 203–4

WEBSTER, L. E. 1982b. 'Stylistic aspects of the Franks Casket', in R. T. Farrell (ed.), *The Vikings*, 20–32

WEBSTER, L. E. 1984. 'The Legacy of Alfred', in J. Backhouse, D. H. Turner and L. E. Webster (eds), *The Golden Age of Anglo-Saxon Art 966–1066*, 18–19

WELCH, M. 1983. *Early Anglo-Saxon Sussex*, BAR British Series 112, Oxford

WERNER, J. 1959. 'Frühkarolingische Silberohrringe von Rastede (Oldenburg)', *Germania* XXXVII, 179–92

WERNER, J. 1985. *The Sutton Hoo Ship Burial: Research and publication between 1939 and 1980*, Oxford

WHEELER, R. E. M. 1935. *London Museum Catalogue: No. 6, London and the Saxons*, London

WHITE, R. 1988. *Roman and Celtic Objects from Anglo-Saxon Graves*, BAR British Series 191, Oxford

WHITELOCK, D. 1967. *Sweet's Anglo-Saxon Reader in Prose and Verse*, Oxford

WHITELOCK, D. 1968. *The Genuine Asser*, Stenton Lecture, Reading

WHITELOCK, D. 1972. 'The pre-Viking age church in East Anglia', *Anglo-Saxon England* 1, 1–22

WHITELOCK, D. 1979. *English Historical Documents c. 500–1042*, English Historical Documents 1, 2nd edition, London

WILSON, D. M. 1960. 'The Fejø Cup', *Acta Archaeologica* XXXI, 147–73

WILSON, D. M. 1964. *Anglo-Saxon Ornamental Metalwork 700–1100 in the British Museum, Catalogue of Antiquities of the Later Saxon Period*, I, London

WILSON, D. M. 1965a. 'Late Saxon Metalwork from the Old Minster, 1964', *Ant. J.* XLV, 262–4

WILSON, D. M. 1965b. 'Some Neglected late Anglo-Saxon Swords', *Med. Arch.* 9, 32–54

WILSON, D. M. 1970. *Reflections on the St Ninian's Isle Treasure*, Jarrow Lecture

WILSON, D. M. 1973. 'The Treasure', in A. Small, C. Thomas and D. M. Wilson, *St Ninian's Isle and its Treasure*, Oxford, 45–148

WILSON, D. M. (ed.) 1976. *The Archaeology of Anglo-Saxon England*, London

WILSON, D. M. 1984. *Anglo-Saxon Art*, London

WILSON, D. M. and BLUNT, C. E. 1961. 'The Trewhiddle Hoard', *Archaeologia* 98, 75–122

WILSON, D. M. and KLINDT-JENSEN, O. 1966. *Viking Art*, London

WILSON, H. A. (ed.) 1918. *The Calendar of St Willibrord*, Henry Bradshaw Society 55, London

WIBIRAL, N. 1987. 'Bemerkungen zum neuen Werk über früh-und hochmittelalterliche Schatzkunst aus Österreichischen Kirchen und Klostern', *Österreichische Zeitschrift für Kunst und Denkmalpflege* 41, heft 3/4, 136–50

WOOD, I. N. 1983. 'The Merovingian North Sea', *Occasional Papers on Medieval Topics* 1, Viktoria Bokforlag Alingsås, 1–26

WOOD, I. N. 1990. 'Ripon, Francia and the Franks Casket in the Early Middle Ages', *Northern History* 26, 1–19

WOOD, I. N. 1991. 'The Franks and Sutton Hoo', in I. N. Wood and N. Lund (eds), *People and Places in Northern Europe 500–1600*, Woodbridge, 1–14

WORMALD, F. 1954. 'The Miniatures in the Gospels of St Augustine, Corpus Christi College, Cambridge, MS 286', in J. J. G. Alexander *et al.* (eds), *Francis Wormald: Collected Writings*, I, 13–35

WORMALD, F. 1984. 'Decorated Initials in English Manuscripts from AD 900 to 1100', in J. J. G. Alexander *et al.* (eds), *Francis Wormald: Collected Writings*, I, 47–75

WORMALD, P. 1984. *Bede and the Conversion of England: the Charter Evidence*, Jarrow Lecture

WRIGHT, C. E. 1951. 'The Dispersal of the Monastic Libraries', *Transactions of the Cambridge Bibliographical Society* III, 208–37

WRIGHT, D. H. 1963. 'The Tablets from Springmount Bog, a key to early Irish palaeography', *AJA* 67, 219

WRIGHT, D. H. 1985. 'The Byzantine Model of a Provincial Carolingian Ivory', *Abstracts of Papers, Eleventh Annual Byzantine Studies Conference, Toronto, Oct. 25–27*, 10–12

WRIGHT, D. H. 1967. *The Vespasian Psalter*, Early English Manuscripts in Facsimile 14, Copenhagen

YORKE, B. 1985. 'The Kingdom of the East Saxons', *Anglo-Saxon England* 14, 1–36

YORKE, B. 1989. 'The Jutes of Hampshire and Wight and the Origins of Wessex', in S. Bassett (ed.), *The Origins of Anglo-Saxon Kingdoms*, 84–96

YOUNG, P. 1638. *Gilberti Foliot episcopi Londinensis, Expositio in Canticum canticorum, una cum compendio Alcuini*, London

YOUNGS, S. M. 1983. 'Silver spoons', in R. L. S. Bruce-Mitford, *The Sutton Hoo Ship-Burial*, III, 189–90

YOUNGS, S. M. *et al.* 1984. 'Medieval Britain and Ireland in 1983', *Med. Arch.* 28, 203–65

YOUNGS, S. M. (ed.) 1989. *'The Work of Angels': Masterpieces of Celtic Metalwork, 6th–9th Centuries AD*, London

YPEY, J. 1962–3. 'Die Funde aus dem frühmittelalterlichen Graberfeld Huinerveld bei Putten im Museum Nairac zu Barneveld', *Berichten Rijksdienst voor het Oudheidkundig Bodemonderzoek* 12–13, 99–152

ZUPITZA, J. (ed.) 1959. *Beowulf*, Early English Text Society 245, London

Lindisfarne
Yeavering • • Bamburgh

Jarrow
Talnotrie • Ruthwell • Bewcastle • • Monkwearmouth
Hexham •

Escomb • Goldsborough
• Whitby
Lastingham • • Lilla Howe
• Ripon

York •

• Cuerdale

Flixborough •

Lincoln •
• Benty Grange

Beeston Tor • Pentney
Repton • • Breedon Bawsey • • North Elmham
Crowland Brandon
Lichfield • • Peterborough • Morley St Peter
• Middle Harling

Brixworth • Dunwich
Worcester • Bury St Edmunds • Sutton Hoo
Hereford • Deerhurst • Ashdon Ipswich
Gloucester Bradwell
Llandeilofawr • Cirencester Aston Rowant
Enfield Minster-in-
Malmesbury • London • Barking Thanet
Taplow Croydon • Reculver
Cheddar Crondall Gravesend Rochester Canterbury
Glastonbury • Winchester
Britford •
Sherborne •
Hamwic • •
Crediton Selsey
Exeter •

Trewhiddle • Anglo–Saxon England 600–900:
principal places mentioned in the text

305

Lenders to the exhibition

United Kingdom
Bamburgh
Executors of the Rt Hon. Lord Armstrong 45, 195
Bedford
Bedford Museum 185
Brandon
Brandon Remembrance Playingfield Committee 66b
Bury St Edmunds
Archaeological Unit, Suffolk County Council 66c–y
St Edmundsbury Borough Museums 40
Cambridge
Fitzwilliam Museum 221c
The Master and Fellows of Corpus Christi College 1, 58, 63, 83b, 233, 242
University Library 2, 165
Canterbury
Canterbury City Museums (The Royal Museum and Art Gallery) 10, 174
Chichester
The Dean and Chapter, and West Sussex Record Office 157
Clitheroe
The Hon. R. C. Assheton 262b
Codford
The Vicar and Parochial Church Council of Codford St Peter 208
Croft on Tees
The Churchwardens and Croft Church Committee, St Peter's Church 115
Cropthorne
The Vicar, Churchwardens and Parochial Church Council of St Michael's Church 209
Derby
Derby Museum and Art Gallery 212
Diss
Ms H. Stevens 143a (uncatalogued)
Dumfries
Dumfries Museum 102
Durham
The Dean and Chapter 79, 81, 89, 98, 99, 100
Eccles
Dr A. P. Detsicas 7
Edinburgh
Historic Scotland, from Jedburgh Abbey 114
Faculty of Advocates 203
National Museums of Scotland 135, 177, 178, 247, 248

Elstow
The Vicar and Churchwardens of Elstow Abbey 207
Gloucester
Gloucester Archaeology, Gloucester City Museums 176
Godalming
The Vicar and Churchwardens, Godalming Parish Church 211
Hanley
Sir Berwick Lechmere, Bt, Hanley Castle 210
Hartlepool
Hartlepool Museum Service 106
Hereford
The Cathedral Library 91
Hexham
The Rector, Churchwardens and Parochial Church Council of Hexham Abbey 110
Hutton le Hole
The Ryedale Folk Museum 112
Ipswich
Ipswich Co-operative Society 33
Jarrow
St Paul's Church 109
St Paul's Church, Jarrow, and St Paul's Jarrow Development Trust 105
King's Lynn
Norfolk Museums Service, King's Lynn Museum 188
Lastingham
The Vicar and Parochial Church Council of St Mary's, Lastingham 112, 113
Lewes
Sussex Archaeological Society, Barbican House Museum 193
Lichfield
The Dean and Chapter 90
Lincoln
City of Lincoln Archaeology Unit 192
Liverpool
National Museums and Galleries on Merseyside, Liverpool Museum 5, 32, 249
London
English Heritage and Lindisfarne Priory Museum 71, 117
English Heritage and St Augustine's Abbey Foundation 18

Museum of London 181, 252
The National Trust 87b
Passmore Edwards Museum 67
The Trustees for Roman Catholic Purposes Registered 86
The Trustees of the Victoria and Albert Museum 140, 175
Monkwearmouth
The Vicar, Churchwardens and Parochial Church Council, St Peter's Church 72, 111
Norwich
Norfolk Museums Service, The Castle Museum 139, 146b, 188, 196
Oxford
The Curators of the Bodleian Library 124, 166, 235
The Visitors of the Ashmolean Museum 11, 21, 48a–e, 180, 186, 259, 260
Rochester
The Dean and Chapter 25
Scunthorpe
Sir Reginald Sheffield, Bt, and Scunthorpe Museums 69
Sheffield
Sheffield City Museums 46, 250
Southampton
Southampton City Museums 44
Whitby
Miss L. A. Strickland 107
Winchester
Winchester Museums Service/Winchester Excavations Committee 136, 200
York
The Dean and Chapter of York 108, 116
York Castle Museum 47
York City Council 204, 253, 254
The Yorkshire Museum 43, 134, 183, 251, 255

Republic of Ireland
Dublin
National Museums of Ireland 64

Belgium
Brussels
Musées Royaux d'Art et d'Histoire 141
Maaseik
Kerkfabriek St Catharina 143

France
Mortain
M. le Maire et la Ville de Mortain (Manche) 137
Paris
Bibliothèque Nationale 24, 123, 155, 168, 213

Germany
Braunschweig
Herzog Anton Ulrich-Museum, Braunschweig 138
Cologne
Erzbischöfliche Diözesan- und Dombibliothek 126, 127
Mainz
Römisch-Germanisch Museum 131, 132, 133
Stuttgart
Württemburgische Landesbibliothek 128

Italy
Bologna
Museo Archeologico Civico (Museo Civico Medievale) 201

Sweden
Stockholm
Kungl. Bibliotheket 154

United States of America
Los Angeles
Los Angeles County Museum of Art 142

Vatican City
Biblioteca Apostolica Vaticana 85, 160

Private Collections
41, 188, 199, 256, 258

Authors of catalogue entries

MMA	Marion Archibald
JMB	Janet Backhouse
RNB	Richard Bailey
DB	Derek Braine
MPB	Michelle Brown
RDC	Robert Carr
CJSE	Chris Entwistle
ACE	Angela Evans
VIE	Vera Evison
CH	Cathy Haith
KL	Kevin Leahy
SM	Susan Mills
PM	Paul Mullarkey
RIP	Ray Page
AP	Andrew Prescott
IR	Ian Riddler
RMS	Michael Spearman
DT	Dominic Tweddle
LW	Leslie Webster
PW	Peter Welford
DMW	David Wilson
SY	Susan Youngs

Acknowledgements

Leslie Webster and Janet Backhouse would like to thank the many people who have contributed to the making of this book and the exhibition it accompanies. First and foremost, we are indebted to the lenders and to all our co-authors and contributors, without whose generosity neither book nor exhibition could have existed. We are especially grateful to those friends and colleagues whose wise counsel and unstinting support have shaped this whole enterprise: Marion Archibald, Michelle Brown, Angela Evans, Simon Keynes, Michael Lapidge, Andrew Prescott, Dominic Tweddle, David Wilson and Susan Youngs.

Our thanks are also due to those who gave help and advice, conjured up illustrations, opened doors and helped to unravel red tape: especially Michel Amandry, Canon John Armson, François Avril, Richard Bailey, David Baker, Bruce Barker-Benfield, Canon A. N. Barnard, Abbot Oddo Bergmair OSB, Martin Biddle, M. A. S. Blackburn, H. W. Böhme, the Rev. L. E. Boyle OP, T. V. Buttrey, Eric Cambridge, Marion Campbell, R. D. Carr, Martin Carver, Juan-Antonio Cervelló-Margalef, Mary Clapinson, John Clark, Canon R. L. Coppin, Rosemary Cramp, Marilyn Deegan, Michel Dhenin, Angela Dillon Bussi, Philip Dixon, Vera Evison, Hermann Fillitz, Richard Gem, Annie Gilbert, Patricia Gill, Barbara Green, Elizabeth Hartley, Sonia Hawkes, Felix Heinzer, N. Holmes, B. Hope-Taylor, Jill Ivy, Simon Jervis, Laurence Keen, Erhard Koppensteiner, E. LeRoy Ladurie, Mme J. Lafontaine-Dosogne, Jim Lang, Kevin Leahy, Rev. Gareth Lloyd, Ken McGowan, Arthur McGregor, Edward Maeder, Sue Margeson, K. Matthews, D. M. Metcalf, Susan Mills, Nancy Netzer, John Newman, Ray Page, Patrick Périn, Fiona Philpott, Lawrence Pordes, Andrée Pouderoux, Graham Reed, Baron Hermann von Richthofen, Hannah Schlee, R. M. Spearman, Helen Stevens, R. B. K. Stevenson, Patricia Stirnemann, Rev. John Tipping, Dr W. Topič-Mersmann, Keith Wade, David Way, Jeffrey West, Stanley West, Börje Westlund, Ben Whitwell, Patricia Wilkinson, Joan Williams, Paul Williamson, Nigel Yates and Patrick Zutschi.

Many colleagues in the British Museum and British Library have also helped in all kinds of ways: particular thanks are due to Gordon Barber, Janet Benoy, Jane Carr, Jennifer Dinsmore, Stephen Dodd, Celestine Enderly, Chris Entwistle, Jim Farrant, Beverley Fryer, R. A. Gardner and the Coins and Medals Department's Museum Assistants, Tricia Gibbs, Ruth Goldstraw, Pamela Goss, Christi Graham, Cathy Haith, M. E. P. Jones, Shelley Jones, Janet Larkin, Deirdre Le Faye, Nick Lee, Margaret Massey, Christine Bard, Ruth Nelson and the Medieval and Later Antiquities Department's Museum Assistants, Rob Miller, Simon Muirhead, Janet Murray, Nick Newbery, Joan Noble, Jon Ould, D. R. Owen, Tony Parker and the British Library Conservation Section, Pamela Porter, Allyson Rae, Fleur Sherman, the late Valerie Springett, Peter Taylor, Jim Thorne, Julia Walton and Ted Woods.

Finally, perhaps our most tangible debt is to those without whom the passage of this book would have been considerably harder: Noël Adams, who, amongst many other labours on the exhibition's behalf, compiled the bibliography and whose meticulous eye brought order to many other intransigent areas of the volume; James Shurmer, most understanding of designers; and our editor, Nina Shandloff, for her wonderfully undaunted patience with a complex and sometimes unruly task.

Illustration acknowledgements

Photographs and drawings have been supplied by the lenders with the following exceptions:
Oskar Anrather and Diocesan Museum, Salzburg 133; Hallam Ashley 139; David Baker and Beds. County Council 207; Beaver Photography, Chichester 157; Martin Biddle 212; Miles Birch and N. Beds. Borough Council 185; British Museum 41, 66b, 67a,w, 69, 183, 208, 209, 257, 258; Michelle Brown figs. 14, 23; Mildred Budny 58, 63, 242; Mildred Budny and Dominic Tweddle 142; Foto Studio Professionale CNB&C, Bologna 201; Studio Photo Maurice Chemin, Mortain 137; Courtauld Institute of Art 136; Philip Dixon figs. 3, 9, 15, 16, 19, 20, 22, 28; Durham University Department of Archaeology figs. 10, 13, and 71, 72, 109, 111, 113, 114, 115, 116; Jim Farrant figs. 1, 4, 7, 29; Soprintendenza Beni Artistici e Storici di Firenze 70b; Sheena Howarth and York Archaeological Trust 253; Simon James figs. 5, 6, 17; B. P. Kaiser and Herzog Anton Ulrich-Museum, Braunschweig 138; Elfriede Mejchar, Vienna 131; National Museums of Scotland 203; Charlie Nickols Photography 134; Norwich Museums Service 188b,d,f,h; Mrs S. E. Hawkes, Oxford Institute of Archaeology and R. L. Wilkins fig. 2, and 7; Pierpont Morgan Library 132; Laboratorio Fotografico Donato Pineider 88; John Rackham 90; Graham Reed 67b,e,i,k,l–v; Sheridan Photo Library fig. 11; Lesley Spooner 199; Foto Tasselli-Ravenna di Bisca Antonio fig. 8; Jim Thorne 45, 108; Ross Trench-Jellicoe 195; Dominic Tweddle figs. 24, 25, and 211; Ch. Valkenberg, Brussels 141; Victoria and Albert Museum fig. 12; David Williams 67c,d,f–h,j; David Wright figs. 18, 21, 26, 27; York Archaeological Trust 43, 204, 254